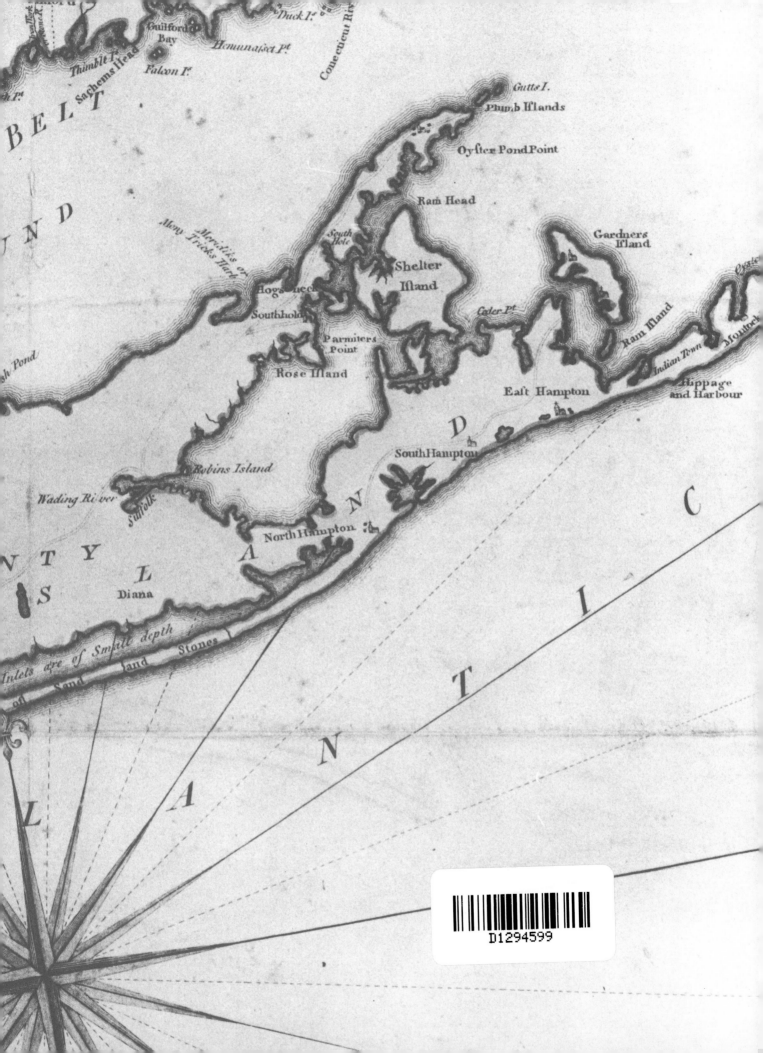

LONG ISLAND IS MY NATION

NEW EDITION

LONG ISLAND IS MY NATION

The Decorative Arts & Craftsmen

1640-1830

Dean F. Failey

With the assistance of
Robert J. Hefner & Susan E. Klaffky

Society for the Preservation of Long Island Antiquities

Society for the Preservation of Long Island Antiquities
161 Main Street
P. O. Box 148
Cold Spring Harbor, New York 11724

Tel: 516-692-4664
Fax: 516-692-5265
splia@aol.com

Printed in the United States of America

Library of Congress Catalog Card Number 98-61714

ISBN 0-9669103-0-3

This second edition was produced with the assistance of Mount Ida Press,
152 Washington Avenue, Albany, New York 12210.

Funding for the dust jacket has been provided by Christie's, the Chipstone Foundation, and
generous friends of the Society for the Preservation of Long Island Antiquities.

Funding for the book was received from "Furthermore," the publication program of the J.M. Kaplan
Fund and we are indebted to Joan K. Davidson, President of "Furthermore," and her staff for this
assistance, as well as for their terrific encouragement and advice.

Endleaf: *Map of the Province of New York*, **1775**
John Montresor (1736-1799)
Engraving on Paper
H. 31 5/8 W. 39 1/2
Society for the Preservation of Long Island Antiquities, 59.23B

TABLE OF CONTENTS

6 Foreword

7 Preface

9-1 Preface to Second Edition

9-5 New Discoveries

11 I. A Meeting Ground of Cultures, 1640-1730

51 II. Fashion and Tradition, 1730-1782

150 III. Long Island Is My Nation, 1782-1830

191 IV. The Craftsmen, 1640-1830

215 Bibliographical Essay

218 Introduction to Appendices

219 Key to Abbreviations and Short Titles

Appendix I
Long Island Woodworking Craftsmen, 1640-1830
222 A. List of Craftsmen
269 B. Sketches of Craftsmen

Appendix II
Long Island Silversmiths, Clockmakers, Watchmakers, and Pewterers, 1640-1830
294 A. List of Craftsmen
299 B. Sketches of Craftsmen

FOREWORD

Not since the mid-thirties when Huyler Held, father of the Society's President in 1976, scouted the Hempstead Plains during his spare moments in search for Long Island vernacular furniture and wrote of his findings in Antiques *has much attention been focused on the Island's rich decorative arts tradition—a tradition whose depth is comparable to other areas with discernible geographic boundaries such as the more celebrated Connecticut River Valley. And yet, Long Island decorative arts were not fashioned in near isolation. They were formed by the spread of influences from all quarters of the compass. Situated in mid-stream, the Island was a meeting ground of cultures in the age of sail and is now an historian's dream, a crossword puzzle of cultural diffusion.*

This bicentennial year project of the Society could not have been undertaken without support from the New York State Council on the Arts, the Suffolk County Office of Cultural Affairs and the Charles E. Merrill Trust, whose grants for this purpose are gratefully acknowledged. Nor would there have been an exhibition without the unfailing support and cooperation of The Museums At Stony Brook, its dedicated staff and exceptional director, Susan Stitt.

This catalogue and exhibition, two years in the making, were carefully orchestrated by Dean F. Failey who joined the Society as curator in July, 1974, to undertake this vast endeavor. His visual acuity, great store of knowledge and ability to see subtle relationships between pieces is well testified to in this superlative catalogue. He has been ably assisted by historian Susan E. Klaffky and researcher Robert J. Hefner whose scholarship is also reflected herein. This publication includes more than one hundred objects not included in the exhibition and thus provides an expanded view of the subject not possible in the gallery space.

To the lenders to the exhibition and to the owners of objects pictured in the catalogue we extend our thanks for participating in this major contribution to an understanding of Long Island decorative arts and craftsmen, 1640–1830.

Robert B. MacKay
Director

PREFACE

It seems incredible that an area as densely populated and strategically located as Long Island could still be so much in the dark about its past more than three hundred years after the first settlement by Europeans. Yet, the last comprehensive history of Long Island was written in the nineteenth century. The obvious need and opportunity for additional research became apparent as we began to prepare this introductory study on Long Island's decorative arts and craftsmen.

We found in the many manuscript repositories a treasure trove of personal papers, account books, and public records. We also quickly realized that years of study will be necessary to organize these materials and create a satisfactory framework to serve as a starting point for intensive investigations of Long Island's political, economic, and social history. Such studies are now recognized as invaluable in fully interpreting the cultural life of a region. The format of this book developed from such an awareness, since we felt that an understanding of broad historic change during the seventeenth and eighteenth century was critical to an understanding of developments in the decorative arts. As this was to be an introductory study, we of course had to be selective in the choice of both objects and information. We were, unfortunately, unable to consider many local private manuscript and decorative arts collections during the course of our investigations for no other reason than lack of time. We look forward to consulting new materials and incorporating new discoveries in future studies. We fully realize that many aspects of Long Island's cultural history deserve systematic in-depth analysis, and we hope that our effort will generate interest in that direction for students of Long Island's past.

Certain important themes emerged as we discovered, selected, and grouped examples of furniture, silver, textiles, and other items. With the exception of the last chapter which deals with Long Island craftsmen, each of the first three sections begins with an essay on what we perceived to be a major theme of the particular time period considered. Brief examinations of families for whom a group of objects has survived and who serve to exemplify the major themes of the chapter follow the essay. A catalogue section, beginning with seating forms of furniture and continuing with tables, chests and case-pieces, miscellaneous forms, silver, metalwares, and textiles, concludes each chapter.

Basic information concerning each object is listed in the accompanying caption with additional information given in the entry. Pertinent references, if any, follow the entry. Several considerations precluded microscopic analysis of furniture woods in most cases. All measurements are given in inches.

We are grateful to the many individuals who became involved in the production of this catalogue and the accompanying exhibition. The support of the Board of Trustees of the Society in allowing me to undertake this project has been gratifying and I hope they feel rewarded for their faith. Robert B. MacKay, director of the Society, has constantly encouraged and promoted this important research. Without the dedicated and untiring efforts of my research assistant, Robert Hefner, and my editor and exhibition assistant, Susan Klaffky, this book would not have been possible. We are also grateful for substantial financial support from the New York State Council on the Arts, the Suffolk County Office of Cultural Affairs, and the Charles E. Merrill Trust.

Essential to our attempt to present an account of Long Island's decorative arts heritage were countless hours of documentary research. I would like to extend thanks to the following institutions and individuals for sharing their manuscript collections and specialized knowledge: James Dunning, manuscript librarian, New-York Historical Society; James Hurley, director, and Anthony Cucchiara, librarian, Long Island Historical Society; Arthur J. Konop, James A. Kelly Institute of Local Historical Studies, St. Francis College; Kevin Fogarty, chief clerk, Queens County Surrogate's Court; Marion Altman, curator of local history, Bryant Library; Mrs. Mary Louise Matera, librarian, Nassau County Museum Reference Library; Mrs. Agnes K. Packard, librarian, Huntington Historical Society; Michiko Taylor, librarian, The Museums At Stony Brook; Dr. Curtis Garrison, archivist, Long Island Room, Smithtown Public Library; Marion Terry, chief clerk, Suffolk County Historical

Society; Lester J. Albertson, Suffolk County Clerk; Merwin S. Woodard, chief clerk, Suffolk County Surrogate's Court; Dr. Jean Peyer; the staffs of the Southampton Colonial Society, the Smithtown Historical Society and the Microfilm Division of the State University of New York at Stony Brook; members of the Junior League of the North Shore, Inc., headed by Mrs. Gilbert Chapman and Mrs. Seth Thayer; and Florence Rosenblum. A very special word of gratitude is due to Miss Dorothy King, librarian, Long Island Collection, East Hampton Free Library, for assisting us beyond the bounds of duty.

In addition to the organizations and individuals mentioned above, many others allowed us to photograph and examine their collections. I am particularly grateful to Mrs. John K. Sands, President, Friends of Raynham Hall; Mrs. Ruth Brucia, Rock Hall; Mrs. Esther Hicks Emory; Mrs. John Tennent, Bowne House Historical Society; Edward Smits, director, Robert Frick, curator, and Robert Eurich, Nassau County Museum; John Collins, director, Huntington Historical Society; Gay Wagner, director, Northport Historical Society; Averill Geus, curator, Home Sweet Home; the Rev. Alexander Sime, Southold Presbyterian Church; the National Park Service staff, Fire Island National Seashore; the staff of the Bridgehampton Historical Society; and many other individuals who have preferred to remain anonymous. Valdemar Jacobsen has been helpful at several stages of this project. Morgan MacWhinnie generously provided information and contributed in many ways to the success of this undertaking.

Because most of the objects we wished to study and include in this catalogue and the exhibition had never before been photographed, photography was a vital part of our work. Joseph Adams, project photographer, responded to tiring sessions and difficult situations by producing brilliant photographs. Other photographs were supplied by Richard Di Liberto, Israel Sack, Inc., Ginsberg & Levy, Bernard & S. Dean Levy, Inc., the Brooklyn Museum, the Henry Francis du Pont Winterthur Museum, Independence National Historical Park, the Litchfield (Connecticut) Historical Society, the Metropolitan Museum of Art, the Museum of the City of New York, the Museum of Fine Arts, Boston, the Minneapolis Institute of Art, and the Nassau County Museum.

The staffs of a number of museums supplied pertinent information. I would like to mention especially, however, Margaret Stearns, Museum of the City of New York, and Dianne Pilgrim and Donald Peirce, the Brooklyn Museum, for their special assistance.

We were fortunate to have Joseph del Gaudio design this catalogue. He combined pages of text and stacks of photographs into a sensitive and attractive book. Randolph Staudinger has demonstrated his usual fine craftsmanship in executing the fabrication of the exhibition.

To Helen Miller fell the unenviable task of converting hundreds of pages of handwritten notes into drafts and finally the finished manuscript. She and the Society's staff patiently dealt with the demands, frustrations, and inconveniences generated by the author. Most patient of all was my wife, Marie.

Dean F. Failey

PREFACE TO THE SECOND EDITION

In the twenty-three years that have passed since the original publication of Long Island Is My Nation, *some significant new discoveries have been made that confirm, change, or add to our original study. In addition to republishing the catalogue, which has been out of print for nearly fifteen years, we have been able to include seventy-three new objects and related entries incorporating this new information.*

Long Island Is My Nation *was conceived as a Bicentennial project, and the catalogue accompanied an exhibition organized by the Society for the Preservation of Long Island Antiquities and held at The Museums at Stony Brook in 1976. Publicity surrounding the exhibition generated the first wave of new information, as well as commentary and observations from visitors and professional colleagues. Perhaps most importantly, the exhibition and catalogue produced an awareness of Long Island's material culture that has made new discoveries possible and was one of our original intended goals.*

Over the past two decades SPLIA has continued to explore aspects of Long Island material culture through exhibitions in its new gallery space in Cold Spring Harbor and through published studies that include Useful Art: Long Island Pottery *(1985);* Woven History, The Technology and Innovation of Long Island Coverlets, 1800-1860 *(1993); and* Long Island Country Houses and Their Architects, 1860-1940 *(1997).*

Other regional organizations have also promoted research into Long Island's past. The formation of a Long Island Studies Institute at Hofstra University portends future research in many areas. At a popular level, the past year has seen Newsday *undertake a major historical survey, "Long Island, Our Story," which will be published in book form. The public response to this series of articles confirms the growing interest that Long Islanders have in their history.*

Further afield, The Henry Francis du Pont Winterthur Museum in Delaware has reinstalled the important Dominy family woodworking and clock shops, along with the collection of tools and templates, in a new gallery. In conjunction with this expanded interpretive display, the museum has acquired several examples of Dominy-made furniture, including an armchair (No. 226), as well as the important Rhode Island-influenced Gardiner family desk-and-bookcase.

Over the past twenty years, there have been a few additions to the Long Island furniture bibliography: Dean F. Failey, "The Furniture Tradition of Long Island's South Fork, 1640-1800," The American Art Journal *(January 1979), pp. 49-64; Jay A. Graybeal and Peter M. Kenny, "The William Efner Wheelock Collection at the East Hampton Historical Society,"* Antiques *(August 1987), pp. 328-339; and Charles Hummel, "Using Tools to Earn a Living and the Dominy Family of East Hampton, Long Island,"* Historic Trades, *Colonial Williamsburg, Vol. III (1997).*

The most intensive follow-up study on any aspect of Long Island furniture was the 1991 exhibition held at The Metropolitan Museum of Art and accompanying catalogue by Peter M. Kenny, Frances Safford Gruber, and Gilbert T. Vincent, American Kasten: The Dutch-Style Cupboards of New York and New Jersey, 1650-1800 *(New York: The Metropolitan Museum of Art, 1991). In* Hearts and Crowns: Folk Chairs of the Connecticut Coast 1720-1840 *(New Haven: New Haven Colony Historical Society, 1977) Robert Trent has not only provided a case study in identifying local chair-making schools and shops and the evolution of products from those shops but also raised consciousness about a Long Island Sound chair style that is critical to understanding Long Island chair design.*

Several furniture scholars—including the late Benno Forman, Neil Kamil and Peter Kenny—have also begun to explore important aspects of early New York and by extension Long Island furniture.[1] However, their work and that of other scholars has been hindered by several historical factors: the loss of artifacts and written records by fire, plunder, and occupation during the Revolutionary War and the departure of thousands of inhabitants, their furniture, and documents after the war; the complexity of the ethnic and cultural make-up of New York's population; the enormous and rapid growth of the city and its outlying suburbs, particularly on

western Long Island; and the tragic loss of many local records in the 1911 fire at the New York State Library in Albany.

Yet piece by piece we have continued to put together the puzzle. The importance of the early towns on the west end of Long Island, the craftsmen who worked there, and the quantity and quality of their production is slowly coming into focus. I am heartened by a number of discoveries and events, serendipitous as they have been. The rediscovery of Thomas Cooper's long-lost, signed desk in North Carolina, coupled with the revelation of his brother Caleb's partial account book that had been kept in his family for many generations, has saved these Southampton craftsmen from total obscurity. We have learned of other craftsmen and identified related groups of furniture, as well.

However, there is so much more we need to know. If we can identify over 60 kasten made in Kings County, for instance, where are the chairs, tables, and smaller case pieces? Similarly, the confirmation of one or more important furniture shops in Oyster Bay and the identification of a significant group of high chests from these shops is rewarding. But why have we not been able to identify a shop or group of related objects from Hempstead, a larger and in many ways more significant town? Beyond the basic identification of Long Island-made objects there lies the more daunting task of interpreting what these artifacts can tell us about Long Island culture. As scholar Edward S. Cooke, Jr., has observed, "we understand little about the material culture in specific rural areas, why certain patterns of production and use gained acceptance, and how the artifacts reveal broader issues of social and economic activity."[2]

The chapter titles of this book had been intended to suggest the many complex issues behind the study of material culture on Long Island, such as the constant tug-of-war between imported fashion and steadfast adherence to tradition. The cultural and intellectual network established by the Society of Friends, or Quakers, is another area that needs to be explored in depth, as it encompassed not only religious ties but also social and economic relationships. The search for a better understanding of such issues should remain at the forefront of future research.

Fortunately, the text of the original publication of Long Island Is My Nation needs only a few corrections. Subsequent microscopic wood analysis has proven the William Wells desk box (No. 31) to be American and either Connecticut or eastern Long Island in origin. A brand by the late eighteenth-century New York City chairmaker, Jacob Smith, was discovered on the armchair owned by the Townsend family of Oyster Bay (No. 94). Finally, the Windsor armchair owned by William Floyd (No. 78) is now recognized as one of four known examples by a Connecticut craftsman, possibly the master of Ebenezer Tracy, the famed Windsor-maker of Norwich, Connecticut.

The republication of Long Island Is My Nation presented certain editorial problems since we wished to keep the original work intact for reference purposes but also wanted to include new material. The solution has been to reprint the original book in its entirety and to add a new section at the beginning. The new discoveries begin on page 9-5, and the original chapters begin on page 11. The new catalogue entries have been arranged in a roughly chronological sequence and by form and category, i.e., chairs, tables, case-pieces, etc., as in the original publication. Cross-references to examples in the original work are referred to by their catalogue listing (e.g., No. 2), whereas the new entries are followed by a capital letter A or B (e.g., 2A). For consistency, the format of the entries has remained the same. Once again we had to be selective about new entries and objects and highlighted key pieces that suggest possible areas of future research. Many other items turned up that confirm earlier attributions to specific towns, but they could not be included due to lack of space.

I am grateful to the Board of Trustees of the Society for the Preservation of Long Island Antiquities; Anthony K. Baker, Chairman of the Publications Committee; Huyler Held, former President; and President Richard Gachot for supporting the

republication of this book and to Robert B. MacKay, the Society's Director, for his unfailing interest, encouragement, and support. The Society's staff were indispensable: Randy Staudinger, Property Manager; Lynda Dunn and Rosemary DeSensi, who typed the new manuscript; and Lynn Pearson, who coordinated the overall production of the catalogue.

Much of the new photography was undertaken, often in difficult situations but always with good humor by Peter Barmonde, and we relied on our original photographer (now retired), Joseph Adams, to find and make prints of objects photographed more than twenty years ago.

For sympathetically melding the original book with the new material, we are indebted to Diana Waite and her staff at Mount Ida Press.

Many of the same individuals and institutions who assisted with the original catalogue and exhibition have provided access to their collections once again. Many new friends have also been generous with their time, support, and assistance. With fear of inadvertently overlooking someone, I would like to acknowledge the following individuals and institutions: Luke Beckerdite, the Chipstone Foundation; James Campbell; Mitzi Caputo, the Huntington Historical Society; Christie's, New York; Skip Chalfant, Wendy Cooper, The Henry Francis du Pont Winterthur Museum; Frank Cowan; the East Hampton Historical Society; Jonathan Fairbanks, the Museum of Fine Arts, Boston; Ken Farmer; Margaret Gass; Averill Geus, Home Sweet Home; Mr. and Mrs. Dudley Godfrey; Roger Gonzales; the Greenlawn-Centerport Historical Association; Dr. Hugh Halsey; Martha Hamilton, Skinner's; Huyler Held; Samuel Herrup; Mr. and Mrs. Valdemar Jacobsen; Dr. Neil D. Kamil; Leigh Keno; Peter Kenny, The Metropolitan Museum of Art; Robert Kissam; Glee Kruger; Frank Levy; Barbara Luck, the Abby Aldrich Rockefeller Folk Art Center, Colonial Williamsburg; Mr. and Mrs. Joseph A. McFalls; Mr. and Mrs. Morgan MacWhinnie; the Milwaukee Museum of Art; the Museum of the City of New York; The Museums at Stony Brook; Dr. and Mrs. Paul Peters; Ron Pook; Israel Sack, Inc.; Mr. and Mrs. Lincoln Sander; Eric Shrubsole; Bruce Sikora; Mr. and Mrs. Richard W. Smith; the Southampton Colonial Society; Kevin Stayton, The Brooklyn Museum; Robert F. Trent; Mr. and Mrs. Fred Vogel; and Eric M. Wunsch.

The republication of Long Island Is My Nation *is possible because of the enthusiastic support of dozens of other individuals whom I can thank only collectively. And once again, I am indebted to my wife, Marie, who put up with all the inconveniences that this project generated.*

Dean F. Failey

1. Benno M. Forman, *American Seating Furniture 1630-1730: An Interpretive Catalogue* (New York: W.W. Norton and Co., 1988). Neil D. Kamil, "Of American Kasten and the Mythology of 'Pure Dutchness,'" review of *American Kasten: The Dutch-Style Cupboards of New York and New Jersey, 1650-1800,* by Peter M. Kenny, Frances Safford Gruber, and Gilbert T. Vincent, *American Furniture 1993,* ed. by Luke Beckerdite (Hanover, N.H.: University Press of New England for the Chipstone Foundation, 1993), pp. 275-282. Neil D. Kamil, "Hidden in Plain Sight: Disappearance and Material Life in Colonial New York," *American Furniture 1995,* ed. by Luke Beckerdite (Hanover, N.H.: University Press of New England for the Chipstone Foundation, 1995). Peter Kenny, "Flat Gates, Draw Bars, Twists, and Urns: New York's Distinctive, Earl Baroque Oval Tables with Falling Leaves," *American Furniture 1994,* ed. by Luke Beckerdite (Hanover, N.H.: University Press of New England for the Chipstone Foundation, 1994).

2. Edward S. Cooke, Jr., *Making Furniture in Preindustrial America: The Social Economy of Newtown and Woodbury, Connecticut* (Baltimore: The Johns Hopkins University Press, 1996), p. 7.

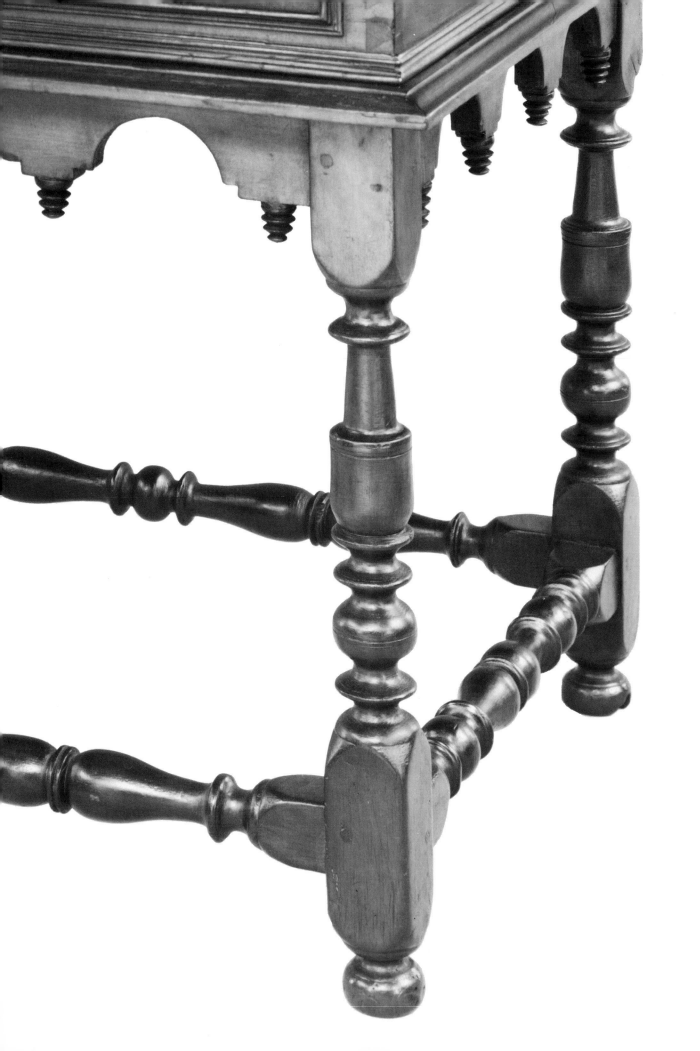

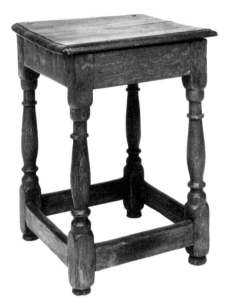

1A. Joint Stool, 1680-1710
East Hampton
Oak, pine
H. 19 7/8 W. 13 D. 12 15/16
Dr. and Mrs. Paul Peters

This is the only identified Long Island joint stool. It descended in the Hedges family of East Hampton and probably was owned by either Stephen Hedges (1634/5-1734) or his son, Daniel Hedges (1677-1734). Until 1997 it remained in East Hampton and in the Hedges family.

2A. Great Chair, 1650-1700
East Hampton or New Haven Colony, Connecticut
Maple, ash
H. 39 1/2 W. 24 1/4 D. 16 3/4
East Hampton Historical Society,
William Efner Wheelock Collection

This chair probably owes its survival to its conversion to a rocking chair. Loss of finials, wear to feet, and a new crestrail have not diminished its powerful form, however. The urn-turnings of front and rear stiles link this chair to the stylistic and craft tradition seen in the 1717 East Hampton Meeting House post (No. 3A). Acquired in the 1890's by William Efner Wheelock, a wealthy part-time resident and collector, this chair is one of dozens of pieces of furniture that reflect the close cultural ties between Long Island and Connecticut. Nevertheless, there is still a bias to identify such pieces as Connecticut, rather than Long Island, in origin.

Refs.: In a 1980 conversation with the author, the noted late American furniture dealer, John Walton, stated that he had found "wonderful things" on Long Island over the years, but never thought of attributing them to a local maker. "People want Connecticut or Rhode Island furniture," he said, "not Long Island."

A similar bias is therefore understandable even among scholars in the field. Jay Graybeal and Peter Kenny in "The William Efner Wheelock Collection of the East Hampton Historical Society," *Antiques* (August 1987), pp. 328-339, are hesitant to attribute pieces to a local maker and even suggest Wheelock may have gone antiquing in Connecticut and brought these objects back to East Hampton, contrary to family history.

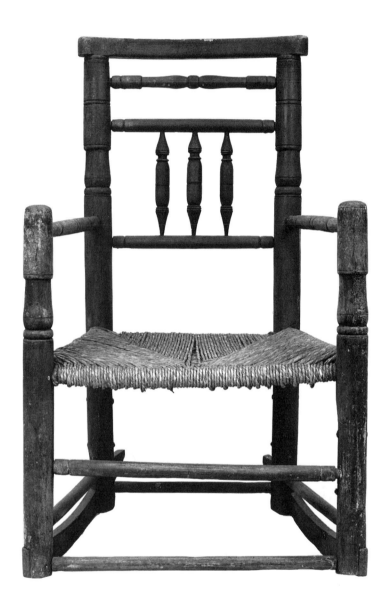

3A. Architectural Post, 1717
1717 Meetinghouse, East Hampton
East Hampton Historical Society

The importance of this relic, saved from the 1717 East Hampton Meetinghouse, lies in the stylistic tradition and heritage embodied in the short baluster turning. This turned element is part of the basic vocabulary of locally made furniture from the seventeenth century (see No. 2A) up through the work of the Dominy family during the early nineteenth century (see No. 226).

4A. Great Chair, 1650-1700
Kings County or Queens County
Maple, oak, hickory
H. 46 W. 27 1/2
Private collection

4B. Great Chair, 1650-1700
Kings County or Queens County
Maple
H. 44 3/4 W. 25 1/2
Milwaukee Art Museum, Layton Art
Collection purchase

Several variations of slat-back armchairs
with flat upper arms over elaborately turned
underarm supports and with finials that feature
multiple flanged turnings (No. 18) are now rec-
ognized not only as being New York in origin
but also as very likely being the products of
craftsmen in one or more of the western Long
Island towns. Benno Forman suggested a
Dutch or northern European tradition for this
group of chairs. Possible makers include Jan
Poppen (Poppe) (active ca. 1675-1689), a chair
and wheel turner who moved from Flatlands,
in Kings County, to Flatbush, and his appren-
tice, Albert Van Ekelen (see Appendix I, pp.
252, 262).

The first group of chairs has winged slats,
as seen here on 4A and 4B and on one at
Winterthur. Traces of the original red-painted
finish are evident in the finely-turned, con-
centric-ring finials of 4A (see details). The
underarm stretcher also displays the turner's
conceit and actual proof of skill in the two
loose rings turned from the solid spindle.

Ref.: Benno M. Forman, *American Seating Furniture,
1630-1730* (New York: W. W. Norton and Co., 1988),
pp. 128-131.

Photographs by William Whear.

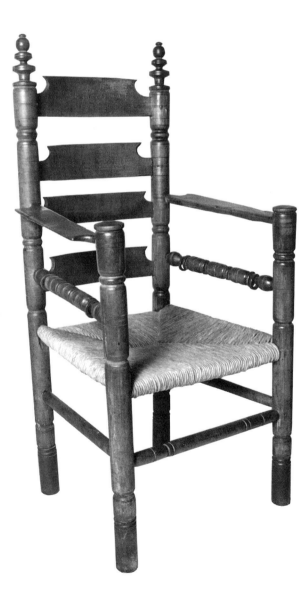

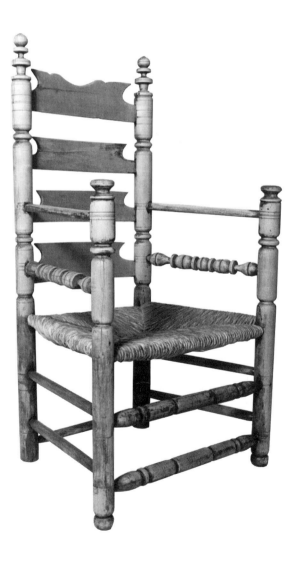

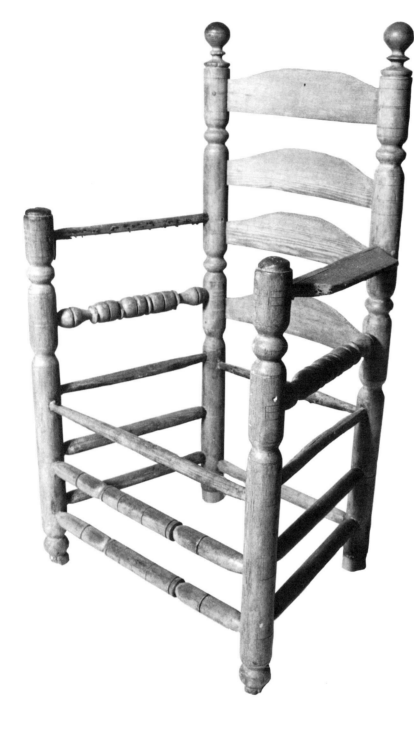

5A. Great Chair, 1680-1710
Kings County or Queens County
Ash
H. 44 3/4 W. 25 1/2
Private collection

The second group of slat-back great chairs includes No. 18, which is missing its finials, hand-grips, and one front stretcher; this example, the most complete, with original feet and finials; and No. 6A. Additional examples are in The Art Institute of Chicago and the Museum of Fine Arts, Boston (see Ref., No. 18). The arrangement of turned elements on the stiles, the similarity of the turnings, and the placement of the arched slats on all five chairs seem to indicate that they are products of the same shop tradition, if not the same craftsman.

Photograph by William Whear.

6A. Great Chair, 1680-1720
Kings County or Queens County
Ash
H. 47 W. 23 3/4
Dr. and Mrs. Paul Peters

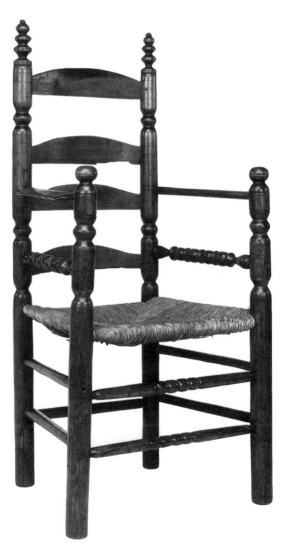

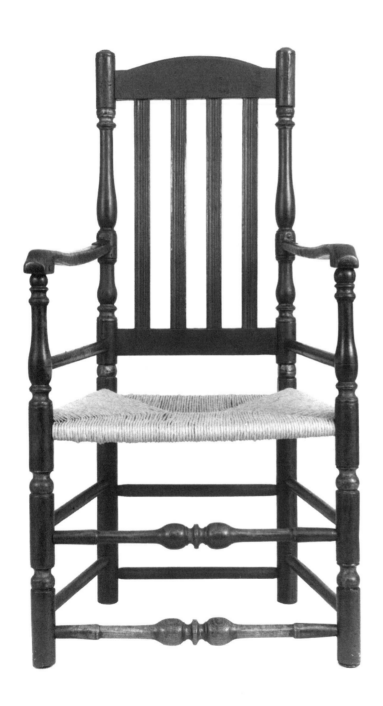

7A. Armchair, 1720-1750
Huntington
Painted maple, pine
H. 43 1/2 W. 23 1/4
Private collection

With a history of ownership in the Gildersleeve family of Huntington, this armchair is one of the few pre-1750 examples that have been identified from this important community. The chair has lost its finials, and the underarm supports are probably early replacements.

8A. Wainscot Armchair, 1720-1740
Huntington
White oak, maple, red cedar, hickory
H. 54 13/16 W. 30 9/16
The Henry Francis du Pont Winterthur Museum, 88.0003

Many important objects survive because of their association with a historical event. During his famous tour of Long Island, George Washington is said to have sat in this chair on April 21, 1790, when he stopped at the house of Zebulon Ketcham in present-day Amityville. A copper plaque, affixed to the chair's back sometime in the nineteenth century, commemorates Washington's visit.

Ketcham had married Hannah Conklin (1744-1826) of Huntington in 1770. Either her father, Israel Conklin (1719-1777), or her grandfather, Jacob Conklin (1676/7-1754), may have been the original owner of this chair, judging from the initials inlaid on the back. According to several early genealogical and historical accounts, Jacob Conklin was one of the wealthiest men in Huntington, and this chair, grand in stature and clearly expensive with its interlaced arches and inlaid initials, suggests an owner of importance. The chair's distinctive form and construction relate it to paneled-back northern English examples, but possible Dutch or northern European influence cannot be discounted. The elongated baluster arm supports are related to a bannister-back armchair possibly associated with the Gildersleeve family of Huntington (see No. 7A).

Ref.: The library of the Huntington Historical Society has genealogical papers and unpublished manuscripts related to the Conklin family including works by Dr. Herbert Seversmith on the Ketcham family; Edwin Soper on the Ketcham family; and the Nellie Ritch Scudder Collection of Long Island Genealogical Records.

Photograph courtesy of Winterthur Museum.

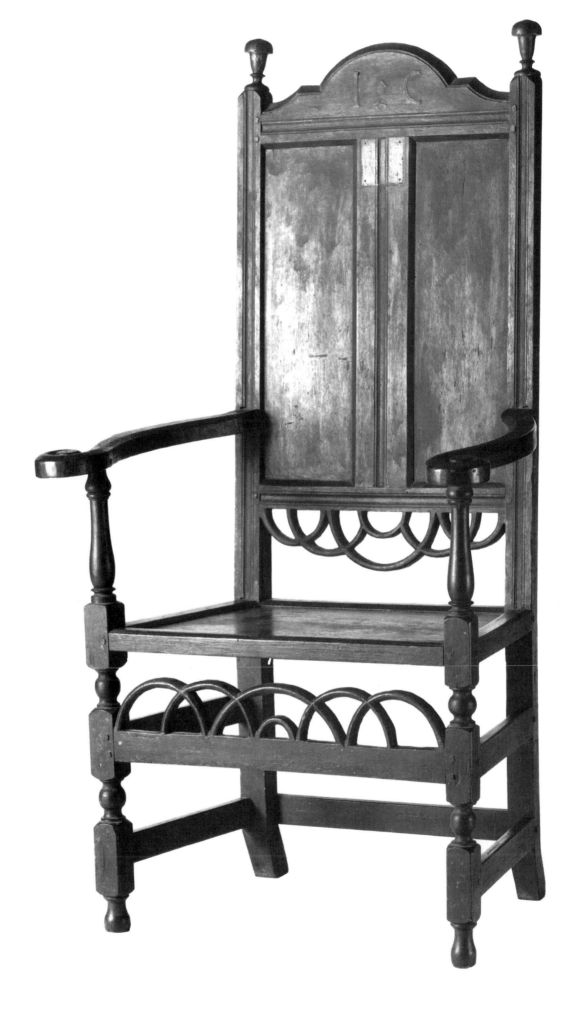

9A. Corner Chair, 1720-1740
East Hampton
Maple
H. 30 1/4 W. (seat) 18 1/2 D. (seat) 18 1/2
East Hampton Historical Society, gift of
Helen Parsons Miller

Family tradition attributes ownership of this
corner chair to Samuel Miller of Fireplace in
East Hampton. The later leather covering of
the seat and arm rail partially obscures a
design that reflects the work of a craftsman
who possessed skills as a turner. It is the only
identified example of a Spanish, or paintbrush,
foot on a Long Island piece of furniture.

Several East Hampton families—the Bakers,
Mulfords, Schellingers (or Schellinx's), and
Dominys—included several generations of
woodworkers, but the attribution of this piece
to a specific maker is not yet possible.

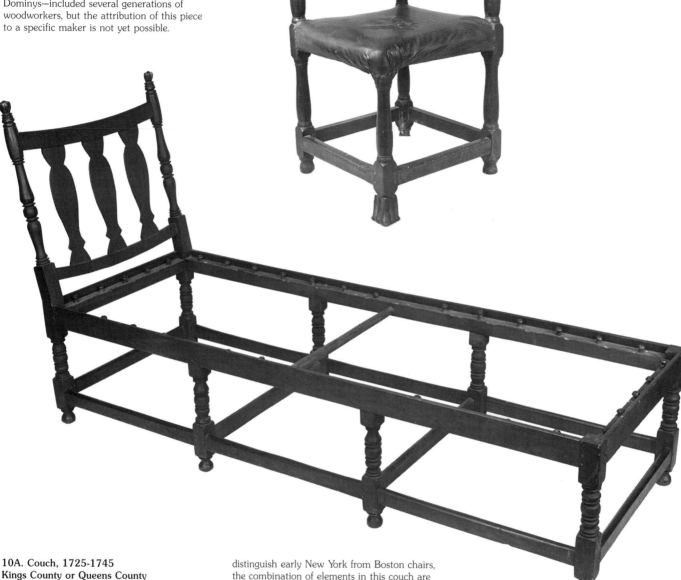

10A. Couch, 1725-1745
Kings County or Queens County
Maple, pine
H. 37 W. 24 L. 68
Society for the Preservation of Long Island
Antiquities, gift of Mrs. Reginald P. Rose,
77.1

This piece was acquired on western Long
Island early in the twentieth century by Mrs.
Harry Horton Benkard of Oyster Bay, the
mother of the donor. The multiple-ring and
squat-baluster turnings and the flattened
urn-shaped finials are seen on New York chairs.
While scholars have debated features that

distinguish early New York from Boston chairs,
the combination of elements in this couch are
unlike any New England examples and there-
fore suggest a New York origin.

Refs.: Roger Gonzales and Daniel Putnam Brown, Jr.,
"Boston and New York Leather Chairs: A Reappraisal,"
American Furniture 1996, ed. by Luke Beckerdite
(Hanover, N. H.: University Press of New England for
the Chipstone Foundation, 1996), pp. 175-194.

Neil D. Kamil, "Hidden in Plain Sight: Disappearance
and Material Life in Colonial New York," *American
Furniture 1995*, ed. by Luke Beckerdite (Hanover, N.H.:
University Press of New England for the Chipstone
Foundation, 1995), pp. 191-249.

11A. Square Table, 1660-1700
East Hampton or New Haven Colony,
Connecticut
Oak
H. 28 1/2 W. 35 1/2 D. 41 5/8
East Hampton Historical Society, William
Efner Wheelock Collection

One of the pieces of furniture acquired between 1890 and 1900 in the East Hampton area by collector William Efner Wheelock, this table represents the conundrum in studying Long Island furniture: what was made locally versus what was brought here by early settlers and through later family marriages? The geographic proximity of eastern Long Island to Connecticut and Rhode Island encouraged cross-Sound communication and travel. The political, commercial, and familial ties to Connecticut and other New England areas enjoyed by most of eastern Long Island's population lasted well into the early nineteenth century and has not been fully explored from a cultural context.

The top, one apron, and the feet of this table have been restored, but it remains a rare survival and important document of seventeenth-century life of this region. The robust disc turnings are related to a cupboard from New Haven associated with Governor Robert Treat (1622-1710).

Ref.: Patricia E. Kane, *Furniture of the New Haven Colony, The Seventeenth-Century Style* (New Haven: The New Haven Colony Historical Society, 1973), pp. 50-51.

12A. Gateleg Table, 1700-1730
Smithtown
Cherry, pine
H. 28 3/4 W. (closed) 24 L. 55
Society for the Preservation of Long Island
Antiquities, 81.29

The vigorous turnings and large size make this an impressive table and indicate that it was produced by a turner or shop joiner of considerable skill. This table descended in a branch of Richard "Bull Rider" Smith's family. The single baluster with collar-leg turnings rather than paired-baluster turnings suggests an early date. The turnings are also suggestive of those on the Floyd family table (No. 26). Sadly, only a remnant of the original top of this table has survived.

Ref.: Purchased from the estate of Mrs. William Smith of Stony Brook at the estate auction on August 28, 1980, held by Raymond Brachfeld.

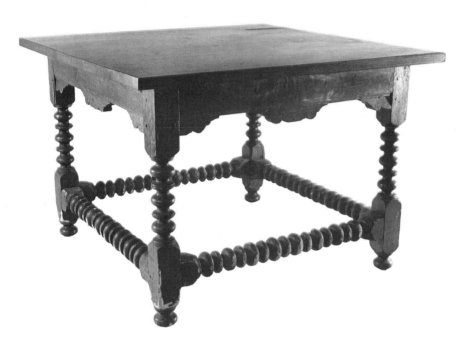

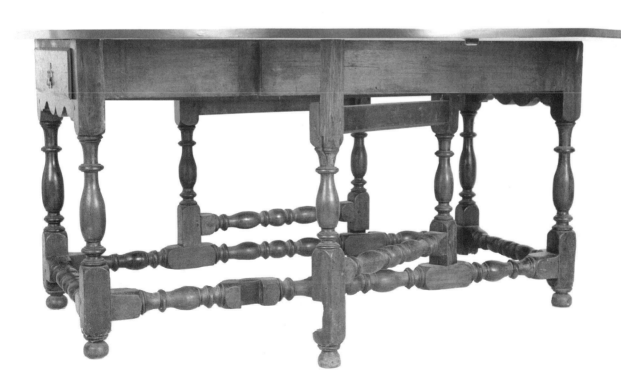

13A. Table, 1700-1735
Possibly Flushing, Queens County
Walnut
H. 23 3/4 W. 25 D. 19 3/4
Mr. and Mrs. Joseph A. McFalls

Only a few small tables have been identified as being from Kings or Queens counties, despite the much larger body of known case-pieces, including more than sixty *kasten*. The discovery of this table in Flushing with characteristic New York baluster-urn and ball turnings offers hope that additional examples can be identified.

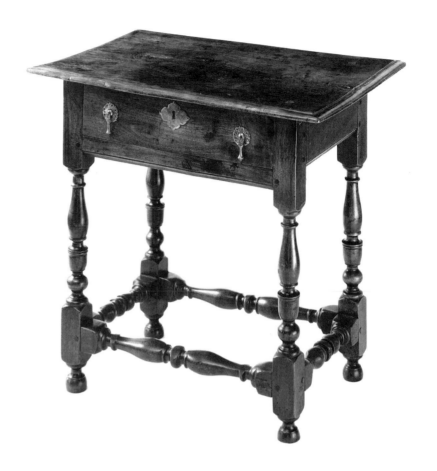

14A. Table, 1710-1750
Kings County or Queens County
Sweetgum, cherry, birch
H. 25 1/2 W. 30 D. 19 5/16
Milwaukee Museum of Art, gift of Virginia and Robert V. Krikorian, M 1987.34

This table was found in Queens County in the 1940's. Its baluster, urn, and multiple ring turnings reflect artisanship associated with northern European traditions that were prevalent in colonial New York and certainly in the five Dutch-settled and five English-settled towns of western Long Island.

Ref.: Gerald W.R. Ward, ed., *American Furniture with Related Decorative Arts, 1660-1830* (New York: Hudson Hills Press, 1991), pp. 86-87.

Photograph courtesy of the Milwaukee Museum of Art.

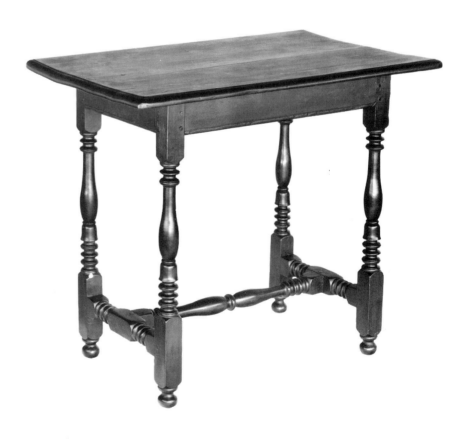

15A. Stand, 1700-1725
Attributed to James or Samuel Clement
(active ca. 1695-1726)
Flushing
Red gum
H. 28 5/8
Private collection

A remarkable survival, this stand provides a rare glimpse of early small New York furniture forms. Although the octagonal top is an early replacement, the original pedestal and the flat scrolled legs suggest the marriage of Anglo and Dutch or Flemish styles. A careful comparison of the pedestal turnings of this stand with the turned legs of the high chest and companion dressing table by Samuel Clement (Nos. 39-40), as well as the similarity of the chamfered edges of the table legs and of the chamfered edges of the stretchers of the dressing table and the high chest, leaves little doubt that the three pieces were made in the same shop. The stand was obtained in Oyster Bay.

Photograph by William Whear.

15B. Stand, 1700-1730
Oyster Bay
Maple, mulberry, red gum, red oak
H. 24 3/4 W. (top) 14
Private collection

One of the three similar known stands, this example was found in an Oyster Bay house. Based on English precedents it suggests an affinity with the Clement-attributed stand (No. 15A). There was a close relationship between the Quaker-populated towns of Oyster Bay and Flushing. The top and base of the stand are joined to the pedestal by turned wooden screw threads.

Photograph by Joan Potter.

16A. High Chest of Drawers, 1700-1730
Attributed to James or Samuel Clement
(active ca. 1695-1726)
Flushing
Walnut
H. 71 W. 39 3/4 D. 21 3/4
Private collection

The scant documentary evidence, coupled with a growing number of actual pieces, suggests that the western Long Island towns supported a number of relatively sophisticated cabinet-making shops. Two groups of William and Mary-style high chests share many similar stylistic and constructional features, including the use of post, rather than cotter-pin, brasses, as on the signed Samuel Clement high chest and dressing table (Nos. 39-40) and on this high chest. Yet we should not focus on Clement alone, given the number of contemporary craftsmen in Flushing and nearby Jamaica. For example, Johannis Cowenhoven and Gabriel Tiebout were clearly working in the William and Mary style as early as 1702-1703, judging by their purchases of glue and furniture escutcheons and drops (brass drawer pulls) from a local merchant (see Appendix I, pp. 274, 287, Teebone).

Ref.: Gabriel Tiebout was identified as "Teebone" in our original study, based on the phonetic spelling of his name in the Lawrence account book. He is probably related to Johannis Tiebout, a New York turner who was made a Freeman of the City in 1698/1699; see Benno M. Forman, *American Seating Furniture, 1630-1730* (New York: W. W. Norton and Co., 1988), p. 130.

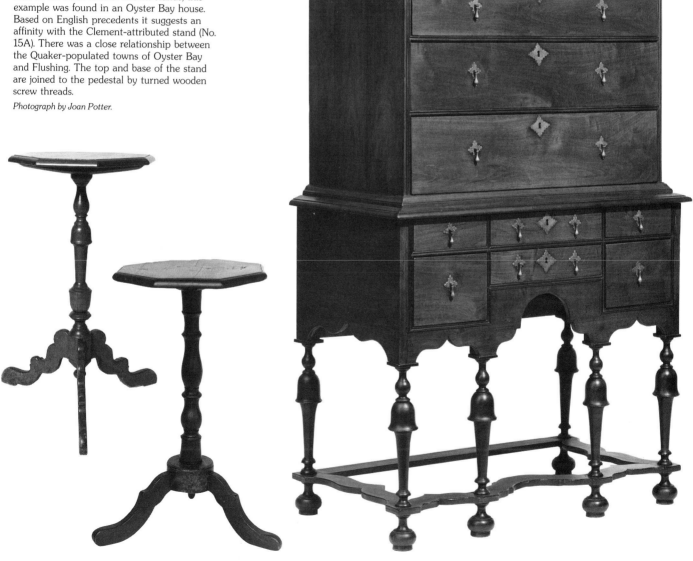

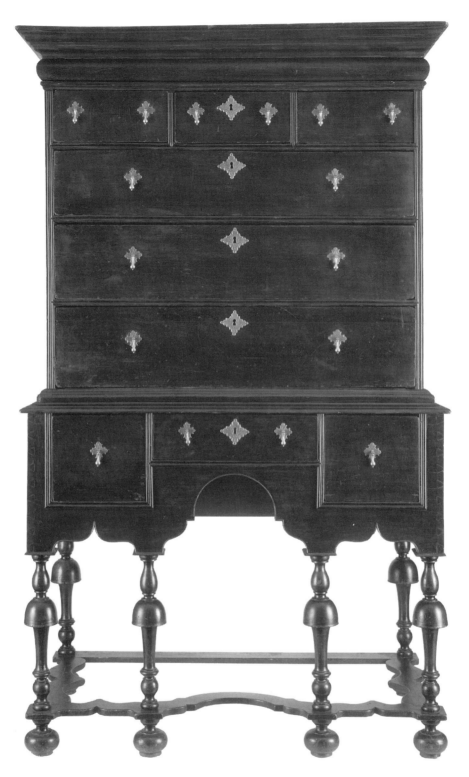

17A. High Chest of Drawers, 1700-1730
Attributed to James or Samuel Clement
(active ca. 1695-1726)
Flushing
Red gum, poplar
H. 71 5/8 W. 43 1/2 D. 23
Private collection

The slight variations between the Lawrence family dressing table (No. 40) and its companion, the signed Samuel Clement high chest of drawers (No. 39) are significant because they help relate several other case pieces to the same shop or shop tradition. These differences include the shape of the cup-turning on the legs, the arrangement of drawers, and the exposed dove-tailing at the case corners, all of which are seen in this high chest. Interestingly, the brass drawer pulls and escutcheons appear to be identical on three of the high chests in this group, suggesting a common source. The exposed dove-tailing on the high chests, which is not seen on William and Mary case-pieces from other American colonies, raises an interesting question about the relationship of Queens County pieces to the Kings County *kasten* that have similarly dovetailed lower cases (see Nos. 19A and 20A).

Ref.: An identical high chest is in a private New York City collection, and another was sold at the Mark Vail Auction Company, July 16, 1994.

Photograph by Gavin Ashworth.

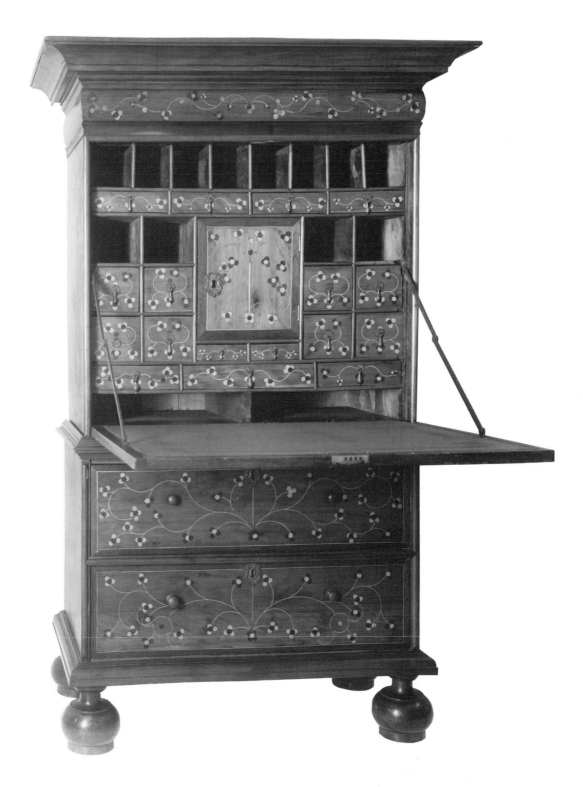

18A. Desk, 1700-1735
Possibly Flushing
Cedar, walnut, tulip poplar
H. 66 3/4 W. 42 D. 22
Museum of the City of New York, Museum
Purchase, Mrs. Elon Huntington, Hooker
Fund, 45.112 a-c

This fall-front desk, believed to have been owned by either Joris Brinckerhoff (1644-1729) or Derick Brinckerhoff (1667-1778), both of Flushing, has been published often, but its importance has seemingly remained unrecog-

nized. The elaborately inlaid design of meandering vines and flowers has always been attributed to Dutch influence; however, the origin of this distinctive vine-and-berry ornamentation is now believed to be southern Wales.

It should not be surprising that this desk may have been made in Flushing, an English-settled town with numerous Anglo furniture-making craftsmen and with an early history as a meeting ground of cultures. Flushing was also host to a very active community of Quakers. The preference of Quakers in Chester

County, Pennsylvania, for similarly inlaid furniture has been documented. The close ties that existed between Quakers on Long Island and in other colonies presents an intriguing area for further study.

Ref.: Lee Ellen Griffith, "The Line-and-Berry Inlaid Furniture of Eighteenth Century Chester County, Pennsylvania," *Antiques* (May 1989), pp. 1202-1211.

Photograph courtesy of the Museum of the City of New York.

19A. Chest with Drawer, 1700-1730
Kings County or Queens County
Gumwood, tulip poplar, yellow pine
H. 35 1/2 W. 53 D. 21
Private collection

Although this chest has no known Long Island provenance and is a previously unknown form, it has stylistic and constructional features that link it strongly to a group of *kasten* made in Kings County in the five Dutch-settled towns (see No. 134). The similarities include the use of molded panels on a red gumwood case, a dovetailed lower case section that is consistent with *kas* construction where a strong base to hold a massive upper section was needed, and similar foot construction. The original escutcheon helps date this piece to the early eighteenth century.

There is, however, an Anglo feeling to this chest that suggests it may have been made by a cabinetmaker of Dutch descent for a customer of English background or by a Dutch-trained English craftsman, much like

the group of later wardrobes (see No. 144) and the desk and bookcase (No. 56A). However, another interesting constructional feature, the use of diagonal pinning of the chest rails and stiles, is associated with Germanic joinery; the straight or symmetrical pinning of mortise-and-tenon joints is commonly found on Dutch examples of joined furniture, such as the Kings County *kasten* (see No. 20A). It is entirely possible that this chest was made in Jamaica or Flushing by a craftsman such as Johannis Cowenhoven (see Appendix I, p. 274). The relationship of this chest to the group of double-paneled chests shown in Nos. 124-126 is also intriguing since they suggest a blending of Anglo and Dutch craft traditions.

Refs.: The chest sold at Sotheby's, *Important Americana, The Collection of Dr. and Mrs. Henry P. Deyerle,* May 27, 1995, lot 675.

Joanie McMillan, "A Baroque Lidded Chest with Drawer: An Example of Cultural Exchange in Colonial America," research paper for Sotheby's American Art Course, January 3, 1996.

20A. *Kas,* 1770-1790
Kings County
Red gum, pine, mahogany
H. 78 3/4 W. 71 1/4 D. 27
Private collection

A recent in-depth study of New York *kasten* has resulted in a better understanding of this important furniture form and has carried our original observations about regional schools and localized styles of *kasten* much further. It now seems evident that the Dutch-settled towns of Kings County were the origin of an elaborate group of *kasten* characterized by large ornate cornices, applied geometric moldings, and applied panels of mahogany on red gumwood carcases. Judging from the many variations among the more than sixty known Kings County-school examples, there were many makers active during the period from the seventeenth century up to the beginning of the nineteenth century. The *kas* illustrated here was originally owned in Brooklyn and was brought to Huntington before 1900 by the Suydam family. It can be dated to the late 1700's by its original brass hardware. The function of the *kas* is clearly indicated in the 1767 will of James DeGraw, a Brooklyn turner: *"to my daughter Anna Van Dyke a large cupboard which now stands in my house with curtains sheets and other clothes, and all that there in is except & in the drawer below."*

Refs.: Peter M. Kenny, Frances Gruber Safford and Gilbert T. Vincent, *American Kasten* (New York: The Metropolitan Museum of Art, 1991).

Will of James DeGraw, Brooklyn, *Collections of The New-York Historical Society: Abstracts of Wills,* 7 (New York: Printed for the Society, 1892-1906).

21A. Desk on Frame, 1685-1695
Probably Flatbush, Kings County
Red gum, mahogany, yellow poplar
H. 35 1/4 W. 33 3/4 D. 24
The Metropolitan Museum of Art,
Rogers Fund, 1944 (44.47)

Acquired from a Flatbush, Brooklyn, house, this desk is a key object linking an elaborate group of Dutch-style *kasten* to a broader Kings County furniture-making tradition. The desk is dated and inscribed in chalk *"1695 Ocktober 12 gelient den P-Q maule Schenk 5 pont,"* probably in reference to a business transaction. It is constructed of red gum and yellow poplar, except for the applied mahogany panels within

molded frames. These features, combined with the use of distinctive dovetail joinery on the case, relates this piece directly to the more than sixty known examples of Kings County *kasten* (see Nos. 20A and 134).

Refs.: Peter M. Kenny, Frances Gruber Safford and Gilbert T. Vincent, *American Kasten* (New York: The Metropolitan Museum of Art, 1991), pp. 19-20. These authors have made this important connection between the desk and the Kings County *kasten* group.

Neil D. Kamil, "Hidden in Plain Sight: Disappearance and Material Life in Colonial New York," *American Furniture 1995*, ed. by Luke Beckerdite (Hanover, N. H.: University Press of New England for the Chipstone Foundation, 1995), pp. 204-206.

Photograph courtesy of The Metropolitan Museum of Art.

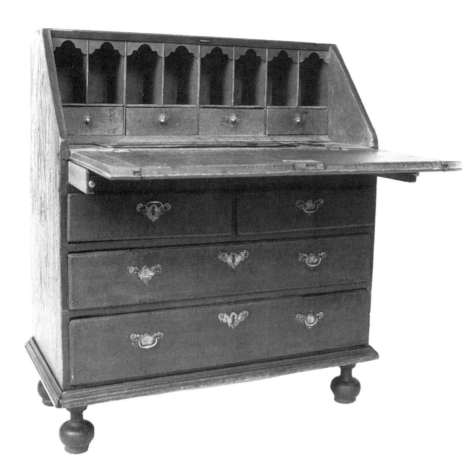

22A. Desk, 1700-1730
Southampton
Maple, pine, poplar
H. 38 1/4 W. 33 1/4 D. 17
Private collection

Until recently, this diminutive desk, which retains its original vermillion-painted surface, had descended in the Jagger family of Southampton (see Nos. 26A and 58A). Several members of this family are documented as joiners (see Appendix I, p. 242), but Southampton had numerous woodworking craftsmen during this early period. The interior of this desk is quite simple, but it contains a sliding well cover, and the drawer sides throughout have a double-bead top, a feature often seen on early Boston-area furniture.

23A. Desk, 1720-1730
Probably Oyster Bay
Walnut, tulip poplar
H. 40 W. 36 D. 19 1/2
Private collection

The Underhill family of Long Island is descended from Captain John Underhill (1597-1672) (see No. 4). The desk was probably made in Oyster Bay, and possible makers include shop-joiner Charles Feke (Feake), brother of the artist Robert; William Stoddard (see Nos. 40A-41A); or one of the many Wright family woodworking craftsmen (Appendix I, pp. 267-268).

Photograph courtesy of Israel Sack, Inc., N.Y.C.

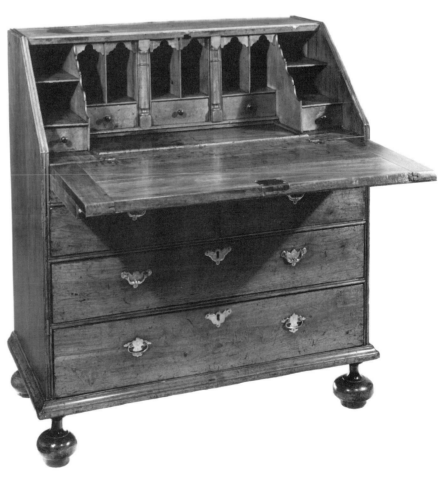

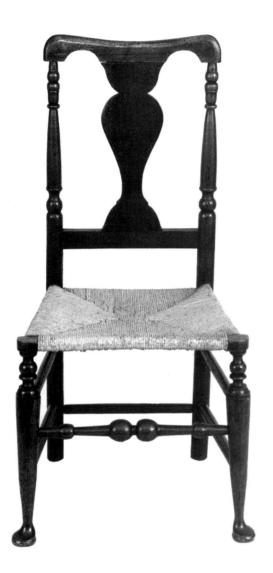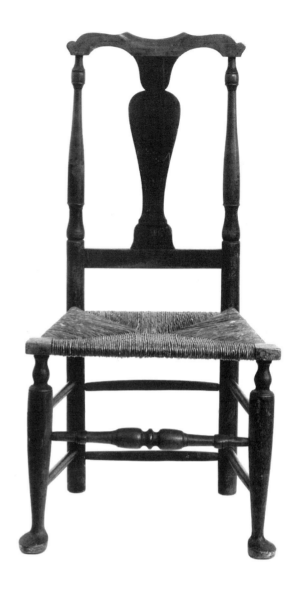

24A. Side Chair, 1750-1800
North Hempstead/Oyster Bay
Maple
H. 40
Huntington Historical Society, Kissam Family Collection

A generic Long Island Sound-area type sometimes referred to as a "York" or "fiddle-back" chair, this example descended in the Kissam-Hewlett-Mott family of Cow Neck. Further study, based on the model research of coastal Connecticut chairs by Robert Trent, might help sort these chairs into more readily identifiable schools. Essentially, this approach requires "mapping" examples with known histories; hence the importance of this example.

One of a larger set, this chair is known to have been in the Kissam-Mott family home in present-day Glenwood Landing or what was then called Cow Neck Peninsula. The original owner could have been Mary Hewlett or her husband, Joseph Kissam II (1731-1815), both of whom were from the same North Hempstead area. This chair was almost certainly made in a Cow Neck Peninsula or North Hempstead shop and had descended in the family.

Ref.: Robert F. Trent, *Hearts and Crowns: Folk Chairs of the Connecticut Coast 1720-1840* (New Haven: The New Haven Colony Historical Society, 1977). This chair

is one of three in the Huntington Historical Society, and a fourth is owned by a descendant. A nearly identical chair descended in the Lewis Samuel Hewlett family of Cow Neck, see Nos. 36A-37A.

25A. Side Chair, 1780-1800
Huntington
Maple
H. 40 3/4
Jean and Lincoln Sander

Purchased at a Carll family estate sale in Dix Hills, this chair is one of a pair retaining its original blue-green paint and may have been owned by Ananias Carll III, the son of Hannah Platt. This possibility raises an intriguing issue about the stylistic similarities of chairs made in the Long Island Sound region and particularly about the relationship of the work of Huntington craftsmen to those in Fairfield County, Connecticut, directly across the Sound.

Throughout the eighteenth century members of the Platt family were closely connected with both Huntington and western coastal Connecticut, particularly Milford. Jonas Platt, a Huntington carpenter, had two sons, Obediah and Timothy, who are known to have moved to Fairfield. A third son, Isaac, is thought to have remained in Huntington; however, an Isaac Platt is recorded as a turner in Milford,

Connecticut, between 1711 and 1760. Ananias Brush, a Huntington shop joiner, is known to have lived in Milford, and the Brush family also had many connections to Fairfield County. This situation suggests that chair styles may have been transmitted across the Sound by both craftsmen and objects. Clearly the turned elements on chairs made in Huntington (Nos. 88 and 96) relate closely to Stratford and Milford examples.

Refs.: Original ownership was ascribed to Ananias Carll II (d. about 1750), but his dates are too early for these chairs. See Frederic Gregory Mather, *The Refugees of 1776 from Long Island to Connecticut* (Albany, N.Y.: J.B. Lyon Company, 1913), pp. 509-511. The chairs were purchased at an on-site estate sale, July 28, 1985, in Dix Hills, conducted by Cantine Kilpatrick.

Robert F. Trent, *Hearts and Crowns: Folk Chairs of the Connecticut Coast 1720-1840* (New Haven: the New Haven Colony Historical Society, 1977), pp. 45-51, 96, Fig. 48. Trent also suggests that the introduction of a stylistic deviation some time around 1770 may have been the result of a Long Island craftsman moving to Connecticut.

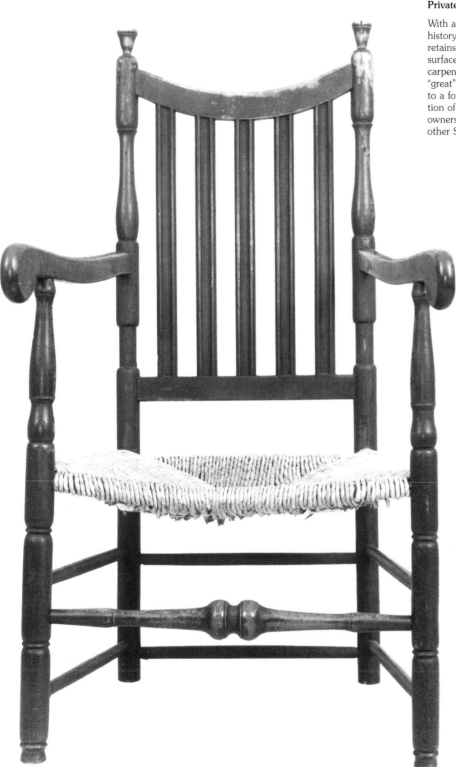

26A. Bannister-back Armchair, 1750-1800
Southampton
Maple, hickory (?)
H. 45 W. 25 1/4
Private collection

With a similar Southampton Jagger family history as a bedstead (No. 60A), this armchair retains much of its original vermillion-painted surface. Daniel Sandford, a Southampton carpenter-joiner, recorded both "elbow" and "great" chairs in his accounts, perhaps referring to a form like this. The nearly pristine condition of this chair and its uninterrupted local ownership make it a landmark in identifying other Southampton examples.

27A. Armchair, 1750-1800
Southold
Maple
H. 44 W. 22 D. 15 1/4
Society for the Preservation of Long Island Antiquities, 88.33

The discovery of similar or identical objects with associations or histories of ownership in the same geographic area strengthens the likelihood that they were made in the same place. Such is the case with this fiddle-back armchair, acquired by SPLIA without a specific provenance but said to have been found on the North Fork. It is identical to No. 99 but with the addition of a second mirror-image turned front stretcher. That chair has an Aquebog history, and it seems almost certain both chairs were made there.

Ref.: The chair illustrated in No. 99 may have a replaced and simplified lower stretcher.

28A. Child's High Chair, 1780-1800
Southampton or East Hampton
Maple, ash
H. 33 1/4
Dr. and Mrs. Hugh Halsey

This child's chair is certainly of South Fork origin. It descended in the Halsey family of Southampton but was possibly originally owned by the Parsons family of Fireplace in East Hampton.

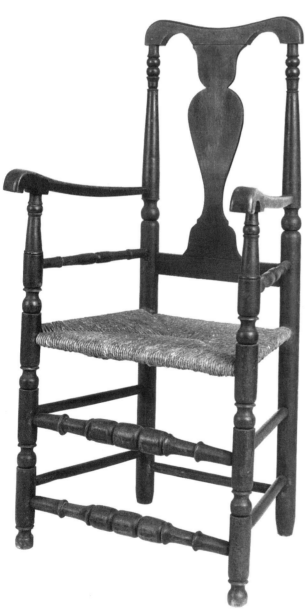

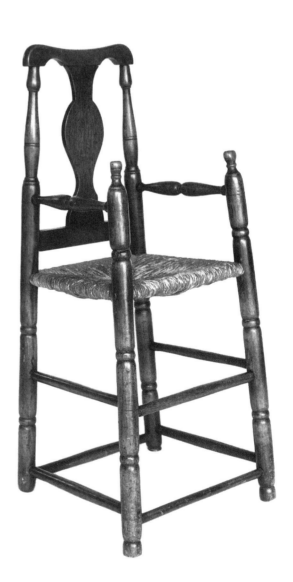

29A. Armchair, 1770-1800
Southampton
Painted maple, pine, hickory (?)
Southampton Colonial Society

30A. Side Chair, 1780-1810
Southampton
Maple
H. 38 1/2 W. 20 D. 15 1/4
Society for the Preservation of Long Island
Antiquities, gift of Margi Wilkinson
Hemingway, 98.1

Both of these chairs have Southampton
histories, the armchair in the Bishop family
and the side chair in the Corwith family. While
the armchair is stylistically earlier, both chairs
derive from a related shop tradition. The
turned elements at the base of the chairback
stiles on both chairs are quite distinctive and
clearly related. The chairs are representative of
the conservative transition from one style to
another and of the adaptation of current
fashion to a familiar traditional form.

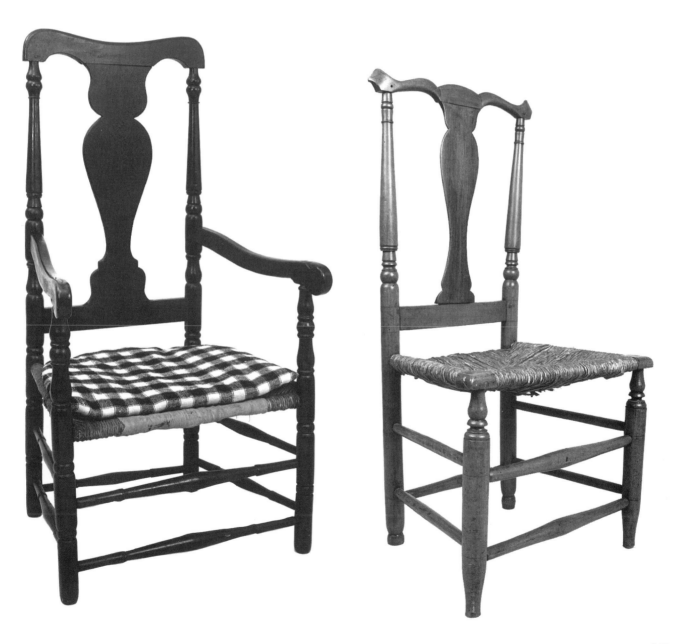

31A. Stand, 1780-1800
Woodbury or Huntington
Maple
Diam. (top) 17 1/8
Society for the Preservation of Long Island
Antiquities, gift of the Wunsch Americana
Foundation, 93.5

32A. Stand, 1780-1800
Woodbury or Huntington
Mahogany
H. 27 3/4 Diam. (top) 17 1/2
Private collection

Both stands descended in the Treadwell or
Hicks families of Oyster Bay-Woodbury. While
one has a fixed top and the other a tilt top, the
similar turnings of the pedestals and identical
leg patterns indicate that they came from the
same shop. Two slightly later tables (Nos. 33A
and 34A), possibly representing the next gen-
eration of craftsmen, have related turnings and
histories of ownership in western Huntington.

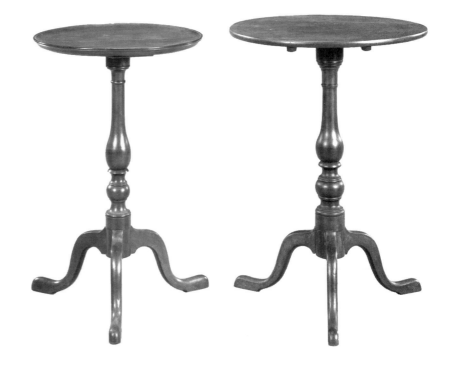

33A. Stand, 1800-1820
Woodbury or Huntington
Maple
H. 28 1/4 Diam. 17 1/8
Private collection

34A. Stand, 1800-1820
Woodbury or Huntington
Maple
H. 28 1/4 W. 15 L. 23 1/2
Greenlawn-Centerport Historical Association

These stands are part of the same Huntington-
Woodbury shop tradition as Nos. 31A and 32A
but may date from the next generation. The
circular-top stand descended in the Gildersleeve
family of Huntington, while the octagonal-top
example was originally owned either by
Cornelius Suydam (d. 1795) or by his son John
(1782-1871), who lived in East Woods (now
Woodbury) and moved to Centerport in the
early nineteenth century.

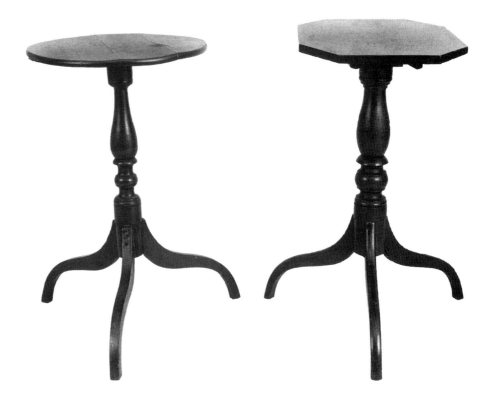

35A. Pair of Stands, ca. 1804
William Pike (active ca. 1804)
Mattituck
Cherry
H. 26 W. 15 1/4 D. 16 1/2
Private collection

Proof that many craftsmen have escaped our
identification through documentary sources is
illustrated in this pair of stands, one of which
is signed by a previously unknown craftsman,
William Pike of Mattituck. One of the stands,
bought at a house sale on the North Fork, is
signed under the top, *"Made by William
Pike/Bethia Horton April, 1804."* Bethia was an
often-used name in the Horton family of
Southold. The second stand, identical but not
signed, was also found on the North Fork.
Henry Pike of Southold, presumably a relative
of William, is noted as a carpenter in a 1780
will (see Appendix I). A second signed William
Pike piece, a painted chest with drawer, is in
the collections of the Nassau County Museum.

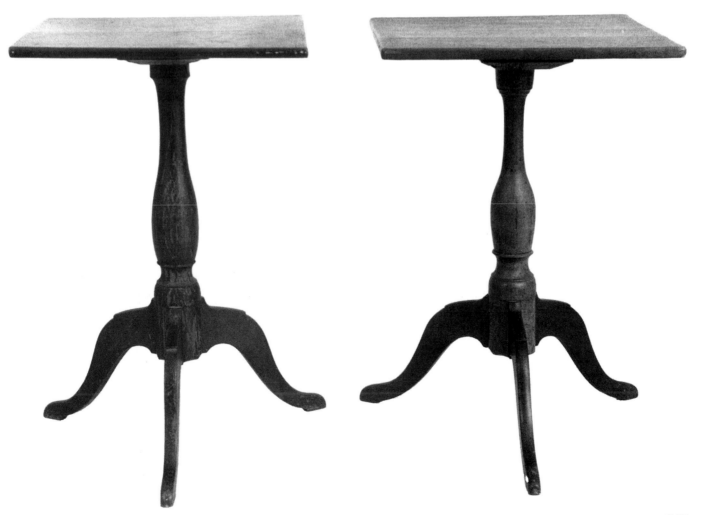

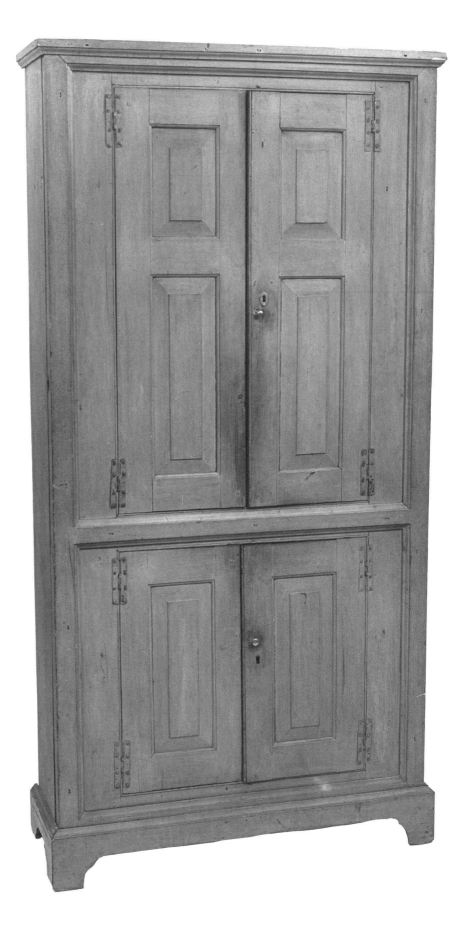

36A. Cupboard, 1760-1780
North Hempstead
Pine, chestnut
H. 85 1/4 W. 43 D. 14 1/2
Society for the Preservation of Long Island
Antiquities, 76.7, gift of Dr. and Mrs.
Milton Hopkins

According to an eighteenth-century diary in
the possession of the Hewlett family, John
Willis was the carpenter-joiner who built the
Lewis Samuel Hewlett homestead, which still
stands in Cow Neck, now Port Washington.
Willis, a previously unrecorded craftsman, may
have made this cupboard and also a settle
(No. 37A), which were part of the original
furnishings of that house. The cupboard, which
retains its original gray-green paint and hard-
ware, demonstrates the interrelationship
between the skills of the carpenter and joiner
during the eighteenth century.

Ref.: The diary, which was owned by Dr. and Mrs.
Milton Hopkins in 1978, is believed to have been given
to the Port Washington Public Library with other
Hewlett family papers.

37A. Settle, 1760-1800
North Hempstead
Pine, walnut, oak or chestnut
H. 43 L. 62 D. 32
Society for the Preservation of Long Island
Antiquities, L. 82.1.33, loan of Dr. and Mrs.
Milton Hopkins

A rare survival of carpenter-joiner-made
furniture, this settle was owned by the Lewis
Samuel Hewlett family of Cow Neck (see also
Nos. 36A, 22 and 112). The arms of the settle
are secured in an upright position by a simple
wooden knob or latch. When released, the
arms fold down to hang at each end, apparently
in order to allow the settle to be used as a
bed. Remnants of the original canvas survive,
secured by a strip of leather through which
tacks or short broad-headed nails have been
hammered. One arm is missing, and a leg has
been restored. A nineteenth-century grain-
painted surface covers the original gray-green
paint.

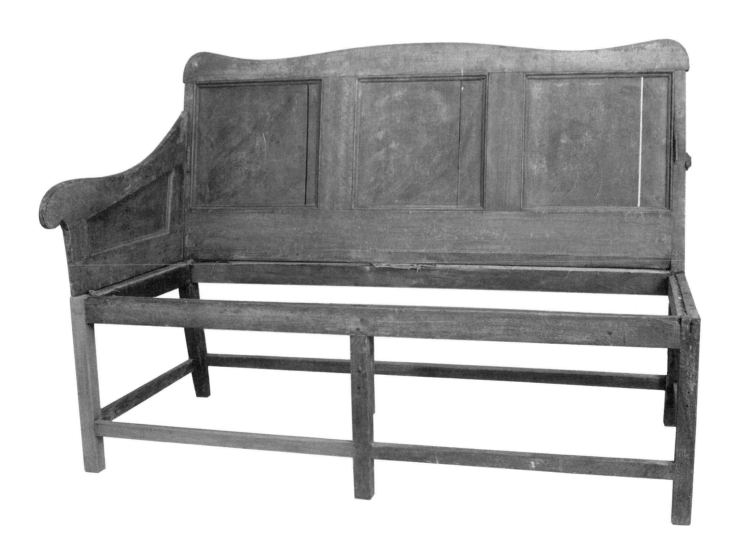

38A. Pulpit, ca. 1750
Meetinghouse, East Hampton
Pine
East Hampton Historical Society

39A. Weathervane, ca. 1717
Meetinghouse, East Hampton
Sheet and wrought iron
East Hampton Historical Society

The second meetinghouse in East Hampton
was built in 1717 and was a rather grand struc-
ture for its time, measuring 45 by 80 feet in
plan. At some point around 1750, the interior
was remodeled, and a new pulpit and other
interior architectural elements reflecting more
recent fashions were installed. These changes
seem to have occurred with the arrival of East
Hampton's third minister, the Reverend Samuel
Buell (1716-1798), a Yale graduate. Indeed, the
elaborate molded panels and distinctive floral
and meandering-vine-and-berry carving on the
pulpit, painted in vivid green and red hues, and
the other interior woodwork are derived direct-
ly from contemporary architectural work found
in the Connecticut River Valley, with which
Buell would have been familiar. The pulpit,
clock, post, weathervane, and a few other
architectural elements were saved when the
church was torn down in 1871 and are now
owned by the East Hampton Historical
Society. The question remains whether
Connecticut craftsmen were hired to undertake
the circa 1750 work or whether local crafts-
men were responsible. The weathervane, a rare
early survival, commemorates the first meet-
inghouse built in 1649 and its successor, the
1717 building.

Ref.: A preserved capital, as well as the pulpit, directly
relate to many of the well-known Connecticut River
Valley doorways such as that from the Daniel Fowler
House, Westfield, Massachusetts, now in the The
Metropolitan Museum of Art, and another from the
Ebenezer Grant House, East Windsor Hill, Connecticut
(1757-1758). See William Hosley, Jr., *The Great River:
Art and Society of the Connecticut Valley, 1635-1820*
(Hartford: The Wadsworth Atheneum, 1985), pp. 63-
100. Sherrill Foster makes a good case for the carved
ornament to have been shipped from Connecticut; see
Sherrill Foster, "The Reverend Samuel Buell of East
Hampton: Tastemaker in the Connecticut Valley
Tradition," *The Connecticut Historical Society Bulletin*,
54 (Summer/Fall 1989), pp. 189-211.

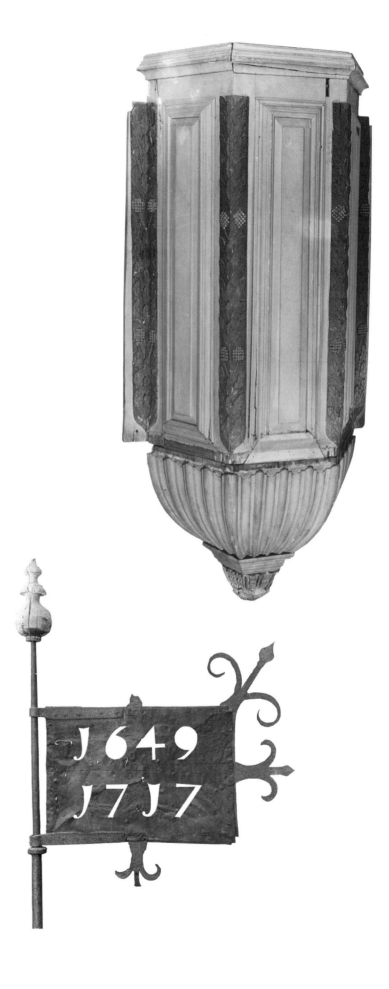

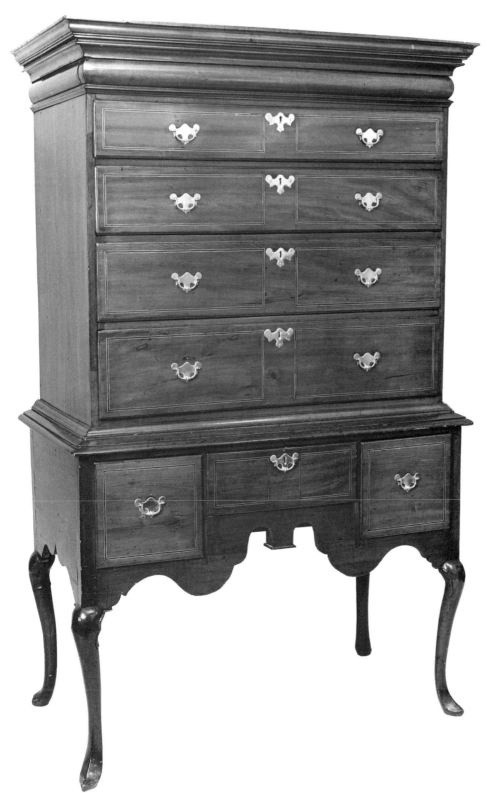

40A. High Chest of Drawers, 1730-1750
Attributed to William Stoddard (1690-1758)
Oyster Bay
Red gum, pine
H. 70 W. 43 D. 22
Private collection

The high chest was never a popular furniture form in the New York City area after the William and Mary period, although the form is synonymous with New England furniture throughout the eighteenth century. The Oyster Bay group of high chests (Nos. 40A-43A, 136-138) suggests a community whose cultural allegiances were directed, in part, across Long Island Sound to Connecticut and Newport, Rhode Island. More specifically, the relationship between Oyster Bay and Newport furniture design was the direct result of numerous family connections, active Quaker communities in both towns, and resultant commerce. This is the only known inlaid piece of furniture from this shop. The bolection drawer cornice is unknown in Rhode Island examples and may indicate an influence from New York examples, such as Nos. 16A, 17A, and 40. In fact, the double-line inlay on the drawers of this high chest is also strikingly similar to the inlay treatment of the signed Samuel Clement high chest, No. 40.

Ref.: Dean F. Failey, "Seventeenth- and Eighteenth-Century Long Island Furniture," *Antiques* (October 1977), p. 739, Fig. 11. An identical high chest made of walnut but without inlay is illustrated in a Florene Maine advertisement, *Antiques* (September 1955), p. 187.

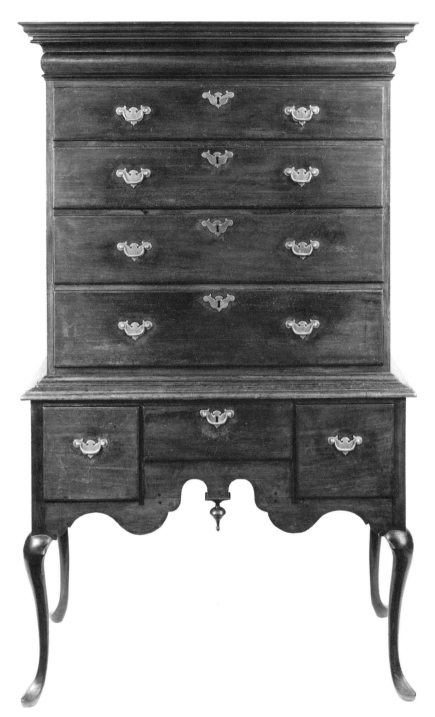

41A. High Chest of Drawers, 1730-1750
Attributed to William Stoddard (1690-1758)
Oyster Bay
Walnut
H. 69 W. 40 1/2 D. 21 1/4
Private collection

Nearly a dozen high chests of drawers have been identified that either have Oyster Bay area histories or can be stylistically associated with documented pieces from this region. All of them suggest a strong Rhode Island relationship in their skirt configurations and slipper feet, as we previously documented (Nos. 55, 136-138). It is now possible to clearly identify a primary shop and at least two secondary or "copycat" shop traditions.

The first group (Nos. 40A-41A and Nos. 136-137) shows a stylistic progression from pieces with a bolection cornice drawer, four upper drawers, single deep lower drawers flanking a single short center drawer, and batwing brasses to cases with five narrower upper drawers, no bolection-molded drawer, a long narrow drawer over three short drawers in the lower section, chamfered corners on the upper case, and later Chippendale-style brasses.

Solomon Townsend, progenitor of the famous Newport cabinetmaking family, moved from Oyster Bay to Newport in 1707. He remained, however, an owner of property in Oyster Bay, where his son, cabinetmaker Christopher (1701-1787) occasionally visited. William Stoddard (1690-1758), a Newport-trained shop-joiner who may have apprenticed in the same shop as Christopher, moved to Oyster Bay to practice his craft and married Mary Hicks. Their daughter, Sarah, married Samuel Townsend, a successful Oyster Bay merchant and possible original owner of the high chest illustrated as No. 136. The related high chests in the first group stylistically date from the mid-1720's, when Stoddard presumably arrived in Oyster Bay, and 1752, when he sold his house and shop to joiner James Whippo. Stoddard is therefore a prime candidate as the link between Newport and Oyster Bay furniture design.

Refs.: "Inscriptions from Fort Hill Cemetery at Oyster Bay, L.I., Copied by Josephine C. Frost," *The Long Island Historical Society Quarterly*, 2 (April 1940), p. 50.

A related cherry high chest without a bolection cornice but with fluted, chamfered corners was sold at Ken Farmer Realty and Auction Co., Raford, Va., April 29, 1995; see *Maine Antiques Digest* (April 1995), p. 12G.

Photograph courtesy of Israel Sack, Inc., N.Y.C.

42A. High Chest of Drawers, 1750-1780
Oyster Bay or Huntington
Cherry, chestnut, tulip poplar
H. 74 1/2 W. 40 D. 18 1/2
Mr. and Mrs. Valdemar Jacobsen

The second group of Oyster Bay area high chests, including this example and No. 138, has less fluid legs, a straight drawer arrangement in the lower case, and either an open arch in the center of the apron or a rounded central pendant. These pieces may not all be by the same craftsman, but they do seem to represent a related shop tradition. Very similar to a high chest from the Youngs family (No. 138), this example was owned by the Carll and/or Platt families of Dix Hills and Huntington (see No. 25A).

Like the group of high chests attributed to William Stoddard (Nos. 40A, 41A, and 136), this second related series of high chests features such variations as single, double, or triple top drawer arrangements and chamfered and fluted corners.

Refs.: Related high chests include R.M. Worth Antiques advertisement, *Maine Antiques Digest* (May 1995), p. 35E; Parke-Bernet Galleries, Inc., *English, American and Other Furniture from the Estate of the Late Alvin Untermyer*, October 2-3, 1964, p. 69, lot 359; Thomas D. and Constance R. Williams advertisement, *The Newtown Bee,* November 10, 1978, p. 69.

43A. High Chest of Drawers, 1740-1760
Oyster Bay
Mahogany, tulip poplar, pine
H. 69 1/4 W. 44 1/2 D. 24
Bruce Sikora

Representative of yet a third group of Oyster Bay high chests and a dressing table (No. 43B), this high chest was owned in the Seaman or Dobson family of Wantaugh. These pieces are characterized by distinctive mitered-drawer dovetails, more curvaceous cabriole legs than Nos. 42A and 138, and an arrangement of two deep lower drawers flanking a short center drawer. Several high chests have chamfered and fluted corners on the upper case.

Ref.: Related high chests include one in a Houston, Texas, private collection with similar apron as No. 43B and with chamfered and fluted corners, and a figured maple high chest owned by Phillip Allen of Great Neck, sold at Sotheby Parke Bernet, Inc., January 26, 1973, lot 706.

43B. Dressing Table, 1740-1770
Oyster Bay
Walnut, tulip poplar, white pine
H. 29 W. 33 3/8 D. 22
Bruce Sikora

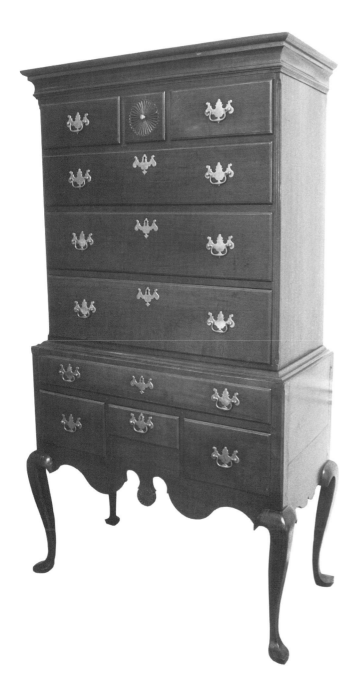

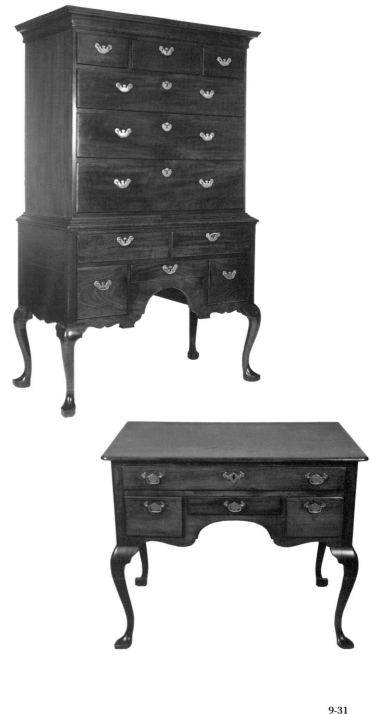

44A. High Chest of Drawers, 1770-1800
Bridgehampton or Southampton
Cherry, pine, poplar
H. 76 W. 40 1/4 D. 20
Private collection

Two groups of high chests, all found either on the South Fork or with Bridgehampton-Southampton histories of ownership, suggest that they were produced by one or more craftsmen working in the same tradition and possibly trained in the same shop (see No. 141). While both groups have similar skirt configurations, the cornice moldings, mid-moldings, drawer arrangements, and proportions vary. Other details of construction are not seen in the documented Dominy high chest, further suggesting that several craftsmen were working in a similar style. Two of these high chests also have the highly unusual feature of stocking or paneled feet usually seen on Philadelphia furniture.

Refs.: Charles F. Hummel, *With Hammer in Hand, The Dominy Craftsmen of East Hampton, New York* (Charlottesville: The University Press of Virginia, 1968), pp. 266-269.

The two stocking-foot high chests are owned by Mr. and Mrs. Morgan MacWhinnie and a Halsey family descendant.

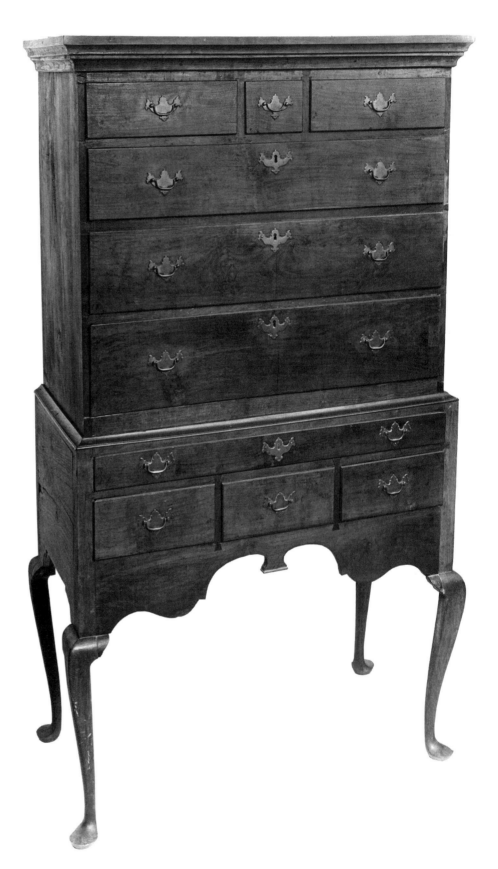

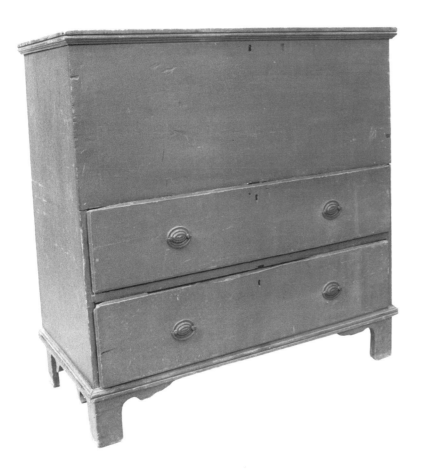

45A. Chest with Drawers, 1809
Attributed to Caleb Cooper (1745-1834)
Southampton
Pine
H. 41 1/4 W. 41 D. 19 1/2
Society for the Preservation of Long Island Antiquities, 98.8, gift of the Hobart D. Betts III Foundation

In rural areas like eastern Long Island, the simple chest with drawer or drawers was probably the most common type of case-furniture made. Since these chests followed a generic form, it is usually not possible to attribute the many surviving ones to specific craftsmen. This example, however, descended directly in the family of carpenter-joiner Caleb Cooper (see No. 47A) and bears a contemporary ink inscription, *"Mary Cooper Southampton April 29 1809."* Family tradition states that this chest was a wedding present for Mary (b. 1788), who was Caleb's daughter.

Cooper's account book reveals that in 1785 he had charged £ 1-16 shillings for a *"Chest with 2 Drawers,"* presumably a piece similar to this one. The original red or vermillion paint found on this example was frequently used on furniture constructed of simple wood such as pine. In November 1786 Cooper charged John Pelletreau, the silversmith, for *"a cradle painted with Vermillion."*

Ref.: Caleb Cooper ledger (1770-1809), p. 28, charged to Timothy Pierson, and p. 31, in the possession of Nancy Boyd Willey (see Ref., 47A).

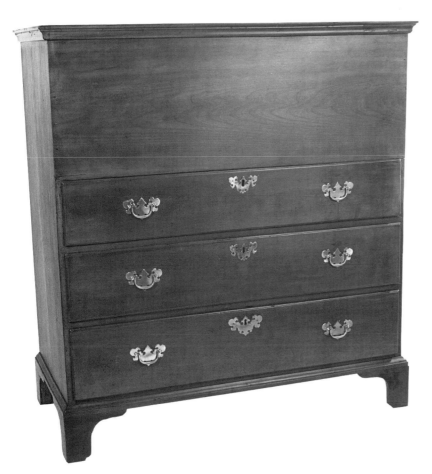

46A. Chest with Drawers, 1780-1800
Southampton
Cherry, oak, pine
H. 46 3/4 W. 43 3/4 D. 20 1/2
Society for the Preservation of Long Island Antiquities, 78.3

Identical to a chest with a history of ownership in the Pelletreau family of Southampton (see No. 123), this example was found in the basement of a Sag Harbor house. Unlike most local chests with drawers, the bracket feet are not simply extensions of the sides but are applied.

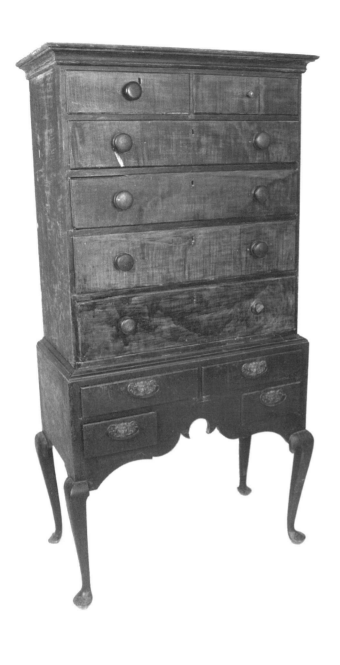
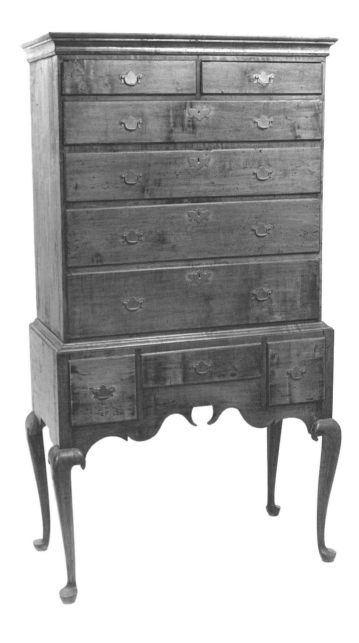

47A. High Chest of Drawers, 1770-1800
Attributed to Caleb Cooper (1745-1834)
Southampton
Maple, pine
H. 72 1/2 W. 39 1/2 D. 20
Society for the Preservation of Long Island
Antiquities, 98.10, gift of the Hobart D.
Betts III Foundation

Versatile Southampton carpenter-joiner Caleb
Cooper is identified in town records only as a
carpenter, but the fortuitous discovery of his
partial account book, which dates from 1770
through 1809, delineates a wide variety of
skills from *"mending"* the Poor House and
repairing the Presbyterian Meetinghouse clock
to making a *"Glass case"* for the Southampton

silversmith Paul Sayre and a book and map
case for the library.

Like his neighbor, Daniel Sanford (*see*
Appendix I, p. 284), Cooper also built boats,
such as four whaleboats made in 1783 for
Benjamin Huntting of Sag Harbor. Cooper's
furniture production included chairs, bedsteads,
tea tables, cupboards, desks, bookcases, and
high chests, presumably similar to this one. An
identical high chest (No. 48A), acquired locally
in the 1890's, is in the Wheelock collection of
the East Hampton Historical Society. Both this
chest and the account book have descended
directly in the Cooper family. A simple fall-
front desk with similar skirt is in the
Southampton Colonial Society collections.

Ref.: The account book, a 122-page ledger kept by
Caleb Cooper from 1770-1809, descended in the
Cooper family through Cooper's son, William H.
Cooper, to Nancy Boyd Willey of Sag Harbor.
Although the account book is now missing, in 1977 I
was able to transcribe those entries pertaining to
woodworking activities. In addition, there was a 152-
page ledger kept by William Cooper (1785-1858) and
dated 1811-1823.

48A. High Chest of Drawers, 1770-1800
Attributed to Caleb Cooper (1745-1834)
Southampton
Maple, pine
H. 67 W. 39 1/2 D. 20
East Hampton Historical Society, The William
Efner Wheelock Collection

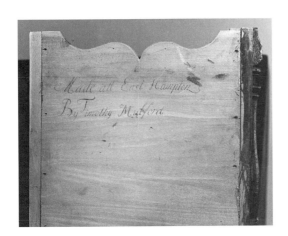

49A. Desk, 1749
Timothy Mulford (b. 1718)
East Hampton
Cherry, pine, poplar
H. 40 1/4 W. 36 1/2 D. 19 3/4
East Hampton Historical Society

Poorly illustrated as No. 230 and unexamined in the original publication of this book, this desk has proven to be an important document, for it demonstrates that even relatively small villages could support the services of several woodworking craftsmen. The desk might easily have been attributed to the Dominy family, but the inscription on an interior drawer indicates otherwise: *"Made att East Hampton/By Timothy Mulford/Bridgehampton may ye 24 1749/John Cook His Box."* Mulford is identified in a land indenture of 1754 as a joiner, and he was one of at least six other Mulford family woodworkers. His shop is said to have been on the corner of Main Street and Buell's Lane, undoubtedly attached to his house, which still stands. Deacon John Cook (1722-1804), for whom the desk was made, lived in Mecox, present-day Bridgehampton. The desk has an old blue-green painted finish.

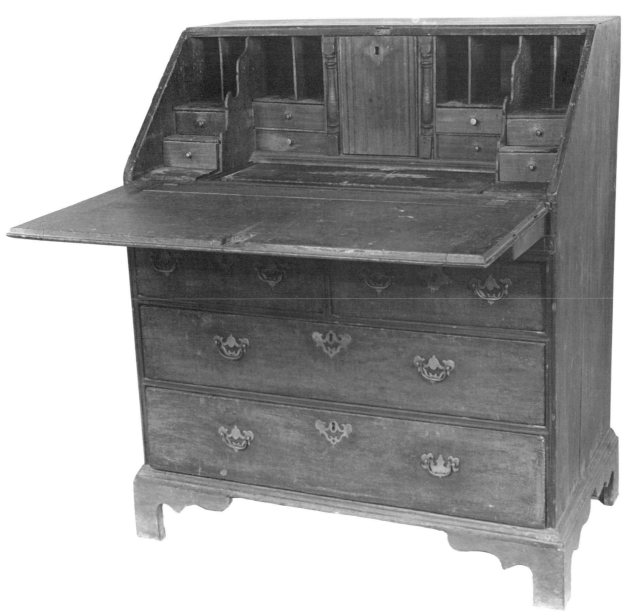

50A. Desk, ca. 1765
Attributed to Ludlow Clark (active ca. 1765)
Coram
Cherry, pine, poplar
H. 41 W. 36 1/2 D. 18 1/4
Private collection

An ink inscription on the document drawer of this desk reads, *"Year 1765 when this desk was made by Old Ludlow Clark the father of Benjamin Clark that now lives at the second house east of the Poor house in Coram...."* The author of the inscription, Richard W. Smith, was the grandson of the desk's original owner Isaac "Petticoat" Smith of Coram, who in turn was the great-grandson of Richard "Bull" Smith of Smithtown. The inscription continues with a terse version of immediate family history and the story of Isaac Smith's capture and imprisonment by Tories following a raid on Coram during the Revolutionary War.

Like numerous Connecticut desks and several other pieces of furniture owned and probably made near Coram, this desk features a compass-star inlay flanked by the initials, *IS*, on its lid. Richard Smith's dating of the desk is apparently based on a chalk inscription on the document drawer reading *"1765."* Ludlow Clark, Goldsmith Davis (see No. 52A), Isaac Smith, and Samuel Satterly (see No. 153 and Appendix I, p. 284) were members of the same militia company in Brookhaven in 1775, thus indicating a possible relationship not only between the client and the maker of the desk but also among several area cabinetmakers. Clark is identified in Appendix I as a joiner. The desk is still in the Smith family.

Ref.: Frederic Gregory Mather, *The Refugees of 1776 from Long Island to Connecticut* (Albany: J.B. Lyon Company, 1913), pp. 1060-1061.

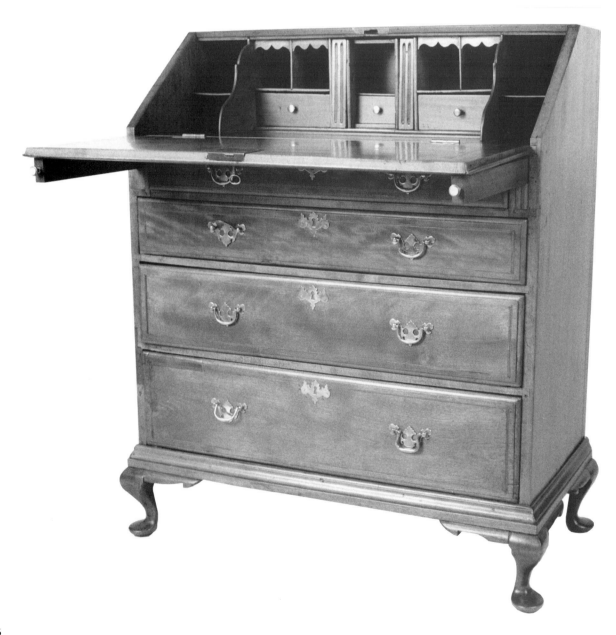

51A. Desk, 1770
Thomas Cooper (d. 1774)
Southampton and Brookhaven
Walnut
H. 43 3/4 W. 40 D. 19 1/2
Society for the Preservation of Long Island
Antiquities, 86.45

An important document and a rare signed example of Long Island furniture, this desk was made by Thomas Cooper, the brother of carpenter-joiner Caleb Cooper of Southampton (see Nos. 45A, 47A, 48A) for Thomas Helme (1728-1818) of Miller Place, Brookhaven. Helme was descended from one of Brookhaven's first settlers and was a prominent member of the community, holding several public offices and serving as Secretary of the Committee of Safety during the Revolution. He married Hannah Smith (1729-1789), granddaughter of Col. William "Tangier" Smith (see No. 20).

Cooper, who is mentioned in the 1769 will of his father, Thomas Cooper, Jr. (1710-1782), apparently moved to Miller Place in the late 1760's. He died there in 1774, according to local tradition from injuries sustained in a fall

during the construction of a barn for the Hopkins family. His headstone in the Miller Place burying ground reads *"Thomas Cooper, Carpenter of Southampton."*

The prospect door of the desk is playfully fashioned as a face with two paper "eyes" under glass. Cooper signed his name and the date of August 1770 in the area surrounding the pupil of the eye on the right. The eye on the left is inscribed *"Thomas Helme Esquire."* The use of inlaid initials on the lid of the desk represents an apparent local preference seen in other Brookhaven desks (Nos. 50A and 52A). The shape of the foot bracket may be useful in identifying work from the Cooper family since it appears as a leg bracket on a table branded by Thomas's nephew, William Cooper (No. 240).

Ref.: Christie's, New York, *Important American Furniture, Silver, Folk Art and Decorative Arts,* October 18, 1986, pp. 156-157, lot 487.

Miller Place local historian Margaret Gass provided information on the Helme family during an interview with then SPLIA curator, Deborah Ducoff-Barone, in late 1986.

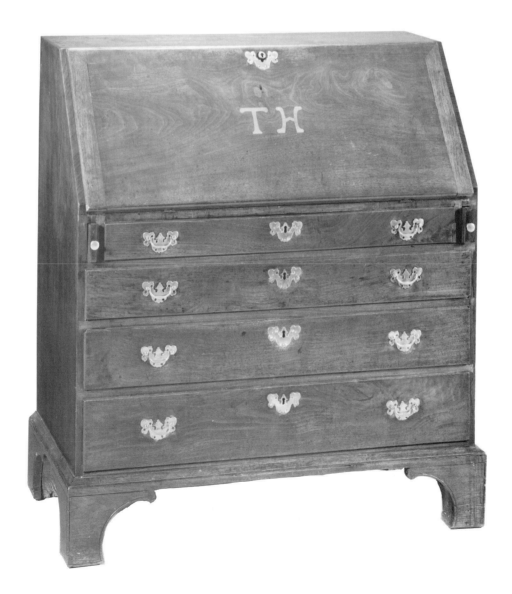

52A. Desk and Bookcase, 1786
Brookhaven
Walnut, maple, chestnut, white pine,
yellow pine
H. 79 3/4 W. 44 D. 23 1/2
The Metropolitan Museum of Art, gift of
Jeanette N. Bedell, 1943 (43.150)

53A. High Chest of Drawers, 1760
Brookhaven
Maple
H. 79 W. 40 1/2 D. 19 1/2
Location unknown

The curious blending of New York and New England fashions and styles can be seen in two newly identified pieces of furniture almost certainly made in a Brookhaven-area shop. The first, a desk and bookcase, is documented as having been made for Goldsmith Davis of Selden, or adjacent Coram, who was the first postmaster of that community. The lid bears an inlaid compass star flanked by the initials *GD* and the date *"1783."*

The second related piece is a high chest of drawers that shares many of the distinctive stylistic features of the desk and bookcase, including identical cornice moldings, canted and fluted corners, ball-and-claw front feet combined with pointed-slipper rear feet, and matching brasses. The remnant of a third case piece by the same maker was once the base of a high chest with a carved circular pinwheel identical to that shown in No. 53A; this base was converted to a base for a compass-star inlaid desk section and is now in the nearby Wading River Historical Society.

Definitive attribution of these pieces is not possible, but probable makers include Samuel Satterly, Ludlow Clark, Austin Roe, Mordecai Homan, or even one of the many Davis family woodworking craftsmen (see Appendix I).

Ref.: Morrison H. Heckscher, *American Furniture in The Metropolitan Museum of Art, Late Colonial Period: The Queen Anne and Chippendale Styles* (New York: The Metropolitan Museum of Art and Random House, 1985), pp. 287-288.

Photograph of 52A courtesy of The Metropolitan Museum of Art.

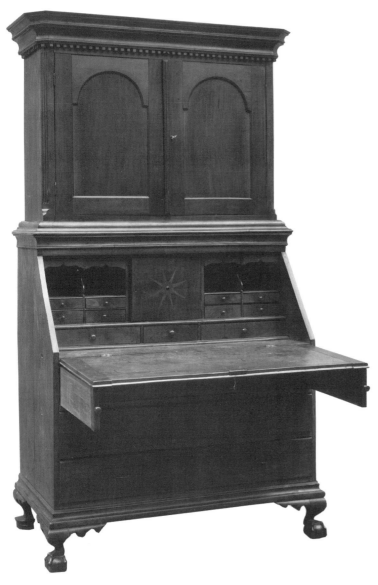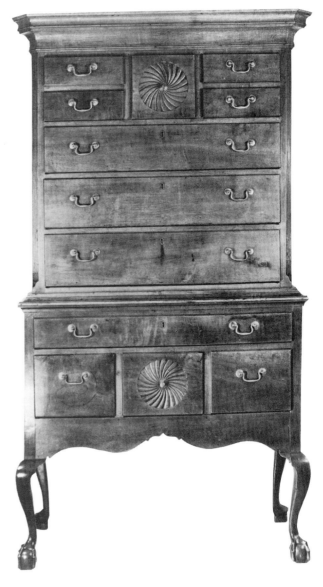

54A. Desk and Bookcase, 1780-1800
Southampton
Cherry, poplar, oak, pine
H. 82 1/2 W. 40 D. 20
Dr. and Mrs. Hugh Halsey

Originally owned by Dr. Stephen Halsey (1757-1837) of Bridgehampton and his wife Hamutal Howell, this desk is unusual for eastern Long Island in having glass panes (later restored) in the upper section. While many local craftsmen were capable of such work (James Howell of Sag Harbor, for example, had *"426 lights [panes] of 6 by 8 and 7 by 9 of sashes"* listed in the inventory of his estate), the extra cost probably led to a more common choice of wood-paneled doors (see Appendix I, p. 277). The ogee bracket feet reflect a Rhode Island influence prevalent on the east end of the Island.

55A. Wardrobe, 1780-1800
Probably Sag Harbor
Cherry, poplar, pine, chestnut
H. 82 1/2 W. 47 D. 22 1/2
Society for the Preservation of Long Island Antiquities, in memory of Christopher Sigerist Beeson, 77.14

Ogee bracket feet have been found on only a few other pieces of furniture with South Fork provenances: an identical wardrobe in the collection of the East Hampton Historical Society; a related chest-on-chest; two desks and bookcases; a desk in the Southampton Colonial Society; and a chest of drawers (SPLIA). Family tradition and the initials *LHF* inscribed on the backboard of this wardrobe indicate that it was originally owned by Lewis Fordham of Sag Harbor.

Ref.: See Dean F. Failey, "The Furniture Tradition of Long Island's South Fork, 1640-1800," *The American Art Journal* (January 1979), pp. 61-63. The first desk and bookcase is illustrated as No. 54A. The second is the Gardiner family desk and bookcase; see Mark J. Anderson and Robert F. Trent, "The Case of the Desk and Bookcase," *Winterthur Magazine* (Spring 1993), pp. 8-9.

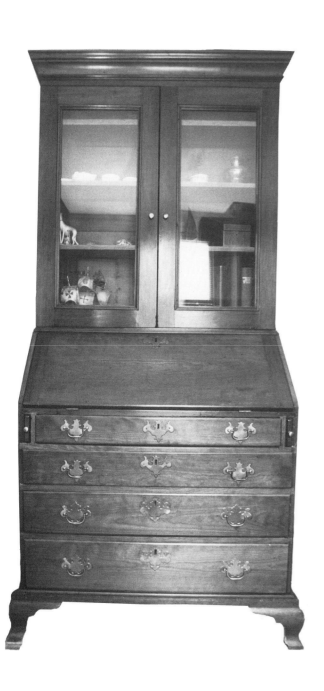

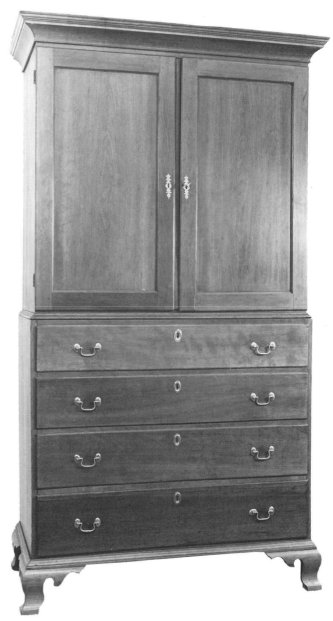

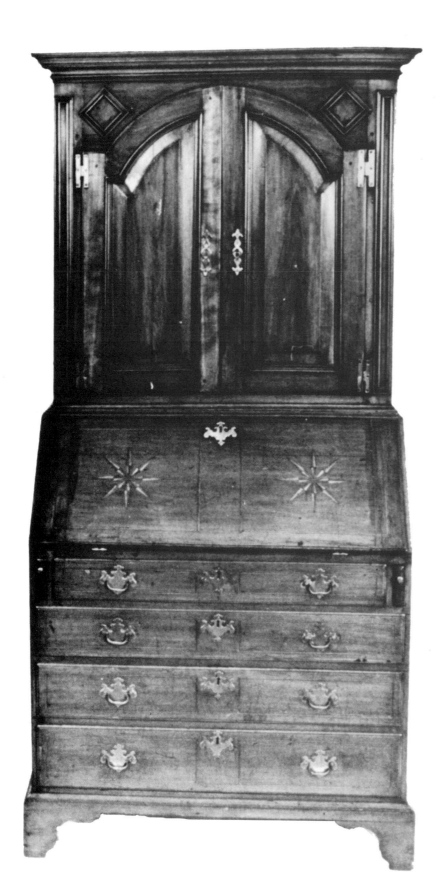

56A. Desk and Bookcase, 1770-1800
Kings County or Queens County
Maple, poplar
H. 77 1/4 W. 36 1/2
Private collection

The continuity and strength of the Dutch furniture tradition in the Dutch-settled towns of western Long Island is evident not only in numerous documentary references (as late as 1815) to "Dutch" cupboards but also in the adaptation and Anglicization of Dutch stylistic elements to later English furniture forms. The Society for the Preservation of Long Island Antiquities has acquired the fourth known example of a Flatlands wardrobe identical to No. 144, and it is part of this extended tradition. The present desk and bookcase seems to share in this tradition with its modified broad cornice molding, applied molded diamonds, and rectangular panels. The inlaid double compass-star inlay on the lid is more often associated with New England furniture and English preferences but is consistent with the merging of these two cultures.

Ref.: The desk and bookcase was sold at Skinner's, October 1978, lot 193.

57A. Desk and Storage Cabinet, 1800-1825
Attributed to Joshua Livingston Wells
(1776-1855)
Aquebogue
Painted yellow pine, pine, tulip poplar
H. 83 W. 43 1/2 D. 29 1/4
Abby Aldrich Rockefeller Folk Art Center,
Colonial Williamsburg, 1981.2000.1

Clearly this complicated piece of furniture, which appears at first glance to be a desk and bookcase but had many other possible uses as well, is an individualized and ingenious custom-made case piece. Although Joshua Livingston Wells was not identified in Appendix 1, other members of the Wells family were. Apparently, Joshua Wells was a multi-skilled craftsman, who built his own house as well as this desk, which descended in the family.

The overall form of the desk is similar to hemispherical-arched doorways seen in eastern Connecticut and Rhode Island. When fully opened, this piece reveals innumerable drawers, storage compartments, and work surfaces. At each side are miniature desks with slant lids, small interior drawers, and larger drawers below. The decoration of the desk is as complicated as its construction, displaying innumerable hand-crafted moldings, mahoganized graining, a slide painted to resemble a decorated oval tea-tray, painted inlay, meandering-vine carving, carved pinwheels, rope-twist and scalloped moldings, and an orange-red painted interior. Some of the carvings are related to a watch box (No. 158).

Ref.: I am indebted to Barbara R. Luck, Curator, the Abby Aldrich Rockefeller Folk Art Center, Colonial Williamsburg, for providing the research information prepared by former curator Richard Miller.

Photograph courtesy of the Colonial Williamsburg Foundation.

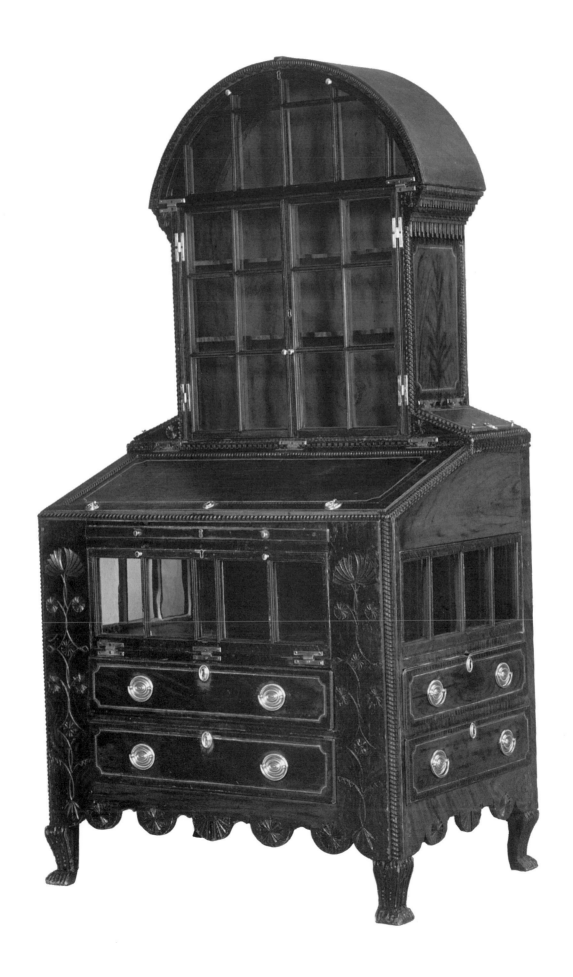

9-41

58A. High Chest of Drawers, 1755-1775
Attributed to John Goddard (1723-1785)
Newport, Rhode Island
Mahogany
H. 82 1/4 W. 38 1/4 D. 20 1/2
Private collection

Thomas Tillinghast and Joseph Tillinghast
(d. 1777) (also spelled and pronounced Tilleness),
both ship captains, are believed to be the
progenitors of the Tillinghast family of East
Hampton and are themselves descendants of
Pardon Tillinghast (1622-1718) of Providence,
Rhode Island. It seems likely that this high
chest, a large oval drop-leaf dining table, and a
rectangular tea table (No. 58B), all of Newport
origin and until recently owned by the family
in East Hampton, were brought here by either
Joseph or Thomas. The convenience and rela-
tive ease of water travel made social and eco-
nomic ties with Connecticut and Rhode Island
routine for eastern Long Islanders and offered
them access to other cultural influences.

Ref.: Jeannette Edwards Rattray, *East Hampton History
including Genealogies of Early Families* (Garden City,
N.Y.: Country Life Press, 1953), pp. 585-589.

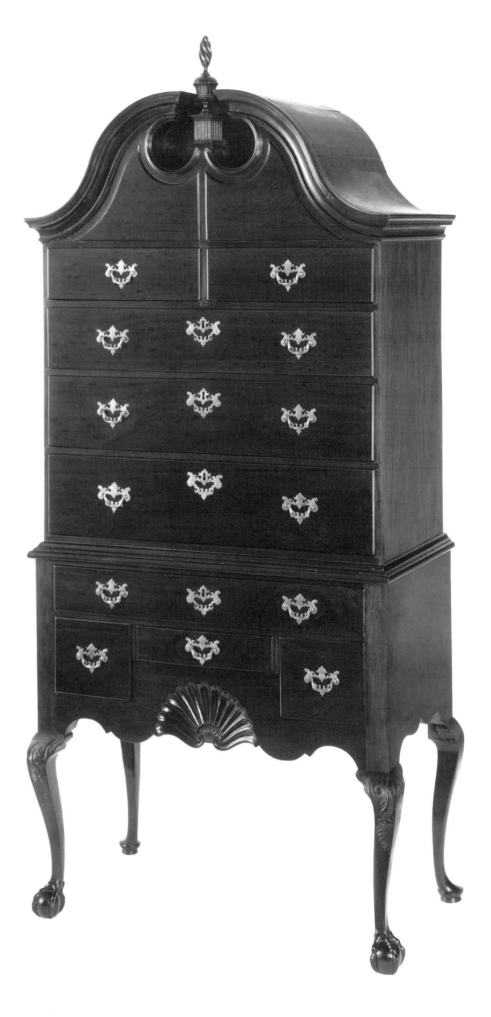

58B. Tea Table, 1760-1775
Attributed to John Goddard (1723-1785)
Newport, Rhode Island
Mahogany
H. 26 W. 31 3/4 D. 19
Private collection

59A. Pair of Side Chairs, 1755-1775
Newport, Rhode Island
Mahogany
H. 38
Dr. and Mrs. Hugh Halsey

These two chairs were part of a set of at least six, all of which have been reduced in height and have had castors added. With a history of ownership in the Halsey family of Southampton, these chairs suggest a conservative pattern of taste even for imported objects. The chairback is almost identical to that in another set of chairs with a South Fork history of ownership (see No. 103). Like that set, these chairs have straight legs but are further embellished with stop-fluting. The seat apron, with brackets and central pendant, is unusual but conforms to aprons on Rhode Island tables.

Ref.: Albert Sack, *The New Fine Points of Furniture, Early American* (New York: Crown Publishers, 1993), pp. 263, 267, illustrates tables with similar aprons.

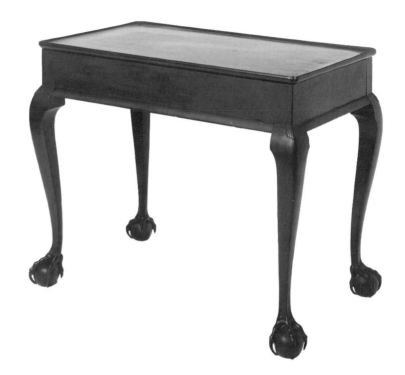

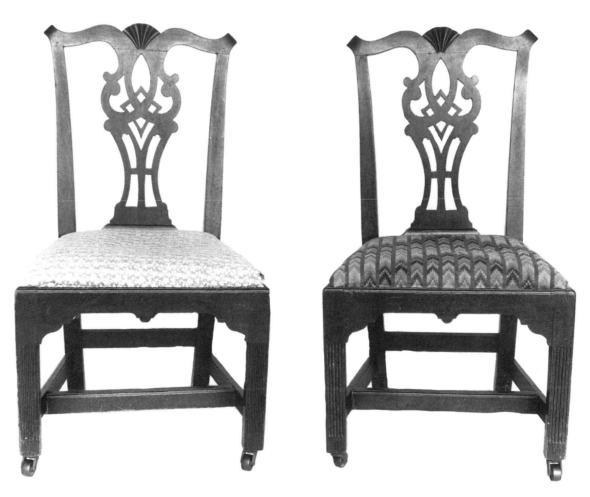

60A. Low-post bedstead, 1750-1800
Southampton
Painted pine
H. 32 3/8 W. 41 1/2 D. 70 3/4
Society for the Preservation of Long Island
Antiquities, gift of Betty Kuss, 78.7

Descended in the Jagger family of
Southampton, this bed, which retains its
original blue-green paint, was obtained from
the Jeremiah Jagger house and family on the
Old Montauk Highway in West Hampton.
A photograph of a chamber in the Old House,
Cutchogue, taken by the Historic American
Buildings Survey in 1940, shows an identical
bed, suggesting that they are the products of a
Southampton craftsman, possibly Daniel
Sandford, who recorded in his accounts the
making of at least 64 bedsteads (see pp.
198-199).

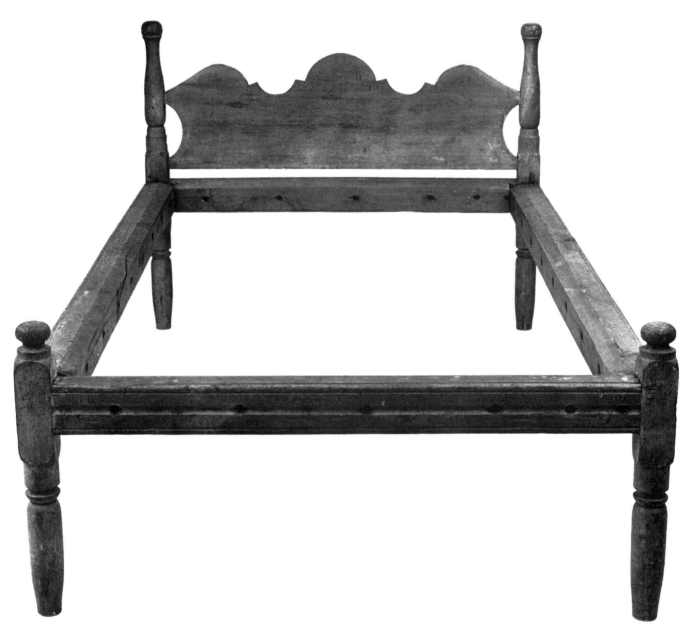

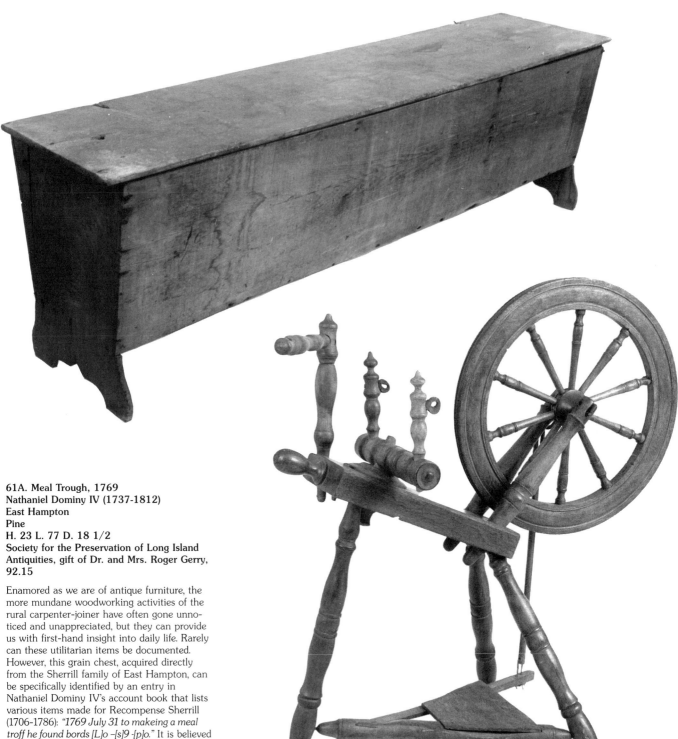

61A. Meal Trough, 1769
Nathaniel Dominy IV (1737-1812)
East Hampton
Pine
H. 23 L. 77 D. 18 1/2
Society for the Preservation of Long Island
Antiquities, gift of Dr. and Mrs. Roger Gerry,
92.15

Enamored as we are of antique furniture, the
more mundane woodworking activities of the
rural carpenter-joiner have often gone unno-
ticed and unappreciated, but they can provide
us with first-hand insight into daily life. Rarely
can these utilitarian items be documented.
However, this grain chest, acquired directly
from the Sherrill family of East Hampton, can
be specifically identified by an entry in
Nathaniel Dominy IV's account book that lists
various items made for Recompense Sherrill
(1706-1786): *"1769 July 31 to makeing a meal
troff he found bords [L]o –[s]9 -[p]o."* It is believed
that this trough was intended for household
rather than barn or kitchen use, perhaps in an
unfinished room.

Ref.: Nathaniel Dominy IV and Nathaniel Dominy V,
Account Book B, 1762-1844 (DMMC, Ms. 59 x 9a, p.
46) the Joseph Downs Collection of Manuscripts and
Printed Ephemera, Winterthur Library, The Henry
Francis du Pont Winterthur Museum, Gardens and
Library, Winterthur, Delaware.

62A. Flax Spinning Wheel, 1770-1810
Branded HC, probably Harvey Colwill
(active ca. 1759-d. 1815)
Oyster Bay
Maple, oak
H. 34 L. 32
Huntington Historical Society,
Kissam Family Collection

Having the same Kissam-Hewlett family
provenance as a set of side chairs (see No.
24A) and branded *"HC,"* this flax wheel can be
attributed to Harvey Colwill or Henry Colwill
of Oyster Bay (see Appendix I, pp. 229, 272).
The turnings on this wheel are nearly identical
to those on wheels made by Isaac and
Ambrose Parish, also from Oyster Bay (Nos.
235, 236). Following the original publication of
this catalogue, information was obtained from
a Colwill (Colwell) descendant who confirmed
that Harvey Colwill was a furniture-making
craftsman and provided photographs of a table
identical to one shown in *Antiques* (October

1977), also with an Oyster Bay-area history.
Supporting the attribution to Colwill is the fact
that he is buried at the Episcopal church in
Glen Cove, suggesting that he lived in the area
adjacent to the Kissam-Hewlett homestead in
Glenwood Landing.

Refs.: Letter to the author from Mrs. Page Stephens,
January 3, 1977.
 Dean F. Failey, "Seventeenth- and Eighteenth-
Century Long Island Furniture," *Antiques* (October
1977), p. 739, Fig. 12.

63A. Teapot, 1750-1775
Elias Pelletreau (1726-1810)
Southampton
Silver, wood
Mark: EP in rectangle
H. 6 11/16
The Newark Museum, Purchase 1995,
Florence B. Selden Bequest and The
Members' Fund, 95.29.1

One of four surviving nearly identical teapots by Southampton silversmith Elias Pelletreau (see No. 245), this example was discovered only recently. It has a direct line of descent in the family of Pelletreau's daughter, Jane, who married Judge Pliny Hillyer of Simsbury, Connecticut, and is engraved with script initials *"EP"* and later initials *"JPA"* (Jane Pelletreau Ashley). Not unexpectedly, it is unrecorded in Pelletreau's account book, nor is it listed in the inventory of his estate. It is quite likely that Elias presented it to Jane as a wedding present, having originally made it for himself.

Ref.: One teapot, catalogue No. 245, is in The Minneapolis Institute of Arts; a second, privately owned, was included in the 1976 exhibition; a third was sold at Christie's, *Important American Silver: The Collection of James H. Halpin*, January 22, 1993, lot 119. This example was sold at a Pook and Pook auction in Pennsylvania in 1994; it was consigned by a direct descendant.

Photograph ©The Newark Museum/Art Resource, New York.

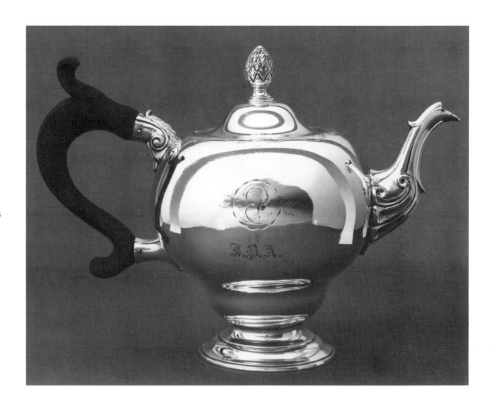

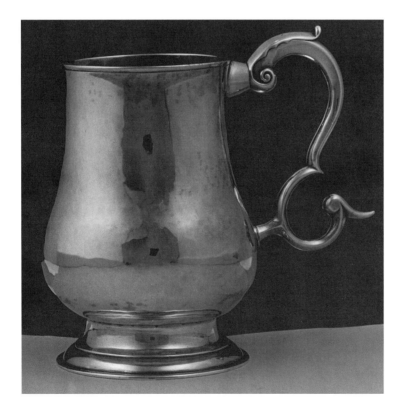

64A. Cann, 1805-1815
William Smith Pelletreau (1786-1842)
Southampton
Silver
Mark: WSP in rectangle
H. 5 1/8
Private collection

William Smith Pelletreau was the grandson of Elias (Nos. 81-82, 191, 243-246) and son of John Pelletreau (No. 192). He probably began learning his trade from his father and grandfather in about 1800 when he was fourteen. William remained in Southampton for a few years, but by 1815 he was working in New York, in partnership with Stephen Van Wyck. This cann therefore predates his partnership. Were it not marked, it would easily be mistaken for the work of Elias Pelletreau, since it is identical to his work and employs the same double-reverse C-scroll handle with furled acanthus leaf. This is one of the few pieces of hollowware bearing his individual mark.

Ref.: Dean F. Failey, "Elias Pelletreau: Long Island Silversmith," master's thesis, Winterthur Program, University of Delaware, 1971.

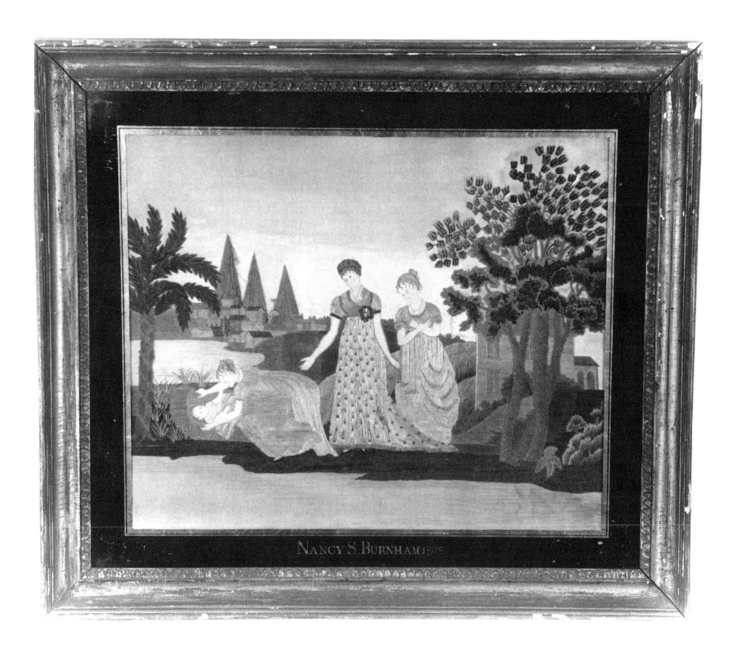

NANCY S. BURNHAM 1806

65A. Needlework Picture, 1806
Nancy S. Burnham
Mrs. Lyman Beecher's School
East Hampton
Silk, watercolor, sequins, chenille
H. 16 1/2 W. 20 1/2
Society for the Preservation of Long Island
Antiquities, 98.9, gift of the Hobart D.
Betts III Foundation

Roxanna Foote Lyman, the wife of East
Hampton minister, Lyman Beecher, and her
sister Mary ran a small private girls' boarding
and day school in the Beechers' house on Main
Street during the first decade of the nineteenth
century. Typically, the girls learned sewing and
needlework. In 1806, the year Nancy Burnham
worked this picture, Eliza Helme, a boarding
student from Brookhaven, wrote her mother,
*"You wrote me word that you thought I had bet-
ter employ more of my time in working on my
piece of embroydery [sic] if I do so Mrs. Beecher
thinks if I work forenoon & afternoon I shall fin-
ish it this quarter & I think I shall."* Three other
needlework pictures, two with biblical scenes
and all similarly framed with eglomise glass, are
known. This frame is original.

Refs.: Letter by Eliza Helme, October 24, 1806,
photostatic copy, the East Hampton Historical Society.

One picture is in the collections of Home Sweet
Home, East Hampton; another in the collections of the
East Hampton Historical Society; a third privately
owned in East Hampton. Burnham was a family resi-
dent on the South Fork in the late eighteenth and
early nineteenth centuries, but we have been unable to
trace her genealogy.

66A. Mourning Embroidery, ca. 1825
Jane M. Hewlett (1811-1834)
North Hempstead
Silk, chenille, paint, ink on silk
H. 18 1/4 W. 23 1/4
Betty Ring

Although this is one of a recognizable group
of mourning pictures that includes an example
by Mary Ann Hewlett in the collections of The
Museums at Stony Brook (No. 67A), we do not
know exactly where the school was located
or who the teacher was. Jane Mitchell Hewlett
was the daughter of Whitehead Hewlett of
Great Neck and granddaughter of George
Hewlett, subject of the memorial. She married
Dr. William Wilmot Kissam (1806-1842).

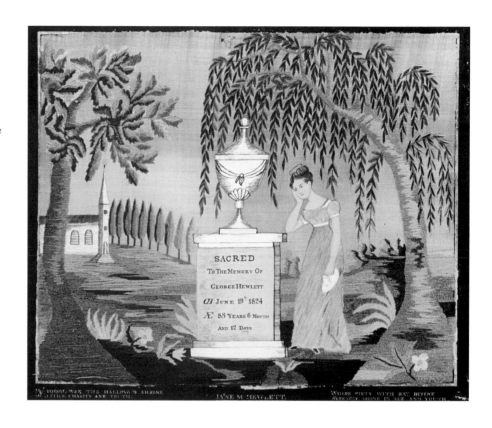

67A. Mourning Embroidery, ca. 1825
Mary Ann Hewlett
North Hempstead
Silk, chenille, paint, ink on silk
H. 18 1/4 W. 23 1/4
The Museums at Stony Brook

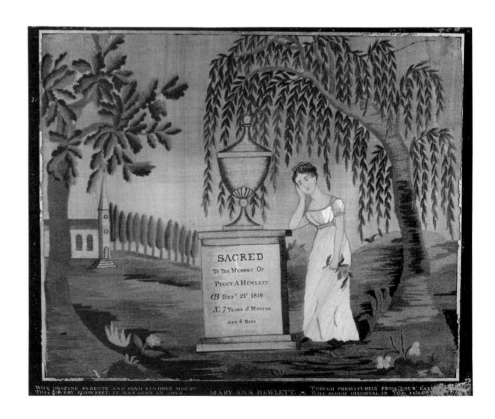

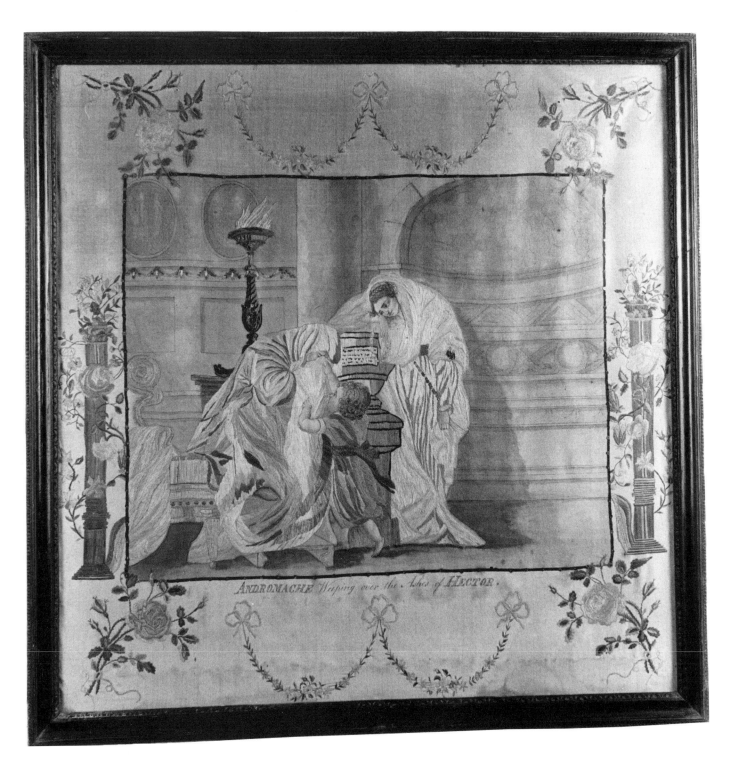

68A. Pictorial Embroidery, ca. 1824
Probably by Anna Charlotte Dering
(1811-1905)
Silk, paint and ink on silk
H. 31 W. 31
Private collection

Andromache Weeping over the Ashes of Hector
was probably embroidered by Anna Charlotte
Dering, daughter of Henry Packer Dering, who
was both Collector of Customs and Postmaster
of Sag Harbor. Although unsigned, it descend-
ed directly in her family. Anna is recorded as a
pupil at Sarah Pierce's Litchfield Academy in
1824-1825, and this picture relates to other

Litchfield examples, which in turn reflect a
regional style centered in Hartford. Attendees
from Long Island enrolled during the same
year included Mary Gardiner of Gardiner's
Island and Mary S. Osbourne of Sag Harbor.

Refs.: Betty Ring, *Girlhood Embroidery: American
Samples and Pictorial Needlework, 1650-1850* (New
York: Alfred A. Knopf, 1993), pp. 218-223.
 Glee Kruger kindly provided confirmation that Anna
Dering was a pupil at the Litchfield Academy.
 Theodore and Nancy Sizer, Sally Schwager, Lynn
Templeton Birchley, and Glee Kruger, *To Ornament
Their Minds: Sarah Pierce's Female Academy, 1792-1833*
(Litchfield, Conn.: The Litchfield Historical Society,
1993), pp. 119, 125.

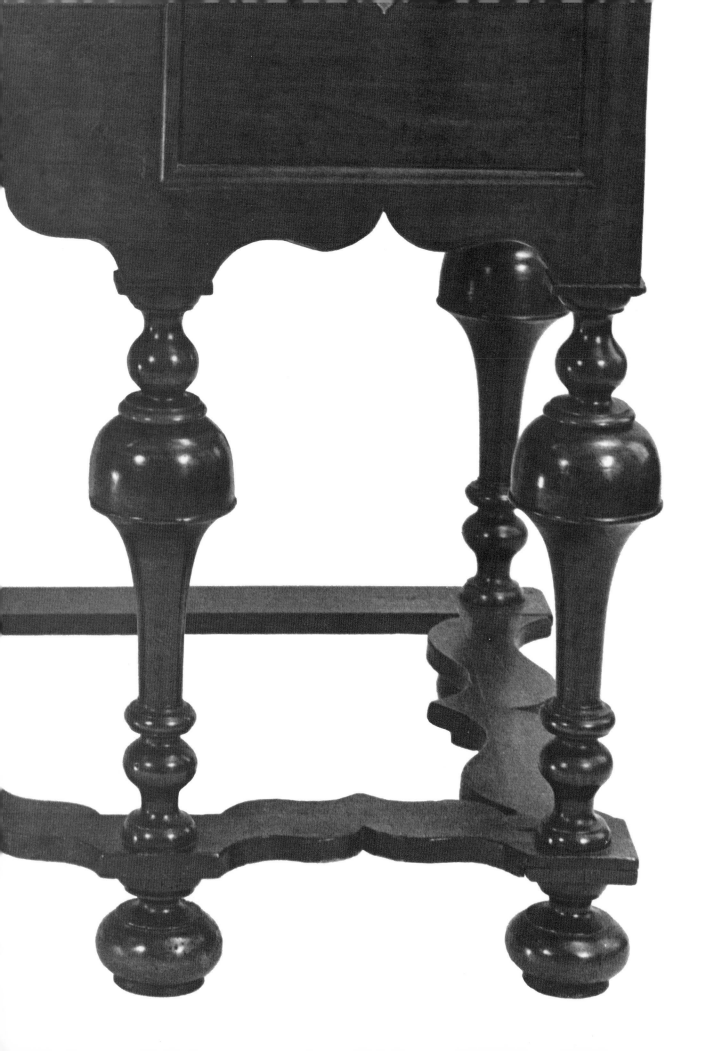

I. A MEETING GROUND OF CULTURES, 1640–1730

Throughout the colonial period, diverse influences affected Long Island's cultural development. Various national and religious groups settled on Long Island and created distinctive cultural patterns based upon their particular values and customs. Although some Frenchmen and Germans found their way to Long Island during this period, the two most important national groups to colonize the region were the Dutch and the English. By the 1640's, they had established separate towns, the Dutch at the west end and the English, initially, at the east end. The patterns of settlement, and political and economic developments, however, eventually brought these groups into contact with each other. By the end of the seventeenth century, cultural interaction was well under way.

The Dutch settled Long Island not long after the founding of New Amsterdam in 1624. Dutchmen purchased land on western Long Island in the 1630's, and scattered settlements no doubt existed during that decade and possibly earlier. The first Dutch town on western Long Island, Brooklyn, was chartered in 1646 and during the next two decades four more Dutch towns received charters—Flatbush in 1653, Flatlands in 1657, and New Utrecht and Bushwick in 1661.

While Dutch settlement was confined to the western end of Long Island, English settlement began at the eastern end. A great many English colonists came to Long Island by way of New England. The need for additional land and the growth of dissension within tightly regulated Puritan communities contributed to the pressures for migration elsewhere. In 1640, a group from the New Haven Colony in Connecticut joined by a group from England settled at Southold on eastern Long Island's north fork. Also in 1640, approximately forty familes from Lynn, Massachusetts, founded Southampton on the south fork. A third group of New Englanders, also from the Massachusetts Bay Colony, settled at East Hampton in 1649.

English colonists rapidly settled the eastern half of Long Island, establishing the towns of Huntington in 1653, Brookhaven in 1655, and Smithtown in 1662. In 1653, several families from Massachusetts founded the town of Oyster Bay on the north shore of western central Long Island. During this period of settlement, Englishmen also established themselves in areas under Dutch control on western Long Island, and the Dutch government granted charters for the following English towns: Flushing and Gravesend in 1645, Hempstead in 1646, Newtown in 1652, and Jamaica in 1656.

By the time England took control of New Netherland from the Dutch in 1664 and organized the colony of New York, three identifiable cultural areas existed on Long Island. The western end, which eventually became Kings County, was distinctly Dutch. The eastern half of Long Island, which became Suffolk County, was English. The western central part of the Island, later Queens County, was also predominantly English, but culturally distinct from the east end because of the presence of Dutch and Quaker settlements in the area and also because of its proximity to the Dutch west end. All three areas were, of course, overwhelmingly rural and farming was the primary economic activity. Certainly, the Dutch and the English faced similar problems in attempting to establish a comfortable self-sufficiency. Yet due to the facts of settlement, different cultural patterns took hold in these three areas.

"Long-Island, the West-end of which lies Southward of New York, runs Eastward above one hundred miles, and is in some places eight, in some twelve, in some fourteen miles broad; it is inhabited from one end to the other. On the West end is four or five Dutch Towns, the rest being all English to the number of twelve, besides Villages and Farm houses."
From Daniel Denton, *A Brief Description of NEW-YORK: Formerly Called New-Netherlands*, London, 1670.

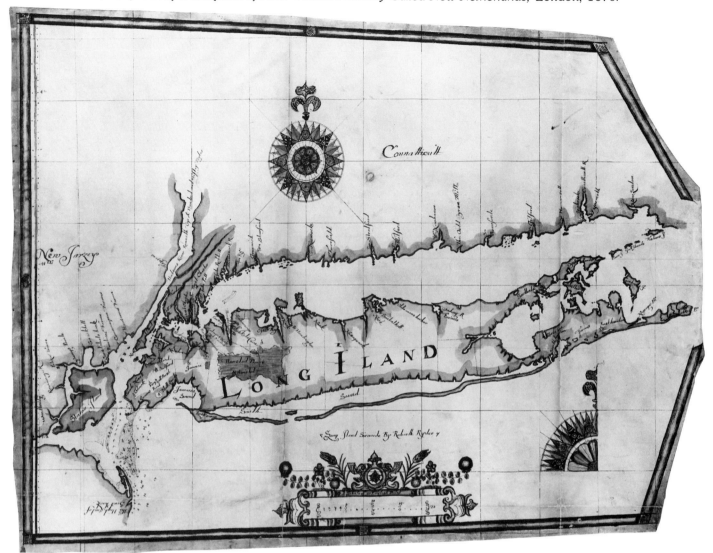

1. Map of Long Island, ca. 1675
Robert Ryder (active ca. 1670–1681)
Ink on vellum
H. 23 3/4 L. 31 3/4
The John Carter Brown Library, Brown University, Providence, Rhode Island

This manuscript map of Long Island was designed from a public land survey of New York made by Robert Ryder about 1675. Five years earlier Ryder executed a private land survey of the same region and drew his 1670 map of Long Island, now in the possession of the New-York Historical Society. Ryder was an active land surveyor in the New York area from 1670 until his death about 1681. He made a number of private surveys and received one other documented public commission to survey Staten Island, which he apparently carried out in 1674.

This Long Island map is included in the Blathwayt Atlas, a collection of forty-eight manuscript and printed maps gathered by William Blathwayt, British Secretary of the Lords of Trade and Plantations from 1679–1696. The map, which is colored and illuminated, is a redrafting on vellum of Ryder's original survey.

The Dutch people who settled western Long Island were farmers whose customs and traditions were those of the rural Netherlands influenced to some degree by the expansive bourgeois commercialism of Amsterdam and other Dutch towns.[1] Most were members of the Dutch Reformed Church, but their religious beliefs incorporated the particular folk traditions long familiar to them.[2] They settled at first on scattered farms rather than in defined communities and only after 1640 did the West India Company encourage settlement in towns for purposes of defense and military security. The Dutch on western Long Island were closely allied by geography as well as through cultural and economic ties with the Dutch in New York City. That community, however, was notably heterogeneous, particularly toward the end of the century, with a diverse population composed of many different ethnic and religious groups, among them Dutch Calvinists, French Huguenots, English Quakers, and Jews. The cultural influences emanating from New York City affected life on western Long Island throughout this early period.

The eastern Long Island towns were settled by New Englanders and were thus naturally allied with that region. The New England Puritans who came to Southold, Southampton, and East Hampton brought with them an ideal of religious community which resulted in the establishment of towns in which religious and political authority were closely linked, much the same as in New England.[3] Their commercial and cultural attachment to New England was a pronounced feature of

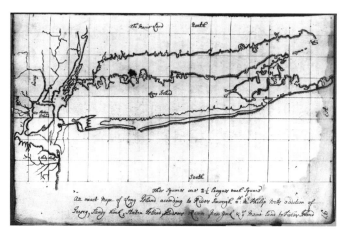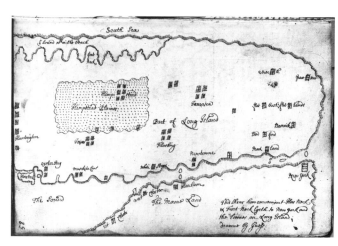

2. Map of Long Island, ca. 1685
Probably James Lloyd (1653–1693), after
Robert Ryder (active ca. 1670–1681) and
Philip Wells (active ca. 1680)
Long Island
Ink on paper
H. 12 1/4 W. 8
The New-York Historical Society

Robert Ryder's importance and reputation as a
surveyor is evidenced by this previously unpub-
lished map of Long Island, contained in the
account book belonging to James Lloyd and his
son, Henry Lloyd I (1685–1763). Beneath the
map, which is drawn on a grid, is the notation:
*"Thes[e] Squares are 2½ Leagues each
Square/An exact Map of Long Island according
to Riders Surveigh w*ᵗʰ*: Mr. Philip Wells addition
of/Jersey, Sandy hook, Staten Island, Hudson
River, New York & y*ᵉ *Maine land to Fishers
Island."* Ryder made a survey of Staten Island
property for Philip Wells in 1680, but Wells'
abilities as a surveyor have gone unnoticed. One
can assume that James Lloyd copied this and
other maps in the account book (Nos. 3, 56) from
manuscript versions. The Lloyd property, a neck
of land on the north shore of Long Island, is set
off in black ink. One of the other maps in the
account book (No. 56) is dated 1685, probably
the approximate date of this map.

3. Map of Western Long Island, ca. 1685
Probably James Lloyd (1653–1693), possibly
after Robert Ryder (active ca. 1670–1681) or
Philip Wells (active ca. 1680)
Ink on paper
H. 12 1/4 W. 8
The New-York Historical Society

Another map in the James and Henry Lloyd I
account book bears the legend: *"This Shews
how convenient Hors Neck & Fort Neck* [the
Lloyd property on Long Island] *lyeth to New
York and the Townes on Long Island."* The map
shows only the portion of Long Island west of
Huntington and names the sixteen major settle-
ments established by the time it was drawn,
about 1685. It also illustrates a notable topo-
graphical feature of western Long Island, Hemp-
stead Plains. As the legend explains, it was
"drawn by Guess."

their way of life. As the Governor of New York complained in 1703: *"Indeed, the
people of the East End of Long Island are not very willing to be persuaded to
believe that they belong to this province. They are full of New England principles."* [4]

To support themselves, Englishmen at the east end farmed the land and
began whaling along the shoreline in small boats. The marketing of whale oil and
the making of barrels to transport the oil became important sources of livelihood in
the seventeenth century. Not surprisingly, Boston was the primary market for whale
oil from the east end. The Governor and Council in New York reported to officials
in England in 1687: *". . . What is produced from their industry is frequently carried
to Boston . . . not-withstanding of the many strict rules and laws made to confine
them to this place. . . ."* [5] Their habit of trading with New England persisted into the
eighteenth century. In 1703, Lord Cornbury wrote to the Lords of Trade in
England that the people of the east end chose *"to trade with the people of Boston,
Connecticut, and Rhode Island,* [rather] *than with the people of New York."* [6]

The western central part of Long Island was also settled largely by English-
men from New England, yet the cultural patterns which emerged in this area were
noticeably different from that of the east end. Although there was contact with New
England, particularly from the town of Oyster Bay, Englishmen on western Long
Island lived in much closer touch with Dutch authority and Dutch traditions. Having
settled closer to the Dutch towns of the west end and having accepted in their town
charters the Dutch government in New Amsterdam as the final political authority,
they frequently came into contact with the Dutch, particularly over political and
religious issues. By the early eighteenth century, Dutch families had moved east-
ward and settled in the towns of Hempstead and Oyster Bay, thus bringing Dutch
and English customs and traditions into immediate contact.

Furthermore, greater religious diversity distinguished the English settlements
on western Long Island from those at the east end. The Dutch reputation for
tolerance, although not always carried out in fact, may have attracted people of
dissenting opinions into Dutch-controlled areas. A report on the various churches in
New Netherland in 1657 noted that the residents of Gravesend were Mennonites
and the Presbyterians in Flushing were *"endowed with divers opinions"* and
"absented themselves from preaching." [7] Englishmen in this area readily accepted
the presence of English Quakers who first came to Long Island not long after the
founding of their sect in England in 1647. Quakers established the communities of
Jericho and Jerusalem and gained support in Flushing, Jamaica, Newtown, Oyster
Bay, and Hempstead during this period. Although little is yet known about the
precise influence of the Quakers on the cultural development of this area, their
presence undoubtedly contributed to the modification of the English and Dutch
traditions which co-existed there.

Surviving examples of early Long Island architecture and furnishings pro-
vide evidence of the various cultural influences operative on Long Island in the

4. *Captain John Underhill,* 1620–1638
England
Oil on canvas
H. 31 W. 26
Society for the Preservation of Long Island
Antiquities, gift of the Myron and Anabel Taylor Foundation, 60.23

Born in 1597 in Warwickshire, England, Underhill came to Massachusetts Bay in 1630 to supervise military training in the Colony. He first appeared in the New York area in 1643 when he took command of the Dutch and English militia in a campaign against the Algonquin Indians. Apparently as partial payment for his military service, he received small tracts of land in New Amsterdam and on Long Island. He also became a member of the Dutch Governor's advisory committee and in 1648 he was appointed the sheriff of Flushing. Over the next several years, he lived first in Southold and then in Setauket and finally settled in Oyster Bay in 1662 or early in 1663. During this period of residence on Long Island, he expressed opposition to Dutch rule and supported efforts to establish British authority over the region. Underhill died at his Oyster Bay home, "Killingworth," in 1672.

This portrait was probably painted before Underhill left England in 1630 or during his visit there in 1638. The artist is unknown.

Refs.: Myron H. Luke, "Captain John Underhill and Long Island," *Nassau County Historical Society Journal,* Winter, 1964, pp. 1–10.
"Newsletter," Society for the Preservation of Long Island Antiquities, February, 1959.

period 1640–1730. The English settlers came from rural areas in England that were still deeply rooted in an Elizabethan-Renaissance decorative tradition with mediaeval influences evident in the methods of house and furniture construction and in some of the carved and painted ornamentation of objects. The Dutch also introduced to Long Island local idioms of furniture and house design, but these settlers were less sequestered from the tides of fashion in their native Holland than the English. Dutch supremacy in trade and on the seas in the seventeenth century was reflected in the decorative arts, and the people of Holland did, for example, show an early taste for Chinoiserie and exotic wood inlays in furniture. European prototypes familiar to each group of colonists were the design sources for early houses and furniture found on Long Island. The Schenck house in Brooklyn (No. 5), the Old House in Cutchogue (No. 8), The Dutch *kas* (No. 35), and the carved English chest (No. 29) represent these transplanted traditions. Modifications of these familiar forms began to occur soon after and eventually a sharing of traditions took place.

A typical and well-documented seventeenth century Long Island Dutch house from Flatlands, the Jan Martense Schenck House (ca. 1675), has been reconstructed in the Brooklyn Museum (No. 5).[8] It is a one-story, two room structure with a steeply pitched roof. It was constructed of wood like most Dutch houses on Long Island, and the method of construction illustrates the typical Dutch practice of giving equal emphasis to regularly spaced vertical posts and transverse beams braced with corner brackets.

The Schenck House from Manhasset (Nos. 6–7), built about 1730, is characteristic of the appearance of Dutch houses after the the addition of a lean-to section to the rear of the original one-room deep structure or after the enlargement of rooms in an existing lean-to section. The flared overhang of the roof is an American development and first appeared in the early eighteenth century. Both Schenck houses have interior features associated with the Dutch—built-in bed boxes and jambless fireplaces—which give the interiors a distinctive Dutch appearance.

The Old House in Cutchogue (No. 8) and the Thompson House in Setauket (Nos. 9, 50) represent the late medieval style and method of construction of English houses on eastern Long Island. The basic floor plan consisted of two rooms, the hall and parlor, placed on either side of the large central chimney. Two chambers on the second floor took their names from the rooms below. The English method of framing was distinctly different from the Dutch in the use of the massive summer beam which spanned the ceiling from chimney to wall and carried much of the weight of the second floor above.

Given Long Island's distinct patterns of cultural development, it is not surprising to find early houses on central Long Island which combine Dutch and English features. A recent study of this architectural phenomenon has suggested that the most typical Long Island farmhouse in this area was *"a long, low, picturesque structure of one-and-a-half stories with little ornamentation."*[9] The blending of traditions occurred with the passing of time, and the mixture of distinctive elements may have resulted from additions to original structures. The framing of the Oyster Bay Room from the Job Wright House, built in Oyster Bay about 1667 by the son of a New England Quaker, and now reconstructed at the Henry Francis du Pont Winterthur Museum, exemplifies the Dutch custom of using transverse supports parallel to the fireplace to bear the weight.[10] Other isolated Dutch features, such as the double door and flared overhanging roofline, appear on other early Oyster Bay houses which are basically English in style.

Noticeably different types of furnishings were found in Dutch and English homes at the western and eastern extremes of Long Island during the seventeenth century. The Dutch preference for certain decorative objects, such as paintings and bright blue and white or polychrome delftware, decidedly flavored the appearance of Dutch interiors. Specific silver forms popular in New York, like the beaker, and the elaborate ornamentation of silver directly reflected Dutch influence. The bed box, linen press, and *kas* were all common and distinctive types of furniture found

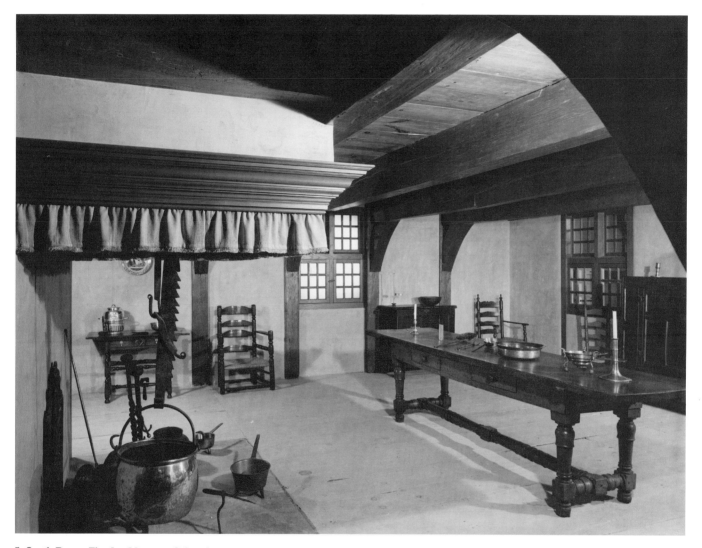

5. South Room, The Jan Martense Schenck House, ca. 1675
Flatlands
The Brooklyn Museum

Jan Martense Schenck, a miller, built a two-room house with garret on Mill Island in Flatlands about 1675. The South room probably served as the kitchen and all-purpose work and living room. The Dutch system of framing is clearly visible. The beams and posts were stained to simulate walnut. Such orderly and well-kept rooms inspired early eighteenth century visitors to New York, such as Sarah Knight, to comment that Dutch women kept their houses *"neat to admiration."*

in Dutch homes. Additionally, since the Dutch introduced many of the fashionable changes in furniture design to England and northern Europe during this period, their influence on the development of New York furniture styles may be more pervasive than generally acknowledged.

Eastern Long Island's ties with New England were discernible in the furnishings of the houses in that area. Inventories of estates, more readily available for Suffolk County than for Queens or Kings Counties, document the presence on Long Island of the same types of furniture and accessories found in rural Massachusetts.[11] The 1682 will of Thomas Diament of East Hampton describes representative furnishings: *"To my eldest sone James Diament . . .* [I leave] *my best fether bed that I usually lie upon and all the furniture belonging to it as Curtains boulsters valliances pellows Coverled blankets pillow beers and a paire of my best sheets together with the bedsted . . . my long table In the bigger Roome with ye forme belonging to it and my greater looking glass and the cobord in the room aforesaid and one of my great chests and three of my best chayres and my great wicker chayre* [and] *also a Chest of Drawers.*[12]

One must remember that even within the easily recognizable English decorative arts tradition, there was considerable room for variation. Because Long Island was settled by many different groups of English colonists, and over a widespread area, there is no single and cohesive seventeenth century Long Island style. The

6. The Minne Schenck House, ca. 1730
Manhasset
Old Bethpage Village Restoration

This Schenck family house, not to be confused with the earlier house in the Brooklyn Museum, originally stood in Manhasset in north central Queens County. The overhang of the roof is an American development and has no European precedent.

7. Bed Box, The Minne Schenck House, ca. 1730
Manhasset
Old Bethpage Village Restoration

influence of the New Haven Colony is evident in a number of chests from the east end, but furniture made or owned in Hempstead or Flushing may be stylistically unrelated. Also, as English influence in the New York colony increased after 1664, so did cultural interaction, not only between Dutch and English, but between the English towns on eastern Long Island and New York City. Silver made by New York silversmiths is surprisingly prevalent on eastern Long Island (Nos. 48–51). It was inevitable, too, that English joiners and cabinetmakers would copy pieces of Dutch furniture, or that out of convenience and necessity, Dutch families would patronize the growing number of English craftsmen.

The objects illustrated in this catalogue document many differences between the Dutch and English traditions, but it is not yet possible to make a definitive statement about the contributions of each group to the decorative arts heritage of Long Island. The complex melange of Dutch, English, French Huguenot, German, and Flemish influences in New York, and their relationship to Long Island's decorative arts history, will require careful examination. Intense urban and suburban development throughout the region and the loss of objects with the passage of time have made this a difficult task. Fortunately, a number of key artifacts have been preserved and provide the opportunity for broadening our understanding of the subject.

[1]Alice P. Kenny, *Stubborn for Liberty: The Dutch in New York* (Syracuse, N.Y.: Syracuse University Press, 1975), p. 11.

[2]*Ibid.*, p. 134.

[3]Michael Kammen, *Colonial New York* (New York: Charles Scribner's Sons, 1975), pp. 38–40.

[4]Letter, Lord Cornbury to the Lords of Trade, June 30, 1703, in *Documents Relative to the Colonial History of the State of New-York,* ed. by E. B. O'Callaghan, IV (Albany, N.Y.: Weed, Parson and Company, 1854) p. 1058.

[5]"The Humble Address of the Governour and Councill of Your Majesty's Province of New Yorke," in *The Documentary History of the State of New York,* ed. by E. B. O'Callaghan, I (Albany, N.Y.: Weed, Parsons & Co., 1850), p. 268.

[6]Letter, Lord Cornbury to the Lords of Trade, June 30, 1703, *op. cit.*

[7]"State of the Churches in New Netherland, Anno 1657," in *The Documentary History of the State of New-York,* ed. by E. B. O'Callaghan, III (Albany, N.Y.: Weed, Parsons, & Co., 1850), p. 106.

[8]Marvin D. Schwartz, "The Jan Martense Schenck House in the Brooklyn Museum," *Antiques,* April 1964, pp. 421–428.

[9]Barbara F. Van Liew, *Long Island Domestic Architecture of the Colonial and Federal Periods* (Setauket, N.Y.: Society for the Preservation of Long Island Antiquities, 1974), p. 14.

[10]John A. H. Sweeney, *The Treasure House of Early American Rooms* (New York: The Viking Press, 1965), p. 22.

[11]Abbott Lowell Cummings, ed., *Rural Household Inventories . . . 1675-1775* (Boston: The Society for the Preservation of New England Antiquities, 1964), pp. 3–83.

8. The Old House, 1649
Cutchogue
Independent Congregational Church and Society of Cutchogue

Built in Southold in 1649 for John Budd, the Old House was moved to Cutchogue ten years later when Budd gave it as a wedding present to his daughter, Anna, and her husband, Benjamin Horton. Its architectural character reflects the medieval English building tradition familiar to Southold's early settlers. Notable features are the assymetrical arrangement of the facade, the small casement windows, and the pilastered chimney top with projecting courses of brick. The house was restored in 1940.

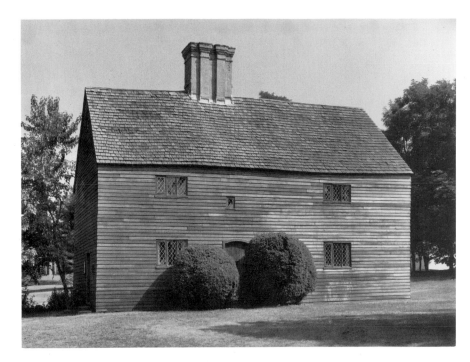

9. Parlor, The Thompson House, ca. 1700
Setauket
Society for the Preservation of Long Island Antiquities

The English method of framing a house emphasized the four corner posts and two or four chimney posts. This system necessitated the use of a massive cross-beam, the summer, which spanned the middle of the room. The parlor usually contained the best furniture in the house. Colonial families used this room for formal entertaining and sometimes as the best bedroom.

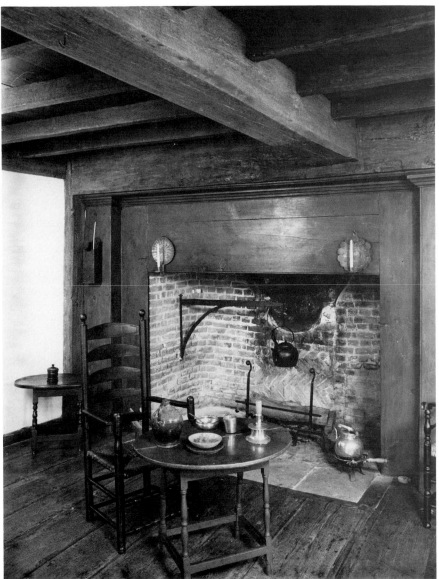

10. The Bowne House, 1661
Flushing
The Bowne House Historical Society, Flushing

The original portion of the structure—the kitchen and chamber above—was built for John Bowne in 1661. The first Quaker meetings, which led to Bowne's arrest and banishment from New Netherland, were held in this house. Quakers continued to worship at the Bowne House and George Fox was a guest there in 1672. Bowne added the dining room in 1680, and his son, Samuel (1667–1745), added the living room, the present entry, and several second floor rooms in 1696. The later addition gave the house a saltbox appearance. Further alteration took place in 1830 when the roof was raised and the north wing built.

THE BOWNE FAMILY OF FLUSHING

11. Dish, ca. 1656
Holland or Germany
Pewter
Diam. 13
The Bowne House Historical Society, Flushing

The German inscription and the elaborate engraving on this dish identify it as a presentation piece given by a godchild to her godmother in 1656. The dish descended in the Bowne family but the connection with a specific family member has not yet been established.

John Bowne (1627–1695) was an Englishman who moved from New England to Flushing in Dutch-controlled western Long Island and worshipped with English Quakers who had settled there. The key events in his life illustrate the interaction among the Dutch, the English, and the Quakers which took place on western Long Island during the seventeenth century.

Bowne emigrated to Boston from England with his father and sister in 1649. After a brief visit to England in 1650, he returned to America and settled his family at Flushing, Long Island. Not long thereafter, however, Bowne returned to Massachusetts, where he became a merchant. He did not make his home in Flushing until 1654.

In 1656, Bowne married Hannah Feake (1637–1677), the sister of the second wife of Captain John Underhill, one of the important political and military figures in Long Island's early history (No. 4). In a letter to John Winthrop, Jr., Underhill wrote that Bowne was a *"verri jentiele young man, of gud abilliti, of a lovli fetture, and gud behafior."*

John Bowne became interested in the activities of the Quakers in Flushing, possibly through his wife who was a member of that sect. Bowne noted in his *Journal* that he had attended a general meeting of Friends in June, 1661, and he also allowed Flushing Quakers to meet in his house despite Dutch Governor Peter Stuyvesant's ban against such activities. Bowne was arrested in 1662, and after refusing to pay the fine, was banished from the colony. Bowne travelled to Holland and argued his case before officials of the Dutch West India Company. His ultimate release and his return to Flushing in 1664 signified an advance of the cause of religious freedom in the colonies.

Unfortunately, little is known of John Bowne's patronage of local craftsmen. One study reports that James Clement, a woodworking craftsman who was probably the father of the Flushing furniture maker, Samuel Clement (see Appendix I), served a term of indenture with John Bowne, but primary evidence which might confirm this information has not yet surfaced. Surviving Bowne family objects, however, clearly demonstrate that Bowne and his family owned furnishings of Dutch, English, and New England origin and provide evidence of the diverse cultural influences which affected his taste and way of life.

Refs.: Mary Powell Bunker, *Long Island Genealogies*, Albany, N.Y., Joel Munsell's Sons, 1895, p. 185.
Letter, John Underhill to John Winthrop, Jr., April 12, 1656, *Massachusetts Historical Society Collections*, 4th ser., VII, p. 183.
Haynes Trebor, "John Bowne and Freedom of Religion," *The Bowne House*, Flushing, N.Y., The Bowne House Historical Society, 1953, pp. 9–19.

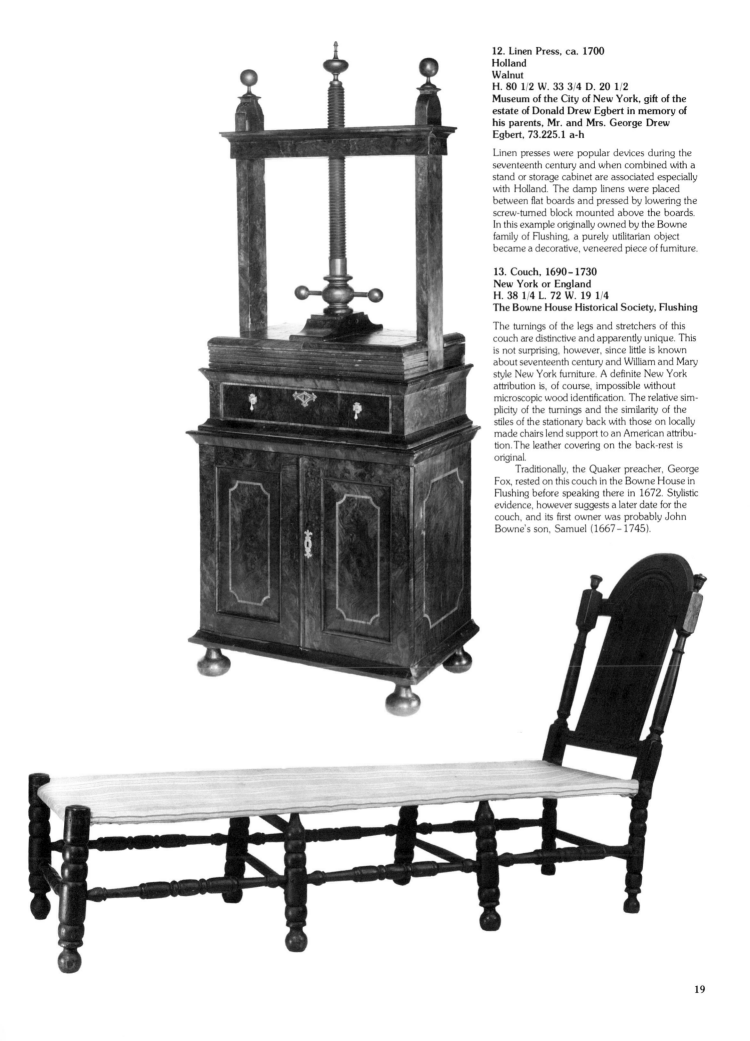

12. Linen Press, ca. 1700
Holland
Walnut
H. 80 1/2 W. 33 3/4 D. 20 1/2
Museum of the City of New York, gift of the
estate of Donald Drew Egbert in memory of
his parents, Mr. and Mrs. George Drew
Egbert, 73.225.1 a-h

Linen presses were popular devices during the seventeenth century and when combined with a stand or storage cabinet are associated especially with Holland. The damp linens were placed between flat boards and pressed by lowering the screw-turned block mounted above the boards. In this example originally owned by the Bowne family of Flushing, a purely utilitarian object became a decorative, veneered piece of furniture.

13. Couch, 1690–1730
New York or England
H. 38 1/4 L. 72 W. 19 1/4
The Bowne House Historical Society, Flushing

The turnings of the legs and stretchers of this couch are distinctive and apparently unique. This is not surprising, however, since little is known about seventeenth century and William and Mary style New York furniture. A definite New York attribution is, of course, impossible without microscopic wood identification. The relative simplicity of the turnings and the similarity of the stiles of the stationary back with those on locally made chairs lend support to an American attribution. The leather covering on the back-rest is original.

Traditionally, the Quaker preacher, George Fox, rested on this couch in the Bowne House in Flushing before speaking there in 1672. Stylistic evidence, however suggests a later date for the couch, and its first owner was probably John Bowne's son, Samuel (1667–1745).

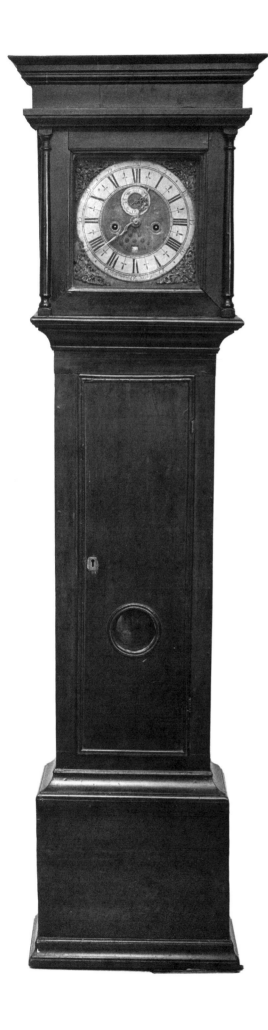

14. Tall-case Clock, 1724–1730
Anthony Ward (active ca. 1717–1724)
New York City
Walnut
H. 80 1/2 W. 21 1/2 D. 12 1/4
The Bowne House Historical Society, Flushing

Samuel Bowne, son of John, probably purchased this clock from Anthony Ward, a clockmaker who moved from Philadelphia to New York in 1724. Virtually nothing is known of Ward's career in New York. This is an important clock, particularly since case pieces of furniture attributable to New York before 1750 are exceedingly rare.

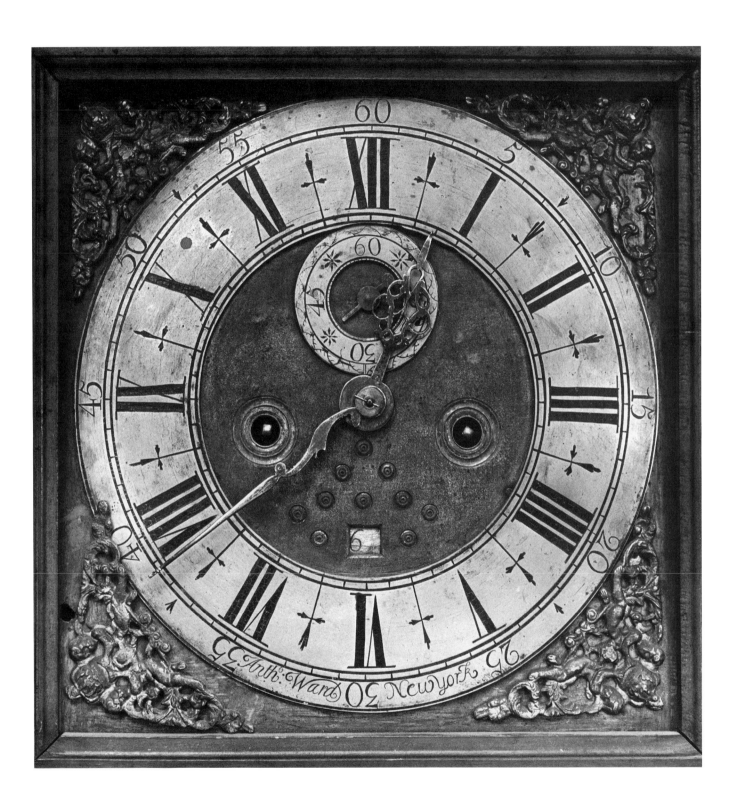

15. Chair-table (top missing), 1640–1690
America or England
Oak
H. 28 3/4 W. 22 D. 21 3/4
Smithtown Historical Society, 58-70

For many generations, the Smiths of Smithtown have cherished this chair-table as a tangible link with the progenitor of their family, Richard "Bull" Smith I (ca. 1613–1692). Although they were practical space-saving items, chair-tables were probably never common in seventeenth century America. The table top, attached to the back by pegs fastened into the arms, could be pivoted to a horizontal or vertical position. If this chair is of American origin, it is one of seven surviving examples with square columnar posts, all of which, except this one, are associated with the Ipswich, Massachusetts area.

Richard Smith may have been living in Massachusetts, probably Boston or Cambridge, about 1639, but by 1643 he was in Southampton, as evidenced by entries in the town records. In 1656, however, he was banished from the town for undetermined reasons, and by 1660 he had settled in Setauket. Three years later, he acquired title to all the land now comprising the town of Smithtown from Lion Gardiner, but he did not secure the title by patent until 1677. It seems likely that he moved his residence to his Nissequogue lands early in 1664.

Refs.: Frederick Kinsman Smith, *The Family of Richard Smith of Smithtown, Long Island,* Smithtown, N.Y., The Smithtown Historical Society, 1967, pp. 3–15.
Richard H. Randall, Jr., *American Furniture in the Museum of Fine Arts, Boston,* Boston, Museum of Fine Arts, 1965, pp. 156–157.

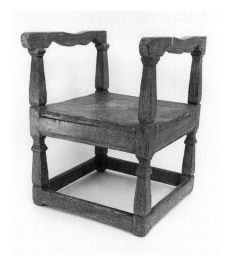

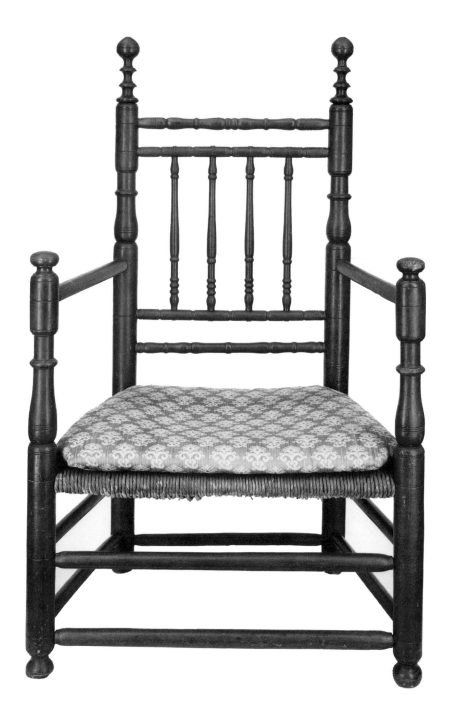

16. Great Chair, 1660–1700
Probably Southold
Oak, maple
H. 54 1/4 W. 33 3/8 D. 25 1/8
The Henry Francis du Pont Winterthur Museum, 57.598

The repetitive ogee-shaped turnings seen here suggest a number of other chairs produced in the New Haven Colony during the seventeenth century. The motif on the back stiles—the ball finials with a disc or ring below—can also be seen on New Haven Colony chairs, although an extra ring appears on this example. The tradition associated with this chair identifies Jonathan Horton (1647–1707) of Southold as the original owner and suggests that his brother, Joshua (1643–1729), was the maker. Joshua Horton is identified as a carpenter in the Southold town records (see Appendix I). Other members of the Horton family including Joshua's brother, Benjamin Horton (active ca. 1667), and Joshua's son and namesake, Joshua (1669–1749), were also woodworking craftsmen.

17. Great Chair
Queens County or New York City
Oak or ash
H. 36 W. 23 D. 17 1/4
The Bowne House Historical Society, Flushing

According to a note found under the upholstery which covered the seat, John Bowne (1627–1695) made this chair in 1651. There is no evidence, however, that Bowne possessed the skills of a turner or woodworker. Despite the distinctive turnings, the chair is not exactly like any other examples known to the author. The elongated ogee spindles and repetitive ogee shaped turnings on the front and back posts suggest chairs made in the New Haven Colony. More relevant, perhaps, is the similarity of the post turnings to those on a chair in the Metropolitan Museum of Art with a history of ownership in the Stryker family. Additionally, the multiple turned top stretcher on the chairback of the Bowne example is related to another group of armchairs with New York or western Long Island histories (No. 18).

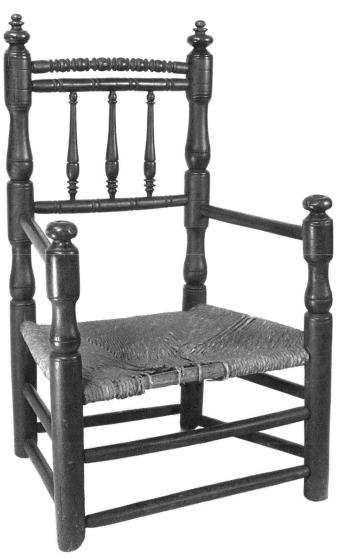

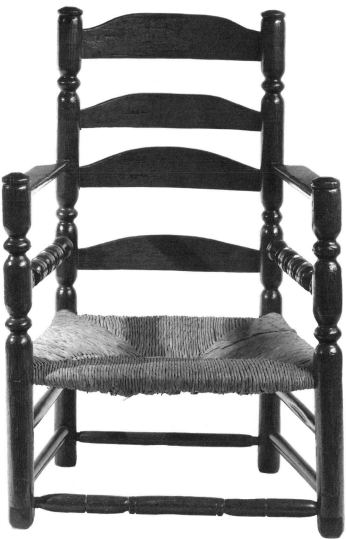

18. Armchair, 1680–1700
Kings County, Queens County or New York City
Oak
H. 39 W. (of seat) 26 D. (of seat) 18
The Brooklyn Museum, 30.885

This armchair was owned on western Long Island and is one of a group of slat-back armchairs with related turnings. A virtually identical example, originally owned in the Riker family of Newtown, is in the Museum of the City of New York, while a similar chair with finials on both the front and back posts is in the Art Institute of Chicago. Still another chair is part of the collections of the Museum of Fine Arts, Boston. Several armchairs having the same flat arms with turned stretchers below, similarly turned posts, and more elaborately shaped slats are extant and constitute a second related group. Some of these chairs were discovered in the New York area. Existing evidence thus suggests a New York provenance for this type of chair.

Refs.: Robert Bishop, *Centuries and Styles of the American Chair, 1640–1970,* New York, E. P. Dutton & Co., Inc., 1972, p. 36.

V. Isabelle Miller, *Furniture by New York Cabinetmakers, 1650 to 1860,* New York, Museum of the City of New York, 1956, pp. 14–15.

Richard H. Randall, Jr., *American Furniture in the Museum of Fine Arts, Boston,* Boston, Museum of Fine Arts, 1965, pp. 157–159.

19. Side Chair, 1665–1700
England
[Beech ?]
H. 44 1/2 W. 20 D. 17
Society for the Preservation of Long Island
Antiquities, 56.13

American colonials imported large quantities of English furniture during the seventeenth and eighteenth centuries, but the early family histories for most examples were forgotten long ago. The Wright family of Oyster Bay, however, has attached great importance to the history of this side chair, which has descended in nine generations of the family. In her will dated 1877, Sarah Wright called it "the Mayflower chair." Despite this tradition, the chair represents a style popular in England after the Restoration, and was probably not transported on the *Mayflower* or the *Anne,* another ship Wright family descendants have mentioned. A significant piece of cultural evidence, this chair serves as a reminder of one of the important aspects of Long Island's early cultural history.

20. Armchair, 1660–1690
England
Present location unknown

Unfortunately, this armchair is known only from an old photograph given to the Society by Miss Helen "Tangier" Smith. A note on the reverse of the photograph reads: *"Old Tangier chair, one of a set of chairs used by Col. W^m Smith (1655–1705) while living in Tangiers and brought by him to this country in 1686."* Smith served as mayor of Tangier in Africa before moving to New York and then Setauket. He apparently brought most of his splendid possessions with him. This chair is probably one of *"Five Large Cane Elbow Chairs"* listed in the inventory of Smith's estate, taken in 1704/05. The inventory is a fascinating document and describes a wide variety of furnishings, including Colonel Smith's portrait, a *"Landskip Screen,"* a violin, five chests of drawers *"of Walnut & Olive Wood,"* a large japanned looking glass, and three turkey work carpets. The total value of his estate was £2,589 4s.

Ref.: Thomas R. Bayles, "The Tangier Smiths," *Long Island Forum,* February, 1947, p. 14.

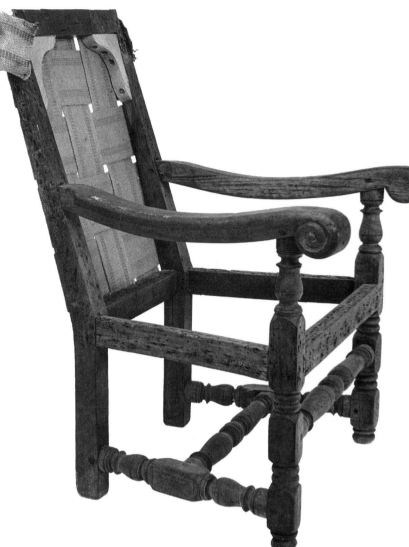

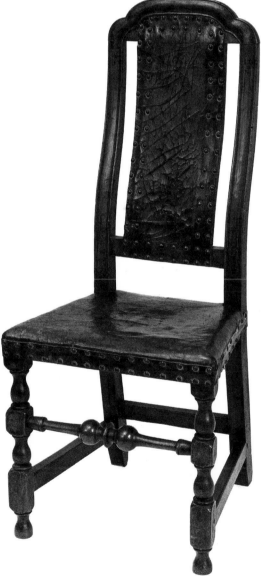

22. Side Chair (one of a pair), 1710–1750
New York City or Boston
Maple, leather (original)
H. 43 3/8 W. 19 D. 18 1/2
Dr. and Mrs. Milton Hopkins

Boston was a center for the manufacture of William and Mary style chairs of this type, and a great many were exported to other colonies. In Philadelphia, such chairs were commonly called Boston chairs. Certainly their popularity must have prompted local imitations. The chair pictured here retains its original leather upholstery and straw stuffing. The Hewlett family of Hempstead owned this example, and an identical chair, now in the possession of The Long Island Historical Society, descended in the Middagh family of Brooklyn.

Refs.: Richard H. Randall, Jr., *American Furniture in the Museum of Fine Arts, Boston,* Boston, Museum of Fine Arts, 1965, pp. 165–167.
Walton H. Rawls, ed., *The Century Book of the Long Island Historical Society,* Brooklyn, N.Y., 1964, p. 142, plate 12.
Norman S. Rice, *New York Furniture Before 1840 in the Collection of the Albany Institute of History and Art,* Albany, N.Y., Albany Institute of History and Art, 1962, p. 20.

21. Armchair, 1690–1710
[American, possibly New York ?]
Walnut
H. 29 3/4 W. 21 3/4 D. 22 3/4
Private collection

Toward the end of the seventeenth century, seating furniture became increasingly luxurious and comfortable as the use of upholstery was introduced. Nevertheless, fully upholstered frames on a chair of this early design are unusual. Joseph Taylor of Southampton, who died in 1682, owned *"a worked great chayre,"* as noted in the inventory of his estate. Such an armchair was probably upholstered with "turkey work," a woven or needlework wool fabric imitating oriental carpets. Either a fabric of this type or leather was probably the original covering on the example illustrated here. Purchased in Southampton almost fifty years ago, this chair has no family history associated with it. Secondary woods, which might indicate a particular provenance, were not used in its construction. No chairs of this type with a New England history have been located. This chair, however, may have been made in New York. Stylistically it relates to French examples, and many French Huguenots emigrated to New York in the 1690's and early 1700's. Some Huguenots, among them Francis Pelletreau and Stephen Bouyer, moved from New York to Southampton to work in the whaling business.

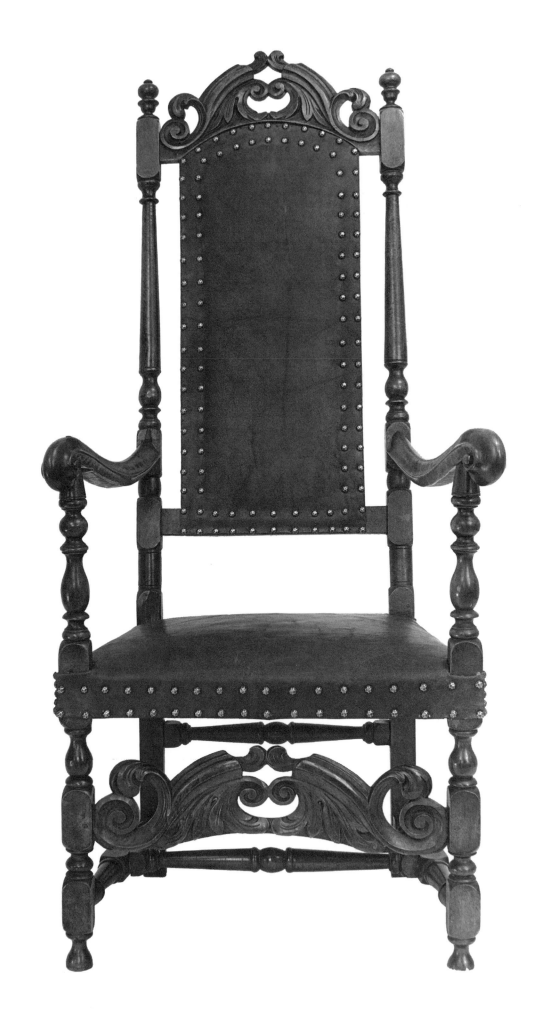

23. Armchair, 1700–1730
Boston
Maple
H. 52 W. 25 D. 17
Smithtown Historical Society, 58-3

According to family tradition, this armchair origi-
nally belonged to Ebenezer Smith (1712–1747)
of Smithtown. If this tradition is correct, it is
possible that Ebenezer inherited the chair from
his father, Richard Smith II (ca. 1645–1720).
The only household items, however, specifically
left to Ebenezer in Richard's will were two pieces
of silver.

The matching carved stretcher and crest rail
on this chair are of unusual design, and only one
chair with nearly identical motifs, probably made
in the same shop, is known. Attributed to the
Boston area, this similar armchair with original
leather covering is in the Henry Francis du Pont
Winterthur Museum.

Refs.: Brock Jobe, "The Boston Furniture Industry,
1720–1740," in *Boston Furniture of the Eighteenth
Century,* Boston, Colonial Society of Massachusetts,
1974, pp. 38–40.
Frederick Kinsman Smith, *The Family of Richard Smith
of Smithtown, Long Island,* Smithtown, N.Y., The
Smithtown Historical Society, 1967, pp. 44–45.

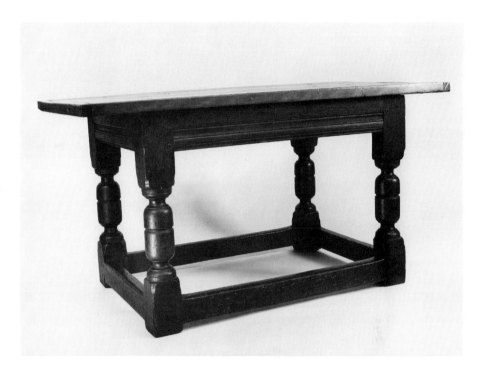

24. Table, 1640–1690
England or America
Oak
H. 29 1/2 W. 57 D. 30
The Bowne House Historical Society, Flushing

Without microscopic wood analysis, it is almost
impossible to establish a provenance for this
stretcher-base table. Bowne family tradition holds
that John Bowne (1627–1695) brought it with
him from England in 1649. It is also possible,
however, that the table was made in Boston,
where Bowne first resided in the colonies, or by
an English craftsman on western Long Island.

25. Table, 1700–1750
Suffolk County
Pine
H. 28 1/2 W. 45 1/4 D. 35 1/2
Mr. and Mrs. Morgan MacWhinnie

Few American trestle-base tables have survived,
probably because they were somewhat crude
and could be disassembled easily by removing
the tops which were separate units. According to
a long-standing tradition, this table was made on
the Floyd estate in Mastic and used in a nearby
tavern. Seventeenth century inventories of east-
ern Long Island estates document the existence
of similar tables. The 1686 inventory of James
Herrick's estate, for example, identifies this type
of table as *"a table & ye forme."*

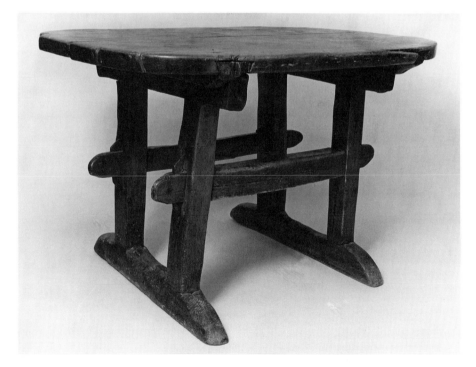

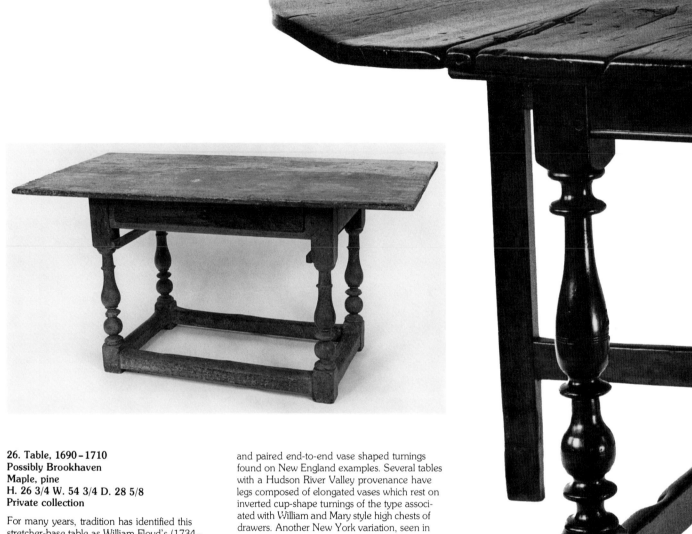

26. Table, 1690–1710
Possibly Brookhaven
Maple, pine
H. 26 3/4 W. 54 3/4 D. 28 5/8
Private collection

For many years, tradition has identified this stretcher-base table as William Floyd's (1734–1821) writing desk. Robust turnings and the heavy scale of the members, however, indicate a date of about 1700. Probably Richard Floyd (1665–1728) of Setauket, William's grandfather, was the original owner. The table is not directly related to other known examples and may be the work of a highly skilled Brookhaven joiner. We have not yet identified any turners active in Brookhaven during this period.

27. Gate-leg Table, 1690–1730
Queens County
Cherry, maple
H. 26 5/8 W. 45 3/4 D. (open) 51 3/4
Nassau County Museum, gift of Mr. Preston Bassett

The vertical supports of gate-leg tables attributed to New York, rarely, if ever, have the balanced and paired end-to-end vase shaped turnings found on New England examples. Several tables with a Hudson River Valley provenance have legs composed of elongated vases which rest on inverted cup-shape turnings of the type associated with William and Mary style high chests of drawers. Another New York variation, seen in this example, is a leg composition of two vase-shaped turnings of unequal size separated by a turned ring or disc. A virtually identical table, without provenance, in the collections of the Wadsworth Atheneum, is illustrated in Wallace Nutting's *Furniture of the Pilgrim Century,* No. 724. It was probably made in the same shop.

This table was purchased from the Onderdonck family of Manhasset, the owners of an important grist mill there. Other Onderdonck family pieces appear in this catalogue (Nos. 34–35, 132).

Refs.: Wallace Nutting, *Furniture of the Pilgrim Century,*
vol. II, New York, Dover Publications, 1965, No. 724.
Norman Rice, *New York Furniture Before 1840 in the
Collection of the Albany Institute of History and Art,*
Albany, N.Y., Albany Institute of History and Art,
1962, pp. 37, 40.

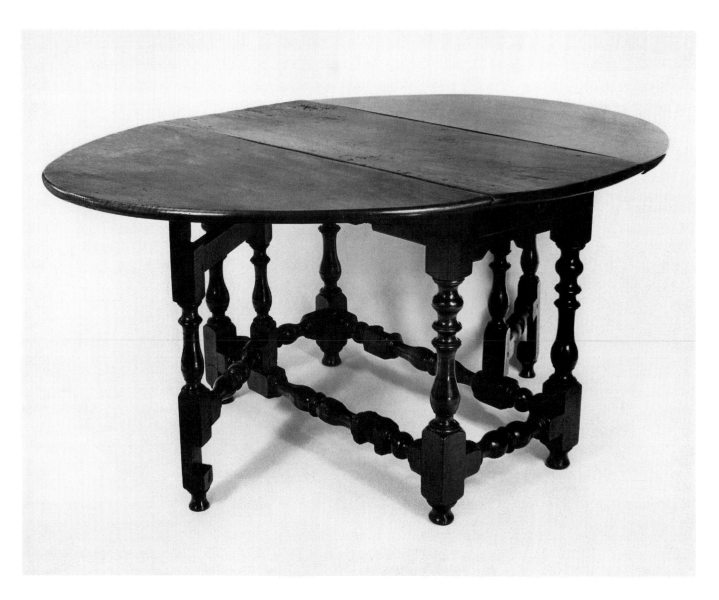

28. Gate-leg Table, 1700–1730
Queens [Nassau] County, probably
Hempstead
Maple, pine
H. 28 W. 47 1/2 D. (closed) 20 (open) 62 1/2
Dr. and Mrs. Roger Gerry

Acquired directly from the Sammis family, this
maple gate-leg table, according to tradition, came
from the Sammis Tavern in Hempstead (No.
148). The far leaf of the table is a replacement.

29. "The Mount House Kitchen," ca. 1830
William Sidney Mount (1807–1868)
Stony Brook
Pencil on paper
Signed lower right *WmSM*
H. 4 13/16 W. 5 3/4
The Museums at Stony Brook, 0.8.4339.6

Thus far, the author has located only a few exam-
ples of the furniture forms, such as tables, which
are repeatedly listed in early Suffolk County
inventories. It is interesting, therefore, to find
documentation of the existence and use of
gate-leg tables in William Sidney Mount's draw-
ing of the kitchen in the Hawkins-Mount house in
Stony Brook. The gate-leg table shown here was
undoubtedly a family piece which, by this late
date, had been moved to the kitchen.

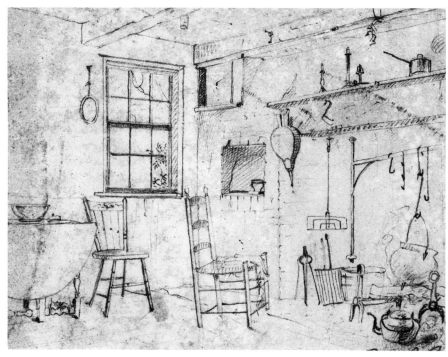

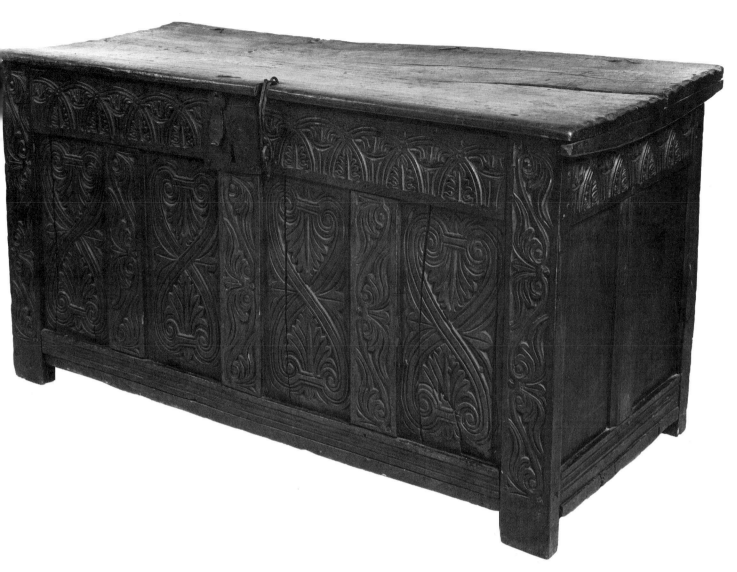

30. Chest, 1620–1640
England
Oak
H. 27 3/4 W. 56 1/8 D. 22 1/4
The Long Island Historical Society, Brooklyn, 193

This is an important piece of furniture in several respects. First, it was one of the earliest donations to the Long Island Historical Society, having been presented before 1881. In addition, this chest provides further documentation of the type of furniture brought to America in the seventeenth century. It was the property of Barnabas Horton (1600–1680) who was born in Mowsley, Leicestershire, England and emigrated first to Ipswich, Massachusetts, and then to Southold sometime after 1640. He was a leading citizen of the town and held several public offices. The inventory of his estate lists six chests. The total assessed value of his property was £405, a large sum for the time.

The use of red oak, the elaborate carving, and the method of panel construction used even on the back of the chest substantiate an English provenance. Two of Horton's sons, Joshua and Benjamin, were woodworkers, but neither were old enough to have made the chest in England (see Appendix I and No. 16).

Ref.: John T. Horton, "Documentary Evidence of the Life and Labors of Barnabas Horton," *New York Genealogical and Biographical Record,* April, 1971, pp. 69–77.

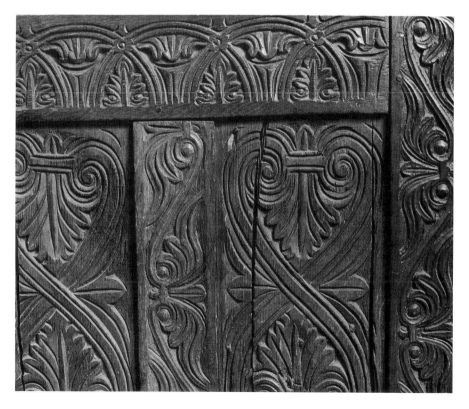

31. Desk Box, ca. 1640
Probably England
Oak
H. 11 W. 27 3/4 D. 22 3/8
The Long Island Historical Society, Brooklyn,
195

Early desks were simply boxes with a slant-top which could conveniently support writing or reading material. The interior of this desk is not fitted with a till or compartments and was probably used for storing papers, books, or valuables.

William Wells (– 1671), one of the first settlers of the town of Southold, was the original owner of this box. A family tradition maintains that he brought the desk box from Norwich, England, to Southold in 1640. If this tradition is accurate, the box provides specific evidence of the English prototypes for carved seventeenth century American furniture ornament. One can see an obvious similarity between the flat, relief-carved, S-scrolled motifs on the sides of this box and the carved ornament on the Osborne family chest (No. 32). Similar motifs appear on a number of examples of seventeenth century furniture made in the New Haven Colony, of which Southold, Long Island, was a part.

William Wells, a direct descendant of the original owner, gave this desk box to the Long Island Historical Society in 1887.

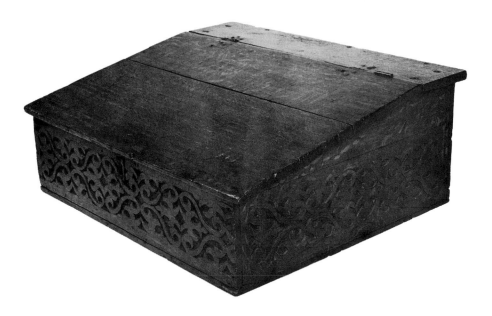

32. Chest, 1640–1660
Attributed to Thomas Mulliner
Probably New Haven, Connecticut
White oak
H. 33 W. 51 D. 23
"Home Sweet Home," East Hampton

Patricia Kane, in *Furniture of the New Haven Colony, The Seventeenth-Century Style,* suggests that this chest may be the earliest documented example of American furniture. Originally owned by Thomas Osborne who came to East Hampton from New Haven in 1650, the chest has been attributed to Thomas Mulliner on the basis of evidence indicating Mulliner was the only joiner and carver active in New Haven in the years immediately preceding 1650.

This chest is certainly the most developed of at least six surviving examples which employ the same motif—architectural arches on the front and, occasionally, the side panels. Ironically, in seventeenth century America, the highly developed and richly carved pieces of furniture are usually among the earliest, and the Osborne chest must be considered a prototype for other New Haven Colony chests, such as No. 33. The end panel of this chest is carved in a simple and completely different manner from the relief-carved front, but the incised line arches on the ends are identical with those on the front panels of two other chests, both having East Hampton histories of ownership (No. 33).

Kane suggests that Mulliner learned his craft from his father in Ipswich, England. Carved motifs similar to those on the chest illustrated here have been identified in Ipswich, which is located in Suffolk County. Identical S-scrolled arabesques appear on the William Wells desk box (No. 31), which came from Norwich in Norfolk County, confirming the fact that the southeastern counties of England were a regional source for the ornament used in the New Haven Colony.

Ref.: Patricia E. Kane, *Furniture of the New Haven Colony, The Seventeenth-Century Style,* New Haven, Conn., The New Haven Colony Historical Society, 1973, pp. 6–7, 10–19.

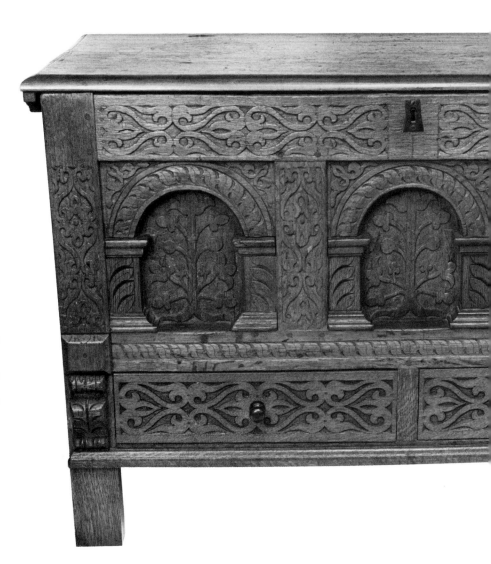

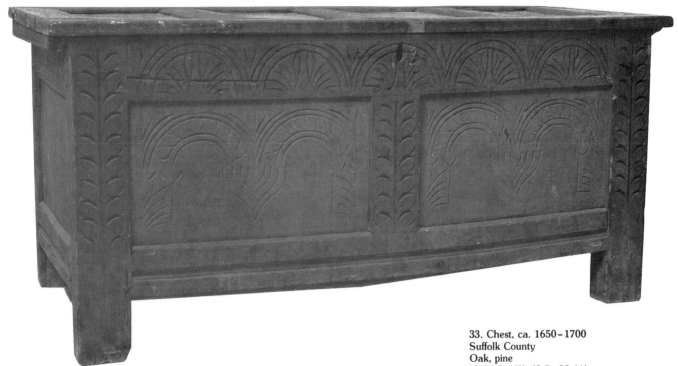

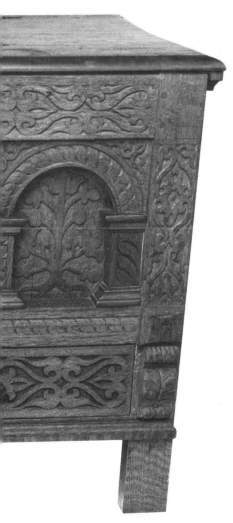

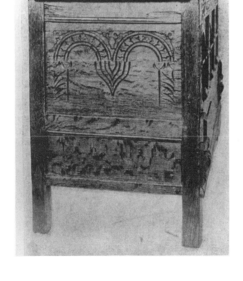

33. Chest, ca. 1650–1700
Suffolk County
Oak, pine
H. 24 3/4 W. 60 D. 22 1/4
Society for the Preservation of Long Island
Antiquities, 75.2

A history of ownership in the Hedges family of East Hampton supports the stylistic evidence of a direct relationship between this example and the Osborne family chest (No. 32). In fact, the shallow carving of the arches on the two front panels of this chest, although not as boldly executed, is virtually identical with the carving on the end panel of the Osborne chest. In addition, the abstract floral stems on the three stiles and the lunettes on the top rail appear in a more developed form on a series of chests made in or associated with the New Haven Colony. One of these examples in the Metropolitan Museum of Art has an East Hampton provenance, apparently in the Stratton family. Another example, privately owned and associated with the Sherrill family of East Hampton, also bears similar carved motifs. Despite these similarities, however, both the panelled lid on the Hedges chest and the shadow molding, rather than carving, on the bottom rails, are unique features which distinguish this chest from the other examples with East Hampton histories.

Ref.: Patricia E. Kane, *Furniture of the New Haven Colony, The Seventeenth-Century Style,* New Haven, Conn., The New Haven Colony Historical Society, 1973, pp. 10–19.

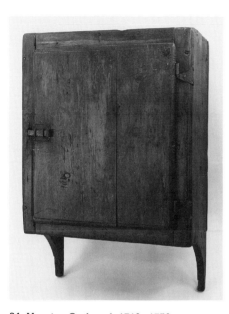

34. Hanging Cupboard, 1710–1750
Queens County
Pine
H. 34 1/2 W. 22 3/4 D. 13
Society for the Preservation of Long Island
Antiquities, 59.53

Hanging cupboards were probably painted the
same color as the walls and considered a part of
the woodwork of the room. Such simple pieces
were less frequently moved and saved than were
free-standing, easily movable objects such as
chairs, chests, and tables. Both the hanging cup-
board and the cupboard with shelves (No. 35)
were acquired by an early Long Island collector,
Huyler Held, Sr., from the Onderdonck house in
Manhasset.

35. Cupboard with Shelves, 1700–1750
Queens County
Pine
H. 68 1/2 W. 42 1/4 D. 15 1/2
Society for the Preservation of Long Island
Antiquities, 59.54

Few cupboards with open shelves below have
survived. A similar pine cupboard of more con-
ventional form, with open shelves above the
closed storage compartment, descended in the
Cowenhoven family of Brooklyn and is now
located in the collections of Sleepy Hollow Resto-
rations. Cupboards of either design were com-
monly part of the kitchen furnishings of Dutch
Long Island homes. The original butterfly hinges
indicate an early eighteenth century date for this
example, which was owned by the Onderdonck
family of Manhasset (Nos. 27, 34, 132).

Ref.: Helen Comstock, *American Furniture, Seven-
teenth, Eighteenth, and Nineteenth Century Styles,*
New York, The Viking Press, Inc., 1962, p. 193.

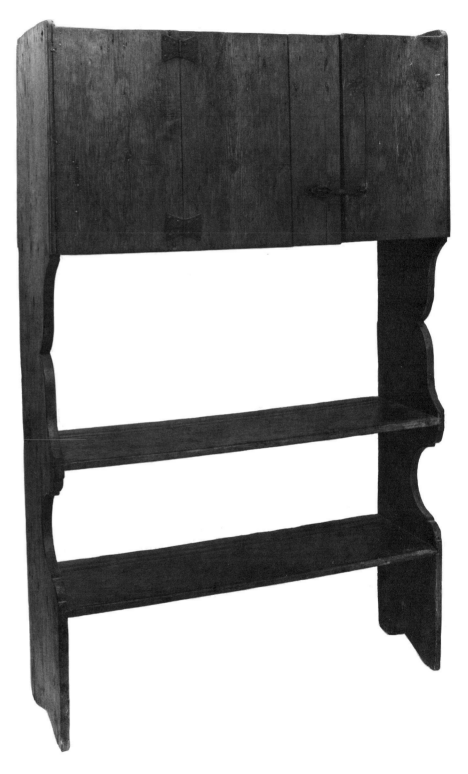

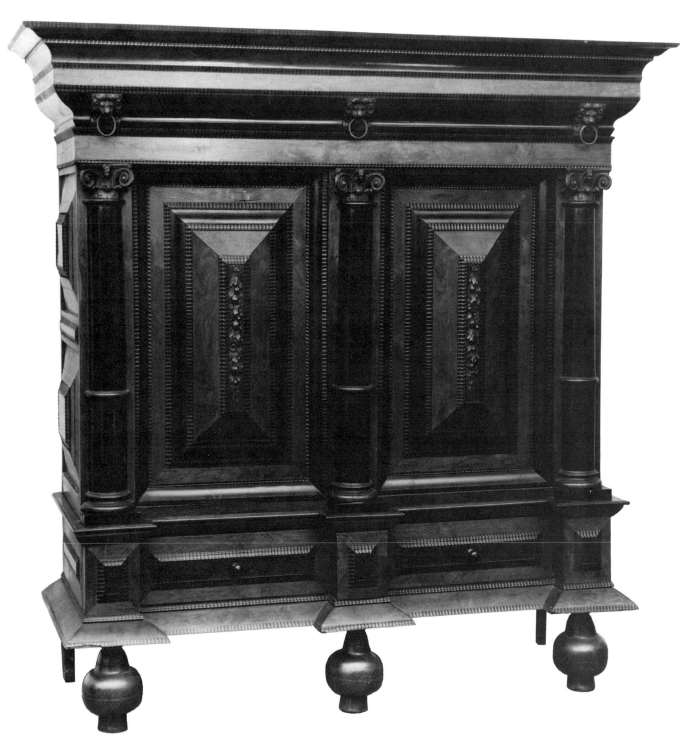

36. *Kas,* 1640–1690
Holland
Walnut, ebony
H. 83 W. 75 1/2 D. 25 5/8
The Brooklyn Museum, 51.157.1

According to family history, Barent Baltus, a Dutch settler, brought this *kas* from Holland to New Netherland in the seventeenth century. Bal-tus settled in Flatbush and later added the sur-name Van Kleeck to conform with English practice.

This example demonstrates the lavishness of many Dutch *kasten.* After about 1625 the Dutch preferred walnut veneers, ebony, and other rich materials for furniture. On this *kas* contrasting woods and the raised panels and architectural columns create bold effects. Applied sculptural reliefs of lions' heads and floral garlands—influ-enced by the architectural designs of Jacob van Campen—adorn the facade. American *kasten* derive from Dutch examples such as this, but do not display the same richness of materials and ornamentation.

Ref.: Marvin D. Schwartz, "The Jan Martense Schenck House in the Brooklyn Museum," *Antiques,* April, 1964, pp. 425, 427.

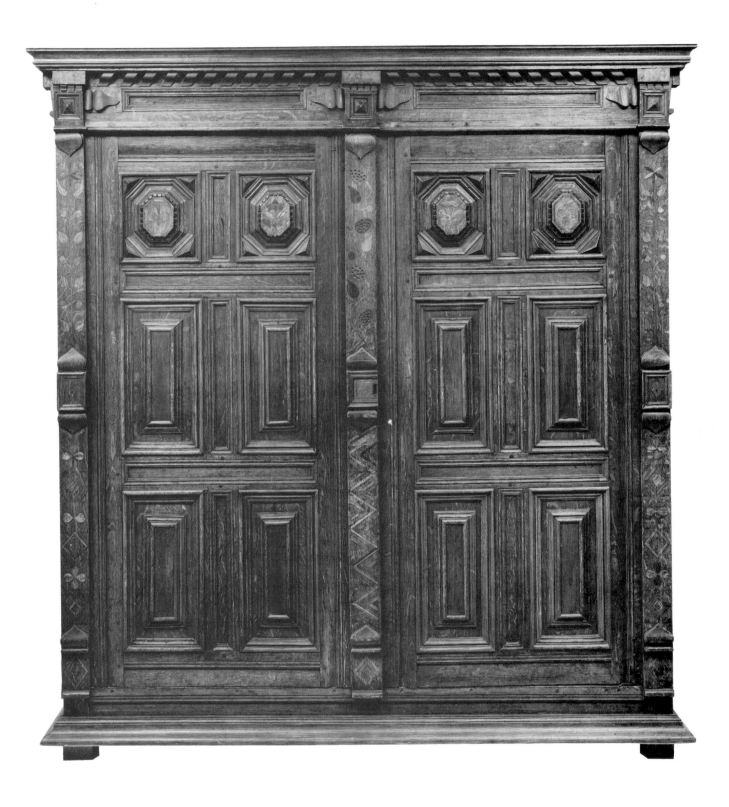

36

37. Cupboard, 1650–1700
New York City, Kings County, or Queens
County
Oak
H. 70 5/8 W. 67 1/4 D. 27 3/8
The Henry Francis du Pont Winterthur
Museum, 52.49

Without question, this cupboard is one of the
most impressive pieces of furniture made in seven-
teenth century America. The elaborate panels,
moldings, and inlay are unique among surviving
examples. Although the origins of its design are
not clear, this cupboard was probably made in
New York or on western Long Island. It does not
relate directly to English or Dutch prototypes and
may represent the work of a Flemish, French, or
German craftsman.

The original owners of the cupboard, the
Hewlett family of Merrick, came to New York
about 1650. In writing about the Hewlett family
and homestead in his 1903 history of Long
Island, historian William S. Pelletreau stated that
"an old clothes press brought from England" was
"still in the garrett," probably in reference to the
cupboard illustrated here.

Ref.: William S. Pelletreau, *A History of Long Island,*
New York, The Lewis Publishing Company, 1903,
p. 103.

38. Chest on Frame or High Chest of Drawers,
1690–1720
New York City, Kings County, or Queens
County
Bilsted (gumwood)
H. 58 W. 45 D. 24 1/2
The Metropolitan Museum of Art, Rogers
Fund, 1936, 36.112a,b

Of the furniture illustrated in this catalogue, the
Metropolitan Museum of Art's chest on frame is
probably the most well known since it is a classic
example of early New York furniture. It is very
similar in design and construction to a cabinet on
frame in the Henry Francis du Pont Winterthur
Museum, and both were probably made in the
same shop. The spiral turned legs suggest a
French Huguenot or Dutch influence—entirely
possible in New York around 1700. The bilsted
or gumwood used here was a favored furniture
wood on western Long Island throughout the
eighteenth century, but one rarely finds this type
of wood in furniture of eastern Long Island (Suf-
folk County) origin. The chest has a history of
ownership in the Mitchel family of Port
Washington.

39. High Chest of Drawers, 1726
Samuel Clement (active ca. 1698–1726)
Flushing
Red gum, ash, elm
H. 72 W. 43 3/8 D. 24 1/2
The Henry Francis du Pont Winterthur
Museum, M57.512

An ink inscription on the front of the backboard in the bottom section of this high chest of drawers reads: *This was made in y'' year 1726/ By me Samuel Clement of flushing/ June y''.* What little is known about Clement (see Appendix I) verifies this signature, placing the high chest in the very small group of signed or labelled American William and Mary style furniture. It is also a key

piece of furniture in establishing the existence of a talented school of New York and western Long Island cabinetmaking. Another high chest of drawers in a private collection is almost identical but is not veneered and the lower central drawer is divided horizontally into two drawers. A third related example is illustrated in Luke Vincent Lockwood's *Colonial Furniture in America.*

Both the high chest and the matching dressing table (No. 40) were originally owned in the Lawrence family of Flushing.

Ref.: Luke Vincent Lockwood, *Colonial Furniture in America,* vol. I, New York, Charles Scribner's Sons, 1921, pp. 78, 81.

40. Dressing Table, ca. 1726
Samuel Clement (active ca. 1698–1726)
Flushing
Red gum, ash, elm
H. 29 11/16 W. 35 5/8 D. 21
The Henry Francis du Pont Winterthur
Museum, M57.511

The turnings, veneer, workmanship, and history of ownership all indicate that this dressing table was made as a companion piece to the signed Samuel Clement high chest of drawers (No. 39).

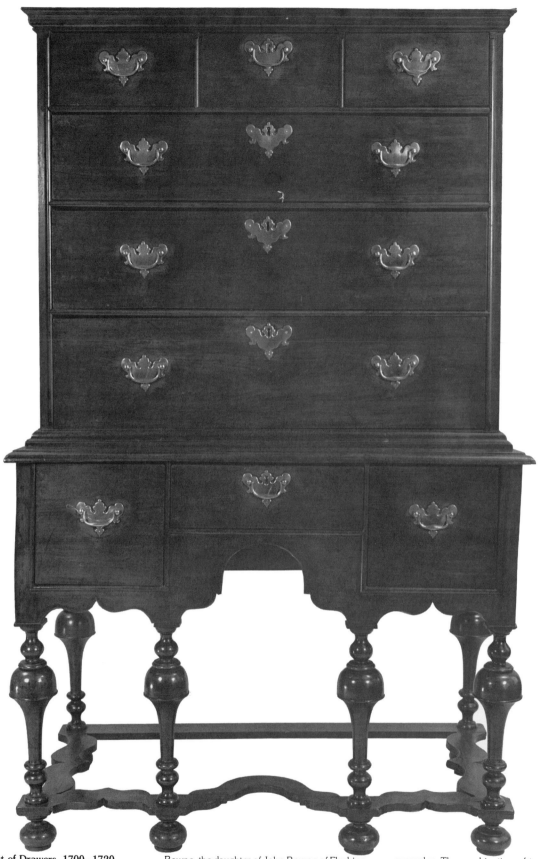

41. High Chest of Drawers, 1700–1720
Possibly New York City or Queens County
Pine, maple
H. 64 W. 41 1/4 D. 22 3/4
The Bowne House Historical Society, Flushing

According to family tradition, William Penn's daughter presented this high chest to Hannah Bowne, the daughter of John Bowne of Flushing, when she married Benjamin Field in 1691. While Hannah may have owned the highboy, it probably dates from a slightly later period, around 1700–1720. Few New York William and Mary high chests survive, but several existing examples have three drawers across the top of the chest, an arrangement not usually found on New England examples. The combination of two deep side drawers in the lower section, a broad mid-section molding, and a light cornice molding also appears on two high chests associated with western Long Island or New York City.

Ref.: V. Isabelle Miller, *Furniture by New York Cabinetmakers, 1650 to 1860,* New York, Museum of the City of New York, 1956, pp. 20–21.

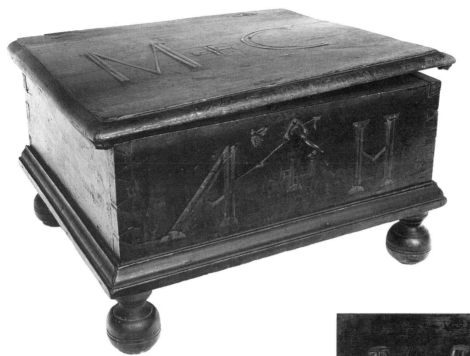

42. Box, 1720–1740
Huntington or Queens [Nassau] County
Fruitwood [apple?], pine
H. 10 3/8 W. 18 1/8 D. 16
Mr. Valdemar Jacobsen

Similar ornamentation and stylistic elements establish a strong connection between this box and the following dressing table (No. 43). Acquired from independent sources, both objects share identically turned feet with an uncommon incised mid-banding, similar molded-edge tops, and distinctive inlay, undoubtedly executed by the same hand. Also, the interior of the box and the interior of the drawers in the dressing table are painted with the same mustard-yellow paint, a late nineteenth or early twentieth century addition which indicates a relatively recent common history of ownership. The initials $M + C$ and $A + H$ are inlaid on the top and front of the box respectively. Boxes of this type of American origin usually date from the seventeenth century. The dovetail construction of this example, however, suggests a date after 1720.

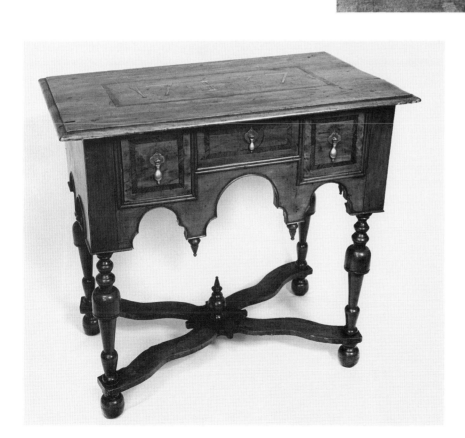

43. Dressing Table, ca. 1737
Huntington or Queens [Nassau] County
Fruitwood [apple ?], pine, maple
H. 30 3/4 W. 34 1/2 D. 21 1/2
Mr. Valdemar Jacobsen

As discussed in the previous entry, the interior paint on this dressing table, which is the same paint that appears on the small valuables box (No. 42), documents a related history for these two objects. Clearly, they came from the same shop. Although made in the William and Mary style, the inlaid date $17 + 37$ on the top of the table and the character of the turnings, which are identical to the double ring turnings on the back stiles of Long Island Queen Anne chairs (Nos. 94–95), indicate a later construction date. Another William and Mary dressing table, while stylistically unrelated, has a top inlaid with initials and the date *1724*, suggesting a certain vogue for this practice.

The use of fruitwood for furniture, in this case probably apple, was common on Long Island, and the author has observed this type of wood in examples with an Oyster Bay area provenance (No. 138).

Owned most recently in the Kirby family of Roslyn, the table may have entered the family through a marriage. Further genealogical research is necessary before a definite attribution as to provenance can be made. The towns of Hempstead, Oyster Bay and Huntington, however, are likely places of origin.

41

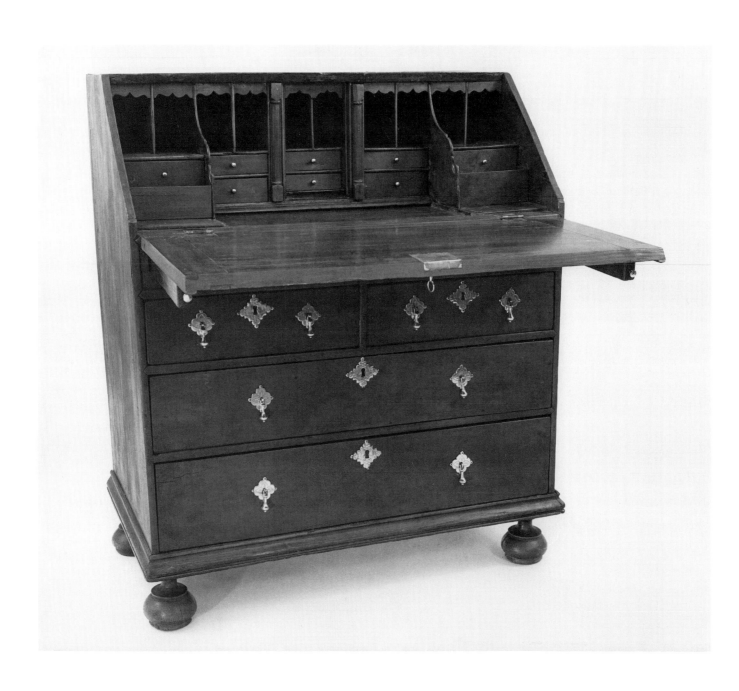

44. Desk, 1725–1750
Suffolk County, possibly East Hampton
Cherry, tulip poplar, pine
H. 41 W. 37 1/2 D. 20 1/4
Society for the Preservation of Long Island
Antiquities, 74.10

First introduced to the American colonies about 1700, the slant-front desk developed from the early desk box (No. 31) and desk-on-frame forms. It is difficult to date this example. The ball feet and keyhole escutcheons appear to be original, suggesting a date before 1730, but the shape of the pigeonholes indicate a later date. Traces of the original red paint appear on this desk and provide evidence of the common rural practice of painting or staining furniture, even that constructed of cherry.

The desk descended in the Talmage family, residents of East Hampton since the seventeenth century. A penciled inscription on the left document drawer reads: *Received Easthampton June 1, 1859 School Bill Debt $6=75 S W Mmiller Colector.*

45. Stand-up Desk, 1710–1750
Suffolk County, possibly Smithtown
Pine
H. 46 3/4 W. 36 D. 20 1/4
Society for the Preservation of Long Island
Antiquities, gift of Miss Carol Lewis Strauss,
69.50

Unlike desks-on-frames, this desk is a single unit with the leg stiles continuing into the compartment section. The interior has two drawers with seven open pigeonholes above. Surprisingly, the single drawer which runs the width of the desk apparently never had brasses or pulls. The elongated double baluster and ring turnings of the legs and the use of pegs for joining all parts except the drawer sides and front indicate a date probably before 1750. Only one other single unit stand-up desk, now in the collections of Colonial Williamsburg, is known, and it has a Massachusetts provenance. Obviously the work of a rural craftsman, this desk may have a Smithtown provenance, as the Society acquired it from a Smithtown donor.

Ref.: Barry A. Greenlaw, *New England Furniture at Williamsburg,* Williamsburg, Va., The Colonial Williamsburg Foundation, 1974, pp. 112–113.

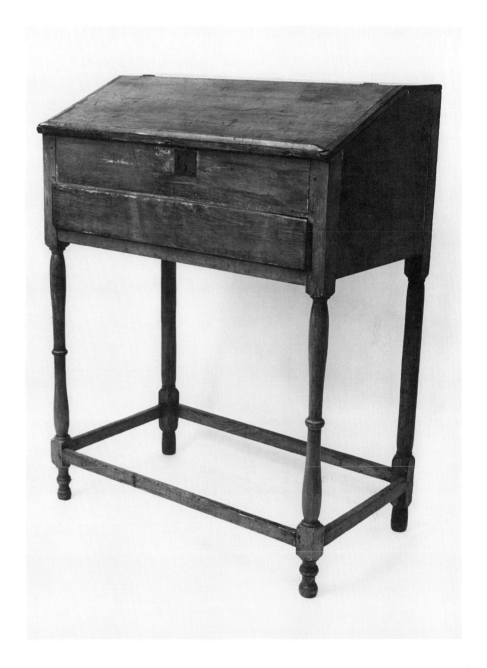

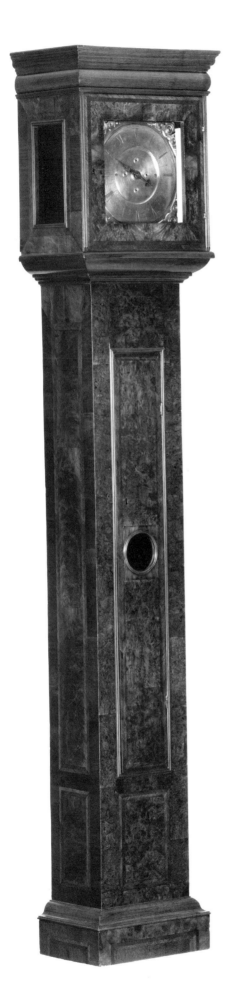

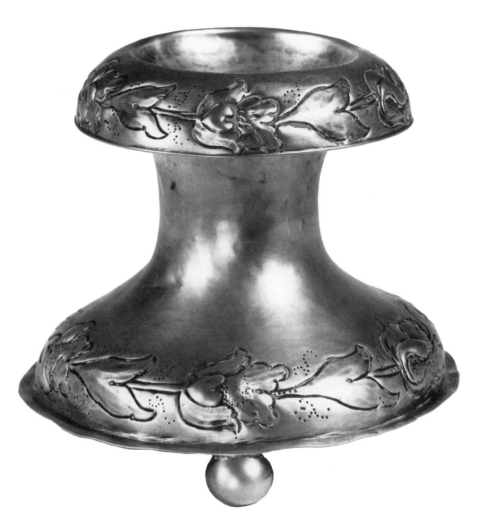

46. Tall-case Clock, 1700–1730
Joseph Lawrence
Possibly Long Island
Walnut, tulip poplar
H. 90 3/8 W. 17 9/16 D. 11 3/16
The Henry Francis du Pont Winterthur
Museum, 63.625a,b

The spectacularly veneered case is not original to
the works of the clock and the two were probably
combined about 1720. Nothing is known of
Joseph Lawrence, and the works may be English
or American. The case may also be of American,
possibly Long Island, origin. According to Winter-
thur's records, the Huntting family of East Hamp-
ton owned this clock which is specifically men-
tioned in the 1864 inventory of Nathaniel Hunt-
ting's estate. Rev. Nathaniel Huntting (1675–
1753), the original owner, married Mary Green
of Boston in 1701, suggesting another possible
provenance for this clock.

Ref.: Jeannette Edwards Rattray, *East Hampton His-
tory, Including Genealogies of Early Families,* East
Hampton, N.Y., By the Author, 1953, p. 397.

47. Standing Salt, ca. 1690
Jacobus van der Spiegel (1668–1708)
New York City
Silver
Mark: *ISV* in trefoil
H. 3 1/4
The Brooklyn Museum, 65.5

A number of late seventeenth or early eigh-
teenth century New York trencher salts have sur-
vived, including a gadroon-decorated pair made
by Van der Spiegel for the Willets family of Flush-
ing. This salt, however, fashioned for the Wester-
velt family of Flatlands, is a unique example of
the spool-shaped Dutch version of the form.
Although fewer than twenty examples of Van der
Spiegel silver exist, they amply demonstrate the
skills of a talented craftsman.

Refs.: *The Brooklyn Museum Handbook,* Brooklyn,
N.Y. The Brooklyn Museum. 1967, p. 297.
Kathryn C. Buhler and Graham Hood, *American Silver:
Garvan and other Collections in the Yale University
Art Gallery,* vol. II, New Haven, Conn., Yale Univer-
sity Press, 1970, pp. 22–23.

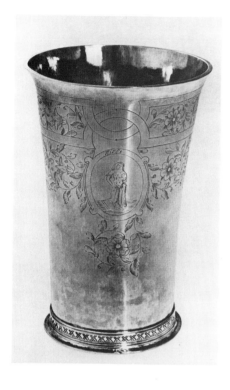

48. Beaker (one of a pair), ca. 1730
Henricus Boelen (1697–1755)
New York City
Silver
Mark: *HB*
H. 6 3/4
The Brooklyn Museum, gift of Timothy Ingraham Hubbard, 21.236

The beaker form of drinking vessel was popular in New York and several made as communion cups have survived, including this example made for the Dutch Reformed Church of Flatlands. The prevalence of the beaker in New York was probably due to the Dutch preference for this form, especially in the seventeenth century, and it is important to note that Dutch silversmiths, or silversmiths of Dutch descent, fashioned all the known New York beakers. The engraved strapwork band around the top is a common motif, as are the figures of Faith, Hope, and Charity. The relatively late date for this example documents the continuation of Dutch influence in English New York.

Refs.: *The Brooklyn Museum Handbook*, Brooklyn, N.Y., The Brooklyn Museum, 1967, p. 316.
Kathryn C. Buhler and Graham Hood, *American Silver: Garvan and other Collections in the Yale University Art Gallery*, vol. II, New Haven, Conn., Yale University Press, 1970, pp. 2–3, 8–10.

49. Porringer, 1710–1730
New York City
Silver
Mark: obliterated
H. 1 7/8 Diam. (of bowl) 5 1/4
Huntington Historical Society, 70.29

The initials *N*H* on the handle of this porringer are thought to be those of the Reverend Nathaniel Huntting (1675–1753), the second Presbyterian minister of East Hampton, and the porringer descended in the Huntting family. The piercings of the handle are typical of other New York examples (No. 67). The silversmith's touchmark is barely visible, but it was apparently contained within a heart- or possibly trefoil-shaped device used by most early New York silversmiths.

50. Tankard, 1700–1720
Cornelius Kierstede (1675–1757)
New York City
Silver
Mark: *CK*
H. 6 5/16 Diam. (of base) 4 13/16
Museum of the City of New York, gift of Miss Mary F. Youngs, 51.100

Distinctive decorative features of New York silver appear on this tankard, including the cocoon-shaped thumbpiece (possibly a replacement), cut-card base banding, and cast, applied figures on the handle. The initials *S/I∗E* on the handle are those of Isaac and Elizabeth Underhill Smith.

Ref.: V. Isabelle Miller, *New York Silversmiths of the Seventeenth Century,* New York, Museum of the City of New York, 1962, No. 40.

51. Tankard, ca. 1710
Benjamin Wynkoop (1675–1728)
New York City
Silver
Mark: *W.K* over ·*B*· in heart
H. 5 3/8 Diam. (of base) 5 1/2
The Museums at Stony Brook

The original owners of this tankard were Samuel Thompson (1668–1749), a prosperous Setauket farmer, and his wife, Hannah Brewster. When he died, Thompson left the tankard to his grandson, Samuel Thompson, and it descended in the family.

This piece displays some of the most distinctive features of early eighteenth century New York silver, including the elaborately engraved baroque arms enclosure, the engraved crenate lid, the cocoon-shaped thumbpiece, and the applied cut-card base banding. Wynkoop avoided the problem of supplying Thompson with a coat of arms by placing the initials *T/SH* within the central shield.

Ref.: V. Isabelle Miller, *New York Silversmiths of the Seventeenth Century,* New York, Museum of the City of New York, 1962, No. 101.

The Thompson House, ca. 1700
Setauket
Society for the Preservation of Long Island Antiquities

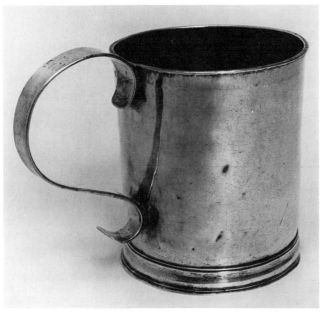

52. Mug, 1705–1740
Peter Van Dyck (1684–1751)
New York City
Silver
Mark: *PVD* **in rectangle**
H. 4 3/8 Diam. (of base) 3 3/4
Private collection

A straight-sided drinking vessel such as this is usually called a mug. The earliest examples had flat strap handles occasionally ornamented with rat-tail beading. Van Dyck made a number of similar mugs, including a pair for the First Presbyterian Church of Southampton and another pair for the First Presbyterian Church of Setauket. This example, however, was a secular piece of silver. The original owners were Matthew (1689–1774) and Elizabeth Chatfield Mulford (–1754) of East Hampton. Their initials were engraved on the handle.

Ref.: R. T. Haines Halsey, *Catalogue of an Exhibition of Silver Used in New York, New Jersey, and the South,* New York, The Metropolitan Museum of Art, 1911, No. 123.

53. Door Knocker, 1640–1700
Probably England
Iron
H. 8 3/4 W. 4 7/16
The Long Island Historical Society, Brooklyn, 240

This bold weathered image of a lion was, according to tradition, the door knocker for the first meetinghouse in Southold, built in 1642. A new meetinghouse was erected in 1684, however, and the door knocker may have been used for this later building. It was probably imported from England.

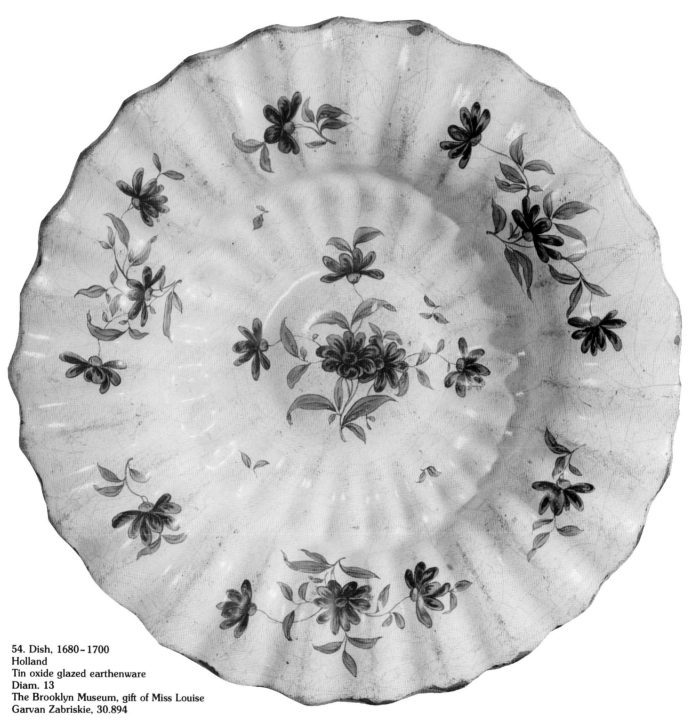

54. Dish, 1680–1700
Holland
Tin oxide glazed earthenware
Diam. 13
The Brooklyn Museum, gift of Miss Louise
Garvan Zabriskie, 30.894

Both Dutch and English colonists used decorative
delftware. Many of the delftware patterns were
designed in imitation of oriental porcelain
although other motifs were also used. In 1701,
John Woolsey, a merchant of Jamaica, Long
Island, recorded in his store account book the
sale of a delft bowl decorated with *"queene Ele-
zabeth and ye Earle of Esecs."* This floral deco-
rated dish descended in the family of Jacobus
Lefferts of Brooklyn.

50

II. FASHION AND TRADITION, 1730-1782

Elements of both fashion and tradition are apparent in the picture of the decorative arts on Long Island during the eighteenth century. The presence of high style fashion on Long Island resulted largely from the importation of objects by the small percentage of well-to-do Long Islanders who could afford and had a taste for more stylish furnishings than were available locally. These objects might represent the latest forms or the most recent vocabulary of ornament, or simply be made of expensive and fashionable materials. Occasionally fashion affected tradition, but never completely transformed or replaced it. Given the predominantly rural character of Long Island, it is not surprising that for most Long Islanders tradition was the fashion. Most of the objects illustrated in this chapter indicate the continued popularity of several basic furniture forms executed in essentially the same style throughout the eighteenth century. Some examples reveal an awareness but little real understanding of stylistic changes and a steadfast reluctance to abandon the familiar.

Although overland transportation and communication facilities were inadequate, eighteenth century Long Islanders nevertheless had access to outside centers of fashion. A number of excellent harbors along the north shore facilitated transportation and trade both with New York and New England. New York mercantile firms regularly shipped a wide range of goods—everything from rum to fabrics—to such towns as Oyster Bay, Huntington, Setauket, Southold, and East Hampton. The towns at the east end also pursued an active trade with New England. It was not until the end of the century that John Lyon Gardiner of East Hampton reported that New York had replaced New England as a primary market. *"Till within thirty years,"* Gardiner wrote in 1798, *"Boston was the place of Markett for . . . this part of Long Island."* [1] This network of trade and communication brought rural Long Island in touch with New York, Newport, Boston, and the Connecticut River Valley and allowed for the introduction of furnishings of more sophisticated design than local craftsmen were producing.

Certain well-to-do families and individuals were largely responsible for the importation of fashionable furniture, silver, ceramics, textiles, and other decorative objects to Long Island. As the discussions of the Lloyd, Martin, Dering, Floyd, and Gardiner families demonstrate, these Long Islanders had personal or business contacts in important centers of fashion such as New York and Boston (see pp. 54–74, 156–165). Some, such as Henry Lloyd, Thomas Dering, and Josiah Martin had lived in fashionable centers or were merchants actively engaged in trade with New England or New York. All of these Long Islanders owned considerable land, and were part of a local landed aristocracy of wealth, status, and influence. Their social position was reflected to varying degrees in their homes and furnishings. Many other prominent and influential Long Island families, including the Smiths of Smithtown and the Townsends of Oyster Bay, were conscious of fashion, and unlike the typical yeoman, occasionally sent to New York for a tankard, a mahogany table, or other stylish objects.

An important but rarely mentioned factor affecting fashion on western Long Island was the establishment there of country homes and estates belonging to wealthy New Yorkers. Governor Thomas Dongan may have been one of the first to

55. High Chest of Drawers, 1740–1770
Oyster Bay
Walnut, tulip poplar, pine
H. 84 W. 42 1/2 D. 21 1/2
Society for the Preservation of Long Island
Antiquities, 61.13.1

The similarity of Rhode Island and Oyster Bay area furniture design, strikingly exemplified in this high chest, was the result of numerous and important family connections as well as commercial intercourse. Solomon Townsend (d. ca. 1720), progenitor of the Newport cabinetmaking family, moved from Oyster Bay to Rhode Island in 1707, but some of his relatives remained on Long Island, and others in Rhode Island, such as Christopher Townsend (1701–1773), occasionally travelled to Long Island. Various members of the Feake, Wright, and Townsend families intermarried and each family included several woodworking craftsmen (see Appendix I). William Stoddard, an Oyster Bay shop-joiner, was yet another important figure who first lived and possibly trained in Rhode Island.

Although Rhode Island practices influenced the design of this high chest, important stylistic differences document its Long Island provenance. The proportions of the high chest establish a decidedly horizontal emphasis, and the two deep drawers in the lower section are rectangular instead of square in the manner of Rhode Island examples. Additionally, the legs are short and appear out of proportion to the mass of the high chest. The three drawer arrangement across the top is a feature associated with New York furniture design but rarely found on New England examples. Finally, the dovetail construction which secures the backboard and drawer sides is not of Newport or Rhode Island quality.

This high chest of drawers and a looking glass also included in this catalogue (No. 155) were owned in the Wright family of Oyster Bay.

Ref.: Joseph K. Ott, *The John Brown House Loan Exhibition of Rhode Island Furniture,* Providence, R.I., The Rhode Island Historical Society, 1965, pp. 99–103.

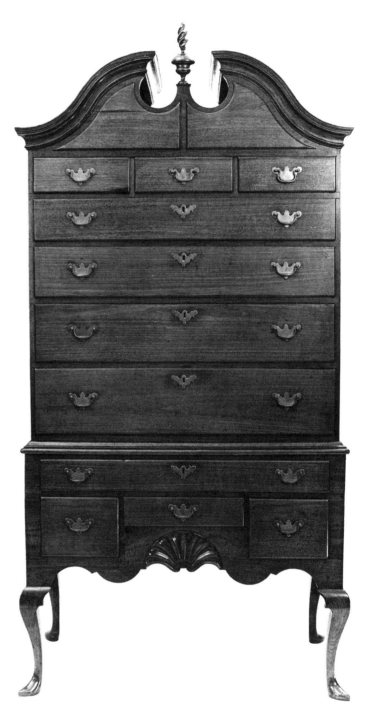

own such a retreat, which he established on land he had purchased in Hempstead shortly after 1684. The same site later became the country seat of George Clark, Secretary of the Province of New York. Clark built a dwelling house there in 1718 which, according to the records concerning its building and furnishing, must have been a handsome structure complete with a balustrade ornamented with carved pineapples on the roof.[2] Long Island continued to be a favorite location for country homes well into the eighteenth century, as noted by the Rev. Andrew Burnaby, a visitor to the Island in 1759: *"Before I left New York, I took a ride upon Long Island, the richest spot, in the opinion of the New Yorkers, of all America; and where they generally have their villas, or country houses."*[3]

A detailed account of the quantity and quality of furnishings brought to Long Island by wealthy families is not possible since few inventories for the period

1700 – 1787 survive. Only the discovery of objects with documented histories or the chance mention of furnishings in letters and family papers provide clues to the nature of fashion on Long Island.

Certainly, imported objects represented the highest level of fashion, yet there were great differences in quality or degree of ornamentation among them, as can be seen, for example, in the New York tea table (No. 113) and stand (No. 110). Several Chippendale style side chairs owned on Long Island and probably made in New York City (Nos. 102 – 103), suggest that the importation of fashion was tempered by generally conservative taste. All of the chairs have simple splats with no carving, and straight legs with stretchers. Individual preferences affected the expression of fashion on Long Island, and some residents must have found it more to their liking to own a Connecticut desk (No. 151) than a New York desk or simple New York chairs rather than elaborate English versions.

For others, locally made objects in the mainstream of fashion were equally acceptable. The high chests of drawers made in the Oyster Bay area (Nos. 55, 136 – 138) illustrate the adaptation of both New York and Rhode Island furniture design and exemplify fashionable local work. So, also, does the silver produced by the Southampton silversmith, Elias Pelletreau.[4]

The abilities of the local craftsman naturally affected their interpretation of the latest fashions. About 1730, the corner cupboard, with a large carved shell capping the interior, became the latest "must" in interior decoration. Lacking the skills of trained carvers, however, Long Island joiners imitated the fashion as best they could by tacking shaped rays, or strips of wood, onto the curved interior dome (Nos. 145 – 147). Similarly, local craftsmen acknowledged the popularity of changing styles in a number of subtle ways. For example, to update the double-panelled blanket chest, local makers simply replaced the earlier William and Mary style turned ball feet with Chippendale style bracket feet (Nos. 127 – 128) while leaving the basic form of the chest unchanged.

Despite the presence of fashionable influences, tradition dominated the character of Long Island's decorative arts. Cultural traditions established during the period of settlement persisted with surprising strength. While all of Long Island took on an increasingly English character in the early eighteenth century, as the accultur- ation of the Dutch progressed, Dutch influence was sufficiently pervasive on western Long Island that the *kas* (Nos. 130 – 135) was not only made in predomi- nantly Dutch towns, but also adopted in English areas such as Oyster Bay. Another important example of continued Dutch influence in furniture design was the application of *kas*-type moldings and raised panels on several English-style ward- robes made in the latter part of the eighteenth century in western Queens or Kings County (No. 144).

Tradition was nowhere mc e evident than in the continued production and acceptance of several furniture forms in essentially the same style from about 1730 through 1820. During the period 1720 – 1740, chair, chest, table, and desk designs in the Queen Anne or the transitional William and Mary/Queen Anne styles were introduced on Long Island. In most instances, these local designs represented modified and simplified versions of high style examples and only minimal stylistic alteration of the basic forms occurred throughout the century.

Recent studies of American furniture have shown that the craftsman played a major role in the introduction of new construction methods and styles to an area.[5] The majority of Long Island craftsmen were trained in a carpenter-joiner tradition which stressed time-honored methods of construction and design, rather than innovation. In many cases, these skills as well as the tools of the craft were passed on in the same family from father to son (see Appendix I). Long Island provided few opportunities for full-time employment to capable furniture makers and, particularly as land became less available, was not attractive to craftsmen who might have introduced new styles and designs from other areas.

The patterns of fashion and tradition remained unchanged on Long Island until the upheaval of the American Revolution. Long Islanders of the eighteenth

century had the opportunity to acquire objects which reflected the current fashions in colonial cities but many chose furnishings more representative of conservative tastes and traditional values. The Queen Anne style, often reduced to its simplest components and combined with selected elements of the William and Mary or Chippendale styles, predominated on rural Long Island before 1782.

[1] John Lyon Gardiner, "Gardiner's East Hampton," *Collections of the New-York Historical Society* (New York: Printed for the Society, 1869), p. 271.

[2] Mrs. Irwin Smith, "Hyde Park, Long Island," *The Nassau County Historical Society Journal,* X (1971), 1–19.

[3] Andrew Burnaby, *Travels through North America,* quoted in Ettie C. Hedges, "Colonial Travelers on Long Island," *New York History,* XIV (April, 1933), 158.

[4] Dean F. Failey, "Elias Pelletreau: Long Island Silversmith," (unpublished Masters thesis, University of Delaware, 1971), pp. 26–33, 64–99.

[5] Benno M. Forman, "Urban Aspects of Massachusetts Furniture in the Late Seventeenth Century," in *Country Cabinetwork and Simple City Furniture,* ed. by John D. Morse (Charlottesville: The University Press of Virginia, 1970), pp. 1–33; John Kirk, *Connecticut Furniture: Seventeenth and Eighteenth Centuries* (Hartford, Conn.: Wadsworth Atheneum, 1967), p. xiv.

56. Map of Lloyd's Neck, 1685
James Lloyd (1653–1693), possibly after
Robert Ryder (active ca. 1670–1681) and
Phillip Wells (active ca. 1680)
Ink on paper
H. 12 1/4 W. 16
The New-York Historical Society

This map is one of several which James Lloyd copied into a surviving account book. As the other maps in the account book (Nos. 2–3) were copied from surveys done by Robert Ryder and Philip Wells, it is entirely possible that Wells and/or Ryder executed this survey of Lloyd's Neck as well. White settlers originally called this neck of land Horse Neck and after the establishment of the Manor, the property was also known as Queens Village. The buildings shown on the map were the houses and farm buildings used by the tenants, Edward Brush, Thomas Fleet, Richard Waring, John Grey and Edward Higby.

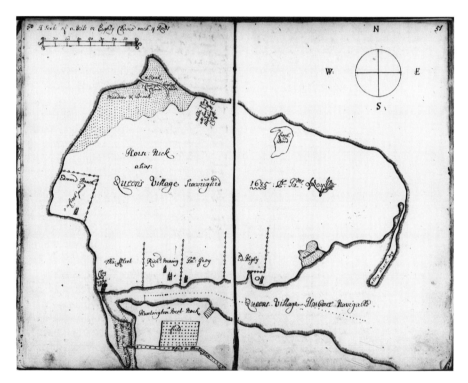

THE LLOYD FAMILY OF LLOYD'S NECK

Among the wealthy and fashionable Long Island families of the eighteenth century were the Lloyds of Lloyd's Neck. James Lloyd (ca. 1653–1693), a Boston merchant, first secured title to part of the Neck through his marriage to Grizzell Sylvester of Shelter Island in 1676. About two years later Lloyd acquired the rest of the property, which totalled more than 3,000 acres, and in 1686 he was granted the Neck as the Lordship and Manor of Queens Village (No. 56).

James Lloyd remained in Boston and leased farmland on the manor to tenants. His son, Henry Lloyd I (1685–1763), however, moved to the manor in 1711, built his house there and actively pursued a career as a gentleman farmer and merchant (Nos. 57, 59). Henry supplied families in the area with merchandise which he imported, secured locally, or produced on the manor. With the aid of tenants and slaves, he farmed his land, raised livestock, and cultivated extensive orchards. Wood was a valuable commodity, and the trees on the Neck were an

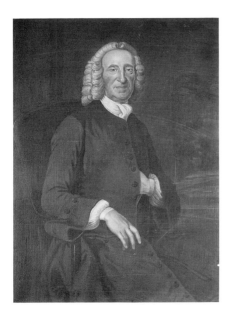

57. *Henry Lloyd I,* **1767**
John Mare (1739–ca. 1795) after John
Wollaston (active ca. 1736–1767)
Oil on canvas
Mrs. Orme Wilson

In May, 1750, Henry Lloyd II requested that his
father visit New York City to sit for his portrait,
and the younger Lloyd offered to pay for the
painting. Henry I agreed and John Wollaston
received the commission. Henry II made the final
payment to his father in June, 1751.

The original portrait is now lost, but John
Mare executed a copy, now in the possession of a
descendant, in 1767. Mare was active in New
York City from about 1760 through 1772.
Undoubtedly, he painted the copy at the request
of one or perhaps all of Lloyd's sons.

Ref.: Helen Burr Smith, "John Mare (1739–c.1795),
New York Portrait Painter," *The New-York Historical
Society Quarterly,* October, 1951, pp. 354–399.

58. Tankard, 1740–1750
Richard Van Dyck (1717–1770)
New York City
Silver
Mark: *RVD* conjoined, in shaped punch
H. 7 5/16 Diam. (of base) 5 3/4
Yale University Art Gallery, Mabel Brady
Garvan Collection, 1932.94

A nineteenth century inscription on this tankard
indicates it was the gift of John Nelson (1654–
1734) to his granddaughter, Rebecca Lloyd
(1718–1797), the daughter of Henry Lloyd I and
his first wife, Rebecca Nelson. The inscription
must be incorrect, however, for Van Dyck was
too young to have fashioned the tankard before
John Nelson's death in 1734. Van Dyck enjoyed
the patronage of the Lloyd family, and it seems
more likely that Henry Lloyd I commissioned
the tankard, possibly on the occasion of
Rebecca's marriage to Melancthon Taylor Wool-
sey in 1742.

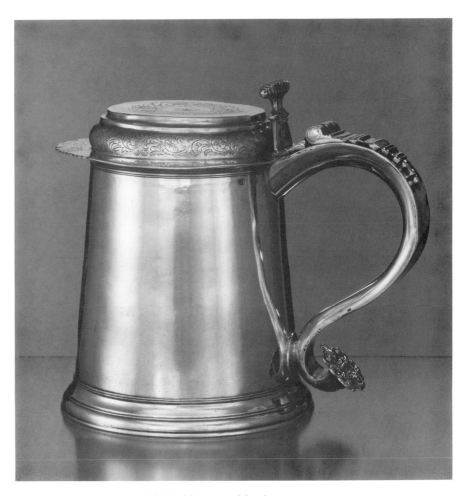

important source of wealth for Henry and his heirs.

When Henry Lloyd moved from Boston to Lloyd's Neck in 1711, he
undoubtedly brought some Boston furniture for his new home. He probably owned
Rhode Island furniture as well, for he had lived in Newport for a time, and had
made at least one payment to a Rhode Island joiner, James Browne, for an
unspecified purchase. After arriving at the manor, he employed local craftsmen to
build his house and occasionally to supply basic household furnishings including
chairs, bedsteads, and a spinning wheel. For fashionable items, however, he
continued to rely on urban craftsmen. In 1714, he purchased *"furniture for a bed,"*
specifically the curtains, valance, testor, and headcloth, from Charles Morris of
Boston. He apparently sent to New York for a Chippendale chest of drawers still
owned in the family and he commissioned spoons from the New York silversmith,
Richard Van Dyck (1717–1770), who also supplied the family with a silver tankard
(No. 58).

Henry bequeathed the manor to his sons, Henry II (1709–1795), John I
(1711–1795), Joseph (1716–1780), and James (1728–1810), who divided the
property among themselves in 1764. Henry Lloyd II acquired his father's house
and the other brothers built houses on the Neck before 1770 (No. 60). Although a
number of capable carpenters were active in Huntington and Oyster Bay at this
time, the Lloyd brothers employed a carpenter from Stamford, Connecticut, Abner
Osborne, to assist with the construction of their houses. Prior to the Revolution,
only Joseph Lloyd and his nephew, John Lloyd II (1745–1792), lived on the Neck.
Henry II and James Lloyd remained in Boston and John Lloyd I in Stamford,
Connecticut.

59. The Henry Lloyd House, 1711
Lloyd's Neck
The State of New York

Henry Lloyd chose a site for his house on the
south side of the Neck near the shore of Lloyd
Harbor. Among the local craftsmen who assisted
with the construction were Michael Wareing,
Nathaniel Williams, and Eleazer Hawkins, who
worked on framing and closing the house, and
Thomas Smith, who also helped with framing
and finishing the interior (see Appendix I). Smith
performed most of the masonry work as well.

60. The Joseph Lloyd House, 1766–1767
**Fireplace wall, southwest bedroom, second
floor**
Lloyd's Neck
**Society for the Preservation of Long Island
Antiquities**

Joseph Lloyd engaged a Connecticut carpenter,
Abner Osborne of Stamford, to close the house
and finish the interior work.

The inventory of the estate of John Lloyd II, taken at Lloyd's Neck in 1793,
provides some evidence of the family's possessions and life style at that date.
Although the total assessed value of the estate excluding real property, £7,745,
indicates substantial wealth, most of that wealth was tied up in credit, particularly in
one large loan of more than £4,000 to John Lloyd I, the father of the deceased.
Although John Lloyd II owned a great many household objects and farming
implements, the inventory reveals no special accumulation of fine furniture. On the
contrary, a great many pieces were described as *"old,"* and the only furniture wood
specifically mentioned was cherry. The inventory suggests that this Lloyd house-
hold had less of an interest in fashion and style or at least owned fewer fashionable
objects than one would expect. This situation reflected in part the family's economic
problems which resulted from the British occupation of Lloyd's Neck during the
Revolution.

Refs.: Henry Lloyd Account Book, 1706–1780, New-York Historical Society, New York, New York.
Henry Lloyd Account Books, 1707–1723, 1706–1737, and 1731–1744, Long Island Historical Society, Brooklyn,
New York.
Henry Lloyd Waste Books, 1703–1706, 1706–1711, and 1711–1720, Long Island Historical Society, Brooklyn, New
York.
Kenneth Scott and Susan E. Klaffky, *A History of the Joseph Lloyd Manor House,* Setauket, N. Y., Society for the
Preservation of Long Island Antiquities, 1976, pp. 7–30.

61. *Josiah Martin,* ca. 1746
Robert Feke (1707–1752)
Oil on canvas
H. 50 1/4 W. 40 3/8
The Toledo Museum of Art, Toledo, Ohio, gift
of Florence Scott Libbey, 45.16

Robert Feke was born in Oyster Bay, Long
Island, probably in 1707. He may have worked
as a tailor during his early life. In 1742, he mar-
ried Eleanor Cozzens of Newport and settled
there. His activity as a portrait painter was limited
before 1745, but after that date he began paint-
ing in earnest and completed approximately fif-
teen to twenty works per year.

It is possible that this portrait of Josiah Martin
and a companion portrait of Mrs. Martin, now in
the Detroit Institute of Arts, were painted while
Feke was visiting his family in Oyster Bay, possi-
bly during the course of one of his painting trips
to Philadelphia in 1746 or 1749. Like Feke's
Philadelphia portraits of 1746, the iconography
of the picture relates to the life of the subject, and
Martin, a wealthy merchant and landowner, fit-
tingly gestures toward the countryside and bay in
the distance.

Refs.: Henry Wilder Foote, *Robert Feke, Colonial Por-
trait Painter,* New York, Kennedy Gallaries, Inc.,
1969, pp. 66, 164–165.
R. Peter Mooz, ''Robert Feke,'' *American Painting to
1776, A Reappraisal,* ed. by Ian M. G. Quimby,
Winterthur, Del., The Henry Francis du Pont Winter-
thur Museum, 1971, pp. 181–192.

THE MARTIN FAMILY OF ROCK HALL

The portrait of Josiah Martin (1699–1778) by Robert Feke depicts a man of
aristocratic bearing, elegantly dressed in a dark coat lined with white satin and a
white brocade waistcoat, and wearing a fine powdered wig (No. 61). A wealthy
merchant and landowner, Martin is representative of the eighteenth century Long
Island aristocracy. He had a taste for fashion and he preferred high style furnishings
for his sophisticated Georgian house, Rock Hall (No. 63).

Martin was apparently born in Antigua and spent most of his early life there.
In 1735, he married his second wife, Mary Yeamans, the daughter of the Governor
of Antigua, and their first son, Samuel, was baptized in Hempstead, Long Island, in
1740. The first record of Martin's ownership of Hempstead land is dated 1742. He
apparently moved to Hempstead around that time but maintained his ties and his
estate in Antigua. In 1750, he became President of the royal Council in that West
Indies colony, but his daughter, Rachel, was baptized in Hempstead during the
same year.

Martin's attachments with England were quite strong. He was a successful
merchant and he undoubtedly traded with England as well as with New England

62. *Mary Elizabeth Martin*, 1771
John Singleton Copley (1738–1815)
Oil on canvas
H. 45 1/2 W. 40
Addison Gallery of American Art, Phillips Academy, Andover, Massachusetts

Mary Elizabeth Martin (bpt. 1762) was the daughter of Josiah Martin (ca. 1737–1786), the nephew of the elder Josiah Martin. In 1761, the younger Josiah married Elizabeth Martin, who was almost certainly his first cousin. The younger Martin family apparently spent most of their time at Rock Hall.

Copley executed this portrait during his seven month painting trip to New York in 1771. The marked contrast of a dark background with a strongly highlighted figure is characteristic of Copley's portraiture at this time. The canvas is almost square, an unusual shape and size for Copley's work, but it was apparently designed to fit the panel above the mantel in the southwest parlor of Rock Hall. Copley may have painted Mary Elizabeth's portrait in New York City or at Rock Hall. According to local tradition, Copley did visit the house, and his interest in the Chinese Chippendale cresting rail on the roof may have inspired his own comments, written in 1771, regarding a *"Chinese enclosure"* for the porches he wished to add to his house in Boston.

Refs.: Marshall B. Davidson, *The American Heritage History of Notable American Houses,* New York, American Heritage Publishing Co., Inc., 1971, pp. 65–66.

Jules David Prown, *John Singleton Copley in America, 1738–1774,* Cambridge, Mass., Harvard University Press, 1966, pp. 82, 223.

and the West Indies. The family attended and supported the Anglican church, St. George's, in Hempstead. Martin's nephew, Josiah (ca. 1737–1786), received an important political appointment as the Provincial Governor of North Carolina in 1771. The Martins remained loyal to England during the Revolution.

Martin purchased approximately 400 acres of meadow and marsh on Long Island's south shore in present-day Rockaway in 1767. Not long after purchasing the property, he arranged for the construction of his splendid Georgian house, Rock Hall. Martin had been living near Cow Bay on the north shore on the Hyde Park estate which had previously belonged to George Clark, Secretary of the Province of New York, and which represented the ultimate in fashion and elegance on Long Island (see p.52). Not surprisingly, Martin required that his new house reflect the same level of taste. With its wide central hall, broad staircase, and elegant interior panelling, Rock Hall is an exceptional example of the eighteenth century high style on Long Island.

Martin's taste in furnishings must have been entirely in keeping with his life style and the setting he had created at Rock Hall. Unfortunately, the inventory of Martin's estate is not extant. If it was taken, the inventory may never have been recorded as Martin died at a time of widespread social and political upheaval during the Revolutionary War. He must have owned a great many English pieces of furniture and the two surviving objects—a Chippendale side chair (No. 65) and a silver cream pot—represent stylish English furniture and silver designs of the period.

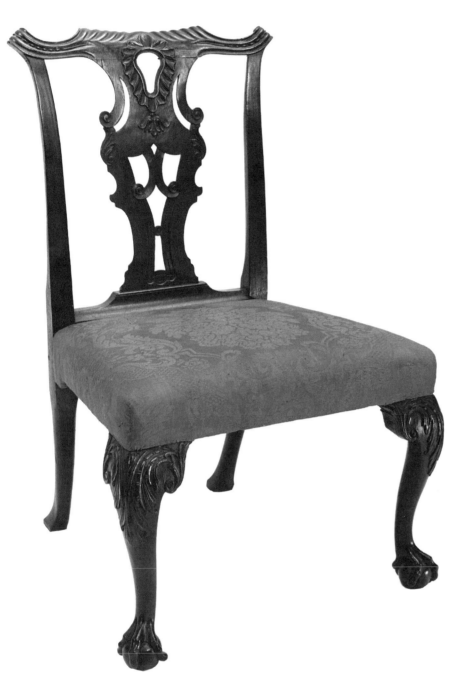

65. Side Chair (one of a pair), 1760–1780
England
Mahogany, oak
H. 38 W. 24 5/8 D. 24
Rock Hall, Lawrence

An important merchant and a Loyalist, Josiah Martin must have imported a considerable quantity of his furniture from England. This chair and its mate were purchased many years ago at an auction of Martin family furniture originally owned at Rock Hall.

63. Rock Hall, ca. 1767
Lawrence
The Town of Hempstead

Rock Hall was probably built shortly after Josiah Martin purchased the tract of land on which it stands in 1767. The identity of the architect/builder has not been established. The central hall plan with its double tier of rooms on each side of the hall and paired end chimneys and the fine exterior trim represent fashionable mid-eighteenth century house design. The two west parlors were significantly retrimmed during the Federal period and the east wing was built in 1881 for James Augustus Hewlett, whose family had acquired the house from the Martins in 1824.

64. *Survey of Rock Hall*, 1817
Morris Fosdick
Hempstead
Ink, watercolor on paper
H. 11 3/4 W. 14 3/4
Rock Hall, Lawrence

Upon the death of Josiah Martin, Dr. Samuel Martin (bpt. 1740–1806) inherited Rock Hall and he in turn left an interest in the property to one of his sisters, Rachel. About 1792, she married Thomas Banister, an attorney, and they apparently lived in the house. Banister purchased his daughter's share of the Rock Hall property in 1817, and probably arranged for this survey. It shows the location of several outbuildings near the house, including the kitchen building and possibly a smokehouse at the west end. The uses of the other structures are not known, although one was probably a chair or carriage house and another probably the ice house known to have stood on the grounds.

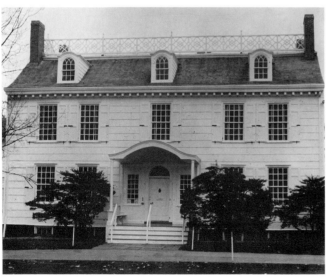

THE SYLVESTER AND DERING FAMILIES OF SHELTER ISLAND

The more than 8,000 acres of land on Shelter Island provided the economic base for the comfortable life style of the proprietors, the Sylvester family. Nathaniel Sylvester (– 1680) became a part owner of Shelter Island in 1651 and settled there in 1652. In 1666, a grant from Governor Richard Nicolls established Sylvester's holdings as an independent manor, and in 1674 he gained title to the entire island.

When Nathaniel Sylvester died, his son, Giles (– 1730), inherited the manor house and most of the island. After Giles' death, Brinley Sylvester (1694–1752), Giles' nephew, acquired the property. Brinley, a resident of Rhode Island, moved to Shelter Island in 1737 and built the present expansive manor house. Other families had acquired land on the island by this date, but the Sylvester estate was still substantial.

The inventory of Brinley Sylvester's estate was taken room-by-room and documents the furnishings of the manor house in 1752. It provides a record of the types of objects owned by a wealthy landholder on eastern Long Island at that time, as evidenced by the following excerpts:

In the Closset in ye Parlour	£
Glass China Ware Earthen .	4.10 –
A Black Walnut Escrutore ..	15.0 –
10 Leather Chairs 10	5.0 –
a Silver hilted Sword	2.10 –
a pair of Silver Spurs	1.4 –
an Ovil Table	1.6 –
a Mahog. Tea Table	2.0 –
an Ovil lg. Table	1.0 –
Clock	13.0 –
Looking Glass	7.0 –
pr. of Handirons Shovel and Tongs [?]	2.0 –
[?] of all Sorts	15.0 –

In the Entry viz

Large Table Chair & pictures	5.0 –

In the Hall

a Looking Glass	10.0 –
a Tea Table and China	3.10 –
an Ovil Table	2.0 –
a Couch	3.0 –
4 Leather Chairs 10	4.0 –
a beaufat of China Ware ...	4.0 –

In the Bedroom

bed and furniture	8.0 –
in the dark room a bed etc.	6.0 –

7 black chairs10 –
a small Table3 –
a low Desk15 –
a pr Dogg Tongs & Shovel .	.14 –
Sundries in the Closset	1.10 –

In the bedroom Chamber

a bed Curtains 4 blankets ..	10.0 –
a bed in the Closset	7.0 –
5 black Chairs 4/	1.0 –
a Chest of Draw'rs	2.6 –
Dressing Table and Glass ..	1.15 –

In the Hall Chamber

a Bed etc.	26.0 –
6 Chairs 12	3.12 –
an Easy Chair	1.0 –
a Stand4 –
a Square Table	1.0 –
a Looking Glass	10.0 –

In the Parlour Chamber

Bed Curtains etc.	8.0 –
Table and Glass5 –
4 Chairs5 –
a Cupboard6 –
a Writing Table1 –
Sundries in the Closset	1.0 –

After his death, Brinley's daughter, Mary Sylvester (1724–1794), inherited the manor house and farm of 1,200 acres. In 1756, she married Thomas Dering (1720–1785), a Boston merchant, in Newport, Rhode Island, where she had been sent to be educated. Thomas and Mary Dering moved to Shelter Island in 1760 and Dering superintended the farming of the large estate.

Thomas Dering came from a line of prosperous Boston merchants, and the family maintained important personal and commercial ties with New England. In

66. *Mary Sylvester*, 1754
Joseph Blackburn (active in America ca.
1754–1763)
Oil on canvas
Signed on the shaft of the crook
H. 48 7/8 W. 40 3/16
The Metropolitan Museum of Art, gift of
Sylvester Dering, 1916, 16.68.1

Mary Sylvester was the daughter of Brinley
Sylvester of Shelter Island and his wife, Mary
Burroughs. She became the wife of Thomas Der-
ing of Boston, and her sister, Margaret, married
David Chesebrough, a prominent Newport
merchant.

Joseph Blackburn came to America in 1754
and he painted his first American subjects that
year. This portrait bears the signature *J. Blackburn
Pinx* on the shaft of the crook, and although
undated, was undoubtedly painted in 1754 when
Blackburn executed a companion portrait of
Mary's sister, Mrs. Chesebrough. According to
family tradition, Blackburn painted both portraits
in New York, but there is no record of his activity
there.

Ref.: Albert Ten Eyck Gardner and Stuart P. Feld,
*American Paintings, a Catalogue of the Collection of
the Metropolitan Museum of Art,* vol. I, New York,
The Metropolitan Museum of Art, 1965, pp. 12–15.

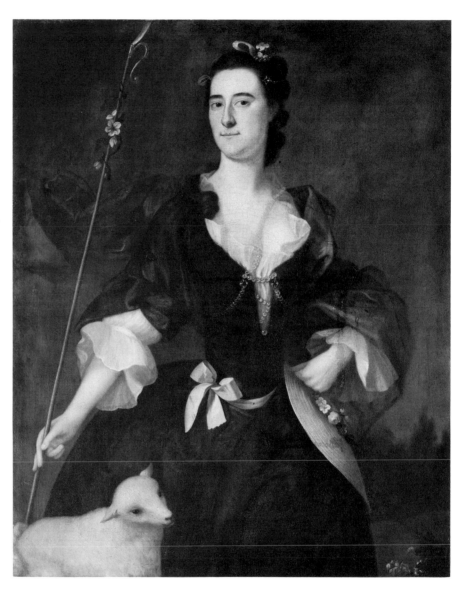

1763, while living on Shelter Island, Dering was appointed Inspector of Trade and
Navigation in the District of the Port of New London.

Evidence of Dering's taste and ownership of decorative objects comes from
a variety of sources. A surviving account book, which he kept in Boston before he
moved to Shelter Island, includes a number of references to work done by the
Boston silversmith, Jacob Hurd (1703–1758), including the fashioning of silver
spoons and shoe buckles and the mending of a coffee pot, butter cup, and cann.
Jacob's son, Nathaniel Hurd (1730–1777), engraved several bookplates for Dering
(Nos. 70–71) which were adopted and used by successive generations of Derings
on Long Island.

A letter from Dering's brother, Henry, in Boston briefly describes the
problems of shipping Thomas' furniture to Shelter Island. The shipper, Henry
wrote, was reluctant to "*take the charge of a Piece of Furniture that is liable
to damage of Brakg* [breaking] *you Desk & Book Case is as should it meet
with an Accident she could not have it repaired without sending to England.*"
What must have been a very impressive piece of English furniture did, however,
reach Shelter Island and was identified in the inventory of Thomas Dering's

estate as *"1 Mahogany Desk & book Case/with look'g glass doors."* Apparently among the other furnishings Dering brought to Shelter Island from Boston were a Queen Anne side chair (No. 72) and a horse-bone foot table (No. 73). Dering may have purchased his tall-case clock made by William Claggett (No. 74) in Newport at the time of his marriage.

The inventory of Dering's estate suggests that he was a man of moderate wealth at the time of his death. The total value of his estate, excluding real property, was £700. Among his household furnishings were a large pier looking glass, a five foot mahogany table, *"6 black walnut framed/leather chairs, open back,"* *"6 black walnut framed Chairs/with red Bottoms,"* *"1 Mahogany framed great Chair/slatted back & bottom,"* a mahogany fire screen, an eight-day clock, a mahogany bureau, and six pictures.

Refs.: Henry and Thomas Dering Account Book, East Hampton Free Library, East Hampton, New York.
Letter, Henry Dering to Thomas Dering, April 30, 1763, East Hampton Free Library, East Hampton, New York.

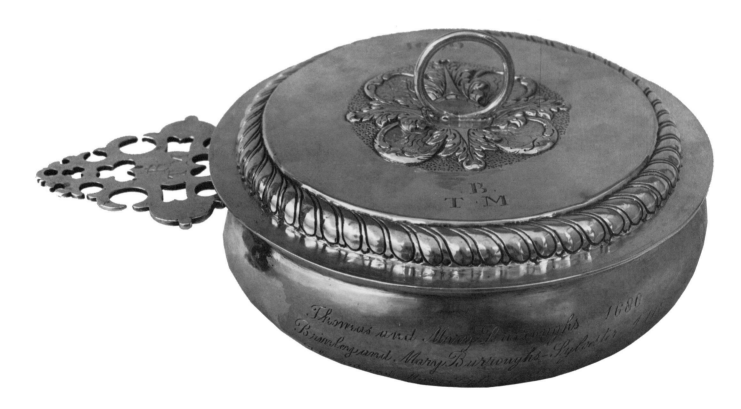

67. Covered Porringer, 1700–1720
Probably New York City
Silver
H. 4 L. 9 1/2
The Metropolitan Museum of Art, gift of Sylvester Dering, 1915, 15.98.3

American covered porringers are rare, and all of the known examples except one were made by New York silversmiths. This example, unfortunately, is unmarked. The character of the spiral band of gadrooning around the early flat lid is suggestive of the work of Peter Van Dyck (1684–1751), and a covered porringer with a simple ring handle which he fashioned is in the Garvan Collection at Yale University. This handle pattern

is similar to those on several porringers made by John Coney, resulting in some previous speculation about a Boston provenance for this example. The porringer, however, was originally owned by Thomas and Mary Burroughs of New York, and it descended to their daughter, Mary, who in 1718 married Brinley Sylvester. The inventory of Sylvester's estate taken in 1753 lists *"a Silver porringer & Cover,"* probably this example.

Refs.: Kathryn C. Buhler, *American Silver, 1655–1825, in the Museum of Fine Arts, Boston,* vol. I, Boston, Museum of Fine Arts, Boston, 1972, p. 64.
Kathryn C. Buhler and Graham Hood, *American Silver, Garvan and other Collections in the Yale University Art Gallery,* vol. II, New Haven, Conn., Yale University Press, 1970, pp. 39–45.

68. Chest of Drawers, 1700–1730
England
Walnut, pine
H. 33 7/8 W. 37 7/8 D. 22 1/2
Private collection

About 1700, many English chests of drawers were veneered in striking oyster-shell patterned walnut or olive wood, and occasionally the top also received an elaborate scrolled inlay treatment. This example was owned on Shelter Island, probably by Nathaniel Sylvester II (1661–1726) or his son, Brinley Sylvester, whose daughter, Mary Sylvester Dering, inherited the chest.

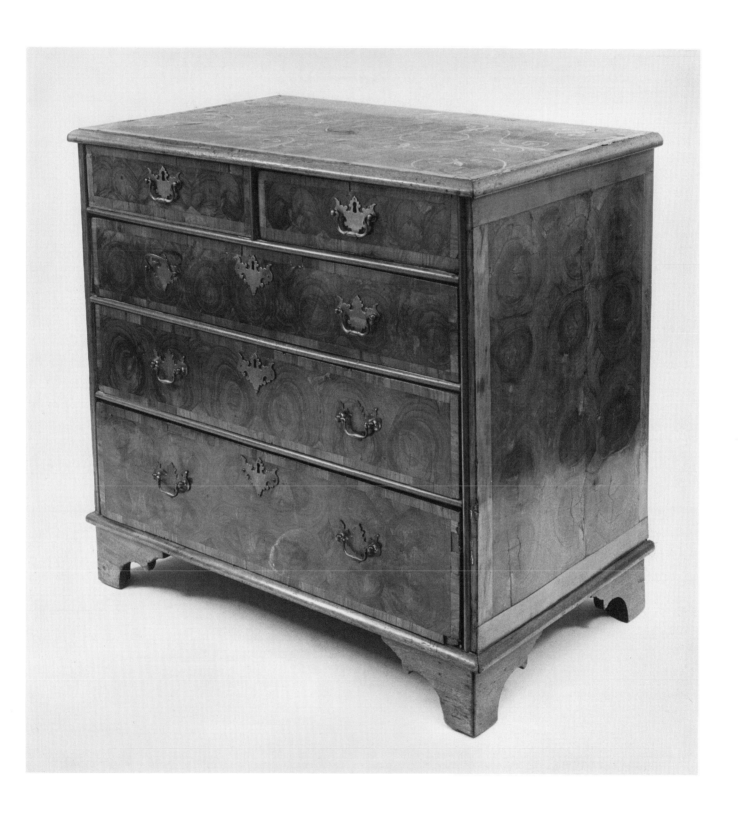

69. *Thomas Dering,* ca. 1810
Possibly after Joseph Blackburn (active in
America ca. 1754–1763)
Oil on canvas
H. 24 W. 18 1/4
Society for the Preservation of Long Island
Antiquities, 966.135

Henry Packer Dering (1763–1822) commis-
sioned this copy of an eighteenth century portrait
of his father, Thomas Dering, about 1810. The
original portrait, possibly by Joseph Blackburn, is
in the Metropolitan Museum of Art.

70. Bookplate for Thomas Dering, ca. 1745
Nathaniel Hurd (1730–1777)
Boston
Line engraving, signed under left bracket
H. 3 7/8 W. 3
Society for the Preservation of Long Island
Antiquities, 966.503

Like many colonial silversmiths, Nathaniel Hurd
was a skilled engraver. He executed numerous
engraved armorial bookplates, and more than a
hundred variations of at least fifty-five different
arms on bookplates have been attributed to
Hurd. While another bookplate for Thomas Der-
ing (No. 71) is the earliest dated Hurd bookplate,
Hurd probably engraved this example at an ear-
lier date when he had just begun to work inde-
pendently. The heavy-handed execution of this
plate indicates a still immature talent. James
Turner, also a Boston silversmith, used this same
elaborate design for a bookplate engraved about
1745. The only other extant example of this
bookplate is in the Metropolitan Museum of Art.

Refs.: Martha Gandy Fales, "Heraldic Emblematic
 Engravers of Colonial Boston," in *Boston Prints and
 Printmakers, 1670–1775,* Boston, Colonial Society of
 Massachusetts, 1973, pp. 205–206, 212–213.
Hollis French, *Jacob Hurd and His Sons Nathaniel and
 Benjamin, Silversmiths, 1702–1781,* Cambridge,
 Mass., Riverside Press, 1939, pp. 102–104.

71. Bookplate for Thomas Dering, 1749
Nathaniel Hurd (1730–1777)
Boston
Line engraving, signed and dated
H. 2 7/8 W. 2 3/8
Society for the Preservation of Long Island
Antiquities, 966.145

This bookplate made for Thomas Dering (1720–
1785) in 1749 is the earliest signed and dated
example by Hurd. Stylistically, the assymetrical
cartouche is later in date than the heavy baroque
form Hurd used for another Dering plate (No.
70). Technically, this plate represents the work of
a more mature and experienced artist. Thomas
Dering's son, Henry Packer Dering (1763–
1822), altered the plate by substituting *Hen͚ P.*
for *Thomas.* Nicoll H. Dering (1794–1867), son
of Sylvester Dering of Shelter Island, also used
two different versions of this plate. In one
instance, he replaced the name *Thomas* with the
initials *N. H.* written in ink, and in the second
instance he substituted *Nicoll H. Dering,*
engraved in modern script, for the original
Thomas Dering.

Refs.: Martha Gandy Fales, "Heraldic Emblematic
 Engravers of Colonial Boston," in *Boston Prints and
 Printmakers, 1670–1775,* Boston, Colonial Society of
 Massachusetts, 1973, pp. 205–206, 212–213.
Hollis French, *Jacob Hurd and His Sons Nathaniel and
 Benjamin, Silversmiths, 1702–1781,* Cambridge,
 Mass., Riverside Press, 1939, pp. 102–104.

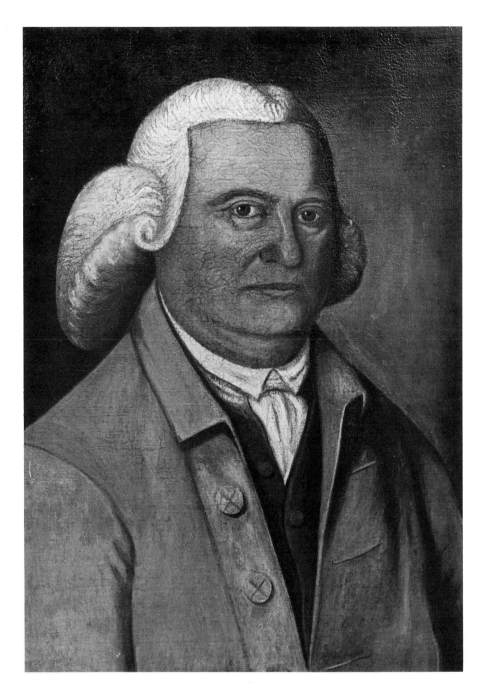

72. Side Chair, 1730–1750
Boston
Walnut
H. 42 W. 22 D. 21
Private collection

Thomas Dering and his wife probably brought
most of their furnishings with them from Boston
when they moved to Long Island in 1760. This
Dering family chair, marked *VII* on the frame, is a
classic example of the Boston Queen Anne style
and is distinguished by the scalloped skirt and
cylindrical turnings of the rear legs. It may be one
of the *"6 black walnut framed chairs"* listed in
Dering's 1785 inventory.

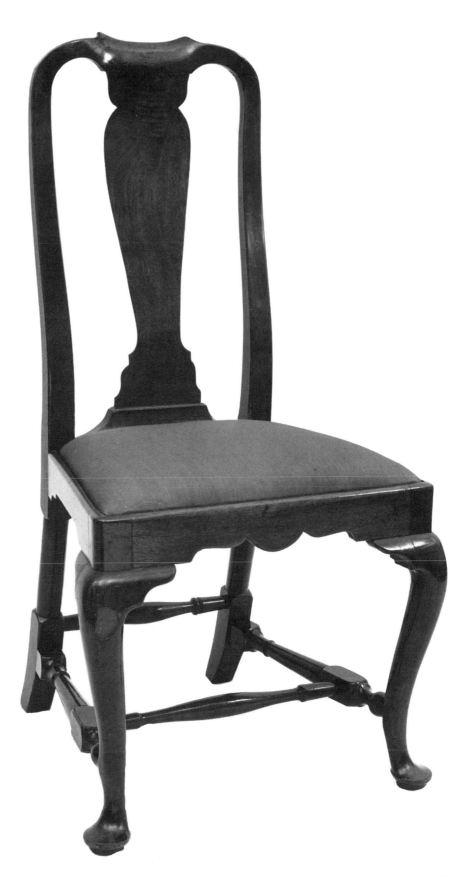

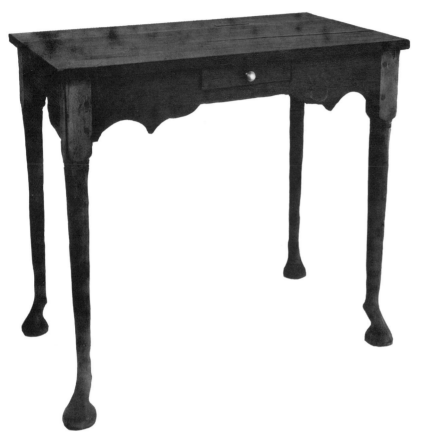

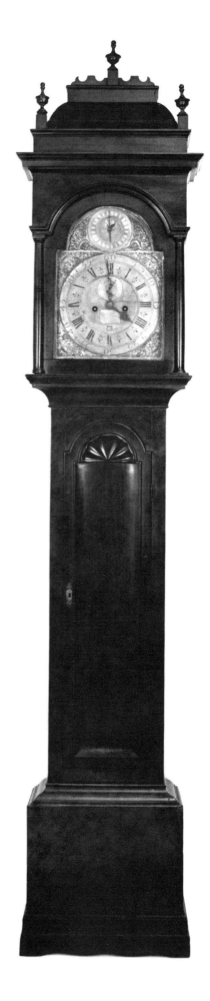

73. Table, 1730–1750
New England or Suffolk County
Pine
H. 26 W. 16 1/2 D. 28 1/8
Private collection

Thomas Dering was supposedly the original owner of this table, and it has descended in the Dering family. References to horse-bone foot furniture appear in a Boston upholsterer's account book by 1730. Dering may have brought the table to Shelter Island when he left Boston in 1760. The table was probably once painted or even japanned. It is possible, given the simplicity of the table, that a local craftsman produced it, copying a more elaborate example.

Ref.: Brock Jobe, "The Boston Furniture Industry, 1720–1740" in *Boston Furniture of the Eighteenth Century*, Boston, Colonial Society of Massachusetts, 1974, p. 42.

74. Tall-case Clock, ca. 1740–1749
William Claggett (1696–1749)
Newport
Mahogany
H. 100 1/2 W. 20 3/8 D. 11
Private collection

Thomas Dering was the original owner of this tall-case clock, which is probably the *"Eight Day Clock"* listed in the inventory of his estate.

Four other Claggett clocks with arched dials and a secondary dial in the arch are known. The smaller dial shows the phases of the moon and indicates the time of high tide. These five clocks are the only American examples having this type of dial which is occasionally found on English clocks.

Additional similarities among the five examples include identical spandrel motifs and, with one exception, the maker's rectangular nameplate in the center of the dial. These similarities, the design of the dial-plate, and the basic style of the clock-case with its sarcophagus-shaped top all suggest a date of about 1740 or earlier. A slightly later date seems likely, however, because of the concave or reverse blocking of the door, capped with a concave shell, and the squat, "cupcake" form finials. These features are not found on any other clock cases original to the Claggett works and are more typical of Newport cabinetwork after 1750.

Ref.: Barry A. Greenlaw, *New England Furniture at Williamsburg*, Williamsburg, Va., The Colonial Williamsburg Foundation, 1974, pp. 96–98.

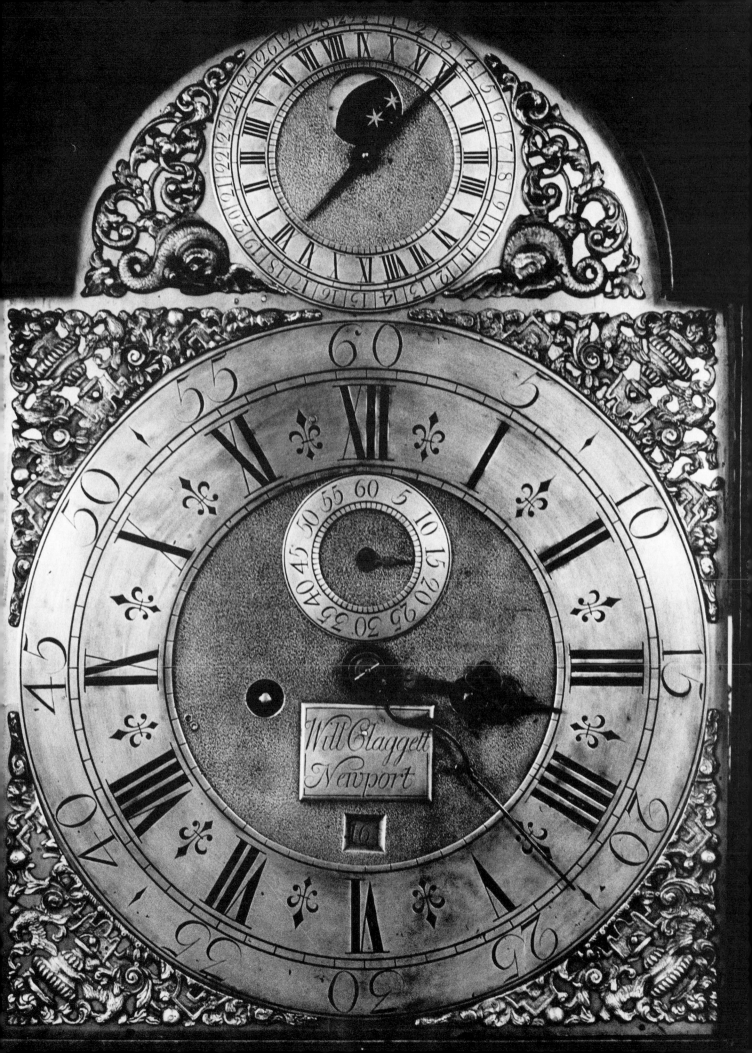

75. *William Floyd,* ca. 1793
Ralph Earl (1751–1810)
Oil on canvas
Signed and dated *R. Earl, pinxt 17*[*?*]
H. 48 1/2 W. 36 1/4
Independence National Historical Park Collection, Philadelphia

Because of the fidelity of the rendering of Floyd's house, it seems likely that Earl visited Long Island to paint this portrait of William Floyd. Earl painted several members of the Floyd family between 1790–1793 (Nos. 83–84, 166).

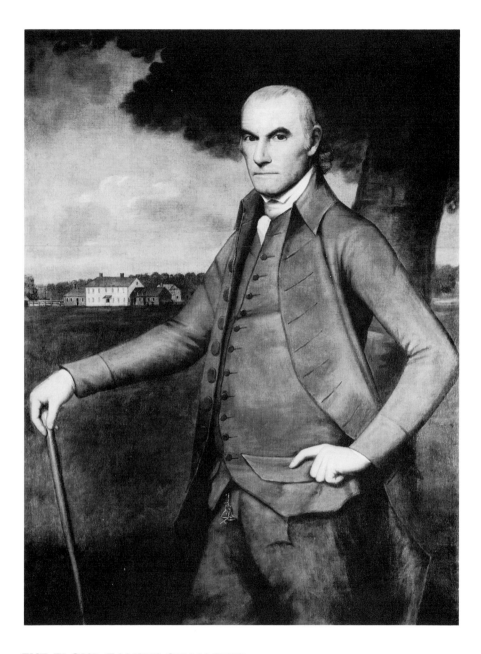

THE FLOYD FAMILY OF MASTIC

William Floyd (1734–1821) is famous for having been a signer of the Declaration of Independence. He spent seventeen years in public service as a delegate to the Continental Congress, a New York state senator, and a representative to the United States Congress. The Ralph Earl portrait of Floyd, painted in 1793 after Floyd had retired from public life, shows a man of plain manner whose gaze is straightforward, direct, and seemingly without affectation (No. 75). His expansive but rather plain house and a large tract of land, the source and symbol of his comfortable means, are pictured in the background. Floyd, like other substantial gentlemen farmers of the day, was interested in fashion, but his interest was tempered by his upbringing on rural Long Island and his limited exposure to urban influences.

The progenitor of the Floyd family on Long Island was Richard Floyd

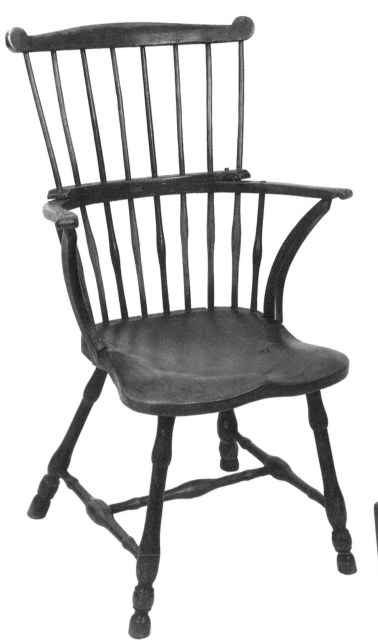

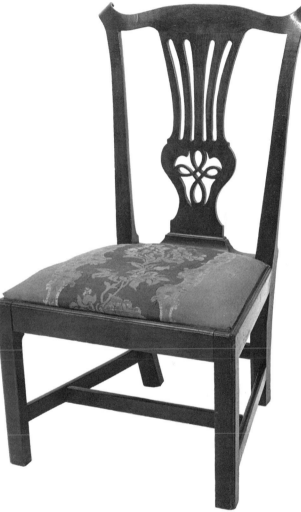

78. Windsor Armchair, 1770–1800
Probably Philadelphia
H. 38 W. 22 D. 17 1/2
Private collection

William Floyd spent a considerable amount of time in Philadelphia, beginning in 1774, as a representative from New York to the Continental Congress. He may have purchased this fan-back windsor armchair, one of a pair, during one of his frequent visits. The inwardly curved arm supports and the shaping of the turned legs suggest a Philadelphia provenance.

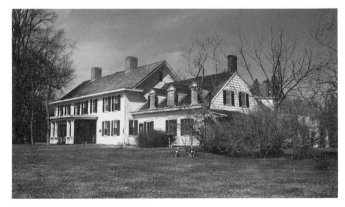

76. The Floyd House, ca. 1724 with later additions
Mastic
National Park Service

77. Side Chair, 1760–1800
New York City
Mahogany
H. 38 1/2 W. 21 D. 20 1/4
Private collection

One of an original set of at least six chairs, this example indicates that Floyd, although well-to-do, had a taste for conservatively styled furniture. He apparently preferred plain straight legs to cabriole legs. This type of splat was especially popular in New York. A New York corner chair in the Henry Francis du Pont Winterthur Museum illustrates an identical treatment of the splat.

Ref.: Joseph Downs, *American Furniture, Queen Anne and Chippendale Periods, in The Henry Francis du Pont Winterthur Museum*, New York, The Macmillan Company, 1952, No. 70.

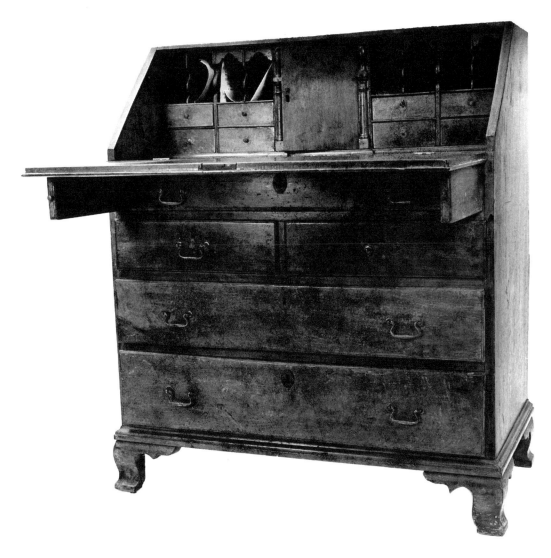

79. Desk, 1760–1790
Suffolk County or New England
Mahogany, chestnut, pine
H. 41 1/4 W. 36 D. 20 1/2
Private collection

This desk descended in the Floyd family and may
have belonged to William Floyd. It is difficult to
assign a provenance as the desk resembles
Rhode Island examples, but the details of con-
struction and design seem somewhat coarse. An
almost identical desk has descended in the Mul-
ford family of East Hampton, suggesting that the
Floyd desk was made on eastern Long Island.

(1620–1690), who came to New England from Wales in 1654. He settled in
Setauket shortly after its founding in 1655 and purchased large holdings of land on
Mastic Neck, directly across the Island on the south shore. Richard's grandson,
Nicoll Floyd (1705–1753), the father of William, was a prosperous farmer on
Mastic Neck. William Floyd was born and raised in Mastic and was only eighteen
years old at the time of his father's death when he assumed the responsibility of
running the large family farm.

A prominent member of his community, Floyd held public office in Brook-
haven from 1769 to 1771. He continued his public service as a representative to
the Continental Congress in which he served from 1774 to 1783. Unlike his fellow
New York delegates, Floyd, who came from a county which actively traded with
Boston, was sympathetic with the Massachusetts position, and he ultimately sup-
ported the question of independence.

After the British occupation of Long Island, Floyd's family fled from the farm
at Mastic to Connecticut. They suffered great personal loss, as did many other Long
Islanders who were forced to leave their homes. In 1780 Floyd submitted a
memorial to the Connecticut Assembly stating that Tories had seized his property in
Mastic and *"took on my estate a Considerable Quantity of Stock of Different kinds
of the Greatest part of my Household furniture, and all my farming utensils, with
some Beds, and Bedding, with other Cloathing."* Floyd returned to Long Island in

80. Case with Bottles
American (case)
Pine, glass
H. 13 1/2 W. 20 D. 13
Private collection

References to a *"case for liquor bottles"* or a *"case with bottles"* frequently appear in eighteenth century inventories of estates, although few have survived intact because of their fragility. According to Floyd family tradition, this case was William Floyd's travelling liquor box

1783 and began to rebuild his farm. His efforts must have been reasonably successful for he was assessed for $17,000 in real and personal property in 1799.

Floyd certainly had some interest in fashion. Numerous receipts document his purchase of expensive suits from Philadelphia and New York tailors. His daughter, Mary Floyd (1763–1805), was supplied with a great deal of finery at the time of her wedding to Col. Benjamin Tallmadge in 1784 and she also used the services of a French hairdresser for the occasion. Colonel Tallmadge noted on the wedding day that William Floyd *"gave a sumptous entertainment to the great number of invited guests."*

If fashion was a part of Floyd's life, however, it was apparently modified to some degree by his conservative taste in the decorative arts reflected in his choice of objects of a rather plain style. Although the furnishings he acquired from New York (No. 77) and Philadelphia (No. 78) were stylish, they were not elaborate examples of high style design. It is also significant that Floyd purchased silver from the Southampton silversmith, Elias Pelletreau, rather than ordering hollow ware from New England or New York craftsmen. In addition to a cann (No. 82) for his daughter, Mary, Floyd purchased a *"pr Silver cans"* in June, 1784, for which he paid Pelletreau £20 14s. 6d.

Ref.: William Q. Maxwell, *A Portrait of William Floyd, Long Islander,* Setauket, N. Y., Society for the Preservation of Long Island Antiquities, 1956, pp. 5–39.

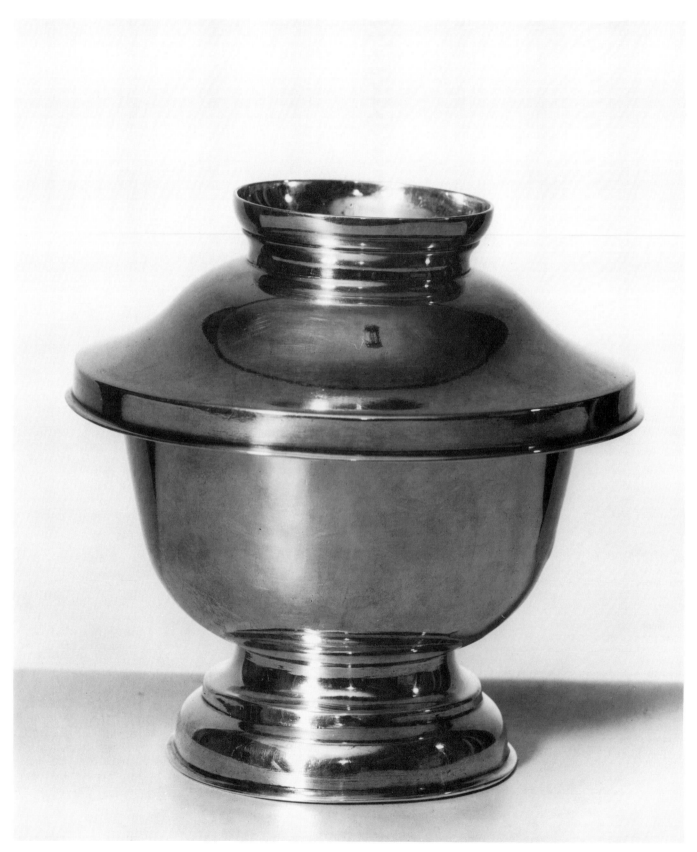

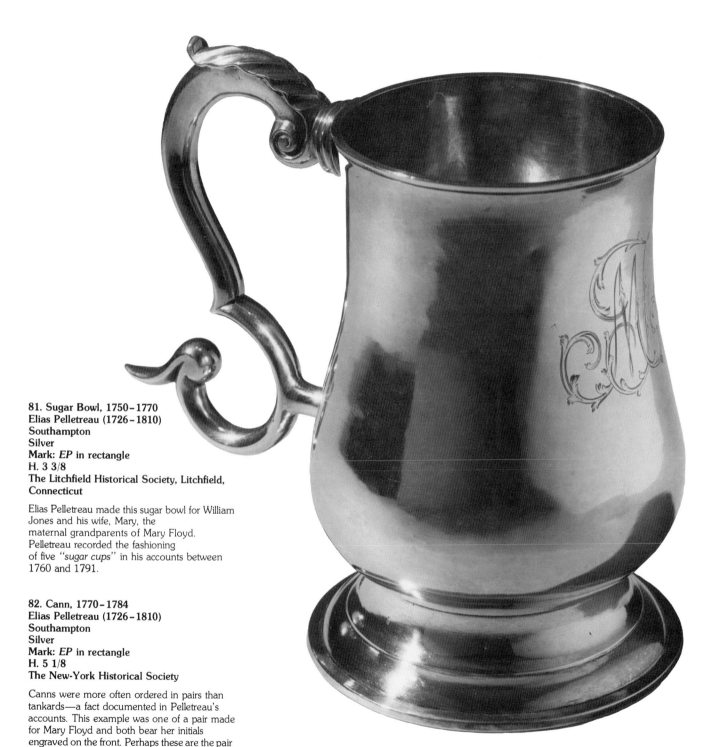

81. Sugar Bowl, 1750–1770
Elias Pelletreau (1726–1810)
Southampton
Silver
Mark: *EP* **in rectangle**
H. 3 3/8
The Litchfield Historical Society, Litchfield,
Connecticut

Elias Pelletreau made this sugar bowl for William
Jones and his wife, Mary, the
maternal grandparents of Mary Floyd.
Pelletreau recorded the fashioning
of five *"sugar cups"* in his accounts between
1760 and 1791.

82. Cann, 1770–1784
Elias Pelletreau (1726–1810)
Southampton
Silver
Mark: *EP* **in rectangle**
H. 5 1/8
The New-York Historical Society

Canns were more often ordered in pairs than
tankards—a fact documented in Pelletreau's
accounts. This example was one of a pair made
for Mary Floyd and both bear her initials
engraved on the front. Perhaps these are the pair
of canns Floyd purchased from Pelletreau in
1784.

Refs: William Q. Maxwell, *A Portrait of William Floyd,*
Long Islander, Setauket, N. Y., Society for the Preser-
vation of Long Island Antiquities, 1956, p. 10.
Elias Pelletreau, Long Island Silversmith, and His
Sources of Design, Brooklyn, N. Y., The Brooklyn
Museum, 1959, No. 63.

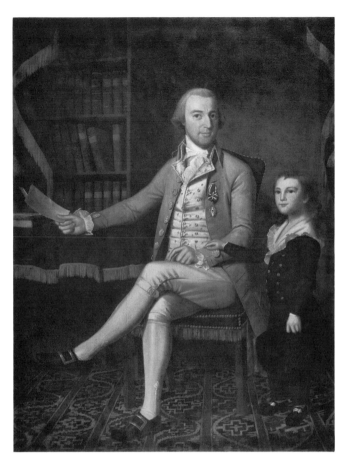

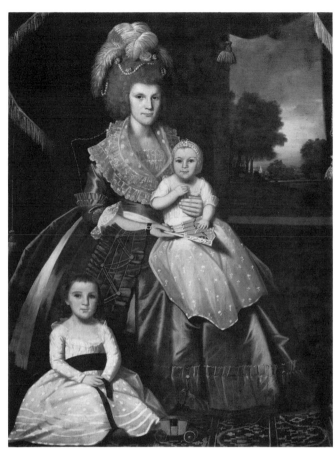

83. *Colonel Benjamin Tallmadge with his Son,* 1790
Ralph Earl (1751–1801)
Oil on canvas
Signed and dated
H. 78 1/4 W. 54 1/8
The Litchfield Historical Society, Litchfield, Connecticut

Born in Setauket, Long Island, Benjamin Tallmadge (1754–1835) graduated from Yale and settled in Connecticut. He distinguished himself as an American intelligence officer during the Revolutionary War, organizing an elaborate intelligence network on Long Island with the assistance of patriots in the Setauket area.

After the war, Tallmadge married Mary Floyd of Mastic, the daughter of William Floyd, and they settled in Litchfield, Connecticut, where Tallmadge became a successful merchant. He also served as a representative from Connecticut in the United States Congress.

Ralph Earl painted this portrait of Tallmadge and his son, William Smith Tallmadge (1785–1822), in Litchfield in 1790.

Refs.: George C. Groce and David H. Wallace, *The New-York Historical Society's Dictionary of Artists in America,* New Haven, Conn. and London, Yale University Press, 1957, pp. 202–203.
Benjamin F. Thompson, *The History of Long Island,* 2d. ed., vol. II, New York, Gould Banks & Co., pp. 482–487.

84. *Mrs. Benjamin Tallmadge with Son and Daughter,* 1790
Ralph Earl (1751–1801)
Oil on canvas
Signed and dated
H. 78 W. 54
The Litchfield Historical Society, Litchfield, Connecticut

Mrs. Tallmadge was the former Mary Floyd, the daughter of William Floyd of Mastic. She married Colonel Benjamin Tallmadge in 1784. Two of their five children appear in the portrait—Henry Floyd Tallmadge (1787–), who is seated on the floor, and Maria Jones Tallmadge (1790–1878), seated on her mother's lap. Earl painted Mrs. Tallmadge and the children in Litchfield at the same time he painted the companion portrait of Colonel Tallmadge and his son (No. 83).

Ref.: Laurence B. Goodrich, *Ralph Earl, Recorder for an Era,* The Research Foundation of the State University of New York, 1967, p. 68.

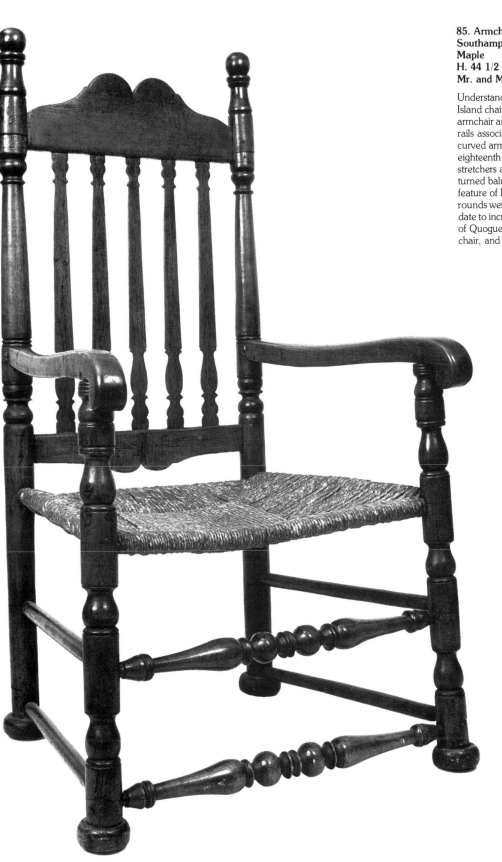

85. Armchair, 1710–1760
Southampton
Maple
H. 44 1/2 W. 26 3/4 D. 24 7/8
Mr. and Mrs. George Post

Understandably, Connecticut and eastern Long Island chairs are often of similar design. Both this armchair and No. 87 have double-arched crest rails associated with Connecticut. The bold curved arms and heavy turnings suggest an early eighteenth century date. The double front stretchers are unusually complex, and the split turned baluster back seen here is not a common feature of Long Island examples. Mushroom-like rounds were added to the cut-off legs at a later date to increase the height of the chair. The Posts of Quogue were the original owners of this armchair, and it has remained in the family.

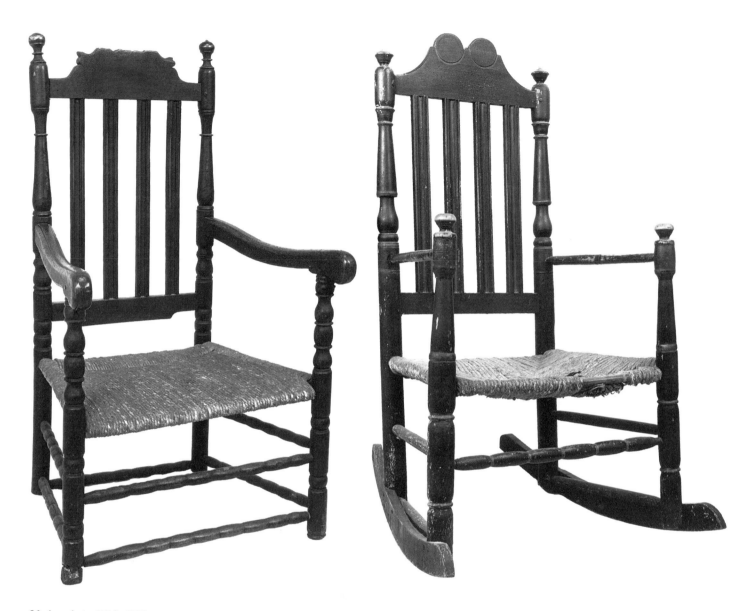

86. Armchair, 1710–1780
Suffolk County
Maple
H. 41 5/8 W. 24 7/8 D. 20 3/4
Suffolk County Historical Society, Riverhead

Chairs with molded or reeded vertical slat-backs constitute one of three chair types popular on Long Island during the eighteenth century. Current evidence indicates that the vast majority if not all of the vertical slat-back chairs were made in Long Island's predominantly English towns. This example comes from the Southold area. The similarity of these chairs to Connecticut examples demonstrates not only the regional exchange of people and ideas but also a common English heritage.

 The top of the crest rail of this chair is missing, and like chair No. 87, this example was at one time altered by the addition of rockers. All of the sausage turned stretchers are apparently original.

87. Armchair, 1720–1780
Stony Brook or Smithtown
Maple
H. 43 W. 26 1/2 D. 30
Society for the Preservation of Long Island Antiquities, 70.18.3

The addition of rockers to this armchair during the nineteenth century probably accounts for its continued use and preservation until the present. Family tradition identifies Alexander Hawkins (1713–1787) as the original owner. Hawkins was born in Stony Brook and settled in nearby Nassakeag at the time of his marriage to Tabitha Satterly about 1738.

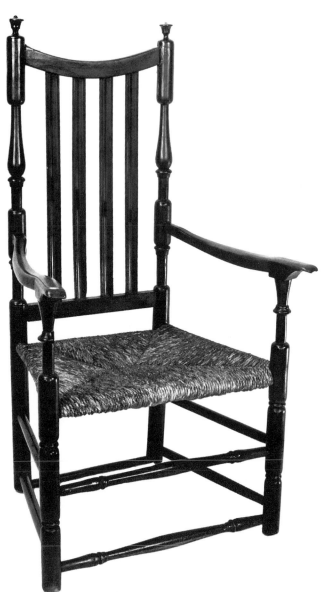

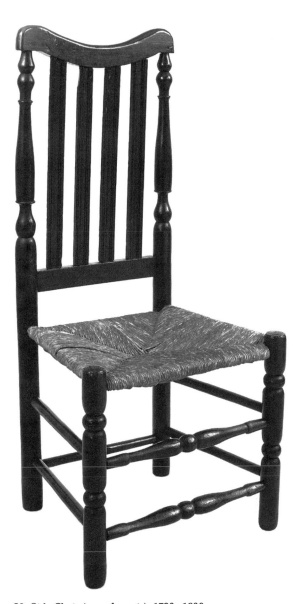

88. Armchair, 1720–1780
Probably Huntington
Maple
H. 44 1/4 W. 25 3/8 D. 21 1/2
Huntington Historical Society, 2121

The history of ownership is unclear but a Huntington family donated this chair to the Huntington Historical Society. The turning of the back posts and the front arm supports is similar to the treatment of another group of chairs with a Huntington provenance (No. 96) and both may have been made in the same shop.

89. Side Chair (one of a pair), 1730–1800
Queens [Nassau] County, probably
Hempstead
Maple
H. 39 W. 18 5/8 D. 15 1/4
Rock Hall, Lawrence

The majority of vertical slat-back chairs have simple dished top rails (No. 88). On this example, however, the rail resembles the yoke-shaped type found on Queen Anne style chairs. The front stretchers of these slat-back chairs are gently turned and only suggest the bold ball and ring motifs acceptable for the vase-shaped splat-back chairs (Nos. 94–98). Either the Martin or Hewlett family owned this chair at Rock Hall in Hempstead.

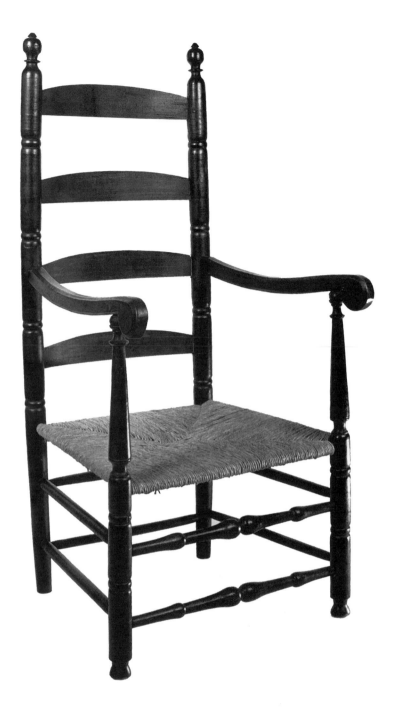

SLAT-BACK CHAIRS

92. Armchair, 1730–1800
Oyster Bay
Maple
H. 50 W. 23 D. 18 1/2
Nassau County Museum, 68.2.74

 Slat-back chairs were made in the seventeenth and eighteenth centuries and by 1800 were probably the most common type of chair found on Long Island. The manufacture of these chairs required little skill or time. Because the turned stiles, stretchers, and slats were made of different woods, the chairs were always painted—usually black, but occasionally red. On the better examples, such as No. 90, turned finials enhance the simple design. This side chair is related to several other examples including the armchair with shaped flat arms and front sausage turned stretchers (No. 91). Both of these chairs came from the Oyster Bay-Jericho area. Another armchair purchased from the Ludlam homestead in Oyster Bay (No. 92) has similar finials but more interesting turnings and is identical to an armchair in Raynham Hall. Two other examples, both with an Oyster Bay-Westbury prove-nance, illustrate a most unusual Long Island variation of the slat-back chair (No. 93). The author has seen only one comparable chair with similar turnings which apparently came from the Hudson River Valley and is now in the collections of the New-York Historical Society.

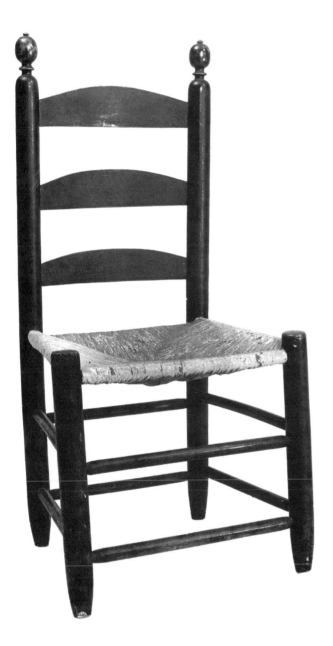

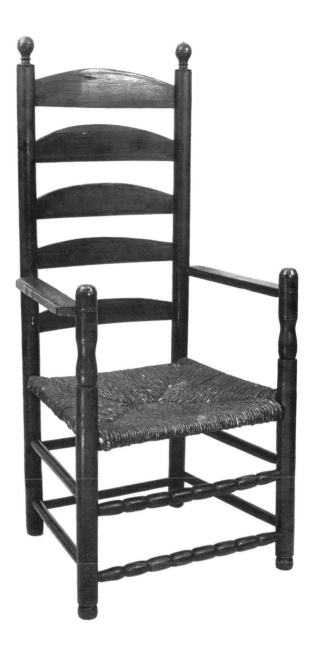

90. Side Chair, 1730–1820
Oyster Bay-Jericho
Maple
H. 38 1/4 W. 18 D. 15
Private collection

91. Armchair, 1730–1820
Oyster Bay-Jericho
Maple
H. 49 W. 24 1/2 D. 19
Society for the Preservation of Long Island
Antiquities, 59.68

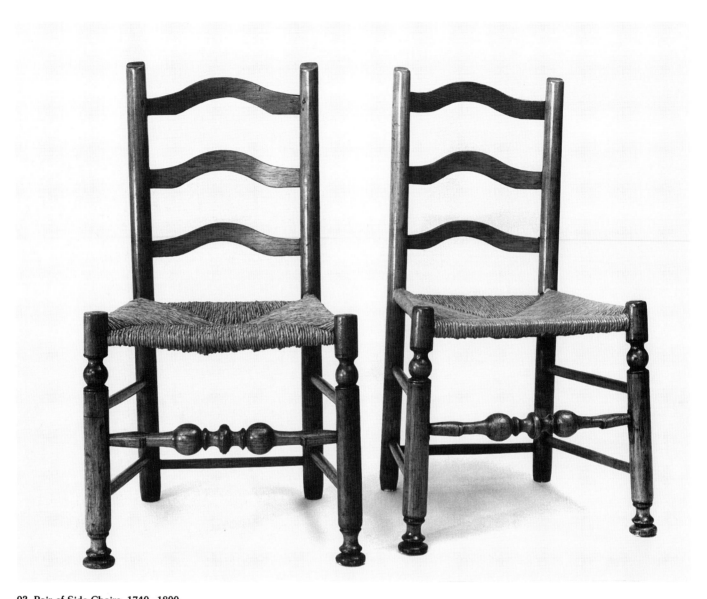

93. Pair of Side Chairs, 1740–1800
Oyster Bay-Jericho
Maple, hickory
H. 33 3/4 W. 20 1/4 D. 15 1/2
Private collection

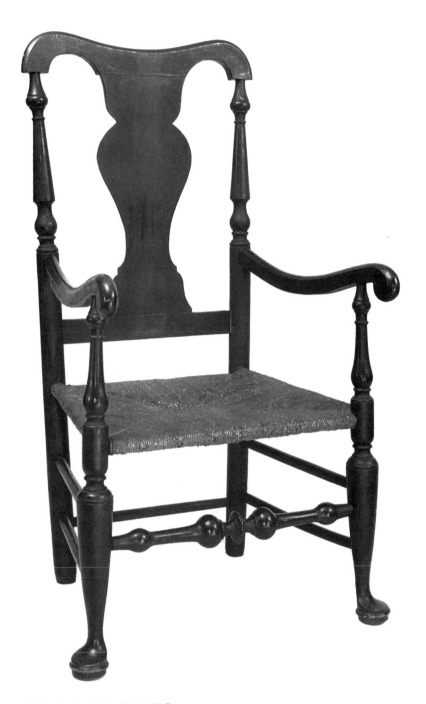

94. Armchair, 1730–1780
Oyster Bay
Maple
H. 47 3/4 W. 24 1/2 D. 22 1/4
Raynham Hall, Oyster Bay, T53.11

SPLAT-BACK CHAIRS

Chairs of this type have been referred to as Dutch splat-backs, fiddle-backs, and york chairs. Charles Hummel, when reviewing Dominy family furniture in *With Hammer in Hand,* was careful to associate the term fiddle-back only with Dominy chairs having a splat or bannister similar to that found on No. 226. Apparently the Dominys did not give a special name to chairs having simple vase-shaped splats, like the examples illustrated here. Hummel calls them *"splat-backs"* and mentions another widely used term, *"Hudson Valley side chair."* Benno Forman, in a 1974 *Antiques* article, suggests that chairs of this type were described, at least in Connecticut, as york chairs, meaning New York chairs. To confuse the issue further, an illustration of a similar chair with a vase-shaped splat appears in a 1797 advertisement in the *Albany Chronicle,* and the text of the ad suggests that the chair was called a fiddle-back.

The question of terminology is, indeed, perplexing. The author has not observed the use of the term fiddle-back on Long Island before 1784, when John Paine, a Southold joiner, recorded in his account book the making of several fiddle-

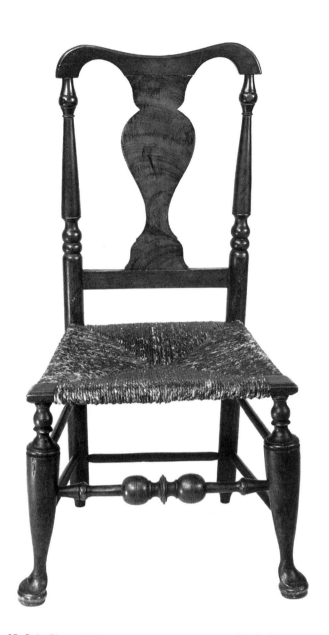

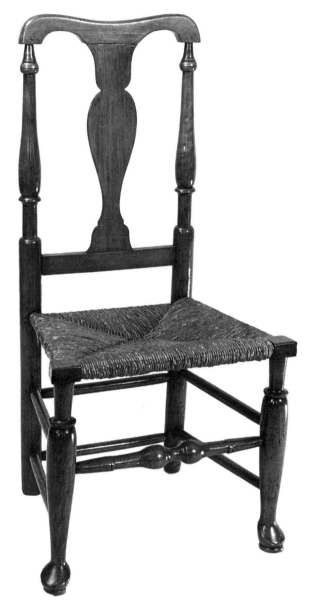

95. Side Chair, 1730–1800
Probably Flushing
Maple
H. 39 3/4 W. 19 1/4 D. 16 3/4
The Bowne House Historical Society, Flushing

96. Side Chair, 1740–1800
Huntington
Maple
H. 40 1/8 W. 20 3/4 D. 15 1/4
Huntington Historical Society, 1039

back chairs. Unfortunately, Long Island inventories provide few specific descriptions of furniture and list only *"great"* or *"common"* chairs. It seems likely, however, that the name "fiddle-back" was used to describe chairs of this design by at least the last two decades of the eighteenth century.

Unquestionably, this type of chair was extremely popular in New York and was made in the Hudson River Valley, in New York City, and on Long Island. Similar chairs are also associated with northern New Jersey and eastern and coastal Connecticut. The New York area was a center for the dissemination of this chair design and most of the well-conceived and probably early examples (Nos. 94–95) have been found on western Long Island. These chairs should not be considered Dutch, however, for in fact they have come from English families in predominantly Anglo communities. Recent studies document the continued production and popularity of this chair type throughout the eighteenth and early nineteenth centuries, and our research confirms these findings.

Chair No. 95 is an unusual painted and grained example, one of a set originally owned by the Bowne family of Flushing. Both this chair and No. 94,

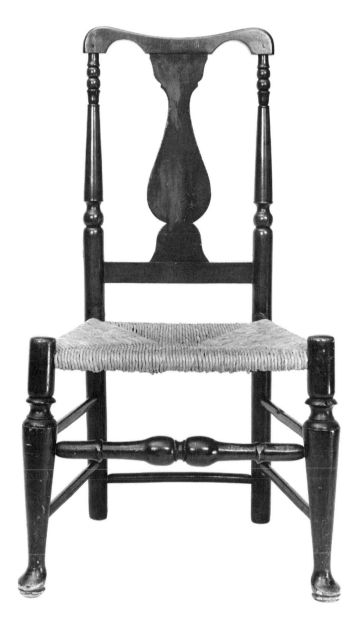

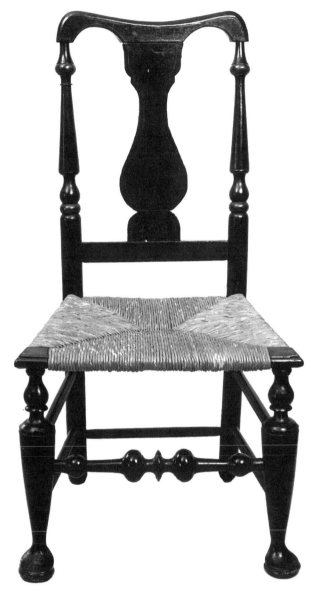

97. Side Chair, 1730–1800
Brookhaven
Maple
H. 39 W. 21 D. 16 1/2
Private collection

98. Side Chair, 1730–1800
Southold
Maple
H. 39 1/2 W. 21 1/4 D. 18 1/2
Mrs. Cornelius J. Rathborne

which descended in the Townsend family of Oyster Bay, were the work of skilled local craftsmen. The proportions, particularly of the backs, are generous, the turnings are well articulated, and the pad feet are clearly defined. Perhaps Charles Feake or William Stoddard, both shop-joiners active in Oyster Bay, made the Townsend chair. Samuel Townsend (1717–1790) married William Stoddard's daughter, Sarah, and he may have owned furniture that his father-in-law made.

One can see in the series of side chairs illustrated here (Nos. 95–98) several variations on the basic form, generally achieved by altering the turnings of the legs and stiles. According to tradition, chair No. 96 was used in Platt's tavern in Huntington. It is a distinctive version of the splat-back type, and an identical chair, not illustrated, in the collections of the Society for the Preservation of Long Island Antiquities also has a Huntington history of ownership in the Prime family. Chair No. 97 displays a less refined leg treatment—the posts of the front legs continue past the juncture with the seat frame. The inversion of the splat on this Brookhaven area chair is a simple technique Long Island craftsmen frequently used to vary the design. A similar example, No. 98, demonstrates quite clearly the problem of

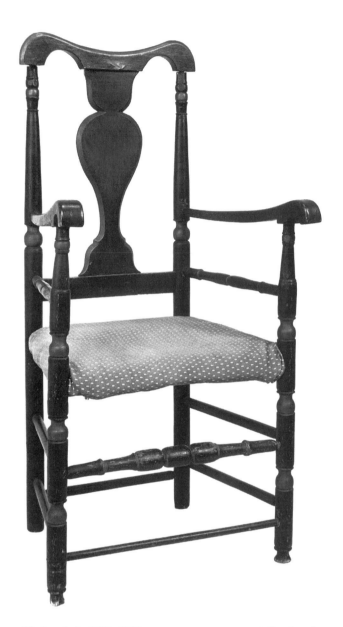
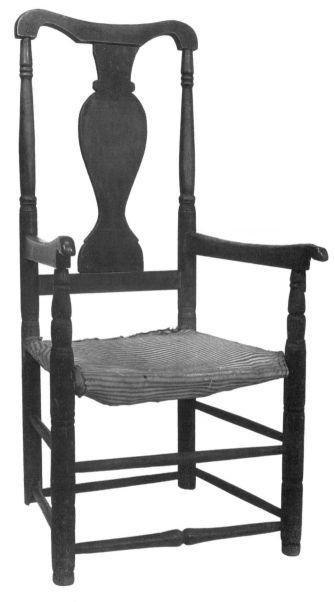

99. Armchair, 1740–1800
Probably Southold
Maple
H. 45 W. 22 1/4 D. 19
Suffolk County Historical Society, Riverhead

100. Armchair, 1750–1810
Southold
Maple
H. 40 3/4 W. 20 1/4 D. 18
Suffolk County Historical Society, Riverhead

attributing these chairs to specific makers or towns. This example also has an inverted splat, and only subtle differences of proportion and slight variations in the turnings distinguish it from No. 95. One might suspect that this chair came from western Long Island but it was, in fact, purchased many years ago in Southold, an eastern Long Island town. Two armchairs (Nos. 99–100) illustrate a characteristic eastern Long Island interpretation of this form. The vertical emphasis seen in No. 99, as well as the repetitive short vase-shaped turnings on the front stiles and the turned stretchers under the arms suggest Connecticut work. This chair was owned in Aquebogue, situated on Long Island's north fork. We have identified several north fork craftsmen including Micah Wells, Rufus Youngs, or John Paine who could have made this armchair or No. 100, originally owned by Samuel L'Hommedieu (1754–1845) of Southold.

Refs.: Benno M. Forman, ''The Crown and York Chairs of Coastal Connecticut and the Work of the Durands of Milford,'' *Antiques,* May, 1974, pp. 1147–1153.
Huyler Held, ''Long Island Dutch Splat Backs,'' *Antiques,* October, 1936, pp. 168–170.
Charles F. Hummel, *With Hammer in Hand: The Dominy Craftsmen of East Hampton, New York,* Charlottesville, Va., The University Press of Virginia, 1968, pp. 246–247, 255–258.

101. Side Chair (one of a pair), 1760–1800
Brookhaven or Smithtown
Mahogany
H. 36 3/4 W. 21 1/4 D. 17 1/2
Private collection

One of the most popular chair-back splat designs in rural America appears on this chair, one of a pair. Smith family history identifies Daniel Smith (1656–1721), son of Richard Smith I (ca. 1613–1692), as the original owner, but stylistically this is impossible. More likely, Daniel Smith (1720–1795), the great-grandson of Richard Smith, was the original owner. The chair has descended in the family.

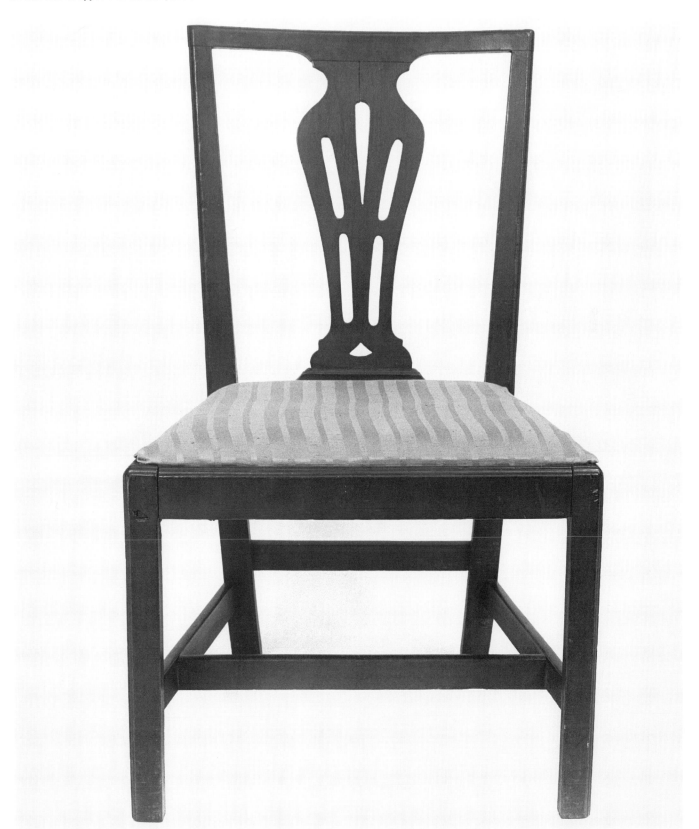

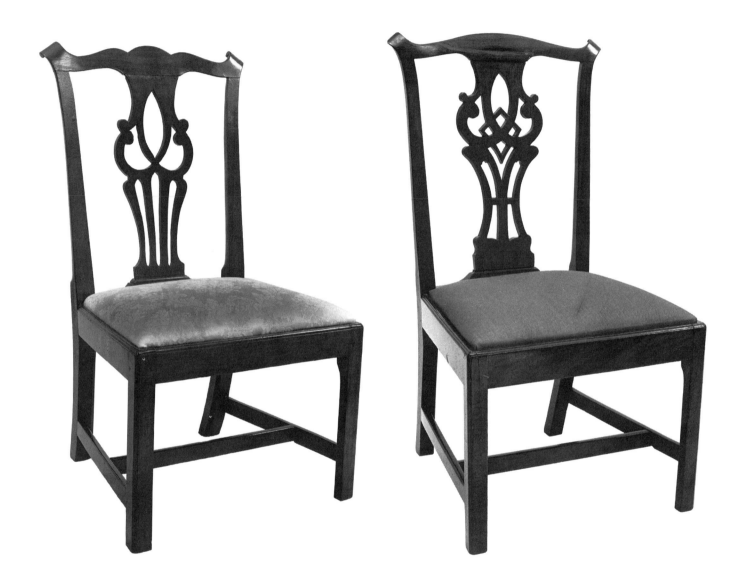

102. Side Chair (one of four), 1760–1790
Possibly Hempstead or New York City
Mahogany
H. 38 3/8 W. 23 1/2 D. 23
Rock Hall, Lawrence

This set of chairs descended in the Hewlett family, but may have originally belonged to the Martin family, the first owners of Rock Hall in Hempstead. Chairs of this basic design were extremely popular in New York and numerous variations have been found on Long Island (No. 103).

103. Side Chair, 1760–1790
Probably New York City
Mahogany
H. 38 3/8 W. 20 5/8 D. 20 3/4
Private collection

Similar in design to No. 102, this chair displays a slightly different splat and crest rail. It is one of three chairs known to have survived from a set of at least eight. The set, which was probably owned in the Mulford family, came into the Dering family of Sag Harbor with the marriage of Lodowick Fosdick Dering (1807–1860) to Eliza Mulford in 1840.

104. Side Chair (one of six), ca. 1785
New York City
Mahogany, tulip poplar
H. 37 1/2 W. 23 D. 18
Society for the Preservation of Long Island
Antiquities, 66.35 a–f

Plate XII in the 1762 edition of Thomas Chippendale's *Gentleman & Cabinet-Maker's Director* illustrates the design source of the splat in this chair, a popular pattern with New York cabinetmakers. This chair is one of a set of six owned by the Society. Judging from the Roman numerals stamped on each chair frame and seat, the original set probably consisted of twelve chairs. The provenance of the chairs can be traced to the Floyd family of Setauket, and possibly Gilbert Floyd (1740–1832) or his father, Benjamin Floyd.

105. Corner Chair, 1720–1800
Southold
Maple
H. 26 7/8 W. 26 D. 20
Suffolk County Historical Society, Riverhead

William Wells III (1683–1762) or William Wells
IV (1706–1778) of Southold was the original
owner of this corner chair. The multiple turnings
of the legs, in comparison to No. 106, suggest
that this example was made before 1750. The
curved armrests were made in two sections, with a
third section applied over the joint, adding
strength and giving focus to the design. A typical
nineteenth century alteration was the addition of
gold paint which highlights the turnings of the
chair.

106. Corner Chair, 1750–1820
Bridgehampton
Maple
H. 29 W. 28 D. 24
Private collection

Although not fashionable in urban areas by the
end of the eighteenth century, corner chairs
remained popular in rural communities into the
early 1800's. The simplified legs and baluster
turned arm supports of this chair typify the work
of most eastern Long Island furniture makers by
the time of the Revolution. In this case, the crafts-
man continued to use early eighteenth century
construction techniques. The chair is pleasing to
the modern eye, but shows a marked decline
when compared with the turnings of the preced-
ing example (No. 105). Traditionally, the Rev.
Ebenezer White (1673–1756) owned this chair,
which has descended in his family. Stylistically,
however, it is more likely that one of his sons,
possibly the Rev. Sylvanus White (1704–1782),
was the original owner.

107. Candle Stand, 1730–1800
Suffolk County
Cherry, oak
H. 40 W. (of base) 10 D. (of base) 10
Mr. and Mrs. Morgan MacWhinnie

The hundreds of variations of candlestand design in rural America testify to the imagination and ingenuity of local craftsmen. The scalloped arm of this stand moves up and down in grooves on the square post upon releasing the pressure of the two thin spring-like strips of wood attached to the arm.

108. Stand, 1730–1800
Suffolk County
Pine
H. 22 Diam. (of top) 12
Mr. and Mrs. Morgan MacWhinnie

Crossbase stands with octagonal tops are frequently associated with Connecticut. Since this stand was found on Long Island's north shore, Connecticut origin, or at least influence, is entirely plausible. The pedestals of other small tables are often turned, but the shape of the pedestal on this example repeats the shape of the octagonal top.

Ref.: John Kirk, *Connecticut Furniture, Seventeenth and Eighteenth Centuries,* Hartford, Conn., Wadsworth Atheneum, 1967, pp. 88–89.

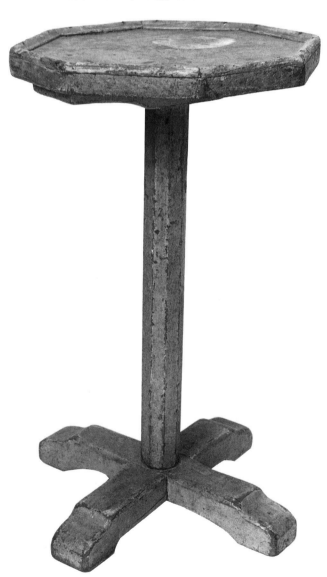

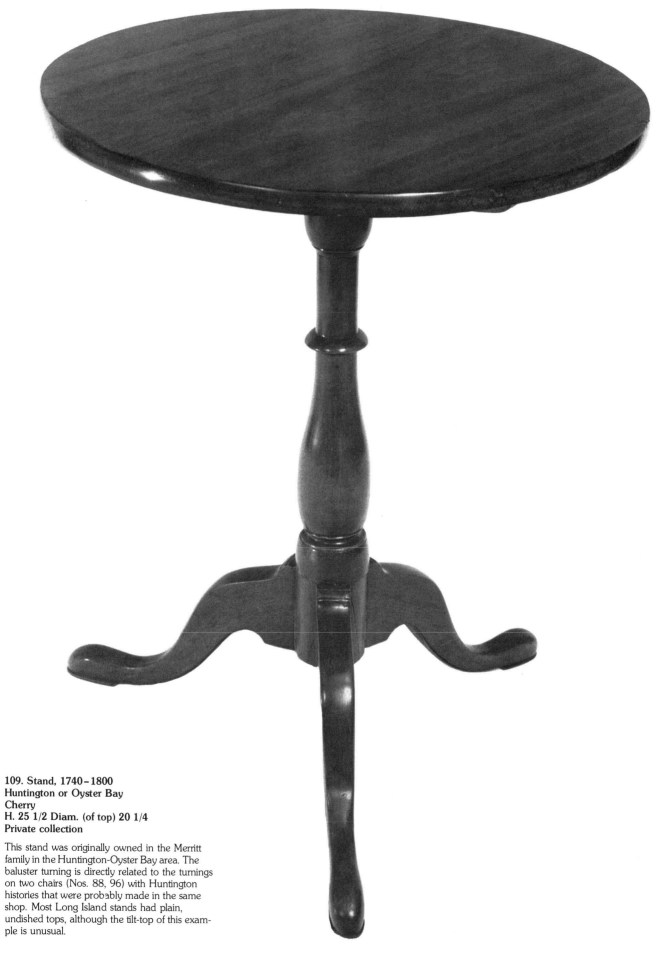

109. Stand, 1740–1800
Huntington or Oyster Bay
Cherry
H. 25 1/2 Diam. (of top) 20 1/4
Private collection

This stand was originally owned in the Merritt
family in the Huntington-Oyster Bay area. The
baluster turning is directly related to the turnings
on two chairs (Nos. 88, 96) with Huntington
histories that were probably made in the same
shop. Most Long Island stands had plain,
undished tops, although the tilt-top of this exam-
ple is unusual.

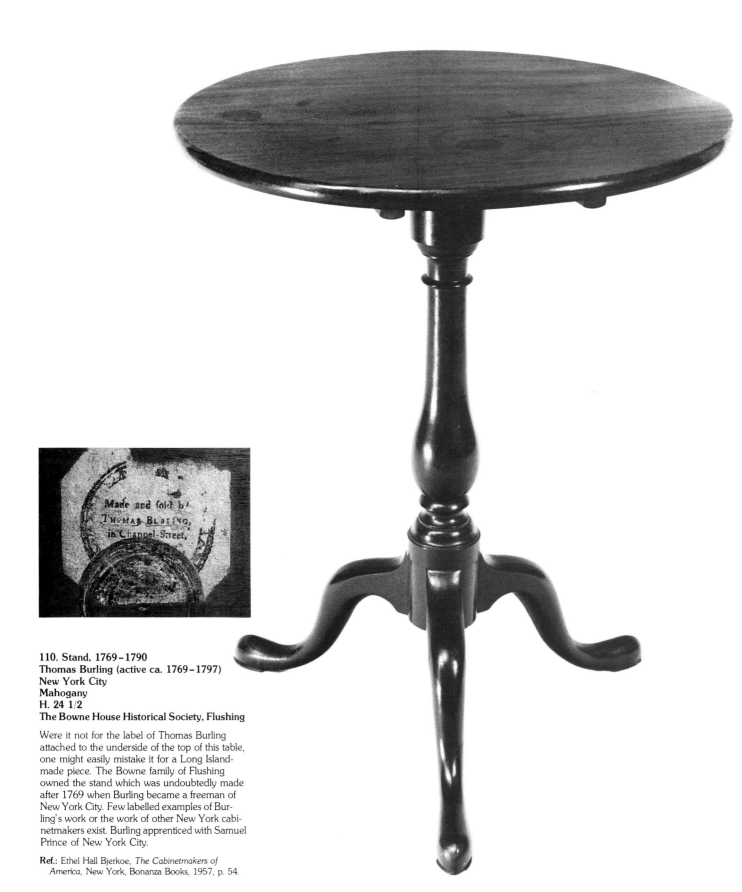

110. Stand, 1769–1790
Thomas Burling (active ca. 1769–1797)
New York City
Mahogany
H. 24 1/2
The Bowne House Historical Society, Flushing

Were it not for the label of Thomas Burling
attached to the underside of the top of this table,
one might easily mistake it for a Long Island-
made piece. The Bowne family of Flushing
owned the stand which was undoubtedly made
after 1769 when Burling became a freeman of
New York City. Few labelled examples of Bur-
ling's work or the work of other New York cabi-
netmakers exist. Burling apprenticed with Samuel
Prince of New York City.

Ref.: Ethel Hall Bjerkoe, *The Cabinetmakers of
America*, New York, Bonanza Books, 1957, p. 54.

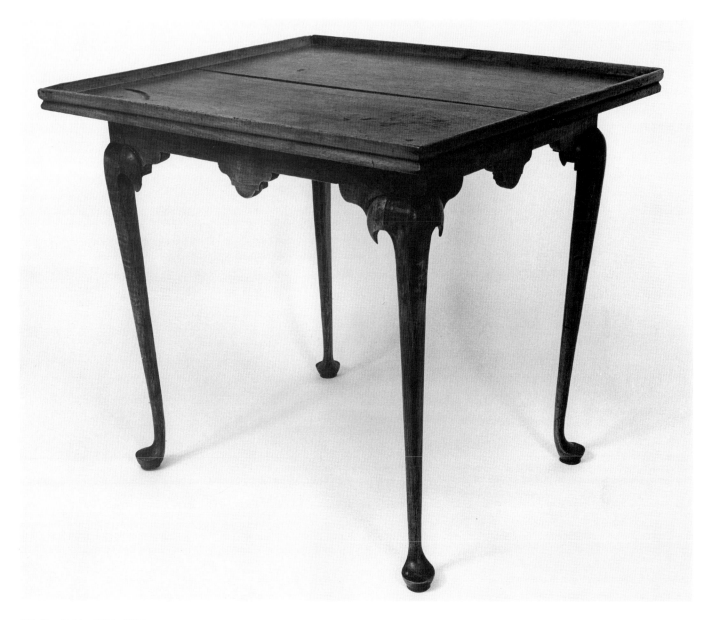

111. Tea Table, 1730–1780
East Hampton
Walnut, maple
H. 27 1/8 W. 31 1/8 D. 26 7/8
Private collection

Perhaps no social activity of the early eighteenth
century was more fashionable than gathering for
tea. In addition to silver and ceramic teapots and
other accoutrements, specially designed tea
tables also became popular. The molding around
the top of the table helped prevent the accidental
loss of cup and saucer. Although Connecticut
influence is discernible in the shape of the skirt
and the leg brackets and in the wide overhang of
the top, family history attributes this table to a
local maker. The initials of an early and possibly
original owner, Recompence Sherrill, are
scratched into the underside of the top.

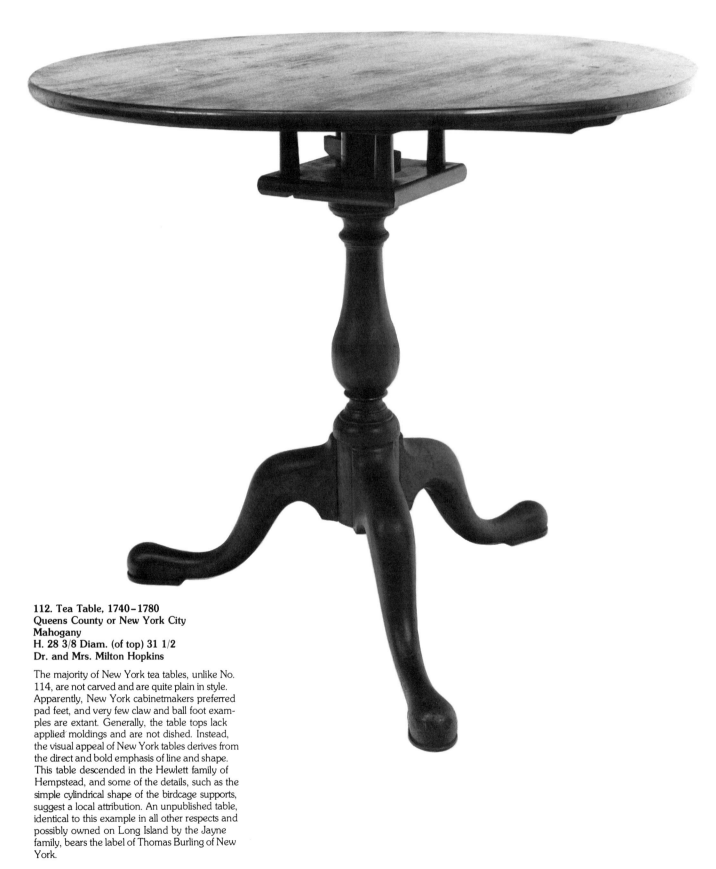

112. Tea Table, 1740–1780
Queens County or New York City
Mahogany
H. 28 3/8 Diam. (of top) 31 1/2
Dr. and Mrs. Milton Hopkins

The majority of New York tea tables, unlike No.
114, are not carved and are quite plain in style.
Apparently, New York cabinetmakers preferred
pad feet, and very few claw and ball foot exam-
ples are extant. Generally, the table tops lack
applied moldings and are not dished. Instead,
the visual appeal of New York tables derives from
the direct and bold emphasis of line and shape.
This table descended in the Hewlett family of
Hempstead, and some of the details, such as the
simple cylindrical shape of the birdcage supports,
suggest a local attribution. An unpublished table,
identical to this example in all other respects and
possibly owned on Long Island by the Jayne
family, bears the label of Thomas Burling of New
York.

94

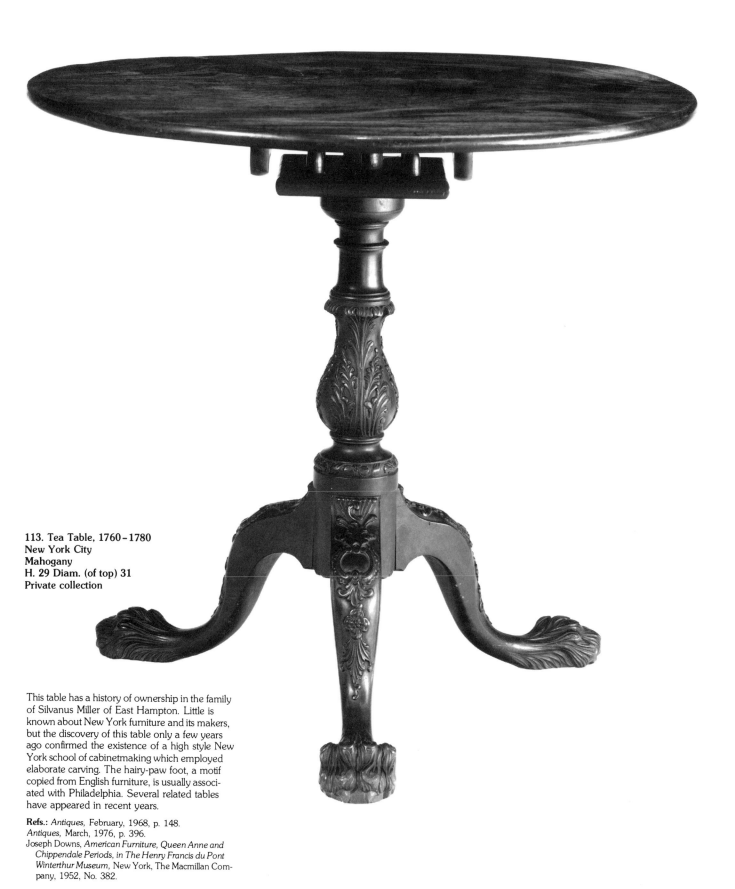

113. Tea Table, 1760–1780
New York City
Mahogany
H. 29 Diam. (of top) 31
Private collection

This table has a history of ownership in the family of Silvanus Miller of East Hampton. Little is known about New York furniture and its makers, but the discovery of this table only a few years ago confirmed the existence of a high style New York school of cabinetmaking which employed elaborate carving. The hairy-paw foot, a motif copied from English furniture, is usually associated with Philadelphia. Several related tables have appeared in recent years.

Refs.: *Antiques*, February, 1968, p. 148.
Antiques, March, 1976, p. 396.
Joseph Downs, *American Furniture, Queen Anne and Chippendale Periods*, in *The Henry Francis du Pont Winterthur Museum*, New York, The Macmillan Company, 1952, No. 382.

114. Table, 1740–1800
Suffolk County
Pine, maple, chestnut
H. 25 W. 42 D. 28
Mr. and Mrs. Morgan MacWhinnie

Tables with battens at both ends of the top are
often called bread-board top tables today. The
original paint has been removed from this exam-
ple, and the grain of the chestnut skirt is highly
visible. Chestnut was once abundant on Long
Island and was used for house frames as well as
furniture, particularly in Suffolk County. Typi-
cally, the top is pine and the legs are maple.

115. Table, 1730–1800
Possibly Huntington
Cherry, pine, oak
H. 28 1/2 W. (open) 41 D. 51
Mr. and Mrs. Morgan MacWhinnie

116. Table, 1730–1800
Southampton
Maple, pine, chestnut
H. 28 1/4 W. (closed) 17 7/8 D. 44 1/4
Private collection

Locally made drop-leaf tables, like the Queen
Anne style chairs (Nos. 94–100), illustrate the
predominance of joiner-made furniture on Long
Island. All of the known examples associated with
Long Island have straight turned legs rather than
cabriole legs cut out from a template pattern. The
craftsman had to shape only the feet and, usually,
the rounded table edge. Although several exam-
ples are related in terms of construction and
provenance, it is impossible without further study
to make a definite attribution to a particular
maker or locale. Table No. 115 has a Huntington
history, while No. 116 has a history of ownership
in the Post family of Southampton.

117. Table, 1770–1800
Jericho or Oyster Bay
Cherry, tulip poplar
H. 28 1/4 W. (closed) 17 1/2 (open) 51 1/2
D. 43
Private collection

Constructed of locally popular cherry, this table descended in a Quaker family from the Jericho-Westbury area and is identical to another example with a similar history.

118. Table, 1760–1800
Possibly Hempstead or New York City
Mahogany, chestnut
H. 27 1/2 W. (open) 48 1/2 D. (open) 48 1/2
Rock Hall, Lawrence, 111

Claw and ball foot furniture is extremely rare on
Long Island, suggesting a New York City attribu-
tion for this table. The use of chestnut in the
construction of the frame, however, is a charac-
teristic feature of much of Long Island cabinet-
work. The Hewlett family of Hempstead owned
the table. It was supposedly among the furnish-
ings of Rock Hall, the Georgian mansion which
the Hewletts purchased in the early nineteenth
century.

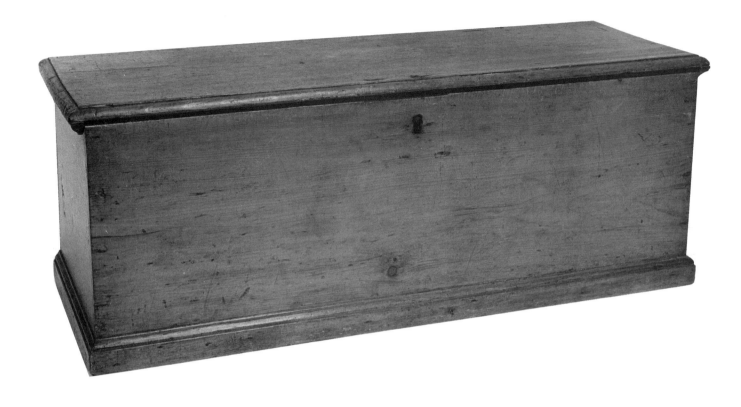

119. Chest, 1740
Thomas Rudgers
Smithtown
Pine
H. 18 1/2 W. 49 D. 18
Smithtown Historical Society, 59-134

Chests of this simple design were common eight-
eenth and early nineteenth century furniture
forms. They are frequently found on Long Island
where they are sometimes called "sea" or "Cap-
tain's" chests. Certainly, Long Island seamen
must have used chests of this type for storage
lockers. Evidence of this association appears on
this example in the form of two ships crudely
drawn on the inside of the till lid. Above the ships
is an inscription which reads: *Caleb Smith His
chest made by Thomas Rudgers at Smith Town
September the 20th Anno Domini noster 1740.*
This chest, like most others, was originally
painted.

Caleb Smith I (1724–1800), the original
owner of the chest, was the son of Daniel Smith
(–1763) and his wife, Hannah Brewster.
Caleb was a young man at the time the chest was
made. He graduated from Yale College in 1744
and perhaps he needed the chest when he
became a student there.

Ref.: Frederick Kinsman Smith, *The Family of Richard
Smith of Smithtown, Long Island,* Smithtown, N.Y.,
The Smithtown Historical Society, 1967, p. 166.

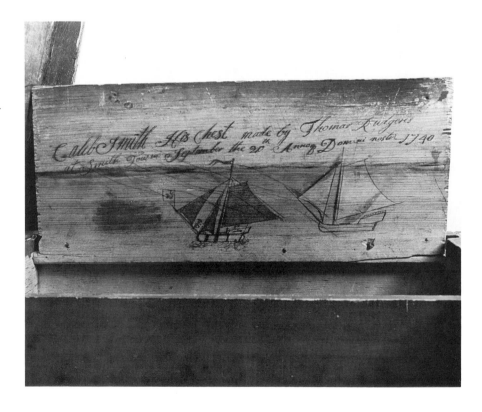

120. Chest with Drawer, 1720–1760
Suffolk County
Pine
H. 35 3/4 W. 38 3/8 D. 17 1/8
Southampton Colonial Society

A simple improvement over the common chest
(No. 119) was the chest with drawer. The perva-
siveness, continuity, and traditional appearance
of this furniture form reflects to a large degree
Long Island's rural character. These chests were
practical, inexpensive, and easily obtainable,
since any local carpenter-joiner could fashion
them. Most were brightly painted and had
applied moldings, making them decorative as
well as functional.

 Because chests of this type were made from
the end of the seventeenth century into the nine-
teenth century, dating them is hazardous at best.
The survival of original brasses can be helpful,
but craftsmen and owners occasionally reused
older brasses. The applied double-bead molding
on this chest may, however, indicate a date prior
to about 1750.

121. Chest with Drawer, ca. 1786
Suffolk County, probably Southampton or
East Hampton
Pine
H. 36 3/4 W. 36 3/8 D. 17 1/8
Private collection

Except for the drawer, chests of this type were
essentially six boards nailed together. The stan-
dard method of creating the bracket feet was to
cut out the extended side boards, usually in the
pattern of a cusped ogival arch. Although the
chest illustrated here was obtained and probably
made in the Bridgehampton area, virtually identi-
cal examples have been found in Queens
County. The date and the letters *AS 1786* are
painted on the back.

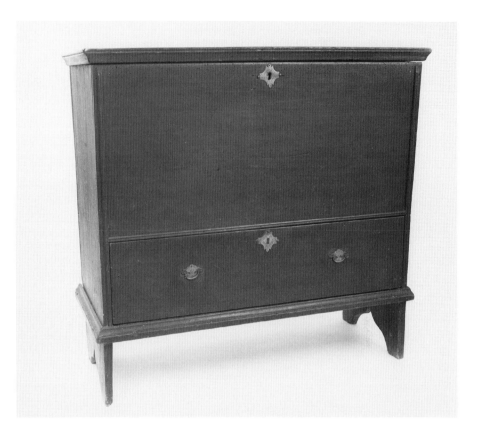

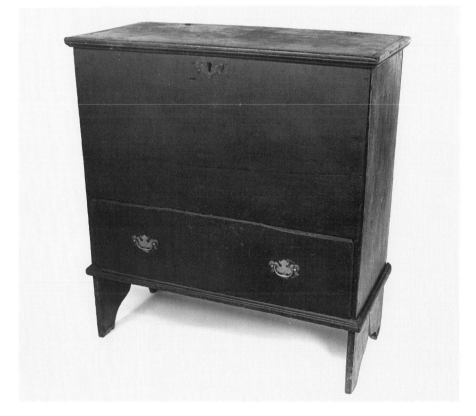

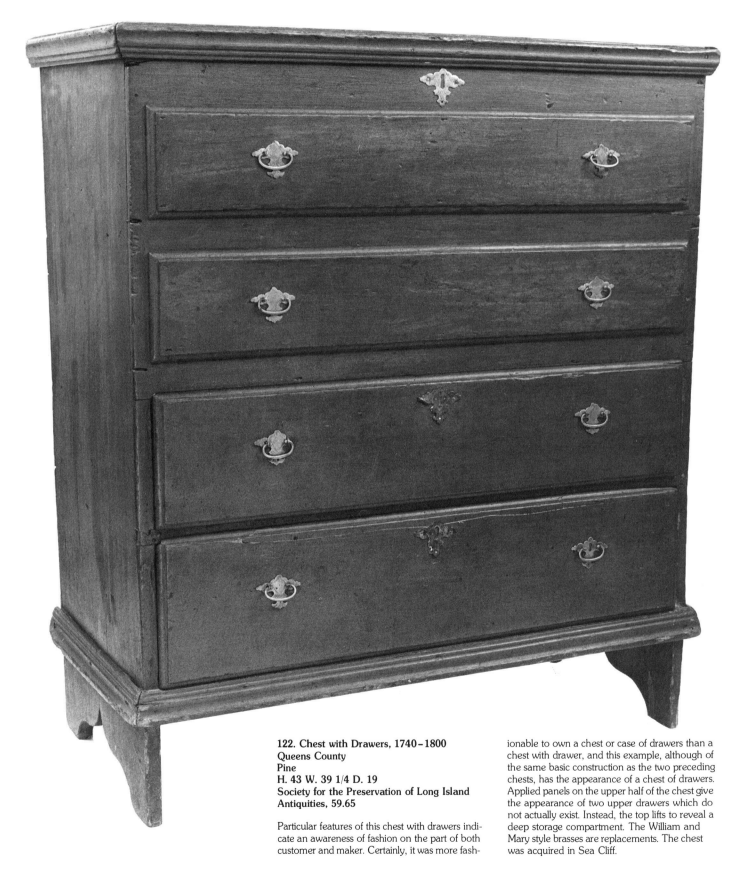

122. Chest with Drawers, 1740–1800
Queens County
Pine
H. 43 W. 39 1/4 D. 19
Society for the Preservation of Long Island
Antiquities, 59.65

Particular features of this chest with drawers indicate an awareness of fashion on the part of both customer and maker. Certainly, it was more fashionable to own a chest or case of drawers than a chest with drawer, and this example, although of the same basic construction as the two preceding chests, has the appearance of a chest of drawers. Applied panels on the upper half of the chest give the appearance of two upper drawers which do not actually exist. Instead, the top lifts to reveal a deep storage compartment. The William and Mary style brasses are replacements. The chest was acquired in Sea Cliff.

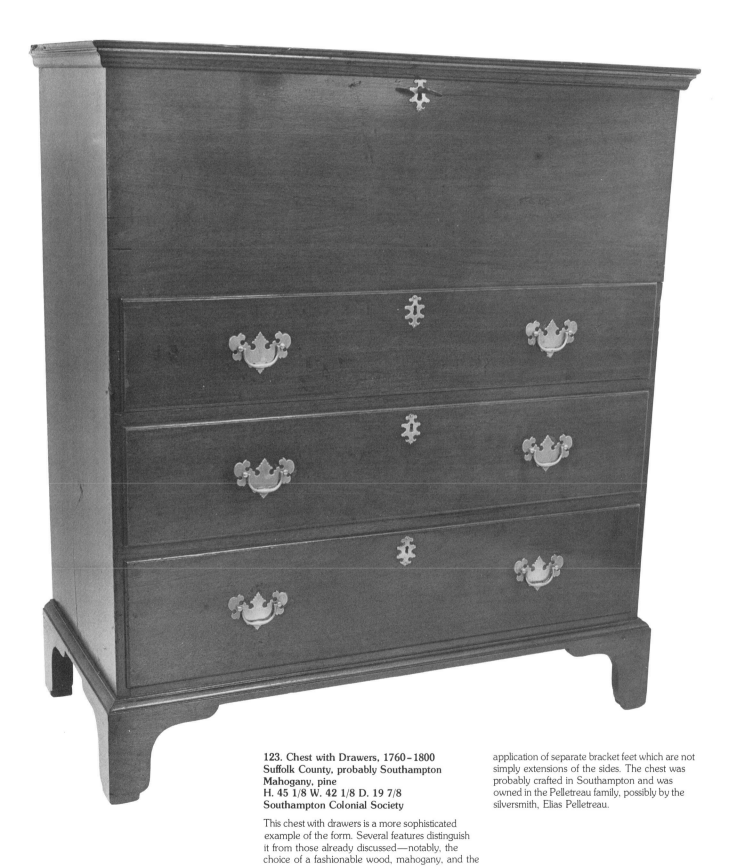

123. Chest with Drawers, 1760–1800
Suffolk County, probably Southampton
Mahogany, pine
H. 45 1/8 W. 42 1/8 D. 19 7/8
Southampton Colonial Society

This chest with drawers is a more sophisticated example of the form. Several features distinguish it from those already discussed—notably, the choice of a fashionable wood, mahogany, and the application of separate bracket feet which are not simply extensions of the sides. The chest was probably crafted in Southampton and was owned in the Pelletreau family, possibly by the silversmith, Elias Pelletreau.

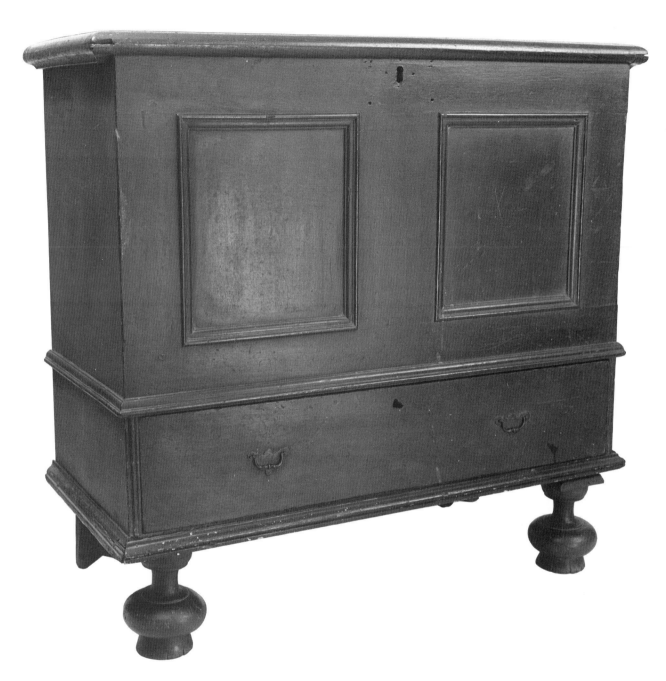

124. Chest with Drawer, 1710–1750
Oyster Bay or Hempstead
Pine
H. 37 1/2 W. 41 D. 19
Raynham Hall, Oyster Bay, T53.9

DOUBLE-PANELLED CHESTS

The double-panelled chest is a furniture form apparently unique to Long Island. More than thirty years ago, Huyler Held, Sr., wrote about the chest form and noted that the few examples he had examined came from eastern Queens County. Of the approximately thirty-five chests of this type now located, those with known histories have come from Oyster Bay, the Westbury-Jericho area, Glen Cove, and Hempstead. It seems likely, therefore, that this variation of the chest with drawer(s) has a provenance limited to eastern Queens County, the area which today comprises Nassau County. Additional detailed study of this furniture form is necessary, but certain new information can be added to the record.

The use of turned ball and stretcher feet, especially on the earliest examples

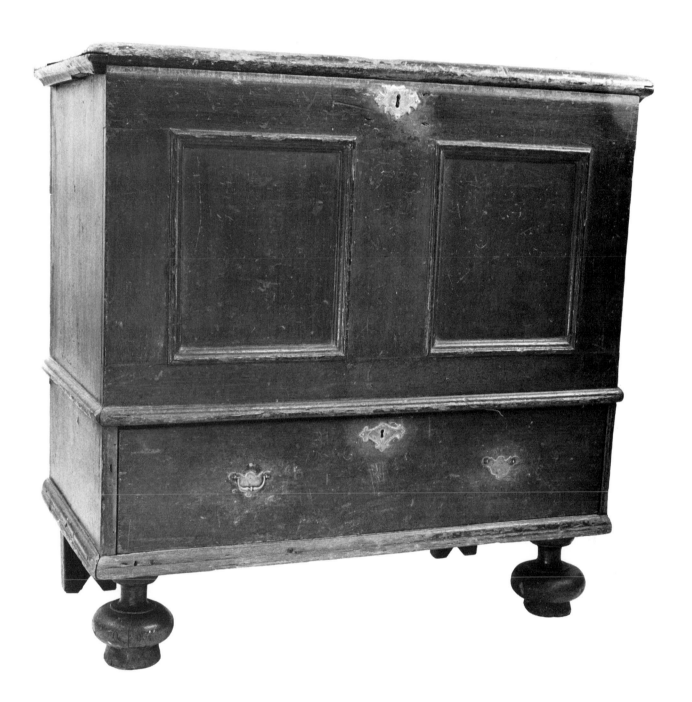

125. Chest with Drawer, 1710–1750
Oyster Bay or Hempstead
Pine
H. 38 1/2 W. 41 D. 19
Society for the Preservation of Long Island
Antiquities, 59.67

(Nos. 124–125), is reminiscent of Dutch *kasten,* but there is no evidence to suggest a Dutch origin for the design of these chests. On the contrary, the double-panelled chest is not found in the Hudson River Valley, Kings County, or western Queens County—all areas with strong Dutch traditions. Those families identified as original owners were of English, often Quaker, descent. This evidence suggests that the double-panelled chest was a regional, and undoubtedly rural, English furniture form.

A brief survey of the examples illustrated shows that, despite alterations in the style of hardware, the eventual introduction of bracket feet, and variations in the size of the panels and the number of drawers, the basic design remained unchanged from about 1710 to 1810. Minor differences in style and construction techniques exist, however, and indicate that at least five or more craftsmen

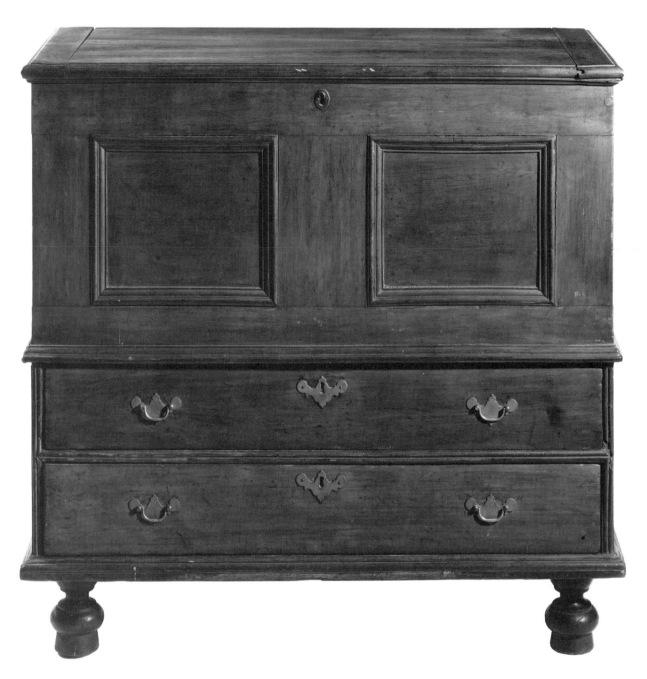

126. Chest with Drawers, 1730–1780
Oyster Bay or Hempstead
Pine
H. 40 1/2 W. 40 1/4 D. 18 3/4
The Brooklyn Museum, 66.181

produced the double-panelled chests. Six of the known examples were probably made by the same individual and also appear to be the earliest in date (Nos. 124–125), suggesting that one craftsman introduced this variation of the form which was then copied by other joiners as well as apprentices. The proportions of these early chests are identical, with visual emphasis given to the upper double-panelled section. An applied molding separates this top compartment from the single drawer below. The profiles of all the moldings in this group of chests are the same. Additionally, the two examples illustrated retain their original feet, each of which is marked with the Roman numerals, *XVIII* and *XXIV* respectively, suggesting that the craftsman who made them was keeping count of the number of chests he produced.

All of the early chests are examples of pegged frame and panel construction.

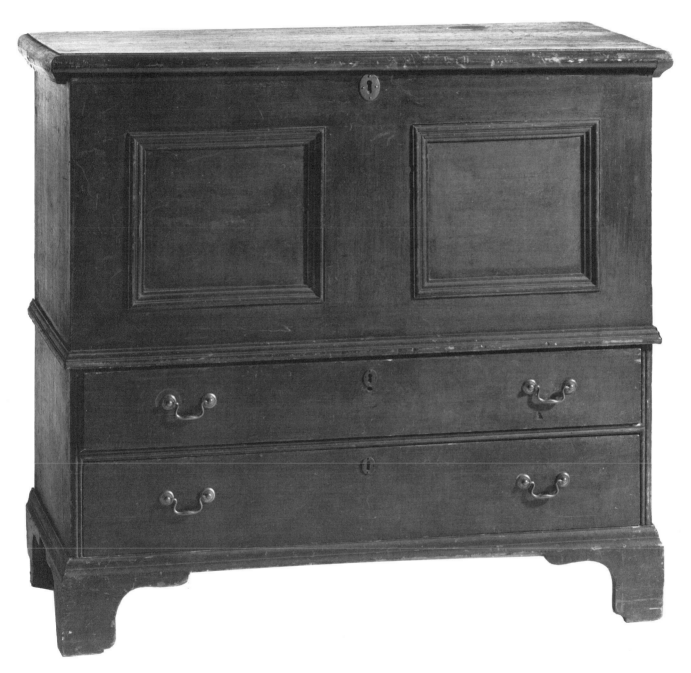

127. Chest with Drawers, 1750–1800
Oyster Bay or Hempstead
Pine
H. 37 3/8 W. 41 3/4 D. 19 3/4
The Henry Francis du Pont Winterthur
Museum, 70.440

The nails which fasten the single board sides to the front are recessed and covered with wooden plugs. Only the drawer sides have dovetailed joints. As with all later examples, the chests are painted—usually red (Nos. 124, 126) or a blue-green (Nos. 125, 127). Two examples made of cherry and one of tiger-stripe maple are known and they were apparently not painted.

More than a dozen double-panelled chests with two drawers have been discovered in recent years. A number of these have moldings identical to those on the single-drawer group discussed previously and they also share similar construction techniques (Nos. 126–127). The smaller panels represent a modification to accommodate two drawers in the lower section and give a horizontal appearance to the chest. These chests have original turned ball and stretcher feet or bracket feet and Queen Anne style or Chippendale style brasses, illustrating the simple way in

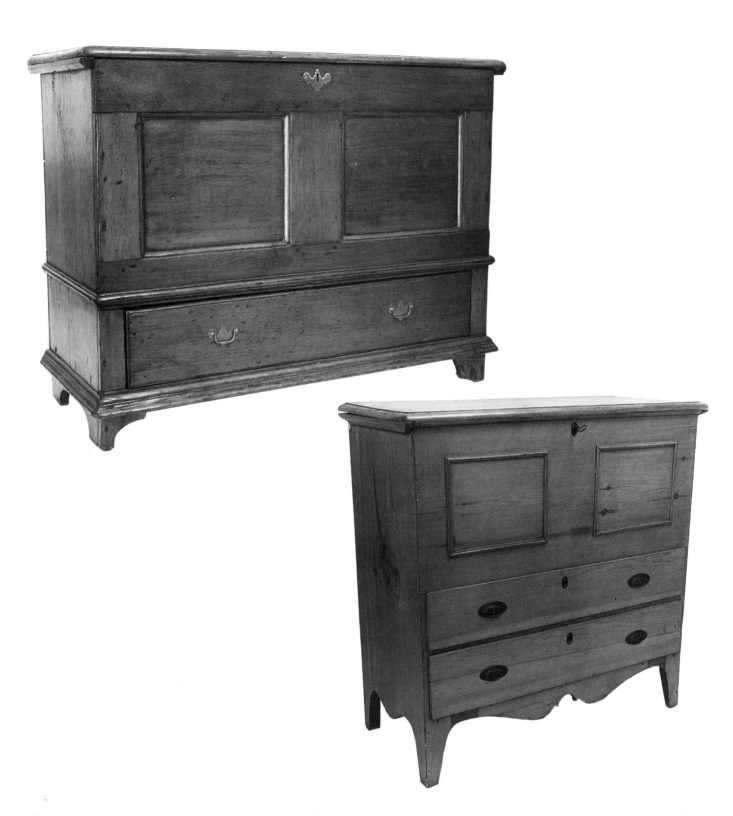

128. Chest with Drawer, 1750–1800
Hempstead
Pine
H. 33 1/2 W. 46 1/2 D. 19
Society for the Preservation of Long Island
Antiquities, 74.11

129. Chest with Drawers, 1790–1820
Queens County
Pine, tulip poplar
H. 42 1/2 W. 41 D. 19 1/2
Smithtown Historical Society, 58-88

which rural craftsmen often responded to new and more fashionable stylistic trends. While Nos. 126 and 127 are related to Nos. 124–125, many other chests clearly exemplify the work of different craftsmen (Nos. 128–129). Panels framed with quarter-round moldings flush with the surface of the chest characterize several examples found in northern Hempstead (No. 128). Chest No. 129 represents the ultimate misunderstanding of the double-panelled chest form but indicates the strength of the tradition. In this example, moldings simply applied to a single board front replace the panel and frame method of construction. The French-style feet and curved skirt also indicate a late eighteenth or early nineteenth century date.

Ref.: Huyler Held, "Chests from Western Long Island," *Antiques*, January, 1939, pp. 14–15.

KASTEN

The *kas* (*kast* in Dutch) was the most important and impressive piece of furniture in a seventeenth century Dutch home and, not surprisingly, it is the furniture form most closely associated with colonial New York. As the majority of Long Island inventories were recorded in English, the term cupboard, rather than *kast,* appears in these documents. Inventory evidence also suggests, through numerous references to *"cupboards & linen within,"* that *kasten* functioned as storage units for linens, clothing, and other textiles. The inventory of the estate of Jannette Couwenhoven, taken in New Utrecht in 1818, includes a reference to *"one cupboard,"* obviously a *kas,* which contained fifteen table cloths, forty-one sheets, twenty-eight pillow cases, forty-four towels, eleven rolls of linen, and an unspecified amount of wearing apparel. Additional documentation of the use of this furniture form appears in the well-known painting, *At the Linen Closet,* by the Dutch artist, Pieter de Hooch (1629 – after 1684), which depicts a woman selecting linens from a *kas.*

Dutch settlers introduced *kasten* to New York and the inventories of Kings County and Queens County estates provide evidence of the popularity of the form in those areas. Many inventories, even those dating near the end of the eighteenth century such as the 1801 inventory of the estate of John Rapelye of Newtown, list *"Dutch"* cupboards, thus documenting the specific association of this form with the Dutch.

Although they vary in size, all *kasten* are characterized by the monumentality and architectural nature of their design. Imported Dutch examples ornamented with columns and relief or applied carving were owned on Long Island in the seventeenth century (No. 36).

The locally made *kasten* illustrated here have applied moldings or fluting suggesting columns or pilasters but no carving. Additional ornamentation is achieved primarily by the use of paint. A grisaille painted example adorned with pendant groups of pomegranates was found in the Hewlett family house in Woodbury and is now in the collections of the Metropolitan Museum of Art. Typically, the *kasten* have shelved interiors, occasionally with a drawer, and two large panelled doors on the front with a single drawer below. Moldings frequently divide the exterior drawer surface and give the appearance of two separate drawers below the doors. A bold architectonic cornice invariably caps the cupboard and most examples rest on large-scale detachable turned disc and stretcher feet (No. 130). In many cases the cornice is a detachable unit, thus facilitating movement of the massive object.

A few early *kasten* were made of oak, but most Long Island examples were constructed primarily of cherry, pine, and tulip poplar. Occasionally inventories mention bilsted or red gum as a primary wood.

The appearance of the *kas* remained virtually unchanged over the approximately 100 years this form was made in New York and on Long Island. Part of a joined furniture tradition, the *kas* was constructed of large panels set into frames secured with pegged mortise and tenon joints. Long Island craftsmen employed these techniques throughout the eighteenth century with one important exception. They occasionally used dovetail construction in the lower section while continuing to use pegged construction for the upper section (No. 133).

As Dutch and English families intermarried and Long Island communities became more homogeneous, it was inevitable that English settlers would make use of the *kas.* Acceptance by English families of the Dutch version of the cupboard was restricted primarily to Kings and Queens Counties. Unfortunately, not a single eighteenth century account book kept by a western Long Island furniture maker has been located, and specific information about the makers and purchasers of *kasten* is unavailable. Two related groups of *kasten* can be attributed to the Westbury-Jericho-Oyster Bay area since they were owned in local Quaker families of English descent. The plain appearance of these *kasten,* ornamented only with

several horizontal applied moldings or simple geometric panels and molded surrounds, seems appropriate to Quaker aesthetics (No. 130).

Interestingly, the characteristic Long Island double-panelled chest is also associated with eastern Queens County (Nos. 124–129). The chest form is, of course, similar to the *kas* form in the use of pegged construction, applied moldings for ornamentation, and detachable turned ball and stretcher feet. It seems likely that the same local craftsmen made both *kasten* and double-panelled chests. Unlike the *kas,* however, the chest was apparently owned only in English families on Long Island and was probably an English form. The author believes that the prototype for the double-panelled chest will be found in England, not in Holland.

The *kasten* associated with western Queens and Kings Counties, areas with sizeable Dutch populations, are generally larger and have more complicated cornices, applied panels, and moldings (No. 134). Following Dutch precedent, the applied panels were often made of a contrasting wood which gave a richer appearance to the surface of the *kas,* and the feet and moldings were sometimes painted black in imitation of ebony (No. 133).

Without question, the subject of Long Island *kasten* requires further detailed research. Hundreds of Long Island families moved to Westchester, Orange, Dutchess, and Ulster Counties throughout the eighteenth century, and many *kasten* found in and attributed to the Hudson River Valley area may be of Long Island origin. Careful study, concentrating on construction techniques and provenance, is necessary and should prove rewarding.

Ref.: T. H. Lunsingh Scheurleer, "The Dutch and their Homes in the Seventeenth Century," in *Arts of the Anglo-American Community in the Seventeenth Century,* Charlottesville, Va. The University Press of Virginia, 1975, pp. 13‑42.

130. *Kas,* **1730–1780**
Oyster Bay-Jericho
Cherry, pine
H. 77 W. 67 D. 23
Society for the Preservation of Long Island Antiquities, 75.7

This *kas,* found in Westbury, is typical of a large group of *kasten* with histories of ownership in English Quaker families of the Oyster Bay-Jericho area.

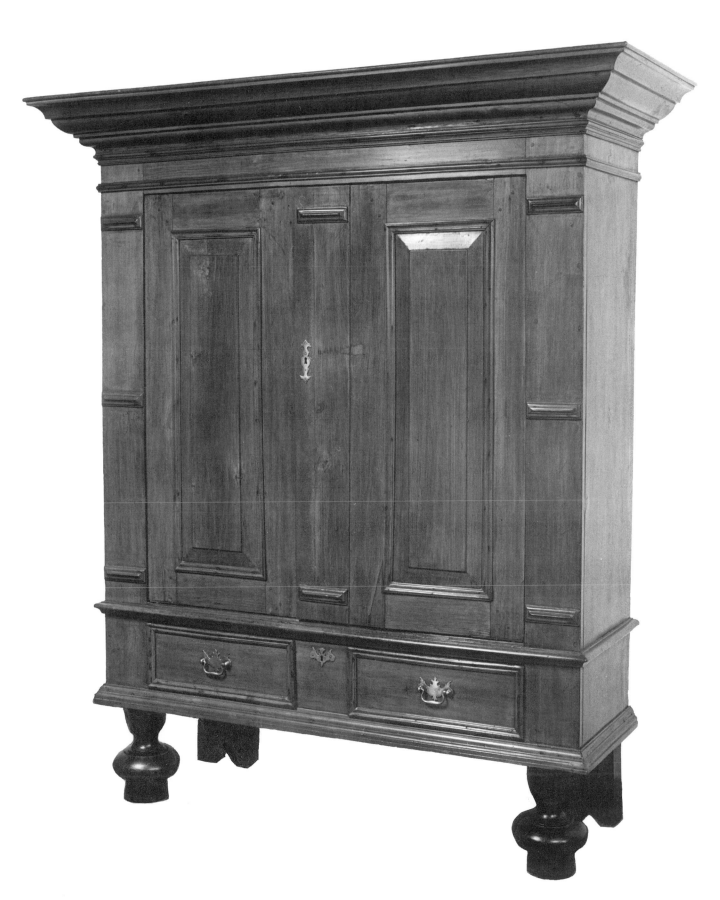

131. *Kas*, 1730–1780
Oyster Bay or Hempstead
Cherry, pine
H. 73 W. 68 1/4 D. 22 1/4
Private collection

The Onderdonck family of Manhasset owned this
kas. An identical example, with feet and cornice
missing, is in Raynham Hall in Oyster Bay and
has a local provenance.

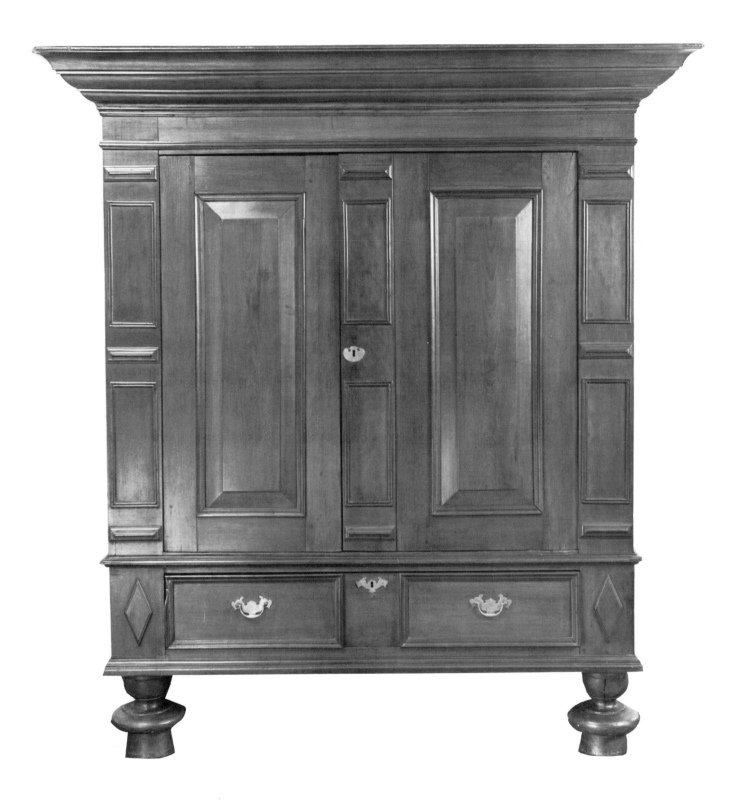

132. *Kas*, 1730–1780
Oceanside
Cherry, pine
H. 73 1/4 W. 62 3/4 D. 21
Nassau County Museum, 65.8.4

Originally, an Oceanside family owned this *kas*.
The horizontal lines across the reeded pilasters
mark the place where it was once cut for easy
moving and storage.

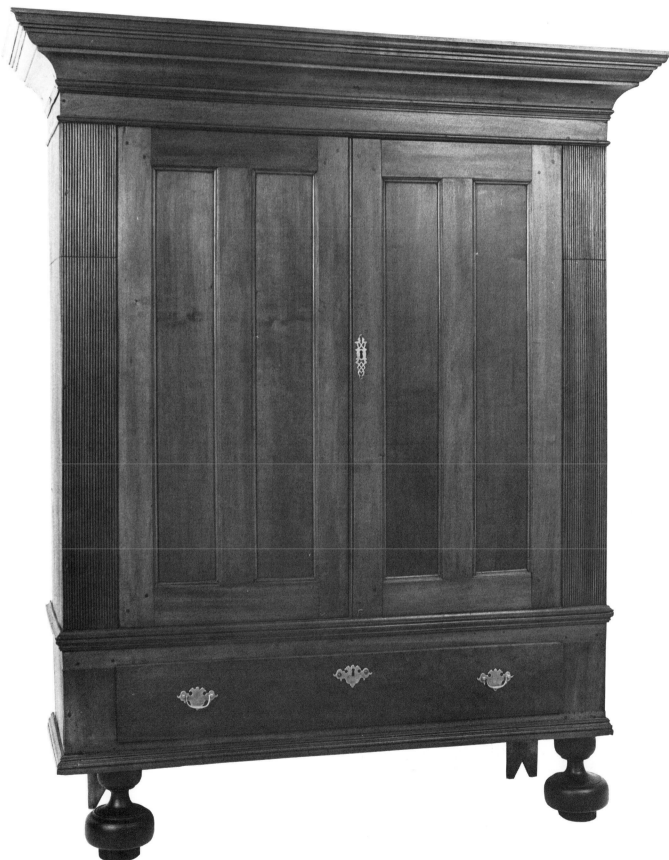

133. *Kas,* ca. 1742
Queens County
Cherry, pine
H. 72 1/2 W. 68 3/4 D. 24 1/8
Nassau County Museum, 68.20.152

Inscribed with the date *1742,* this kas was found
in an old house directly across the street from the
Schenck House (No. 6) in Manhasset. Several of
the moldings have been restored but were ebon-
ized to match the original moldings still intact.

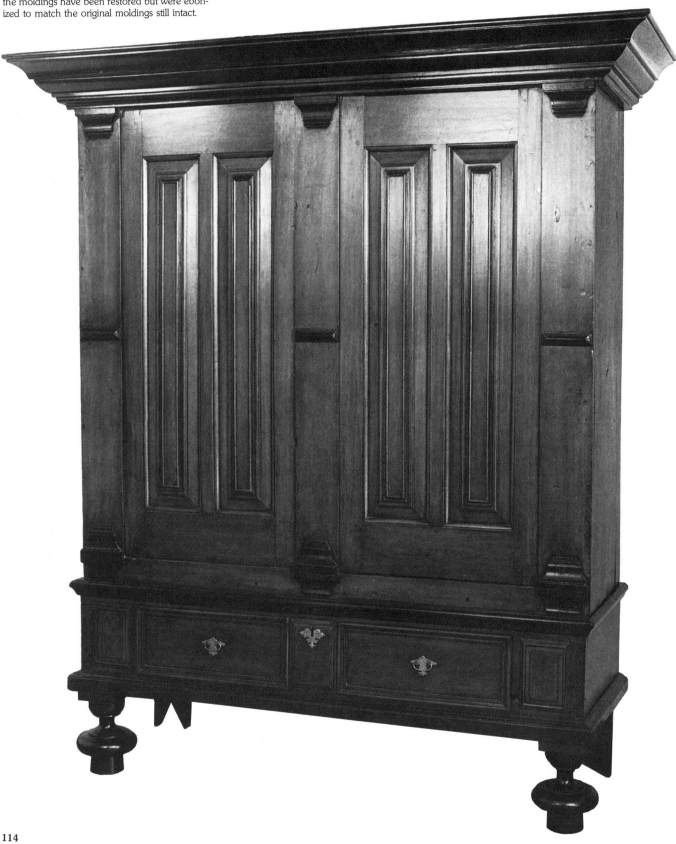

114

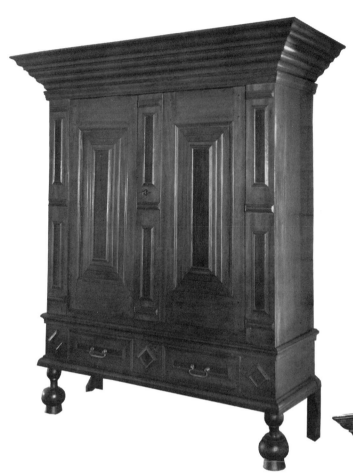

134. *Kas,* 1720-1780
Kings County
Present location unknown, Stanley Mixon photograph for the Historic American Buildings Survey, Library of Congress

When this photograph was taken for the Historic American Buildings Survey in 1940, this *kas* stood in the Wyckoff-Bennett House in Brooklyn. The use of contrasting woods, probably black walnut, is evident in the applied panels.

135. *Kas,* 1740-1800
[Suffolk County ?]
Pine
H. 71 5/8 W. 57 3/8 D. 23 7/8
The Museums at Stony Brook

According to museum records, this cupboard, which obviously derives from the *kas* form, came from an old house in Setauket. It is similar to a *kas* at the Henry Francis du Pont Winterthur Museum which came from the Hudson River Valley. Traces of old painted decoration are still visible.

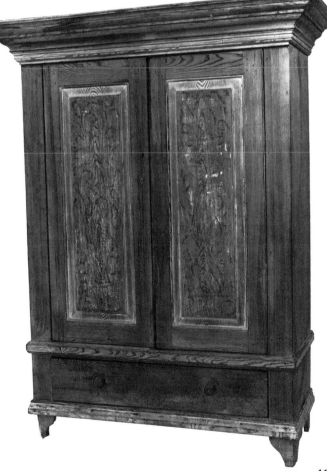

115

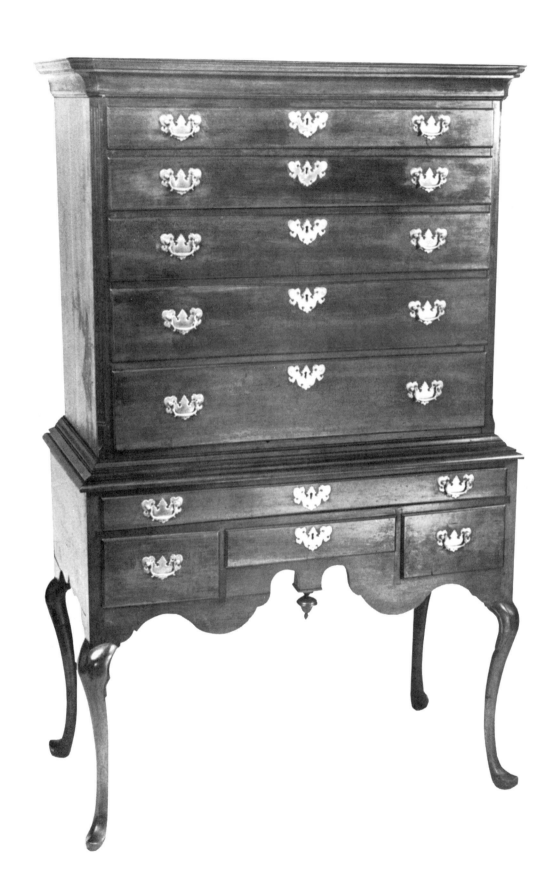

136. High Chest of Drawers, 1730–1750
Oyster Bay
Cherry, tulip poplar
H. 73 W. 45 D. 22
Raynham Hall, Oyster Bay, F.61.6

Unquestionably, a direct relationship exists between Rhode Island and New York furniture design. Rhode Island influence is apparent in this high chest, originally owned by the Townseend family of Oyster Bay. The dramatic *cyma-reversa* curve of the outline of the skirt, the removable legs, the pointed slipper feet, and the lambrequin-scrolled knee brackets are typical Rhode Island features. Yet, the proportions of the piece and the fluted and chamfered corners suggest a New York influence. Furthermore, Rhode Island craftsmen did not often use cherry in furniture of this sophistication.

Additional evidence, although still fragmentary, further supports a local provenance. Examples of similar design with local histories of ownership have been found in the area (No. 137). Furthermore, several Oyster Bay craftsmen had contacts with Rhode Island (see No. 55 and Appendix I).

Ref.: V. Isabelle Miller, *Furniture by New York Cabinetmakers, 1650 to 1860,* New York, Museum of the City of New York, 1956, pp. 26–27.

137. High Chest of Drawers, 1730–1750
Oyster Bay
Apple, tulip poplar
H. 70 W. 40
Miss Florene Maine

This high chest, which descended in the Cocks [Cox] family of Oyster Bay, illustrates many of the same stylistic features as No. 136 but is probably not from the same shop. Unlike most Rhode Island examples, the top drawer is continuous rather than subdivided into several smaller units. The cornice molding, which includes a unique pulvinated frieze, is particularly bold and well articulated. Inventory and account book evidence documents the use of fruitwood, particularly cherry and occasionally apple, in Long Island furniture. As late as 1797, William Satterly, a Setauket cabinetmaker, owned a stock of apple boards, as noted in the inventory of his estate (see Appendix I).

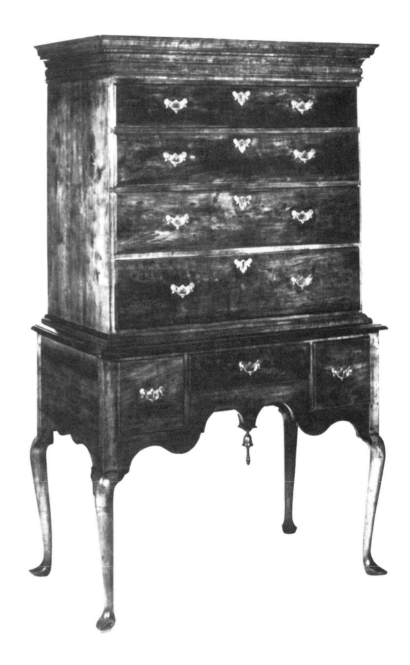

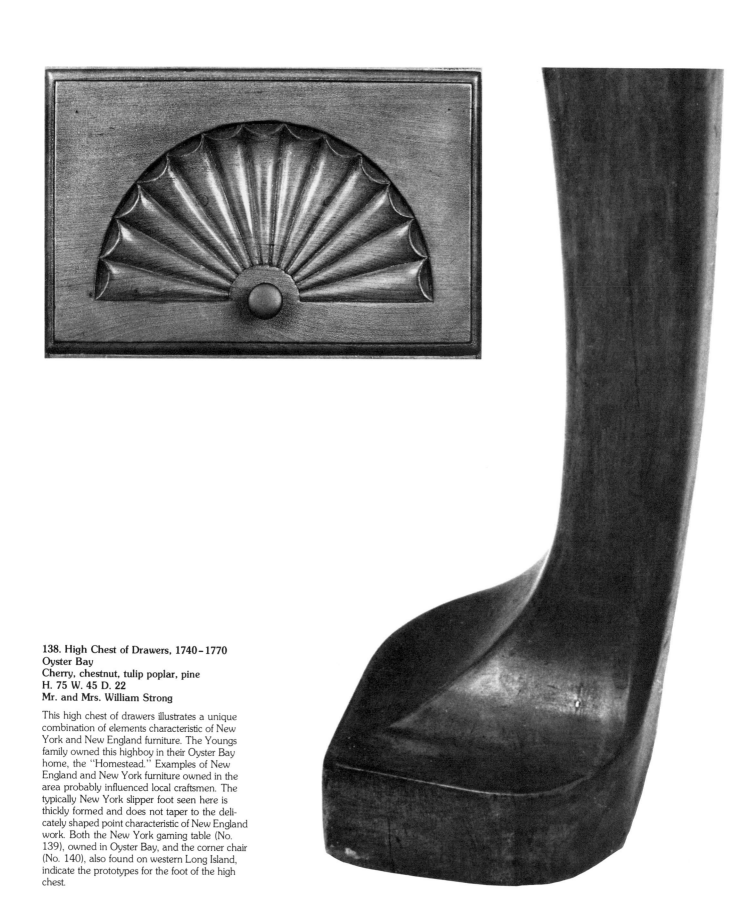

138. High Chest of Drawers, 1740–1770
Oyster Bay
Cherry, chestnut, tulip poplar, pine
H. 75 W. 45 D. 22
Mr. and Mrs. William Strong

This high chest of drawers illustrates a unique
combination of elements characteristic of New
York and New England furniture. The Youngs
family owned this highboy in their Oyster Bay
home, the "Homestead." Examples of New
England and New York furniture owned in the
area probably influenced local craftsmen. The
typically New York slipper foot seen here is
thickly formed and does not taper to the deli-
cately shaped point characteristic of New England
work. Both the New York gaming table (No.
139), owned in Oyster Bay, and the corner chair
(No. 140), also found on western Long Island,
indicate the prototypes for the foot of the high
chest.

118

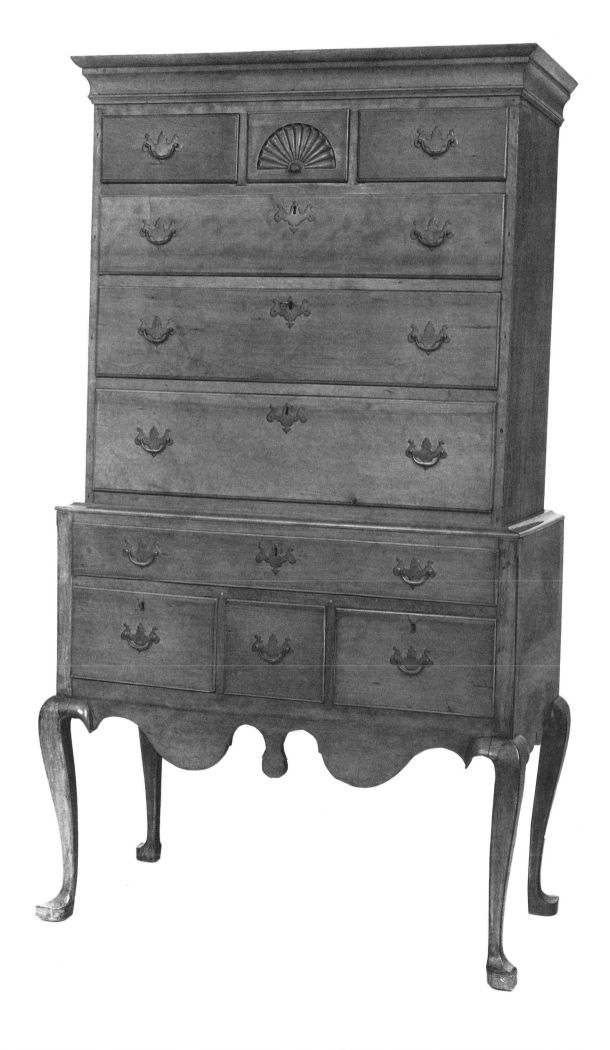

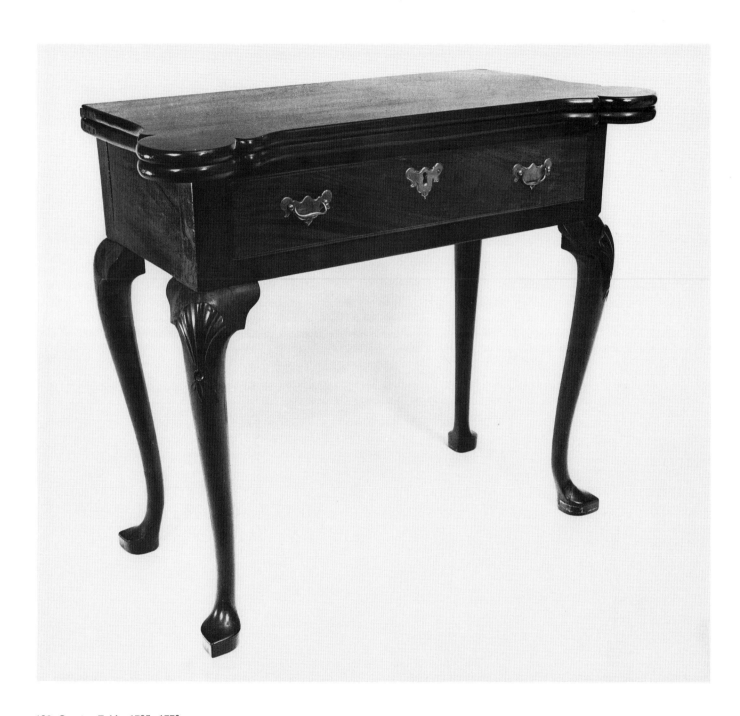

139. Gaming Table, 1735–1770
Probably New York City
Mahogany
H. 28 1/2 W. 34 D. (closed) 16 7/8
(open) 32 1/2
Private collection

140. Corner Chair, 1730–1770
New York City, Kings County, or Queens
County
Mahogany or walnut, pine
H. 31 1/4 W. 32 1/4 D. 21 3/4
Private collection

See previous entry

120

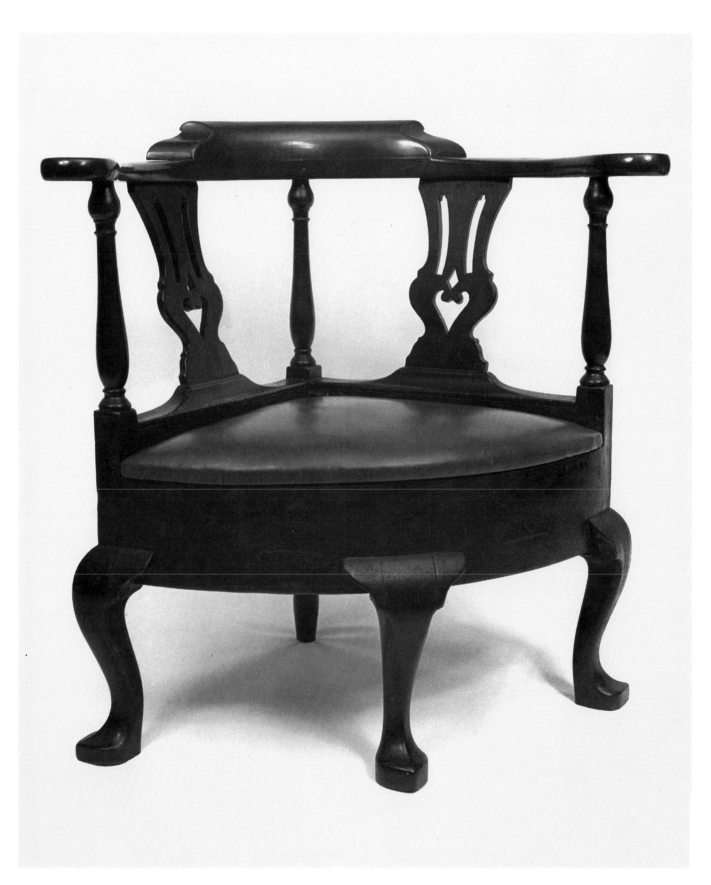

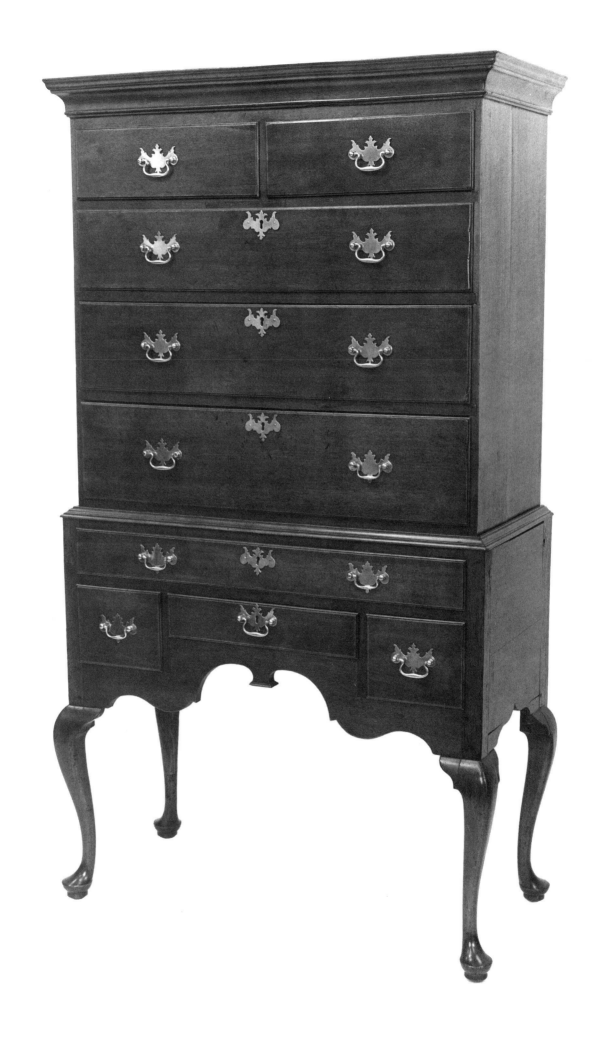

141. High Chest of Drawers, 1770–1800
Suffolk County, probably south fork
Walnut, pine, tulip poplar
H. 74 W. 40 D. 19 1/2
Society for the Preservation of Long Island
Antiquities, 965.305

As indicated by the inventories of Long Island estates, high chests of drawers were more widely owned on eastern Long Island than in the western counties of Kings and Queens. This was due in part to the strong influence of New England on the cultural development of Suffolk County and the eastern fringes of Queens County. The high chest of drawers, or highboy, was never a common New York furniture form but was extremely popular in New England throughout the eighteenth century.

While this high chest relates to certain Connecticut and Rhode Island examples, it is also similar to several New York high chests. In fact, a high chest signed by a New York City cabinetmaker, Robert Carter, was obtained from an East Hampton estate and suggests another possible design source (No. 142).

A high chest attributed to Nathaniel Dominy V is similar to this example in many respects. Both have the same skirt outline, although the Dominy high chest has a central pendant not found here. They also have identical one-piece cornices and lower section moldings. The construction techniques are similar as well. On both chests, each front leg has a center ridge placed at a forty-five degree angle to the front of the chest. The circular discs under the pad feet of this example are less worn, but match those on the Dominy high chest. The rear legs of both also have wide stiles which form a continuous flat edge, thus allowing the chests to be placed tightly against the wall. The backboards of the upper sections of both examples are nailed, while the lower sections have backboards tenoned into the leg stiles.

Despite these similarities, we cannot positively attribute this high chest of drawers to Nathaniel Dominy V. The leg template on the Dominy chest has not been compared with this example. Furthermore, a number of cabinetmakers were active on eastern Long Island during this period and any of them could have fashioned this piece.

The donors of this chest purchased it in Bridgehampton. According to tradition, a Bridgehampton craftsman made the high chest for Matthew Hildreth, in whose family it descended.

Ref.: Charles F. Hummel, *With Hammer in Hand: The Dominy Craftsmen of East Hampton, New York,* Charlottesville, Va., The University Press of Virginia, 1968, pp. 266–269.

142. High Chest of Drawers, 1750–1780
Robert Carter (active ca. 1783)
New York City
Mahogany, tulip poplar
H. 73 1/2 W. 41 1/2
Bernard & S. Dean Levy, Inc. New York City

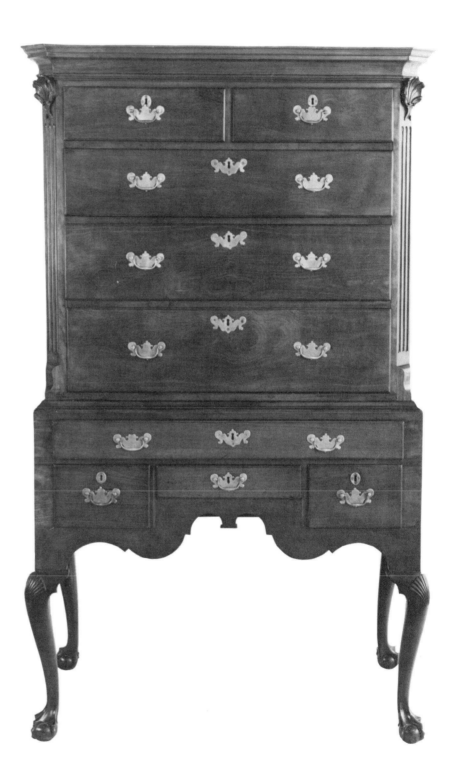

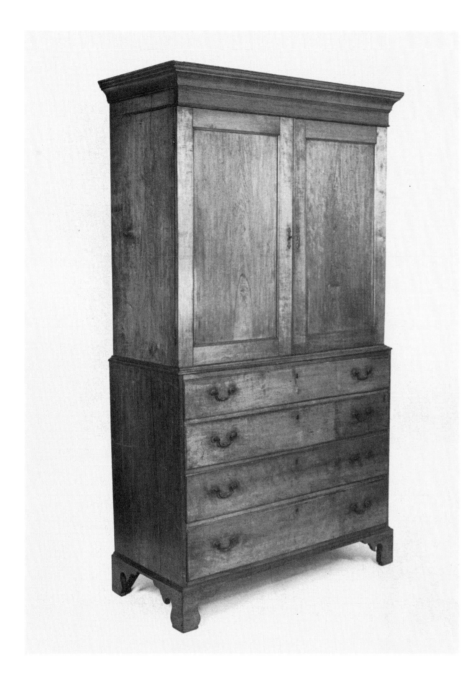

143. Wardrobe, 1770–1800
Suffolk County
Cherry, chestnut, pine
H. 82 W. 43 D. 22
Private collection

Wardrobes or linen presses of this type were extremely popular in the New York area during the second half of the eighteenth century. The use of cherry, chestnut, and pine was common on eastern Long Island, and all three woods appear on this wardrobe from the Miller family of Wading River.

144. Wardrobe, 1780–1810
Flatlands
Cherry, black walnut, tulip poplar
H. 86 W. 58 1/2 D. 23
Private collection

Continuing Dutch influence on New York furniture forms of the late eighteenth century is evidenced in this wardrobe originally obtained from a Flatlands family. Two identical examples also from Flatlands are extant. Several features associated with the *kas*, such as the bold cornice, applied moldings, and panels of contrasting woods, have been transferred to this popular New York form. Despite the early decorative features and the Chippendale style bracket feet, the original Federal style hardware on one of the identical wardrobes indicates a date in the last quarter of the eighteenth century.

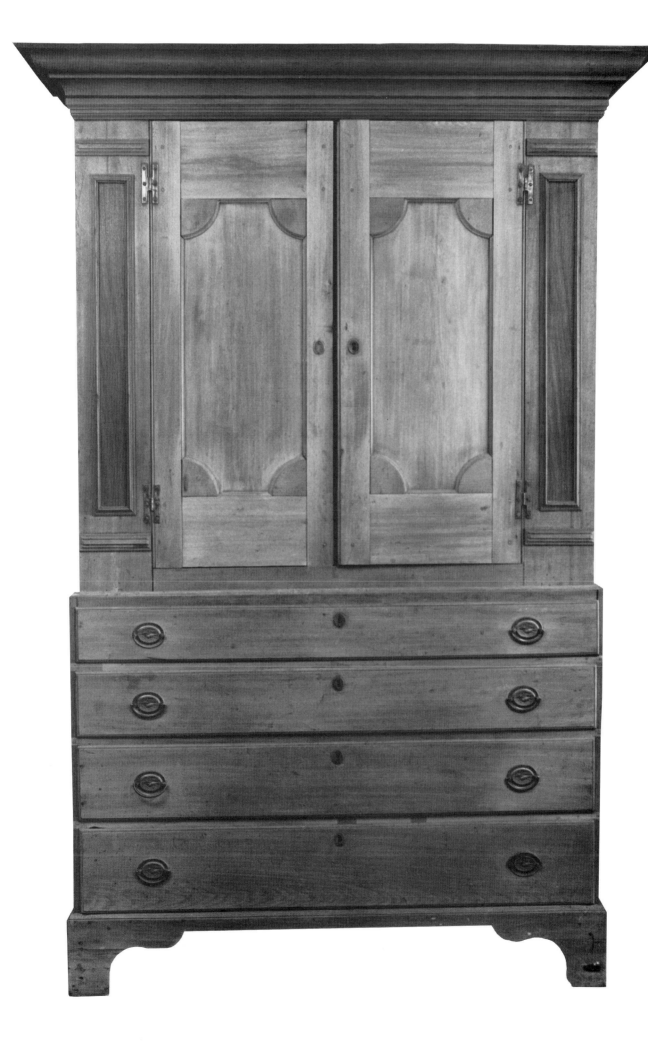

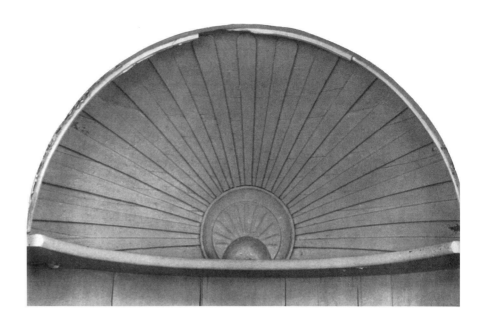

CORNER CUPBOARDS

Although corner cupboards were among the furnishings of some late seventeenth century English homes, they did not become popular in America until about 1720–1730. Cupboards were built as separate free-standing units or incorporated into a scheme of decorative panelling and built into the woodwork. Architectural in character, corner cupboards had either panelled (No. 145) or glazed doors (No. 146) in the upper section, combined with a panelled door or doors on the bottom. Flanking pilasters were also quite common. The upper portion of the cupboard usually contained three or four shelves, shaped to complement the large shell or fan which often capped the interior. The cupboard was painted the same color as the woodwork in the room, but the interior was often highlighted with a bright, if not stunning, orange-red hue.

Long Island craftsmen employed a short-cut method of creating the shell, possibly because they lacked the skills necessary to carve this feature. Multiple layers of wood, each cut in a semi-circular shape, were first glued or nailed together with each layer overlapping the layer below. The effect of a scalloped shell was then achieved by simply applying flat tapered strips of wood radiating from the center (No. 145).

Corner cupboards are not associated with any particular part of Long Island, and inventories of estates suggest that they were used primarily for the storage and display of dishes and glassware. The inventory of the estate of Dr. John Waters of Flushing, dated 1807, describes *"a corner closet with china and Earthenware."* David Gardiner in his *Chronicles of East Hampton*, written in 1840, provides a vivid description of a corner cupboard as it appeared in an eighteenth century East Hampton interior: *"In the corner of the room was the cupboard, within which, upon the circular, brilliantly painted shelves, was displayed so as to produce the most striking effect, the various tableware, comprising china of variegated hues and multiform patterns, and all those fanciful articles of domestic economy so gratifying to the eyes of the frugal and thrifty housewife."*

A cupboard from the Job Smith House (No. 145), dating from approximately 1730, represents several related examples from the Smithtown area. Another cupboard of the same style (No. 146) once stood in the circa 1740 Smith-Havens House in East Moriches. The craftsman cut each of the shelves of this example in a different pattern. Both of these examples were built into the woodwork of the most elaborate room in the house. Both the exterior and interior were originally painted a dark gray, although a bright orange was applied to the interior sometime in the eighteenth century. Corner cupboards remained popular in rural areas into the early nineteenth century. An example from a Setauket house has Federal style pilasters and dentiling (No. 147). Similar woodwork exists in other Setauket area houses.

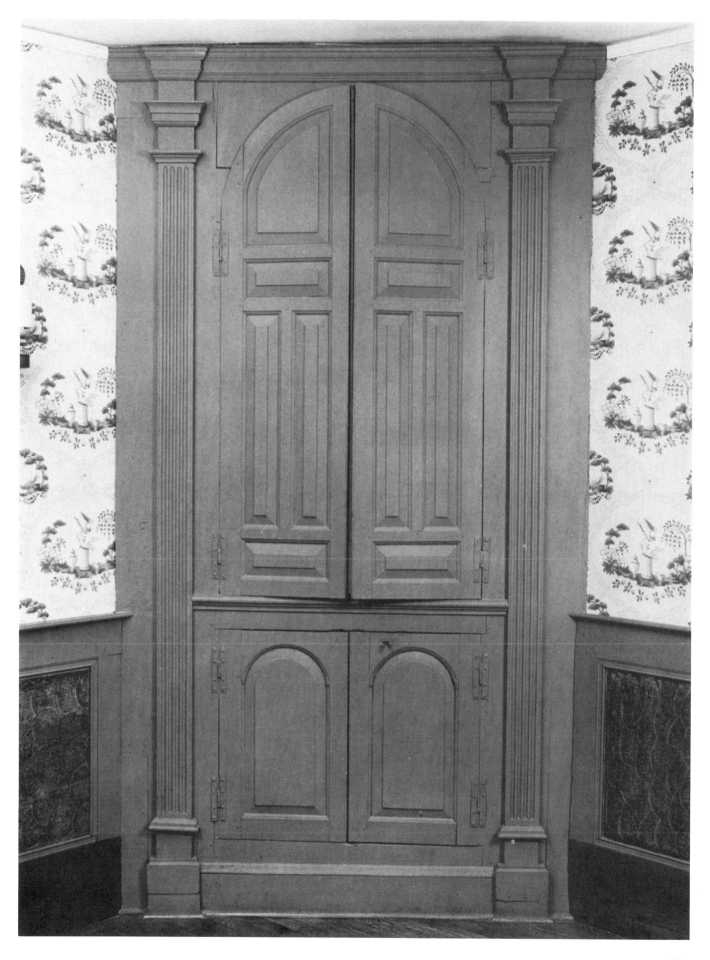

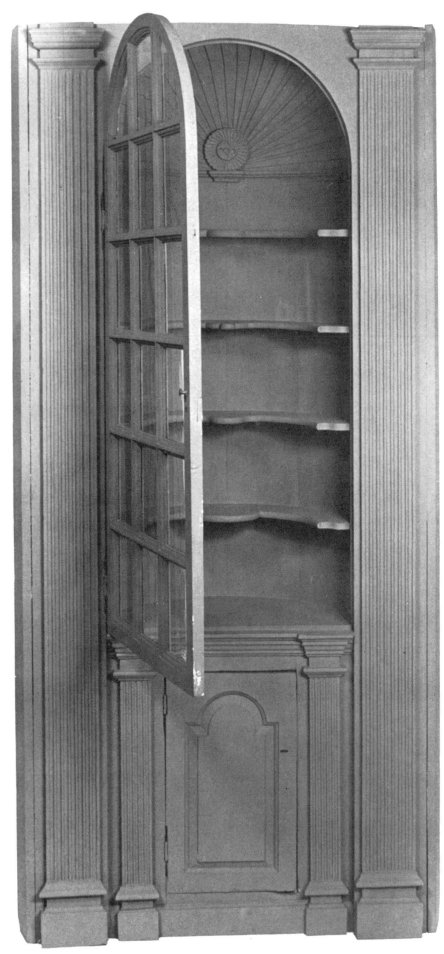

146. Corner Cupboard, 1725–1750
East Moriches
Pine
H. 96 W. 44
The Museums at Stony Brook

147. Corner Cupboard, 1800–1820
Setauket
Pine
H. 88 1/2 W. 57 3/4
Society for the Preservation of Long Island
Antiquities

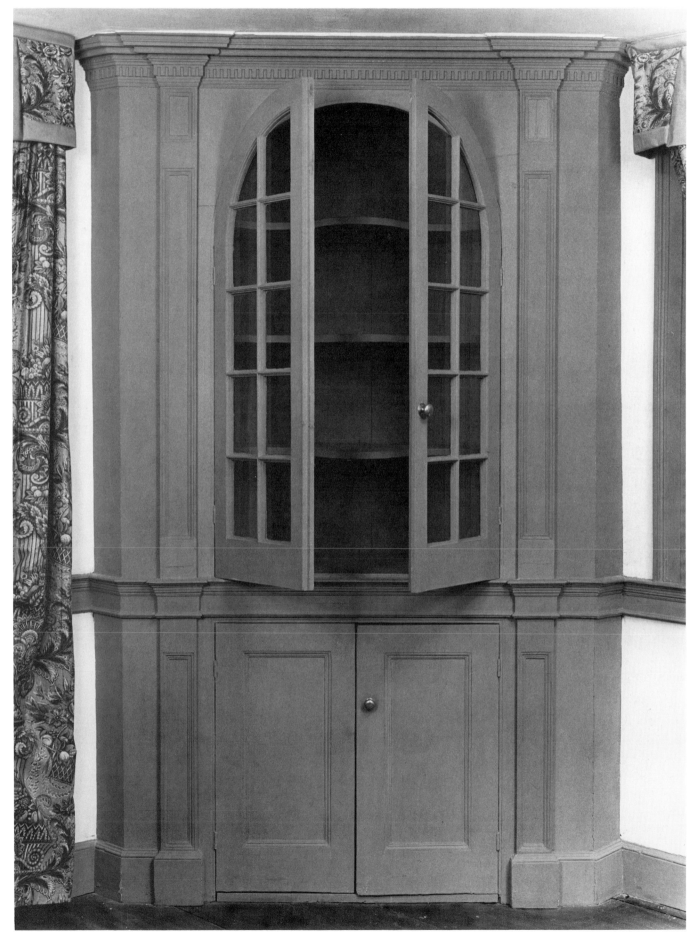

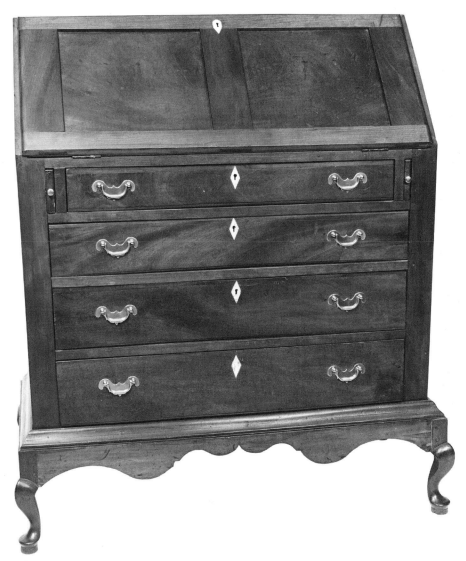

148. Desk on Frame, 1740–1770
Queens [Nassau] County, possibly Hempstead
Cherry, tulip poplar
H. 46 5/8 W. 41 1/2 D. 20 1/2
Nassau County Museum, 67.483

Most desks on frames with scalloped skirt, short cabriole legs, and pad feet are associated with Connecticut. This example, however, was purchased from a member of the Sammis family and it came from the former Sammis house and tavern in Hempstead. The two-panel slant-front lid is unique, as are the wide front stiles which bracket the drawers. Both the brasses and inlaid ivory keyhole escutcheons are later additions.

Ref.: John T. Kirk, *Connecticut Furniture, Seventeenth and Eighteenth Centuries,* Hartford, Conn., Wadsworth Atheneum, 1967, pp. 68–69.

149. Desk and Bookcase, 1760–1780
Oyster Bay or Jericho
Walnut, tulip poplar
H. 82 W. 39 3/4 D. 21 5/8
Private collection

A surprising variety of furniture forms abound on Long Island because of its central geographical location and diverse cultural influences. Double-domed or arched-top desk and bookcases are rare in America. Both New England and Pennsylvania examples are known, but it is impossible to attribute regional popularity of the form to either area.

 Dr. James Townsend (1729–1790) of Jericho owned this example. The inventory of his estate lists a *"Book Case & Desk,"* probably this piece, valued at £5. It descended in the Townsend family and according to family tradition was locally made. Although local cabinetmakers used walnut, cherry is more often the primary wood in Long Island-made furniture.

Ref.: Charles E. Buckley, "The Furniture of New Hampshire," *Antiques,* July, 1964, p. 57.
Luke Vincent Lockwood, *Colonial Furniture in America,* vol. I, New York, Charles Scribner's Sons, 1921, pp. 221–222.
Wallace Nutting, *Furniture Treasury,* vol. I, New York, The Macmillan Company, 1948, Nos. 682, 683.

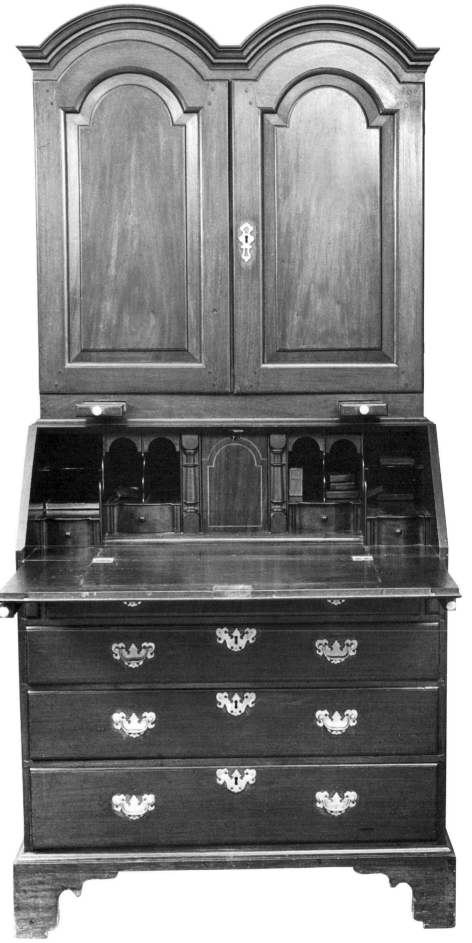

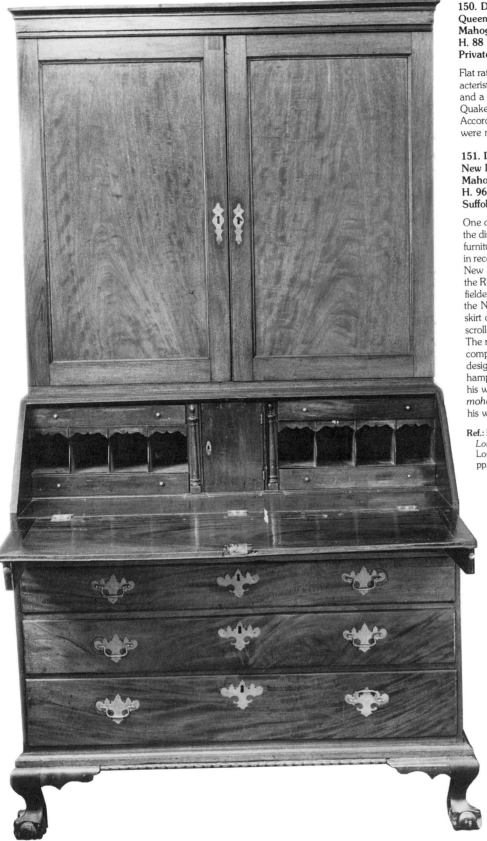

150. Desk and Bookcase, 1760-1790
Queens County or New York City
Mahogany, tulip poplar, pine
H. 88 W. 50 5/8 D. 25 3/8
Private collection

Flat rather than scrolled or bonnet tops are characteristic of New York case furniture. This desk and a similar example have descended in a Quaker family from the Westbury-Jericho area. According to family tradition, both examples were made locally.

151. Desk and Bookcase, 1770-1800
New London County, Connecticut
Mahogany, tulip poplar
H. 96 1/2 W. 50 1/2 D. 24 7/8
Suffolk County Historical Society, Riverhead

One can see in this desk and bookcase many of the distinctive features of New London County furniture which have been studied and delineated in recent years. The proximity of Rhode Island to New London County undoubtedly accounts for the Rhode Island influence in the bonnet top and fielded panels of the pediment. Characteristic of the Norwich, Connecticut region is the five-element skirt design consisting of ball and claw feet, scrolled brackets, and a central scrolled pendant. The rayed shells and gentle blocking of the desk compartment also suggest Norwich furniture design. David Gelston (1744-1828) of Bridge-hampton was the first owner of this desk and in his will, dated 1827, he mentioned his *"large mohogany desk and bookcase,"* which he left to his wife.

Ref.: Minor Myers, Jr. and Edgar de N. Mayhew, *New London County Furniture, 1640-1840,* New London, Conn., The Lyman Allyn Museum, 1974, pp. 8, 46-48, 50, 63.

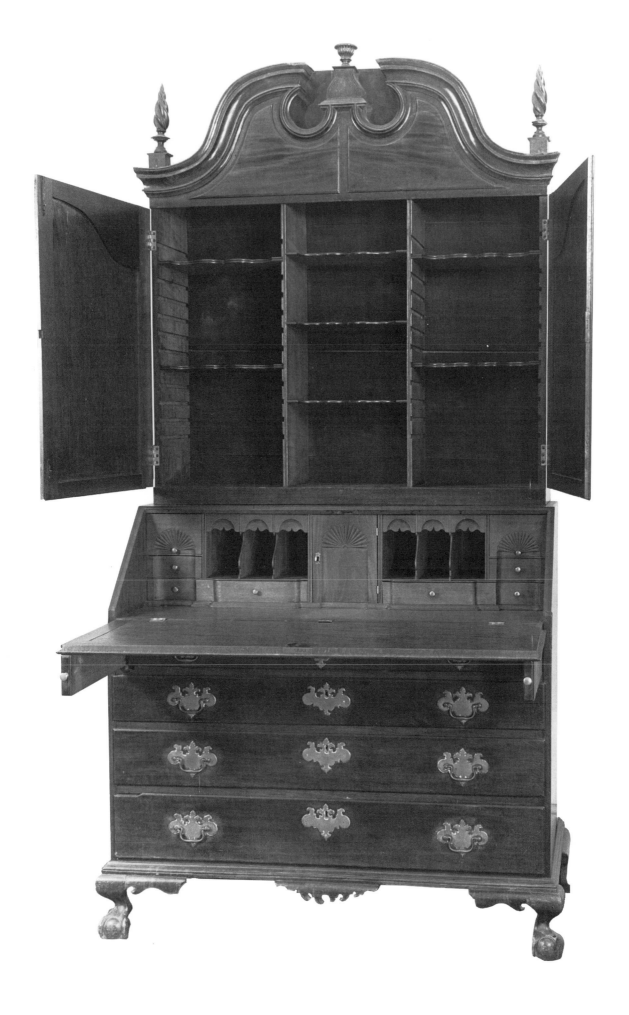

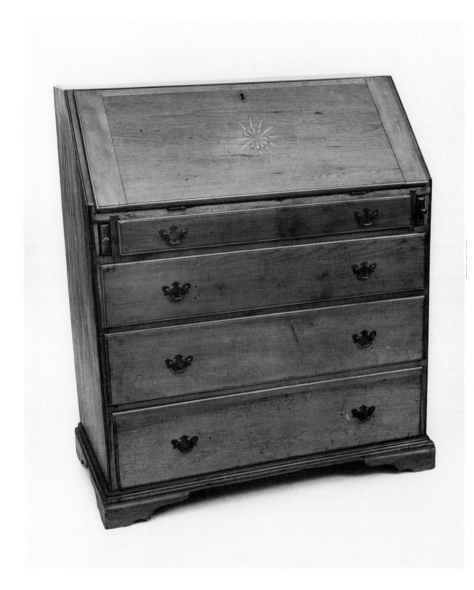

152. Desk, 1760–1780
Possibly Jonas Squam
[Sag Harbor ?]
Mahogany
H. 40 3/4 W. 36 D. (closed) 18 7/8
Society for the Preservation of Long Island
Antiquities, 61.9

In an article published in the Society's *Newsletter* a number of years ago, a Queen Anne style desk-on-frame, similar to the desk illustrated here, was attributed to a Sag Harbor cabinetmaker on the basis of a schoolgirl's composition, written in the nineteenth century, which related the following information from an old note found in the desk: *"Bought of Jonas Squam cabinet maker of Sag Harber this day Dec 16 1773 one bay mahogany secretary—Value £5-9ˢ—For which he is to receive 1 firkin winter butter and 11 lbs. of linen yarn as payment."*

While there is no reason to question the authenticity of the note, the desk in question had undergone several changes, including the replacement of the original bottom section with the base of a high chest of drawers. Unquestionably, however, the maker of the upper slant-front desk compartment was the same individual who fashioned the desk illustrated here. Both desks have identical inlaid star motifs on their slant fronts, and the arrangement of their interior compartments is also the same. Nothing further has been learned about the elusive Jonas Squam.

Ref.: Gerald Shea, "The Two 'Asterisks'," *Newsletter,* Society for the Preservation of Long Island Antiquities, June, 1959.

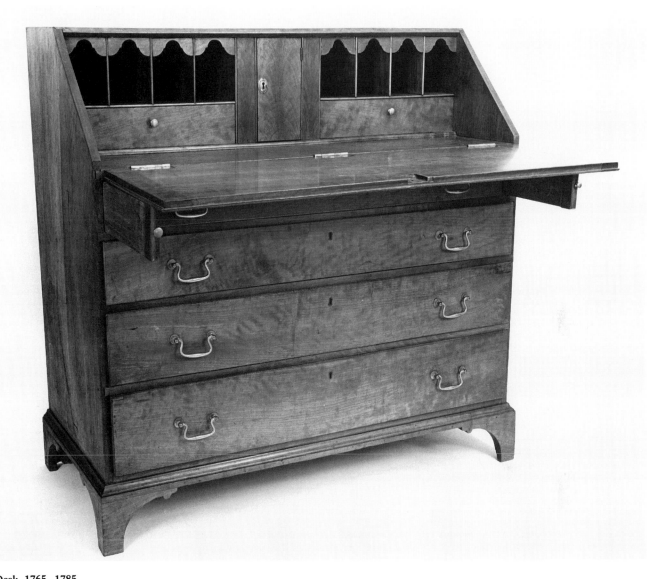

153. Desk, 1765–1785
Setauket or Smithtown
Cherry, chestnut, pine
H. 43 1/2 D. 21
Smithtown Historical Society, 62-228

Reportedly, the original owner of this desk was
William Arthur (1695–1785) of Smithtown. The
desk stood in the Arthur-Howell-Blackman
House, in which the family lived until 1960. It is
similar in many respects to a desk attributed to
Samuel Satterly (1722–), a Setauket
cabinetmaker and carpenter, in an article in the
Long Island Forum. Both examples probably
came from the same shop.

Samuel Satterly could not have made the
Arthur desk at such a young age, but another
Satterly family cabinetmaker, William Satterly
(–1797) perhaps made this desk and the
related example (see Appendix I).

Ref.: Emily B. Steffens, "Old Island Writing Desk," *Long
Island Forum*, April, 1947.

154. Looking Glass, 1740–1760
[American ?]
Walnut, pine
H. 65
Ginsburg & Levy, Inc., New York City

This looking glass was associated with a Huntington family. With the exception of the pierced plume motif in the center of the crest, the style of this glass suggests a slightly earlier date than that of the following example.

155. Looking Glass, 1740–1770
New York or England
Walnut, pine
H. 44 3/4 W. 20 1/2
Society for the Preservation of Long Island Antiquities, 61.13.2

Both this looking glass and a high chest of drawers also illustrated (No. 55) descended in the Wright family of Oyster Bay. Portions of an eighteenth century document containing a notice of an estate sale and mentioning Oyster Bay covered the back of the looking glass. Other glasses of this design were owned in New York and either made there or imported from England.

Ref.: Joseph Downs, *American Furniture, Queen Anne and Chippendale Periods, in The Henry Francis du Pont Winterthur Museum,* New York, The Macmillan Company, 1952, No. 246.

156. Looking Glass, 1770–1800
New York City
Mahogany
H. 32 1/2 W. 18 1/4
Southampton Colonial Society

Looking glasses of almost identical design were made in New York by several makers including William Wilmerding. The Pelletreau family of Southampton owned this example.

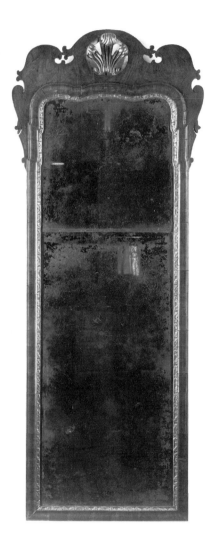

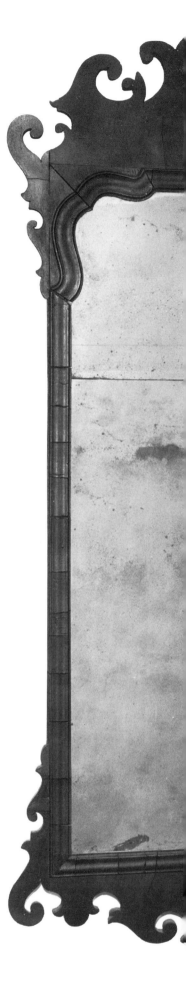

157. Pipe Box, 1740–1790
Jericho or Oyster Bay
Walnut
H. 26 3/4 W. 6 1/2 D. 5 1/4
Private collection

The simple dignity of this unusual closed pipe box suggests its Quaker origins. The original owner was Samuel Willis (1704–1790) of Jericho. The box descended directly in the family. An interesting cultural sidelight is Willis' connection with the Lloyd family of Lloyd's Neck. Willis surveyed the division of the Neck to which the four Lloyd brothers had agreed after the death of their father, Henry Lloyd I, in 1763. At that time, Willis placed an order for a silver tankard with Joseph Lloyd, the only brother in residence on the Neck. Joseph in turn placed the order with his brother, Henry II, in Boston. When the tankard was shipped, Henry enclosed a note stating that he hoped Willis would approve of the piece, *"being as well made as it could be here."*

158. Watch Box, 1770–1820
Suffolk County or Connecticut
Cherry
H. 9 1/2 W. 8 D. 3 1/2
Private collection

Carved pinwheel motifs and spiral gadrooning are both commonly found on Connecticut furniture. The proximity of Connecticut, particularly the port of New London, to Long Island allowed for an exchange of ideas, craftsmen and occasionally furniture and silver. The nature and arrangement of decorative motifs along the base suggests a date close to 1800. Obtained in Remsenburg, this display box for a small pocket watch was owned in the Halsey family.

159. Baby Cage, 1750-1810
Queens [Nassau] County
[Walnut ?]
H. 17 W. 24 1/2 D. 24 1/2
**Society for the Preservation of Long Island
Antiquities, 60.44.3**

This baby cage rests on castors under the four
corner blocks. A small child, supported under the
arms by the circular "top," could thus propel
himself around a room. Since the frame extends
some distance out from the center, objects on
tables or low surfaces remained out of reach. This
example was found in present-day Nassau
County, and the simple turnings suggest a date
after 1750.

160. Tape Loom, 1750-1800
Suffolk County
Pine
H. 24 W. 8
Mr. and Mrs. Morgan MacWhinnie

Small tape looms were common household arti-
cles used to weave narrow bands of cloth for
decorative edging or binding. This example,
found in Southampton, bears the name *SARAH
TOBY*, the initials *S T*, and decorative carved
pinwheel and pierced heart motifs.

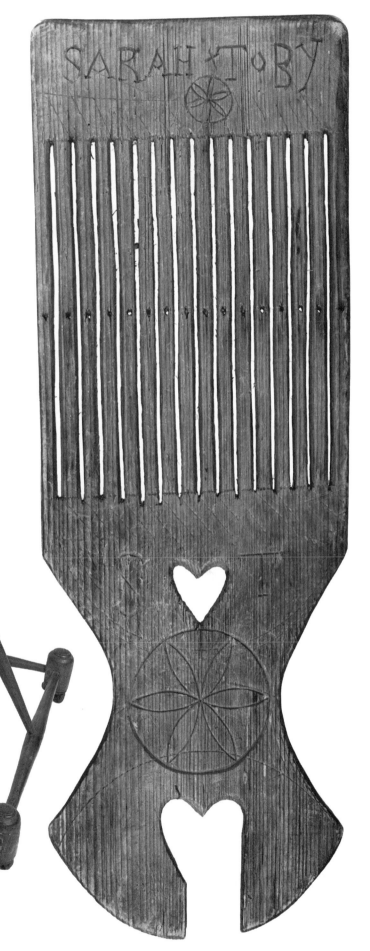

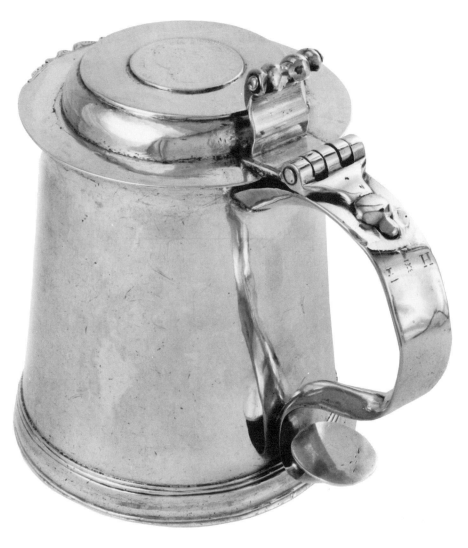

161. Tankard, ca. 1726–1740
John Hastier (1691–1771)
New York City
Silver
Mark: *IH* in rectangle
H. 5 1/2 D. (of base) 4 7/8
Museum of the City of New York, 61.171

John Hastier became a Freeman of New York City in 1726. Sometime after this date, he fashioned a tankard for Captain James Fanning (1694–1779), the son of Thomas and Frances Fanning of Southhold, and his wife, Hannah Smith (1702/3–1750), the daughter of Richard Smith II of Smithtown. The Museum of the City of New York acquired the tankard from a Smith descendant.

A favorite decorative device of New York silversmiths, the incorporation of an inset coin in the lid, appears on this tankard. Hastier used a 1694 Austrian thaler in this instance. Since this type of decoration was no longer fashionable after about 1740, Hastier probably made the tankard prior to that date.

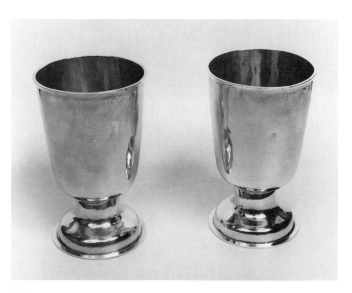

162. Communion Cups, 1720–1740
Simeon Soumaine (1685–1750)
New York City
Silver
Mark: *SS* in rectangle
H. 6 Diam. (of base) 3 7/8
Presbyterian Church of Southold

Numerous examples of eighteenth century Long Island church silver indicate a preference even on eastern Long Island for the work of New York City silversmiths, especially Peter Van Dyck and Simeon Soumaine. The design of these cups for the Southold Presbyterian Church is appropriately simple and chaste. Soumaine also made a more elaborately engraved baptismal bowl for St. George's Church, an Anglican parish in Hempstead.

164. Tankard, ca. 1751–1755
Elias Pelletreau (1726–1810)
Southampton
Silver
Mark: *EP* in rectangle
H. 8 3/8 Diam. (of base) 5 1/4
The Yale University Art Gallery, 1866.5

Four examples of domed tankards by Pelletreau survive but none correspond with the four "high top" tankards listed in Pelletreau's account books between 1761 and 1769. New Englanders favored tankards of this design but the Pelletreau tankards are the only known New York examples with finials. An inscription on this tankard indicates it was *formerly the property of | President Naphtali Daggett* [of Yale University] *and Sarah his wife.* In all probability, Pelletreau made the tankard between 1751 and 1755 when Daggett served as pastor of the church in Smithtown, Long Island. Daggett returned to New Haven in 1755 with his new wife, Sarah Smith of Smithtown.

163. Tankard, 1730–1750
Simeon Soumaine (1685–1750)
New York City
Silver
Mark: *SS* in rectangle
H. 6 5/8 Diam. (of base) 4 7/8
Society for the Preservation of Long Island Antiquities, 73.17

The engraved initials *S/D∗H* on the handle are those of the tankard's original owners, Daniel (1690–1763) and Hannah Smith (1698–1761) of Smithtown, who also owned a surviving tankard by another New York silversmith, Henricus Boelen (1697–1755). Long Island's most noted silversmith, Elias Pelletreau, apprenticed under Simeon Soumaine.

Ref.: Millicent Stow, *American Silver,* New York, M. Barrows and Company, Inc., 1950, No. 20.

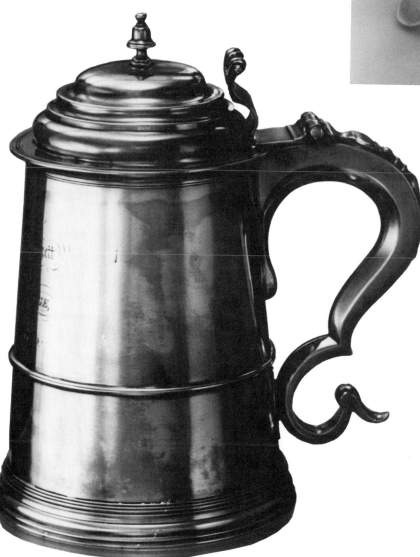

165. Porringer, ca. 1750–1769
Elias Pelletreau (1726–1810)
Southampton
Silver
Mark: *EP* in rectangle
Private collection

The Pelletreau account books document thirty-four orders for porringers, and all but nine of the entries refer to purchases of pairs or sets. This example belonged to Anna Floyd (No. 166), the sister of William Floyd of Mastic, and her initials *A*F* are engraved on the key-hole pattern handle. She married High Gelston Smith (1754–1792) of East Moriches in 1769.

166. *Anna Floyd*, 1792
Ralph Earl (1751–1810)
Oil on canvas
Signed and dated
H. (within frame) 22 W. (within frame) 19
Private collection

Earl may have visited Long Island in 1792 to paint the portraits of at least two members of the Floyd family, William Floyd's sister, Anna, seen here, and his son-in-law, Ezra L'Hommedieu. This portrait bears Earl's signature *R. Earl pinxt.* and the date *1792*. The L'Hommedieu portrait, now on loan to the Museum of Fine Arts, Boston, is also signed and dated.

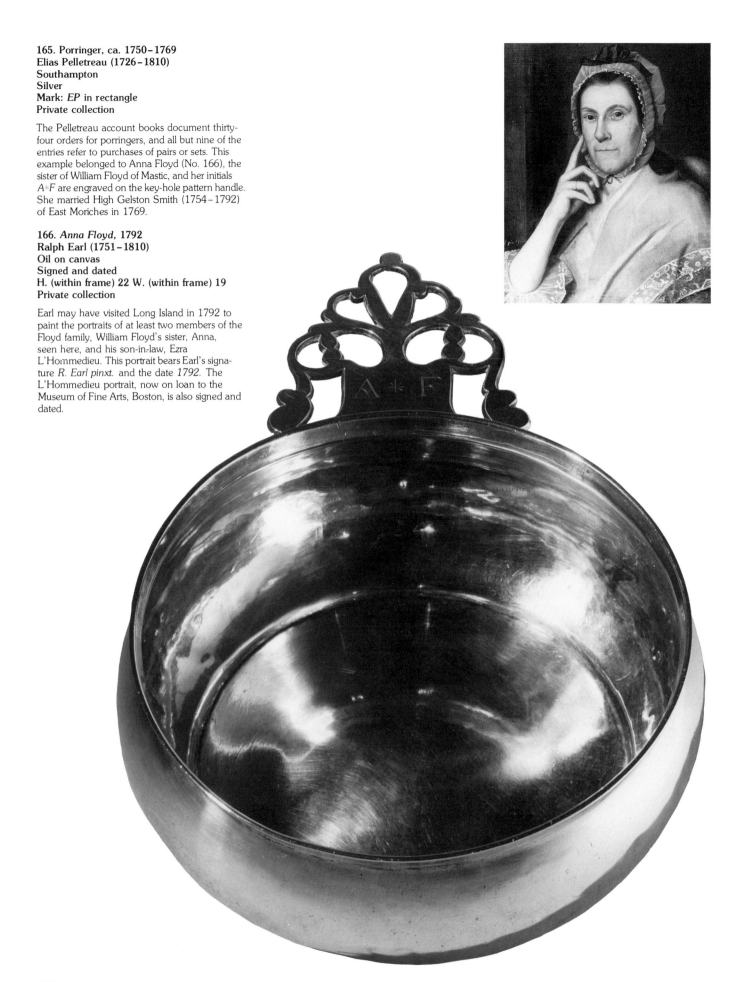

167. Pepper Box, ca. 1769
Elias Pelletreau (1726–1810)
Southampton
Silver
Mark: *EP* in rectangle
H. 3 1/2
Private collection

Cylindrical and octagonal shaped pepper boxes
were popular silver forms during the first half of
the eighteenth century, and remained popular
with many of Pelletreau's eastern Long Island
customers at a later date. This example, marked
with the initials *R∗W,* presumably those of Ruth
Woodhull (1732–1822), may be the box Pelle-
treau described in his accounts for 1769 as *"Pep-
per Box Round"* with the accompanying letters
"R∗W." Ruth Woodhull's husband, William Smith
(1720–1799), purchased the box in 1769.

168. Locket and Beads, ca. 1750–1757
Elias Pelletreau (1726–1810)
Southampton
Gold
L. 12 1/8
The Yale University Art Gallery, The John
Marshall Phillips Collection, 1956.10.3

The fashioning of jewelry was an important part
of an eighteenth century silversmith's work. Pelle-
treau's account books show that for almost every
year for the work recorded the total value of the
jewelry produced exceeded the value of the hol-
low ware. Pelletreau recorded numerous orders for
"beeds" and he probably made this complex
double string with hollow locket, bearing the ini-
tials *HP* in script, for his sister, Hannah, who
married Edward White in 1757.

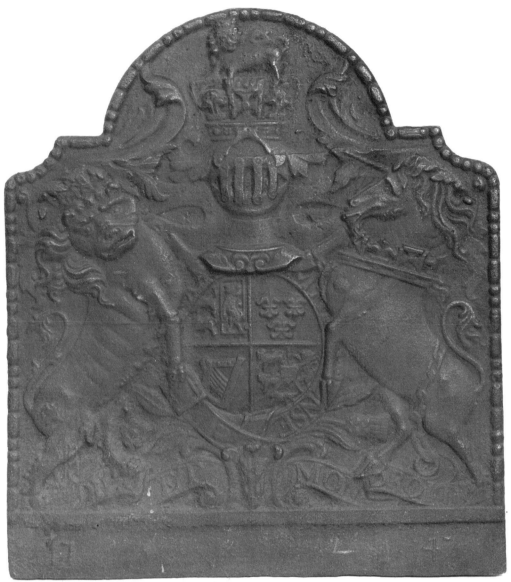

169. Fireback, 1745 or 1747
Oxford Furnace, Warren County, New Jersey
Iron
H. 31 1/2 W. 29 1/4
The Long Island Historical Society, Brooklyn,
478

In addition to their decorative function, firebacks
protected the brick and masonry fireplace walls
from rapid deterioration due to constant and
excessive heat. This fireback, salvaged from an
unidentified Flushing house, was made at the
Oxford Furnace in New Jersey, which was in
operation between 1745 and 1758. Portions of
the date and the name *OXFORD* are no longer
visible on the bottom of the fireback. An identical
example in the Brooklyn Museum was originally
used in the Nicholas Schenck House in Canarsie,
suggesting that New York provided a market for
New Jersey ironware.

170. Andirons, 1750–1800
Possibly New York City
Iron, brass
H. 20
Private collection

171. Andirons, 1750–1800
Possibly New York City
Iron, brass
H. 23
Private collection

The fireplace was a focal point of eighteenth century life, and even functional accoutrements such as andirons served a decorative purpose as well. Brass was the most elegant material for andirons (No. 218), but its extremely high cost, especially before the Revolution, greatly limited the ownership of such luxury items. Andirons with iron shafts and bases and brass finials represented an economical compromise. The faceted diamond and flame design seen here on the finials of both pairs is frequently found on Long Island. Local blacksmiths may have purchased the cast brass finials and added them to bases of their own manufacture.

172. Candlestand, 1760–1800
William Seaman
Jericho-Westbury
Iron, brass
H. 56 W. (of arm) 20 3/4
Private collection

According to family tradition, William Seaman, a blacksmith, made this candlestand with adjustable arm. The Covert family from nearby Glen Cove owned a similar stand now at the Henry Francis du Pont Winterthur Museum.

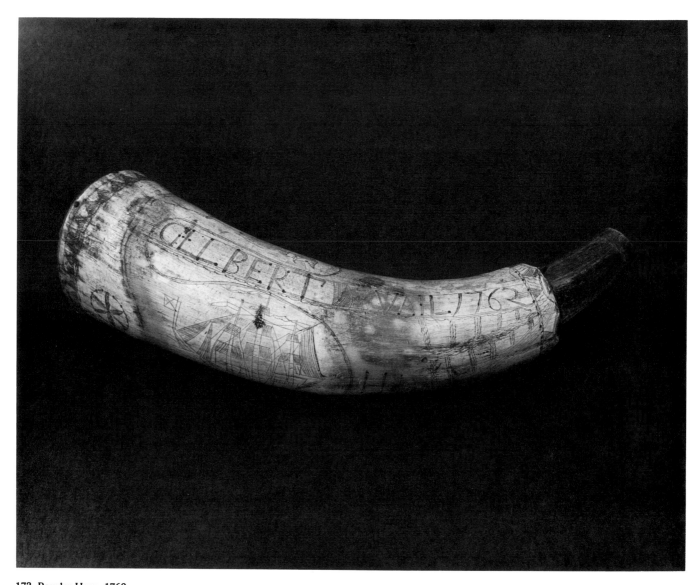

173. Powder Horn, 1762
[Gilbert Vail ?]
Suffolk County
Ox or cow horn
L. 12 1/4
Suffolk County Historical Society, Riverhead

Gilbert Vail, the original owner, was probably a
resident of the north fork, and he may have
ornamented this horn himself. Since many east-
ern Long Islanders were mariners, the engraved
ship possibly relates to Gilbert Vail's career.

174. Powder Horn, 1750–1775
New York City or Albany
Ox or cow horn
L. 13 1/2
Raynham Hall, Oyster Bay, TX 307

Six or more powder horns with the same elabo-
rately etched English coats of arms and render-
ings of the Hudson and Mohawk River Valleys
are extant. A skilled craftsman in New York City
or Albany was undoubtedly responsible for the
fine ornamentation of these horns. Solomon
Townsend (1746–1811) of Oyster Bay owned
this spended example.

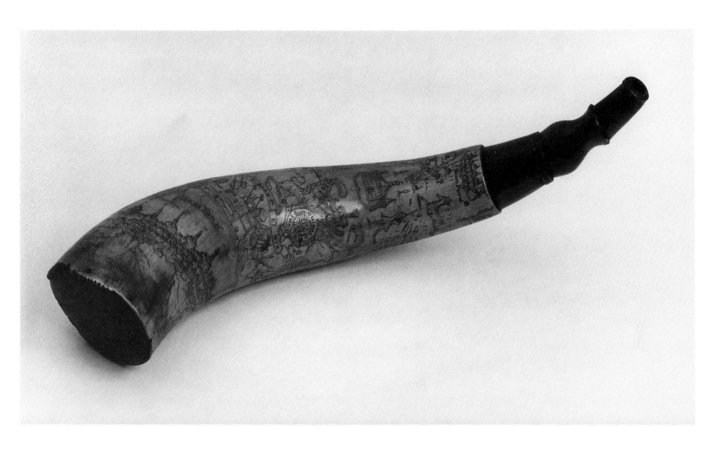

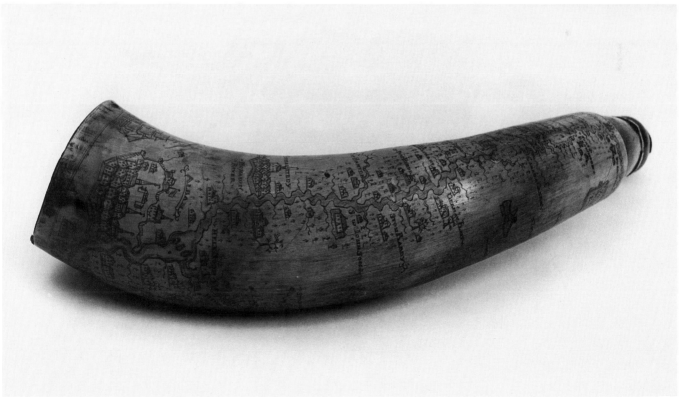

175. Double Pocketbook, 1755
Oyster Bay
Wool
H. (open) 7 W. 6 1/2
Raynham Hall, Oyster Bay

Worked or needlework pocketbooks were fashionable between 1740 and 1790 and were used by both men and women. The vertical stitch used here in a zigzag pattern is popularly known today as bargello, flamestitch, or Florentine, but in eighteenth century America it was called the Irish stitch. The pocketbook was made for Samuel Townsend (1717–1790) of Oyster Bay in 1755, possibly by his wife or one of his daughters.

Ref.: Susan B. Swan, "Worked Pocketbooks," *Antiques*, February, 1975, pp. 298–303.

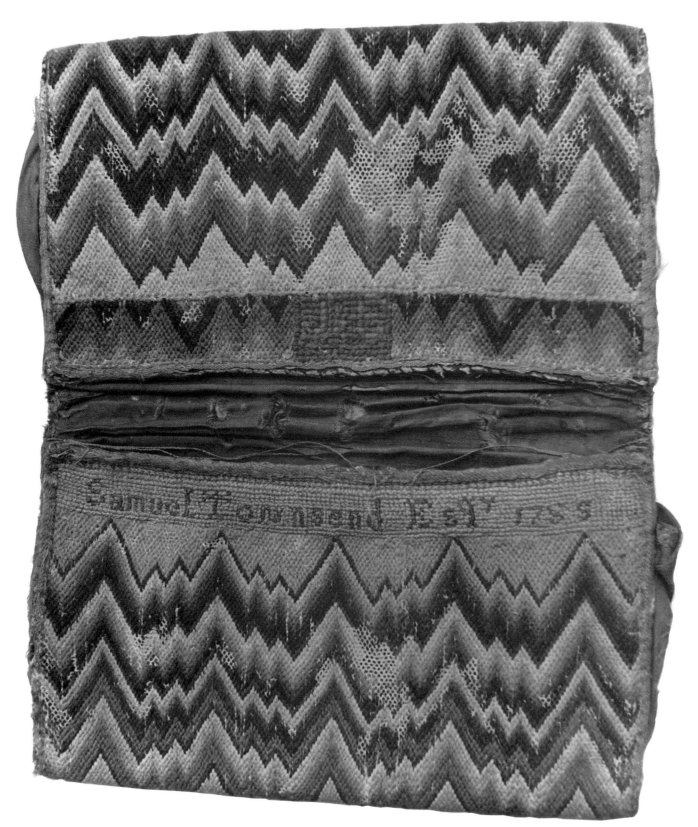

176. Double Pocketbook, 1773
Oyster Bay
Wool
H. 7 1/2 W. 7
Raynham Hall, Oyster Bay, TX 309

An old pasted label on an inside pocket reads: *"Made By our great grandMother Mary Mien Townsend Moyles a Daughter of John Allen @ Great Neck."* The paper label bearing the date *"1773"* clarifies the worked but faded date which appears to either side of the label. On the opposite pocket, however, the name *William Miles* is still discernible. The Irish stitch is worked in a jagged diamond design sometimes called a carnation pattern.

Ref.: Susan B. Swan, "Worked Pocketbooks," *Antiques*, February, 1975, pp. 298–303.

177. Crewel Panel, 1750–1770
Smithtown
Wool on linen
H. 35 W. 37
The Museums at Stony Brook

The family of Caleb Smith (1724–1800) of Smithtown owned this crewel panel which was probably part of a set of bed hangings. The traditional pattern was inspired by imported Indian chintz owned in New York by the end of the seventeenth century.

Ref.: Alice Baldwin Beer, *Trade Goods, A Study of Indian Chintz in the Collection of the Cooper-Hewitt Museum of Decorative Arts and Design*, Washington, D.C., Smithsonian Institution Press, 1970, pp. 35, 37.

178. Bed Hanging, 1760–1775
Probably England
Cotton
Raynham Hall, Oyster Bay

More than half a dozen examples of block-printed blue resist textiles have been found on Long Island including this bed hanging printed with a large-scale floral design in two shades of blue. These textiles are also associated with the Hudson River Valley and Connecticut, suggesting that New York City was a center for their importation from England. The edges of the panel are bound with a similarly printed border.

Ref.: Florence M. Montgomery, *Printed Textiles, English and American Cottons and Linens 1700–1850*, New York, The Viking Press, Inc., 1970, pp. 194–211.

III. LONG ISLAND IS MY NATION, 1782–1830

In the aftermath of the American Revolution, Long Islanders were faced with the problem of reestablishing their homes and lives, but within a framework of new political and economic allegiances. A conservative attitude, reflected in their adherence to tradition and familiar patterns of living, was only to be expected. Significant social and economic changes, however, occurred during this period which affected developments in the decorative arts, altering to varying degrees customer preferences and the styles and sources of furnishings on Long Island.

The effects of the war were immediate and disastrous for most Long Islanders. After the Battle of Long Island in August, 1776, British forces occupied all of the Island and several thousand refugees fled to Connecticut.[1] When they were first able to return six years later, many Long Islanders found their farms and homes in ruin. For the thousands of Loyalists who had remained on Long Island, the future was equally uncertain and vast numbers chose to depart in 1782 with the evacuating British army. Sylvester Dering, the son of Thomas Dering of Shelter Island (No. 69) wrote a poignant letter in 1783 describing the situation for returning families: *"You will find by the date of this letter that we have removed from Connectcut & are returned again to our farm on this Island, which has been very much damaged in Wood, Fences & Buildings during the late war. . . . I make this War a very unfortunate one for us, we are now beginning the world as it were anew & with a common blessing we shall put ourselves in as happy a situation as we was before the War."*[2]

The disruptions of the war affected patrons and craftsmen alike. Elias Pelletreau, the Southampton silversmith, was forced to seek safety with his family in Connecticut, while the Setauket cabinetmaker Austin Roe remained on Long Island, acting as a Patriot spy. William Floyd and hundreds of other Long Island families lost most of their personal possessions and household furnishings when they became refugees. Families which stayed behind often fared no better, their furniture and silver confiscated by Loyalists or lost to American raiding parties, their homes and farms damaged by occupying troops. John Paine, a Southold carpenter-joiner, recorded in his account book the preparations and repairs necessary to ready Ezra L'Hommedieu's house for occupancy in 1783, and noted his efforts to *"helpe up your goods to the house."*[3] It was a scene repeated many times over.

Long Island remained rural and agrarian well into the early nineteenth century (No. 179). British traveller William Strickland described the pastoral character of western Long Island in 1795: *"The Houses constructed of wood and neatly painted in various colors and in various fashions, are situated among orchards, and groves of trees, and fields of luxuriant verdure . . . being the abodes of rustics chiefly of Dutch descent whose chief occupation is that of raising vegitables for the supply of the market of New-York. . . ."*[4]

Another observer, Timothy Dwight, president of Yale College, found the Long Island of 1811 not only rural but also provincial. He stated of Long Islanders: *"Almost all their concerns are absolutely confined to a house, or to the neighborhood; and the neighborhood rarely extends beyond the confines of a small hamlet. Habitually bounded by these confines, the mind is neither very much inclined, nor very able, to look beyond them."*[5] Dwight's perception of a primarily static, agrarian

179. *Elmhurst, Long Island,* 1839
Queens County
Oil on canvas
H. 21 W. 27
Society for the Preservation of Long Island
Antiquities, 68.15

The back of the canvas bears the inscription
Elmhurst, L. I./ 1839. The scene illustrates the
rural character of western Long Island well into
the nineteenth century.

society was reiterated several years later by Samuel Fleet, the Huntington publisher of *The Long-Island Journal of Philosophy and Cabinet of Variety.* Fleet pointed out that Long Island had experienced *"no increase of population by new settlers, men of wealth and enterprise, but a general departure of our youth of promise."*[6]

Turning to the decorative arts, it would appear that Dwight's conclusions were generally correct. A marked time-lag and stylistic gap existed between furniture made by the Dominy family (No. 226) and current fashions available in the cities (Nos. 199–201). Adaptations of the latest neo-classical styles by other local craftsmen also revealed a naive understanding of current developments (Nos. 204–206).

Customer preference, of course, affected the nature of the objects produced. Elias Pelletreau and his son, John, were perfectly capable of producing silver forms in the neo-classical style but their customers requested types of silver no longer fashionable in New York City (Nos. 191–192). The probate records for this period provide additional documentation of the taste for conservative and traditional forms which predominated on Long Island, although residents of the western counties seem to have been more aware of fashion due to their proximity to New York. For Suffolk and Queens Counties, most early nineteenth century inventories still listed *"fiddle backed"* and *"slat back"* chairs (Nos. 90–93, 94–100), and chests with one or two drawers (Nos. 120–123). Cherry, pine, and walnut rather than mahogany were the favored furniture woods. Many of the new furniture forms or descriptive terms associated with furniture of the Federal period rarely appear in the inventories. The few sideboards listed, for example, were owned in port towns or commercial centers such as Sag Harbor and Jamaica. Even men of wealth and sophisticated taste like John Lyon Gardiner were comfortable living with less fashionable and more familiar furnishings (see pp. 156–165).

This picture of rural Long Island, however, is incomplete and not entirely accurate. During the period 1782–1830 patterns of slow growth and development—apparent in increased population and commercial activity and improved transportation and communication facilities—began to emerge, and these develop-

ments eventually transformed the craft system and the character of Long Island's decorative arts.

Most important was the growth of certain Long Island towns into identifiable local centers of commerce and communication with a concentration of services and population in a defined area. At the east end Sag Harbor became a local commercial center during the second half of the eighteenth century and was named an official port of entry for the United States Customs Service in 1789. By the 1790's it was a flourishing sea-oriented community, later to become a major whaling port (No. 180). Sag Harbor was the home of the first regularly published Long Island newspaper, *Frothingham's Long Island Herald,* which appeared in 1791. The weekly marine list of visiting sloops as well as the variety and tone of the advertisements in the *Herald* are evidence of a different Long Island than the region Timothy Dwight saw as *"insular"* and *"Sequestered in a great measure from the world."*[7] Typical statements in the *Herald* announced the availability of *"a beautiful assortment of European and India goods"* and *"a consignment of Looking Glasses"* from New York, or outlined a proposal *"to run a stage from Sagg Harbour to New York weekly."*

Huntington and Hempstead also became local centers of communication and trade, each publishing their own newspaper by the late 1820's. Notices in these papers advised readers of the establishment of a stage route between Smithtown and Brooklyn or appealed for the construction of turnpikes, such as the route proposed between Flushing and Huntington.

The development of western Long Island towns was affected by their proximity to New York, particularly as that port city became increasingly active as a focal point for foreign and interstate trade. The village of Brooklyn (No. 182) increased in population from about 5,200 in 1820 to 15,000 inhabitants in 1830, and even Timothy Dwight was forced to admit that Jamaica had *"acquired a polish not visible in the towns further eastward"* because of *"its neighborhood to New York and from having long been a customary resort for the inhabitants of that city."*[8]

Social and economic change influenced Long Island's decorative arts history in both obvious and subtle ways. No longer was it necessary to travel to New York or to trust an agent to obtain furnishings. Merchants like Samuel L'Hommedieu in Sag Harbor or Silas White in Bridgehampton now offered looking glasses and

180. *A Chart of the Port of Sag Harbor,* ca. 1800
Sag Harbor
Ink on paper
Private collection

The port town of Sag Harbor as it appeared about 1800 is accurately represented in this crude sketch, possibly executed by a visiting seaman since the German word *"Housen"* is used instead of the English *"houses."* Distinguishable structures along the waterfront include William Rysam's wharf and salt works (No. 197) and the main ropewalk. The houses depicted with sketches run along Division Street and some still stand.

181. *Light House on Sands Point,* 1809–1820
Sands Point
Watercolor, ink on paper
H. 9 5/8 W. 14 3/8
Society for the Preservation of Long Island
Antiquities, 59.22

The Sands Point lighthouse and adjoining
keeper's house were built in 1809. The structures
remained in service until 1924 and they still stand
today. The lighthouse was probably a local point
of interest and according to this primitive water-
color also functioned as an inn. The construction
of numerous lighthouses along the coast of Long
Island during the early nineteenth century is evi-
dence of increased shipping activity.

182. *Summer Scene, Brooklyn,* ca. 1820
Francis Guy (ca. 1760–1820)
Oil on canvas
H. 42 3/4 W. 66 1/4
The Long Island Historical Society, Brooklyn

Brooklyn's rapid growth in the nineteenth cen-
tury resulted in interesting juxtapositions of eigh-
teenth century Dutch farmhouses with newer
Federal style buildings. One of the shops depicted
in the view of Front and James Streets was that of
Benjamin Meeker, house carpenter and joiner.

furniture for sale which they imported from New York. The appeal of such
merchandise was evident in the numerous advertisements which began *"just
received from New York."*

The greater availability of presumably sophisticated and stylish city-made
objects resulted in increased competition for local markets. A number of Long
Island cabinetmakers advertised that they had employed *"first rate workmen from
the city of New York,"* obviously believing that the announced presence of urban-
trained workers in their shops would promote business. Nathan Tinker, a Sag
Harbor cabinetmaker, stated in 1822 that he would sell *"a large assortment of
articles . . . five percent cheaper than . . . in New York,"*[9] while William V. Smith of

154

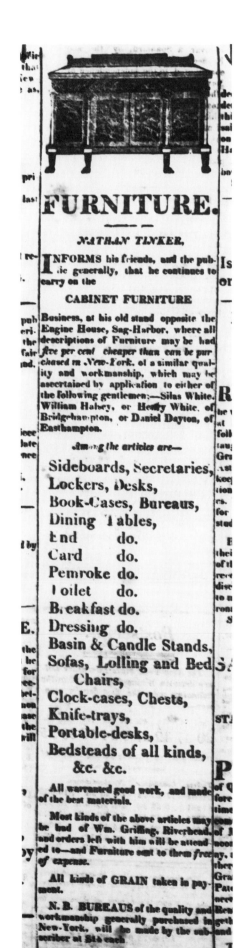

FURNITURE.

NATHAN TINKER,

INFORMS his friends, and the public generally, that he continues to carry on the

CABINET FURNITURE

Business, at his old stand opposite the Engine House, Sag-Harbor, where all descriptions of Furniture may be had five per cent cheaper than can be purchased in New-York, of a similar quality and workmanship, which may be ascertained by application to either of the following gentlemen:—Silas White, William Halsey, or Henry White, of Bridge-hampton, or Daniel Dayton, of Easthampton.

Among the articles are—

Sideboards, Secretaries,
Lockers, Desks,
Book-Cases, Bureaus,
Dining Tables,
End do.
Card do.
Pembroke do.
Toilet do.
Breakfast do.
Dressing do.
Basin & Candle Stands,
Sofas, Lolling and Bed
 Chairs,
Clock-cases, Chests,
Knife-trays,
Portable-desks,
Bedsteads of all kinds,
 &c. &c.

All warranted good work, and made of the best materials.

Most kinds of the above articles may be had of Wm. Griffing, Riverhead, and orders left with him will be attended to—and Furniture sent to them free of expense.

All kinds of GRAIN taken in payment.

N. B. BUREAUS of the quality and workmanship generally purchased in New-York, will be made by the subscriber at $16 each.

Brooklyn advertised in 1826 that he could produce chairs *"to equal in strength and beauty . . . any in the Union,"* which he would sell *"cheap, if not cheaper than the New York prices."* [10]

With the growth of towns and new competitive pressures, the craft system on Long Island eventually became more intensively business oriented, with firms, partnerships, and *"manufactories"* being established and with craftsman actively devoting themselves to the marketing of their products. Saleability increasingly required the production of more stylish or specialized forms. Numerous windsor and fancy chair shops were established during this period, and a craftsmen like Joseph Van Nostrand of Brooklyn, although calling himself a carpenter-joiner, also advertised a special service, the manufacture of *"Book Binders, presses, Printing Presses . . . Jullers presses, copper-plate presses, etc."* [11] Silversmiths and jewelers, like Samuel Smith of Brooklyn and Elijah Simons of Sag Harbor, produced their own metalwork, frequently made and repaired jewelry, watches, and clocks, and sold imported wares as well. Simons' success was such that he employed the East Hampton clockmaker, Felix Dominy, beginning in 1820 to produce clock gears. [12]

Concentration on one aspect of business, such as cabinetmaking, rather than woodworking in general, or the employment of individual specialists within a larger firm were also significant developments during this period. For the previous 150 years the multi-talented carpenter-joiner had supplied the woodworking needs of his community—building homes, repairing tools, making furniture, and supplying dozens of small household articles. With the growth of towns and the greater availability of fashionable but inexpensive imported furnishings, only specialized shops could, in the long run, compete successfully. One has only to glance at the account book of Sullivan Cook, a Bridgehampton carpenter-joiner, and compare the few basic furniture forms he produced from 1807 through the 1830's with the variety of specialized items advertised by Sag Harbor cabinetmakers to understand the dilemma faced by many of the traditionally trained craftsmen. While Cook made chests, desks, and rocking chairs, and altered *"Draws into Burrows,"* [13] the Sag Harbor entrepreneur Nathan Tinker offered sideboards, bookcases, *"Dining/ End/ Card/ Pembroke/ Toilet/ Breakfast/ [and] Dressing"* tables among many other forms. [14]

The period 1782–1830 marked the beginning of the commercialization of the craft system on Long Island. The process was gradual and a complete transformation did not occur before 1830. Eighteenth century traditions were slow to change in a predominantly rural environment, and many customers still bought conservatively while some craftsmen continued to operate in familiar ways, combining carpentry with cabinetry and producing forms and styles that were outmoded by urban standards. The craft system, however, was changing and the characteristic pattern of eighteenth century craftsmanship was coming to an end.

[1]Frederic Gregory Mather, *The Refugees of 1776 from Long Island to Connecticut* (Albany, N.Y.: J. B. Lyon Company, 1913) deals with this subject in depth.
[2]Letter, Sylvester Dering to Mrs. Monk, July 15, 1783, East Hampton Free Library, East Hampton, New York.
[3]John Paine Account Book, December 3, 1783, microfilm reel S, Institute for Colonial Studies, State University of New York at Stony Brook, Stony Brook, New York.
[4]William Strickland, *Journal of a Tour in the United States of America, 1794–1795,* ed. by Rev. J. E. Strickland (New York: The New-York Historical Society, 1971).
[5]Timothy Dwight, *Travels in New England and New York* (4 vols.; London: Printed for William Baynes and Son et. al., 1823), III, 234.
[6]*The Long-Island Journal of Philosophy and Cabinet of Variety* (Huntington, N.Y.: Published by Samuel Fleet, 1826), p. 2.
[7]Dwight, *Travels, op. cit.,* pp. 218, 234.
[8]*Ibid.,* p. 227.
[9]Advertisement, *The Corrector,* August 3, 1822.
[10]Advertisement, *Long Island Star,* August 10, 1826.
[11]*Ibid.,* October 19, 1826.
[12]Charles F. Hummel, *With Hammer in Hand: The Dominy Craftsmen of East Hampton, New York* (Charlottesville, Va.: The University Press of Virginia, 1968), pp. 226—227.
[13]Sullivan Cook Account Book, December 29, 1813, Suffolk County Historical Society, Riverhead, New York.
[14]Advertisement, *The Corrector,* January 18, 1823.

THE GARDINER FAMILY OF GARDINER'S ISLAND

One of the wealthiest and most prominent families on Long Island during the Revolutionary and post-Revolutionary periods was the Gardiner family of Gardiner's Island. In 1640, Lion Gardiner (ca. 1599–1663) acquired and settled on the 3,300 acre island situated at Long Island's east end between the north and south forks, which he named the Isle of Wight. Lion Gardiner's son, David (1636–1689), secured a patent establishing the Island as an independent manor in 1686. Successive generations of Gardiners improved the land, raising a variety of crops and livestock. The family developed close personal and business ties with Connecticut, trading primarily with Connecticut towns and marrying into several prominent Connecticut families, including the Griswolds and the Saltonstalls. The surviving account books kept by David Gardiner (1738–1774), the sixth proprietor of Gardiner's Island, and his son, John Lyon Gardiner (1770–1816), provide extensive information about these two influential members of the family, particularly about their taste in furnishings and their patronage of craftsmen. The accounts and the extant Gardiner family furniture and silver document the variety of regional sources available to the Gardiners and the eclectic mixing of objects which resulted.

David Gardiner graduated from Yale College in 1759 and five years later assumed the management of the family properties. As a wealthy landholder, Gardiner must have had a strong sense of his own position in the community. He apparently wished to live in fashionable surroundings for he began construction of a suitably large and impressive *"mansion house"* to replace the earlier structures on the Island in 1774. He hired carpenters from Huntington—John Carll, John Smith, Selah Hubbs, and Samuel Haviland—to build the house and secured a Connecticut mason, Daniel Chittenden, to lay the stone foundation.

Possibly in preparation for furnishing his new house, Gardiner purchased a number of pieces of furniture, many of them from East Hampton craftsmen, during the early 1770's. In 1773, Ruben Hedges of East Hampton made a table, a chair, and a spinning wheel for Gardiner. Another local joiner, David Baker, supplied a tea table and a bed post. Gardiner also paid Obediah Jones £20 for *"cabnet work,"* a looking glass, and for *"bottoming"* six chairs. David may have acquired some of the impressive Gardiner family furniture which survives, perhaps ordering the Thomas Townsend chest-on-chest (No. 188) through Aaron Isaacs, the East Hampton merchant who provided him with six mahogany chairs *"from Nantucket"* in 1772. Gardiner may also have purchased several pieces of furniture in Connecticut where he owned land and maintained business connections (Nos. 186–187).

For silver Gardiner turned to a local craftsman, the Southampton silversmith Elias Pelletreau. Among his purchases were a teapot, a milk pot, sugar tongs, spoons, several chains of gold beads, and a *"pare of Jewells."* Gardiner's satisfaction with local products suggests an attachment to the traditional values of the locale despite an awareness of and interest in fashionable trends.

David Gardiner died the same year that he began construction of his mansion house. In his will dated 1774, he provided that the income from the renting of farms on the Island be used for the completion of the house. The inventory of his estate provides little specific information about his household furnishings but documents his substantial wealth. The total value of his personal property, excluding his house and land, was £3,338, and in addition he had invested more than £7,000 in bonds and notes.

John Lyon Gardiner was only four years old when he inherited Gardiner's Island from his father. He became the seventh proprietor when he reached his maturity in 1791. He graduated from the College of New Jersey, later Princeton, and he valued intellectual pursuits throughout his life. He amassed a substantial library at Gardiner's Island and wrote a brief history of nearby East Hampton. A student of the natural history of his island, John Lyon corresponded with the famous ornithologist, Alexander Wilson, on subjects of common interest.

184. Lantern Clock, ca. 1690
John Cutbush (active ca. 1700)
Maidstone, England
Brass
H. 14 1/2 W. 6 1/2 D. 6
Mr. Robert D. L. Gardiner

Many of the first East Hampton colonists origi-
nally came from Maidstone, England, and it is
possible that the Gardiners acquired this clock
through one of several marriages into East
Hampton families. A late eighteenth century tall-
case clock also owned in the Gardiner family was
made by *R. Cutbush* of Maidstone, England.

185. Mourning Ring, 1751
Gold, paste gem
Unmarked
East Hampton Free Library

Mourning rings were traditionally given to mem-
bers of the funeral party. This ring, inscribed
DAVID GARDINER 1751, was made at the time
of the death of David Gardiner (1691–1751),
the fourth proprietor of Gardiner's Island.

186. High Chest of Drawers, 1750–1800
Hartford County or New London County,
Connecticut
Cherry, pine, chestnut
H. 92 W. 43 1/2 D. 21 1/2
Mr. Robert D. L. Gardiner

Although the exact line of descent of this high
chest of drawers in the Gardiner family is
unknown, it was apparently owned on Gardiner's
Island. It is related in design to several case pieces
of furniture made in Litchfield and Hartford
Counties, yet is not exactly like any of them.
While the central finial rests on a plinth with
curled ends also found on a chest attributed to
the Booth family of Southbury, Connecticut, the
lower shell with dentiled surround also appears
on a high chest with a Suffield, Connecticut his-
tory. Since the Gardiners' commercial and family
ties were primarily with the Connecticut River
Valley area and New London, Hartford or New
London Counties seem the most logical prove-
nance for this example.

Refs.: Barry A. Greenlaw, *New England Furniture at
Williamsburg.* Williamsburg, Va., The Colonial Wil-
liamsburg Foundation, 1974, pp. 94–96.
John Kirk, *Connecticut Furniture, Seventeenth and
Eighteenth Centuries,* Hartford, Conn., Wadsworth
Atheneum, 1967, p. 54.

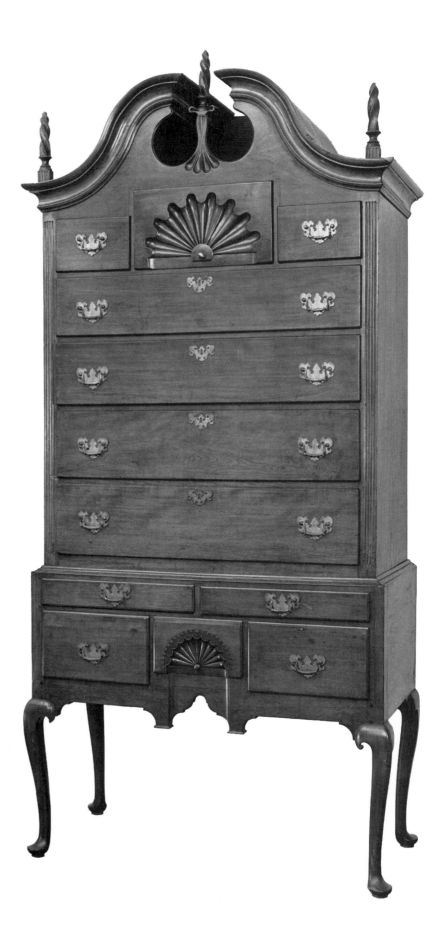

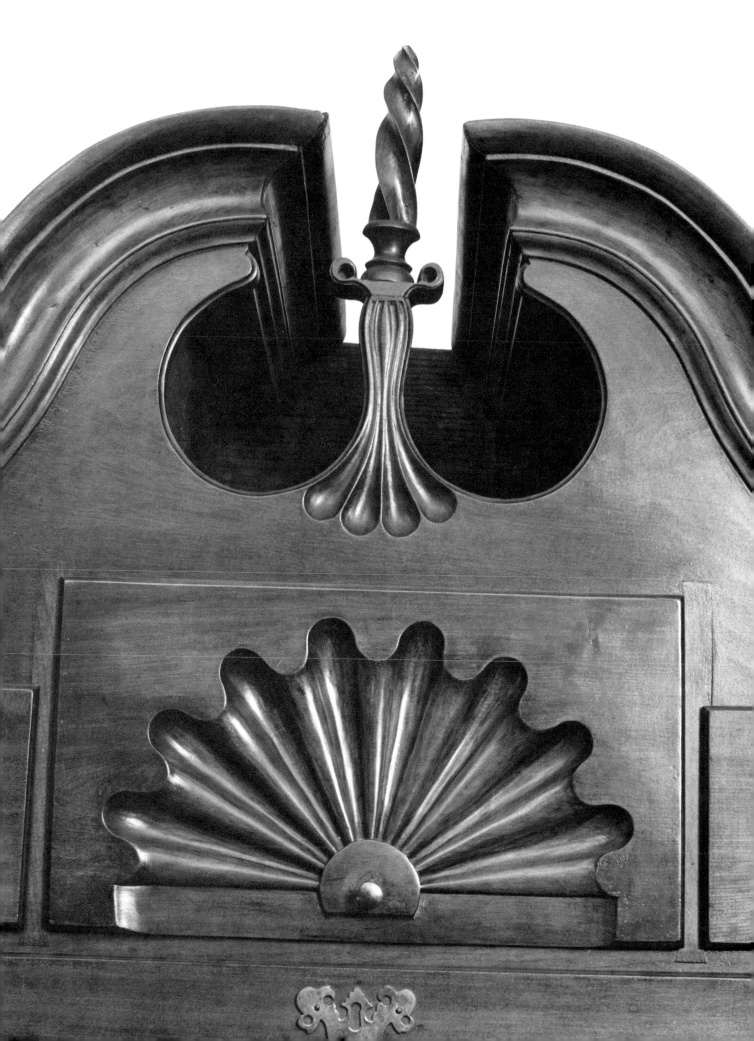

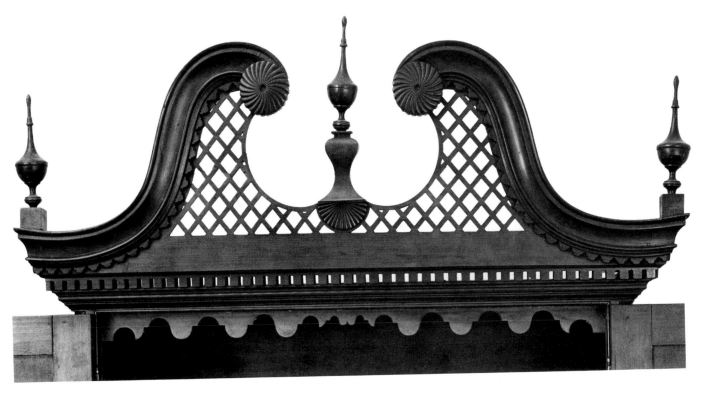

187. Desk and Bookcase, 1770-1800
Hartford County, Connecticut
Cherry, pine
H. 89 1/2 W. 39 1/2 D. (closed) 22 1/2
Mr. Robert D. L. Gardiner

Inventiveness and originality of composition make this an outstanding statement of Connecticut furniture design. Several of the decorative features seen here, including the engaged quarter-columns and pierced fretwork pediment, have been associated with the East Windsor, Connecticut cabinetmaker, Eliphalet Chapin (1741-1807). More recently, these characteristics have been linked with furniture of the Hartford area in general.

As one can see in the detail photograph, the unusual rounded and scalloped dentiling which follows the curve of the scrolled pediment is repeated in larger scale on the front of the shelves of the bookcase section. This same motif appears on a clock with a Stonington-Norwich area history. The interior retains a marvelous orange-pink paint. The treatment of the lower course of dentiling which runs across the front and around the sides is also extraordinary as it is actually cut-out to heighten the effect of alternating projecting and receding spaces. The circular fans of the pediment have their counterpart in a larger but similar motif on the central drawer of the desk compartment.

It is possible that David Gardiner owned this desk and bookcase, but his son, John Lyon, may also have purchased it or acquired it through his wife Sarah Griswold, the niece of a former Connecticut governor, Roger Griswold.

Ref.: John Kirk, *Connecticut Furniture, Seventeenth and Eighteenth Centuries*, Hartford, Conn., Wadsworth Atheneum, 1967, pp. 62, 75.

After acquiring the family property, Gardiner set about improving and remodelling his house. In 1796, Nathaniel Dominy and Samuel Schellenger installed new cherry bannisters, and in 1800 Gardiner ordered marble slabs from New York for the dining room fireplace. Apparently planning to repaint the interior of the house, he entered the following memorandum in his notebook in 1802:

"*Aug. 3ᵈ 1802 Mem. to paint*
New Chamber & my bedroom white
Further Room Green —
Front Ladies Chamber light green
Dining Room - Green -
Lower entry
Above dᵒ } *stone colour*
Mrs. Wordens room
On my bedroom same colour as Dining room —."

A man of wealth, status, and learning, Gardiner had a taste for sophisticated furnishings and decorative objects. He acquired a number of pieces of furniture from New York City, including a sideboard, a looking glass, a sofa, a carpet, and a mahogany bedstead which, he instructed, was to be "*plain neat and fashionable. . . .*" In 1797, Gardiner ordered two Liverpool pitchers from England and he requested that they be decorated with the family coat of arms "*and the name John Lyon Gardiner, Esq., Isle of Wight.*" He secured bookplates from the Boston silversmith, Paul Revere (1735-1818), and when he decided to have the family arms engraved on a pitcher made by John Pelletreau in 1802, he commissioned Amos Doolittle (1754-1832) of New Haven, Connecticut, to do the engraving.

Yet, like his father, John Lyon Gardiner faithfully patronized a number of local craftsmen. James Howell of Sag Harbor made eighteen chairs, a stand, and a bedstead for Gardiner in 1801. Isaac Wickham of East Hampton supplied a table and a knife box. Gardiner offered the largest share of business to Nathaniel Dominy V. Entries in both the Dominy and Gardiner account books between 1791 and 1816 document Gardiner's purchase of everything from chairs to desks including such special items as a "*Clotheshorse*" and two picture frames. One of the most ambitious commissions Dominy received was that for a maple desk and bookcase still owned in the family and possibly patterned after the design of the Rhode Island chest-on-chest (No. 188).

Gardiner also purchased flatware and hollow ware from local silversmiths. Elias Pelletreau fashioned a tankard for Gardiner in 1791 (No. 191) and his son, John, made a porringer in 1802 (No. 192). John Chatfield Hedges of East

160

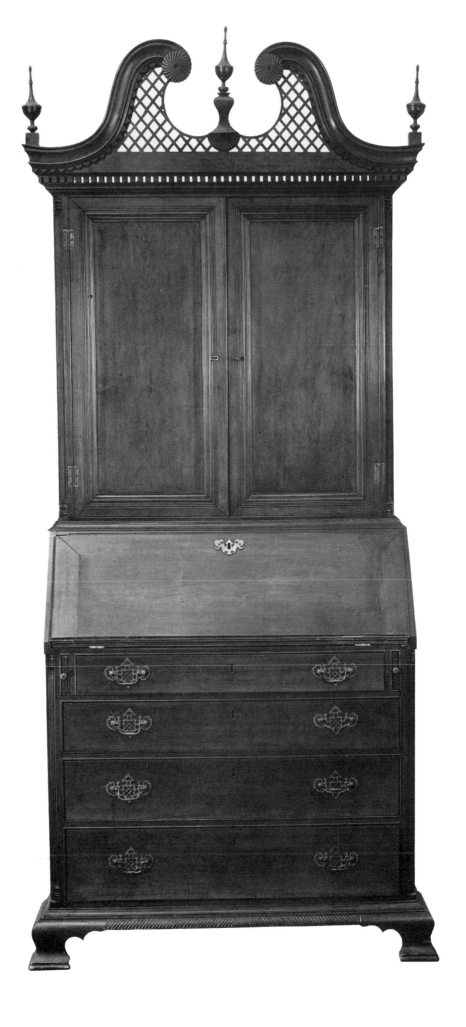

188. Chest-on-Chest, 1760–1774
Thomas Townsend (1742–1827)
Newport
Mahogany, chestnut, tulip poplar
H. 36 3/4 W. 44 D. 21 3/8
Mr. Robert D. L. Gardiner

The Gardiners' taste in furnishings was eclectic. They patronized local craftsmen as well as New York and Connecticut cabinetmakers, and this chest-on-chest documents yet another source of furniture for the family. Significantly, a handwritten label is affixed to the inside of the top drawer of the lower section. It reads: *Made by/Thomas Townsend/Newport/Rhode Island.*

Although a member of the famous Newport cabinetmaking family, Thomas Townsend (1742–1827) is not a well-known figure. This chest-on-chest is the only labelled example of his work located thus far. With the exception of the missing cup bases for the side finials, it is identical in all respects to a privately owned chest-on-chest probably made for Moses Brown of Providence. Both chests have the same original brasses and hidden wooden spring locks on the two top drawers. Chestnut is also a secondary wood in both examples. If David Gardiner, the sixth proprietor of Gardiner's Island, was the original owner of this example, Townsend would certainly have made this chest-on-chest before Gardiner's death in 1774. This approximate date lies within the period when Thomas Townsend, who later became an innkeeper, was actively engaged in cabinetmaking.

Refs.: Ethel Hall Bjerkoe, *The Cabinetmakers of America,* New York, Bonanza Books, 1957, p. 218.
Joseph K. Ott, "Some Rhode Island Furniture," *Antiques,* May, 1975, pp. 942–943.

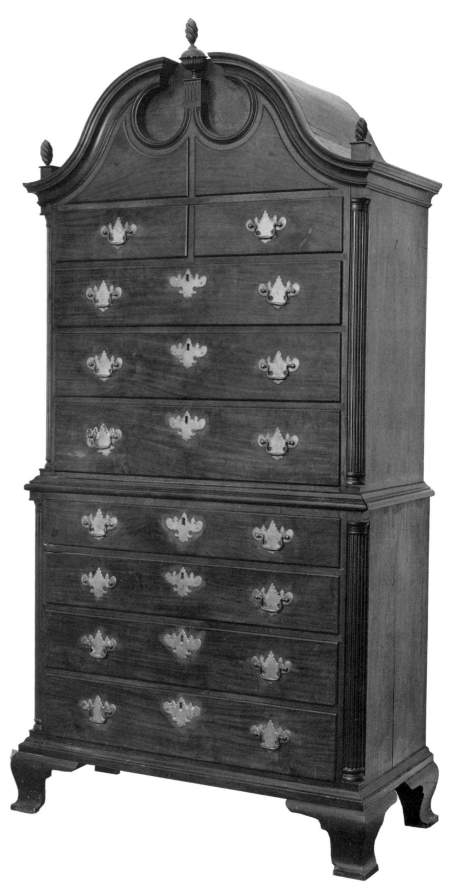

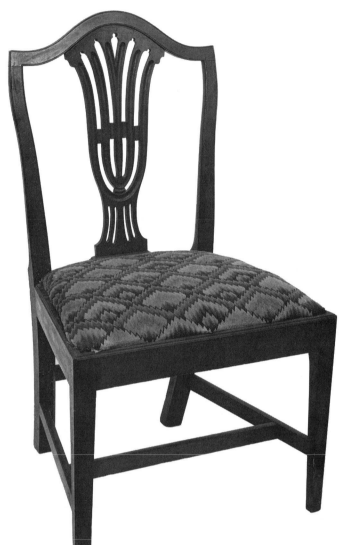

190. *John Lyon Gardiner,* ca. 1810
Artist unknown
Oil on canvas
Mr. Robert D. L. Gardiner

189. Side Chair (one of four), 1785–1810
Probably Connecticut
[Cherry?]
H. 38 1/4 W. 21 5/8 D. 20 1/8

Mr. Robert D. L. Gardiner

Chairs of this type are associated with Connecticut and Rhode Island. During the late eighteenth and early nineteenth centuries, however, the Gardiners travelled to Connecticut frequently, and this fact substantiates a Connecticut attribution. The needlework seats are apparently original to the chairs and, according to family tradition, were the handiwork of Mary Gardiner Thompson (1748–1786), the daughter of Colonel Abraham Gardiner and the wife of Isaac Thompson of Islip. If this tradition is correct, it establishes an early date for the chairs corresponding to the period when flame-patterned Irish stitch needlework was popular.

Hampton made a sugar dish and creampot in 1796 and supplied Gardiner with two porringers in 1798. From David Hedges, Gardiner obtained spoons, buckles, a *"coco"* (coconut) dipper, and for his son, David Johnson Gardiner *"50 gold beads"* and a silver cup. Benjamin Coleman, a Sag Harbor silversmith, also made a three-pint pitcher and several rings.

Although John Lyon Gardiner was by far the wealthiest individual in East Hampton, his taste in furnishings was typical of a general and widespread pattern of patronage on Long Island after the war whereby many residents selectively obtained some furnishings from local craftsmen while importing more sophisticated items. The apparent dichotomy between a growing awareness and availability of fashion on the one hand and a certain satisfaction with traditional forms and local craftsmanship on the other was a central theme during this period.

Refs.: David Gardiner Account Book, 1770–1799, East Hampton Free Library, East Hampton, New York.
John Lyon Gardiner Account Book, 1791–1793, East Hampton Free Library, East Hampton, New York.
John Lyon Gardiner Journal and Farm Book, 1793–1807, East Hampton Free Library, East Hampton, New York.
John Lyon Gardiner Day Books, 1797–1801, 1801–1807, East Hampton Free Library, East Hampton, New York.
John Lyon Gardiner Notebooks, 1801–1802, 1808–1809, East Hampton Free Library, East Hampton, New York.
John Lyon Gardiner, "Gardiner's East Hampton," *Collections of the New-York Historical Society* (New York: Printed for the Society, 1869), pp. 223–276.
Charles F. Hummel, *With Hammer in Hand: The Dominy Craftsmen of East Hampton, New York,* Charlottesville, Va., The University Press of Virginia, 1968, pp. 289–291, 301–303, 323–324, 327–332.

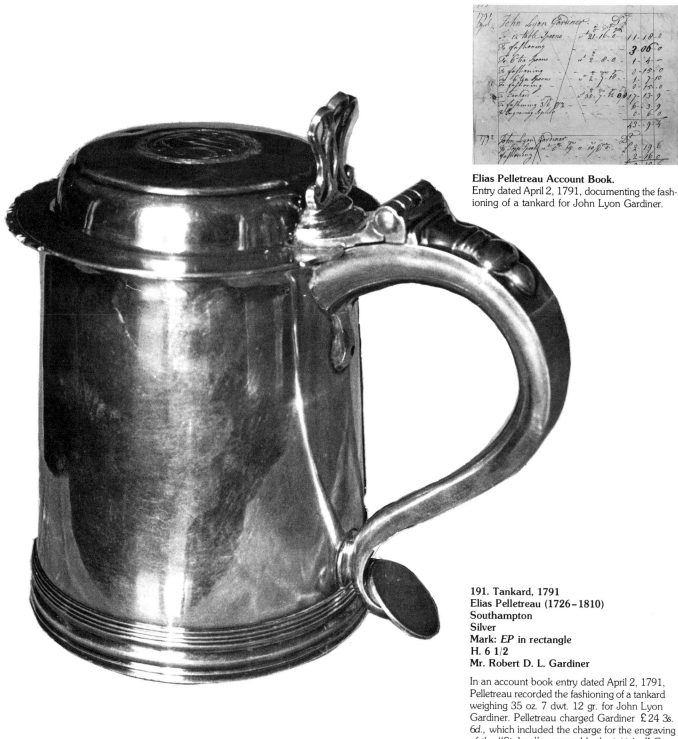

191. Tankard, 1791
Elias Pelletreau (1726–1810)
Southampton
Silver
Mark: *EP* **in rectangle**
H. 6 1/2
Mr. Robert D. L. Gardiner

In an account book entry dated April 2, 1791, Pelletreau recorded the fashioning of a tankard weighing 35 oz. 7 dwt. 12 gr. for John Lyon Gardiner. Pelletreau charged Gardiner £24 3s. 6d., which included the charge for the engraving of the "Sipher," presumably the initials *JLG* on the lid. A corresponding entry, dated April 22, 1791, in John Lyon Gardiner's account book confirms the purchase.

The date *1792,* which is engraved on the base, was added in the nineteenth century. Perhaps the Gardiner family intended to indicate the year in which John Lyon Gardiner attained his majority, but the correct date was actually 1791.

Most significantly, the tankard reflects the conservative aspect of Gardiner's taste and the traditional character of life on eastern Long Island. Not only is this a late date for the fashioning of this type of hollow ware, but the style of the tankard is out-of-date and comparable to examples made before 1750.

192. Porringer, 1802
John Pelletreau (1755–1822)
Southampton
Silver
Mark: *EP* **in rectangle**
L. 8 1/8
Private collection

On January 20, 1802, John Lyon Gardiner
wrote the following entry in his day book: *"John
Peltreau I wish you to make for me two silver
porringers to middling sise with the Citter JLG: &
1802 on them to be sent to J Dayton where your
money will be."*

A corresponding entry in Pelletreau's
account book documents his fashioning of the
porringers, which together weighed 16 oz. 6 dwt.
and cost Gardiner £11 15s., including £3 12s.
for workmanship. This surviving porringer is thus
completely documented. Interestingly, it bears
the touchmark of Elias Pelletreau, although John
was apparently the maker.

193. Mantle Garniture
China
Porcelain
H. (covered vase) 11 1/2
Mr. Robert D. L. Gardiner

Garniture sets were purely ornamental. The Gar-
diners, like many Long Island families, became
involved in whaling and shipping ventures which
led to their acquisition of objects from the China
trade such as Chinese porcelain. A Chinese
export Empire style ebony sofa has also
descended in the Gardiner family.

194. Side Chair, 1780–1810
Islip
Mahogany
H. 36 3/4 W. 21 7/8 D. 21
The Valentine House, Roslyn

Similar chairs are found in New Jersey and Con-
necticut as well as on Long Island. Although
made in the Chippendale style, these chairs prob-
ably date from the last few decades of the eigh-
teenth century. The inscription *Wm. Mott* in
black paint appears on the inside of the seat frame
of this example. Whether this inscription identifies
the maker or the owner is not known, but the
Mott family was living in Islip by the end of the
eighteenth century. A similar chair, originally
owned by Dr. Richard Udall (1752–1841) of
Islip, was reportedly made by an Islip *"casket
maker."*

195. Side Chair, 1790–1810
Probably Connecticut or Rhode Island
[Mahogany ?]
H. 38 W. 20 7/8 D. 19 3/4
Private collection

As with No. 189, it is difficult to attribute this side chair either to Connecticut or Rhode Island. Unfortunately, the history of ownership in the Youngs family of Oyster Bay only complicates the question since Oyster Bay families had connections with Connecticut and Rhode Island. It is possible that an Oyster Bay craftsman made the chair, especially since a pair of similar chairs have a definite Oyster Bay history.

196. Windsor Armchair, 1789–1812
Isaac Kitchell (active ca. 1789–1812)
New York City
H. 35 1/4 W. 21 1/2 D. 24 3/4
Private collection

Windsor chairs were popular on Long Island and used in almost every room of the house, although the term *"windsor chair"* does not generally appear in Long Island inventories of estates until the 1790's. Advertisements in newspapers and occasional entries in craftsmen's account books document the local manufacture of these chairs but many were also imported from New York. The discovery of several examples branded *I^c. Kitchel* on eastern Long Island suggests that he sold his chairs through an agent, possibly in Sag Harbor.

197. Windsor Armchair, 1794
Nathaniel Dominy V (1770–1852)
East Hampton
Mahogany
H. 28 1/2 W. 22 D. 15 1/2
Private collection

Nathaniel Dominy V made a set of windsor armchairs in November, 1794, for Captain William Johnson Rysam of Sag Harbor. After family intermarriage in the nineteenth century, the set descended in the Dering family. Four chairs from the set have been located, and one signed and dated example has previously been published. They are all owned by Dering family descendants.

Interestingly, the medial stretchers on three of the four chairs are of different design. The author has personally examined only one of the three recently located examples, but photographs indicate that at least one other chair has the inscription, *Nov^r 11, 1794, WR* chiseled under the seat.

Family tradition indicates that the set originally consisted of nine chairs. The inventory of Rysam's estate, however, lists only two sets of six chairs each, both sets having a total appraised value of 48s.

Ref. Charles Hummel, *With Hammer in Hand: The Dominy Craftsmen of East Hampton, New York,* Charlottesville, Va., The University Press of Virginia, 1968, pp. 252–253.

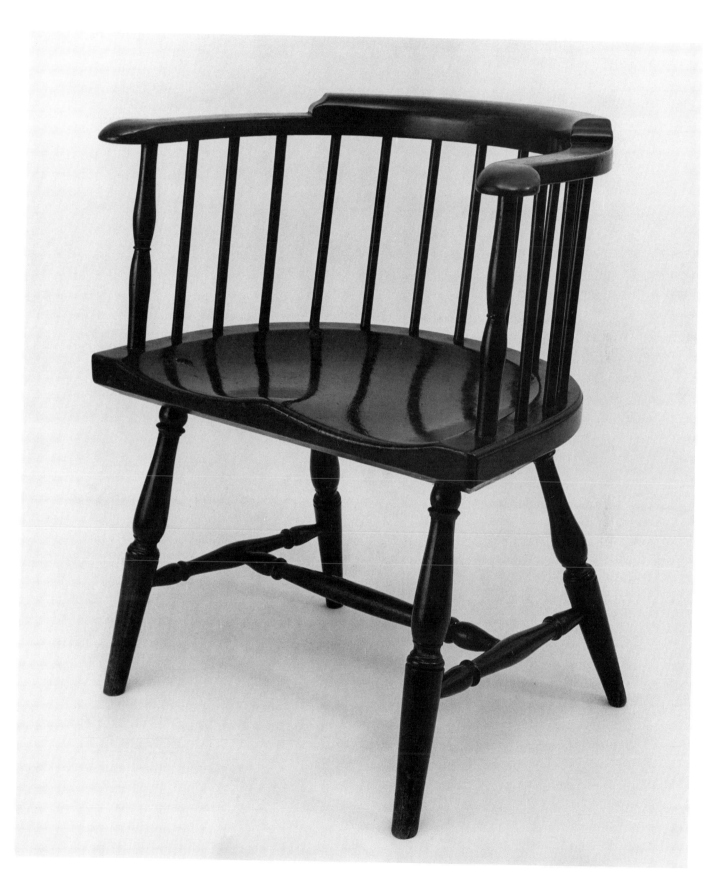

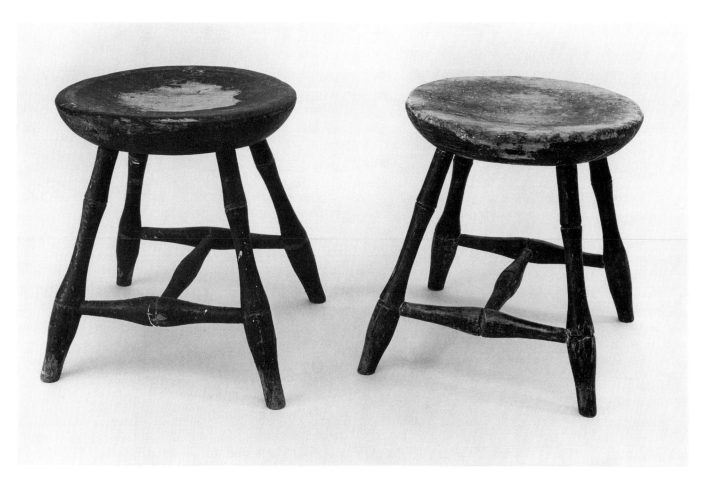

198. Pair of Stools, 1800–1820
Sag Harbor
Pine
H. 12 5/8 W. 12 1/4 D. 12 1/4
Society for the Preservation of Long Island
Antiquities, 70.31.5

These simple, bamboo-turned windsor stools bear the conjoined *HPD* brand of their original owner, Henry Packer Dering (1763–1822), first customs officer and postmaster of Sag Harbor. He was the son of Thomas and Mary Sylvester Dering, whose portraits are illustrated in this catalogue (Nos. 66, 69). These stools were undoubtedly made in one of the several chair-making or cabinetmaking establishments in Sag Harbor.

199. Armchair, 1810–1820
Sag Harbor or New York City
Maple, pine
H. 33 1/4 W. 21 1/2 D. 18
Private collection

Fancy chairs were often made in the same shops as windsor chairs but unlike the universal windsors were intended for use in the best rooms. The painted and gilt decoration on these chairs assumed many forms. This example, originally part of a larger set owned by Henry Packer Dering of Sag Harbor (Nos. 198, 200), was grained to resemble rosewood.

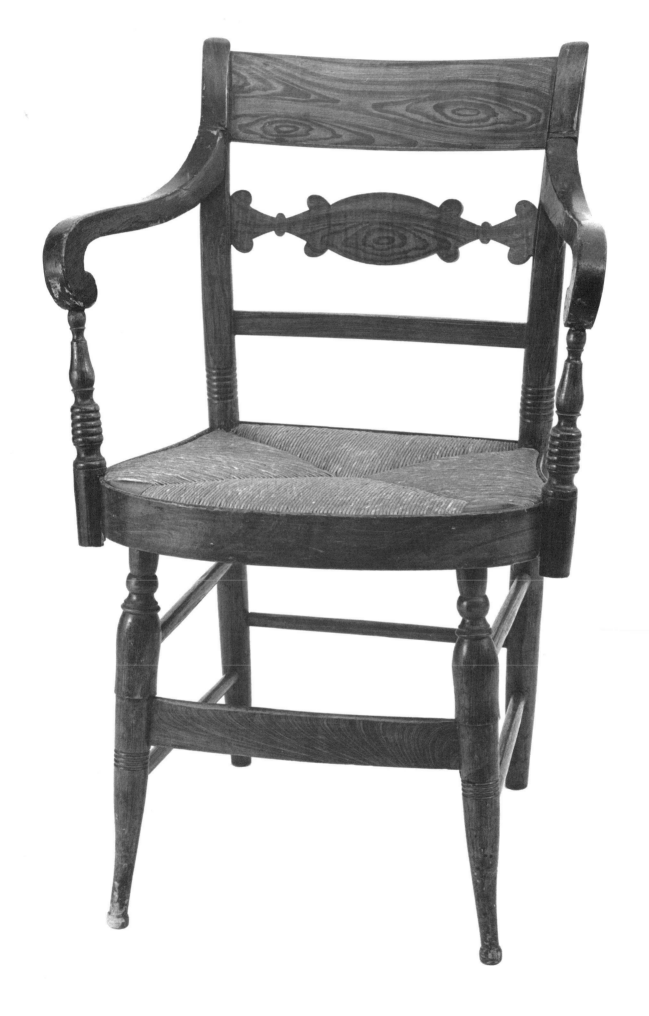

200. Easy Chair, ca. 1806
New York City or Sag Harbor
Mahogany
H. 34 3/4 W. 24 1/2 D. 31
Society for the Preservation of Long Island
Antiquities, 70.31.3

Thomas Sheraton referred to the bergère form of low-backed easy chair as a *"cabriole armchair stuffed all over."* The French origin of this type of design is especially evident in the styling of the legs. Henry Packer Dering (1763–1822) was probably the original owner of this chair, which has the date *1806* inscribed on the frame.

Ref.: *Thomas Sheraton's Cabinet Dictionary,* vol. I, *Praeger Reprints on Arts, Crafts, and Trades,* ed. by Charles F. Montgomery, New York, Praeger Publishers, 1970, p. 19.

201. Sofa, 1805–1815
New York City
Mahogany
H. 37 1/2 W. 78
Society for the Preservation of Long Island
Antiquities, gift of Miss Alice Lawrence, 68.6

Elizabeth Woodhull Smith (1762–1839), the daughter of General Nathaniel Woodhull and Ruth Floyd and the wife of John Smith, was the original owner of this sofa. It is a classic example of the best New York furniture design of the first decade of the nineteenth century. Swags of drapery and tied sheaves of wheat are carved on the upper back rail and these motifs appear on several related sofas. None of the examples, however, can definitely be attributed to the workshop of Duncan Phyfe.

Refs.: Helen Comstock, *American Furniture,* New York, The Viking Press, 1962, No. 534.
Charles F. Montgomery, *American Furniture, The Federal Period,* in *The Henry Francis du Pont Winterthur Museum,* New York, The Viking Press, 1966, pp. 310–312.

202. Stand, 1800–1830
Oyster Bay
Mahogany
H. 29 Diam. (of top) 23 1/4
Private collection

Stands of this basic design with "spider legs" were found throughout Long Island from about 1800–1830. While many of these tables, which illustrate endless variations in the turnings of the pedestal, have been attributed to the Dominy family in East Hampton, it is obvious that other craftsmen were producing them as well. An Oyster Bay family originally owned this table.

203. Pembroke or Breakfast Table, 1790–1820
Queens County
Cherry
H. 27 7/8 W. (closed) 19 5/8 (open) 39 1/8
D. 34 1/2
Private collection

Small drop-leaf tables with leaves supported by fold-out brackets or wings hinged to the frame were popularly known as breakfast tables. The ovolo corners of the top and the tapered legs are typical Federal style features while the cross-stretcher is a retention from the Chippendale style. Even at this late date cherry rather than mahogany was used and accepted on western Long Island.

204. Chest of Drawers, 1790–1815
Suffolk County, possibly Sag Harbor
Cherry, tulip poplar
H. 36 5/8 W. 40 7/8 D. 20
Society for the Preservation of Long Island Antiquities, 76.2

By the early nineteenth century chests of drawers were commonly referred to as bureaus. Fashionable elements of the Federal style—the curved "French feet," the serpentine skirt, and line inlay—appear on this example. Originally obtained from a Shelter Island family, this chest may have been made in nearby Sag Harbor. The thick drawer sides and the outlines of the original rectangular brasses with notched corners close to the drawer ends indicate the work of a local cabinetmaker.

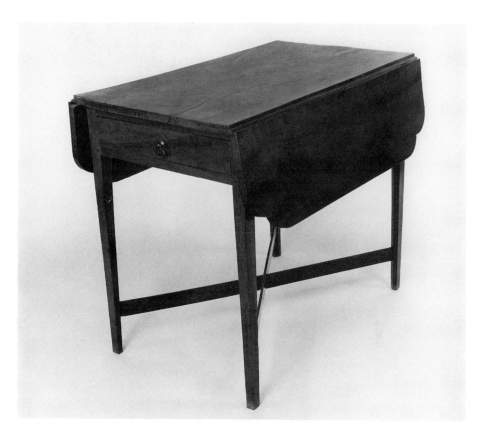

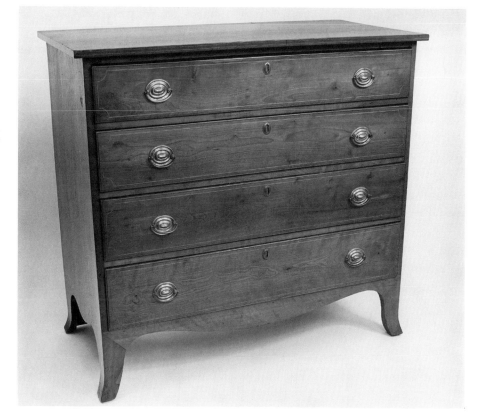

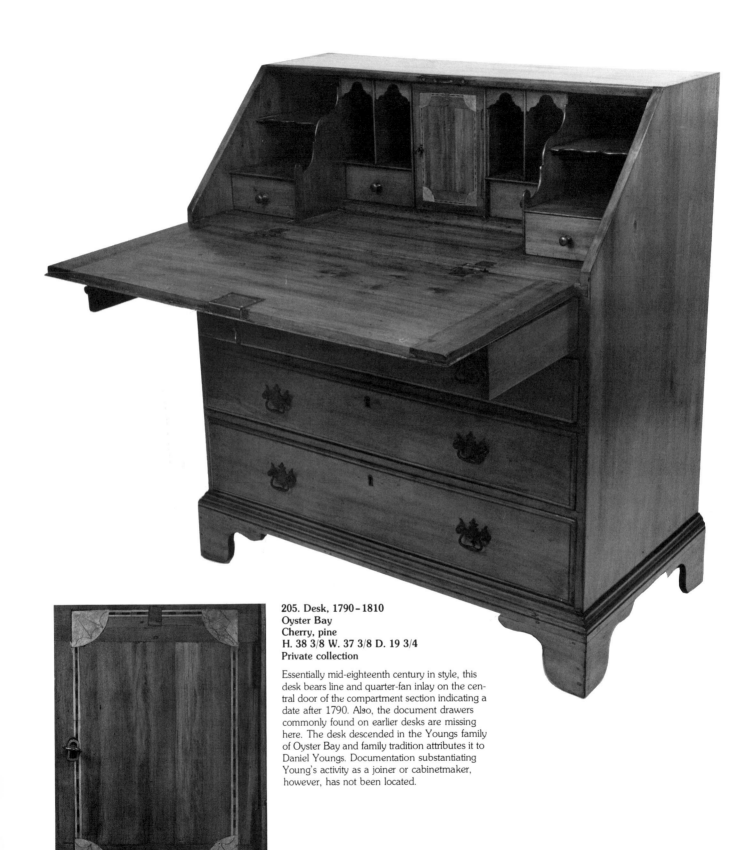

205. Desk, 1790–1810
Oyster Bay
Cherry, pine
H. 38 3/8 W. 37 3/8 D. 19 3/4
Private collection

Essentially mid-eighteenth century in style, this
desk bears line and quarter-fan inlay on the cen-
tral door of the compartment section indicating a
date after 1790. Also, the document drawers
commonly found on earlier desks are missing
here. The desk descended in the Youngs family
of Oyster Bay and family tradition attributes it to
Daniel Youngs. Documentation substantiating
Young's activity as a joiner or cabinetmaker,
however, has not been located.

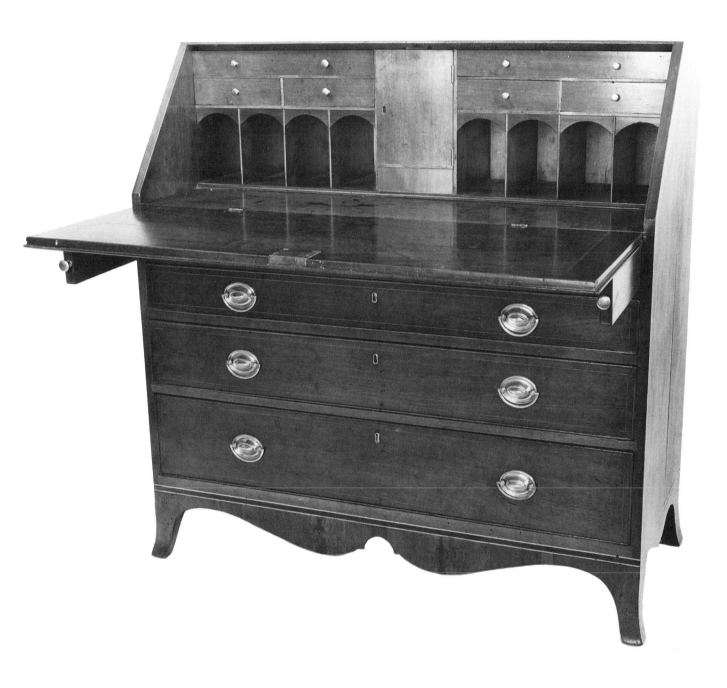

206. Desk, ca. 1800–1820
Suffolk County
Cherry, tulip poplar, chestnut
H. 43 1/8 W. 43 1/8 D. 19 7/8
Society for the Preservation of Long Island Antiquities, gift of Mr. and Mrs. Charles Niles, 965.13

Precise documentation of the introduction of the neo-classical furniture styles to eastern Long Island must await further research. Undoubtedly, local furniture suppliers and makers were importing and producing Federal style furniture by the 1790's. Nevertheless, local craftsmen like the Dominys were still making furniture in the Queen Anne and Chippendale styles at the end of the eighteenth century.

This desk is of local origin and is constructed of local woods. The simplistic use of line stringing or inlay and the false series of drawers on the left side of the interior compartment which conceal, in actuality, a single deep drawer, further suggest its rural provenance. The donors purchased the desk at an auction on Long Island's south fork. The Parsons family of the East Hampton-Amagansett area originally owned the desk, and according to family tradition, it was locally made.

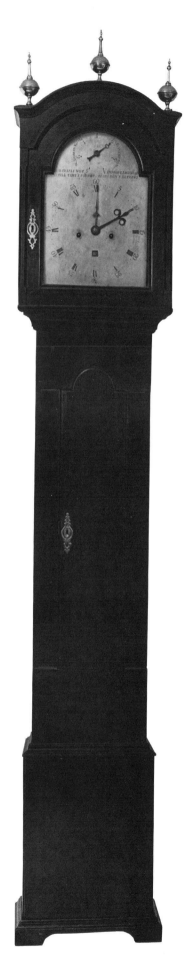

207. Tall-case Clock, 1790
Nathaniel Dominy IV (1737–1812)
East Hampton
Cherry, pine; pewter dial
H. 89 W. 17 D. 9 1/4
Society for the Preservation of Long Island
Antiquities, 75.14

The case of this previously unrecorded clock is related in appearance to some of the best examples of Dominy's work between 1780 and 1790. Similar to the Dominy family's treatment of other furniture made of cherry, the wood has been stained to produce a finish resembling walnut or mahogany. The original keyhole escutcheons and brass finials are unusual and probably reflect the preferences of the customer. The only clock listed in the Dominy accounts for 1790, the date which appears on the dial, was made for Aaron

Isaacs, an East Hampton merchant. The cost of the clock was £20, the same amount Dominy charged Thomas Baker for a similar eight-day strike and repeater clock made in 1787 and recorded in the accounts in 1788. It is possible, however, that this example is the clock which Nathaniel Dominy IV made for John Gardiner, entered in Dominy's accounts April 5, 1791. The pewter dial, made and engraved by Nathaniel IV, bears the inscription *O TRIFLE NOT/TILL TIME'S FORGOT:/IMPROVE EACH BEAT:/DEATH DON'T RETREAT*. In the late 1780's Nathaniel IV engraved several dials with sobering reminders of human mortality.

Ref.: Charles F. Hummel, *With Hammer in Hand: The Dominy Craftsmen of East Hampton, New York*, Charlottesville, Va., The University Press of Virginia, 1968, pp. 274–280, 282–284.

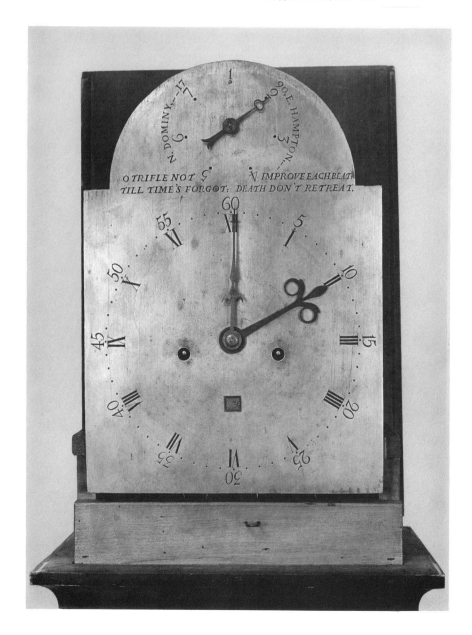

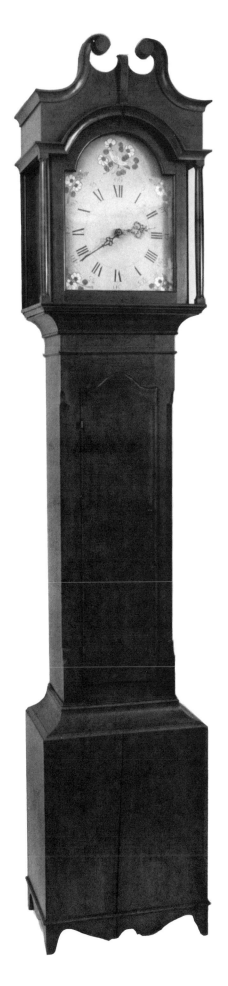

208. Tall-case Clock, 1790–1820
Setauket or Suffolk County (case)
Cherry, pine
H. 92 7/8 W. 18 1/4 D. 11 1/4
Private collection

The present owner obtained this clock from the closing of the estate of a member of the Mount family in Setauket over thirty years ago. According to tradition, the Mounts had owned the clock since about 1800. Documentation of this history of ownership appears in the first dated genre painting by William Sidney Mount (1807–1868), *Rustic Dance After a Sleigh Ride* (No. 209), executed in 1830, which shows the clock standing in the far corner of the room, probably the parlor of the Hawkins-Mount House in Stony Brook. The youthful figure surveying the scene from the portrait on the wall may be the artist himself.

An intriguing possibility as to the manufacture of the clock case is suggested in an 1809 advertisement of the Setauket cabinetmaking firm of Greene and Woodhull, which noted that *"clock cases of any description"* could be *"made of the best materials and on the shortest notice"* (see Appendix I).

209. *Rustic Dance after a Sleigh Ride,* 1830
William Sidney Mount (1807–1868)
Oil on canvas
Signed and dated *William S. Mount. 1830*
H. 22 W. 27 1/4
Museum of Fine Arts, Boston, M. and M. Karolik Collection, 48.458

210. Tablespoon, 1790–1820
John C. Hedges (1770–1798) or David
Hedges (1779–1857)
East Hampton
Silver
Mark: *HEDGES.* in rectangle
L. 8 3/8
Private collection

211. Tablespoon, 1785–1800
Elias Pelletreau (1726–1810)
Southampton
Silver
Mark: *EP* in rectangle
L. 8
Private collection

212. Tablespoon, 1795–1815
John C. Hedges (1770–1798) or David
Hedges (1779–1857)
East Hampton
Silver
Mark: *HEDGES.* in rectangle
L. 8 1/4
Private collection

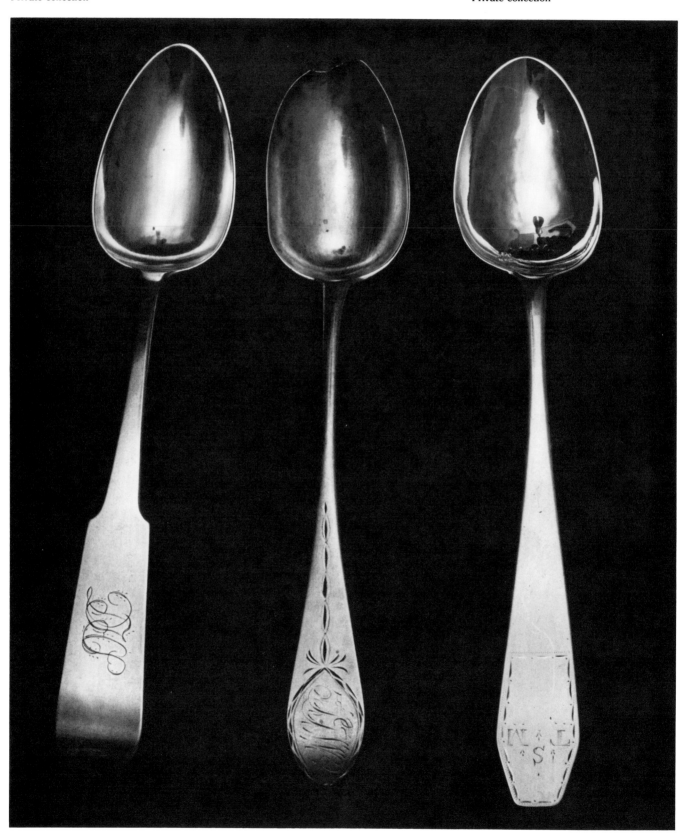

213. Creampot, 1790–1800
Daniel Van Voorhis (1751–1824)
New York City or Brooklyn
Silver
H. 5 5/8
Private collection

Both this creampot and the pitcher (No. 214)
descended in the family of Jeremiah Vanderbilt.
The twist handle is a characteristic New York
feature.

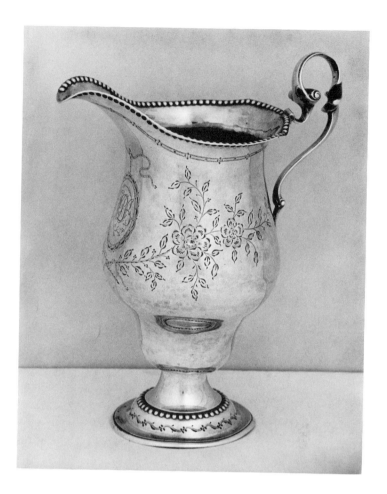

214. Pitcher, 1790–1800
Daniel Van Voorhis (1751–1824)
New York City or Brooklyn
Silver
H. 10 7/8
Private collection

Van Voorhis' career took him to Philadelphia,
Princeton, New Jersey, Vermont, and New York.
He undoubtedly fashioned this pitcher in New
York City or Brooklyn, since it was made for a
Queens County resident, Jeremiah Vanderbilt.
The fact that Van Voorhis used a two initial mark
on this pitcher while applying the more familiar
three initial touchmark to a creampot, also made
for Jeremiah Vanderbilt (No. 213) should end the
previous confusion as to Van Voorhis' use of a
two initial mark.

Ref.: Kathryn C. Buhler and Graham Hood, *American
Silver, Garvan and other Collections in the Yale Uni-
versity Art Gallery, vol. II, New Haven, Conn., Yale
University Press, 1970, pp. 132–134.

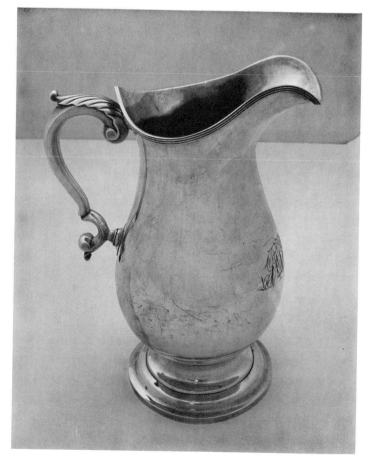

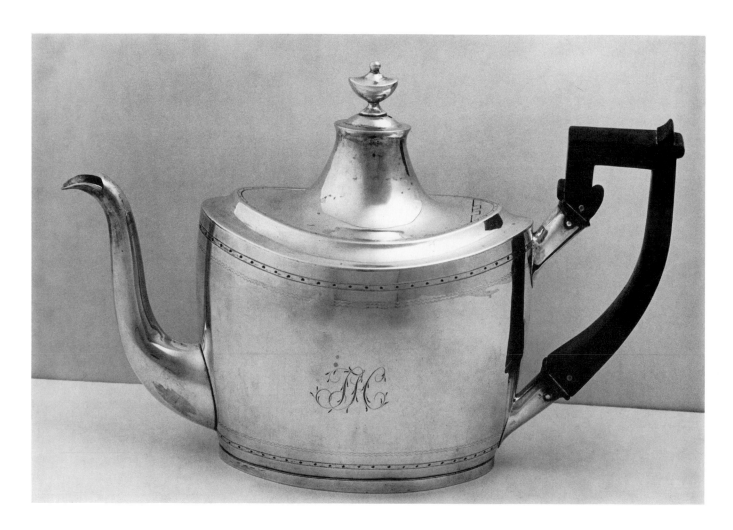

215. Teapot (part of a set), ca. 1795–1814
[John ?] Sayre (1771–1852)
Southampton or New York City
Silver
H. 6 1/4
Private collection

The mark *I:SAYRE* has in recent years been
attributed to John Sayre while the script mark *J
Sayre* is now thought to be his brother Joel's
touchmark. These assumptions may be correct
since John Sayre probably worked in Southamp-
ton before moving to New York, and this teapot
and other silver in the possession of Southamp-
ton families bear the Roman letter touchmark. A
matching sugar bowl and creampot are part of
the set (Nos. 216–217).

Ref.: Darling Foundation of New York State Early Amer-
 ican Silversmiths and Silver, *New York State Silver-
 smiths*, Eggertsville, N.Y., 1964, p. 156.

**216. Sugar Bowl (part of a set), ca. 1795–
1814**
[John ?] Sayre (1771–1852)
Southampton or New York City
Silver
H. 4 7/8
Private collection

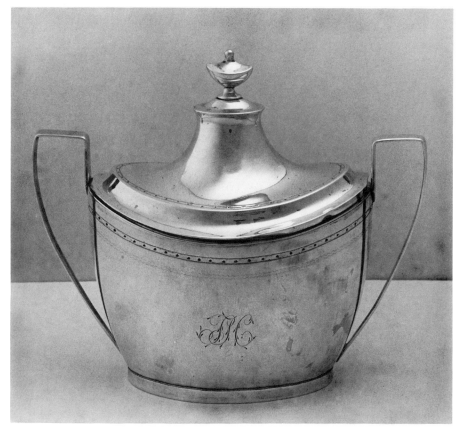

217. Creampot (part of a set), ca. 1795 – 1814
[John ?] Sayre (1771 – 1852)
Southampton or New York City
Silver
H. 4 7/8
Private collection

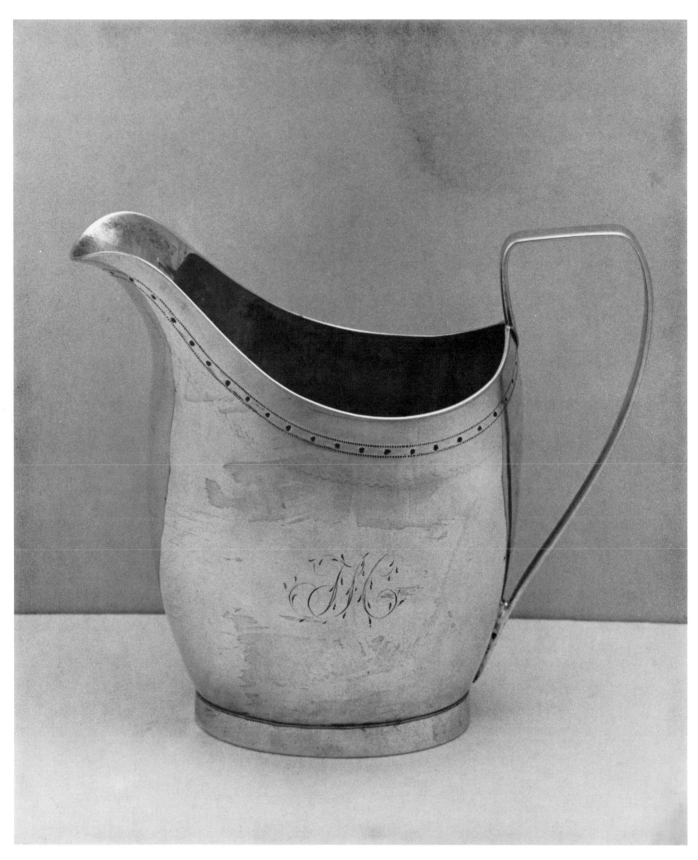

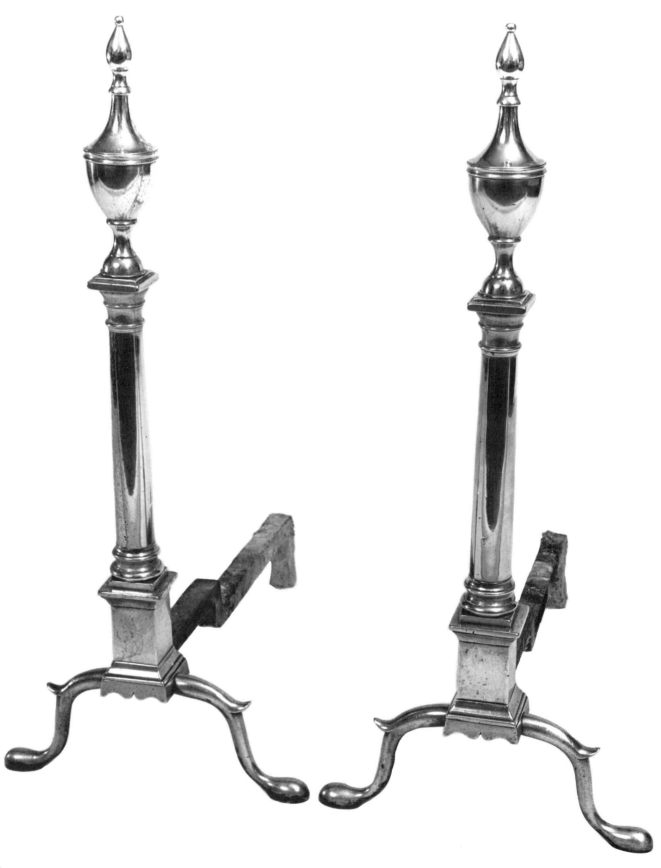

218. Andirons, 1795–1810
Richard Wittingham
New York City
Brass, iron
H. 26 L. 19 7/8
Private collection

By the 1790's brass andirons were more readily available than they had been before the Revolution. This elegant pair, topped with neo-classical urns and marked *R. WITTINGHAM/N. YORK*, was owned in an Oyster Bay family.

219. Jug, 1800
Sag Harbor
Redware
H. 12 1/2 W. 9 1/2
The Henry Francis du Pont Winterthur Museum, G52.54

Abundant clay deposits on Long Island encouraged the early manufacture of earthenware although information about eighteenth century potters and potteries is scarce. This jug was probably produced in the Sag Harbor area as the inscription on it reads: *M^r. Silas Ruiment/Sag-Harbour-Long-Island/Oct^r 7 1800* and on the reverse side *We know the right/And yet the wrong we do/We know the wrong/And yet the wrong pursue.*

220. Platter, 1800–1840
Huntington
Redware
L. 12 3/4 W. 8 1/4
Society for the Preservation of Long Island Antiquities, 957.698

Earthenware was probably produced in Huntington throughout the eighteenth century although the earliest documentation of the existence of a Huntington pottery dates from 1805. One of the first firms was Samuel J. Wetmore & Co., in operation about 1805. In 1825, Benjamin Keeler took over the business but in 1827 he sold the pottery to Henry Lewis and Nathan Gardiner, who operated it until 1854.

This slip-decorated platter can be attributed to Huntington on the basis of its similarity to shards with identical patterns discovered at the site of the potteries.

Refs.: Mrs. Irving S. Sammis, "The Pottery at Huntington, Long Island," *Antiques*, April, 1923, pp. 161—165.

Romanah Sammis, "The Pottery at Huntington, New York," *Long Island Forum*, March, 1939, pp. 7–8, 19.

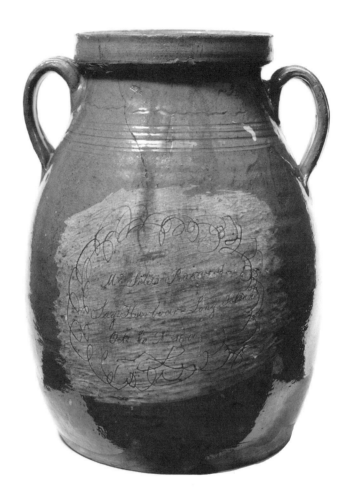

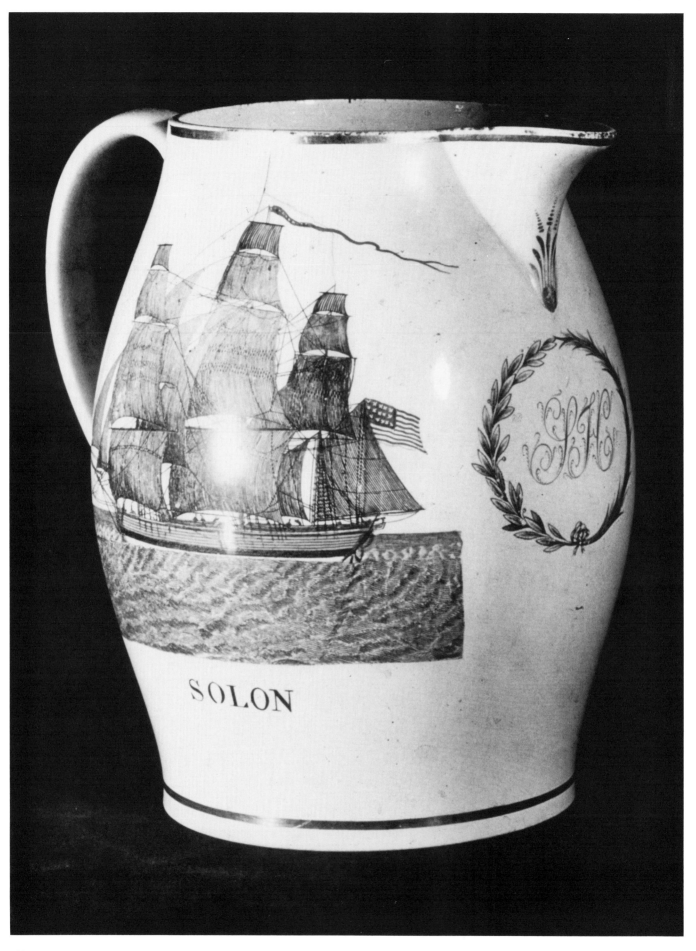

SOLON

221. Pitcher, 1800–1810
Liverpool, England
Creamware
Private collection

Isaac Hicks (1767–1820) was typical of the highly successful self-made American. The son of a Quaker farmer and tailor, Hicks maintained his farm in Westbury but also established himself as a successful merchant in New York City. Hicks owned several ships, and the brig *Solon*, depicted on the Liverpool pitcher that he ordered from England, was noted for being the first American ship to sail on the Black Sea.

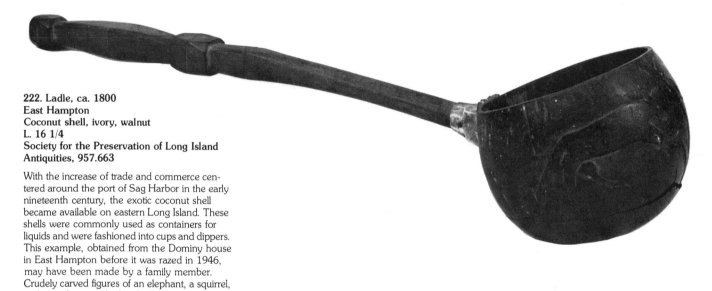

222. Ladle, ca. 1800
East Hampton
Coconut shell, ivory, walnut
L. 16 1/4
Society for the Preservation of Long Island Antiquities, 957.663

With the increase of trade and commerce centered around the port of Sag Harbor in the early nineteenth century, the exotic coconut shell became available on eastern Long Island. These shells were commonly used as containers for liquids and were fashioned into cups and dippers. This example, obtained from the Dominy house in East Hampton before it was razed in 1946, may have been made by a family member. Crudely carved figures of an elephant, a squirrel, and a cat decorate the bowl, which is joined to the wooden handle by an ivory socket.

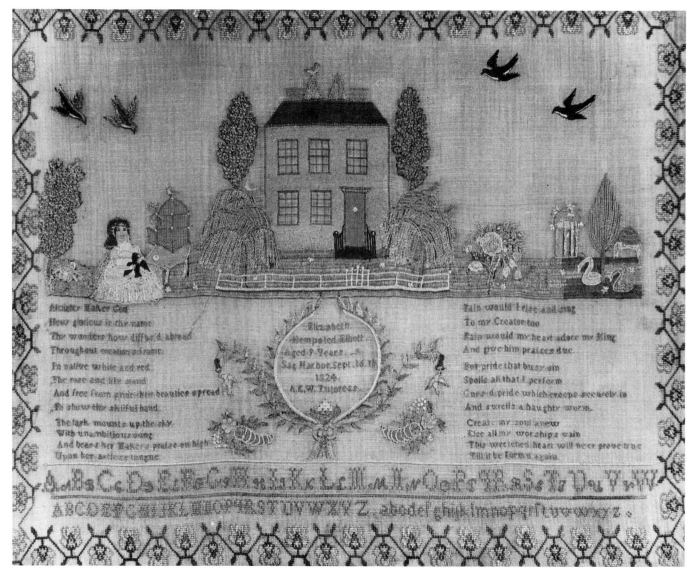

Advertisement, May 27, 1809
Suffolk Gazette
Sag Harbor

223. Sampler, 1824
Elizabeth Hempstead Elliott, age 9
Sag Harbor
Silk on linen
L. 18 1/4 W. 22
The Museums at Stony Brook

In this sampler finely embroidered verse has been
combined with a delightfully naive pictorial scene.
Elizabeth Elliott may have been the daughter of
the Sag Harbor watch and clockmaker, Zebulon
Elliott. Several schools for young women adver-
tised in local newspapers, but the tutoress of
Elizabeth Elliott, noted on the sampler only by the
initials *A. E. W.*, remains unidentified.

224. Sampler, 1815
Sarah Gould
Huntington Academy, Huntington
H. (frame included) 23 3/4 W. (frame included)
19 1/4
Huntington Historical Society, 900

Samplers were the work of young ladies who
learned various types of handwork in local
schools and academies. In addition to several
renderings of the alphabet, the embroideress has
included a depiction of the Presbyterian Church
and what appears to be the Academy. The
names and death dates of other family members
were added at a later date. According to an 1825
newspaper advertisement, the Huntington Acad-
emy was still operating and had hired "*a LADY
of the first ability to instruct in Sewing, Painting,
Ornamental and Plain Needle Work.*"

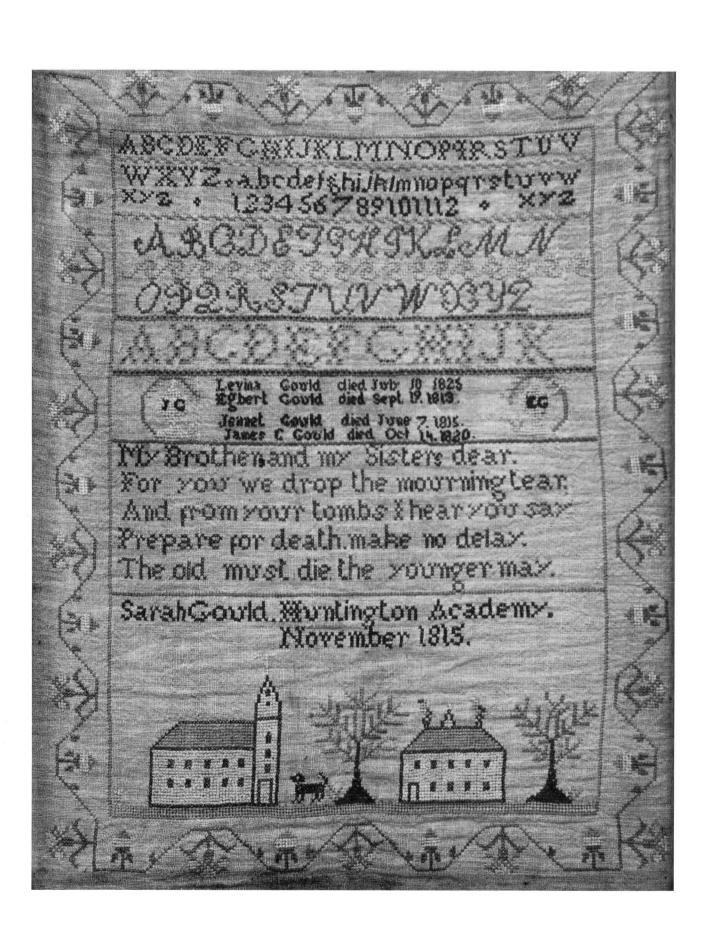

IV. THE CRAFTSMEN, 1640–1830

THE WOODWORKING CRAFTSMEN

For many years it has been widely assumed that few Long Island craftsmen active between 1640–1830 were capable of producing furniture, the notable exception being the Dominy family of East Hampton. The Dominys, however, recorded in their account books only ten transactions for furniture with nonresidents of East Hampton.[1] Obviously, other craftsmen were supplying furnishings and household articles for the residents of other Long Island towns. After an extensive investigation of primary records, we have been able to identify more than one thousand craftsmen active during this period. While many of them may never have made an object more complicated than a bench, others produced furniture, farm equipment, and tools and constructed buildings which adequately served the needs of Long Islanders for more than one hundred-fifty years.

Existing manuscripts, including the account books of sixteen woodworking craftsmen active from about 1750–1830, provide detailed information about the type of craft practice which existed on Long Island during the eighteenth and early nineteenth centuries. When reviewing these documents in conjunction with the numerous examples of Long Island furniture from the same period, it becomes clear that woodworking craftsmanship on Long Island is best understood in terms of a carpenter-joiner tradition which evolved out of seventeenth century practice and which characterized the craft system by 1740. The eighteenth century craftsmen working in this tradition possessed multiple skills, pursued their trades to varying degrees on a part-time basis, and more often than not owned small farms. Most Long Island furniture was made by joiners trained in a joined furniture tradition who initially employed pegged frame and panel construction but later adopted some rudimentary cabinetmaking techniques.[2] These artisans were not specialists and almost all of them engaged in carpentry and sometimes other woodworking activities, including coopering, wheelwrighting, or wagonmaking. A precise division of skills simply did not exist. Jeremiah Remsen of Hempstead made furniture and sleighs, while Micah Wells of Aquebogue combined furniture making with house carpentry and work on *"cooper stuff."* Even during the first quarter of the nineteenth century in a fast-growing town like Brooklyn craftsmen advertised combined *"House Carpenters and Cabinetmaking"* businesses and styled themselves both carpenters and joiners.[3]

The term carpenter was a popular occupational designation for Long Island woodworkers of the eighteenth century and many known furniture makers like Daniel Sandford of Southampton identified themselves as carpenters. Other craftsmen called themselves joiners and it was not until 1797 that two Long Island woodworkers, Austin Roe and William Satterly, both of Setauket, first used the term cabinetmaker when identifying their occupations. At the time, however, both men were also actively working as house carpenters. The confusion in the use of occupational terms was merely a reflection of the non-specialization of tasks which was the dominant feature of the carpenter-joiner craft tradition on Long Island.

The eighteenth century craft system developed from the characteristic pattern of craft activity established in the seventeenth century. Most of the early

225. Interior of the Reconstructed Dominy Woodworking Shop, ca. 1750
The Henry Francis du Pont Winterthur Museum

The Dominy woodworking shop was originally attached to the rear of the Dominy house in East Hampton. In 1946, when the house was being demolished, both the woodworking and clock-making shops were saved by a local resident and incorporated into a beach clubhouse. In 1957, the Winterthur Museum acquired the original work benches and more than 1,000 Dominy tools and painstakingly constructed replicas of the shops to house these objects.

colonists were yeomen or farmers, and each community required and attempted to attract individuals with special woodworking skills. In 1676, for example, the town of Oyster Bay granted John Robison, a joiner, a home lot with *"Timber suffitiantt ffor his youse* [use] *on his trade."*[4] Inevitably, these craftsmen served in a general capacity in response to a wide variety of needs and rarely were they able to specialize. John Parsons of East Hampton was typical, acting as a cooper, wheel-wright, housewright, and furniture maker.

Most of the woodworkers who settled on Long Island during the seventeenth and early eighteenth centuries were rurally trained carpenter-joiners, but some craftsmen versed in current furniture styles and cabinetmaking techniques established themselves on western Long Island. English, Dutch, and French Huguenot craftsmen initially attracted to New York City moved to Long Island, possibly because they could acquire land there. Some of these woodworkers possessed cabinetmaking skills and in their use of dovetailed construction and veneering were notably advanced over the typical Long Island joiner. Samuel Clement, a Flushing furniture maker, had clearly received training in these newer techniques which he employed on the veneered high chest of drawers he made in 1726 (No. 39). Johannis Cowenhoven and Gabriel Teebone were probably working in the fashionable William and Mary style, which demanded cabinetmaking techniques, at an even earlier date. Both bought William and Mary style furniture hardware in 1702 from a Jamaica merchant and Teebone also purchased glue.[5]

The late seventeenth and early eighteenth centuries constituted a period of active settlement on Long Island and the stylistic impact of new craftsmen moving into the region is discernible in surviving furniture. Most notable perhaps was the school of cabinetmaking strongly influenced by Rhode Island furniture design which developed in the Oyster Bay area between 1700 and 1750 (Nos. 55, 136–137). The family and commercial ties that existed between Rhode Island and Oyster Bay Quakers were extremely important. The famous Newport cabinetmaking family, the Townsends, originally came from Oyster Bay, where several woodworking members of the family, including Henry, John, and Daniel Townsend, remained active. William Stoddard, a shop-joiner, came to Oyster Bay from Newport and he was probably an influential furniture maker in the area. Stoddard's contemporary, Charles Feke, was also a shop-joiner who had family connections in Rhode Island.

226. Armchair, 1790–1820
Nathaniel Dominy V (1770–1852)
East Hampton
Maple
H. 44 W. 26 D. 20
Mr. and Mrs. Morgan MacWhinnie

This chair represents a previously unrecorded variation on one of Dominy's favorite chair designs. Dominy called this particular splat pattern a *"fiddle-back."* The Dominy account books contain no specific references to fiddle-back armchairs but frequently mention *"great"* chairs, possibly in reference to examples of this type. A dark brown or black stain, intended to give the appearance of walnut or mahogany, is intact on this chair. One other Dominy armchair with pad feet is currently known.

Ref.: Charles F. Hummel, *With Hammer in Hand: The Dominy Craftsmen of East Hampton, New York,* Charlottesville, Va., The University Press of Virginia, 1968, pp. 254–258.

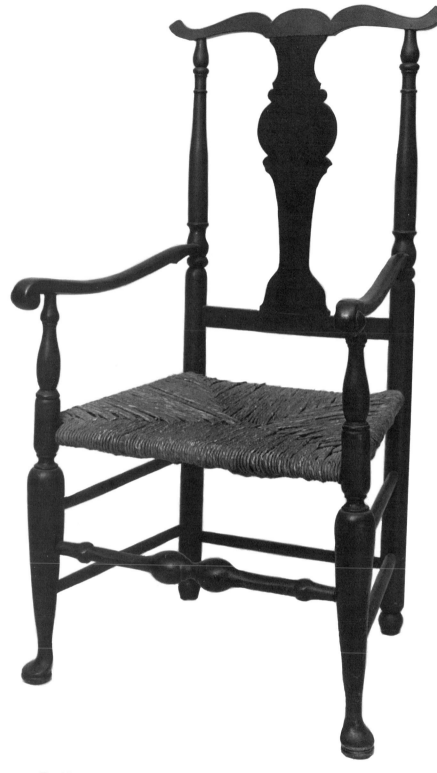

By 1740, however, the movement of outside craftsmen to Long Island had apparently slowed to a point where the infusion of new techniques and skills was no longer an important factor affecting the development of the craft system. Rather, the pattern of craftsmanship which quickly became characteristic and most significant was that based on the traditional transferral of tools and skills from father to son or to another member of the family. Repeatedly, craftsmen bequeathed their tools to their sons. Joshua Garlick made such a provision in his will, leaving his joiner's, turner's, cooper's, and carpenter's tools to his sons, Joshua and John, *"to bee Devided between them when they are capable to use them."*[6] Successive generations of woodworking craftsmen could be found in the Baker, Dominy, and Mulford families of East Hampton; the Culver and Foster families of Southampton; the Paine and King families of Southold; the Doughty and Weekes

193

families of Oyster Bay; the Mott family of Hempstead; and the Bloodgood
family of Flushing, to name but a few. This pattern of inherited skills and design
concepts largely explained the continuity of furniture styles on Long Island during
the eighteenth century. Unquestionably the emphasis was on imitation of technique
and form, not on innovation.

A second factor affecting the eighteenth century craft system and contribut-
ing to the perpetuation of the carpenter-joiner tradition was Long Island's rural,
agrarian economy. The boundaries of Long Island towns encompassed large
geographical areas but settlement within them was scattered and the village centers
were extremely small, usually consisting of only a few structures. Most of the towns'
residents lived apart from each other on their own farms. At the time of the
Revolution the villages of Hempstead and Oyster Bay consisted of only about a
dozen buildings.[7] There were no streets lined with craftsmens' shops as there were
in eighteenth century Boston or New York. Instead, craftsmen and merchants
usually worked in shops adjacent or attached to their homes, an arrangement
confirmed by the many inventories listing goods or tools in the *"shop chamber"*
and represented by the Dominy and Pelletreau houses and shops which survived
into this century (Nos. 225, 227, 243).

Craft activity in these agrarian communities tended to be part-time rather
than full-time. The conclusions presented in several recent studies of rural craftsmen
accurately describe the situation on Long Island as well.[8] The woodworker gener-
ally owned his own house and shop and worked his own farm of about 100 acres,
thus establishing for himself a degree of self-sufficiency which lowered his cost of
living. With his special skills he could provide products and services in exchange for
whatever items he needed.

Undoubtedly some craftsmen spent more time farming than they did
working in their shops. Isaac Briggs, described as a farmer in the probate records
when he died in Brookhaven in 1814, obviously made some furniture judging from
the tools, paint, glue, lumber, and *"chair slats"* among his effects. Walter Howell of
Southampton, also identified as a farmer, owned woodworking tools, a turning
lathe, work benches, and eleven new chairs at the time of his death. A few
craftsmen found agricultural work especially profitable. John Paine substantially
increased his income each year by marketing thousands of gallons of cider pro-

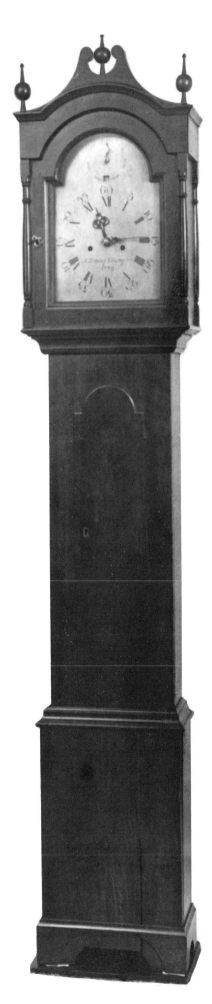

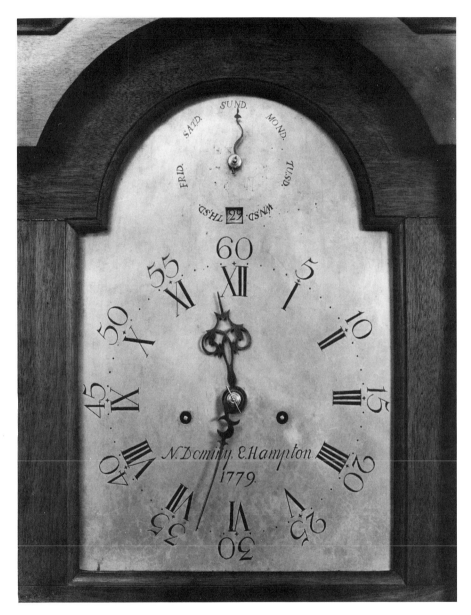

228. Tall-case Clock, 1779
Nathaniel Dominy IV (1737–1812)
East Hampton
Walnut, pine; pewter dial
H. 87 3/8 W. 17 1/2 D. 8 5/8
Private collection

According to family tradition, Nathaniel Dominy IV made this clock for Nathaniel Seaman (ca. 1724–1816) of Jerusalem. After Seaman's death in 1816, the clock descended directly in the family to the present owner. This clock is not recorded in the Dominy accounts, and it is the earliest tall-case clock by Nathaniel Dominy IV to display some of the complex features found in his later work.

Most of Dominy's early tall-case clocks were one-hand timepieces. This example, however, has an eight-day, strike and repeater mechanism

and a day-of-the-month calendar and day-of-the-week indicator at the top of the pewter dial. The case is constructed of walnut, a more expensive wood than the pine or cherry usually used in Dominy clocks. The design of the case is itself distinctive, being more elaborate than the only similar published example. Few Dominy clocks have finials, but those seen here are similar to the brass finials which ornament a clock made for John Lyon Gardiner in 1791.

Dominy used skeletonized plates to support the movement of his clocks thereby saving expensive brass. This clock, however, is one of only two known Dominy clocks which have solid brass plates in the movement.

Ref.: Charles F. Hummel, *With Hammer in Hand: The Dominy Craftsmen of East Hampton, New York*, Charlottesville, Va., The University Press of Virginia, 1968, pp. 274–285, 289–291.

duced from his horse-powered cider mill. Paine also rented out his team and plow and charged for his sons' labor on nearby farms in Southold such as that belonging to Ezra L'Hommedieu. The Setauket carpenter-joiner John Bayles not only assisted Abraham Woodhull and Samuel Thompson with house carpentry and repairs of their household and farm equipment but also spent considerable time in the fields, reaping and cradling oats with the help of his apprentice. An entry in Nathan Topping Cook's account book, however, best illustrates the importance of agricultural pursuits to even the busy craftsman. In the midst of a series of entries dated 1797, possibly relating to the building of a house for David Hedges of Bridgehampton, Cook noted: *"this Day quit to harvest."* [9]

In addition to farming and woodworking, the rural craftsman often practiced a secondary trade. John Parsons, the seventeenth century East Hampton woodworker was also a weaver while the Southampton carpenter-joiner Daniel Sandford occasionally worked as a shoemaker. John Paine, who found it convenient to make his own bedcord for the beds he produced in his shop, discovered a wider market for this product in the maritime community of Southold. During inclement weather rope making was an ideal activity and Paine produced ship rope, fish line, and *"porpos"* nets.

It was sometimes more lucrative to pursue a secondary trade than to continue working as a joiner. Braddock Corey found butchering more profitable in Sag Harbor than house building or furniture making. Austin Roe, a Setauket cabinetmaker, is best remembered not as a skilled craftsman, but as an innkeeper. With increasing competition in the nineteenth century, it became more difficult for a part-time joiner to earn a living. Isaac Wickham of East Hampton was trained as a joiner but eventually established himself as a merchant-storekeeper, and Daniel Sammis of Huntington abandoned carpentry for the operation of a sawmill and lumber yard.

An important aspect of the carpenter-joiner's woodworking business was the production of the numerous small items required in many eighteenth and nineteenth century households. The craftsmen supplied such standard kitchen equipment as bread trays, butter molds, rolling pins, dry sinks, dough troughs, salt boxes, mortars and pestles, and brooms. Among the more unusual items craftsmen sometimes produced were picture frames, rulers, writing slate frames, crutches, and ink stands. The women of the house, as well as professional weavers, obtained looms, spinning wheels, swifts, spools, and hetchel boards. The manufacture of flax and wool spinning wheels and winders was, in fact, a most important enterprise for several woodworkers. Nicholas Townsend of Jamaica produced wheels in quantity, selling twenty-eight of them to the merchant Joseph Lawrence in 1769. Apparently Henry Townsend of Oyster Bay also supplied Lawrence with a number of spinning wheels in 1771. Other craftsmen who made a specialty of the production of spinning wheels were Isaac and Ambrose Parish of Oyster Bay and David Sayre of Bridgehampton (Nos. 235–237).

A great deal of the woodworker's time was spent repairing furniture, farm equipment, and household articles. Entries for *"mending"* occur so frequently in craftsmen's account books that one is led to believe that few pieces of broken furniture were ever discarded. Spinning wheels received hard wear and constantly required new parts. Other tools and utensils suffered from extensive use and the handles of hoes and axes, pot lids, gun stocks, and other miscellaneous parts of objects were commonly replaced. In 1831, Septimus Osborne mended twenty-four desks at Clinton Academy in East Hampton. Nathan Topping Cook briefly itemized in his accounts several furniture repairs as follows: *"to Put one Post to a Chair . . . To Scrue on a Stand top . . . to put Six Rounds* [stretchers] *in a Chair . . . To Put on a Leef on a table."* [10] Craftsmen also altered furniture in response to new styles and fashions, particularly after the Revolutionary War. Pardon Tabor and Sullivan Cook serviced frequent requests to add rockers to chairs, and Septimus Osborne and Cook remodeled old style chests with one or two drawers into bureaus.

The production of miscellaneous items and repair work were necessary

facets of a craftsman's business but the furniture he made is the primary focus of this study. As discussed in previous chapters, Long Island furniture of the eighteenth century was most generally characterized by its "plain" appearance. Among the cultural factors contributing to the development of this plain style was Long Island's carpenter-joiner tradition. The furniture maker was trained in a system and a method which did not encourage innovation and he worked in a rural setting where he was not regularly exposed to new ideas. Consequently, he continually repeated the same design concepts, largely ignoring changes in fashion, and in the process the furniture he made was distilled to its basic form, without elaborate frills or excessive ornamentation.

Decorative effects were achieved almost solely through the use of applied moldings and paint or stain. Craftsmen often attempted to make "country" woods look more exotic and fashionable or to disguise the use of several disparate woods in a single object by staining or painting their furniture. Storekeepers' account books document joiners' frequent purchases of *"Spanish brown,"* lampblack and varnish, and references to painting or staining furniture commonly appear in craftsmen's account books. In 1759, for example, Daniel Sandford debited an account for *"cullering 2 chests"* and for *"pollishing and varnish."*[11] Usually the account book entries do not specify color, with the exception of the black paint regularly applied to chairs. Surviving furniture and inventory references, however, indicate that red and blue were popular colors, particularly for chests and tables. The original but now darkened surfaces of other pieces of Long Island furniture (No. 226) provide evidence of the practice of staining to achieve the appearance of mahogany or walnut.

The carpenter-joiner obtained almost all of the wood he needed for making furniture from local sources. One of Long Island's prime commercial resources was timber, and abundant stands of oak, black walnut, chestnut, maple, hickory, tulip poplar (white wood), white pine, red gum (bilsted), black cherry, and apple trees provided the woodworker with the raw materials necessary for his craft. Cherry, pine, maple, and walnut were favored primary furniture woods and red gum was also widely used on western Long Island even at the end of the eighteenth century. The inventory of the estate of Peppurell Bloodgood, a Flushing joiner, taken in 1795, documents his possession of a stock of twenty bilsted boards at that date. At the time of his death in 1809, James Howell, a Sag Harbor cabinetmaker, was working on several pieces of furniture made of black walnut, and the 1797 inventory of William Satterly's estate, itemized a large supply of cabinetwood including *"523 feet cherry Boards/100 dᵒ Maple & Apple Tree dᵒ* [and] *Pine Boards."*[12]

Although mahogany was the favored furniture wood during the latter half of the eighteenth century, it was not commonly used in Long Island furniture until after the Revolution. Furnishings made of mahogany are listed more frequently in nineteenth century inventories and advertisements of the period often feature a local cabinetmaker's use of that wood.

Mahogany was, of course, imported and expensive. Nathan Tinker's list of coffin prices published in a Sag Harbor newspaper indicates the relative value of mahogany and other cabinetwoods during the early nineteenth century: *"Mahogany, best wood $20/ Bay Mahogany* [$]16/ *Cherry* [$]9/ *White wood, polished* [$]6/ *Pine wood* [polished] [$]5/ *White wood* [$]5/ *Pine wood* [$]4.50."[13]

Although local merchants generally supplied craftsmen with mahogany, both John Paine in Southold and the Dominys in East Hampton obtained this wood from some of their own customers. Ezra L'Hommedieu operated a sawmill in Southold from which Paine obtained mahogany boards. The probable source for the Dominys is documented in a fascinating entry dated 1798 in John Lyon Gardiner's "Farm Journal and Account Book." Gardiner explained that a *"double geared sawmill built by N Dominie Junʳ"* on *"Studdy hill"* for ship captain William Johnson Rysam of Sag Harbor (No. 197) had been dismantled and shipped on an armed vessel *"To the Bay of Honduras to saw mahogany."*[14]

Furniture Forms as Noted in the Account Books of Long Island Woodworking Craftsmen

The accompanying chart itemizes the furniture forms and some of the household articles recorded in the surviving account books of seventeen known Long Island furniture makers. The reader should keep in mind that these accounts are not complete records of furniture production, nor have all the specific subcategories of production for each form—for example, *"low post"* bedsteads—been given. These figures simply indicate the types and relative quantities of objects produced on Long Island from about 1750–1830. With the exception of Jeremiah Remsen, all of the craftsmen listed on the chart worked in Suffolk County. Hopefully similar information about craftsmen active on western Long Island will eventually surface and allow fruitful comparisons of craft practice and furniture production in Long Island's distinct cultural areas.

	John Parsons (active ca. 1674–1693) East Hampton	Nathaniel IV, Nathaniel V, and Felix Dominy (1714–1868) East Hampton	William Hunting (1738–1816) East Hampton	Septimus Osborne (active ca. 1811–1852) East Hampton	Nathan Topping Cook (active ca. 1792–1822) Bridgehampton	Sullivan Cook (active ca. 1807–1868) Bridgehampton	William Cooper (active ca. 1807–1830) Sag Harbor	Pardon T. Tabor (1789–1842) Sag Harbor
Bedsteads	1	73	38	13	9	3		2
Bedsteads, couch								
Bedsteads, trundle						1		
Benches			2	11	1	3		
Bookcases		1						
Boxes					1	1		
Breadtrays					4	1		
Bureaus		17			2			
Buttons		82	12					
Candle boxes		1			1			
Cartridge boxes					1			
Case of drawers		1	4		4			
Chairs	2	328	109	2	134	4		
Chairs, easy		1				2		
Chairs, elbow								
Chairs, great		8			1			
Chairs, rocking		12	1	1		2		
Cheese presses			2			2		
Chests		3	10	23	10	14		
Chests of drawers		2	1					
Chests with drawers		12			3			
Clock cases		57				1		1
Clothes presses		2						
Coffins	X	X	X	X	X	X		X
Cradles		6	3	4	2			1
Cupboards		1	3	1	1	2		
Cutting boxes								
Desk and bookcases		1						
Desks		6	2			2		
Desks, writing		7		1		2		
Frames, looking glass		7						
Frames, picture		8						
Frames, slate					2	1		
Hat blocks								
Hetchel boards					5			
Inkstands								
Knifeboxes		1		1				
Lapboards								
Looms				1				
Paper presses								
Rolling pins					1			
Rulers				1	3			
Spinning wheels	X	X			X			
Stands		79	6	12	6			
Stools								
Stoves								
Tables	1	90	17	14	15			
Tables, dressing					2			
Tables, toilet						1		1
Trunks		2						
Washboards								
Wig boxes								
Other activities								
Agricultural labor		X			X	X		
Coopering	X					X		
House carpentry	X	X	X	X	X	X	X	X
Mill carpentry		X			X	X		
Ship carpentry			X			X	X	X
Tool making	X	X	X	X	X	X		X
Sled making						X		
Wheelwrighting/ Wagon making	X	X	X		X	X		

	Daniel Sandford (1734–1811) Southampton	John Paine (1739–1815) Southold	Micah Wells (1733–1790) Aquebogue	Daniel Smith (active ca. 1769–1814) Brookhaven	Jedediah Williamson (active ca. 1788–1837) Brookhaven	Daniel Sammis (active ca. 1817–1834) Huntington	Jeremiah Remsen (active ca. 1813–1832) North Hempstead
Bedsteads	64	6	10	1	2	1	25
Bedsteads, couch	1						
Bedsteads, trundle		4					6
Benches	1			1		2	1
Bookcases	1	1	1				
Boxes							
Breadtrays	10	1				1	
Bureaus							
Buttons							
Candle boxes							
Cartridge boxes	1						
Case of drawers	8		7				
Chairs	236	113				3	
Chairs, easy							
Chairs, elbow	3						
Chairs, great	1	1	2				
Chairs, rocking		1					
Cheese presses		1	1				
Chests	60	3	11			6	26
Chests of drawers			11				
Chests with drawers		2					
Clock cases							
Clothes presses							
Coffins	X	X			X	X	X
Cradles	12	2	2			6	
Cupboards	9	3					
Cutting boxes							4
Desk and bookcases		1					
Desks	4		1			2	8
Desks, writing							2
Frames, looking glass		1					
Frames, picture							1
Frames, slate							
Hat blocks		X				X	
Hetchel boards							
Inkstands	2						
Knifeboxes							
Lapboards			1				
Looms	1						
Paper presses							1
Rolling pins		1					
Rulers							
Spinning wheels	X	X	X				
Stands	14	8	1		1		3
Stools	3						
Stoves		1					
Tables	46	9	19		1	2	19
Tables, dressing							
Tables, toilet							2
Trunks				1		1	
Washboards						1	3
Wig boxes	1						
Other activities							
Agricultural labor	X	X	X	X	X		
Coopering		X	X		X	X	
House carpentry	X	X	X	X	X	X	X
Mill carpentry	X	X				X	
Ship carpentry	X	X					
Tool making	X	X	X	X	X	X	X
Sled making	X	X			X		X
Wheelwrighting / Wagon making	X	X	X	X	X	X	X

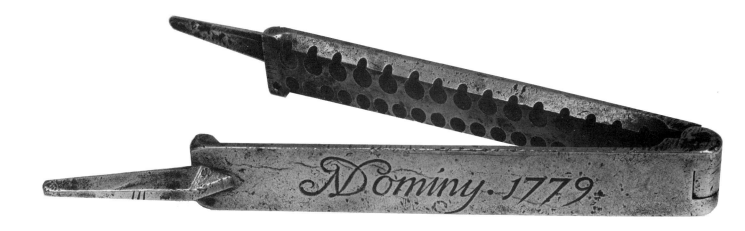

229. Shot Mold, 1779
Nathaniel Dominy IV (1737–1812)
East Hampton
Brass
L. 7 5/8
Society for the Preservation of Long Island Antiquities

Nathaniel Dominy IV made a variety of molds for casting sinkers, buttons, bullets, and shot. He first carved the patterns for the molds in wood and then sand-cast them in brass. Dominy made several shot molds in 1779 and he signed and dated them on one arm. Surviving patterns in the Dominy shop at Winterthur indicate that Dominy drilled the holes for pouring the lead into the finished molds after casting. This example originally had wooden handles.

Ref.: Charles F. Hummel, *With Hammer in Hand: The Dominy Craftsmen of East Hampton, New York,* Charlottesville, Va., The University Press of Virginia, 1968, pp. 230–231, 245–246.

230. Desk, ca. 1760
Timothy Mulford (active ca. 1754–1760)
East Hampton
East Hampton Historical Society

Numerous woodworking craftsmen were active in East Hampton during the eighteenth century but very few pieces of furniture can be attributed with any certainty to a specific maker. Timothy Mulford, however, a documented East Hampton joiner (see Appendix I), signed this desk and dated it 1760. The wood, cherry or pine, is covered with a blue-green paint. The arrangement of the interior compartment is similar to that of an earlier style East Hampton desk (No. 44).

The vast amount of extant primary source material relating to the craft system on Long Island has enabled us to establish the overall pattern of craft activity described above. Similarly, surviving furniture has led to certain conclusions about style and form, and the accompanying chart, listing the types and quantities of furniture forms entered in the account books kept by seventeen woodworking craftsmen, also suggests the range and extent of furniture production during the eighteenth and early nineteenth centuries. Unfortunately, it is not yet possible to associate groups of furniture with specific makers, except in the case of the Dominys where surviving objects and documents have allowed a thorough, in-depth analysis of their craft practice. Perhaps this introduction to Long Island furniture and craftsmanship will generate new discoveries leading to a more complete understanding of the craft system during this period.

THE SILVERSMITHS

Silversmithing was not suited to a rural environment, and few successful eighteenth century American silversmiths worked outside of the larger towns or cities. Silver and gold objects were luxury items, symbols of status and station. The concentration of wealth in urban areas resulted in a more reliable market for the silversmith's wares. Long Islanders who could afford silver were also able to obtain it easily in New York, Newport, or Boston. Largely for these reasons, Long Island never supported more than a few silversmiths until the early nineteenth century when silversmith-jeweler-watchmakers opened shops in developing Long Island towns.

Very little is known about the silversmiths active on Long Island before 1750. The only seventeenth century silversmith associated with Long Island was Jesse Kip, who worked in New York before "retiring" to Newtown where he owned several mills. The town records and the militia rolls from the first half of the eighteenth century give the names of several local silversmiths but no additional information about their craft activities is available. One can only speculate, for example, that the John Hutton mentioned in the Oyster Bay town records for 1735 may be the John Strangeways Hutton who worked in New York City and Philadelphia.[15]

Standing alone in terms of the success of his business and what is currently known about his life and work is Elias Pelletreau. Born in Southampton and trained in *"the art and mystery"* of the goldsmith in New York City by the Huguenot master, Simeon Soumaine, Pelletreau chose to return to his home and familiar surroundings about 1750. His abilities and local fame sustained his career over the next half century. It is entirely possible that his reputation and moderate prosperity account for the decisions of several Southampton area youths to pursue the career of silversmith, although not all were apparently successful. In addition to Pelletreau's son, John, and his grandson, William, these Southampton silversmiths included Silas and David Howell, Edward White, Lewis Stanbrough, and the Sayres—Paul, Caleb, John, and Joel.

Several other silversmiths were active on Long Island's east end. Benjamin and Joseph Prince, contemporaries of Elias Pelletreau, operated a shop in Southold, but neither their marks or their silver have been identified. John Chatfield Hedges

231. Child's Chair, 1790–1820
Possibly Nathan Topping Cook (active ca. 1791–1822)
Bridgehampton
Maple, hickory
Private collection

Both this chair and an account book kept by Nathan Topping Cook were found in a Cook family house in Bridgehampton when it passed out of the family several years ago. The Cook account book, one of two which have survived, contains several entries for *"Little Chairs,"* possibly in reference to the type of child's high chair illustrated here.

and his brother, David, worked in East Hampton. John died in 1798 at the age of twenty-eight and David probably took over the small shop on Main Street at that time. A somewhat romanticized description of David Hedges' shop written in 1856 provides some insight into his craft activity: *"Next to the Academy, on the right, stands a low dingy building, with a little diamond window. . . . The old shop was divided into two apartments, the one more appropriately designated the work shop, while the other, containing a forge and sets of curious double rollers, served as a forge room, or place in which the heavier branches of the trade, which comprised gun-smithing, locksmithing, etc., were carried on. The little window of which I have spoken, looked out from the latter, or forge room."*[16]

As this quote suggests, the rural silversmith, like the woodworking craftsman, spent a considerable amount of his time engaged in a variety of miscellaneous activities. Elias Pelletreau repaired everything from warming pans to spectacles and *"rectified"* watches and clocks as well. He derived a substantial portion of his income from the sale of jewelry marketed by agents on a commission basis. Even Pelletreau, who was singularly fortunate in being able to establish a profitable business, depended upon the produce of his 125 acre farm. In order to practice their craft with some success, John and Joel Sayre left Southampton for New York City, as did Pelletreau's grandson, William Smith Pelletreau. David Hedges and Nathaniel Potter of Huntington began their careers as silversmiths but eventually took up other pursuits, Potter becoming a merchant and both men serving as representatives to the state legislature.

The era of town growth on Long Island which followed the Revolution dictated the same changes for the silversmith that it had for the furniture maker. The eighteenth century rural silversmith worked on demand and was not able to stock his shelves with products like the *"Plated goods & fancy articles of the most fashionable kinds"* advertised by the Brooklyn *"Watchmakers, Jewellers & Silversmiths,"* Samuel Smith and John Lowe in 1826.[17] This new type of craftsman-merchant supplied merchandise imported from New York City and is well represented by Elijah Simons of Sag Harbor who offered his customers *"WARRANTED WATCHES of the newest fashions"* in addition to jewelry and an *"assortment of fashionable spoons."*[18] The rural silversmith's business, like the furniture maker's business was in a process of transition and becoming increasingly commercialized during the early nineteenth century.

[1]Charles F. Hummel, "The Dominys of East Hampton, Long Island, and Their Furniture," in *Country Cabinetwork and Simple City Furniture,* ed. by John D. Morse (Charlottesville, Va.: The University Press of Virginia, 1968), pp. 40, 41.

[2]The question of the distinction between joinery and cabinetmaking is discussed in Benno M. Forman, "Urban Aspects of Massachusetts Furniture in the Late Seventeenth Century," in *ibid.,* pp. 1–34.

[3]Advertisement, *Long Island Star,* July 6, 1809.

[4]*Oyster Bay Town Records* (8 vols.; New York: Tobias A. Wright, 1924), I, 228.

[5]Woolsey Family Account Book, Hillhouse Family Collection, Yale University Library, New Haven, Connecticut, pp. 5, 24.

[6]Will of Joshua Garlick, *Minutes of the Court of Sessions for Suffolk County and Court of Common Pleas, 1669–1684,* Suffolk County Clerk's Office, Riverhead, New York, p. 79.

[7]John Graves Simcoe, *Simcoe's Military Journal* (New York: Bartlett and Welford, 1844), between pages 94 and 95.

[8]Carl Bridenbaugh, *The Colonial Craftsman* (Chicago: The University of Chicago Press, 1966), pp. 33–64; Charles F. Hummel, *With Hammer in Hand: The Dominy Craftsmen of East Hampton, New York* (Charlottesville, Va.: The University Press of Virginia, 1968), pp. 215–243; Jackson Turner Main, *The Social Structure of Revolutionary America* (Princeton, N.J.: Princeton University Press, 1973), pp. 68–163, 273–275.

[9]Nathan Topping Cook Account Book, Private Collection, p. 52.

[10]Nathan Topping Cook Account Book, Private Collection, pp. 32, 43, 48.

[11]Daniel Sandford Account Book, 1759, Queensboro Public Library, Jamaica, New York.

[12]Inventory of the estate of William Satterly, 1797, Suffolk County Surrogate's Court, Riverhead, New York.

[13]Advertisement, *The Corrector,* August 3, 1839.

[14]John Lyon Gardiner Journal and Farm Book, 1798, East Hampton Free Library, East Hampton, New York.

[15]Darling Foundation of New York State Early American Silversmiths and Silver, *New York State Silversmiths* (Eggertsville, N.Y.: By the Author, 1964), p. 107.

[16]"The Old Silversmith, A Reminiscence of East Hampton," 1856, signed B.H.H., Long Island Historical Society, Brooklyn, New York (manuscript).

[17]Advertisement, *Long Island Star,* November 23, 1826.

[18]Advertisement, *Suffolk Gazette,* December 24, 1804.

232. Cradle, 1770–1830
Setauket
Pine
H. 15 L. 37
Society for the Preservation of Long Island
Antiquities, 51.27

According to tradition, this cradle was made for
John Denton (1772–1850) of Setauket. Both
highly and minimally skilled woodworking crafts-
men produced crudely and simply fashioned cra-
dles such as this.

233. Stove, 1800–1830
Setauket
Pine
H. 7 3/4 W. 9 1/4 D. 9 1/16
Society for the Preservation of Long Island
Antiquities, gift of Miss Kate W. Strong, 68.5

During the eighteenth and early nineteenth centuries, these objects, popularly known today as foot warmers, were called stoves. In 1784, John Bayles, a Setauket carpenter-joiner made a *"stove with bail"* for Abraham Woodhull (*see* Appendix I). The example illustrated here was also owned and undoubtedly made in Setauket. The original owner was Juliana Hawkins (1774–1842), wife of Zopher Hawkins (1757–1847). The decorative piercings in the shape of a heart, circles, and the initials *JH,* allowed the heat generated by coals inside the stove to escape. An important feature of this stove is its original brown and black painted surface executed in imitation of marble. The donor's father purchased this stove at an auction at the Hawkins homestead in South Setauket.

234. Cutlery Tray, 1790–1830
Southampton
Cherry
L. 15 W. 11
Private collection

Customers constantly requested various small household articles including numerous boxes and trays for utensils, candles, money, and other items. The dovetailed construction of this tray, which came from Southampton, suggests it was made in a joiner's shop.

203

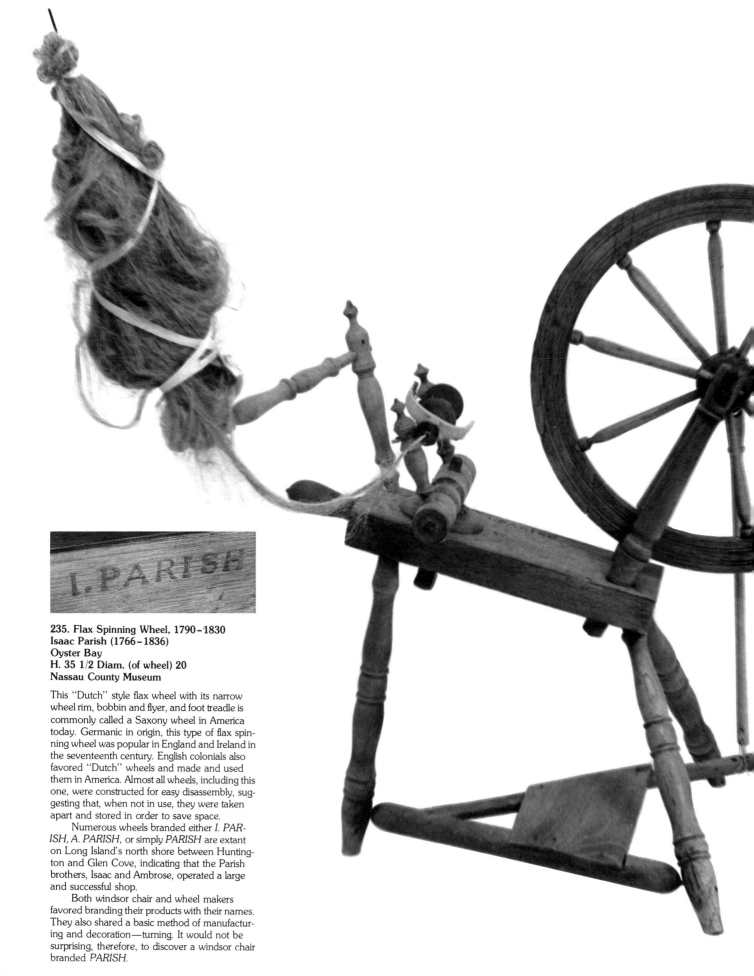

235. Flax Spinning Wheel, 1790–1830
Isaac Parish (1766–1836)
Oyster Bay
H. 35 1/2 Diam. (of wheel) 20
Nassau County Museum

This "Dutch" style flax wheel with its narrow wheel rim, bobbin and flyer, and foot treadle is commonly called a Saxony wheel in America today. Germanic in origin, this type of flax spinning wheel was popular in England and Ireland in the seventeenth century. English colonials also favored "Dutch" wheels and made and used them in America. Almost all wheels, including this one, were constructed for easy disassembly, suggesting that, when not in use, they were taken apart and stored in order to save space.

Numerous wheels branded either *I. PARISH, A. PARISH,* or simply *PARISH* are extant on Long Island's north shore between Huntington and Glen Cove, indicating that the Parish brothers, Isaac and Ambrose, operated a large and successful shop.

Both windsor chair and wheel makers favored branding their products with their names. They also shared a basic method of manufacturing and decoration—turning. It would not be surprising, therefore, to discover a windsor chair branded *PARISH.*

204

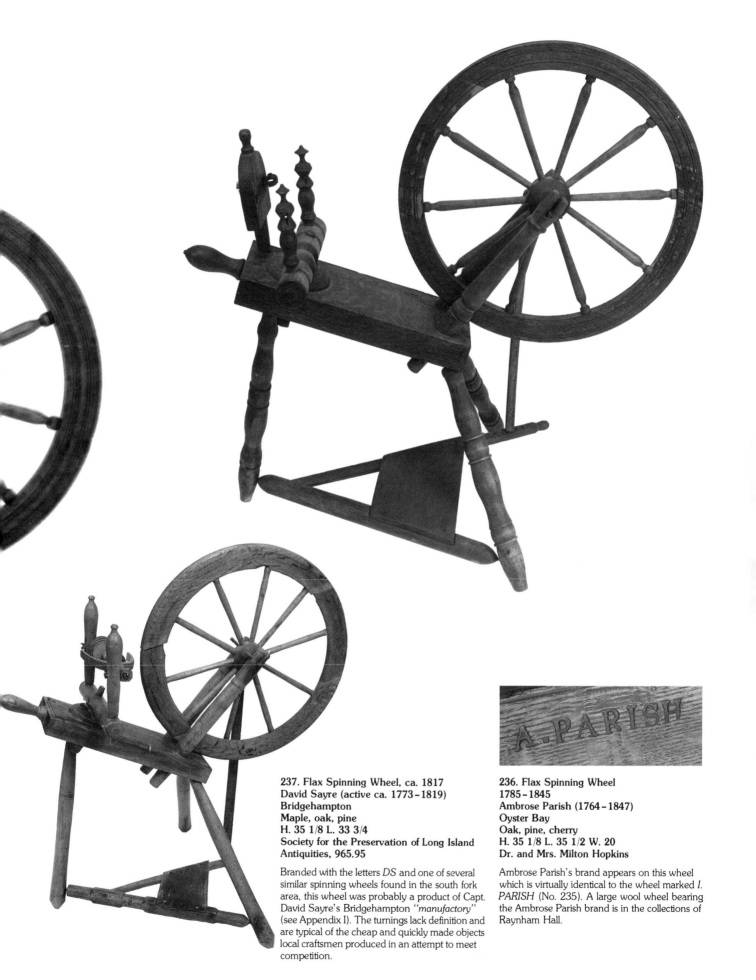

237. Flax Spinning Wheel, ca. 1817
David Sayre (active ca. 1773–1819)
Bridgehampton
Maple, oak, pine
H. 35 1/8 L. 33 3/4
Society for the Preservation of Long Island
Antiquities, 965.95

Branded with the letters *DS* and one of several
similar spinning wheels found in the south fork
area, this wheel was probably a product of Capt.
David Sayre's Bridgehampton *"manufactory"*
(*see* Appendix I). The turnings lack definition and
are typical of the cheap and quickly made objects
local craftsmen produced in an attempt to meet
competition.

236. Flax Spinning Wheel
1785–1845
Ambrose Parish (1764–1847)
Oyster Bay
Oak, pine, cherry
H. 35 1/8 L. 35 1/2 W. 20
Dr. and Mrs. Milton Hopkins

Ambrose Parish's brand appears on this wheel
which is virtually identical to the wheel marked *I.
PARISH* (No. 235). A large wool wheel bearing
the Ambrose Parish brand is in the collections of
Raynham Hall.

205

238. Chest, 1800–1840
Probably Felix Dominy (1800–1868)
East Hampton and Fire Island
Pine
H. 17 1/4 W. 46 1/4 D. 16 1/4
Society for the Preservation of Long Island
Antiquities, 965.388

The ubiquitous chest was more often nailed together than joined with dovetails. This example may owe its more sophisticated construction to the fact that its maker was probably Felix Dominy. The painted signature *F Dominy 12/F.I.* is on the back of the chest. While the meaning of the number *12* is uncertain, the *F.I.* may stand for Fire Island, where Dominy was living after 1835 (see Appendix I).

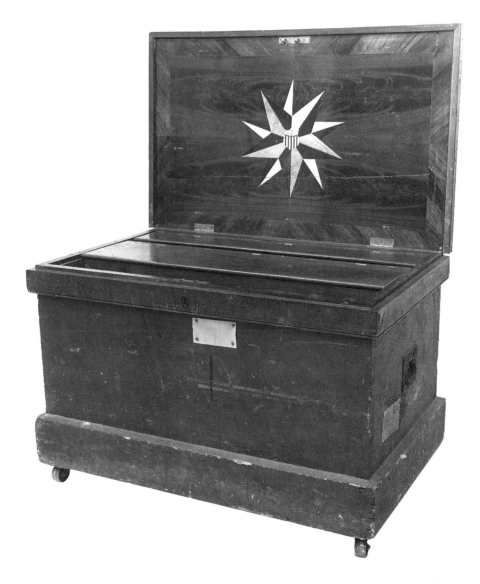

239. Carpenter's Tool Chest, ca. 1820
Possibly Henry M. Stanton
Long Island
Pine, mahogany
H. 26 7/8 W. 41 1/4 D. 25 7/8
Private collection, courtesy of the Northport
Historical Society Museum

Although the exterior is typical of numerous sea-
men's chests of the nineteenth century, the inte-
rior of this chest is elaborately ornamented with
veneer and an inlaid design and fitted out with
multi-level sliding mahogany tool compartments.
Both the original woodworking tools and the
inlaid shield on the chest top bear the initials or
name of the original owner, Henry M. Stanton,
who was a carpenter or ship carpenter.

240. Table, 1797–1830
William Cooper (active ca. 1797–1830)
Sag Harbor
Pine
H. 22 1/2 W. 35 3/4 D. 35 1/4
Society for the Preservation of Long Island
Antiquities, 966.482

William Cooper is best known as a boat builder,
and the Gardiner family account books docu-
ment his activity between 1797 and 1827. Like
most Long Island woodworkers, Cooper per-
formed various woodworking tasks and he occa-
sionally made furniture (see Appendix I). This
simple table is branded underneath the top: *W^M.
COOPER/ SAG-HARBOR.*

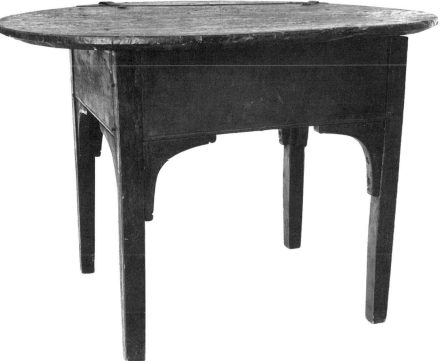

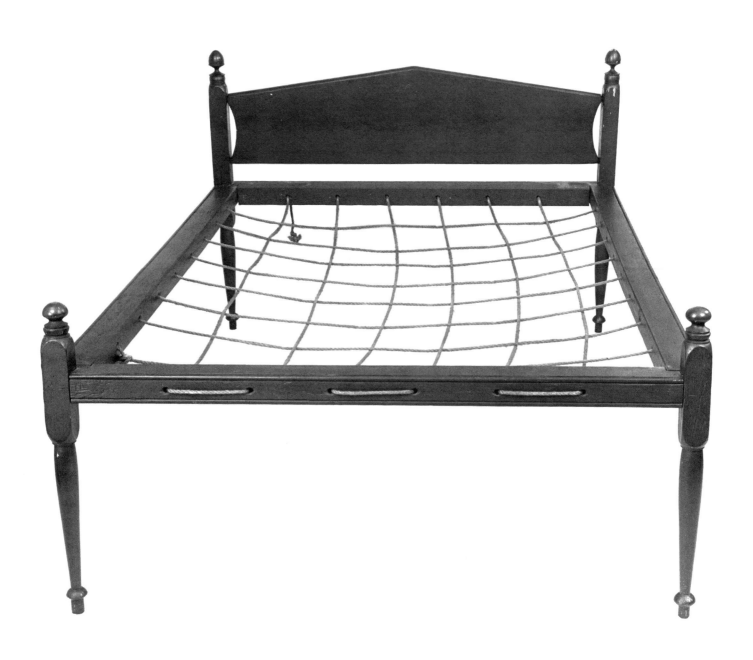

241. Bed, 1790–1810
Hempstead
Maple, pine, [chestnut?]
H. 36 W. 58 L. 74
Rock Hall, Lawrence

A bed of this type might have been described in a
joiner's account book as a low-post bedstead. If
made of less fancy woods, as was this example,
bedsteads were usually *"cullered"* or painted.
The Hewlett or Martin family of Rock Hall origi-
nally owned this bed.

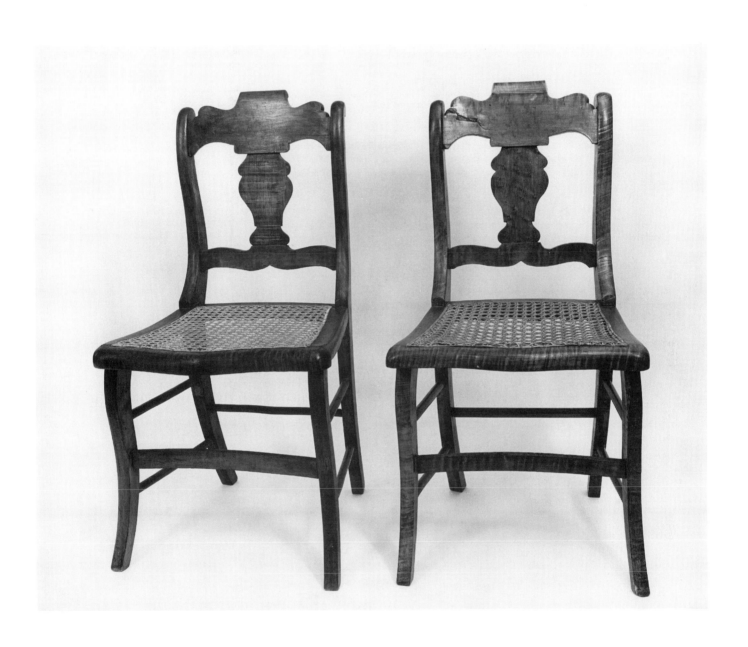

242. Pair of Side Chairs, 1830–1849
Nathan Tinker (active ca. 1819–1849)
Sag Harbor
Maple
H. 32 3/8 W. 17 3/4 D. 18
Mr. and Mrs. Louis R. Vetault

Nathan Tinker operated the largest cabinetmaking establishment on eastern Long Island during the early nineteenth century, yet these are the first signed pieces from his shop to be located. One chair of the pair bears the painted inscriptions *N. Tinker* and *Sag Harbor* on the underframe.

243. Elias Pelletreau House and Shop, ca. 1686
Southampton
Photograph from an engraving in George Rogers Howell, *The Early History of Southampton, L.I. . . ., 1887*

The Pelletreau house and adjacent silversmith's shop were originally built about 1686 for Stephen Bouyer, a merchant and friend of Elias Pelletreau's father. The house was demolished in the late nineteenth century. The shop, which has undergone some alteration, is maintained by the Southampton Colonial Society.

244. Porringer, 1750–1807
Elias Pelletreau (1726–1810)
Southampton
Silver
Mark: *EP* in rectangle
L. 7 Diam. (of bowl) 4 11/16
Private collection

In 1802, Philip Howell purchased two 5-gill porringers and in 1807 five additional porringers from Pelletreau. Perhaps this porringer, which descended in the Howell family and bears the initials *P*∗*H,* was one of the seven noted in Pelletreau's account books. An identical porringer with the initials *P*∗*H* is in the Henry Francis du Pont Winterthur Museum.

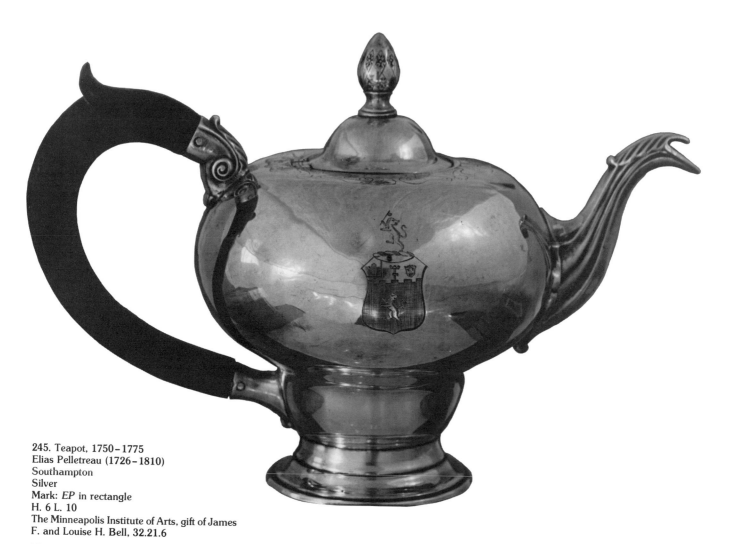

245. Teapot, 1750–1775
Elias Pelletreau (1726–1810)
Southampton
Silver
Mark: *EP* in rectangle
H. 6 L. 10
The Minneapolis Institute of Arts, gift of James F. and Louise H. Bell, 32.21.6

Most rural eighteenth century silversmiths in America did not have the skills required to produce large pieces of silver, such as teapots and tankards, or a clientele which demanded such items. Elias Pelletreau, however, was a notable exception. He recorded in his account books the fashioning of seventeen teapots, sixteen of them dating from before the Revolution. Unfortunately, it is not possible to link this example with certainty to any of the account book entries. Perhaps the initials *M/IP* on the base were those of John Mitchel who purchased teapots from Pelletreau in 1763 and 1769. In both cases, Pelletreau charged £9 11s. 11d. for the silver and £5 4s. for workmanship.

246. Tea Tongs, 1760–1790
Elias Pelletreau (1726–1810)
Southampton
Silver
Mark: *EP* in rectangle
L. 4 3/4
Private collection

These tongs, with arms cast and chased in a pierced design typical of the rococo style, are the only surviving example of this type by Pelletreau.

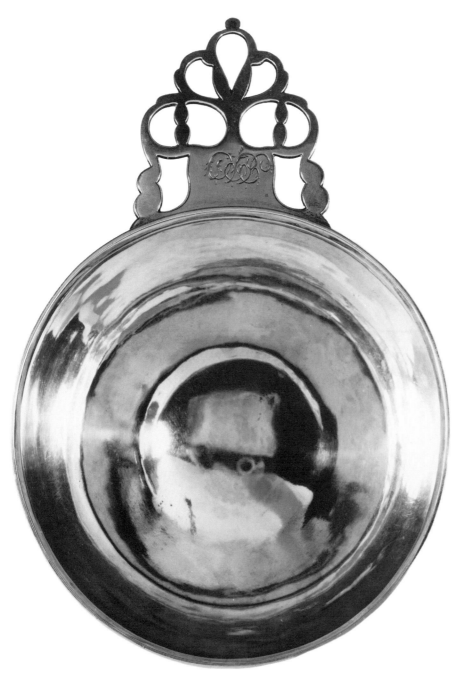

247. Porringer, 1790–1810
John Chatfield Hedges (1770–1798) or David Hedges (1779–1857)
East Hampton
Silver
Diam. (of bowl) 5 1/4
Private collection

Since David Hedges apparently continued to use the same *HEDGES.* touchmark that his brother John had used, it is difficult, if not impossible, to distinguish between the silver the brothers made. The script initials *PPO* are engraved on the handle.

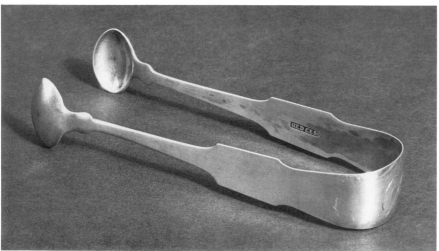

248. Tea Tongs, ca. 1805
Probably David Hedges (1779–1857)
East Hampton
Silver
L. 7 3/8
Private collection

249. Teaspoon, 1802–1815
Benjamin Coleman (active ca. 1802–1820)
Sag Harbor
Silver
L. 5 1/2
Private collection

Only a few spoons survive to represent Coleman's silverwork. He also made jewelry and supplied a cup and a three pint pitcher for John Lyon Gardiner.

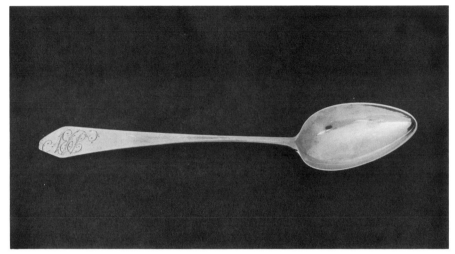

250. Tablespoon, ca. 1795
Paul Sayre (active ca. 1780–1800)
Southampton
Silver
L. 7 3/8
Private collection

251. Teaspoon, ca. 1795
Paul Sayre (active ca. 1780–1800)
Southampton
Silver
L. 6 1/8
Private collection

These spoons were made for members of the Jennings family of North Sea. The script initials on the tablespoon and teaspoon respectively are *EHJ* and *DHJ*.

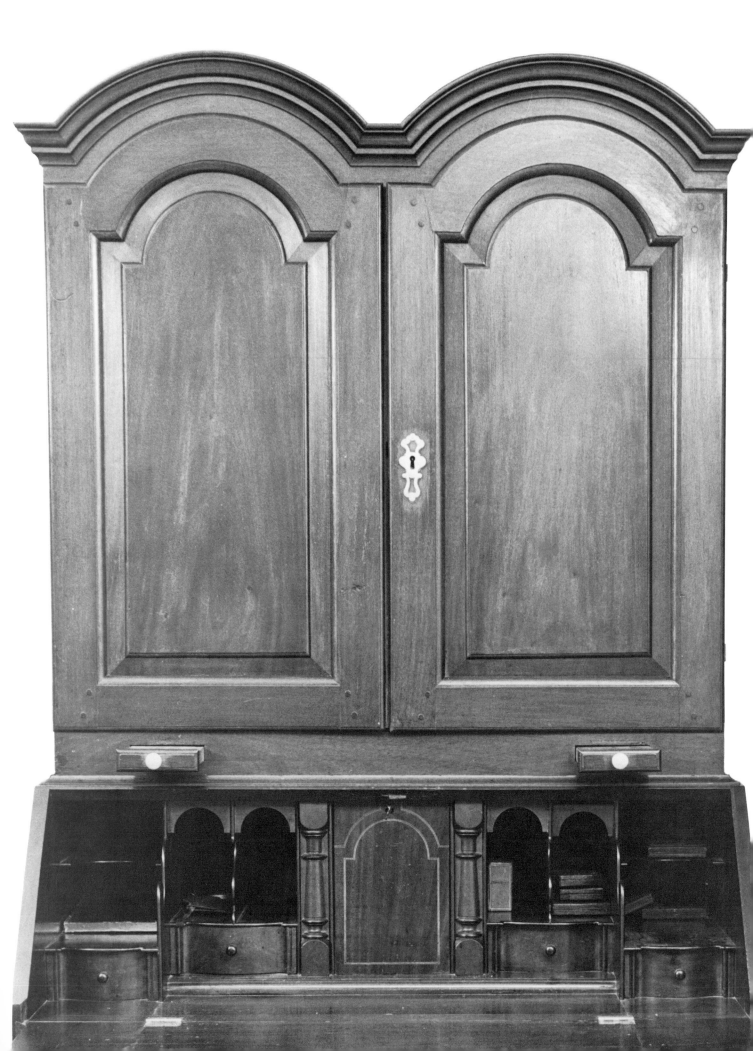

BIBLIOGRAPHICAL ESSAY

One of the goals of the research for this exhibition was the identification of woodworking craftsmen and silversmiths active on Long Island during the period 1640 to 1830. After an extensive search of the primary sources, we were able to compile the appendices to this catalogue which include the names of more than 1,000 Long Island craftsmen. In order to explain further the bibliographical information given in the appendices and to identify for other researchers the archival materials pertinent to Long Island's social and cultural history during the seventeenth and eighteenth centuries, a brief essay on the nature and location of the primary sources is in order.

Our discussion will focus on the various types of primary evidence rather than the repositories themselves and we will mention only briefly here the most significant general collections of Long Island materials. Two institutions stand out for the diversity and comprehensiveness of their collections. They are the East Hampton Free Library in East Hampton and the Long Island Historical Society in Brooklyn. The researcher will also find important material in the collections of the Nassau County Historical Museum in East Meadow, the New-York Historical Society in New York City, and the Queensboro Public Library in Jamaica.

We examined several types of documents in an attempt to identify craftsmen's occupations and to determine their craft activities. The most important sources were account books, probate records, deed and mortgage records, the various collections of town records, newspaper advertisements, and city directories.

Account Books

A craftsman's account book provides information about his craft practice and lifestyle and is an invaluable source. We have consulted the account books kept by seventeen Long Island craftsmen active during the period in question. The dates of the craftsmen's account books and the locations of the books are as follows: the Nathan Topping Cook account book (1792–1822), microfilm, Henry Francis du Pont Winterthur Museum, Winterthur, Delaware; the Sullivan Cook account book (1808–1839), Suffolk County Historical Society, Riverhead, New York; the William Cooper day book (1808–1812), Queensboro Public Library, Jamaica, New York; the Felix Dominy account book (1818–1827), Henry Francis du Pont Winterthur Museum; the Felix Dominy and Nathaniel Dominy VII account book (1809–1862), East Hampton Free Library, East Hampton, New York; the Nathaniel Dominy IV and Nathaniel Dominy V account book (1762–1844), Henry Francis du Pont Winterthur Museum, photocopy in the East Hampton Free Library; the Nathaniel Dominy V account book (1798–1847), Henry Francis du Pont Winterthur Museum; the John Paine account book (1761–1815), microfilm, incorrectly identified in the index to the microfilm collection as the John Prime account book, Microfilm Collection of the Institute for Colonial Studies, State University of New York at Stony Brook, Stony Brook, New York; the John Parsons account book (1674–1685), photocopy, New-York Historical Society, New York City; the Jeremiah Remsen account book (1813–1832), Bryant Memorial Library, Roslyn, New York; the Daniel Sammis account books (1817–1834), Huntington Historical Society, Huntington, New York; the Daniel Sandford account book (1754–1803), Queensboro Public Library; the Daniel Smith account book (1792–1814), Charles Embree Lawrence Collection, Smithtown Public Library, Smithtown, New York; the John Stansbury account book (1811–1823), Long Island Historical Society, Brooklyn, New York; the Pardon Tabor account book (1817–1841), Queensboro Public Library; the Micah Wells account book (1754–1787), Suffolk County Historical Society. The account books of two Long Island

silversmiths are also extant. Three account books kept by Elias Pelletreau (1760–1766, 1766–1800, 1800–1810) are in the East Hampton Free Library. Another Pelletreau account book (1766–1776) is in the Long Island Historical Society. Nathaniel Potter's day book (1807–1839) is in the Huntington Historical Society.

Supplementing these craftsmen's account books are a great many other account books, day books, and receipt books for this period which have survived. Long Island residents often recorded in their books the purchase of furniture or silver and identified the craftsmen who supplied these items. Entries in store ledgers frequently document a craftsman's purchase of the materials needed for his trade, thereby indicating his occupation. Several of these account books merit special notice.

The John and Samuel Bowne account book (1649–1702) has entries in both English and Dutch. It is one of the few seventeenth century account books to survive on Long Island and is now in the New-York Historical Society. The East Hampton Free Library owns an important collection of Gardiner family account books, notably the David Gardiner account books (1760–1769, 1770–1799) and the John Lyon Gardiner account books (1791–1793, 1801–1807) and day books (1797–1801, 1802–1807, 1807–1810).

The account books kept by the Lloyd family of Lloyd's Neck are also informative. The James and Henry Lloyd I account book (1676–1684) and a separate Henry Lloyd I account book (1706–1780) are located in the New-York Historical Society. The Long Island Historical Society also owns four Henry Lloyd I account books dating from 1706 through 1740.

Among the most useful merchant's account books are the Samuel Townsend account book (1758–1760) in the East Hampton Free Library and an unidentified Oyster Bay merchant's account book (1750–1751) in the New-York Historical Society. Entries in the latter book indicate that this was also a Samuel Townsend account book. An unidentified Franklinville store ledger in the Suffolk County Historical Society provides information about craftsmen active on the north fork.

The following institutions have extensive collections of Long Island account books for this period: the East Hampton Free Library, the Long Island Historical Society, the Nassau County Historical Museum, the New-York Historical Society, and the Queensboro Public Library. Students of Long Island history can find smaller collections at the Bryant Memorial Library, the Huntington Historical Society, the New York Public Library, the Smithtown Public Library, and the Suffolk County Historical Society.

Probate Records

We were able to identify many Long Island craftsmen from the probate records filed in county Surrogate's courts. These records include inventories, wills, letters of administration, and miscellaneous papers relating to the probate of estates. Frequently, these documents name the occupation of the deceased or specify the occupations of the witnesses to the instruments or the administrators of the estates.

Surrogate's courts for the three Long Island counties—Suffolk, Kings, and Queens—were established in 1787. Prior to that time, most instruments of probate were recorded in the Surrogate's Court in New York City. The will libers filed there contain many Long Island wills for the period 1665 to 1787. Both the will libers and the letters of administration, the earliest of which date from the eighteenth century, are available in abstract in the New-York Historical Society's *Collections* for the years 1892 to 1906, a fifteen volume series entitled *Abstracts of Wills.* One can also find abstracts of the Suffolk County wills recorded in New York in a single volume,

Abstracts of Wills 1665-1787, in the Suffolk County Surrogate's Court in Riverhead. The abstracts in this volume sometimes identify the occupations of witnesses and administrators whereas those in the New-York Historical Society volumes do not include this information.

The will libers in the Surrogate's Court in New York City also contain early inventories of estates dating from 1668 to 1720. Another group of inventories, which date from 1725 to 1753, are recorded in a separate liber called "Inventory Book 1730-1752" and are available on microfilm at the Queens College Historic Documents Collection, Queens College, Flushing. A separate group of inventories recorded in New York, also from the period 1725-1753, are available at the New-York Historical Society. One can find a useful listing of early New York inventories in the Surrogate's Court in New York City and the New-York Historical Society in Kenneth Scott's "Early New York Inventories of Estates" in the June, 1965 issue of the *National Genealogical Society Quarterly.*

A group of inventories dated 1666 to 1775 were recorded in New York City but later deposited at the Court of Appeals in Albany. These inventories are now located in the Queens College Historic Documents Collection where they are available on microfilm. Kenneth Scott listed these inventories in a second article entitled "New York Inventories, 1666-1775" in the December, 1968 issue of the *National Genealogical Society Quarterly.*

During the seventeenth century local officials on Long Island also recorded a number of wills and inventories. In Suffolk County, a traveling court, the Court of Sessions, convened in different towns and recorded many instruments during this period. One can find these documents in *Minutes of the Court of Sessions for Suffolk County and Court of Common Pleas 1669-1684,* a separate volume stored in the vault in the Suffolk County Clerk's Office in Riverhead. In addition, some seventeenth century wills and inventories were recorded in Suffolk County Deed Liber A, which is also located in the vault of the Suffolk County Clerk's Office.

In Queens County, one can find wills and inventories from 1688 through 1732 recorded in Deed Libers A, B, and C which are available on microfilm at the City Register Office of Queens County in Jamaica. Few wills and inventories were recorded in Kings County. Those extant date from 1680 to 1706 and some are in Dutch. The researcher can find them in Kings County Deed Liber A located at the James A. Kelly Institute for Local Historical Studies at St. Francis College in Brooklyn. This liber is also on microfilm at the City Register Office of Kings County in Brooklyn.

Probate records for the period 1787-1830 are located in the county Surrogate's courts. The records in the Suffolk County Surrogate's Court in Riverhead are easily accessible and quite extensive. An alphabetical catalog lists each decedent for whom there is a will, inventory, or letters of administration on file. One can find the libers of wills and letters of administration in the records room. The original inventories, which we were able to consult for this study, are now in storage, but they are available on microfiche. Suffolk County inventories were often filed with an estate information sheet which frequently specifies the occupation of the deceased.

Probate records in the Queens County Surrogate's Court in Jamaica are also available for the period 1787 to 1830. The libers of wills and letters of administration are shelved in the records room, but the collection of inventories, which is apparently incomplete and not well organized, is filed in a separate room.

The Kings County Surrogate's Court in Brooklyn also has probate records for this period, but, unfortunately, the collection of inventories is very incomplete. The wills and letters of administration are recorded in libers located in the records room, and the invento-

ries are stored separately.

In some cases, the families of the deceased kept copies of the inventories and, consequently, one can also find these documents in manuscript collections. The repositories noted in the introduction to this essay also have some early inventories of Long Island estates.

Records of Deed and Mortgage
Among the public documents useful for our purposes were deeds, or land indentures, and mortgages. Early deed and mortgage libers for all Long Island counties are extant and available to the researcher.

The Suffolk County Clerk's office in Riverhead has libers of deeds continuous from 1687. Libers A through E cover the period from 1687 to 1820. Liber A is stored in the vault, but Libers B through E are shelved in the main records room. The first liber of Suffolk County mortgages begins with the year 1755. These libers are also continuous through 1830 and are shelved in a room adjacent to the main records room.

The first Queens County deeds on record on microfilm in the City Register Office of Queens County in Jamaica date from the 1680's and the deed libers are continuous through 1830. Queens County mortgage records are available for the mid-eighteenth century through 1830. The Queensboro Public Library has one of the original mortgage libers, *Record of Mortgages 1754-1760.*

The Kings County deed and mortgage libers are located at the James A. Kelly Institute of Local Historical Studies, St. Francis College, Brooklyn. The earliest Kings County deeds date from the last half of the seventeenth century and the earliest mortgages from the mid-eighteenth century. These documents are available on microfilm at the City Register Office of Kings County in Brooklyn.

The parties to deeds also retained copies of the instruments. Researchers will, therefore, find some of these documents in historic documents collections on Long Island. Each of the major repositories mentioned in the introduction above has a collection of deeds for the period in question. In addition, the published town records include land indentures.

Town Records
The Long Island town governments, of course, kept records of their activities and proceedings. Most of these records have survived and for many towns they have been published. With the exception of the Kings County towns whose records are unpublished and other unpublished records for the towns of Southold and Brookhaven, we have used only the published records. Undoubtedly, the town clerks' offices in each town have additional material on file that has not been printed. While each set of published town records differs somewhat in terms of the kinds of documents recorded, all of the records contain information useful for the identification of Long Island craftsmen. The type of document most frequently recorded was the land indenture, and the occupations of the parties to the indenture were often noted. Tax lists, town censuses, and other types of lists published in the records occasionally specify occupations. The town accounts list debts to craftsmen for carpentry work on town buildings, for making furniture for the schoolhouses or meetinghouses, or for making coffins for decedents who had been in the town charge. Furthermore, town officials also recorded agreements to erect buildings, naming the carpenters and usually describing the particulars of the structures they were to build. In some cases, these agreements specified interior work such as finishing with wainscot or cupboards. Finally, the seventeenth century town records include those wills and inventories of estates recorded by the town officials.

Published town records are available for the following Long Island towns: Brookhaven, 1657-1789; East Hampton, 1650-

1955 (town records and town trustees records); North and South Hempstead, 1654–1880; Huntington, 1653–1873; Jamaica, 1656–1751; Newtown; 1656–1690 (town records and town court records); Oyster Bay, 1653–1795; Riverhead, 1792–1886; Smithtown, 1650–1780; Southampton, 1639–1929 (town records and town trustees records); Southold, 1651–1780. Additional unpublished records for the town of Brookhaven are on microfilm in the Microfilm Collection of the Institute for Colonial Studies at the State University of New York at Stony Brook. The Suffolk County Historical Society also has in its collections a typescript copy of Liber D of the Southold town records which has not been published.

Researchers will find the unpublished town records for Bushwick, Flatbush, Flatlands, Gravesend, and New Utrecht in the James A. Kelly Institute of Local Historical Studies at St. Francis College in Brooklyn. The original manuscript libers have been transcribed and the records of Bushwick, Flatbush, Flatlands, and New Utrecht have been translated from Dutch to English. The early records of Brooklyn and Flushing have not survived.

Newspapers and Directories

A number of issues of several Long Island newspapers dating from the late eighteenth and early nineteenth centuries are extant. They are scattered in different repositories, and we were unable to consult every available issue in our time period. The following list of Long Island newspapers is not a complete guide to surviving issues, but only a summary of the issues we examined.

The first newspaper published on Long Island was apparently the *Brooklyne Hall Super-Extra Gazette.* The only known issue of this paper, which is now lost, was dated June 8, 1782. Henry Stiles in his *History of the City of Brooklyn* quotes extensively from this issue.

Two other Brooklyn newspapers, the *Long Island Courier* and the *Long Island Star,* provide information about Long Island craftsmen. The Long Island Historical Society owns fifteen issues of the Courier dating from October 15, 1800 to October 20, 1802. The researcher can see these issues on microfilm. The *Star* was first published in Brooklyn in 1809, and the Long Island Historical Society has a complete collection of issues from 1809 through 1863. These are also available to the researcher on microfilm.

In 1821, the *Long Island Farmer and Queens County Advertiser* was first published in Jamaica. Issues of this paper through January 27, 1825, are located in the Long Island Historical Society where one can see them on microfilm.

A Hempstead newspaper, the *Long Island Telegraph and General Advertiser,* first appeared on May 16, 1830. The name was changed to the *Inquirer* in November, 1830, and it was published under this heading through May 4, 1833. The Nassau County Historical Museum has a complete collection of these newspapers on microfilm.

The *Portico,* a Huntington newspaper, was first published in 1826. The Huntington Historical Society has a continuous collection from March 30, 1826 through March 8, 1827.

The surviving collections of Sag Harbor newspapers are more complete than the collections of west end papers. In 1791, David Frothingham began publication of the first Sag Harbor paper, *Frothingham's Long Island Herald.* The Long Island Historical Society has approximately 150 issues of this paper dating from June 7, 1791 to December 17, 1798. The *Suffolk County Herald* was first published in Sag Harbor in 1802. The East Hampton Free Library has issues from September 4, 1802 through October 18, 1802. The Long Island Historical Society also has approximately forty issues of the *Herald* covering the period June 19, 1802 to January 3, 1803.

Another Sag Harbor paper, the *Suffolk Gazette,* was published from February 20, 1804 to February 23, 1811. The East Hampton Free Library has a complete set of the *Gazette* as well as a complete collection of the *Suffolk County Recorder* which was published in Sag Harbor from October 19, 1816 to October 11, 1817. The *American Eagle,* which was occasionally called the *American Eagle and Suffolk County General Advertiser,* was published in Sag Harbor in 1817 but beginning in 1821 was published in Huntington. The East Hampton Free Library has issues of this paper from February 6 to March 27, 1819. The Long Island Historical Society has four issues, the first dated January 10, 1818, and the last dated December 4, 1823. *The Corrector,* an important early nineteenth century Sag Harbor paper, was first published in 1822. The East Hampton Free Library has a complete collection of *The Corrector* from August 3, 1822 to December 30, 1840 and from May 17, 1848 to December 31, 1853.

New York City directories and separate Brooklyn directories list the occupations of Brooklyn residents. The earliest Brooklyn listing appears in John Buell's *The New York and Brooklyn Directory and Register, for the Year 1796.* A Brooklyn directory for 1802 was appended to *Longworth's American Almanac, New-York Register, and City-Directory, for the Twenty-Seventh Year of American Independence.* Longworth again printed a Brooklyn listing in his directory for 1811. More than ten years later Alden Spooner published the first separate Brooklyn directory entitled *Spooner's Brooklyn Directory for the Year 1822.* Spooner published Brooklyn directories for 1823 through 1826 and 1829. Lewis Nichols compiled the *Brooklyn Directory for the Year 1830,* which was published by Alden Spooner.

INTRODUCTION TO APPENDICES

The classification of craftsmen's occupations is discussed at length in the section on Long Island craftsmen in this catalogue. Frequently, the occupational titles given in primary sources—whether specified by the craftsmen or ascribed to them by their contemporaries—do not satisfactorily denote each craftsman's capabilities or indicate the full range of his activities. We have discovered craftsmen identified as carpenters who made furniture and several cabinetmakers who built houses. As one might expect on rural Long Island, the woodworker usually possessed multiple skills and could provide the services of furniture maker, carpenter, cooper and wheelwright as the need arose. Therefore, based on extensive documentation for the period 1640–1830, we have included in the following list of craftsmen almost every type of woodworker on the assumption that each one of them was a potential furniture maker. We have chosen, however, to exclude shipwrights active after 1700 and coopers active after 1750, because the evidence suggests a greater degree of specialization in those areas beyond those dates. The reader will note that the term cabinetmaker appears only occasionally in this chart. Throughout the eighteenth century on Long Island, the term joiner was used in preference to the designation cabinetmaker. Only in those cases where a craftsman called himself a cabinetmaker or identified his craft as cabinetmaking have we identified him as a cabinetmaker.

Whenever possible, we have given the occupational title which the craftsman himself used, or, if such evidence was lacking, we have listed the occupation mentioned in contemporary sources. When the sources do not specify occupations, we have deduced a craftsman's skills from other primary evidence, for example, the inventories of estates and account book entries.

A number of problems arise when attempting to determine occupation from the inventory of an estate. By the time of his death, a craftsman may have turned over some of his tools to his successor. The inventory, therefore, is not always an accurate or complete record of his possessions relating to his craft practice. Moreover, inventories necessarily vary according to the interest and knowledge of those recording the information. Some inventories will list only "carpenter's" or "joiner's" tools, while others itemize the number and kinds of tools. In general, if the inventory lists a variety and a substantial number of tools and supplies, we have identified the craftsman's occupation on the basis of that evidence.

We have listed multiple occupations when we have documentation that a craftsman possessed multiple skills. If we have detailed information about a craftsman's life, skills, or craft practice, we have presented that information separately in the sketches of individual craftsmen which follow the chart. If there is a sketch for a particular craftsman, it is indicated on the chart by an asterisk before the individual's name.

The dates given in this chart are activity dates unless otherwise noted. Since the probate of a will often occurs many months after an individual's death, we have assumed that the date of probate is an approximate death date, and have used the abbreviation "d. ca." We have, however, assumed that the dates of inventories are exact death dates.

The place names which appear in the chart occasionally designate the village, but more frequently, the township in which the craftsman worked.

When we suspect that certain information is correct but lack specific documentation, we have placed the information in brackets with a question mark. The short titles and abbreviations which appear in the chart are explained in the key which follows.

KEY TO ABBREVIATIONS AND SHORT TITLES

AB	Account Book
Adkins, *Setauket*	Adkins, Edwin P. *Setauket: The First Three Hundred Years, 1655–1955.* New York: David McKay Co., Inc., n.d.
Banta, *Sayre Family*	Banta, Theodore M. *Sayre Family: Lineage of Thomas Sayre, a Founder of Southampton.* New York: The De Vinne Press, 1901.
Bergen, *Kings County*	Bergen, Teunis G. *Register in Alphabetical Order, of the Early Settlers of Kings County. . . .* New York: S. W. Green's Son, 1881.
BhTR	*Brookhaven Town Records, 1662–1679.* New York: Tobias A. Wright, 1924.
	Records of the Town of Brookhaven. Books A–B. New York: The Derrydale Press, 1930–1932.
Bigelow, *BD*	*Brooklyn Directory for 1832–1833.* New York: William Bigelow, 1832.
Bryant Memorial Library	Bryant Memorial Library, Roslyn, New York.
Buell, *NYBD*	Buell, John. *The New York and Brooklyn Directory and Register, for the Year 1796.* New York: John Law, 1796.
BwTR	Bushwick town records, James A. Kelly Institute of Local Historical Studies, St. Francis College, Brooklyn, New York. (Manuscript.)
Carpenter, *Carpenter Family*	Carpenter, Daniel Hoogland. *History and Genealogy of the Carpenter Family in America, from the Settlement at Providence, R.I., 1637–1901.* Jamaica, N.Y.: The Marion Press, 1901.
Colonial Institute Records, SUSB	Microfilm Collection of the Institute for Colonial Studies, State University of New York at Stony Brook, Stony Brook, New York.
Court of General Sessions	*Minutes of the Court of General Sessions of the Peace and also of Common Pleas, 1722–1787.* Queens County Clerk's Office, Jamaica, New York.
Court of Sessions	*Minutes of the Court of Sessions for Suffolk County and Court of Common Pleas, 1669–1684.* Suffolk County Clerk's Office, Riverhead, New York.
CROB	City Register Office of Kings County, Brooklyn, New York.
CROJ	City Register Office of Queens County, Jamaica, New York.
Darling Foundation, *Silversmiths*	Darling Foundation of New York State Early American Silversmiths and Silver. *New York State Silversmiths.* Eggertsville, New York: By the Author, 1964.
DB	Day Book
Dwight, "Gelston Family," *NYGBR*, 1871	Dwight, Benjamin W. "The Gelston Family." *New York Genealogical and Biographical Record,* July, 1871.
Eaton, "William Thorn," *NYGBR*, 1889	Eaton, A. W. H. "William Thorn and some of his Descendants." *New York Genealogical and Biographical Record,* April, 1889.
EHFL	East Hampton Free Library, East Hampton, New York.
EHTR	*Records of the Town of East Hampton, Long Island, Suffolk Co., N.Y.* Vols. I–V. Sag Harbor, N.Y.: Town of East Hampton, 1887–1905.
EH *Trustees Records*	Sleight, H. D., ed. *Journal of the Trustees of the Freeholders and Commonalty of East Hampton Town.* Vols. I–III. Riverhead, N.Y.: Harry Lee Publishing Co., 1927.
Failey, "Elias Pelletreau"	Failey, Dean F. "Elias Pelletreau: Long Island Silversmith." Unpublished Master's thesis, Winterthur Program, University of Delaware, 1971.
FbTR	Flatbush town records, James A. Kelly Institute of Local Historical Studies, St. Francis College, Brooklyn, New York. (Manuscript.)
FlTR	Flatlands town records, James A. Kelly Institute of Local Historical Studies, St. Francis College, Brooklyn, New York. (Manuscript.)
Griffin, *Journal*	Griffin, Augustus. *Griffin's Journal. First Settlers of Southold . . . First Proprietors of Orient; Biographical Sketches.* Orient, N.Y.: By the Author, 1857.
GTR	Gravesend town records, James A. Kelly Institute of Local Historical Studies, St. Francis College, Brooklyn, New York. (Manuscript.)
HHS	Huntington Historical Society, Huntington, New York.
Hillhouse Collection, Yale	Hillhouse Family Collection, Yale University Library, New Haven, Connecticut.
Holsten, "Byram Account Book"	Holsten, Margaret. "The Account Book of Ephraim Niles Byram, Sag Harbor, New York." Unpublished Master's thesis, Cooperstown Program, State University of New York at Oneonta, 1976.
Howell, *History of Southampton*	Howell, George Rogers. *The Early History of Southampton, L.I., New York, with Genealogies.* New York: J. N. Hallock, 1866.
HTHO	Huntington Town Historian's Office, Huntington, New York.
HTR	Street, Charles R., ed. *Huntington Town Records, Including Babylon, Long Island, N.Y.* Vols. I–III. Huntington, N.Y.: The Long Islander Print, 1887–1889.
Hummel, *With Hammer in Hand*	Hummel, Charles F. *With Hammer in Hand: The Dominy Craftsmen of East Hampton, New York.* Charlottesville, Va.: The University Press of Virginia, 1968.
JTR	Frost, Josephine C., ed. *Records of the Town of Jamaica, Long Island, N.Y.* Vols. I–III. Brooklyn, N.Y.: Long Island Historical Society, 1914.
KCSC	Kings County Surrogate's Court, Brooklyn, New York.

Latting, "Wright Family" *NYGBR,* 1872 — Latting, John J. "Wright Family of Oyster Bay, L.I." *New York Genealogical and Biographical Record,* January, 1872.

LIHS — Long Island Historical Society, Brooklyn, New York.

Longworth, *NYCD* — Longworth, D. *Longworth's American Almanac, New-York Register, and City Directory.* . . . New York: By the Author, 1802, 1811.

Ludlam, *Parish Genealogy* — Ludlam, Julia Parish. *A Genealogy of the Descendants of Mathew Parish of Oyster Bay, Long Island.* n. p., 1897.

Mather, *Refugees* — Mather, Frederic Gregory. *The Refugees of 1776 from Long Island to Connecticut.* Albany, N.Y.: J. B. Lyon Company, 1913.

Moore, *Index* — Moore, Charles B. *Town of Southold, Long Island: Personal Index prior to 1698, and Index of 1698.* New York: J. Medole, 1868.

NCHM — Nassau County Historical Museum, East Meadow, New York.

Nichols, *BD* — Nichols, Lewis. *Brooklyn Directory for the Year 1830.* Brooklyn, N.Y.: A. Spooner, 1830.

NSHTR — *Records of the Towns of North and South Hempstead, Long Island, N.Y.* Vols. I– VIII. Jamaica, N.Y.: Long Island Farmer Print, 1896–1904.

NUTR — New Utrecht town records, James A. Kelly Institute of Local Historical Studies, St. Francis College, Brooklyn, New York.

N.Y. Doc. Hist. — O'Callaghan, E. B., ed. *The Documentary History of the State of New York.* Vols. I– IV. Albany, N.Y.: Weed, Parsons & Co., 1850.

NYGBR — *New York Genealogical and Biographical Record.* New York: New York Genealogical and Biographical Society.

NYHS — New-York Historical Society, New York, New York.

NYHS *Abstracts* — *Collections of the New-York Historical Society. Abstracts of Wills.* Vols. I–XV. New York: Printed for the Society, 1892– 1906.

NYHS *Collections,* 1891 — *Collections of the New-York Historical Society. Muster Rolls of New York Provincial Troops, 1755–1764.* New York: Printed for the Society, 1891.

NYPL — New York Public Library, New York, New York.

N.Y. Wills — *Suffolk County Wills Recorded in New York. Abstracts of Wills 1665–1787.* Suffolk County Surrogate's Court, Riverhead, New York.

OBTR — *Oyster Bay Town Records.* Vols. I–VIII. New York: Tobias A. Wright, 1924.

Onderdonk, *Names* — Onderdonk, Henry. *Jamaica Records, 1656–59; also Names in Jamaica.* Long Island Historical Society, Brooklyn, New York. (Manuscript.)

——. *List of all the Inhabitants of Hempstead, Long Island.* Long Island Historical Society, Brooklyn, New York. (Manuscript.)

——. *Names in the Records of Hempstead.* Long Island Historical Society, Brooklyn, New York. (Manuscript.)

Perrine, *Wright Family* — Perrine, Howland Delano. *The Wright Family of Oyster Bay, L.I. with the Ancestry of and Descent from Peter Wright and Nicholas Wright, 1423–1923.* New York: By the Author, 1923.

Peyer, "Jamaica Inhabitants" — Peyer, Jean, "Genealogical Information on Jamaica Inhabitants." In the possession of the author.

QbPL — Queensboro Public Library, Jamaica, New York.

QCCO — Queens County Clerk's Office, Jamaica, New York.

QCHDC — Queens College Historic Documents Collection, Queens College, Flushing, New York.

QCSC — Queens County Surrogate's Court, Jamaica, New York.

Rattray, *East Hampton History* — Rattray, Jeannette Edwards. *East Hampton History, Including Genealogies of Early Families.* Garden City, N.Y.: Country Life Press, 1953.

RB — Receipt Book

RTR — Downs, Dr. Arthur Channing, Jr., ed. *Riverhead Town Records 1792–1886.* Huntington, N.Y.: The Long-Islander, 1967.

Salmon, *Records* — Salmon, William. *The Salmon Records: a Private Register of Marriages and Deaths of the Residents of the Town of Southold.* . . . Edited by William A. Robbins. New York: New York Genealogical and Biographical Society, 1918.

Sanford, *Sandford Families* — Sanford, Grover Merle. *The Sandford/Sanford Families of Long Island.* Baltimore: Gateway Press, Inc., 1975.

SCCO — Suffolk County Clerk's Office, Riverhead, New York.

SCHS — Suffolk County Historical Society, Riverhead, New York.

SCSC — Suffolk County Surrogate's Court, Riverhead, New York.

Seversmith, *Colonial Families* — Seversmith, Herbert Furman. *Colonial Families of Long Island, New York and Connecticut: being the Ancestry and Kindred of Herbert Furman Seversmith.* Vols. I–IV. East Hampton Free Library, East Hampton, New York. (Typescript.)

ShCS — Southampton Colonial Society, Southampton, New York.

ShdTR — Case, J. Wickham, ed. *Southold Town Records.* Vols. I–II. New York: S. W. Green's Son, 1882–1884.

ShTR Pelletreau, William S., ed. *Records of the Town of Southampton, Long Island, N.Y.* Vols. I–V. Sag Harbor, N.Y.: John H. Hunt, 1877–1910.

Sh *Trustees Records* Sleight, H. D., ed. *Trustees Records of the Town of Southampton.* Vols. I–II. Published by the Town, n.d.

SmHS Smithtown Historical Society, Smithtown, New York.

SmPL Smithtown Public Library, Smithtown, New York.

SmTR Pelletreau, William S., ed. *Records of the Town of Smithtown, Long Island, N.Y.* Huntington, N.Y.: Long Islander Print, 1898.

 Sleight, Harry D., ed. *Town Records of Town of Smithtown, Long Island, N.Y. . . .* Published by the Town, 1929.

SPLIA Society for the Preservation of Long Island Antiquities, Setauket, New York.

Spooner, *BD* Spooner, Alden, *Spooner's Brooklyn Directory for the Year. . . .* Brooklyn, N.Y.: By the Author, 1822–1826, 1829.

Stiles, *History of Brooklyn* Stiles, Henry R. *A History of the City of Brooklyn. . . .* Brooklyn N.Y.: Published by subscription, 1867.

Stoutenburgh, *Dutch Reformed Church* Stoutenburgh, Henry A. *A Documentary History of the Dutch Congregation of Oyster Bay, Queens County, Island of Nassau (Now Long Island).* Vols. I–II. New York: Eben Storer, 1902. Vols. III–IX. New York: The Knickerbocker Press, 1903–1905.

Thompson, *History of Long Island* Thompson, Benjamin F. *The History of Long Island; from its Discovery and Settlement, to the Present Time.* New York: Gould, Banks & Co., 1843.

TMN *Town Minutes of Newtown.* Vols. I–II. New York: The Historical Records Survey, 1940–1941.

 Minutes of the Town Courts of Newtown, 1656–1690. New York: The Historical Records Survey, 1940.

Torrey, *David Roe of Flushing* Torrey, Clarence Almon. *David Roe of Flushing, Long Island, and some of his Descendants. A Record of Six Generations.* Tarrytown, N.Y.: Roe Printing Co., 1926.

Townsend, *Townsend Genealogy* Townsend, Margaret. *Townsend-Townsend 1066–1909. The History, Genealogy and Alliances of the English and American House of Townsend.* New York: Broadway Publishing Co., 1909.

Vail, *Vail Family* Vail, Henry H. *Genealogy of some of the Vail Family Descended from Jeremiah Vail at Salem, Mass., 1639.* New York: n.p., 1901.

Van Buren, *S. C. Wills* Van Buren, Elizabeth R., comp. *Abstracts of Wills of Suffolk County Recorded at Riverhead, New York.* East Hampton Free Library, East Hampton, New York. (Typescript.)

Waller, *History of Flushing* Waller, Henry D. *History of the Town of Flushing, Long Island, New York.* Flushing, N.Y.: J. H. Ridenour, 1899.

Winterthur The Henry Francis du Pont Winterthur Museum, Winterthur, Delaware.

Wright, *Taber Descendants* Wright, Anna Allen and Wright, Albert Hazen. *Descendants of Joseph and Philip Sons of Philip Taber from Rhode Island, Connecticut & Long Island.* n.p., 1952.

Youngs, *Youngs Family* Youngs, Selah. *Youngs Family. Vicar Christopher Yonges, his Ancestors in England and his Descendants in America; a History and Genealogy.* New York: n.p., 1907.

APPENDIX I
LONG ISLAND WOODWORKING CRAFTSMEN, 1640–1830

A. LIST OF CRAFTSMEN

Name	Occupation	Date	Location	Birthplace	Age	Document	Source
Abbie, Obediah	Carpenter	1681	East Hampton	—	—	Land indenture, 1681	BhTR
Abrahams, James	Carpenter	1824–1830	Brooklyn	—	—	Spooner, BD, 1824, 1826, 1829 Nichols, BD, 1830	— —
Ackley, John	Carpenter	1824–1830	Brooklyn	—	—	Spooner, BD, 1824–1826, 1829 Nichols, BD, 1830	— —
Adams, John	Carpenter/Millwright	1681–1690	Oyster Bay/Huntington	—	—	Town order, 1681 Assessment roll, 1688 Land indenture, 1690	OBTR HTR HTR
Adams, M.	Carpenter	1681	Huntington	—	—	Onderdonk, Names	LIHS
Adriaansz, Jan	Carpenter	1681–1684	Bushwick	—	—	Statement of debt, 1684 —	BwTR Bergen, Kings County
Agenl, Barent	Carpenter	1761	Queens County	Ireland	28	Muster roll, 1761	NYHS Collections, 1891
Agin, Henry	Carpenter	1760	Queens County	Ireland	28	Muster roll, 1760	NYHS Collections, 1891
Akely, John	Joiner	1823	Brooklyn	—	—	Spooner, BD	—
*Albertse, Rut	Carpenter/Joiner	1675–1698	Flatbush	—	—	Agreement, 1678 —	FbTR Bergen, Kings County
Albertson, Derick	Carpenter/Millwright	1708–1732	Oyster Bay	—	—	Land indentures, 1708, 1711, 1721, 1732	OBTR
Albertson, Derick, Jr.	Millwright	1739	Oyster Bay	—	—	Land indenture, 1739	OBTR
Albertson, Richard	Millwright	1740	Oyster Bay	—	—	Land indenture, 1740	OBTR
Albertson, William	Carpenter	1810	Southold	—	—	—	Salmon, Records, SCHS
Alkason, James	Carpenter	1758	Queens County	Pennsylvania	20	Muster roll, 1758	NYHS Collections, 1891
Allen, Levi	Carpenter	1825–1826	Brooklyn	—	—	Spooner, BD	—
Allen, Sandford	Carpenter	1830	Brooklyn	—	—	Nichols, BD	—
Anderson, Joshua	Carpenter	1829	Brooklyn	—	—	Spooner, BD	—
Andrews, Samuel	Carpenter/Shipwright	1663–1678	Oyster Bay	—	—	Land indenture, 1678 —	OBTR Latting, "Wright Family," NYGBR, 1872
Angus, William	Carpenter	1823	Brooklyn	—	—	Spooner, BD	—
Aplebee, Thomas	Carpenter	1756	Oyster Bay	—	—	Land indenture, 1756	OBTR
Applegate, Lewis	Carpenter	1822–1830	Brooklyn	—	—	Spooner, BD, 1822–1823, 1825–1826 Nichols, BD, 1830	—
Applegate, William	Carpenter	1802	Brooklyn	—	—	Longworth, NYCD	—
Arthur, Platt	Shop joiner	1807	Huntington	—	—	Land indenture, 1807	Deed Liber D, SCCO
Bacher, Philip	Carpenter	1825	Brooklyn	—	—	Spooner, BD	—
Back, Simeon	Carpenter	d. 1810	Flatbush	—	—	Inventory	KCSC
*Bageley, Anthony	Carpenter	d. 1746	Flushing	—	—	Inventory	QCHDC
Bailey, Abraham	Carpenter	1822–1826	Brooklyn	—	—	Spooner, BD, 1822, 1825, 1826	—

Name	Occupation	Date	Location	Birthplace	Age	Document	Source
*Bailey, James	Carpenter	d. 1799	Southold	—	—	Estate information sheet	SCSC
						Inventory	SCSC
*Baker, David	Carpenter/ Joiner	1764–1773	East Hampton	—	—	Agreement, 1764	EH *Trustees Records*
						David Gardiner AB	EHFL
Baker, Jonathan	Carpenter	d. ca. 1748	East Hampton	—	—	Will	NYHS *Abstracts,* IV
Baker, Nathan	Carpenter/ Joiner	1682	East Hampton	—	—	Town account, 1682	EHTR
Baker, Capt. Nathaniel	Carpenter	b. 1699– d. 1772	East Hampton	—	—	Town account, 1731	EH *Trustees Records*
						Agreement, 1744	EH *Trustees Records*
						—	Rattray, *East Hampton History*
Baker, Stephen	Carpenter	1758	Queens County	New Jersey	19	Muster roll, 1758	NYHS *Collections,* 1891
Baker, Stephen	Carpenter	d. 1814	East Hampton	—	—	Estate information sheet	SCSC
Baker, William	Joiner	1758–1784	Hempstead	—	20 (in 1758)	Muster roll, 1758	NYHS *Collections,* 1891
						Land indenture, 1784	NSHTR
Baldwin, Clark	Carpenter	1826	Brooklyn	—	—	Spooner, *BD*	—
Baldwin, John	Carpenter	1823–1830	Brooklyn	—	—	Spooner, *BD,* 1823, 1826, 1829	—
						Nichols, *BD,* 1830	—
Baly, William	Carpenter	1760	Queens County	Ireland	20	Muster roll, 1760	NYHS *Collections,* 1891
Banks, William	Carpenter	1829–1830	Brooklyn	—	—	Spooner, *BD,* 1829	—
						Nichols, *BD,* 1830	—
Barrints, Hope	Carpenter	d. 1671	Brooklyn	—	—	Notation of death	NYHS *Abstracts,* I
*Bartholomew, Josiah	Carpenter/ Innkeeper	d. 1687/88	Southampton	—	—	Town order, 1685	ShTR
						Inventory	Deed Liber A, SCCO
Barton, Benjamin	Carpenter	1826–1830	Brooklyn	—	—	Spooner, *BD,* 1826	—
						Nichols, *BD,* 1830	—
Barton, Joseph	Carpenter	1732	Jamaica	—	—	Onderdonk, *Names*	LIHS
						—	Peyer, "Jamaica Inhabitants"
Bass, Lyman	Carpenter	1825	Brooklyn	—	—	Spooner, *BD*	—
*Bates, William	Joiner	1750	Oyster Bay	—	—	Merchant's [Samuel Townsend?] AB	NYHS
Bayles, Elias, Jr.	Wheelwright	1750–1760	Jamaica	—	—	—	Peyer, "Jamaica Inhabitants"
*Bayles, John	Carpenter	1783–1803	Setauket	—	—	Abraham Woodhull AB	EHFL
						Land indenture, 1787	Deed Liber C, SCCO
						Dr. Samuel Thompson diary	NYPL
Bayley, Benjamin	Joiner	1761	Suffolk County	—	—	Letters of administration, estate of Peter Bradley, 1761	NYHS *Abstracts,* VI
Baylis, Thomas	Carpenter	1830	Brooklyn	—	—	Nichols, *BD*	—
Bayly, John	Carpenter	d. ca. 1730	Huntington	—	—	Letters of administration	NYHS *Abstracts,* III

Name	Occupation	Date	Location	Birthplace	Age	Document	Source
Beck, Peleg	Carpenter	1802	Brooklyn	—	—	Longworth, *NYCD*	—
Bedell, John	Carpenter	1826	Brooklyn	—	—	Spooner, *BD*	—
Bedell, Moses	Carpenter	1822–1830	Brooklyn	—	—	Spooner, *BD,* 1822–1823, 1825 Nichols, *BD,* 1830	— —
*Beebe, Asa	Joiner	1759	Southold	New London, Connecticut	23	Muster roll, 1759	NYHS *Collections,* 1891
*Beebe, Eliphalet	Joiner	1759	Southold	New London, Connecticut	19	Muster roll, 1759	NYHS *Collections,* 1891
*Beedel, Abijah	Carpenter/Joiner	d. ca. 1820	Hempstead	—	—	Inventory	QCSC
Belding, Ebenezer	Carpenter	1703	East Hampton		—	Land indenture, 1703	EHTR
Belger, John	Carpenter	1826–1830	Brooklyn	—	—	Spooner, *BD,* 1826, 1829 Nichols, *BD,* 1830	— —
Bennet, Anson	Carpenter	1829–1830	Brooklyn	—	—	Spooner, *BD,* 1829 Nichols, *BD,* 1830	— —
Bennet, Charles	Carpenter	1829–1830	Brooklyn	—	—	Spooner, *BD,* 1829 Nichols, *BD,* 1830	— —
*Bennet, Cornelius	Carpenter/Joiner	d. 1784	Brooklyn	—	—	Inventory Letters of administration	NYHS NYHS *Abstracts,* XII
*Bennet, George	Carpenter	d. 1796	Oyster Bay	—	—	Inventory	QCSC
*Bennet, John	Joiner/Turner	d. 1797	Huntington	—	—	Inventory	SCSC
Bennet, William	Carpenter	1829–1830	Brooklyn	—	—	Spooner, *BD,* 1829 Nichols, *BD,* 1830	— —
Bennet, William Adriaense	Cooper	d. before 1644	Kings County	—	—	—	Bergen, *Kings County*
Bergen, Joris	Carpenter	bpt. 1649–d. after 1736	Brooklyn	—	—	—	Bergen, *Kings County*
Berry, Peter	Carpenter	1825–1830	Brooklyn	—	—	Spooner, *BD,* 1825, 1829 Nichols, *BD,* 1830	— —
Berry, Richard	Carpenter	1826–1830	Brooklyn	—	—	Spooner, *BD,* 1826, 1829 Nichols, *BD,* 1830	— —
Biggs, Isaac	Joiner	1759–1766	Brookhaven	—	—	Will of Nathaniel Biggs, 1759 Will of Richard Woodhull, 1766	*N.Y. Wills,* SCSC *N.Y. Wills,* SCSC
Bird, Daniel	Carpenter	1825	Brooklyn	—	—	Spooner, *BD*	—
Bishop, John	Joiner	1776	Southampton	Southampton	25	Muster roll, 1776	Mather, *Refugees*
Blackwell, John	Carpenter	1825	Brooklyn	—	—	Spooner, *BD*	—
Bloodgood, Frans	[Carpenter?]	1659	Flushing	—	—	"Bloodgood Family"	EHFL
Bloodgood, John	Wheelwright	bpt. 1672–d. ca. 1716	Flushing	—	—	"Bloodgood Family" Letters of administration	EHFL QCHDC
*Bloodgood, Peppurell	Carpenter/Joiner	d. 1795	Flushing	—	—	Inventory	QCSC
*Bloodgood, Robert	Carpenter	1812	Flushing	—	—	Leonard Lawrence DB	NYHS

Name	Occupation	Date	Location	Birthplace	Age	Document	Source
Bloodgood, William	Carpenter	bpt. 1667–d. ca. 1720	Flushing	—	—	Onderdonk, *Names* "Bloodgood Family"	LIHS EHFL
*Blydenburgh, Thomas	Carpenter/ Joiner	1794–1801	Smithtown	—	—	Blacksmith's [Richard McCoon?] AB Store ledger Elias Smith AB, 1796–1817	Lawrence Collection, SmPL Lawrence Collection, SmPL Lawrence Collection, SmPL
Bolden, William	Carpenter	1716	Jamaica	—	—	Onderdonk, *Names*	LIHS
Bond, Newell	Carpenter	1829–1830	Brooklyn	—	—	Spooner, *BD*, 1829 Nichols, *BD*, 1830	— —
*Borroughs, John	Carpenter/ Joiner	1665–d. 1678	Newton	—	—	Inventory List of town officers, 1665–1677	QCHDC TMN
Bossley, John	Turner	1760	Kings County	Germany	28	Muster roll, 1760	NYHS *Collections*, 1891
Bourdett, Peter	Carpenter	1822–1830	Brooklyn	—	—	Spooner, *BD*, 1822–1823, 1825–1826, 1829 Nichols, *BD*, 1830	— —
Bourdett, Peter E.	Carpenter	1822–1825	Brooklyn	—	—	Spooner, *BD*, 1822–1823, 1825	—
Bradley, James	Carpenter	1825–1829	Brooklyn	—	—	Spooner, *BD*, 1825, 1829	—
Brass, John	Carpenter	1720–1730	Jamaica	—	—	—	Peyer "Jamaica Inhabitants"
Brewster, Benjamin	Carpenter	1760	Brookhaven	—	—	Selah Strong book	Kate Strong Papers, Colonial Institute Records, SUSB
Brewster, William Havens	Carpenter	1760	Brookhaven	—	—	Selah Strong book	Kate Strong Papers, Colonial Institute Records, SUSB
*Briggs, Isaac	Joiner	d. 1814	Brookhaven	—	—	Inventory Estate information sheet	SCSC SCSC
*Brower, John J.	Joiner	1833–1838	Smithtown	—	—	Smithtown store ledger	Lawrence Collection, SmPL
Brown, Alanson	Carpenter	1824–1825	Brooklyn	—	—	Spooner, *BD*	—
*Brown, Daniel	Carpenter	1726–d. ca. 1785	Southold	—	—	Land indenture, 1726 John Racket AB —	ShdTR NYHS Griffin, *Journal*
*Brown, David	Joiner	1791	Suffolk County	—	—	Franklinville store ledger	SCHS
Brown, James	Carpenter	d. 1805	Southold	—	—	Bail slip, 1804 —	SCCO Salmon, *Records*, SCHS
Brown, Peter	Cooper	d. ca. 1748	Southold	—	—	Will	NYHS *Abstracts*, IV
*Brown, Sylvanus	Carpenter	d. 1805	Riverhead	—	—	Inventory	SCSC
Brown, William	Carpenter	1760	Brookhaven	—	—	Selah Strong book	Kate Strong Papers, Colonial Institute Records, SUSB
Brown, William	Joiner	1823–1830	Brooklyn	—	—	Spooner, *BD*, 1823–1826, 1829 Nichols, *BD*, 1830	— —

Name	Occupation	Date	Location	Birthplace	Age	Document	Source
*Brush, Ananias, Jr.	Shop joiner	1772–1778	Huntington/ New Milford, Connecticut	—	30	Land indentures, 1772, 1773 Loyalty oath list, 1778	Deed Liber C, SCCO HTR
Brush, Benjamin	Carpenter	1778–1782	Huntington	—	33 (in 1778)	Loyalty oath list, 1778 Record of work, Fort Golgotha, 1782	HTR HTR
Brush, Daniel	Carpenter	1813	Smithtown	—	—	Estimate of property, 1813	SmTR
Brush, Jecomah	Carpenter	1782	Huntington	—	—	Record of work, Fort Golgotha, 1782	HTR
Brush, John	Carpenter	1803	Huntington	—	—	Estate information sheet, estate of David Wicks, 1803	SCSC
*Bryant, Jonathan	Carpenter/ Joiner	1711–1759	Huntington	—	—	Henry Lloyd I AB Will of Moses Scudder, 1759	LIHS *N.Y. Wills,* SCSC
Buckbee, Ridman	Cabinetmaker	1823	Brooklyn	—	—	Spooner, *BD*	—
Buffet, Nathaniel	Carpenter	d. 1814	Huntington	—	—	Estate information sheet	SCSC
*Bulkeley, Augustus	Cabinetmaker	1825	Sag Harbor	—	—	Advertisement, *The Corrector,* Dec. 10, 1825	EHFL
Bull, John	Joiner	1670–1676	Flushing/ Newton	—	—	Land indentures, 1670, 1676	TMN
Bunce, George	Carpenter	1758–d. ca. 1760	Hempstead	Suffolk County	35 (in 1758)	Muster roll, 1758 Will	NYHS *Collections,* 1891 NYHS *Abstracts,* VI
Bunce, Jacob	Carpenter	d. ca. 1741	Huntington	—	—	Will	NYHS *Abstracts,* III
Bundy, Simeon	Carpenter	1760	Suffolk County	Connecticut	24	Muster roll, 1760	NYHS *Collections,* 1891
Burling, Elias	Wheelwright	1688	Hempstead	—	—	Onderdonk, *Names*	LIHS
Burling, Jon	Wheelwright	1688	Hempstead	—	—	Onderdonk, *Names*	LIHS
Burnitt, Dan[iel]	Carpenter	1709	Southampton	—	—	Land indenture, 1709	EHTR
Burns, Thomas	Carpenter	1829–1830	Brooklyn	—	—	Spooner, *BD,* 1829 Nichols, *BD,* 1830	— —
*Burtis, John	Carpenter/ Joiner	d. 1823	Jamaica	—	—	Inventory	QCSC
Butler, John	Carpenter	1826	Brooklyn	—	—	Spooner, *BD*	—
Buys, Jan	Carpenter	1668	Flatbush	—	—	Land indenture, 1668	FbTR
*Byram, Eliab P.	Carpenter/ Joiner	b. 1769– d. 1854	Sag Harbor	—	—	U.S. census, 1850 Advertisements, *The Corrector,* Jan. 18, 1834, July 8, 1834 —	 EHFL Holsten, "Byram Account Book"
*Byram, Ephraim N.	Joiner/ Clockmaker	b. 1809– d. 1881	Sag Harbor	—	—	Advertisement, *The Corrector,* Jan. 18, 1834 — —	EHFL Holsten, "Byram Account Book" Thompson, *History of Long Island*

Name	Occupation	Date	Location	Birthplace	Age	Document	Source
*Byram, Henry P.	Cabinetmaker	b. 1805– d. 1866	Sag Harbor	—	—	Advertisements, *The Corrector*, Oct. 11, 1828, Dec. 12, 1829, July 31, 1830, Dec. 1, 1832, Jan. 18, 1834, May 5, 1834, May 31, 1834	EHFL
						—	Holsten, "Byram Account Book"
Cadles, Joseph	Carpenter	1668	Flushing	—	—	Onderdonk, *Names*	LIHS
Cadles, Joseph	Carpenter	1769–1770	Hempstead	—	—	Land indentures, 1769, 1770	NSHTR
Campbell, Aaron	Carpenter	1826–1829	Brooklyn	—	—	Spooner, *BD,* 1826, 1829	—
Campbell, Abiel	Carpenter	1824–1825	Brooklyn	—	—	Spooner, *BD*	—
Cane, Joseph	Carpenter	d. ca. 1773	Suffolk County	—	—	Letters of administration	QCHDC
Cape, Israel	Carpenter	1810	Southold	—	—	—	Salmon, *Records,* SCHS
Carle, Jacob	Carpenter	1758	Queens County	Queens County	23	Muster roll, 1758	NYHS *Collections,* 1891
*Carle, John	Carpenter/ Joiner	d. 1819	North Hempstead	—	—	Inventory	KCSC
*Carle, Silas	Joiner/ [Carriagemaker?]	1833–1841	Smithtown	—	—	Smithtown store ledger	Lawrence Collection, SmPL
*Carll, John	Carpenter/ Joiner	1805– d. 1842	Huntington	—	—	Inventory Statement of debt, 1805	SCSC SCSC
Carman, Joseph	Carpenter	1789	South Hempstead	—	—	Will	QCSC
Carpenter, Ashindam	Carpenter	1826	Brooklyn	—	—	Spooner, *BD*	—
Carpenter, Hope	Carpenter	b. 1662– d. 1713	Jamaica	—	—	Will of John Carpenter, Sr., 1695 —	Deed Liber A, CROJ Seversmith, *Colonial Families*
*Carpenter, John, Sr.	Carpenter	d. ca. 1695	Jamaica	—	—	Will	Deed Liber A, CROJ
*Carpenter, John, Jr.	Carpenter	1695–d. ca. 1736	Jamaica	—	—	Will of John Carpenter, Sr., 1695 Will	Deed Liber A, CROJ Deed Liber C, CROJ
*Carpenter, Joseph	Carpenter	1674	Oyster Bay	—	—	Land indenture, 1674 —	OBTR Carpenter, *Carpenter Family*
Carpenter, Josias	Carpenter	1704–1719	Oyster Bay	—	—	Land indentures, 1704, 1706, 1719	OBTR
Carpenter, Nehemiah	Joiner	1736–1755	Jamaica	—	—	Will of John Carpenter, Jr., 1736 Record of meeting, 1755	Deed Liber C, CROJ QbPL
Carpenter, Samuell	Carpenter	1695	Jamaica	—	—	Will of John Carpenter, Sr., 1695	Deed Liber A, CROJ
Carpenter, William	Carpenter	1718	Oyster Bay	—	—	Land indenture, 1718	OBTR
Case, Henry	Carpenter	1829–1830	Brooklyn	—	—	Spooner, *BD,* 1829 Nichols, *BD,* 1830	— —
Case, John	Carpenter/ Joiner	1768–1787	Southold	—	—	Will of James Reeve, 1768 Land indenture, 1782 Will	*N.Y. Wills,* SCSC ShdTR *N.Y. Wills,* SCSC

Name	Occupation	Date	Location	Birthplace	Age	Document	Source
Case, Theophilus	Carpenter	1704–d. 1716	Southold	—	—	Land indenture, 1704 —	ShdTR Moore, *Index*
Case, William	Carpenter	1829–1830	Brooklyn	—	—	Spooner, *BD,* 1829 Nichols, *BD,* 1830	— —
* Chamberlain, James	Cabinetmaker	1822	Hempstead Harbor	—	—	Advertisement, *The Long Island Farmer and Queens County Advertiser,* Mar. 28, 1822	LIHS
Chaplain, Joseph	Carpenter	1711	Huntington	—	—	Henry Lloyd I AB	LIHS
Chase, Philip	Carpenter	d. ca. 1786	Southold	—	—	Letters of administration	NYHS *Abstracts,* XIV
Chetcam, Samuell	Carpenter	1714	Jamaica	—	—	Land indenture, 1714	JTR
Claesz, Jan	Cooper	d. 1661	Flatbush	—	—	—	Bergen, *Kings County*
Clark, Duncan	Carpenter	1826	Brooklyn	—	—	Spooner, *BD*	—
Clark, Lucius	Carpenter	1829–1830	Brooklyn	—	—	Spooner, *BD,* 1829 Nichols, *BD,* 1830	— —
Clark, Ludlow	Joiner	1762	Suffolk County	Suffolk County	20	Muster roll, 1762	NYHS *Collections,* 1891
Clark, Samuel, Jr.	Carpenter	1738	Southold	—	—	Land indenture, 1738	BhTR
Clark, Thomas	Carpenter	1684–d. 1733	Southold	—	—	Town order, 1684 Land indenture, 1701 —	ShdTR ShdTR Moore, *Index*
Clark, William	Carpenter	1829–1830	Brooklyn	—	—	Spooner, *BD,* 1829 Nichols, *BD,* 1830	— —
Clarke, Edmond	Carpenter	1679	Southampton	—	—	Will of Samuel Clarke, Sr., 1679	*N.Y. Wills,* SCSC
Clarke, Samuel, Sr.	Carpenter	1675–d. 1679	Southampton	—	—	Land indenture, 1675 Inventory Will	ShTR QCHDC *N.Y. Wills,* SCSC
Clarke, Samuel, Jr.	Carpenter	1679	Southampton	—	—	Will of Samuel Clarke, Sr., 1679	*N.Y. Wills,* SCSC
Clarke, Samuel	Carpenter	1700	Southold	—	—	Town account, 1700	Liber D, ShdTR, SCHS
Clarwater, Johanns	Carpenter	1760	Kings County	Ulster County, New York	42	Muster roll, 1760	NYHS *Collections,* 1891
Clayton, Jeremiah	Carpenter	1823–1830	Brooklyn	—	—	Spooner, *BD,* 1823, 1826, 1829 Nichols, *BD,* 1830	— —
Clayton, Sidney	Carpenter	1826	Brooklyn	—	—	Spooner, *BD*	—
* Cleaves, Joshua, Jr.	Joiner	1816	Flushing	—	—	James Hauxhurst AB	NYPL
* Clement, James	Carpenter/ Joiner	1697–d. ca. 1725	Flushing	—	—	John Bowne AB Census, 1698 Will	NYPL *N.Y. Doc. Hist.,* I NYHS *Abstracts,* II
* Clement, Samuel	Joiner	1715–1726	Flushing	—	—	Signed and dated high chest Census, 1698 Militia roll, 1715	Winterthur *N.Y. Doc. Hist.,* I Waller, *History of Flushing*
* Clement, Samuel	Carpenter	d. 1799	Flushing	—	—	Inventory	QCSC
Cleveland, Icabod	Carpenter	d. ca. 1768	Suffolk County	—	—	Letters of administration	QCHDC
Cline, Thomas	Joiner	1760	Queens County	Germany	24	Muster roll, 1760	NYHS *Collections,* 1891

Name	Occupation	Date	Location	Birthplace	Age	Document	Source
Cock, John	Carpenter	1730–1745	Oyster Bay	—	—	Land indentures, 1730, 1734, 1745	OBTR
Cock, William	Carpenter	1754	Oyster Bay	—	—	Land indenture, 1754	OBTR
Coles, Abraham	Carpenter	1796	Oyster Bay	—	—	Adriaen Hegeman Diary	Stoutenburgh, *Dutch Reformed Church*
Coley, David	Carpenter	1762	Suffolk County	England	23	Muster roll, 1762	NYHS *Collections,* 1891
*Colles, Barry	Carpenter/ Cabinetmaker	1809	Brooklyn	—	—	Advertisements, *Long Island Star,* July 6, 1809, Dec. 19, 1809	LIHS
Collwell, Tillot	Carpenter	1785	Oyster Bay	—	—	Will of Deborah Steven, 1785	NYHS *Abstracts,* XIII
*Collwill, Harvey	Carpenter/ Joiner	1759	Oyster Bay	—	—	Samuel Townsend AB	EHFL
Collwill, Henry	Joiner	1768	Oyster Bay	—	—	Land indenture, 1768	OBTR
Collyer, Abraham	Carpenter	1825–1830	Brooklyn	—	—	Spooner, *BD,* 1825–1826, 1829 Nichols, *BD,* 1830	— —
Colman, David	Carpenter	1826	Brooklyn	—	—	Spooner, *BD*	—
Colon, Jonas	Chairmaker	1811	Brooklyn	—	—	Longworth, *NYCD*	—
Colyer, Peter	Housewright	d. ca. 1778	Huntington	—	—	Will	NYHS *Abstracts,* X
Combes, Joshua	Carpenter	1823	Brooklyn	—	—	Spooner, *BD*	—
Combs, Elias	Cabinetmaker	1811	Brooklyn	—	—	Longworth, *NYCD*	—
*Commerford, John	Chairmaker	1829–1830	Brooklyn	—	—	Advertisement, *Long Island Star,* June 4, 1829 Spooner, *BD,* 1829 Nichols, *BD,* 1830	LIHS — —
Comstick, Phineas	Joiner	1759	Suffolk County	Connecticut	19	Muster roll, 1759	NYHS *Collections,* 1891
Concklin, Hubbard	Carpenter	1769	Huntington	—	—	Will of Stephen Wood, 1769	*N.Y. Wills,* SCSC
Conger, Joel	Carpenter	1824–1830	Brooklyn	—	—	Spooner, *BD,* 1824–1826, 1829 Nichols, *BD,* 1830	— —
Conklin, Jacob	Carpenter	1815	[Oyster Bay?]	—	—	Underhill DB, E	NCHM
Conkling, Cornelius, Jr.	Carpenter	1725	East Hampton	—	—	Agreement, 1725	EHTR
Conkling, David	Carpenter	1826	Brooklyn	—	—	Spooner, *BD*	—
Conkling, Enos	Joiner	d. ca. 1757	Southold	—	—	Letters of administration	*N.Y. Wills,* SCSC
Conkling, John	Joiner	1757	Southold	—	—	Letters of administration, estate of Enos Conkling, 1757	*N.Y. Wills,* SCSC
Conkling, John D.	Carpenter	1822–1823	Brooklyn	—	—	Spooner, *BD*	—
Conkling, Platt	Carpenter	1778– d. 1803	Suffolk County	—	27 (in 1778)	Loyalty oath list, 1778 Inventory	HTR SCSC
Conkling, Nathan	Carpenter/ Joiner	1768–1793	East Hampton	—	—	Nathaniel Dominy IV AB	Winterthur
Connell, Terrence	Carpenter	1824–1825	Brooklyn	—	—	Spooner, *BD*	—
Connor, Jacob	Carpenter	1830	Brooklyn	—	—	Nichols, *BD*	—

Name	Occupation	Date	Location	Birthplace	Age	Document	Source
* Cook, Ellis	Carpenter	1651– d. 1679	Southampton	—	—	Town order, 1651 Inventory Will	ShTR QCHDC *N.Y. Wills,* SCSC
* Cook, Nathan Topping	Joiner	1792– d. 1822	Bridgehampton	—	—	Nathan Topping Cook AB, 1792–1824 Inventory	Winterthur SCSC
* Cook, Sullivan	Joiner	1807– 1868	Bridgehampton	—	—	Sullivan Cook AB Agreement, 1807/08 Inventory	SCHS QbPL SCSC
Cook, William	Carpenter	1754	Oyster Bay	—	—	Land indenture, 1754	OBTR
Cooker, Joseph	Carpenter	1830	Brooklyn	—	—	Nichols, *BD*	—
Cookrilors, Baldwin	Carpenter	1829–1830	Brooklyn	—	—	Spooner, *BD,* 1829 Nichols, *BD,* 1830	— —
Cooper, Caleb	Carpenter	1771	Southampton	—	—	Town account, 1771	Sh *Trustees Records*
Cooper, Joseph	Joiner	1767	Oyster Bay	—	—	Land indenture, 1767	OBTR
Cooper, Leonard	Carpenter	1824–1830	Brooklyn	—	—	Spooner, *BD,* 1824–1826, 1829 Nichols, *BD,* 1830	— —
Cooper, Samuel	Cooper	1705	Southampton	—	—	Land indenture, 1705	Deed Liber A, SCCO
Cooper, Thomas	Carpenter	d. ca. 1774	Brookhaven	—	—	Letters of administration	QCHDC
*Cooper, Thomas	Carpenter/ Joiner	1767–1774	Southampton	—	—	Elias Pelletreau AB Will	LIHS *N.Y. Wills,* SCSC
* Cooper, William	Boat builder/ Joiner	1807–1830	Sag Harbor	—	—	Advertisement, *The Suffolk Gazette,* Dec. 14, 1807 William Cooper AB Advertisement, *The Corrector,* July 3, 1830	EHFL QbPL EHFL
*Corey, Braddock	Carpenter/ Joiner/ Butcher	b. 1735– d. 1808	Sag Harbor	—	—	Inventory Probate records —	SCSC SCSC Mather, *Refugees*
Cornelesz, Jan	Carpenter	1668–1672	Flatbush/ Flatlands	—	—	Land indenture, 1668 —	FbTR Bergen, *Kings County*
Cornell, Richard	Cabinetmaker	1822–1830	Brooklyn	—	—	Spooner, *BD,* 1822–1826, 1829 Nichols, *BD,* 1830	— —
Cornell, Samuel	Wheelwright	1774	Hempstead	—	—	Land indenture, 1774	NSHTR
Corwin, Edward	Carpenter	d. ca. 1760	Southold	—	—	Will	NYHS *Abstracts,* VI
Corwin, Edward	Carpenter	1760	Suffolk County	Suffolk County	30	Muster roll, 1760	NYHS *Collections,* 1891
*Corwin, Mathias	Joiner	1792–1805	Riverhead	—	—	Franklinville store ledger Overseers account, 1805	SCHS RTR
Covert, Nicholas	Carpenter	1822–1823	Brooklyn	—	—	Spooner, *BD*	—
*Covert, Tunus	Joiner	d. 1821	Queens County	—	—	Inventory	QCSC
Cowenhoven, Garret	Carpenter	1826	Brooklyn	—	—	Spooner, *BD*	—
*Cowenhoven, Johannis	Joiner	1702	Jamaica	—	—	Woolsey family AB	Hillhouse Collection, Yale
Cowenhoven, John	Carpenter	d. ca. 1761	Bushwick	—	—	Will	NYHS *Abstracts,* VI
Cozine, John	Carpenter	1829–1830	Brooklyn	—	—	Spooner, *BD,* 1829 Nichols, *BD,* 1830	— —

Name	Occupation	Date	Location	Birthplace	Age	Document	Source
Craft, Isaac	Joiner	1758	Oyster Bay	Oyster Bay	23	Muster roll, 1758	NYHS *Collections*, 1891
Creasey, Arthur	Carpenter	1688–1690	East Hampton	—	—	Town accounts, 1688, 1690	EHTR
Creed, Augustine	Carpenter	1700–1710	Jamaica	—	—	—	Peyer, "Jamaica Inhabitants"
Creed, Augustine	Carpenter	1758	Jamaica	Jamaica	47	Muster roll, 1758	NYHS *Collections*, 1891
Crocker, Warren	Carpenter	1822–1826	Brooklyn	—	—	Spooner, *BD*	—
Crook, Samuel	Carpenter	1710	Southold	—	—	Land indenture, 1710	ShTR
* Crooker, Joseph	Carpenter/ Joiner/ Turner	d. 1829	Oyster Bay	—	—	Inventory	QCSC
* Cropsey, Valentine	Carpenter/ Joiner/ Turner	d. 1827	New Utrecht	—	—	Inventory	KCSC
* Crossman, Abner	Carpenter	d. 1812	Huntington	—	—	Inventory	SCSC
Crum, John A.	Cabinetmaker	1824–1829	Brooklyn	—	—	Spooner, *BD*, 1824–1826, 1829	—
* Culver, Gershom	Carpenter/ Joiner	d. ca. 1715	Southampton	—	—	Will	*N.Y.Wills*, SCSC
* Culver, Gershom	Carpenter	1762–1763	Southampton	—	—	Elias Pelletreau AB	EHFL
Culver, James	Carpenter/ Joiner	1755–1759	Southampton	Suffolk County	25 (in 1759)	Will of Jeremiah Culver, 1755	*N.Y. Wills*, SCSC
						Muster roll, 1759	NYHS *Collections*, 1891
Culver, Jeremiah	Carpenter	d. ca. 1758	Southampton	—	—	Will	NYHS *Abstracts*, V
Culver, Jesse	Carpenter	d. ca. 1789	Southampton	—	—	Will	SCSC
Culver, Moses	Carpenter	1789	Southampton	—	—	Will of Jesse Culver, 1789	SCSC
Cumberson, Thomas	Carpenter	1829–1830	Brooklyn	—	—	Spooner, *BD*, 1829 Nichols, *BD*, 1830	— —
Cumberson, William	Carpenter	1823–1830	Brooklyn	—	—	Spooner, *BD*, 1823–1826, 1829 Nichols, *BD*, 1830	— —
Curby, Richard	Carpenter	d. ca. 1688	Oyster Bay	—	—	Will	Deed Liber A. CROJ
Curby, Thomas	Carpenter	1688	Oyster Bay	—	—	Will of Richard Curby, 1688	Deed Liber A. CROJ
Curwin, William	Carpenter	1761	Southold	Southold	17	Muster roll, 1761	NYHS *Collections*, 1891
Darling, Joseph	Carpenter	1817	Smithtown	—	—	Elias Smith AB, 1816–1835	Lawrence Collection, SmPL
Darling, William	Carpenter	1824	Brooklyn	—	—	Spooner, *BD*	—
Daval, John	Joiner	1771	Shelter Island	—	—	Will of Jonathan Havens, 1771	NYHS *Abstracts*, VII
Davall, John	Carpenter	d. 1778	Sag Harbor	—	—	Estate information sheet Inventory	SCSC SCSC
Daves, Joseph	Carpenter	1684	Brookhaven	—	—	Agreement, 1684	BhTR
Davidson, Josiah	Carpenter	1727	Southold	—	—	Ackerly Book 1	SCHS
Davis, Daniel	Carpenter	1763	Brookhaven	—	—	Ackerly Book 5	SCHS
Davis, David	Carpenter	1825–1826	Brooklyn	—	—	Spooner, *BD*	—

Name	Occupation	Date	Location	Birthplace	Age	Document	Source
Davis, Capt. Samuel	Carpenter	b. 1701 – d. ca. 1761	Brookhaven	—	—	Will	NYHS *Abstracts,* VI
						—	Rattray, *East Hampton History*
Davis, Samuel, Jr.	Carpenter	1761	Brookhaven	—	—	Will of Samuel Davis, Sr., 1761	NYHS *Abstracts,* VI
Davis, William	Carpenter	1802	Brooklyn	—	—	Longworth, *NYCD*	—
Davison, Josiah	Joiner	1752	Brookhaven	—	—	Land indenture, 1752	BhTR
Dayton, David	Carpenter	d. ca.1782	Suffolk County	—	—	Letters of administration	*N.Y. Wills,* SCSC
*Dayton, James	Carpenter	1792	Setauket	—	—	Abraham Woodhull AB	EHFL
Deacon, John	Carpenter	1826	Brooklyn	—	—	Spooner, *BD*	—
Dean, Isaac	Carpenter	1742–1750	Oyster Bay	—	—	Land indentures, 1742, 1749, 1750	OBTR
Dean, Jacob	Wheelwright	1710–1720	Jamaica	—	—	—	Peyer, "Jamaica Inhabitants"
Dean, Jonathan	Carpenter	1729	Jamaica	—	—	Land indenture, 1729	JTR
Dean, Nicholas	Carpenter	1717	Oyster Bay	—	—	Land indenture, 1717	OBTR
Dean, Samuel	Wheelwright	1720–1730	Jamaica	—	—	—	Peyer, "Jamaica Inhabitants"
*Dean, Samuel	Joiner	1733	Brookhaven	—	—	Joseph Jayne AB	NYHS
*Deane, Joseph	Carpenter	1723	Huntington/ Oyster Bay	—	—	Henry Lloyd I AB	LIHS
Deane, Nicholas	Carpenter	1716	Jamaica	—	—	Underhill DB, E	NCHM
Deane, Samuel	Carpenter	1782	Huntington	—	—	Record of work, Fort Golgotha, 1782	HTR
Deare, James	Carpenter	1822	Brooklyn	—	—	Spooner, *BD*	—
Debevoise, Francis	Carpenter	1826–1830	Brooklyn	—	—	Spooner, *BD,* 1826 Nichols, *BD,* 1830	— —
*De Fres, ———	Carpenter/ Joiner	1663	Flatbush	—	—	Town account, 1663	FbTR
DeGraw, James	Turner	d.ca.1767	Brooklyn	—	—	Will	NYHS *Abstracts,* VII
*DeMott, James	Carpenter	d. 1826	Hempstead	—	—	Inventory	QCSC
*DeMott, John	Carpenter/ Joiner	d. 1819	Hempstead	—	—	Inventory	QCSC
Denike, Thomas	Carpenter	1824–1830	Brooklyn	—	—	Spooner, *BD,* 1824– 1826, 1829 Nichols, *BD,* 1830	— —
Denton, George	Carpenter	1796	Brooklyn	—	—	Buell, *NYBD*	—
Denton, Samuel	Cooper	1736	Jamaica	—	—	Land indenture, 1736	JTR
*Depaw, Luck	Carpenter/ Cooper/ Joiner	1676–1690	Newtown	—	—	Land indenture, 1676 Court actions, 1686, 1690	TMN TMN
Devoe, Isaac	Cabinetmaker	1822–1829	Brooklyn	—	—	Spooner, *BD,* 1822– 1826, 1829	—
Devosne, John	Carpenter	1826	Brooklyn	—	—	Spooner, *BD*	—
Dezendorf, Frederick	Carpenter	1822–1830	Brooklyn	—	—	Spooner, *BD* 1822– 1826, 1829 Nichols, *BD,* 1830	— —
Dezendorf, Henry	Carpenter	1825	Brooklyn	—	—	Spooner, *BD*	—

Name	Occupation	Date	Location	Birthplace	Age	Document	Source
Dezendorf, James	Carpenter	1822–1830	Brooklyn	—	—	Spooner, *BD,* 1822–1826, 1829	—
						Nichols, *BD,* 1830	—
Dickinson, Abraham	Carpenter	1822–1826	Brooklyn	—	—	Spooner, *BD*	—
Dodge, Daniel	Carpenter	1763	Oyster Bay	—	—	Land indenture, 1763	OBTR
Dodge, George	Carpenter	1829–1830	Brooklyn	—	—	Spooner, *BD,* 1829	—
						Nichols, *BD,* 1830	—
*Dodge, John	Carpenter	1808	[Oyster Bay?]	—	—	Receipt, 1808	Willets Collection, NCHM
Dodge, Nathaniel	Carpenter	1750	Oyster Bay	—	—	Land indenture, 1750	OBTR
Dodge, Tristan	Carpenter	1731–1776	Oyster Bay	—	—	Land indentures, 1731, 1741, 1743, 1753, 1776	OBTR
Dolbear, Eli	Carpenter	1802	Brooklyn	—	—	Longworth, *NYCD*	—
*Dolhemus, Daniel	Wheelwright/ Joiner	1692	Flatlands	—	—	Statement of debt, estate of Peter Hansen, 1692	QCHDC
Dolton, George	Carpenter	1830	Brooklyn	—	—	Nichols, *BD*	—
Doman, ——	Carpenter	1646	Brooklyn	—	—	—	Bergen, *Kings County*
*Dominy, Felix	Carpenter/ Joiner/ Clockmaker	b. 1800– d. 1868	East Hampton	East Hampton	—	Letter, Felix Dominy to Temperance Dominy, n.d.	EHFL
						Inventory	SCSC
						—	Hummel, *With Hammer in Hand*
Dominy, Nathaniel III	Carpenter	b. 1714– d. 1778	East Hampton	East Hampton	—	—	Hummel, *With Hammer in Hand*
						Land indenture, 1730	Deed Liber B, SCCO
*Dominy, Nathaniel IV	Clockmaker/ Watchmaker/ Joiner	b. 1737– d. 1812	East Hampton	East Hampton	—	Probate records of Samuel Stratton, 1790	SCSC
						—	Hummel, *With Hammer in Hand*
*Dominy, Nathaniel V	Clockmaker/ Joiner	b. 1770– d. 1852	East Hampton	East Hampton	—	—	Hummel, *With Hammer in Hand*
Dorlon, Joseph	Carpenter	1826–1830	Brooklyn	—	—	Spooner, *BD,* 1826, 1829	—
						Nichols, *BD,* 1830	—
*Dorlon, Joseph	Cabinetmaker	1830–1832	Hempstead	—	—	Advertisement, *Long Island Telegraph and General Advertiser,* May 20, 1830	LIHS
						Advertisement, *Inquirer,* June 14, 1832	LIHS
Dougherty, William	Carpenter	1796–1802	Brooklyn	—	—	Buell, *NYBD*	—
						Longworth, *NYCD*	—
Doughty, Charles	Carpenter	1819	Flushing	—	—	Leonard Lawrence DB	NYHS
*Doughty, Elias	Turner	1723	Oyster Bay	—	—	Henry Lloyd I waste book	LIHS
*Doughty, Isaac	Carpenter	1770– d. 1803	Oyster Bay	—	—	Will of Edmond Wood, 1770	NYHS *Abstracts,* VI
						Will of John Van Wagenen, 1782	NYHS *Abstracts,* XI
						Inventory	QCSC
Doughty, Isaiah	Carpenter	1760	Queens County	Long Island	20	Muster roll, 1760	NYHS *Collections,* 1891

Name	Occupation	Date	Location	Birthplace	Age	Document	Source
Doughty, Obadiah	Carpenter	d. before 1767	Flushing	—	—	Will of Mary Doughty, 1767	NYHS *Abstracts,* VII
Doughty, Timothy	Carpenter	1760–1770	Jamaica	—	—	—	Peyer, "Jamaica Inhabitants"
Downing, Daniel	Joiner	1690–1700	Jamaica	—	—	—	Peyer, "Jamaica Inhabitants"
Downing, Daniel	Carpenter	1799–1807	Oyster Bay	—	—	Adriaen Hegeman Diary	Stoutenburgh, *Dutch Reformed Church*
Downs, Albert	Carpenter	1830	Brooklyn	—	—	Nichols, *BD*	—
Downs, William	Carpenter	1826	Brooklyn	—	—	Spooner, *BD*	—
Doxey, John	Carpenter	1758	Queens County	Queens County	22	Muster roll, 1758	NYHS *Collections,* 1891
Duffy, Charles	Carpenter	1829–1830	Brooklyn	—	—	Spooner, *BD,* 1829 Nichols, *BD,* 1830	— —
Durlan, Joseph	Carpenter	1825–1830	Brooklyn	—	—	Spooner, *BD,* 1825 Nichols, *BD,* 1830	— —
Duryea, Abraham	Carpenter	1810–1813	Huntington	—	—	Whitney Family AB	HTHO
*Duryea, Edmond N.	Cabinetmaker	1824–1830	Brooklyn	—	—	Advertisement, *Long Island Star,* May 20, 1824 Spooner, *BD,* 1824–1826 Nichols, *BD,* 1830	LIHS — —
Duryea and Hunter	Cabinetmakers	1824	Brooklyn	—	—	Spooner, *BD*	—
Dwight, Hiram	Carpenter	1825	Brooklyn	—	—	Spooner, *BD*	—
Ears, Benjamin	Carpenter	1759	Kings County	New Jersey	27	Muster roll, 1759	NYHS *Collections,* 1891
Eddy, Elisha	Joiner	1760	Suffolk County	Connecticut	29	Muster roll, 1760	NYHS *Collections,* 1891
Edwards, Ephraim	Carpenter	1701	East Hampton	—	—	Land indenture, 1701	EHTR
Edwards, Joseph	Carpenter	1825–1826	Brooklyn	—	—	Spooner, *BD*	—
Eglestone, Ambrose	Carpenter	1759	Suffolk County	Connecticut	39	Muster roll, 1759	NYHS *Collections,* 1891
Ellis, Samuel	Carpenter	1701	East Hampton	—	—	Town account, 1701	EHTR
*Eltyge, Jan	Carpenter/ Joiner	1663	Flatbush	—	—	Town account, 1663 —	FbTR Bergen, *Kings County*
Enians, Jan	Master Cooper	1678	Flatbush	—	—	Apprenticeship indenture, 1678	FbTR
Eueret, Richard	Carpenter	1758	Queens County	Queens County	40	Muster roll, 1758	NYHS *Collections,* 1891
Everet, Thomas	Carpenter	1707	Jamaica	—	—	Land indenture, 1707	JTR
Exanson, Daniel	Carpenter	1759	Kings County	Dublin, Ireland	39	Muster roll, 1759	NYHS *Collections,* 1891
Farrington, Richard	Carpenter	1822–1825	Brooklyn	—	—	Spooner, *BD,* 1822, 1825	—
Farrington, Samuel	Carpenter	1823	Brooklyn	—	—	Spooner, *BD*	—
*Feke, Charles	Shop joiner	1744–1750	Oyster Bay	—	—	Land indentures, 1744, 1750 Merchant's [Samuel Townsend?] AB	OBTR NYHS

Name	Occupation	Date	Location	Birthplace	Age	Document	Source
Feke, John	Carpenter	1663	Oyster Bay	—	—	—	Latting, "Wright Family," *NYGBR*, 1872
Ferguson, George	Turner	1760	Kings County	Ireland	41	Muster roll, 1760	NYHS *Collections*, 1891
Ffuthy, Arthur	Carpenter	1684– d. 1719	Brookhaven	—	—	Apprenticeship indenture, 1684, master Agreement, 1685 Employment agreement, 1685 Land indenture, 1689 Land indenture, 1709 Will	BhTR BhTR BhTR BhTR Deed Liber A, SCCO *N.Y. Wills*, SCSC
Finch, Jeremiah	Joiner	1758	Queens County	Greenwich, Connecticut	30	Muster roll, 1758	NYHS *Collections*, 1891
Firth, John	Muscial instrument maker	1829	Brooklyn	—	—	Spooner, *BD*	—
Fisher, John	Carpenter	1826	Brooklyn	—	—	Spooner, *BD*	—
*Fithian, Aaron	Carpenter		Sag Harbor	—	—	Inventory —	SCSC Rattray, *East Hampton History*
*Fithian, Lt. Enoch	Carpenter	b. 1646– d. 1727	East Hampton	—	—	— East Hampton town account, 1704 Land indenture, 1705	Rattray, *East Hampton History* EHTR EHTR
Fithian, Samuel	Carpenter	1684	East Hampton	—	—	Town account, 1684	EHTR
*Fleet, Simon	Joiner	d. 1723	Suffolk County/ [Huntington?]	—	—	Inventory	NYHS
Fleet, Thomas	Carpenter	1778–1785	Huntington	—	38 (in 1778)	Loyalty oath list, 1778 Land indenture, 1785	HTR Deed Liber C, SCCO
Foard, Thomas	Carpenter	1760	Queens County	Long Island	26	Muster roll, 1760	NYHS *Collections*, 1891
Folke, Jesse	Carpenter	1826–1830	Brooklyn	—	—	Spooner, *BD*, 1826, 1829 Nichols, *BD*, 1830	— —
*Foot, Simson	Joiner	d. 1734	Jamaica	—	—	Inventory	QCHDC
*Ford, Thomas	Joiner	1696	Flushing	—	—	John Bowne AB	NYPL
Ford, Thomas	Carpenter	d. ca. 1743	Flushing	—	—	Will	NYHS *Abstracts*, III
Fordenbrook, Henk	Carpenter	1759	Queens County	Prussia	42	Muster roll, 1759	NYHS *Collections*, 1891
Foster, Horace	Carpenter	1824–1829	Brooklyn	—	—	Spooner, *BD*, 1824– 1826, 1829	—
Foster, Jeremiah	Carpenter/ Cooper/ Joiner	1760–1784	Southampton	Suffolk County	22 (in 1760)	Muster roll, 1760 Will of Stephen Foster, Sr.	NYHS *Collections*, 1891 NYHS *Abstracts*, XII
Foster, John	Carpenter	1705	Hempstead	—	—	Land indenture, 1705	NSHTR
Foster, John	Carpenter	1830	Brooklyn	—	—	Nichols, *BD*	—

Name	Occupation	Date	Location	Birthplace	Age	Document	Source
*Foster, Stephen, Sr.	Carpenter/ Cooper/ Joiner	d. ca. 1784	Southampton	—	—	Will	NYHS *Abstracts,* XII
Foster, Stephen, Jr.	Carpenter/ Cooper/ Joiner	1784	Southampton	—	—	Will of Stephen Foster, Sr.	NYHS *Abstracts,* XII
Fowler, Benjamin	Carpenter	1825	Brooklyn	—	—	Spooner, *BD*	—
Fowler, Jerome	Carpenter	1826	Brooklyn	—	—	Spooner, *BD*	—
Fowler, John	Carpenter	1826	Brooklyn	—	—	Spooner, *BD*	—
Fowler, Moses	Carpenter	d. ca. 1781	Flushing	—	—	Will	NYHS *Abstracts,* X
Fowler, William	Carpenter	1826	Brooklyn	—	—	Spooner, *BD*	—
Frasier, William	Carpenter	1760	Queens County	Ireland	26	Muster roll, 1760	NYHS *Collections,* 1891
Freeland, Cornelius	Carpenter	1825	Brooklyn	—	—	Spooner, *BD*	—
Freeland, Jacob	Carpenter	1825	Brooklyn	—	—	Spooner, *BD*	—
Freeman, Samuel	Carpenter	ca. 1700– 1710	Jamaica	—	—	—	Peyer, "Jamaica Inhabitants"
French, George	Carpenter	1830	Brooklyn	—	—	Nichols, *BD*	—
Frost, William	Shipwright	1677–1695	Oyster Bay	—	—	Land indentures, 1677, 1684, 1685, 1695	OBTR
Fulleman, Barney	Cooper	1696	Flatbush	—	—	—	Bergen, *Kings County*
Furman, Gabriel	Wheelwright	1723	Newtown	—	—	Land indenture, 1723	JTR
Furman, Joseph	Cooper	d. ca. 1750	Newtown	—	—	Will	NYHS *Abstracts,* IV
Furnal, Thomas	Joiner	1826	Brooklyn	—	—	Spooner, *BD*	—
Gail, Jacob	Carpenter	1710–d. ca. 1720	Jamaica	—	—	Letters of administration	Deed Liber C, CROJ
						—	Peyer, "Jamaica Inhabitants"
Garlick, John	Carpenter/ Joiner/ Turner/ Cooper	1677	East Hampton	—	—	Will of Joshua Garlick, Sr.	*Court of Sessions,* SCCO
*Garlick, Joshua, Sr.	Carpenter/ Joiner/ Turner/ Cooper	d. 1677	East Hampton	—	—	Will	*Court of Sessions,* SCCO
						Inventory	*Court of Sessions,* SCCO
Garlick, Joshua, Jr.	Carpenter/ Joiner/ Turner/ Cooper	1677	East Hampton	—	—	Will of Joshua Garlick, Sr.	*Court of Sessions,* SCCO
*Gate, William	Joiner	1769–1772	Smithtown	—	—	Philetus Smith AB	Lawrence Collection, SmPL
Gelston, John	Carpenter	1768	Flatbush	—	—	Will of John Hegeman, 1768	NYHS *Abstracts,* VII
Genens, David	Carpenter	1684–1685	Brookhaven	—	—	Agreements, 1684, 1685	BhTR
Gerretse, Claes	Wheelwright	1664–1665	Flatbush	—	—	—	Bergen, *Kings County*
Gildersleeve, Jason	Carpenter	1829–1830	Brooklyn	—	—	Spooner, *BD,* 1829 Nichols, *BD,* 1830	— —

Name	Occupation	Date	Location	Birthplace	Age	Document	Source
Glover, Charles	Shipwright	1650 – d. 1665	Southold	—	—	Court action —	NHTR Moore, *Index*
Glover, David	Carpenter	1825 – 1830	Brooklyn	—	—	Spooner, *BD*, 1825, 1826 Nichols, *BD*, 1830	—
Glover, Frederick	Carpenter	1825 – 1830	Brooklyn	—	—	Spooner, *BD*, 1825, 1826, 1829 Nichols, *BD*, 1830	— —
Glover, Joseph Jr.	Carpenter	1818	Southold	—	—	—	Griffin, *Journal*
Glover, Samuel	Shipwright	1698 – 1711	Southold	—	—	Land indentures, 1698, 1711	ShdTR
Golder, William	Carpenter/ Wheelwright	1717 – 1734	Jamaica	—	—	Land indentures, 1717, 1734	JTR
*Goldsmith, Davis	Carpenter/ Joiner	d. 1817	Southold	—	—	Inventory	SCSC
Gracey, Mathew	Carpenter	1760	Kings County	New Jersey	25	Muster roll, 1760	NYHS *Collections*, 1891
Graham, Peter	Carpenter	1826	Brooklyn	—	—	Spooner, *BD*	—
* Grave, John	Carpenter	d. 1679	Newtown	—	—	Inventory	QCHDC
* Green, Lewis F.	Cabinetmaker	1809	Setauket	—	—	Advertisement, *Suffolk Gazette*, July 29, 1809	EHFL
Greesie, Mathew	Carpenter	1759	Queens County	Middletown, New Jersey	24	Muster roll, 1759	NYHS *Collections*, 1891
Griffin, David	Carpenter	1822 – 1823	Brooklyn	—	—	Spooner, *BD*	—
Griffin, George	Carpenter	1826	Brooklyn	—	—	Spooner, *BD*	—
* Griffing, Amon T.	Carpenter	d. 1817	Bushwick	—	—	Inventory	KCSC
Griffiths, William	Carpenter	1760	Queens County	Wales	27	Muster roll, 1760	NYHS *Collections*, 1891
Grimsted, Henry	Carpenter	1829 – 1830	Brooklyn	—	—	Spooner, *BD*, 1829 Nichols, *BD*, 1830	— —
Grover, James	Carpenter	1652	Gravesend	—	—	Agreement, 1652	GTR
Gutie, Daniel	Carpenter	1677	Kings County	—	—	—	Bergen, *Kings County*
Haff, Uriah	Wheelwright	1714	Flushing/ Oyster Bay	—	—	Land indentures, 1714, 1716	OBTR
Haight, Samuel	Carpenter	d. 1712	Flushing	—	—	Inventory	QCHDC
* Haines, Benjamin	Wheelwright	d. ca. 1714	Southampton	—	—	Will	NYHS *Abstracts*, II
Haines, David	Wheelwright	1714	Southampton	—	—	Will of Benjamin Haines, 1714	NYHS *Abstracts*, II
* Haines, Deacon	Carpenter	1755	Southampton	—	—	Southampton town account, 1755	Sh *Trustees Records*
Hale, Patrick	Turner	1759	Queens County	Ireland	27	Muster roll, 1759	NYHS *Collections*, 1891
Hall, Joseph Sr.	Carpenter	d. ca. 1744	Hempstead	—	—	Will	NYHS *Abstracts*, III
Hall, Joseph, Jr.	Carpenter	1744	Flushing	—	—	Will of Joseph Hall, Sr.	NYHS *Abstracts*, III
* Hall, William	Cabinetmaker	1802 – 1804	Sag Harbor	—	—	Advertisement, *Suffolk County Herald*, Sept. 4, 1802 Advertisement, *The Suffolk Gazette*, Feb. 20, 1804	EHFL EHFL
Hallett, William	Carpenter	d. 1707	Newtown	—	—	Inventory	QCHDC

Name	Occupation	Date	Location	Birthplace	Age	Document	Source
*Halliock, Caleb	Carpenter/ Joiner	1790	Riverhead	—	—	Franklinville store ledger	SCHS
Halliock, Thomas	Carpenter	1800–1822	Smithtown	—	—	Inventory, estate of Isaac Smith, 1800 Estimate of property, 1813 Caleb Smith AB, 1819–1844	SCSC SmTR Lawrence Collection, SmPL
Hallock, Henry	Carpenter	1792	Suffolk County	—	—	Probate records, estate of Isaac Robbins, 1792	SCSC
Hallock, William	Carpenter	1824–1826	Brooklyn	—	—	Spooner, *BD*	—
Hallocks, John	Carpenter	1687–1691	Southold/ Brookhaven	—	—	Land indentures, 1687, 1690 Land indenture, 1691	ShdTR BhTR
Halsey, William	Joiner	1776	Southampton	Southampton	21	Muster roll, 1776	Mather, *Refugees*
Halsey, William	Carpenter	1795	Southampton	—	—	Letters of administration, estate of Benjamin King	SCSC
Halstead, Joseph	Carpenter	1753	Hempstead	—	—	Land indenture, 1753	NSHTR
Hamilton, Gawin	Carpenter	1824–1826	Brooklyn	—	—	Spooner, *BD*	—
Hamilton, John	Carpenter	1823	Brooklyn	—	—	Spooner, *BD*	—
Hammond, Thomas	Carpenter	1822–1825	Brooklyn	—	—	Spooner, *BD*, 1822–1823, 1825	—
*Hand, William	Cabinetmaker	1831	Sag Harbor	—	—	Advertisement, *The Corrector,* Jan. 8, 1831	EHFL
Hannah, Sanford	Carpenter	1826–1830	Brooklyn	—	—	Spooner, *BD*, 1826, 1829 Nichols, *BD* 1830	— —
Hare, Edward	Carpenter	ca. 1690–1700	Jamaica/ Hempstead	—	—	—	Peyer, "Jamaica Inhabitants"
*Harleson, Benjamin	[Joiner?]	d. 1828	Brooklyn	—	—	Inventory	KCSC
Harper, James	Carpenter	1829	Brooklyn	—	—	Spooner, *BD*	—
*Harris, Stephen	Carpenter/ Wheelwright	d. 1814	Southampton	—	—	Inventory	SCSC
Harrison, Silas	Joiner	1826–1829	Brooklyn	—	—	Spooner, *BD*, 1826, 1829	—
Harrod, John	Carpenter	d. ca. 1741	Brookhaven	—	—	Will	NYHS *Abstracts,* IV
Harrud, George	Carpenter	1687	Southold	—	—	Apprenticeship indenture, 1687, apprentice	ShdTR
Hart, John	Carpenter	1677	Brookhaven	—	—	Town account, 1677	BhTR
Hart, John	Carpenter	1688	Newtown	—	—	Land indenture, 1688	TMN
Hass, Abraham	Cabinetmaker	1830	Brooklyn	—	—	Nichols, *BD*	—
Hatfield, George	Carpenter	1822–1830	Brooklyn	—	—	Spooner, *BD*, 1822–1823, 1825–1826 Nichols, *BD*, 1830	— —
Hathaway, Ebenezer	Carpenter	1826	Brooklyn	—	—	Spooner, *BD*	—
Hauxhurst, Jonathan	Carpenter	1758	Queens County	Queens County	19	Muster roll, 1758	NYHS *Collections,* 1891
*Havens, Jeremiah	Carpenter/ Joiner	1793–1796	Riverhead	—	—	Franklinville store ledger	SCHS
*Havens, Peter	Carpenter/ Joiner	1799– d. 1803	Shelter Island	—	—	Statement of debt, 1799 Inventory	SCSC SCSC

Name	Occupation	Date	Location	Birthplace	Age	Document	Source
*Havens, R. E.	Cabinetmaker	1831	Sag Harbor	—	—	Advertisement, *The Corrector*, August 13, 1831	EHFL
Havens, Thomas	Carpenter	1784	Brooklyn	—	—	Will of John Ellison, 1784	NYHS *Abstracts*, XIII
Haviland, John	Carpenter	1781	Hempstead	—	—	Land indenture, 1781	NSHTR
Haviland, Samuel	Carpenter	1782	Huntington	—	—	Record of work, Fort Golgotha, 1782	HTR
Hawkins, David	Carpenter	1771	Brookhaven	—	—	Mortgage, 1771	Mortgage Liber A, SCCO
						Land indenture, 1771	Deed Liber C, SCCO
Hawkins, Edward	Joiner	1759	Suffolk County	New London, Connecticut	22	Muster roll, 1759	NYHS *Collections*, 1891
Hawkins, Eleazer	Carpenter	1711	Huntington	—	—	Henry Lloyd I AB	LIHS
Hawkins, Israel	Carpenter	1760	Brookhaven	—	—	Selah Strong book	Kate Strong Papers, Colonial Institute Records, SUSB
Hawse, John	Carpenter	1651–1663	Gravesend	—	—	Agreements, 1651, 1657, 1660, 1663,	GTR
						List of landholders, 1657	GTR
						—	Bergen, *Kings County*
Hawxhurst, Allen	Carpenter	1825–1826	Brooklyn	—	—	Spooner, *BD*	—
Haynes, Benjamin	Carpenter	d. ca. 1697	Southampton	—	—	Will	Deed Liber A, SCCO
Haynes, Smith	Carpenter	1826	Brooklyn	—	—	Spooner, *BD*	—
Hayr, John	Carpenter	1826	Brooklyn	—	—	Spooner, *BD*	—
Hazzard, James	Carpenter	1773	Newtown	—	—	Will of William Hazzard, 1773	NYHS *Abstracts*, VIII
Hebard, Shubael	Carpenter	1822–1829	Brooklyn	—	—	Spooner, *BD*, 1822–1823, 1825–1826, 1829	—
Hedges, Daniel	Carpenter	1822–1826	Brooklyn	—	—	Spooner, *BD*, 1822–1823, 1825–1826	—
Hedges, Ezekiel	Joiner	1754	East Hampton	—	—	Will of Nathaniel Huntting, 1754	NYHS *Abstracts*, V
Hedges, Isaac	Carpenter	d. 1676	East Hampton	—	—	Inventory	*Court of Sessions*, SCCO
Hedges, Isaac	Carpenter	1705	East Hampton	—	—	Town account, 1705	EHTR
Hedges, Jeremiah	Carpenter	1733–1734	East Hampton	—	—	Town account, 1733 Town account, 1734	EHTR EH *Trustees Records*
*Hedges, Ruben	Joiner	1773	East Hampton	—	—	David Gardiner AB	EHFL
Hedges, Samuel	Carpenter	1703	East Hampton	—	—	Record of work, 1703	EHTR
*Hegeman, Elbert	Carpenter/Joiner	d. 1821	Queens County	—	—	Inventory	QCSC
Helmes, Thomas	Carpenter	1681	Brookhaven	—	—	Agreement, 1681	BhTR
Hendricks, Pieter	Carpenter	1684	Brooklyn	—	—	—	Bergen, *Kings County*
Hendrickson, Garrett	Carpenter	d. 1804	Jamaica	—	—	Inventory	QCSC

Name	Occupation	Date	Location	Birthplace	Age	Document	Source
Hendrickson, Scott	Carpenter	1822–1830	Brooklyn	—	—	Spooner, *BD*, 1822–1823, 1825 Nichols, *BD*, 1830	— —
Herbert, Alpheus	Carpenter	1826	Brooklyn	—	—	Spooner, *BD*	—
Herbert, John	Carpenter	1822–1823	Brooklyn	—	—	Spooner, *BD*	—
Herrick, James	Joiner	1740–d. ca. 1761	Southampton	—	—	Will of Ezekial Sayre, 1740 Will of John Mackie, 1758 Town account, 1758, Will	*N.Y. Wills,* SCSC NYHS *Abstracts,* V Sh *Trustees Records* *N.Y. Wills,* SCSC
*Hess, John H.	Cabinetmaker	1826–1830	Brooklyn	—	—	Spooner, *BD*, 1826 1829 Nichols, *BD*, 1830 Advertisement, *Long Island Star,* April 5, 1827	— — LIHS
Hewlett, George	Carpenter	1657–1659	Hempstead	—	—	Town accounts, 1657, 1659	NSHTR
Hicks, Augustine	Chairmaker	1797	Jamaica	—	—	Will of Abraham Keteltas, 1797	QCSC
Hicks, George	Chairmaker	1797	Jamaica	—	—	Will of Abraham Keteltas, 1797	QCSC
Higbee, Daniel	Carpenter	d. 1790	Huntington	—	—	Estate information sheet	SCSC
Higbee, Nathaniel	Carpenter	d. ca. 1778	Jamaica	—	—	Will	NYHS *Abstracts,* IX
*Hildreth, John T.	Cabinetmaker	1832–1834	Brooklyn	—	—	Advertisement, Bigelow *BD,* 1832 Advertisement, *The Inquirer,* Feb. 5, 1834	— NCHM
Hildrith, James	Carpenter	d. ca. 1722	Southampton	—	—	Will	*N.Y. Wills,* SCSC
Hill, Henry	Carpenter	1826–1830	Brooklyn	—	—	Spooner, *BD*, 1826, 1829 Nichols, *BD*, 1830	— —
Hinchman, John	Carpenter	ca. 1760–1770	Jamaica	—	—	—	Peyer, "Jamaica Inhabitants"
Hinchman, John	Joiner	ca. 1770–1780	Jamaica	—	—	—	Peyer, "Jamaica Inhabitants"
Holmes, Samuel	Carpenter	d. ca. 1679	Gravesend	—	—	Will	NYHS *Abstracts,* I
Homan, Daniel	Carpenter	1824–1825	Brooklyn	—	—	Spooner, *BD*	—
*Homan, Mordecai	Carpenter/ Joiner	1702– d. 1755	East Hampton/ Southold	—	—	Land indenture, 1702 Town account, 1729 —	ShdTR EH *Trustees Records* Moore, *Index*
Homan, Mordecai	Millwright/ Joiner	1760–1762	Southampton/ Brookhaven	—	—	Town order, 1760 Land indenture, 1762	ShdTR Deed Liber B, SCCO
Hood, Thomas	Carpenter	1829–1830	Brooklyn	—	—	Spooner, *BD*, 1829 Nichols, *BD*, 1830	— —
Hoogland, Elbert	Carpenter	1797	Oyster Bay	—	—	Adriaen Hegeman Diary	Stoutenburgh, *Dutch Reformed Church*
*Hooper, Bartholomew	Carpenter	d. 1684	Southold	—	—	Inventory Power of attorney, 1686	QCHDC ShdTR
*Hooper, George H.	Carver/ Gilder	1823–1824	Brooklyn	—	—	Advertisement, *Long Island Star,* July 3, 1823 Spooner, *BD*, 1824	LIHS —
Hopking, George	Carpenter	1829–1830	Brooklyn	—	—	Spooner, *BD*, 1829 Nichols, *BD* 1830	— —

Name	Occupation	Date	Location	Birthplace	Age	Document	Source
Horton, Benjamin	Carpenter	1667	Southold	—	—	—	Wayland Jefferson Papers, Colonial Institute Records, SUSB
Horton, Jabez	Carpenter	d. 1811	Southold	—	—	Inventory	SCSC
Horton, Jonathan	Carpenter	1810	Southold	—	—	—	Salmon, *Records*
Horton, Joshua	Carpenter	b. 1643– d. 1729	Southold	—	—	Apprenticeship indenture, 1687	ShdTR
						Land indenture, 1696	ShdTR
						Debt release, 1702	ShdTR
						—	Moore, *Index*
Horton, Joshua, Jr.	Cooper	b. 1669– d. 1749	Southold/ Elizabeth- town, N.J.	—	—	Land indenture, 1697	ShdTR
						—	Moore, *Index*
How, Nathaniel	Turner	1758	Queens County	Connecticut	39	Muster roll, 1758	NYHS *Collections,* 1891
Howard, Christopher	Carpenter	d. 1799	Kings County	—	—	Inventory	KCSC
*Howell, Arthur	Carpenter/ Cooper/ Joiner	d. 1683	Southampton	—	—	Inventory	*Court of Sessions,* SCCO
Howell, Charles James	Carpenter/ Joiner	1809	Sag Harbor	—	—	Inventory, estate of James Howell, 1809	SCSC
Howell, Daniel	Carpenter	1812	Southampton	—	—	Probate records	SCSC
Howell, Isaiah	Joiner	1761	Southold	Southold	18	Muster roll, 1761	NYHS *Collections,* 1891
*Howell, James	Carpenter/ Joiner	1791– d. 1809	Sag Harbor	—	—	John Lyon Gardiner AB	EHFL
						Inventory	SCSC
*Howell, Jesse	Carpenter	1742	Southampton	—	—	Town account, 1742	Sh *Trustees Records*
*Howell, Jonathan	Joiner	d. ca. 1807	Southold	—	—	Record of vendue, 1807	Howell Collection, SCHS
Howell, Joseph	Cooper	1699	Southampton	—	—	Land indenture, 1699	Deed Liber A, SCCO
*Howell, Walter	Carpenter/ Joiner	1820	Southampton	—	—	Inventory	SCSC
Hubbs, Jacobus	Carpenter	1760	Huntington	Huntington	n. r.	Muster roll, 1760	NYHS *Collections,* 1891
Hudson, Nerua	Carpenter	1825	Brooklyn	—	—	Spooner, *BD*	—
Hudson, Richard	Carpenter	1780	Southold	—	—	Will of Silas Moore, 1780	*N.Y. Wills,* SCSC
Hughes, Daniel T.	Cabinetmaker	1826–1829	Brooklyn	—	—	Spooner, *BD,* 1826–1829	—
Hulse, George	Carpenter	1825	Brooklyn	—	—	Spooner, *BD*	—
Humphreys, Thomas	Joiner	ca. 1690– 1700	Jamaica	—	—	—	Peyer, "Jamaica Inhabitants"
Hunt, Charles	Carpenter	1825–1826	Brooklyn	—	—	Spooner, *BD,* 1825–1826	—
Hunt, John	Carpenter	1757	Bushwick	—	—	Will of Charles De Bevoise, 1757	NYHS *Abstracts,* V
Hunt, Moses	Carpenter	1829–1830	Brooklyn	—	—	Spooner, *BD,* 1829	—
						Nichols, *BD,* 1830	—
Hunt, Nathaniel	Carpenter	1796	Newtown	—	—	Will	QCSC
Hunt, William	Carpenter	1825	Brooklyn	—	—	Spooner, *BD*	—

Name	Occupation	Date	Location	Birthplace	Age	Document	Source
Hunter and Duryea	Cabinetmakers	1824	Brooklyn	—	—	Spooner, *BD* Advertisement, *Long Island Star*, May 20, 1824	LIHS
Hunter, William	Carpenter	1829–1830	Brooklyn	—	—	Spooner, *BD*, 1829 Nichols, *BD*, 1830	— —
Hunting, John	Cooper	1729	East Hampton	—	—	Land indenture, 1729	Deed Liber B, SCCO
Hyde, David	Carpenter	1826	Brooklyn	—	—	Spooner, *BD*	—
Ingraham, John	Carpenter	1826	Brooklyn	—	—	Spooner, *BD*	—
Ingraham, William	Cooper	1726	Oyster Bay	—	—	Land indenture, 1726	OBTR
Ireland, Jacob	Carpenter	1805	Smithtown	—	—	Elias Smith AB, 1796–1805	Lawrence Collection, SmPL
Ireland, John	Carpenter	1768	Huntington	—	—	Land indenture, 1768	Deed Liber C, SCCO
Ireland, Joseph	Millwright	1748	Oyster Bay	—	—	Land indenture, 1748	OBTR
* Iveson, John	Cabinetmaker	1822	Hempstead Harbor	—	—	Advertisements, *The Long Island Farmer and Queens County Advertiser*, Mar. 28, 1822	LIHS
Jackson,	Carpenter	1796	Brooklyn	—	—	Buell, *NYBD*	—
Jackson, Corns	Chairmaker	1759	Hempstead	Hempstead	—	Muster roll, 1759	NYHS *Collections*, 1891
Jacobs, William	Carpenter	1824	Brooklyn	—	—	Spooner, *BD*	—
Jagger, Elias	Joiner	1760	Southampton	Southampton	29	Muster roll, 1760	NYHS *Collections*, 1891
* Jagger, Samuel	Carpenter/ Joiner	1789– d. 1845	Southampton	—	—	Record of Samuel Jagger AB, 1789–1823 Elias Pelletreau, Jr. AB Inventory	ShCS ShCS SCSC
Jans, Auco	Carpenter	1680	Flatbush	—	—	Agreement, 1680	FbTR
Janse, Abraham	Carpenter	1664	Bushwick	—	—	—	Bergen, *Kings County*
Janse, Andries	Cooper	1692	Flatbush	—	—	Land indenture, 1692	FbTR
Janse, Arent	Carpenter	1641	Kings County	—	—	—	Bergen, *Kings County*
Janse, Christoffel	Carpenter	1675–1687	Flatbush/ Flatlands	—	—	— Land indenture, 1680	Bergen, *Kings County* FbTR
Janse, Frans	Carpenter	1660–1661	Flatbush	—	—	—	Bergen, *Kings County*
Jansen, Derck	Cooper	1677	Flatbush	—	—	Land indenture, 1677	FbTR
Jansen, Evert	Carpenter	1681	Flatlands	—	—	Apprenticeship indenture, 1681, apprentice	FlTR
Jansen, Stooffel	Carpenter	1681	Flatlands	—	—	Apprenticeship indenture, 1681, master	FlTR
Jarigs, Gerber	Wagonmaker	1665	Flatbush	—	—	Land indenture, 1665	FbTR
Jarvis, John	Joiner	1805	Huntington	—	—	Inventory, estate of Ebenezer Blackley, 1805	SCSC
Jayne, William	Cooper	1688–1735	Brookhaven	—	—	Land indenture, 1688 Land indentures, 1728, 1735	Deed Liber A, SCCO Deed Liber B, SCCO

Name	Occupation	Date	Location	Birthplace	Age	Document	Source
Jeffrey, Toby	Carpenter	1760	Suffolk County	Narragansett, Rhode Island	22	Muster roll, 1760	NYHS *Collections,* 1891
Jeners, Thomas	Carpenter	1680–1682	Brookhaven	—	—	Agreements, 1680, 1682	BhTR
Jenkins, Thomas	Carpenter	1826	Brooklyn	—	—	Spooner, *BD*	—
*Jennings, Elias	Carpenter	ca. 1789–1823	Southampton	—	—	Record of Samuel Jagger AB, 1789–1823	ShCS
Jennings, Nelson	Cabinetmaker	1831	Hempstead	—	—	Advertisement, *Inquirer,* Nov. 13, 1831	NCHM
Jennings, Paul	Carpenter	1826	Brooklyn	—	—	Spooner, *BD*	—
*Jervis, Nicholas	Carpenter/ Joiner	1808–1828	Smithtown	—	—	Elias Smith ABs	Lawrence Collection, SmPL
Johnes, Ezekiel	Joiner	1754	East Hampton	—	—	Letters of administration, estate of Edward Johnes, 1754	*N.Y. Wills,* SCSC
Johnes, Obadiah	Joiner	1756	Southampton	—	—	Land indenture, 1756	Deed Liber B, SCCO
Johns, Thomas	Joiner	1776	Southampton	Southampton	30	Muster roll, 1776	Mather, *Refugees*
Johnson, Ebenezer	Carpenter	1717	Southold	—	—	Land indenture, 1717	ShdTR
Johnson, Edward	Shipwright	1711–1714	Southold	—	—	Receipt, 1711 Apprenticeship indenture, 1714, master	ShdTR ShdTR
Johnson, Job	Carpenter	1829–1830	Brooklyn	—	—	Spooner, *BD,* 1829 Nichols, *BD,* 1830	— —
Johnson, William	Carpenter	1830	Brooklyn	—	—	Nichols, *BD*	—
*Johnson, William Martin	Carpenter/ Joiner	1790–1795	East Hampton	—	—	—	John Howard Payne, "Our Neglected Poets," *United States Magazine,* 1838
Johnstone, Alex	Carpenter	1762	Suffolk County	Ireland	22	Muster roll, 1762	NYHS *Collections,* 1891
Jones, Edward	Carpenter	b. 1650– d. 1726	East Hampton	—	—	—	Rattray, *East Hampton History*
Jones, Elisha	Carpenter	1829	Brooklyn	—	—	Spooner, *BD*	—
Jones, Geffrey	Ship carpenter	1664	Southold	—	—	Land indenture, 1664	ShdTR
Jones, John	Carpenter	1704– d. 1706	East Hampton	—	—	Land indenture, 1704 —	EHTR Rattray, *East Hampton History*
Jones, John	Carpenter	1829–1830	Brooklyn	—	—	Spooner, *BD,* 1829 Nichols, *BD,* 1830	— —
Jones, John S.	Carpenter	1830	Brooklyn	—	—	Nichols, *BD*	—
*Jones, John Thomas	Carpenter/ Joiner	d. 1828	Jamaica	—	—	Inventory	QCSC
*Jones, Obadiah	Joiner	1774	East Hampton	—	—	David Gardiner AB	EHFL
Juer, Michah	Carpenter	1648	Gravesend	—	—	Agreement, 1648 —	GTR Bergen, *Kings County*
Kellam, Robert	Carpenter	1778	Huntington	—	64	Loyalty oath list, 1778	HTR
Kelly, John	Carpenter	1650	Southampton	—	—	Court action, 1650	ShTR

Name	Occupation	Date	Location	Birthplace	Age	Document	Source
*Ketcham, Israel	Carpenter/ Joiner	1755–1795	Huntington	—	—	Israel Ketcham AB Land indenture, 1767 Will	NCHM NCHM NCHM
Ketcham, John	Carpenter	1772	Newtown	—	—	Will of Lambert Woodard, 1772	NYHS *Abstracts, XIII*
*Ketcham, Nathaniel	Carpenter/ Joiner	d. 1810	Islip	—	—	Inventory	SCSC
Ketcham, Ruben	Carpenter	1778	Huntington	—	33	Loyalty oath list, 1778	HTR
Ketcham, Samuel	Carpenter	ca. 1710– 1720	Jamaica	—	—	—	Peyer, "Jamaica Inhabitants"
Kent, James	Carpenter	1826–1830	Brooklyn	—	—	Spooner, *BD,* 1826 Nichols *BD,* 1830	— —
Kilwether, Coonrot	Carpenter	1761	Kings County	Germany	32	Muster roll, 1761	NYHS *Collections,* 1891
King, Benjamin	Carpenter	1795	Southampton	—	—	Letters of administration	SCSC
King, Benjamin	Joiner	1778– d. 1793	Southold	—	—	Suffolk County inhabitants, 1778 —	*NYGBR,* 1973 Mather, *Refugees*
King, Elisha	Joiner	1733	—	—	—	Will of Joseph King, 1733	NYHS *Abstracts, III*
King, Jonathan	Carpenter	1770–1778	Southold	—	—	Suffolk County inhabitants, 1778 — Inventory, unidentified estate, 1770	*NYGBR,* 1973 Mather, *Refugees* QCHDC
*King, Joseph	Joiner	d. ca. 1733	Southold	—	—	Will	NYHS *Abstracts, III*
*King, Peleg C.	Chairmaker	1804	Sag Harbor	—	—	Advertisement, *Suffolk Gazette,* July 9, 1804	EHFL
King, Samuel	Cooper	1656–1713	Southold	—	—	Land indentures, 1656, 1713	ShdTR
Kip, Nicas	Cooper	1681	Flatbush	—	—	Apprenticeship indenture, 1681, apprentice	FbTR
Kirby and Buckbee	Cabinetmakers	1823	Brooklyn	—	—	Spooner, *BD,*	—
Kirby, John	Cabinetmaker	1823	Brooklyn	—	—	Spooner, *BD*	—
Kirk, Arthur	Carpenter	1730–1739	Oyster Bay	—	—	Land indentures, 1730, 1739	OBTR
*Lamberson, John	Carpenter/ Joiner	d. 1826	Jamaica	—	—	Inventory	QCSC
Lame, Joseph	Carpenter	d. ca. 1773	Brookhaven	—	—	Letters of administration	QCHDC
Landon, Joseph	Carpenter	1699/1700	Shelter Island/ Southold	—	—	"G. S." AB	EHFL
Lane, Daniel	Joiner	1759	Suffolk County	Suffolk County	19	Muster roll, 1759	NYHS *Collections,* 1891
Langdon, William	Carpenter	1760	Hempstead	—	—	Will of Ezekial Langdon, 1760	NYHS *Abstracts, VI*
Langley, George	Carpenter	1694	Flushing	—	—	Onderdonk, *Names*	LIHS
Laraza, Peter	Carver	1830	Brooklyn	—	—	Nichols, *BD*	—
Larew, George	Carpenter	1826	Brooklyn	—	—	Spooner, *BD*	—
Larrabe, John	Joiner	1758	Queens County	England	22	Muster roll, 1758	NYHS *Collections,* 1891

Name	Occupation	Date	Location	Birthplace	Age	Document	Source
Latham, John, Jr.	Carpenter	1759	Suffolk County	Groton, Connecticut	20	Muster roll, 1759	NYHS *Collections*, 1891
Lawell, John	Carpenter	1760	Queens County	Ireland	19	Muster roll, 1760	NYHS *Collections*, 1891
Lawrence, John	Carpenter	1682–1685	Brookhaven	—	—	Agreements, 1682, 1685	BhTR
Lawrence, Matthias	Carpenter	1758	Queens County	Germany	46	Muster roll, 1758	NYHS *Collections*, 1891
Lawrence, Richard	Carpenter	1826–1830	Brooklyn	—	—	Spooner, *BD*, 1826, 1829 Nichols, *BD*, 1830	— —
Leeming, Thomas	Cooper	1698	Southampton	—	—	Land indenture, 1698	Deed Liber A, SCCO
*Lefford, William	Carpenter/ Joiner	d. 1808	Huntington	—	—	Inventory	SCSC
Lekey, William	Carpenter	1675	Gravesend	—	—	Agreement, 1675	GTR
Leonard, Sylvanus	Carver	1830	Brooklyn	—	—	Nichols, *BD*	—
Leveridge, William	Carpenter	d. ca. 1754	Newtown	—	—	Letters of administration	QCHDC
Lewis, William	Carpenter	1777	Jamaica	—	—	Will of Noah Smith, 1777	NYHS *Abstracts*, XIII
Lockwood, Isaac	Carpenter	1829	Brooklyn	—	—	Spooner, *BD*	—
*Long, Richard F.	Cabinetmaker	1807– d. 1819	Huntington	—	—	Nathaniel Potter DB Inventory	HHS SCSC
Long, Seymour	Carpenter	1825	Brooklyn	—	—	Spooner, *BD*	—
Longworth, Thomas	Shipwright	1698	Southold	—	—	Land indenture, 1698	ShdTR
Losee, Daniel	Carpenter	1829	Brooklyn	—	—	Spooner, *BD*	—
Lovett, John	Carpenter	1794–1800	Brookhaven	—	—	Land indenture, 1794 Probate records, estate of Thomas Avery, 1800	DeedLiber C, SCCO SCSC
Lowe, William	Carpenter	1826–1830	Brooklyn	—	—	Spooner, *BD*, 1826, 1829 Nichols, *BD*, 1830	— —
*Lowerre, John H.	Carpenter/ Joiner	d. 1831	Flushing	—	—	Inventory	QCSC
Lowglass, Samuel	Joiner	1770	Huntington	—	—	Mortgage indenture, 1770	Mortgage Liber A, SCCO
Lucas, Amos	Carpenter	1759	Suffolk County	Middletown, New York	21	Muster roll, 1759	NYHS *Collections*, 1891
Lucas, Archibald	Carpenter	1826	Brooklyn	—	—	Spooner, *BD*	—
Ludlam, Joseph	Cooper	1669–1689	Oyster Bay	—	—	Land indentures, 1669, 1684, 1686, 1689	OBTR
Luqueer, Abraham	Carpenter	1822–1830	Brooklyn	—	—	Spooner, *BD*, 1822–1826, 1829 Nichols, *BD*, 1830	— —
Luyster, Peter	Carpenter	1656–1683	Flatlands/ Flatbush/ Newtown	—	—	—	Bergen, *Kings County*
McCord, William	Turner	1759	Queens County	Ireland	38	Muster roll, 1759	NYHS *Collections*, 1891
McCord, William	Turner	1761	Kings County	Ireland	30	Muster roll, 1761	NYHS *Collections*, 1891

Name	Occupation	Date	Location	Birthplace	Age	Document	Source
*McCoun, Walter	Carpenter/ Blacksmith	d. 1822	Brooklyn	—	—	Inventory	KCSC
McFall, John	Turner	1829–1830	Brooklyn	—	—	Spooner, *BD,* 1829 Nichols, *BD,* 1830	— —
Mackee, David	Joiner	1760	Suffolk County	Suffolk County	22	Muster roll, 1760	NYHS *Collections,* 1891
McLoed, Simon	Carpenter	1824–1826	Brooklyn	—	—	Spooner, *BD*	—
Mackrell, James, Jr.	Carpenter	1803	Jamaica	—	—	Will	QCSC
Macoun, Jesse	Carpenter	1802	Brooklyn	—	—	Longworth, *NYCD*	—
Major, George	Carpenter	1822–1824	Brooklyn	—	—	Spooner, *BD*	—
Maltbie, John	Joiner	1704–d. ca. 1706	Southampton	—	—	Land indenture, 1704 Will	Deed Liber A, SCCO NYHS *Abstracts,* I
*Mapes, Timothy	Chairmaker	1824–1825	Sag Harbor/ Riverhead/ Southold	—	—	Advertisement, *The Corrector,* June 26, 1824, May 21, 1825	EHFL
Mapes, William	Carpenter	1822–1825	Brooklyn	—	—	Spooner, *BD*	—
Marsh, Benjamin	Carpenter	1825	Brooklyn	—	—	Spooner, *BD*	—
Marsh, George	Carpenter	1824	Brooklyn	—	—	Spooner, *BD*	—
Marsh, John	Millwright	1698	Brooklyn	—	—	—	Bergen, *Kings County*
*Marshall, Joseph	Cooper	d. 1685	Southampton	—	—	Inventory	*Court of Sessions,* SCCO
Marston, John	Wheelwright	d. ca. 1753	Flushing	—	—	Will	NYHS *Abstracts,* IV
Marvin, Moses	Carpenter	d. 1796	Brookhaven	—	—	Probate records	SCSC
Marvin, Seth	Carpenter	1784	Brookhaven	—	—	Letters of administration, estate of Seth Marvin, Sr. 1784	*N.Y. Wills,* SCSC
Mather, Ebenezer	Carpenter	1761	Southampton	—	—	Will of Hezekiah Reeve, 1761	*N.Y. Wills,* SCSC
*Maxon, Nathan T.	Cabinetmaker	1831	Sag Harbor	—	—	Advertisement, *The Corrector,* August 13, 1831	EHFL
Mead, Peter	Carpenter	1822–1825	Brooklyn	—	—	Spooner, *BD*	—
*Meeker, Benjamin	Carpenter/ Cabinetmaker/ Builder	1809–1829	Brooklyn	—	—	Advertisement, *Long Island Star,* July 6, 1809, Dec. 19, 1809 Spooner, *BD,* 1822, 1824–1826, 1829 Nichols, *BD,* 1830 "Summer Scene, Brooklyn," ca. 1820	LIHS — — LIHS
Meeker, Samuel	Carpenter	1822	Brooklyn	—	—	Spooner, *BD*	—
Merrill, John, Jr.	Carpenter	1803	East Hampton	—	—	David Gardiner AB	EHFL
*Messenger, Samuel	Carpenter/ Joiner	d. 1816	Queens County	—	—	Inventory	QCSC
Michell, John	Carpenter	1679	East Hampton	—	—	Agreement, 1679	BhTR
Miller, Andrew	Cooper	1693	Brookhaven	—	—	Land indenture, 1693	Deed Liber A, SCCO

Name	Occupation	Date	Location	Birthplace	Age	Document	Source
Miller, Elezer	Carpenter	1725	East Hampton	—	—	Agreement, 1725	EHTR
*Miller, Josiah	Carpenter/ Joiner/ Glasier	d. 1728	Brookhaven	—	—	Inventory	QCHDC
Miller, Samuel	Carpenter	1822	Smithtown	—	—	Elias Smith AB, 1818	Lawrence Collection, SmPL
Mills, Aurelius	Joiner	d. ca. 1759	Flushing	—	—	Will	NYHS *Abstracts*, V
Mills, Zebulon	Carpenter	1733	Jamaica	—	—	Land indenture, 1733	JTR
Minnon, William	Carpenter	1759	Suffolk County	New London, Connecticut	26	Muster roll, 1759	NYHS *Collections*, 1891
Mintonyne, John	Carpenter	1803–1830	Brooklyn	—	—	Land indenture, 1803	Deed Liber 8, CROB
						Spooner, *BD*, 1822, 1824–1825	—
						Nichols, *BD*, 1830	—
Mintonyne, John, Jr.	Carpenter	1822–1823	Brooklyn	—	—	Spooner, *BD*	—
Mintonyne, William	Carpenter	1826–1830	Brooklyn	—	—	Spooner, *BD*, 1826, 1829	—
						Nichols, *BD*, 1830	—
Mitchell, Jeremiah	Joiner	1662	Flushing	—	—	Onderdonk, *Names*	LIHS
Monfort, Daniel	Carpenter	1804	Oyster Bay	—	—	Adriaen Hegeman Diary	Stoutenburgh, *Dutch Reformed Church*
Monfort, Jacobus	Carpenter	1715–1723	Oyster Bay/ Bushwick	—	—	Land indentures, 1715, 1723	OBTR
Monfort, Peter	Carpenter	1782	Flushing	—	—	Leonard Lawrence DB	NYHS
Monfort, Peter	Carpenter	d. 1807	Oyster Bay	—	—	Inventory	QCSC
Montagh, John	Carpenter	1802	Brooklyn	—	—	Longworth, *NYCD*	—
Montangie, Jan	Master cooper	1681	Flatbush	—	—	Apprenticeship indenture, 1681, master	FbTR
Montany, John	Carpenter	1796–1802	Brooklyn	—	—	Buell, *NYBD*	—
						Longworth, *NYCD*	—
Moon, Henry	Carpenter	1822–1830	Brooklyn	—	—	Spooner, *BD*, 1822–1826, 1829	—
						Nichols, *BD*, 1830	—
Moon, Jacob	Carpenter	1823–1826	Brooklyn	—	—	Spooner, *BD*	—
Moon, James	Carpenter	1822–1830	Brooklyn	—	—	Spooner, BD. 1822–1826	—
						Nichols, *BD*, 1830	—
Moon, John	Builder	1822–1826	Brooklyn	—	—	Spooner, *BD*, 1822, 1826	—
Moon, Martin	Carpenter	1830	Brooklyn	—	—	Nichols, *BD*	—
Moore, Alexander	Carpenter	1802–1823	Brooklyn	—	—	Longworth, *NYCD*, 1802	—
						Spooner, *BD*, 1822–1823	—
Moore, John	Carpenter	1824–1830	Brooklyn	—	—	Spooner, *BD*, 1824–1826	—
						Nichols, *BD*, 1830	—
*Moore, Samuel	Carpenter/ Turner	1810–1825	Brooklyn	—	—	Advertisement, *Long Island Star*, March 29, 1810	LIHS
						Spooner, *BD*, 1825	—

Name	Occupation	Date	Location	Birthplace	Age	Document	Source
*Moore, Simon	Carpenter	1765– d. 1802	Southold	—	—	Ezra L'Hommedieu AB Salmon AB —	SCHS Southold Free Library Salmon, *Records*
Morehouse, Calvin	Carpenter	1822–1830	Brooklyn	—	—	Spooner *BD,* 1822–1825, 1829 Nichols, *BD,* 1830	— —
Morehouse, Smith	Carpenter	1823–1830	Brooklyn	—	—	Spooner, *BD,* 1823 1826, 1829 Nichols, *BD,* 1830	— —
Morgan, John	Carpenter	1756–1792	Huntington	—	—	Land indenture, 1756 Record of work, Fort Golgotha, 1782 Land indenture, 1792	Deed Liber B, SCCO HTR Deed Liber C, SCCO
Morrel, Abraham	Carpenter	1825–1826	Brooklyn	—	—	Spooner, *BD*	—
Morrel, James	Carpenter	1822–1826	Brooklyn	—	—	Spooner, *BD,* 1822, 1824–1826	—
Morrell, Benjamin	Carpenter	1758	Oyster Bay	Oyster Bay	19	Muster roll, 1758	NYHS *Collections,* 1891
Morrell, James	Carpenter	1823	Brooklyn	—	—	Spooner, *BD*	—
Morrell, Thomas	Carpenter	1758	Oyster Bay	Oyster Bay	18	Muster roll, 1758	NYHS *Collections,* 1891
Morris, Benjamin	Carpenter	1826	Brooklyn	—	—	Spooner, *BD*	—
Moser, Isaac	Carpenter	1802	Brooklyn	—	—	Longworth, *NYCD*	—
Moser, Joseph	Carpenter/ Builder	1802–1830	Brooklyn	—	—	Longworth, *NYCD* Spooner, *BD,* 1822, 1824–1826 Nichols, *BD,* 1830	— — —
Mosier, John	Carpenter	1796	Brooklyn	—	—	Buell, *NYBD*	—
Mott, Adam	Carpenter	1790	North Hempstead	—	—	Will	QCSC
Mott, Jacob	Carpenter	1734	Oyster Bay	—	—	Land indenture, 1734	OBTR
Mott, Jacob	Carpenter	1826	Brooklyn	—	—	Spooner, *BD*	—
Mott, John	Carpenter	1703–1729	Oyster Bay	—	—	Land indentures, 1703, 1720, 1727, 1729	OBTR
Mott, John	Carpenter	d. ca. 1751	Hempstead	—	—	Will	NYHS *Abstracts,* IV
*Mott, John	Carpenter/ Joiner	1799	Brookhaven	—	—	Inventory, estate of Thomas Avery, 1799	SCSC
Mott, Jonathan	Carpenter	1713	Oyster Bay	—	—	Land indenture, 1713	OBTR
Mott, Samuel	Carpenter	1790	North Hempstead	—	—	Will of Adam Mott, 1790	QCSC
Mott, Samuel	Carpenter	d. ca. 1781	Hempstead	—	—	Will	NYHS *Abstracts,* X
Mount, Thomas	Joiner	1792	Brookhaven	—	—	Probate records, estate of John Armstrong, 1792	SCSC
Mow, John	Turner	1758	Queens County	Connecticut	21	Muster roll, 1758	NYHS *Collections,* 1891
Mudge, Michael	Millwright	1746	Oyster Bay	—	—	Land indenture, 1746	NSHTR
Muffit, John	Joiner	1760	Queens County	Ireland	20	Muster roll, 1760	NYHS *Collections,* 1891

Name	Occupation	Date	Location	Birthplace	Age	Document	Source
Mulford, Abraham	Carpenter	1752	East Hampton	—	—	Town account, 1752	EH *Trustees Records*
Mulford, Edward	Joiner	b. 1730–d. ca. 1754	East Hampton	—	—	Will —	NYHS *Abstracts*, V Rattray, *East Hampton History*
Mulford, Jeremiah	Carpenter	1725	East Hampton	—	—	Agreement, 1725	EHTR
Mulford, John	Carpenter	1703	East Hampton	—	—	Town account, 1703	EHTR
Mulford, Matthew	Carpenter	1725	East Hampton	—	—	Agreement, 1725	EHTR
Mulford, Thomas	Carpenter	1703–1734	East Hampton	—	—	Record of work, 1703 Town account, 1734	EHTR EH *Trustees Records*
*Mulford, Timothy	Joiner	b. 1718–1760	East Hampton	—	—	Land indenture, 1754 Signed and dated desk —	Deed Liber B, SCCO East Hampton Historical Society Rattray, *East Hampton History*
Munsell, Isaac	Carpenter	1800	Brookhaven	—	—	Land indenture, 1800	Deed Liber C, SCCO
Murphy, James	Carpenter	1760	Kings County	Ulster County, New York	23	Muster roll, 1760	NYHS *Collections*, 1891
Naybor, James	Cooper	d. ca. 1671	Huntington	—	—	Will	NYHS *Abstracts*, I
Neil, John	Carpenter	1826	Brooklyn	—	—	Spooner, *BD*	—
Neily, Samuel	Carpenter	1760	Kings County	Ulster County, New York	20	Muster roll, 1760	NYHS *Collections*, 1891
Newell, George	Carpenter	1826	Brooklyn	—	—	Spooner, *BD*	—
*Newman, John	Carpenter/Shipwright	d. 1697	Oyster Bay	—	—	Grant of land, 1681 Inventory	OBTR QCHDC
Newton, James	Carpenter	1822	Smithtown	—	—	Elias Smith AB, 1818	Lawrence Collection, SmPL
Nichols, Isaac	Cabinetmaker	1796–1823	Brooklyn	—	—	Buell, *NYBD*, 1796 Longworth, *NYCD*, 1802, 1811 Spooner, *BD*, 1823	— — —
Nicholls, William	Carpenter	1826	Brooklyn	—	—	Spooner, *BD*	—
Norris, John	Carpenter/Cooper	1729	Southampton	—	—	Will of Robert Norris, 1729	NYHS *Abstracts*, XI
Norris, Robert	Carpenter/Cooper	d. ca. 1729	Southampton	—	—	Will	NYHS *Abstracts*, XI
Norton, Nathaniel	Carpenter	1668–d. 1685	Brookhaven	—	—	Agreements, 1668, 1672 Inventory	BhTR *Court of Sessions*, SCCO
Oakley, Samuel	Carpenter	d. 1800	Smithtown	—	—	Inventory	SCSC
Oates, Robert	Chairmaker	1759	Suffolk County	Ireland	44	Muster roll, 1759	NYHS *Collections*, 1891
Okey, John	Carpenter	1822	Brooklyn	—	—	Spooner, *BD*	—
O'Neil, Charles	Carpenter	1830	Brooklyn	—	—	Nichols, *BD*	—
O'Neil, William	Carpenter	1826	Brooklyn	—	—	Spooner, *BD*	—
Organ, Samuel	Joiner	1826	Brooklyn	—	—	Spooner, *BD*	—
*Oriel, James	Joiner	d. 1815	Hempstead	—	—	Inventory	QCSC

Name	Occupation	Date	Location	Birthplace	Age	Document	Source
*Osborn, Septimus	Carpenter/Joiner	1811–d. ca. 1852	East Hampton	—	—	Jonathan Mulford AB Gardiner and Parsons AB Letters of administration	EHFL EHFL SCSC
Outwater, Jacob	Fan sash maker	1830	Brooklyn	—	—	Nichols, *BD*	—
Overton, Daniel	Carpenter	1804	Setauket	—	—	Dr. Samuel Thompson diary	NYPL
Overton, Newton	Carpenter	1802	Setauket	—	—	Dr. Samuel Thompson diary	NYPL
Overton, Thomas	Carpenter	1760–1765	Southold	Southold	23 (in 1760)	Muster roll, 1760 Land indenture, 1765	NYHS *Collections*, 1891 Deed Liber B, SCCO
Owen, Ebenezer	Carpenter	1732	Brookhaven	—	—	Joseph Jayne AB	NYHS
Owen, Even	Joiner	1683	Brookhaven	—	—	Land indenture, 1683	BhTR
*Owen, George	Carpenter	d. 1684	Brookhaven	—	—	Inventory	*Court of Sessions*, SCCO
Owen, George	Carpenter	1729	Brookhaven	—	—	Joseph Jayne AB	NYHS
Owen, Jonathan	Carpenter	1696	Brookhaven	—	—	Agreement, 1696	BhTR
Owen, Moses	Carpenter	1701–1713	Brookhaven	—	—	Land indentures, 1701, 1705 Land indenture, 1713	Deed Liber A, SCCO BhTR
Owens, William	Carpenter	1762	Suffolk County	England	25	Muster roll, 1762	NYHS *Collections*, 1891
*Paine, Ezra	Carpenter	b. 1767–1788	Southold	—	—	John Paine AB Paine Family Register	Colonial Institute Records, SUSB Colonial Institute Records, SUSB
*Paine, John	Carpenter/Joiner	b. 1739–d. 1815	Southold	—	—	John Paine AB David Conkling AB Inventory	Colonial Institute Records, SUSB Landon Papers, LIHS SCSC
*Paine, John, Jr.	Carpenter/Joiner	b. 1763–d. 1821	Southold	—	—	John Paine AB Paine Family Register	Colonial Institute Records, SUSB Colonial Institute Records, SUSB
*Paine, Joshua	Carpenter/Joiner	b. 1765–1788	Southold	—	—	John Paine AB Paine Family Register	Colonial Institute Records, SUSB Colonial Institute Records, SUSB
*Paine, Phineas	Carpenter	b. 1769	Southold	—	—	John Paine AB	Colonial Institute Records, SUSB
Pangburn, Samuel	Carpenter	1826	Brooklyn	—	—	Spooner, *BD*	—
*Parish, Ambrose	Joiner/Turner	b. 1764–d. 1847	Oyster Bay	—	—	—	Ludlam, *Parish Genealogy*
*Parish, Daniel	Joiner	b. 1724–d. 1805	Oyster Bay	—	—	Merchant's [Samuel Townsend?] AB Land indenture, 1756 —	NYHS OBTR Ludlam, *Parish Genealogy*
*Parish, Isaac	Joiner/Turner	b. 1766–d. 1836	Oyster Bay	—	—	Henry Hagner DB —	QbPL Ludlam, *Parish Genealogy*

Name	Occupation	Date	Location	Birthplace	Age	Document	Source
* Parish, Townsend	Carpenter	b. 1732– 1828	Oyster Bay	—	—	Samuel Townsend AB —	EHFL Ludlam, *Parish Genealogy*
Parkinson, William	Joiner/ Undertaker	1829	Brooklyn	—	—	Spooner, *BD*	—
Parks, George	Carpenter/Joiner	1717–1722	Huntington	—	—	Henry Lloyd I AB James and Henry Lloyd AB	LIHS NYHS
Parks, John	Carpenter	1830	Brooklyn	—	—	Nichols, *BD*	—
* Parsons, John	Carpenter/ Cooper/ Joiner/Weaver	1674– 1693	East Hampton	—	—	John Parsons AB	NYHS
Patcher, Harvey	Builder	1822	Brooklyn	—	—	Spooner, *BD*	—
Patterson, William	Carpenter	1824	Brooklyn	—	—	Spooner, *BD*	—
Patty, Edward	Carpenter	1696	Southold	—	—	Land indenture, 1696	Deed Liber A, SCCO
Patty, Joseph	Carpenter	1696–1712	Southold	—	—	Land indenture, 1696 Land indenture, 1707 Agreement, 1712	Deed Liber A, SCCO ShdTR ShdTR
Payne, Silas	Carpenter	1830	Brooklyn	—	—	Nichols, *BD*	—
Pearce, Mr.	Joiner	1782	Oyster Bay	—	—	Record of debt, estate of Mr. Townsend, 1782	NYHS
Pearsall, Nathaniel	Carpenter	1672– d. 1705	Hempstead	—	—	List of town officers, 1672– 1685 Inventory	NSHTR QCHDC
Pease, John	Carpenter	1829	Brooklyn	—	—	Spooner, *BD*	—
* Peck, Curtis	Carpenter	1806	Flushing	—	—	Edward Lawrence RB	NYHS
Peck, Joseph	Carpenter	1778	Southold	—	—	Suffolk County inhabitants, 1778	*NYGBR,* 1973
Pell, Samuel	Shipwright	1681	Oyster Bay	—	—	Town order, 1681	OBTR
Penny, Isaac	Carpenter	1760–1786	Suffolk County	Suffolk County	32 (in 1760)	Muster roll, 1760 Will of Josiah Goodall, 1786	NYHS *Collections,* 1891 *N.Y. Wills,* SCSC
Penny, Nathan	Carpenter	1763–d. ca. 1768	Southold	—	—	Will of Nathan Benjamin, 1763 Will	*N.Y. Wills,* SCSC NYHS *Abstracts,* VII
Penny, William	Joiner	1759	Suffolk County	Suffolk County	17	Muster roll, 1759	NYHS *Collections,* 1891
Peters, George	Cooper	1751	Oyster Bay	—	—	Land indenture, 1751	OBTR
Pettit, Foster	Chairmaker	1831	Hempstead	—	—	Advertisement, *Inquirer,* Feb. 18, 1831	NCHM
Pettit, John	Carpenter	1758	Hempstead	—	—	Will of John Tredwell, 1758	NYHS *Abstracts,* V
Pettit, Samuel	Carpenter	1823–1829	Brooklyn	—	—	Spooner, *BD,* 1823–1826, 1829	—
Pettit, Simon	Carpenter	1822	Brooklyn	—	—	Spooner, *BD*	—
Petty, Benjamin	Carpenter	1795	Riverhead	—	—	Land indenture, 1795	Deed Liber C, SCCO
* Petty, Jeremiah	Carpenter/ Blacksmith	d. 1795	Riverhead	—	—	Inventory	SCSC
Phalin, William	Carpenter	1826	Brooklyn	—	—	Spooner, *BD*	—

Name	Occupation	Date	Location	Birthplace	Age	Document	Source
Philips, John	Carpenter	1829	Brooklyn	—	—	Spooner, *BD*	—
Pike, Henry	Carpenter	d. ca. 1780	Southold	—	—	Will	*N.Y. Wills,* SCSC
Platt, Jonas	Carpenter	1723	Huntington	—	—	James and Henry Lloyd AB	NYHS
*Plumbe, Samuel, Sr.	Carpenter/ Joiner	1727 – d. ca. 1752	Huntington	—	—	Henry Lloyd WB Town account, 1728 Will	LIHS HTR NYHS *Abstracts,* IV
Plumbe, Samuel, Jr.	Carpenter/ Joiner	1752	Huntington	—	—	Will of Samuel Plumbe, Sr. 1752	NYHS *Abstracts,* IV
Polhemus, Theodorus	Wheelwright/ Cooper	d. ca. 1722	Jamaica	—	—	Will	NYHS *Abstracts,* II
*Pontine, Thadies	Carpenter	d. 1814	Jamaica	—	—	Inventory	QCSC
*Poole, Dears	Carpenter/ Wagonmaker	d. 1808	Hempstead	—	—	Inventory	QCSC
Poole, Pierce	Carpenter	d. ca. 1785	Queens County	—	—	Letters of administration	NYHS *Abstracts,* XIII
*Poppen, Jan	Turner	1675 – d. before 1689	Flatlands/ Flatbush	—	—	— —	FbTR Bergen, *Kings County*
Porter, Samuel	Carpenter	1825 – 1830	Brooklyn	—	—	Spooner, *BD,* 1825 – 1826, 1829 Nichols, *BD,* 1830	— —
Post, James	Carpenter	1825	Brooklyn	—	—	Spooner, *BD*	—
Post, John	Carpenter	d. 1687	Southampton	—	—	Inventory	*Court of Sessions,* SCCO
Post, Lieut.	Carpenter	1665	Southampton	—	—	Agreement, 1665	ShTR
Post, Richard	Carpenter	1651	Southampton	—	—	Town order, 1651	ShTR
Powell, Amos	Carpenter	1786	Oyster Bay	—	—	Court action, 1786	*Court of General Sessions,* QCCO
Powers, Lawrence	Joiner	1826	Brooklyn	—	—	Spooner, *BD*	—
Pratt, John	Carpenter	1693 – 1727	Oyster Bay	—	—	Land indentures, 1693, 1700, 1713, 1714, 1719, 1723, 1727	OBTR
Pratt, John	Carpenter	1771	Oyster Bay	—	—	Land indenture, 1771	OBTR
Presher, John	Turner	1826	Brooklyn	—	—	Spooner, *BD*	—
Price, Michael	Carpenter	1761	Queens County	Ireland	25	Muster roll, 1761	NYHS *Collections,* 1891
Racket, John Mather	Carpenter	1808	Southold	—	—	Bail slip, 1808	SCCO
Ramsay, Robert	Turner	1802	Brooklyn	—	—	Longworth, *NYCD*	—
Rand, Charles	Carpenter	1825 – 1826	Brooklyn	—	—	Spooner, *BD*	—
Rapalye, Daniel, Sr.	Carpenter	d. ca. 1728	Brooklyn	—	—	Will	NYHS *Abstracts,* XI
Rapalye, Daniel, Jr.	Carpenter	1728	Brooklyn	—	—	Will of Daniel Rapalye, Sr. 1728	NYHS *Abstracts,* XI
Rapalye, Joris	Carpenter	1728	Brooklyn	—	—	Will of Daniel Rapalye, Sr. 1728	NYHS *Abstracts,* XI
Rayner, Nathaniel	Carpenter	d. 1803	Southampton	—	—	Inventory	SCSC
Raymond, Alfred	Carpenter	1829 – 1830	Brooklyn	—	—	Spooner, *BD,* 1829 Nichols, *BD,* 1830	— —

Name	Occupation	Date	Location	Birthplace	Age	Document	Source
Raymond, James	Carpenter	1829–1830	Brooklyn	—	—	Spooner, *BD*, 1829 Nichols, *BD*, 1830	— —
Reede, Thomas	Carpenter	1658	Newtown	—	—	Land indenture, 1658	TMN
Reeve, Elias	Carpenter	1801–1802	Smithtown	—	—	Elias Smith AB, 1796–1805	Lawrence Collection, SmPL
Reeve, John	Carpenter	1715	Southold	—	—	Land indenture, 1715	ShdTR
Reeve, Moses	Builder	1825	Brooklyn	—	—	Spooner, *BD*	—
Remsen, Abraham	Carpenter	1822–1830	Brooklyn	—	—	Spooner, *BD*, 1822–1826, 1829 Nichols, *BD*, 1830	— —
Remsen, Arthur	Carpenter	1825–1830	Brooklyn	—	—	Spooner, *BD*, 1825–1826, 1829 Nichols, *BD*, 1830	— —
*Remsen, Jeremiah	Carpenter/Joiner	1813–1832	North Hempstead	—	—	Jeremiah Remsen AB	Bryant Memorial Library
Remsen, Nicholas	Carpenter	1825	Brooklyn	—	—	Spooner, *BD*	—
Rengenir, ———	Carpenter	1663	Flatbush	—	—	Town account, 1663	FbTR
Renne, James	Carpenter	d. ca. 1774	Newtown	—	—	Will	NYHS *Abstracts*, VIII
*Renne, Samuel	Carpenter/Joiner	d. 1801	Queens County	—	—	Inventory	QCSC
Reynolds, Isaac	Carpenter	1826	Brooklyn	—	—	Spooner, *BD*	—
Rhodes, Benjamin	Carpenter	1802	Brooklyn	—	—	Longworth, *NYCD*	—
Rhodes, William	Chairmaker	1831	Hempstead	—	—	Advertisement, *Inquirer*, Feb. 18, 1831	NCHM
Richmond, Warren	Carpenter	1824–1830	Brooklyn	—	—	Spooner, *BD*, 1824–1826 Nichols, *BD*, 1830	— —
Riddle, Jacob	Carpenter	1829–1830	Brooklyn	—	—	Spooner, *BD*, 1829 Nichols, *BD*, 1830	— —
Roads, John	Joiner	1758	Jamaica	Jamaica, New York	39	Muster roll, 1758	NYHS *Collections*, 1891
Robbins, Isaac	Carpenter	1782	Brookhaven	—	—	Will of William Clark, 1782	Van Buren, *S.C. Wills*, EHFL
Robertson,	Carpenter	1802	Brooklyn	—	—	Longworth, *NYCD*	—
Robinson, Alexander	Carpenter	1822	Brooklyn	—	—	Spooner, *BD*	—
Robison, John	Joiner	1676	Oyster Bay	—	—	Grant of land, 1676	OBTR
*Roe, Austin	Carpenter/Cabinetmaker/Innkeeper	b. 1749–d. 1830	Setauket	—	—	Abraham Woodhull AB Land indenture, 1797 Burl, "Notes on Roe Family" —	EHFL Deed Liber C, SCCO EHFL Adkins, *Setauket*
Roe, Henry	Carpenter	1822–1830	Brooklyn	—	—	Spooner, *BD*, 1822–1826, 1829 Nichols, *BD*, 1830	— —
*Roe, Phillips	Carpenter/Joiner	1762–d. 1815	Brookhaven	—	—	Elias Pelletreau AB Inventory	EHFL SCSC
Roger, Jonathan	Carpenter	1829	Brooklyn	—	—	Spooner, *BD*	—
Roger, Joseph	Turner	1759	Suffolk County	Lyme, Connecticut	38	Muster roll, 1759	NYHS *Collections*, 1891

Name	Occupation	Date	Location	Birthplace	Age	Document	Source
Rogers, Capt.	Carpenter	1762	Southampton	—	—	Town account, 1762	Sh *Trustees Records*
Rogers, Abraham	Joiner	1776	Southampton	Southampton	19	Muster roll, 1776	Mather, *Refugees*
Rogers, Bettauel	Carpenter	1830	Brooklyn	—	—	Nichols, *BD*	—
Roop, David	Carpenter	1826–1830	Brooklyn	—	—	Spooner, *BD,* 1826 Nichols, *BD,* 1830	— —
Roose, David	Carpenter	1804	Smithtown	—	—	Elias Smith AB, 1796–1805	Lawrence Collection, SmPL
Rose, Jonathan	Cooper	1696	Brookhaven	—	—	Land indenture, 1696	Deed Liber A, SCCO
* Rose, Major	Carpenter	1814	Brookhaven	—	—	Inventory, estate of William Rose, 1814	SCSC
* Rose, Timothy	Joiner	1733	Brookhaven	—	—	Joseph Jayne AB	NYHS
Rose, William	Carpenter	d. 1814	Brookhaven	—	—	Inventory	SCSC
* Ross, Robert	Cabinetmaker	1811	Brooklyn	—	—	Longworth, *NYCD* Advertisement, *Long Island Star,* June 12, 1811	— LIHS
Rowland, Smith	Joiner	1758	Queens County	Queens County	19	Muster roll, 1758	NYHS *Collections,* 1891
Rudyard, Thomas	Carpenter	1772	Brookhaven	—	—	Will of Eleazer Hawkings, 1772	*N.Y. Wills,* SCSC
* Ruland, John	Joiner	d. 1768	Hempstead	—	—	Inventory	Deed Liber C, CROJ
Ruland, Luke	Shop joiner	1778	Huntington	—	25	Loyalty oath list, 1778	HTR
* Rusco, David, J.	Carpenter/Joiner	d. 1806	Huntington	—	—	Inventory	SCSC
* Russel, Bazillai	Cabinetmaker	1832	Brooklyn	—	—	Advertisement, Bigelow, *BD,* 1832	—
Ryder, Amos	Carpenter	1825	Brooklyn	—	—	Spooner, *BD*	—
Ryder, John	Carpenter	1798	Flushing	—	—	Leonard Lawrence DB	NYHS
Ryder, Samuel	Carpenter	1822–1825	Brooklyn	—	—	Spooner, *BD*	—
Ryder, Stephen	Carpenter	1795	Flushing	—	—	Leonard Lawrence DB	NYHS
Salick, Mathias	Carpenter	1758	Queens County	Germany	21	Muster roll, 1758	NYHS *Collections,* 1891
Salt, Morris	Carpenter	1824–1826	Brooklyn	—	—	Spooner, *BD*	—
* Sammis, Daniel	Carpenter	1817–1834	Huntington	—	—	Daniel Sammis ABs	HHS
Sammis, Philip	Carpenter	1782	Huntington	—	—	Record of work, Fort Golgotha, 1782	HTR
Sammis, Silas	Carpenter	1782	Huntington	—	—	Mortgage indenture, 1767	Mortgage Liber A, SCCO
						Land indenture, 1768	Deed Liber C, SCCO
						Record of work, Fort Golgotha, 1782	HTR
Sammis, Stephen	Carpenter	d. 1805	Suffolk County	—	—	Inventory	SCSC
Sammis, Zopher	Carpenter	1829–1833	Smithtown	—	—	Elias Smith AB, 1816–1835	Lawrence Collection, SmPL
* Sandford, Daniel	Carpenter/Joiner	b. 1734–d. 1811	Southampton	—	—	Daniel Sandford AB Will of Thomas Sandford, 1785 Inventory —	QbPL Van Buren, *S.C. Wills,* EHFL SCSC Sanford, *Sand-Families*

Name	Occupation	Date	Location	Birthplace	Age	Document	Source
Sandford, Ezekiel	Wheelwright	b. 1648–1716	Hartford/ Southampton	—	—	Town grant, 1678 Agreement, 1686 —	ShTR ShTR Sanford, Sandford Families
Sands, Samuel	Carpenter	1825	Brooklyn	—	—	Spooner, BD	—
*Satterly, Samuel	Joiner	b. 1777–1792	Setauket	—	—	— — Abraham Woodhull AB	Emily B. Steffens, "The Satterlys of Setauket," Long Island Forum, April, 1943 Emily B. Steffens, "Old Island Writing Desk," Long Island Forum, April, 1947 EHFL
* Satterly, William	Carpenter/ Joiner	1792– d. 1797	Setauket	—	—	Abraham Woodhull AB Inventory	EHFL SCSC
Saunders, Abiel	Carpenter	1826	Brooklyn	—	—	Spooner, BD	—
Saust, John	Carpenter	1808	Brookhaven	—	—	Bail slip, 1808	SCCO
*Sayre, David	Joiner	1770– d. 1830	Southampton	—	—	Will of William Mulford, 1773 Will of Rev. Silvanius White, 1782 Will of James Brown, 1787 — Advertisement, The American Eagle, March 27, 1819	N.Y. Wills, SCSC N.Y. Wills, SCSC Van Buren, S.C. Wills, EHFL Dwight, "Gelston Family," NYGBR, 1871 LIHS
Sayre, Ezekiel	Joiner/ Blacksmith	d. ca. 1740	Southampton	—	—	Will	N.Y. Wills, SCSC
Sayre, Foster	Carpenter	1826	Brooklyn	—	—	Spooner, BD	—
Schellinx, Jacob	Cooper	1685– d. 1714	East Hampton	—	—	Town account, 1685 Land indenture, 1704 —	EHTR EHTR Rattray, East Hampton History
*Schellinx, William	Carpenter/Joiner/ Cooper	1697–1725	East Hampton	—	—	Town account, 1698 Land indentures, 1697, 1702, 1723 Mary Hunting AB	EHTR EHTR EHFL
Schellinx, William	Carpenter	d. 1719	East Hampton	—	—	Inventory	QCHDC
Scovell, Thomas	Carpenter	1760	Suffolk County	Lyme, Connecticut	20	Muster roll, 1760	NYHS Collections, 1891
*Sealey, William	Carpenter	1806	Hempstead	—	—	Henry Hagner AB	QbPL
Seaman, Nathaniel	Carpenter	d. ca. 1756	Jerusalem [Wantagh]	—	—	Will	NYHS Abstracts, V
*Seaman, Stephen	Carpenter	1818–1848	Oyster Bay	—	—	Receipts, 1818, 1848	Woodnutt Papers, NCHM
Searing, Samuel	Carpenter	1826–1830	Brooklyn	—	—	Spooner, BD, 1826, 1829 Nichols, BD, 1830	— —
Seeds, William	Carpenter	1830	Brooklyn	—	—	Nichols, BD	—
Seers, Samuel	Carpenter	1760	Kings County	New England	28	Muster roll, 1760	NYHS Collections, 1891

Name	Occupation	Date	Location	Birthplace	Age	Document	Source
Sesicle, Nicolas	Turner	1758	Queens County	Switzerland	18	Muster roll, 1758	NYHS *Collections,* 1891
Shackerly, William	Carpenter	1826	Brooklyn	—	—	Spooner, *BD*	—
Sharpe, William	Carpenter	1802	Brooklyn	—	—	Longworth, *NYCD*	—
Shaw, Thomas	Cooper	1695	Southampton	—	—	Land indenture, 1695	Deed Liber A, SCCO
Sheffield, William	Carpenter	1826	Brooklyn	—	—	Spooner, *BD*	—
Sheidbolt, Ezekiel	Carpenter	1738–1753	Oyster Bay	—	—	Land indentures, 1738, 1745, 1748, 1750, 1753	OBTR
Sherrill, Henry	Carpenter	1776	East Hampton	—	22	Muster roll, 1776	Mather, *Refugees*
*Sherrill, Jeremiah	Carpenter/ Joiner	1769–1778	East Hampton	—	—	Nathaniel Dominy IV AB —	Winterthur Rattray, *East Hampton History*
Shipmen, Jacob	Carpenter	1829	Brooklyn	—	—	Spooner, *BD*	—
Simons, Nicholas	Carpenter	1823–1826	Brooklyn	—	—	Spooner, *BD*	—
Simons, Peter	Carpenter	1704	Southold	—	—	Land indenture, 1704	ShdTR
Simonson, Daniel	Carpenter	1829	Brooklyn	—	—	Spooner, *BD*	—
Simonson, Morris	Carpenter	1822–1830	Brooklyn	—	—	Spooner, *BD,* 1822–1826, 1829 Nichols, *BD,* 1830	— —
Simonson, Nicholas	Carpenter	1825	Brooklyn	—	—	Spooner, *BD*	—
*Skillman, Thomas	Carpenter/ Joiner	d. 1814	Riverhead	—	—	Statement of debt Inventory	SCSC SCSC
Skinner, Henry	Carpenter	1760	Suffolk County	Hanover [England?]	30	Muster roll, 1760	NYHS *Collections,* 1891
Slecht, Barent	Wheelwright	1687–1693	Brooklyn	—	—	—	Bergen, *Kings County*
*Smith, Carman	Chairmaker	1826	Huntington	—	—	Advertisement, *The Portico,* July 20, 1826	HHS
Smith, Cornelius	Carpenter	1711–1722	Huntington	—	—	Henry Lloyd I AB	LIHS
Smith, Crawford	Turner	1830	Brooklyn	—	—	Nichols, *BD*	—
*Smith, Daniel	Carpenter	1769–1814	Brookhaven	—	—	Will of Charles J. Smith, 1769 Abraham Woodhull AB Brookhaven tax list, 1775 Land indenture, 1795 Daniel Smith AB	*N.Y. Wills,* SCSC EHFL EHFL Deed Liber C, SCCO Lawrence Collection, SmPL
Smith, Ebenezer	Cooper	1709	Jamaica	—	—	Land indenture, 1709	JTR
Smith, Edwin	Carpenter	1822–1830	Brooklyn	—	—	Spooner, *BD,* 1822–1826, 1829 Nichols, *BD,* 1830	— —
Smith, Eliphalet	Carpenter	1813	Smithtown	—	—	Estimate of property, 1813	SmTR
Smith, Ephraim	Carpenter	1825–1830	Brooklyn	—	—	Spooner, *BD,* 1825–1826, 1829 Nichols, *BD,* 1830	— —
Smith, Gabriel	Carpenter	1788	Newtown	—	—	Will	QCSC
Smith, Hassel	Carpenter	1796–1802	Brooklyn	—	—	Buell, *NYBD,* 1796 Longworth, *NYCD,* 1802	— —

Name	Occupation	Date	Location	Birthplace	Age	Document	Source
Smith, Jacob	Carpenter	1825–1829	Brooklyn	—	—	Spooner, *BD*, 1825, 1829	—
Smith, James	Carpenter	1813–1819	Smithtown	—	—	Estimate of property, 1813 Assessment roll, 1819	SmTR Lawrence Collection, SmPL
Smith, John	Japanner	1829	Brooklyn	—	—	Spooner, *BD*	—
Smith, John B.	Carpenter	1829–1830	Brooklyn	—	—	Spooner, *BD*, 1829 Nichols, *BD, 1830*	— —
Smith, John George	Carpenter	1760	Kings County	Germany	24	Muster roll, 1760	NYHS *Collections*, 1891
Smith, Nathaniel	Carpenter	1743	Islip	—	—	Land indenture, 1743	SCHS
Smith, Nicolas	Carpenter	1690	Huntington	—	—	Land indenture, 1690	HTR
Smith, Noah	Wheelwright	d. ca. 1785	Jamaica	—	—	Will	NYHS *Abstracts*, XIII
Smith, Rowland	Carpenter	1759	Hempstead	Hempstead, New York	19	Muster roll, 1759	NYHS *Collections*, 1891
Smith, Samuel	Carpenter	1803–1819	Smithtown	—	—	Inventory, estate of Samuel Hallock, 1803 Estimate of property, 1813 Assessment roll, 1819	SCSC SmTR Lawrence Collection, SmPL
Smith, Thomas	Carpenter	d. 1685	Brookhaven	—	—	Inventory	*Court of Sessions*, SCCO
* Smith, Thomas	Carpenter/ Joiner	1711–1730	Huntington	—	—	Henry Lloyd I AB Town account, 1730	LIHS HTR
Smith, Titus	Carpenter	d. ca. 1813	Huntington	—	—	Estate information sheet	SCSC
Smith, William	Cabinetmaker	1805	Huntington	—	—	Land indenture, 1805	Deed Liber C, SCCO
Smith, William	Carpenter	1803–1819	Smithtown	—	—	Inventory, estate of Samuel Hallock, 1803 Estimate of property, 1813 Assessment roll, 1819	SCSC SmTR Lawrence Collection, SmPL
Smith, William C.	Carpenter	1822–1830	Brooklyn	—	—	Spooner, *BD*, 1822–1826, 1829 Nichols, *BD*, 1830	— —
* Smith, William V.	Chairmaker	1826	Brooklyn	—	—	Spooner, *BD* Advertisement, *Long Island Star*, Aug. 10, 1826	— LIHS
* Sniffen, Peter	Carpenter/ Joiner	d. 1785	Oyster Bay	—	—	Inventory	QCSC
Snow, Caleb	Carpenter	1825–1826	Brooklyn	—	—	Spooner, *BD*	—
Somendyke, Nicholas	Carpenter	1796	Brooklyn	—	—	Buell, *NYBD*	—
Sommers, Joseph	Joiner	1761	Southold	Southold	17	Muster roll, 1761	NYHS *Collections*, 1891
Soper, William	Carpenter	1778	Huntington	—	60	Loyalty oath list, 1778	HTR
Southland, Barnard	Carpenter	1761	Kings County	Germany	37	Muster roll, 1761	NYHS *Collections*, 1891
Spalding, William	Carpenter	1829	Brooklyn	—	—	Spooner, *BD*	—
Spear, Samuel	Carpenter	1825	Brooklyn	—	—	Spooner, *BD*	—
Spinning, John	Carpenter	1822	Brooklyn	—	—	Spooner, *BD*	—

Name	Occupation	Date	Location	Birthplace	Age	Document	Source
Springer, Henry	Carpenter	before 1745	Oyster Bay/ Westchester County, New York	—	—	Land indenture, 1745	OBTR
Springer, James	Carpenter	1713–1727	Oyster Bay	—	—	Land indentures, 1713, 1714, 1715, 1719, 1723, 1727	OBTR
*Squam, Jonas	Cabinetmaker	1773	Sag Harbor	—	—	—	SPLIA Newsletter, June, 1959
Stanley, David	Carpenter	1830	Brooklyn	—	—	Nichols, *BD*	—
*Stansbury, Isaac	Carpenter/ Joiner	1823	Flushing	—	—	John Stansbury AB	LIHS
*Stansbury, John	Carpenter/ Joiner	1809–1823	Flushing	—	—	John Stansbury AB Joseph Lawrence Farming and Household AB	LIHS LIHS
Stansbury, John	Carpenter	1826	Brooklyn	—	—	Spooner, *BD*	—
Stanton, Benjamin	Carpenter	1753	Oyster Bay	—	—	Land indenture, 1753	OBTR
Stead, William	Carpenter	1734	Jamaica	—	—	Land indenture, 1734	JTR
Stephenson, William	Carpenter	1822–1823	Brooklyn	—	—	Spooner, *BD*	—
Stewart, John	Cooper	1695	Jamaica	—	—	Land indenture, 1695	JTR
Stewart, John	Carpenter/ Joiner	1822–1830	Brooklyn	—	—	Spooner, *BD*, 1822–1823, 1829 Nichols, *BD*, 1830	— —
Stillwell, Daniel	Carpenter	1829	Brooklyn	—	—	Spooner, *BD*	—
Stillwell, John	Carpenter	1823–1830	Brooklyn	—	—	Spooner, *BD*, 1822, 1825–1826, 1829 Nichols, *BD*, 1830	— —
Stillwell, Laban	Carpenter	1829–1830	Brooklyn	—	—	Spooner, *BD*, 1829 Nichols, *BD*, 1830	— —
Stoddard, Walter	Carpenter	1822–1830	Brooklyn	—	—	Spooner, *BD*, 1822, 1825–1826, 1829 Nichols, *BD*, 1830	— —
*Stoddard, William	Joiner	1752–d. ca. 1758	Oyster Bay	—	—	Land indenture, 1752 Will	OBTR NYHS *Abstracts*, V
Stoofhoff, William	Carpenter	1826	Brooklyn	—	—	Spooner, BD	—
Story, Joseph	Shop joiner	1760	Suffolk County	Norwich, Connecticut	24	Muster roll, 1760	NYHS *Collections*, 1891
Stratton, Abraham	Joiner	d. ca. 1763	Southampton	—	—	Will	NYHS *Abstracts*, VI
Stretton, Cornelius	Carpenter	1703	East Hampton	—	—	Record of work, 1703	EHTR
Stringham, John	Carpenter	1822–1826	Brooklyn	—	—	Spooner, *BD*, 1822, 1825–1826	—
Strong, John	Joiner	1768	Southampton	—	—	Land indenture, 1768	Deed Liber C, SCCO
Stroup, George	Carpenter	1829	Brooklyn	—	—	Spooner, *BD*	—
Stroup, Uriah	Carpenter	1826–1829	Brooklyn	—	—	Spooner, *BD*, 1826, 1829	—
Suagdon, William	Carpenter	1756	Hempstead	—	—	Mortgage record, 1756	QbPL

Name	Occupation	Date	Location	Birthplace	Age	Document	Source
Suydam, Reneer	Carpenter	1769	Brooklyn	—	—	Will of William Boerum, 1769	NYHS *Abstracts,* VII
Sweezer, John	Carpenter	1826	Brooklyn	—	—	Spooner, *BD*	—
*Sweezey, John	Carpenter/ Joiner	d. 1814	Brookhaven	—	—	Inventory	SCSC
*Swezey, Christopher	Carpenter/ Joiner/ Miller	d. 1798	Brookhaven	—	—	Inventory Estate information sheet	SCSC SCSC
Swift, _____	Cabinetmaker	1822	Brooklyn	—	—	Spooner, *BD*	—
Swift, Lemuel	Carpenter	1824–1826	Brooklyn	—	—	Spooner, *BD*	—
Swift, Mott	Carpenter	1826	Brooklyn	—	—	Spooner, *BD*	—
*Tabor, Amon, Sr.	Carpenter/ Joiner	b. 1706– d. 1786	Southold	—	—	Land indenture, 1752 Will of Benjamin Brown, 1774 — —	ShdTR *N.Y. Wills,* SCSC Wright, *Taber Descendants* Griffin, *Journal*
Tabor, Amon, Jr.	Carpenter	b. 1745–d. ca. 1828	Southold	—	—	Will of Benjamin Brown, 1774 Will of Samuel Youngs, 1777 —	N.Y. *Wills,* SCSC N.Y. *Wills,* SCSC Wright, *Taber Descendants*
Tabor, Cornelius	Carpenter	1829	Sag Harbor	—	—	Pardon T. Tabor AB	QbPL
*Tabor, Pardon T.	Carpenter/ Joiner	b. 1789– d. 1842	Sag Harbor	—	—	Pardon T. Tabor AB —	QbPL Wright, *Taber Descendants*
*Talmage, Simus	[Carpenter?]	d. 1723	East Hampton	—	—	Inventory	QCHDC
Tayler, Samuel	Joiner	1761	East Hampton	East Hampton	19	Muster roll, 1761	NYHS *Collections,* 1891
Tayler, Thomas	Carpenter	1822–1826	Brooklyn	—	—	Spooner, *BD*	—
Taylor, John	Carpenter	1826–1830	Brooklyn	—	—	Spooner, *BD,* 1826, 1829 Nichols, *BD,* 1830	— —
*Teebone, Gabriel	Joiner	1702–1703	Jamaica	—	—	Woolsey family AB	Hillhouse Collection, Yale
Teneyck, Josias	Carpenter	1830	Brooklyn	—	—	Nichols, *BD*	—
Teunissen, Jan	Carpenter	1680–1685	Flatbush	—	—	Subscription list, 1680 Land indenture, 1685	FbTR FbTR
Thaustrey, Isaac	Carpenter	1818	Flushing	—	—	Leonard Lawrence DB	NYHS
Theunisz, Denys	Master carpenter	1680–1682	Flatbush/ New Utrecht	—	—	Land indentures, 1680, 1681 Statement of debt, 1682	FbTR NUTR
Thomas, Thomas	Carpenter	1822–1825	Brooklyn	—	—	Spooner, *BD*	—
Thompson, Archibald	Cabinetmaker	1829	Brooklyn	—	—	Spooner, *BD*	—
Thompson, Elias	Carpenter	1829	Brooklyn	—	—	Spooner, *BD*	—
Thompson, James	Carpenter	1830	Brooklyn	—	—	Nichols, *BD*	—
Thompson, John	Cabinetmaker	1826	Brooklyn	—	—	Spooner, *BD*	—

Name	Occupation	Date	Location	Birthplace	Age	Document	Source
Thorn, John	Carpenter	1696–1700	Flushing/ Chesterfield, New Jersey	—	—	John Bowne AB —	NYPL Eaton, "William Thorn," *NYGBR,* 1889
*Thorn, Stephen	Carpenter/ Joiner	d. 1750	Flushing	—	—	Inventory	QCHDC
Thornicraft, Robert	Joiner	1780	Oyster Bay	—	—	Land indenture, 1780	OBTR
Thornicraft, Thomas	Cooper	1736	Oyster Bay	—	—	Land indenture, 1736	OBTR
*Thurston, Joseph	Carpenter/Joiner	d. 1688	Jamaica	—	—	Inventory	Deed Liber A, CROJ
*Tilley, David	Carpenter	1747–1755	Jamaica	—	—	Woolsey family AB	Hillhouse Collection, Yale
Tilliston, Samuel	Carpenter/ Wheelwright	1761	Smithtown	—	—	Caleb Smith AB, 1819–1844	Lawrence Collection, SmPL
Tindle, John	Carpenter	1829–1830	Brooklyn	—	—	Spooner, *BD,* 1829 Nichols, *BD,* 1830	— —
*Tinker, Nathan	Cabinetmaker	1819– d. 1849	Sag Harbor	—	—	Advertisements, *American Eagle and Suffolk County General Adver- tiser,* Feb. 6, 1819; *The Corrector,* Aug. 3, 1822– April 21, 1849	EHFL
Titus, James	Carpenter	1758	Queens County	Queens County	35	Muster roll, 1758	NYHS *Collections,* 1891
Tooker, Abijah	Carpenter	d. ca. 1751	Brookhaven	—	—	Letters of administration	QCHDC
Tookes, John	Carpenter	1679	Brookhaven	—	—	Agreement, 1679	BhTR
Toomy, William	Joiner	1759–1760	Queens County	Ireland	26 (in 1760)	Muster roll, 1759, 1760	NYHS *Collections,* 1891
Topper, John	Carpenter	1826	Brooklyn	—	—	Spooner, *BD*	—
Townsend, Daniel	Carpenter	1723–1732	Oyster Bay/ Westchester County, New York	—	—	Land indentures, 1723, 1725, 1726, 1730, 1732	OBTR
Townsend, Henry	Millwright	1661	Oyster Bay	—	—	Agreement, 1661	OBTR
*Townsend, Henry	Joiner	1729–1771	Oyster Bay	—	—	Land indentures, 1729, 1730, 1731, 1734, 1746, 1763 Record of mortgage, 1758 Samuel Townsend AB Letter, Henry Townsend to "Brother Larance," Feb. 1, 1771	OBTR QbPL EHFL Lawrence Scrap- book, EHFL
Townsend, John	Carpenter	1694	Oyster Bay	—	—	Land indenture, 1694	Deed Liber A, SCCO
Townsend, John	Cooper	1737	Oyster Bay	—	—	Land indenture, 1737	OBTR
Townsend, John	Carpenter	1723–1751	Oyster Bay	—	—	Land indentures, 1723, 1746, 1747, 1750, 1751	OBTR
Townsend, Nathaniel	Carpenter	1723	Oyster Bay	—	—	Land indenture, 1723	OBTR
*Townsend, Nicholas	Joiner/ Turner	1769–1776	Jamaica	—	—	Record of vendue, 1776 Records of charges Joseph Lawrence AB	QbPL QbPL LIHS

Name	Occupation	Date	Location	Birthplace	Age	Document	Source
*Travally, Thomas	Cooper	d. 1687	Southampton	—	—	Inventory	*Court of Sessions,* SCCO
Tredwell, Timothy	Carpenter	1735	Hempstead	—	—	Land indenture, 1735	Deed Liber B, SCCO
*Trim, Christopher	Carpenter	d. 1797	Huntington	—	—	Inventory	SCSC
Tucker, Peter	Carpenter	1758	Queens County	England	30	Muster roll, 1758	NYHS *Collections,* 1891
Tuenes, Jan	Carpenter	1680	Flatbush	—	—	Subscription list, 1680	FbTR
Tully, Nicholas	Carpenter	1822	Brooklyn	—	—	Spooner, *BD*	—
Turner, Daniel	Carpenter	1716	Brookhaven	—	—	Agreement, 1716	BhTR
Tusteene, Thomas	Carpenter	b. 1680– d. 1736	Southold	—	—	Land indenture, 1711 —	ShdTR Moore, Index
Tuttle, Barzillai	Carpenter	1796	Brooklyn	—	—	Buell, *NYBD*	—
Tuttle, Joseph	Carpenter	1824–1830	Brooklyn	—	—	Spooner, *BD,* 1824–1826, 1829 Nichols, *BD,* 1830	— —
*Tymmer, Klas	Carpenter/ Joiner	1663	Flatbush	—	—	Town account, 1663	FbTR
Underhill, Benjamin	Carpenter	1732	Hempstead	—	—	Land indenture, 1732	NSHTR
Underhill, Daniel	Carpenter	1752–1793	Oyster Bay	—	—	Land indenture, 1752 Robert Townsend AB	OBTR EHFL
*Underhill, Samuel	Cabinetmaker	1810	Brooklyn	—	—	Advertisement, *Long Island Star,* April 5, 1810	LIHS
Vail, Samuel	Carpenter	1822–1830	Brooklyn	—	—	Spooner, *BD,* 1822–1826, 1829 Nichols, *BD,* 1830	— —
*Vail, Thomas	Carpenter	b. 1734– d. 1801	Southold	—	—	Inventory Notice of vendue, *Suffolk County Herald,* Sept. 4, 1802 —	SCSC EHFL Vail, *Vail Family*
Valentine, Absolom	Carpenter	1829–1830	Brooklyn	—	—	Spooner, *BD,* 1829 Nichols, *BD,* 1830	— —
Valentine, George	Carpenter	1825–1830	Brooklyn	—	—	Spooner, *BD,* 1825–1826, 1829 Nichols, *BD,* 1830	— —
Valentine, Israel	Carpenter/ Wheelwright	1820–1842	Huntington	—	—	Whitney family AB	HTHO
Van Cott, Garrit	Carpenter	1826	Oyster Bay	—	—	Inventory	NCHM
Vandenmark, Henk	Carpenter	1759	Queens County	Kingston, New York	44	Muster roll, 1759	NYHS *Collections,* 1891
Van der Gouw, Gilles	Carpenter	1639	Flatlands	—	—	—	Bergen, *Kings County*
Vandervoort, Paul	Carpenter	d. ca. 1782	Bushwick	—	—	Will	NYHS *Abstracts,* X
Van Dine, Denyse	Carpenter	1822–1830	Brooklyn	—	—	Spooner, *BD,* 1822, 1824– 1826 Nichols, *BD,* 1830	— —
Van Driest, Jan	Carpenter	d. before 1697	Flatlands/ Gravesend	—	—	—	Bergen, *Kings, County*
*Van Dwyn, Garret	Carpenter/ Wheelwright	d. 1706	New Utrecht	—	—	Inventory	NYHS

Name	Occupation	Date	Location	Birthplace	Age	Document	Source
Van Dyckhuysen, Jan	Carpenter	1646 – d. ca. 1702	Brooklyn/ Flatlands	—	—	—	Bergen, *Kings County*
*Van Ekelen, Albert	Turner	1684	Flatbush	—	—	Apprenticeship indenture, 1684, apprentice	FbTR
						—	Bergen, *Kings County*
Van Fleet, Samuel	Carpenter	1826	Brooklyn	—	—	Spooner, *BD*	—
Van Hoochten, Frans	Carpenter	1662	Flatlands	—	—	—	Bergen, *Kings County*
Van Hoose, Martis	Carpenter	1760	Kings County	Holland	36	Muster roll, 1760	NYHS *Collections,* 1891
*Van Nostrand, Aaron, Sr.	Turner/ Joiner	1693 – d. ca. 1751	Flatbush/ Hempstead	Albany, New York	—	—	Stoutenburgh, *Dutch Reformed Church*
						Will	NYHS *Abstracts,* IV
*Van Nostrand, Aaron, Jr.	Turner	d. ca. 1764	Jamaica	Flatbush	—	Land indenture, 1764	Deed Liber D, QCCO
						—	Stoutenburgh, *Dutch Reformed Church*
*Van Nostrand, Anthony	Carpenter/ Joiner	d. 1802	Oyster Bay	—	—	Inventory	QCSC
Van Nostrand, David	Carpenter	d. 1796	North Hempstead	—	—	Inventory	QCSC
*Van Nostrand, Isaac	Carpenter/ Wheelwright	d. 1829	Flushing	—	—	Inventory	QCSC
Van Nostrand, John	Turner	d. ca. 1753	Hempstead	Flatbush	—	—	Stoutenburgh, *Dutch Reformed Church*
Van Nostrand, John	Carpenter	1820	Jamaica	—	—	Inventory, estate of David Lamberson, 1820	QCSC
*Van Nostrand, Joseph	Carpenter/ Joiner	b. 1806 – d. 1851	Brooklyn	—	—	—	Stoutenburgh, *Dutch Reformed Church*
						Advertisements, *Long Island Star,* Aug. 10, 1826, Oct. 19, 1826, June 21, 1827	LIHS
						Spooner, *BD,* 1826	—
*Van Nuyse, Jan Auckes	Carpenter/ Joiner	1615 – 1710	Flatbush/ Jamaica	Amsterdam	—	—	Bergen, *Kings County*
						Agreement, 1678	FbTR
Van Pelt, John	Carpenter	1759	Kings County	Brunswick, New Jersey	25	Muster roll, 1759	NYHS *Collections,* 1891
Van Sickle, John	Carpenter	1829 – 1830	Brooklyn	—	—	Spooner, *BD,* 1829 Nichols, *BD,* 1830	— —
*Van Sindern, Ulfranus	Carpenter/ Joiner	d. 1804	Flatlands	—	—	Inventory	KCSC
Van Wickelen, Evert	Carpenter	1664 – 1687	Flatbush	—	—	—	Bergen, *Kings County*
*Van Wyck, Samuel	Carpenter/ Joiner/ Wheelwright	d. 1831	North Hempstead	—	—	Inventory	QCSC

Name	Occupation	Date	Location	Birthplace	Age	Document	Source
Van Wyck, Theodorus	Carpenter	1705	Hempstead	—	—	Will of John Wilkins, 1705	NYHS *Abstracts*, I
Veeder, Nicholas	Joiner	1826	Brooklyn	—	—	Spooner, *BD*	—
Velser, William	Carpenter	1819–1825	Smithtown	—	—	Caleb Smith AB, 1819–1844	Lawrence Collection, SmPL
Veteto, John	Joiner	1761	Oyster Bay	Oyster Bay	22	Muster roll, 1761	NYHS *Collections*, 1891
Villelo, John	Joiner	1758	Queens County	Queens County	19	Muster roll, 1758	NYHS *Collections*, 1891
Voorhees, John	Carpenter	1782	Flatlands	—	—	Will of Robert Voorhees, 1782	NYHS *Abstracts*, IX
Voorhees, Ruby	Carpenter	1760	Queens County	New Jersey	17	Muster roll, 1760	NYHS *Collections*, 1891
Wainwright, Thomas	Carpenter	1822–1823	Brooklyn	—	—	Spooner, *BD*	—
Wainwright, William	Carpenter	1826	Brooklyn	—	—	Spooner, *BD*	—
Wakeman, William	Carpenter	1824–1826	Brooklyn	—	—	Spooner, *BD*	—
*Waldron, I.	Joiner	1759	Queens County	—	—	Probate records, estate of Jacobus Lott, 1759	LIHS
Waldron, Johanes	Turner	1774	Flatbush	—	—	Will of Peter Leffertse, 1774	NYHS *Abstracts*, XI
Walton, John F.	Master joiner	1823–1830	Brooklyn	—	—	Spooner, *BD,* 1823–1825 Nichols, *BD,* 1830	— —
Walton, William	Carpenter	1822–1823	Brooklyn	—	—	Spooner, *BD*	—
Wansaer, Antony	Cooper	1684	Flatbush	—	—	Land indenture, 1684	FbTR
Ward, Barnabas	Chairmaker	1796	Brooklyn	—	—	Buell, *NYBD*	—
*Ward, John	Carpenter/ Joiner	1682	Brookhaven	—	—	Agreement, 1682	BhTR
Ward, William	Carpenter	1762	Suffolk County	Suffolk County	17	Muster roll, 1762	NYHS *Collections*, 1891
*Wareing, Michael	Carpenter/ Joiner	1711–1712	Huntington	—	—	Henry Lloyd I AB	LIHS
*Warner,	Joiner	1801	Brooklyn	—	—	Advertisement, *Long Island Courier,* Nov. 18, 1801	LIHS
Warner, James	Carpenter	1829–1830	Brooklyn	—	—	Spooner, *BD,* 1829 Nichols, *BD,* 1830	— —
Warren, Elisha	Carpenter	1824–1825	Brooklyn	—	—	Spooner, *BD*	—
Warren, John	Carpenter	1824	Brooklyn	—	—	Spooner, *BD*	—
Waterman, James	Carpenter	1825	Brooklyn	—	—	Spooner, *BD*	—
Waters, David	Joiner	d. ca. 1733	Jamaica	—	—	Will	NYHS *Abstracts*, III
Waters, Henry	Carpenter	1824	Brooklyn	—	—	Spooner, *BD*	—
Waters, Samuel	Carpenter	1829–1830	Brooklyn	—	—	Spooner, *BD,* 1829 Nichols, *BD,* 1830	— —
Waters, William	Cooper	1748–1750	Oyster Bay	—	—	Land indentures, 1748, 1750	OBTR
Watson, John	Cabinetmaker/ Carpenter	1823–1824	Brooklyn	—	—	Spooner, *BD*	—
Watson, Luke	Carpenter	1663	Jamaica	—	—	Agreement, 1663	JTR

Name	Occupation	Date	Location	Birthplace	Age	Document	Source
Watts, Henry	Carpenter	1826	Brooklyn	—	—	Spooner, *BD*	—
Watts, Samuel	Builder	1822–1826	Brooklyn	—	—	Spooner, *BD, 1822, 1824, 1826*	—
*Weaber, William	Joiner/ Nurseryman	d. 1806	Flushing	—	—	Inventory	QCSC
Weaver, William	Carpenter	1822–1824	Brooklyn	—	—	Spooner, *BD*	—
Webb, Daniel	Carpenter	1829–1830	Brooklyn	—	—	Spooner, *BD, 1829* Nichols, *BD, 1830*	—
Webb, Ebenezer	Carpenter	1829–1830	Brooklyn	—	—	Spooner, *BD, 1829* Nichols, *BD, 1830*	— —
Webb, George	Carpenter	1826	Brooklyn	—	—	Spooner, *BD*	—
Webb, Henry	Carpenter	1824	Brooklyn	—	—	Spooner, *BD*	—
Webb, William	Carpenter	1778	Southold	—	—	Suffolk County inhabitants, 1778	*NYGBR,* 1973
Webster, Moses	Carpenter	1759	Queens County	Oxford, [England?]	26	Muster roll, 1759	NYHS *Collections,* 1891
Weeden, Thomas	Carpenter	1730–1738	Oyster Bay/ Westchester County, New York	—	—	Land indentures, 1730, 1738	OBTR
*Weekes, Henry	Carpenter	1700– d. 1744	Oyster Bay	—	—	Land indentures, 1700, 1713, 1716, 1718 Inventory	OBTR Deed Liber C, CROJ
Weekes, Jesse	Turner	1778	Huntington	—	33	Loyalty oath list, 1778	HTR
Weekes, Silas	Carpenter	1747–1751	Oyster Bay	—	—	Land indentures, 1747, 1751	OBTR
*Weeks, Daniel	Carpenter	1697	Oyster Bay	—	—	Inventory, estate of John Newman, 1697	QCHDC
Weeks, Daniel	Cooper	1758	Oyster Bay	—	—	Land indenture, 1758	OBTR
Weeks, David	Cooper	1753	Oyster Bay	—	—	Land indenture, 1753	OBTR
Weeks, Jacob	Cooper	1745–1760	Oyster Bay	—	—	Land indentures, 1745, 1760	OBTR
*Weeks, Joseph S.	Cabinetmaker	1829–1830	Brooklyn	—	—	Advertisement, *Long Island Star,* June 4, 1829 Spooner, *BD, 1829* Nichols, *BD, 1830*	LIHS — —
Weeks, Richard	Joiner	d. ca. 1717	Oyster Bay	—	—	Will	Deed Liber C, CROJ
*Weeks, Samuel	Chairmaker	1789–1827	Oyster Bay	—	—	Robert Townsend DB Robert F. Underhill AB Assessment list, 1789	EHFL SPLIA EHFL
Weeks, Solomon	Cooper	1748–1758	Oyster Bay	—	—	Land indentures, 1748, 1750, 1758	OBTR
Weeks, Webb	Carpenter	1793	Oyster Bay	—	—	Robert Townsend DB	EHFL
Welch, Lawrence	Moulder	1829	Brooklyn	—	—	Spooner, *BD*	—
Welling, Charles	Carpenter	d. 1734	Jamaica	—	—	Inventory	QCHDC
Welling, John C.	Cabinetmaker	1830	Brooklyn	—	—	Nichols, *BD*	—
Welling and Brown	Cabinetmakers	1830	Brooklyn	—	—	Nichols, *BD*	—
*Wells, Daniel, Jr.	Carpenter	1810	Riverhead	—	—	Town account, 1810	RTR

Name	Occupation	Date	Location	Birthplace	Age	Document	Source
*Wells, Elisha	Carpenter	b. 1766– d. 1849	Aquebogue	—	—	Elisha Wells AB	SCHS
Wells, Jeremiah	Shop joiner/ Builder	1822–1830	Brooklyn	—	—	Spooner, *BD,* 1822–1826, 1829 Nichols, *BD,* 1830	— —
*Wells, Jonathan	Carpenter	1814–1827	Southold	—	—	Samuel S. Vail AB	NYHS
Wells, Joshua	Carpenter	b. 1664– d. 1736	Southold	—	—	— ShdTR, Ed. note	Moore, *Index*
*Wells, Micah	Carpenter/ Joiner/ Cooper/ Turner	b. 1733– d. 1790	Aquebogue	—	—	Micah Wells AB	SCHS
Wells, Nathaniel	Joiner	1759	Suffolk County	Suffolk County	19	Muster roll, 1759	NYHS *Collections,* 1891
Wells, Nicoll	Carpenter	1820	Riverhead	—	—	Ackerly Book 1	SCHS
Wells, Nicoll	Joiner	1822–1830	Brooklyn	—	—	Spooner, *BD,* 1822–1826, 1829 Nichols, *BD,* 1830	— —
Wells, Obediah	Carpenter	1808–1811	Riverhead	—	—	Bail slip, 1808 Ackerly Book 1	SCCO SCHS
Wells, Parshall	Shop joiner/ Carpenter	1822–1830	Brooklyn	—	—	Spooner, *BD,* 1822–1826, 1829 Nichols, *BD,* 1830	— —
Wessels, Richard	Carpenter	1830	Brooklyn	—	—	Nichols, *BD*	—
*Weston, Valentine W.	Cabinetmaker	1816	Brooklyn	—	—	Advertisement, *Long Island Star,* June 12, 1816	LIHS
Whaley, James	Carpenter	1825–1826	Brooklyn	—	—	Spooner, *BD*	—
*Whaley, Thomas	Carpenter/ Joiner	d. 1821	Queens County	—	—	Inventory	QCSC
Whedon, Jared	Joiner	1759	Suffolk County	Branford, Connect-icut	21	Muster roll, 1759	NYHS *Collections,* 1891
Wheelar, Melancton	Carpenter	1822	Smithtown	—	—	Elias Smith AB, 1818	Lawrence Collection, SmPL
*Wheeler, Ebenezer	Carpenter/ Joiner	1810–1819	Smithtown	—	—	Caleb Smith AB	SmHS
Wheeler, John	Carpenter	1778–1782	Huntington	—	53 (in 1778)	Loyalty oath list, 1778 Record of work, Fort Golgotha, 1782	HTR HTR
Whimster, David	Carpenter	1826–1829	Brooklyn	—	—	Spooner, *BD,* 1826, 1829	—
*Whippo, James	Joiner	1752	Oyster Bay	—	—	Land indentures, 1752, 1753	OBTR
White, Amos	Carpenter	1826	Brooklyn	—	—	Spooner, *BD*	—
White, Carll	Carpenter	1825–1826	Brooklyn	—	—	Spooner, *BD*	—
White, Cornelius	Carpenter	1822–1830	Brooklyn	—	—	Spooner, *BD,* 1822–1826, 1829 Nichols, *BD,* 1830	— —
White. Edward	Carpenter	1682	Southampton/ Oyster Bay	—	—	Land indenture, 1682	OBTR
*White, John	Carpenter/ Joiner	d. 1662	Southampton	—	—	Will Inventory	ShTR ShTR
White, Joseph	Carpenter	1778	Huntington	—	48	Loyalty oath list, 1778	HTR

Name	Occupation	Date	Location	Birthplace	Age	Document	Source
White, Sylvanus	Carpenter	1822–1830	Brooklyn	—	—	Spooner, *BD,* 1822–1826, 1829 Nichols, *BD,* 1830	— —
Whiteher, Abraham	Shipwright	d. ca. 1690	Southold	—	—	Receipt, 1690	ShTR
Whitman, Isaic	Carpenter	1807	Huntington	—	—	Inventory, estate of Ebenezer Blackley, 1807	SCSC
Whitman, Nathaniel	Carpenter	1759	Huntington	—	—	Will of Zebulon Whitman, 1759	*N.Y. Wills,* SCSC
Whitman, Walter	Carpenter	1825–1830	Brooklyn	—	—	Spooner, *BD,* 1825–1826, 1829 Nichols, *BD,* 1830	— —
Whitney, James	Carpenter	1826	Brooklyn	—	—	Spooner, *BD*	—
Whittaker, Hiram A.	Cabinetmaker	1831	Hempstead	—	—	Advertisement, *Inquirer,* Nov. 13, 1831	NCHM
Whitteker, Jonathan	Carpenter	1731	Huntington	—	—	Town account, 1731	HTR
Whitting, John	Carpenter	1826	Brooklyn	—	—	Spooner, *BD*	—
Wick, Zeb	Carpenter	1771	Southampton	—	—	Town account, 1771	Sh *Trustees Records*
Wicks, Conklin	Carpenter	1822	Smithtown	—	—	Elias Smith AB, 1818	Lawrence Collection, SmPL
*Wickham, Isaac	Carpenter/ Joiner	1791– d. 1825	East Hampton	—	—	Jonathan Mulford AB David Hedges AB John Lyon Gardiner AB John Lyon Gardiner DB Inventory	EHFL EHFL EHFL EHFL SCSC
Wicks, David	Carpenter	d. ca. 1803	Huntington	—	—	Probate records	SCSC
Wicks, Thomas	Carpenter	d. 1670	Huntington	—	—	Inventory	*Court of Sessions,* SCCO
Wilkins, William	Joiner	1822–1824	Brooklyn	—	—	Spooner, *BD*	—
Williams, Daniel	Carpenter	1728–d. ca. 1730	Oyster Bay	—	—	Land indenture, 1728 Will	OBTR NYHS *Abstracts,* XI
Williams, Jonas	Carpenter	1748–1785	Huntington	—	—	Land indentures, 1748, 1752 Land indenture, 1785	OBTR Deed Liber C, SCCO
Williams, Nathaniel	Carpenter	1711	Huntington	—	—	Henry Lloyd I AB	LIHS
Williams, Robert	Carpenter	1759	Hempstead	—	—	Onderdonk, *Names*	LIHS
*Williamson, David	Carpenter/ Joiner	1789– d. 1814	Southold	—	—	Franklinville Store ledger Inventory	SCHS SCSC
*Williamson, Jedediah	Carpenter/ Joiner/ Wheelwright	1788– d. 1837	Stony Brook	—	—	Jedediah Williamson AB	Museums at Stony Brook
Willis, Isaac	Carpenter	d. 1736	Suffolk County	—	—	Inventory	SCSC
Willis, Milton	Carpenter	1823–1826	Brooklyn	—	—	Spooner, *BD*	—
Willmarth, Nathan	Carpenter	1775	Huntington	—	—	Will of Peter Colyer, 1775	NYHS *Abstracts,* X
*Willmott, Alexander	Joiner	1697–d. ca. 1721	New Haven, Connecticut/ Southampton	—	—	Land indenture, 1697 Town account, 1698, 1699 Will	ShTR EHTR NYHS *Abstracts,* II

Name	Occupation	Date	Location	Birthplace	Age	Document	Source
Wilson, James	Carpenter	1822–1824	Brooklyn	—	—	Spooner, *BD,* 1822, 1824	—
Wilson, William	Joiner	1682	Oyster Bay	—	—	Land indenture, 1682	OBTR
*Wind, Samuel	Carpenter	1675	Southold	—	—	Record of debt, estate of Joseph Youngs, 1675	*Court of Sessions,* SCCO
Wood, John	Carpenter	1706–1722	Oyster Bay	—	—	Land indentures, 1706, 1719, 1721, 1722	OBTR
Wood, Richard	Cooper	1710	Southampton	—	—	Land indenture, 1710	Deed Liber B SCCO
Wood, Robert	Carpenter	1829–1830	Brooklyn	—	—	Spooner, *BD,* 1829 Nichols, *BD,* 1830	— —
Wood, Samuel	Turner	1792	Hempstead	—	—	Land indenture, 1792	NSHTR
Wood, Theopholis	Carpenter	d. ca. 1795	Smithtown	—	—	Probate records	SCSC
Wood, Thomas	Carpenter	1698	Oyster Bay	—	—	Land indenture, 1698	OBTR
Wood, William	Carpenter	1826	Brooklyn	—	—	Spooner, *BD*	—
Woodhull, Claudius	Carpenter	1825–1826	Brooklyn	—	—	Spooner, *BD*	—
*Woodhull, James	Cabinetmaker	1809	Setauket	—	—	Advertisement, *Suffolk Gazette,* July 29, 1809	EHFL
Woodruff, David	Carpenter	1760–d. ca. 1795	Southampton	Southampton	26 (in 1776)	Muster roll, 1760 Muster roll, 1776 Will	NYHS *Collections,* 1891 Mather, *Refugees* Van Buren, *S.C. Wills,* EHFL
Woodruff, Isaac	Carpenter	d. 1813	Brookhaven	—	—	Inventory	SCSC
Woodruff, John	Joiner	1774	Jamaica	—	—	Will of William Smith, 1774	NYHS *Abstracts,* VIII
*Woodward, _____	Cabinetmaker	1819	Sag Harbor	—	—	Advertisement, *American Eagle and Suffolk County General Advertiser,* Feb. 6, 1819, Aug. 7, 1819	LIHS
*Woolley, Henry	Carpenter	1770's	[Oyster Bay?]	—	—	Mott-Appleby receipts	NCHM
Worden, Ananias	Carpenter	1753	Oyster Bay	—	—	Land indenture, 1753	OBTR
*Worth, Laban	Carpenter/Joiner	1792–d. 1814	Brookhaven	—	—	Abraham Woodhull AB Inventory Newspaper clipping, May 20, 1816	EHFL SCSC Roe Family Papers, EHFL
Wortman, James	Carpenter	1823–1826	Brooklyn	—	—	Spooner, *BD,* 1823–1824, 1826	—
Wright, Edmund	Joiner	d. ca. 1750	Oyster Bay	—	—	Will	NYHS *Abstracts,* IV
Wright, Frost	Carpenter	1822–1830	Brooklyn	—	—	Spooner, *BD,* 1822–1826, 1829 Nichols, *BD,* 1830	— —
Wright, Gideon	Cooper	d. ca. 1750	Oyster Bay	—	—	Land indentures, 1750	OBTR
Wright, Gilbert	Carpenter	1771	Oyster Bay	—	—	Land indenture, 1771	OBTR
Wright, Jacob	Carpenter	1758	Queens County	Suffolk County	21	Muster roll, 1758	NYHS *Collections,* 1891
*Wright, Jesse	Carpenter/Joiner	d. 1816	Oyster Bay	—	—	Inventory Will	QCSC QCSC
Wright, Job	Carpenter	b. 1636–d. 1706	Oyster Bay	—	—	—	Perrine, *Wright Family*

Name	Occupation	Date	Location	Birthplace	Age	Document	Source
Wright, Jotham	Joiner	b. 1708– d. 1777	Oyster Bay/ Rye, New York	—	—	—	Perrine, *Wright Family*
*Wright, Stephen	Joiner	1792	Oyster Bay	—	—	Robert Townsend DB	EHFL
*Wright, William	Joiner	b. 1757– d. 1822	Oyster Bay	—	—	Record of debt, estate of Samuel Townsend, 1796 —	EHFL Perrine, *Wright Family*
*Wyckoff, Folkert	Carpenter	d. 1814	Bushwick	—	—	Inventory	KCSC
Young, Henry	Carpenter	1824–1826	Brooklyn	—	—	Spooner, *BD*	—
Young, Nathan	Carpenter	1823–1830	Brooklyn	—	—	Spooner, *BD,* 1823–1826, 1829 Nichols, *BD,* 1830	— —
Youngs, Benjamin	Carpenter	b. 1668– d. 1742	Southold	Southold	—	Land indenture, 1698 —	ShdTR Youngs, *Youngs Family*
Youngs, David	Cooper	b. 1683– d. 1716	Southold	Southold	—	—	Youngs, *Youngs Family*
*Youngs, Henry	Carpenter/ Joiner	d. 1830	Brooklyn	—	—	Inventory	KCSC
*Youngs, Joseph	Carpenter/ Joiner	b. 1756– d. 1837	Franklinville/ Eatonville, New York	Franklinville	—	—	Youngs, *Youngs Family*
Youngs, Josiah	Cooper	1700– d. 1732	Southold	Southold	—	Land indenture, 1700 —	ShdTR Youngs, *Youngs Family*
Youngs, Richard	Carpenter	b. ca. 1674– d. 1730	Oyster Bay	Oyster Bay	—	Land indentures, 1725, 1726, 1727, 1738 Land indentures, 1722, 1724 Inventory	OBTR Youngs Collection, NCHM Youngs Collection, NCHM
*Youngs, Rufus	Carpenter/ Joiner	1769– d. 1828	Riverhead	—	—	Inventory —	SCSC Youngs, *Youngs Family*
Youngs, Samuel	Carpenter	b. ca. 1640– d. 1702	Southold	Salem, Massachu- setts	—	Land indentures, 1693, 1702 —	ShdTR Youngs, *Youngs Family*
Youngs, Samuel	Wheelwright	1712	Oyster Bay	—	—	Land indenture, 1712	OBTR
*Youngs, Thomas	Carpenter	b. ca. 1645– d. 1720	Oyster Bay	—	—	—	Youngs, *Youngs Family*
Youngs, Thomas	Carpenter	1736	Oyster Bay	—	—	Land indenture, 1736	OBTR
*Youngs, Thomas	Joiner	b. 1763– d. 1838	Franklinville	Franklinville	—	Franklinville store ledger —	SCHS Youngs, *Youngs Family*
*Youngs, Waite	Joiner	b. ca. 1712– d. 1736	Southold	—	—	Inventory —	QCHDC Youngs, *Youngs Family*

B. SKETCHES OF CRAFTSMEN

Albertse, Rutgert (active ca. 1675–1698), Flatbush
In 1678, Albertse and Jan Van Nuyse agreed to build a parsonage house in Flatbush (FbTR). Portions of this agreement indicate that these carpenters possessed other woodworking skills as well. They were to finish three ground floor rooms and a hall, "all partitioned of with wainscoting and planed, (fitted and fastened in place) as is befitting." In addition, they were to provide "a bedstead and a four poster" for the parsonage.

According to biographical information in Bergen, *Kings County,* Albertse was living in Flatbush by 1675. His name appears on the town assessment roll for that year and also on the census of 1698.

Bageley, Anthony (–1746), Flushing
Bageley owned woodworking tools. The inventory of his estate (QCHDC) mentions specifically a broadax, an auger, an adze, a drawknife, two jointer planes, a plow plane, an ogee plane, a half-round plane, and a chisel.

Bailey, James (–1799), Southold
The estate information sheet (SCSC) gives Bailey's occupation as carpenter. In addition to listing a "Chest of Tools," the inventory itemizes numerous other woodworking tools. Bailey also owned at the time of his death "200 boards and 4 plank" and a "Mill frame and Timber" appraised at $40.00.

Baker, David (active ca. 1764–1773), East Hampton
Apparently, like many other craftsmen of the period, Baker was a carpenter who also made some furniture. In 1764, he entered into an agreement with the town of East Hampton to make a new wheel for the meeting house bell (EH *Trustees Records*). Separate entries dated 1773 and recorded on a loose sheet in the David Gardiner account book (EHFL) document that Baker made "a Tea Table for Bette" at a cost of £1 and a "bed post" at a cost of 3*s. 6d.*

Bartholomew, Josiah (–1688), Southampton
Identified from the inventory of his estate (Deed Liber A, SCCO) as a carpenter, Bartholomew owned the following woodworking tools: "one tenant saw, one Joyners plow/ 3 creas plains/ 2 rabbitting plains/ all with Irons/ 1 Rabit plain stock/ a broad ax/ a whip saw 1 square/a hand saw/ 1 grindstone/ one narrow ax/ a Lathing hamar/ 6 old augars a little saw." A Southampton town order of 1685 (ShTR), indicates that Bartholomew was then working as an innkeeper.

Bates, William (active ca. 1750), Oyster Bay
An entry in an Oyster Bay account book (NYHS), probably kept by Samuel Townsend, a prosperous merchant, records Bates' purchase of six brass handles and three escutcheons, thus suggesting that he made some furniture.

Bayles [Baylis], John (active ca. 1783–1803), Setauket
One can find documentation of Bayles' woodworking activities in the account book of Abraham Woodhull of Setauket (EHFL). The first entries, dated 1783 and 1784, credit Bayles for "hooping" meat casks and making a "stove without bail," undoubtedly a small foot warmer. In 1784, Bayles and his apprentice also worked on Woodhull's farm reaping and cradling oats. During the next few years, Bayles supplied Woodhull with two plows, an ox yoke, a cradle, a tub, and a "cart and wheels." Bayles probably assisted with the construction of Woodhull's new house in 1791, for entries of that date credit Bayles with shaving shingles and numerous days of work.

Bayles worked for Woodhull through 1797 performing such tasks as making a lye tub, mending a plow, and repairing a cart.

Bayles also worked for Dr. Samuel Thompson of Setauket from 1800 through 1803. As noted in Dr. Thompson's diary (NYPL), Bayles assisted with repairs and minor alterations of Thompson's house and made a "cabbin" bedstead for Thompson in 1800.

Beebe, Asa (active ca. 1759), Southold
Ebenezer (d. 1775), Nathaniel (active ca. 1749–1754), and Samuel Beebe (d. 1792) of New London, Connecticut, are all documented woodworking craftsmen. A Suffolk County militia muster roll for 1759 lists Asa Beebe, a joiner, also born in "N. London." He was probably a relative of the Connecticut family.

Beebe, Eliphalet (active ca. 1759), Southold
The Suffolk County militia muster roll for 1759 also lists Eliphalet Beebe, a joiner, born in New London. He was probably related to Asa Beebe, mentioned above, and to the Connecticut craftsmen as well.

Beedel, Abijah (–ca. 1820), Hempstead
The undated inventory of Beedel's estate (QCSC) lists numerous woodworking tools, hinges, planks, and "Spanish Brown" among his personal effects.

Bennet, Cornelius (–1784), Brooklyn
The letters of administration for Bennet's estate (NYHS *Abstracts,* XII) give his occupation as carpenter. The probate records for this estate (NYHS) include the notice of cash payment from John Chesser for a coffin and an inventory which contains one of the few specific references to ownership of a "Dutch Cubboard." Bennet also owned a chest with tools, oak shingles, oak lath, sixty-two joists, a "bilsted chest," a crosscut saw, "1 Bilsted top for a stand," and "a part of a house frame."

Bennet, George (–1796), Oyster Bay
The inventory of Bennet's estate (QCSC) lists a "lathe and carpenters tools," thus indicating that he was a craftsman. However, these tools may have been used only for repairs on his farm.

Bennet, John (–1797), Huntington
The inventory of Bennet's estate (SCSC) provides ample evidence that he was a joiner and a turner. Among his effects were six unfinished rakes, two unfinished tables, four unfinished spinning wheels, forty planes of various types, saws, gimlets, gouges, chisels, mandrils and bits, files, augers, hammers, squares, two glue pots, a workbench, and two lathes.

Bloodgood, Peppurell (–1795), Flushing
The inventory of Bloodgood's estate (QCSC) indicates that he was a carpenter capable of making simple furniture. He owned a "carpenters" workbench, chest, and tools as well as "6 boxes tools and old iron, one barell whiting, two glue pots, 2 boxes paints," and "twenty bilsted boards." The inventory lists several items in quantity—for example, seven tea canisters, two rat traps, and two mouse traps. These may have been some of the objects he made.

Bloodgood, Robert (active ca. 1812), Flushing
In 1812, Leonard Lawrence of Flushing noted in his day book (NYHS) that Bloodgood had made a coffin.

Blydenburgh, Thomas (active ca. 1794–1801), Smithtown
Blydenburgh is identified as a carpenter/joiner in three Smith-

town/Brookhaven account books (Lawrence Collection, SmPL). An unidentified blacksmith's account book, possibly that of Richard McCoon, documents Blydenburgh's purchase of hinges and locks in 1794 and 1795. According to entries in an unidentified store ledger, Blydenburgh made a "Large Table" for which he charged £2 2s. 10d. and a "Rocking Cradle" for which he charged £1 8s. Finally, there is in the Elias Smith account book, dated 1796–1817, an 1801 entry against the estate of Philetus Smith, deceased, which reads: "Cash paid Thomas Blydenburgt to making a Coffin Ten Dollars and twenty five cents."

Borroughs, John (– 1678), Newtown
The inventory of Borrough's estate (QCHDC) indicates that he was a substantial yeoman as well as a carpenter/joiner. He owned several coarse wood tools, such as axes and a crosscut saw, as well as planes, chisels, augers, gouges, files, and saws. His inventory also mentions a "new paire wheels" and "staple and hookes," the latter possibly referring to simple chest staples or hinges. In addition to his craft practice and farming activities, Burroughs served as the Newtown town clerk from 1665 to 1677 (TMN).

Briggs, Isaac (– 1814), Brookhaven
The estate information sheet (SCSC) gives Brigg's occupation as farmer, yet the inventory of his estate indicates that he made chairs and possibly other furniture. Numerous woodworking tools, paint, glue, fifty-six cedar boards, and "chair slats" were among his effects.

Brower, John J. (active ca. 1833–1838), Smithtown
Brower's purchases of materials from an unidentified Smithtown store, as noted in the store ledger (Lawrence Collection, SmPL), suggest that he was making furniture. Between 1833 and 1838, he bought screws, files, brads, chisels, sandpaper, "brass butts," brass nails, and blacking.

Brown [Browne], Daniel (active ca. 1726–1785), Southold
Brown identified himself as a carpenter in a land indenture of 1726 (ShdTR). Several years later, he sawed 500 feet of "Bords," mended a cart, and made a bedstead for John Racket of Southold, as noted in Racket's account book for 1731–1737 (NYHS).

Brown, David (active ca. 1791–1792), Suffolk County
The ledger kept by an unidentified Franklinville storekeeper (SCHS) has provided clues to several woodworking craftsmen from Long Island's north fork. Entries in this ledger suggest that Brown was a joiner since he purchased "brasses," table hinges, "handels," a lock, screws, and "scutchins" in 1791 and 1792.

Brown, Sylvanus (– 1805), Riverhead
The inventory of Brown's estate (SCSC), taken room by room, mentions the "Carpenters Shop" but does not list any woodworking tools.

Brush, Ananias, Jr. (active ca. 1772–1778), Huntington/ New Milford, Connecticut
A deed dated 1772 (Deed Liber C, SCCO) documents Brush's occupation and residence that year. He was a shop joiner then living in New Milford, Connecticut. His father was a Huntington resident. By 1778, the younger Brush was residing in Huntington as his name appears on a list of Huntington residents who took a British loyalty oath that year (HTR).

Bryant [Bryan], Jonathan (active ca. 1711–1759), Huntington
The account and waste books of Henry Lloyd I (LIHS) provide information about several Huntington craftsmen. One of these was Bryant who appears in dated entries from September, 1711, until October, 1720. At various times, Lloyd, a merchant, supplied Bryant with tools and hardware, notably a handsaw, a hammer, a file, chisels, an auger, compasses, a chest, and cupboard locks. Bryant performed general carpentry tasks for Lloyd, such as "mending ye floor." He also made furniture including "4 chairs for ye kitchen," a "close stool," several bedsteads, and a chest. On one occasion, Lloyd credited Bryant for "bottoming" a number of chairs. Two major projects which Bryant completed were the building of a pew for Lloyd in the Huntington meeting house, for which he charged £2 4s., and the making of a "Script Door," at a cost to Lloyd of £4 10s. In 1759, Bryant witnessed the will of Moses Scudder (N.Y. Wills, SCSC) and in that document he called himself a joiner.

Bulkeley, Augustus (active ca. 1825), Sag Harbor
Bulkeley was one of the many men who worked in the Sag Harbor cabinetmaking shop of Nathan Tinker. *The Corrector* of December 10, 1825 carried a notice that Tinker would be absent from Sag Harbor for a few months, but "all those who may want anything in the line of his business" could call on Augustus Bulkeley, to whom Tinker had left "the Transaction of his business."

Burtis, John (– 1823), Jamaica
The inventory of Burtis' estate (QCSC) mentions a chest of tools, whitewood, cherry wood and "lumber," paint brushes, spokes, sleigh runners, and a turning lathe.

Byram, Eliab. P. (1769–1854), Sag Harbor
The United States census for 1850 gives Byram's occupation as carpenter. Additional documentary evidence, however, and family tradition reveal that he was a skilled woodworker who operated a cabinetmaking shop in Sag Harbor and trained his two sons, Henry P. and Ephraim Byram, in woodworking.

Henry Byram began advertising his cabinetmaking business in *The Corrector* in 1829. In January, 1834, he announced in that paper that he was leaving Sag Harbor for a few weeks and that his customers could secure furniture from Eliab or Ephraim Byram. Henry, however, did not return to Sag Harbor. Eliab ran the shop and announced in *The Corrector* for July 8, 1834, that he would accept payment in money or goods. Several years later he was appointed superintendent of lumber for Suffolk County.

Byram, Ephraim (1809–1881), Sag Harbor
Byram had wide-ranging scientific interests and remarkable mechanical skills. He made musical instruments, nautical instruments, telescopes, clocks, and a planetarium. Benjamin Thompson in his *History of Long Island* called Byram "a self-taught mechanic and philosopher,—a sort of prodigy in practical science." The planetarium was an extraordinary accomplishment for the time. Audiences as far away as Harrisburg, Pennsylvania, and Washington, D.C., viewed this display and it brought Byram considerable national attention.

Byram appears in this listing, however, because his original training was in woodworking. He worked for at least a brief period of time in a family cabinetmaking shop with his father, Eliab, and his brother, Henry. According to Margaret Holsten's, "The Account Book of Ephraim Niles Byram," this craftsman was very active during the 1840's and 1850's, when he turned balusters and legs for furniture and made architectural bases, columns, and capitals.

Byram, Henry P. (1805–1866), Sag Harbor
Like his brother, Ephraim, mentioned above, Henry Byram was a fascinating and multi-talented individual who probably learned woodworking from his father, Eliab. By 1828, Henry was working independently for he advertised that year in *The Corrector* that he made coffins "at the shortest notice." A year later, he placed an advertisement in *The Corrector* describing a "new & Cheap Establishment" where, "having taken the shop formerly occupied by Eliab Byram," he intended to carry on the cabinetmaking business. He also stated that he employed "one of the first rate workmen from the city of New York." Byram ran this ad for thirty-three weeks until he adopted a new advertising format which first appeared in *The Corrector* on July 31, 1830. He used verse to describe the products of his shop, as the following example illustrates:

From sideboards of the finest cut
 to Workstands for the ladies,
And stands whereon your candles put,
 And Cradles for your babies.

Byram advertised again in 1832 and, finally, in 1834, he informed the public that he was "bringing his Cabinet making business to a close." One can find additional biographical information about Byram in an unpublished Master's thesis, entitled "The Account Book of Ephraim Niles Byram," by Margaret Holsten. The former Long Island cabinetmaker moved to the South and spent thirty years there promoting the improvement of agricultural techniques. After returning to Sag Harbor, he was injured in an experiment with a powered projectile and eventually lost his life.

Carle, John (–1819), North Hempstead
Identified as a woodworking craftsman from the inventory of his estate (KCSC), Carle possessed at the time of his death a "turning lathe and cabinett tools, . . . Wheel benches and lumbar, work benches and lumbar, sixteen spinning wheel rims," and a frame saw.

Carle, Silas (active ca. 1833–1841), Smithtown
An unidentified Smithtown store ledger (Lawrence Collection, SmPL) lists a number of purchases debited against the account of "Silas Carle & Nephew," which indicates that they were active furniture makers and, possibly, carriage makers. Between 1833 and 1841, they bought paint in a variety of colors, enormous quantities of linseed oil and "Bright Varnish," copal varnish for furniture, and glue. There is no mention of the nephew's name.

Carll, John (active ca. 1805–1842), Huntington
Carll must have operated one of the largest woodworking shops in western Suffolk County, yet there is very little evidence extant about his work except the inventory of his estate (SCSC). This document is given in part below. He may have been working at the end of the eighteenth century, but the first record of his cabinetry skills is a statement of debt against the estate of Ebenezer Blackley (SCSC), dated February 20, 1805, for a "Small Wheel," several repairs to wheels, turpentine, a pine coffin, a cherry table, a low chest, and "1 high chest in part." Carll may have found carriage- and wagon-making more lucrative than furniture-making, as the inventory suggests.

one sett blacksmith tools	$20.00
100 bushel coals	7.00
300 lb. iron	11.00
one chest tools	20.00
64 plank in the shop	16.00
20 boards	3.00
5 kegs with nails	10.00
6 window sash	.50

one lott lumbar in shop	3.00
one cut bedsted	2.00
one bed sted	5.00
one lot of planes	1.50
one cart body	3.00
one paint keg, stone jug & table	2.00
15 augors	2.50
one keg white lead	1.50
lumbar overhead in shop	2.50
one lot screws	50
lot old iron	75
old squares & rings	50
5 hand screws	62
3 work benches	7.00
400 weel	72.00
3 grindstone	2.00
sett of harness	6.00
sett of harness	7.00
lot of single harness	7.00
one lott of single harness	12.00
1 sett double harness	15.00
8 ox yokes	3.00
5 ox chains	2.50
10 old ploughs	10.00
12 pitch pine plank	3.00
9 waggon plank	4.50
4 chestnut plank	2.00
lott timber	2.50
lott of wagon timber	8.00
1500 shingles	30.00
5 drags	2.50
3 waggon frames	50
18 pine timber	2.00
lott of locust posts	10.00
lott timber	18.00
2 light waggons	35.00
2 waggon	18.00
one Red waggon	8.00
A broad wheel waggon	21.00
one thu broad wheel waggon	12.00
one thu broad wheel waggon	16.00
a five [horse?] waggon	35.00
a bread wheel waggon	12.00
ox cartt	9.00
Light top carriage	85.00
Light [Mage?] Carriage	85.00

Carpenter, John, Sr. (–ca. 1695), Jamaica
In his will proved in 1695 (Deed Liber A, CROJ), Carpenter left his "carpentry shop tools" to his sons, John, Hope, and Samuell.

Carpenter, John, Jr. (–ca. 1736), Jamaica
John Carpenter, Jr., inherited some of his father's "carpentry shop tools" and in turn left all his "Carpenters and turning tools" to his son, Nehemiah (Deed Liber C. CROJ).

Carpenter, Joseph (active ca. 1674–1678), Oyster Bay
A land indenture dated 1674 (OBTR) documents Carpenter's residence in Oyster Bay and his occupation as a carpenter. There is evidence in this craftsman's family history of the interaction between Oyster Bay and Rhode Island. According to information in Carpenter, *Carpenter Family,* Joseph's father, William, was also a woodworking craftsman who settled in Pawtuxet, Rhode Island.

Chamberlain, James (active ca. 1822), Hempstead Harbor
Chamberlain worked in partnership in the cabinetmaking business with John Iveson, but a notice in *The Long Island Farmer and Queens County Advertiser* for March 28, 1822, announced the dissolution of their partnership.

Cleaves, Joshua, Jr. (active ca. 1816), Flushing
A notation in James Hauxhurst's account book (NYPL) documents that Cleaves made "a maple short post bedstead" in exchange for a load of white oak timber in 1816.

Clement, James (active ca. 1697), Flushing
John Bowne's account book (NYPL) contains an entry, dated 1697, crediting Clement for "work done about ye meeting house" and 'for my childs cofin" and "sleys cofin." Clement is listed in the Flushing census for 1698 (*N.Y. Doc. Hist.*, I) with his wife, Sarah, and their nine children. His five sons were Thomas, Jacob, Joseph, Samuel, mentioned below, and Nathan.

Clement, Samuel (active ca. 1715–1726), Flushing
Knowledge of Clement's cabinetmaking skills derives solely from the existence of a signed high chest of drawers and a matching dressing table in the collections of the Henry Francis du Pont Winterthur Museum. The high chest bears the inscription: "This was made in ye year 1726/By me Samuel Clement of flushing/June ye" (No. 39).

A 1698 census of the inhabitants of Flushing (*N.Y. Doc. Hist.*, I) lists a Samuel Clement, the son of James Clement, mentioned above. Samuel probably learned his craft from his father. A further reference to Clement's residence in Flushing appears in a Flushing militia roll for 1715, reprinted in Henry Waller's *History of the Town of Flushing*, which lists a "Saml Clemment."

Clement, Samuel (–1799), Flushing
The relationship of this Samuel Clement to earlier woodworking Clements is not known. While the inventory of his estate (QCSC) suggests that he was a farmer, he did own "carpenter tools" valued at £1 8s.

Colles, Barry (active ca. 1809), Brooklyn
In 1809, Colles formed a partnership with Benjamin Meeker to conduct the "House Carpenters and Cabinet Making Business," as noted in the July 6 issue of the *Long Island Star*. Their shop was on Main Street "adjoining Mr. Moon's Lumber Yard." The following December, however, a statement appeared in the *Star* announcing the termination of the partnership.

Colwill, Harvey (active ca. 1759), Oyster Bay
An entry in Samuel Townsend's account book (EHFL) suggests that Colwill was a woodworking craftsman. In July, 1759, he exchanged 270 feet of boards for a pair of "Desk butt hinges" and "a parcell of Screws and uses."

Commerford, John (active ca. 1829–32), Brooklyn
Commerford advertised in the June 4, 1829 issue of the *Long Island Star* that he operated a "Chair Manufactory" at 18 Hicks Street, where he had on hand "a variety of the newest fashioned chairs, viz. Fancy and Windsor, curled maple, Grecian post, rosewood imitation of curled maple, rocking and small chairs of every description." He added that he had worked as a foreman "in one of the largest establishments in the city of New York." There is a listing for Commerford in Spooner's *Brooklyn Directory* for 1829, but an advertisement in Bigelow's *Directory* for 1832 states that another cabinetmaker, John T. Hildreth, occupied the Hicks Street shop.

Cook, Ellis (active ca. 1651–1679), Southampton
Cook, a carpenter, had apparently reached an agreement with the officers of the town of Southampton to help with the construction of a meeting house, but a town order of 1651 (ShTR) released him from his obligation. His personal property, as described in the inventory of his estate (QCHDC), included a cask of nails valued at 7£, axes, saws, augers, "other implements," and "cutting knife." His will also documents his ownership of carpenter's tools (*N.Y. Wills*, SCSC).

Cook, Nathan Topping (active ca. 1792–1822), Bridgehampton
Cook's account book (Winterthur) provides information about his activities as a carpenter, wheelwright, and furniture maker from 1792 through 1822. His familial relationship to Sullivan Cook, mentioned below, is not known, but they did work together on a number of occasions. Sullivan Cook's account book (SCHS) contains entries crediting Nathan for assistance with making furniture and coffins. The inventory of Nathan's estate (SCSC), dated 1822, shows that he was a farmer-craftsman. It is reproduced in full below.

2 sheats	2	50
Bedtick pillows & feathers	10	0
Under Bead	2	0
Winder Curtains	1	50
Looking Glass	2	0
1 Beadsted	1	50
Beading & Beading	6	50
do	6	50
1 Bedsted	3	0
Clock	20	0
2 tables	8	0
1 par of and irons	2	0
1 carpet	10	0
1 do	4	0
Draws	5	0
do	2	0
3 Dutch Wheal	6	0
1 Looking Glass	7	0
10 Chairs	4	0
Beading & Bedding	6	0
do	6	0
1 stand	1	0
Case & 3 bottles		75
2 Beadite	2	50
Candlestick	1	50
20 par of sheets	20	0
2 Barreals of poark	30	0
½ do of beef	4	0
Timber	6	0
4 Meet cart	4	50
2 Tables	1	50
Reel	1	50
Chest		50
1 par of oxen	40	0
2 cow	36	0
1 cow	17	0
1 cow	16	0
1 cow	13	0
1 tow year old	9	0
1 do	10	0
1 heifer	12	50
1 stear	9	0
2 calves	10	0

Old mar	25	0
Yong mar	60	0
Yong mar	50	0
Hay 5 tons	45	0
do 1½ tons	13	50
14 sheep	17	50
Hay 3 tons	27	0
70 Bushels of corn at 5/6	48	12
28 Bushels of rye	17	50
60 Bushels of oats	18	60
200 lb of flax	28	0
75 lb of pork ham	28	0
7½ Bushels Barley	4	68
Grain on the ground	140	0
25 bushels wheat	33	0
1 Waggon	20	0
Small waggon	30	0
Sleigh	12	0
1 ox harrow	2	50
do wooden	1	50
Hors harrow	1	0
Plow	6	0
5 Hogs	26	0
Hog Manure	27	50
Shingles	12	0
Potatoes 25 bushels	6	25
Ashes 12 tons	36	0
500 feet of boards	6	50
450 feet of oak do	5	0
3 shuvels	1	50
6 forks	4	50
3 rakes		75
2 ox chains	2	0
4 ox yoke	4	0
Harness	5	0
Axes spades chains	5	0
2 grind stones	2	0
70 posts	7	0
130 rails	8	0
2 crackles	2	50
7 saws hand	8	0
2 Broad axes	[?]	0
3 drawing knives	[?]	0
1 Adds 5 Augers	11	0
3 Jinters 2 fore plane		
2 Jack plane		
3 smooth planes	5	0
plow & mould planes	3	0
2 par of chisels 10		
sash chisels Bits		
Compases mandle	6	0
3 Gouges 6 squares		
1 bit stock 4 hammers		
4 gages 2 lines	5	0

Cook, Sullivan (active ca. 1808–1868), Bridgehampton
Cook was both a house carpenter and a furniture maker. His account book (SCHS) documents his craft practice from 1808 through the 1830's and reveals the range of woodworking activities in which he was involved.

Cook had a working relationship with Nathan Topping Cook who was probably a relative. In 1807/08, the two carpenters

reached an agreement with Jesse Woodruff to build Woodruff's house (QbPL). Several account book entries also provide evidence of occasional cooperation between Sullivan and Nathan Topping Cook. Cook also used the services of Silas Cook, Topping Rogers, David Rogers, and James Rogers for house construction.

Among the furniture forms Cook made were chairs, rocking chairs, easy chairs, foot benches, bedsteads, clock cases, chests, tables, cupboards, and desks. He also supplied wagons, sleighs, farm tools, coffins, and miscellaneous items, such as a bread shovel, for his customers. At the time of his death in 1868, Cook's estate, as described in the inventory (SCSC), was worth over four thousand dollars, but his carpenter's tools had an estimated value of only $3.00.

Cooper, Thomas (active ca. 1767), Southampton
Two entries, dated 1767, in an Elias Pelletreau account book (LIHS) reveal that Cooper was both a joiner and a carpenter. Pelletreau credited Cooper for making a bookcase, for fixing a desk, and for "3 Days with his printice Building Little house." In his will, dated 1774, Cooper identified himself as a carpenter (N.Y. Wills, SCSC).

Cooper, William (active ca. 1807–1830), Sag Harbor
There is a local tradition that Cooper was an excellent boat-builder, and, indeed, he advertised in the Suffolk Gazette for December 14, 1807, that he carried on the "boat building business . . ." and would make "on the shortest notice and most reasonable terms, Whale and Fish boats, Long Boats, Batteaux, Skiffs, etc." His day book (QbPL), however, provides evidence of other woodworking activities. In 1808, for example, he obtained 52 feet of cherry boards from George Gavit and in return made "1 Cherry Table." Other entries, dated 1809, 1811, and 1812, document carpenter's work done for Samuel Chester, Christopher Chester, and Henry P. Dering. He was still active in 1830, for a July 3 advertisement in The Corrector for that year mentioned a blacksmith's shop located "a few rods east of Mr. William Coopers shop."

A simple table which bears his brand and which he possibly made appears in this catalogue (No. 240).

Corey, Braddock (1735–1808), Sag Harbor
Typical of the rural craftsman who found it necessary to pursue several occupations, Corey combined carpentry and joinery with butchering. In fact, judging from the papers filed in connection with the probate of his estate (SCSC), animal slaughtering was a far more profitable and active vocation than woodworking. Nevertheless, apparently several years before his death, Corey helped build a house for John Hicks and he also made window sashes, a "cubbard," and six chairs. The inventory of his estate (SCSC) provides ample evidence of his later occupation as a butcher. It lists many butcher's tools as well as fifteen joiner's planes, four screw augers, thirteen chisels and gouges, four "old saws," and a "Basket of old nails."

Corwin, Mathias (active ca. 1792–1805), Riverhead
Corwin's account with a storekeeper near Riverhead, recorded in the store ledger (SCHS), identifies him as a possible furniture maker. He purchased plane irons, gimlets, handsaws, chisels, and "brasses" over a five year period from 1792 to 1797. A second document, a Riverhead town overseers account for 1805 (RTR), confirms Corwin's cabinetmaking activity. In that year, the town paid him £4 15s. "for town desk."

Covert, Tunis (–1821), Queens County
The inventory of Covert's estate (QCSC) lists woodworking tools and materials and mentions his shop, indicating that he was proba-

bly a joiner. At the time of his death, he had in his possession four troughs, a tar trough, a turning lathe, a grindstone, one oil jug and two cups, a workbench, a "Calking Iron," a set of bench planes, four small planes, two adzes, three squares, three boxes "with gimblits etc.," twelve gouges and chisels, compasses, a handsaw, a compass saw, a crosscut saw, a frame saw, three drawknives, a brace and bits, seven augers, a cooper's adze and "crowes," a frow, a "Wheel pit," quilting frames, and "All the lumber in the shop."

Cowenhoven, Johannis (active ca. 1702), Jamaica
Cowenhoven purchased ten escutcheons and ten "Drops" or William and Mary style furniture brasses from the Jamaica merchant, George Woolsey, in 1702, as noted in the Woolsey family account book (Hillhouse Collection, Yale). This evidence suggests that Cowenhoven was a furniture maker.

Crooker, Joseph (– 1829), Oyster Bay
Crooker was certainly a carpenter and could easily have made simple furniture. The inventory of his estate (QCSC) lists the following assortment of tools: four hand saws, three augers, hammers, twenty-three planes in addition to "plank groving plaines," a dozen chisels, compasses, gouges, two Compass saws, a "fine saw," files, gimlets, and gauges.

Cropsey, Valentine (– 1827), New Utrecht
The inventory of Cropsey's estate (KCSC) reveals he was an active and multi-skilled craftsman. A bedstead, a quilting frame, a new set of wagon wheels, and a "lot of spinning wheels" were among the objects he made. He owned at the time of his death pine boards, locust wood, forty feet of cherry boards, a workbench, a turning lathe, a "Javeling Machine," seven saws, eleven augers, twenty-five chisels and gouges, fifty-three planes, three drawknives, and a number of gimlets, files, and compasses.

Crossman, Abner (– 1812), Huntington
The inventory of Crossman's estate (SCSC) itemizes a number of woodworking tools and materials including a cutting box, four saws, five planes, four augers, a large adze, nine "carpenters" chisels, a "compass gouge," a brace and bits, and ten pine boards.

Culver, Gershom (– 1715), Southampton
Although Culver called himself a yeoman in his will (N.Y. Wills, SCSC), he left carpenter's and joiner's tools to his son, Jeremiah.

Culver, Gershom (active ca. 1762–1763), Southampton
It seems that Culver, continuing a family tradition, was also a woodworking craftsman. Elias Pelletreau noted in his account books (EHFL) on two occasions that Culver supplied him with teapot handles, and in a separate entry Pelletreau credited Culver for "cuting out a handel and Blacking."

Dayton, James (active ca. 1792), Setauket
Abraham Woodhull's account book (EHFL) reveals that Dayton worked for several weeks in 1792, probably on the construction of Woodhull's new house. A few entries specifically document carpentry and painting. Dayton also made a workbench, and one can assume that he, like other carpenters of the time, possessed basic cabinetry skills.

Dean, Samuel (active ca. 1733), Brookhaven
Joseph Jayne, a Brookhaven blacksmith, provided Dean with a hundred brads, a "paire of bits," hinges for a cupboard, and a

square in 1733. This transaction, noted in Jayne's account book (NYHS), suggests that Dean made furniture.

Deane, Joseph (active ca. 1723), Huntington or Oyster Bay
A 1723 entry in Henry Lloyd's account book (LIHS) credits Deane for "making a cart & a axel tree."

De Fres, ____ (active ca. 1663), Flatbush
A Flatbush town account of 1663 (FbTR) documents a payment of "board money for De Fres while he was making the seats" for the church.

De Mott, James (– 1826), Hempstead
James was probably related to John De Mott, mentioned below. The inventory of his estate (QCSC) lists a sizeable assortment of woodworking tools as follows: "5 saws, 3 planes, 2 hammers/ oil stone, 2 jointers/ Moveing plow/ 2 Chalk lines, Vice, rule, Rippers/ 7 planes dividers/ planes, square ax/ drawing knifes/ 2 squares, 2 axes/ hang chisels/ Augers, chisels, bone box gouges/ brace and bits, . . ./ ads, files, planes, gouges/ 1 lot of plains, . . ./ Ax hammer, lead sundries." The number of planes among his tools suggests that he was a joiner as well as a carpenter.

De Mott, John (– 1819), Hempstead
The inventory of De Mott's estate (QCSC) documents his ownership of farming implements, livestock, and some woodworking tools—specifically, a turning lathe and a number of planes, chisels, and augers.

Depaw, Luke (active ca. 1676–1690), Newtown
In 1676, Depaw, then a carpenter of New York City, purchased a house and lot in Newtown, as noted in a land indenture of that date (TMN). He was also a cooper and probably a joiner. The record of a court action of 1690 (TMN) includes testimony stating that Depaw had promised to repair a "Loome."

Dodge, John (active ca. 1808), [Oyster Bay?]
According to a notation on a loose receipt in the William Willets accounts (Willets Collection, NCHM), John Dodge made a coffin for William Willets in 1808.

Dolhemus, Daniel (active ca. 1692), Flatlands
One of the papers relating to the probate of the estate of Peter Hansen (QCHDC) records Hansen's debt to Dolhemus "for making a wheel," possibly a spinning wheel.

Dominy, Felix (1800–1868), East Hampton
As with the other Dominy family craftsmen, the life and work of Felix Dominy has been analyzed in depth in Charles Hummel's *With Hammer in Hand*. The son of Nathaniel V and grandson of Nathaniel IV, Felix received his training in woodworking and clockmaking from his family. He also spent about two years, from 1815 through 1817, as an apprentice in New York City, probably with a watchmaker. Felix made some furniture but is better-known today for the several tall-case clocks he made. As the Dominy's business declined in East Hampton after 1810, Felix turned to making clock gears for Elijah Simons, a Sag Harbor watchmaker. Felix's familiarity with metal work enabled him to secure the contract for covering the dome of the Montauk lighthouse with copper in 1833. The lack of craft activity for the Dominys, however, seems to have prompted his move to Babylon, Long Island, by 1835. He became keeper of the Fire Island lighthouse and in 1847 he was operating a hotel.

Although he had apparently given up his craft practice by that time, a recently-discovered letter (EHFL) suggests that he continued to to use his woodworking skills. The letter, addressed to his mother, is undated, but it was probably written from Fire Island after he became keeper of the lighthouse:

> . . . [We] are glad you will write to us or we should hardly be able to get the news from the Hook. You mentioned the vine on the shop. but how does the one on the frame look and have you any gooseberries? I have made a french bedstead & today a pair of squash squeezers & fixed the crank to wind up the weight in the LT house. I am going to make a pair of winding stairs like those in the mill for the upper story in the LT. House as the ones there are very close together & we can hardly get up. I wish I could ask father how to begin but I guess I can make something better than the old ones. . . . I expect to go to Babylon in the moring & be in East Hampton on the 27th of August in the evening—Tell Nancy to put on her spectacles and write to us. Nat said today he guesses Grandpa was at work on a wheel and uncle lewis on an old waggon, as tis a rainy day.

Dominy, Nathaniel IV (1737–1812), East Hampton
While Nathaniel IV probably learned his woodworking skills from his father, Nathaniel III, the source of his training as a clockmaker is still conjectural. He seems to have preferred clockmaking and specialized in this activity once his son, Nathaniel V, was able to assume most of the woodworking tasks in the late 1780's. Nathaniel IV, of course, also made furniture and tools and used his carpenter's skills at various times. One can find an excellent detailed analysis of Dominy's craft practice and the products of his shop in Charles Hummel's well-known *With Hammer in Hand.*

Dominy, Nathaniel V (1770–1852), East Hampton
The son of Nathaniel IV, Nathaniel Dominy V undoubtedly learned woodworking from his father. He must have been fully trained by the late 1780's. Perhaps because his father specialized in clockmaking, Nathaniel V turned primarily to cabinetmaking, general carpentry, wheelwright's work, and mill- and house-building. From 1804 to 1806 he worked on the design and construction of the "smock" or "Hook" mill, which still stands at the end of Main Street in East Hampton. The various furniture forms made by the Dominys have been examined and discussed in detail in Charles Hummel's *With Hammer in Hand.* The Dominy shop and tools have been preserved and relocated at Winterthur. The survival of these artifacts has contributed in many cases to the positive attribution of pieces to the Dominys, and in particular to Nathaniel V, the most active cabinetmaker in the family.

Dorlon, Joseph (active ca. 1830), Hempstead
Dorlon advertised his "Furniture and Looking Glass Warehouse" in the *Long Island Telegraph and General Advertiser* on May 20, 1830. He stated that he had in stock and was "constantly manufacturing Furniture and Looking Glasses of every discription,. . . ." He added that he would not extend credit but would accept payment in goods. On the following July 22, he announced in the *Telegraph* that he also repaired violins. He closed his shop sometime before June 14, 1832, when William Raynor advertised in the *Inquirer* that he was Dorlon's successor in the cabinetmaking business. Perhaps this craftsman was the same Joseph Dorlon, a carpenter, who was living in Brooklyn from 1826 through 1830, as noted in the Brooklyn directories.

Doughty, Elias (active ca. 1723), Oyster Bay
In 1723, Henry Lloyd I recorded in his waste book (LIHS) a payment of 15s. to Doughty for a spinning wheel.

Doughty, Isaac (active ca. 1770–1803), Oyster Bay
As noted in the inventory of his estate (QCSC), Doughty owned a chest of carpenter's tools, appraised at $15, and a "carpenters work bench." When he witnessed the will of Edmond Wood in 1770 (NYHS *Abstracts,* VI), Doughty identified himself as a carpenter, and in 1782, when he witnessed the will of John Van Wagenen (NYHS *Abstracts,* XI), he called himself a house carpenter.

Duryea, Edmond N. (active ca. 1824–1826), Brooklyn
The first reference to Duryea occurs in an advertisement of the cabinetmaking shop of Hunter and Duryea in the May 20, 1824 issue of the *Long Island Star.* The address given in the advertisement was 40 Fulton Street, but Spooner's *Brooklyn Directory* for 1824 places them at 46 Fulton Street. They apparently ended their partnership shortly thereafter for Duryea is listed alone in Spooner's *Directory* for 1825. His address that year was 6 Poplar Street, and the following year, 86 Fulton Street. There is no reference to Hunter in either the 1825 or 1826 *Directory.*

Eltyge, Jan (active ca. 1663), Flatbush
According to Bergen, *Kings County,* Eltyge, a carpenter, bought a farm and building lot in Flatbush in 1663. The town account for that year (FbTR) notes a debt to Eltyge for wainscoting for a seat, probably a church pew.

Feke [Feekes] [Feake], Charles (active ca. 1744–1750), Oyster Bay
Feke identified himself as a shop joiner in a land indenture of 1744 and as a joiner in a land indenture of 1750 (OBTR). An Oyster Bay merchant, probably Samuel Townsend, noted in his account book (NYHS) in 1750 that Feke had purchased nails and a half dozen dovetail hinges.

Fithian, Aaron (1774–1809), Sag Harbor
A number of saws and "carpenters tools" are noted in the inventory of Fithian's estate (SCSC). He also owned a one-half interest in the sloop *Union.*

Fithian, Lt. Enoch (1646–1727), East Hampton
An East Hampton town account for 1704 (EHTR) credits a Lieutenant Fithian "for a coffin." This was Enoch Fithian, who is identified as an East Hampton carpenter in a land indenture of 1705 (EHTR).

Fleet, Simon (–1723), Suffolk County/[Huntington?]
Although Fleet died in the West Indies, his residence was in Suffolk County, probably Huntington. The inventory of his estate (NYHS) indicates that he made furniture. Among his possessions were "a tennant saw," several jointers and planes, augers, gouges, a small saw, "7 logs of logwood," a large oval table, "part of a small table," a "joiners saw," chisels, a "turners chissel," a lathe, and "sundries of joiners [work?]."

Foot, Simson (–1734), Jamaica
The inventory of Foot's estate (QCHDC) documents Foot's ownership of a "small jointer," a "Joyners plow," a gouge, a small saw, an auger, a "tennant saw," "11 logs of logwood," and "part of a small table." It seems likely that he made some furniture.

Ford, Thomas (active ca. 1696), Flushing
Ford made a table for John Bowne in 1696, as recorded in Bowne's account book (NYPL).

Foster, Stephen, Sr. (– 1784), Southampton
In his will proved in 1784 (NYHS *Abstracts*, XII), Foster stated that he was a carpenter and left his "carpenters coopers and joiners tools" to his sons, Stephen and Jeremiah.

Garlick, Joshua Sr. (– 1677), East Hampton
In his will (*Court of Sessions*, SCCO) Garlick made the following bequest: "I doe give my tooles to my sons Joshua and John equally to bee Devided betweene them when they are capable to use them." These tools, listed in a brief inventory, were "ye Joyners Tooles 15ˢ, 4 Turning tools 4ˢ, ye Coopers Tooles 15ˢ/ the Carpenters tooles & one spade & stubing hough [£]3 16[ˢ]."

Gate, William (active ca. 1769 – 1772), Suffolk County
The account book of Philetus Smith in the Charles Embree Lawrence Collection (SmPL) contains one reference to Gate's craft activity, an undated entry noting that Gate made a bedstead for Mary Tredwell. Smith was apparently an executor of her estate.

Goldsmith, Davis (– 1817), Southold
The inventory of Goldsmith's estate (SCSC) itemizes a variety of woodworking tools, including nineteen planes (plow, molding and bench), three augers, four axes, one adze, one drawknife, four saws, eleven chisels, eight gouges, five gimlets, three squares, three guages, one pair of compasses, three files, two rules, a bevel, and a screwdriver.

Grave, John (– 1679), Newtown
The inventory of Grave's estate (QCHDC) lists a small number of woodworking tools. In addition, several references to doors and hardware for doors suggest that he was a carpenter.

Greene, Lewis F. (active ca. 1809), Setauket
On July 29, 1809, Greene and his partner, James Woodhull, advertised their "Cabinet Business," located in Setauket, in the Sag Harbor paper, the *Suffolk Gazette*. They did not describe the types of furniture they made, but they did specify that they would supply "Clock cases of any description, . . . on the shortest notice."

Griffing, Amon T. (– 1817), Bushwick
According to the inventory of Griffing's estate (KCSC), he owned "3 chests with Carpenters tools, 1 buck saw and crowbar," and a work bench at the time of his death.

Haines, Benjamin (– ca. 1714), Southampton
Haines identified himself as a wheelwright in his will proved in 1714 (NYHS *Abstracts*, II). He left his wheelwright's and joiner's tools and the timber "seasoning" for his trade to his son, David.

Hains, Deacon (active ca. 1755), Southampton
A Southampton town account for 1755 (Sh *Trustees Records*) notes a credit to Hains "for making a coffin . . . and other services."

Hall, William (active ca. 1802 – 04), Sag Harbor
One can find evidence of Hall's cabinetmaking activities in an advertisement he first placed in the *Suffolk County Herald* on September 4, 1802:

CABINET AND CHAIR MAKING
The Subscriber Respectfully informs the public, that any kind of cabinet work or Windsor Chairs, may be had of him, which he will endeavor to execute to the satisfaction of all who will favor him with their employ.

The *Suffolk Gazette* carried this same advertisement in 1804 but no notice of Hall appears after that date. Lacking further evidence, it has been impossible to determine the success or extent of his business.

Halliock, Caleb (active ca. 1790), Riverhead
Halliock's purchases from an unidentified Franklinville store, recorded in the store ledger (SCHS), suggest that he made furniture. During the 1790's, he bought "brasses," a gimlet, a handsaw, a brush, chest hinges, and a double spring lock.

Hand, William (active ca. 1831), Sag Harbor
Hand placed an advertisement in the January 8, 1831 issue of *The Corrector* requesting "immediately a boy of from 14 to 15 years of age" for the cabinetmaking business.

Harleson, Benjamin (– 1828), Brooklyn
The inventory of Harleson's estate (KCSC) lists fan sash tools, tap molds, and a turning lathe.

Harris, Stephen (– 1814), Southampton
Among the possessions described in the inventory of Harris' estate (SCSC) were joiner's tools, "wheel timber that is dressed," and wagon Timber."

Havens, Jeremiah (active ca. 1793 – 1796), Riverhead
One can state that Havens possibly made furniture on the basis of evidence contained in the ledger of an unidentified Franklinville store (SCHS). Between 1793 and 1796, Havens purchased from that store a lock, carpenter's compasses, "brasses," a rule, and gimlets.

Havens, Peter (active ca. 1799 – 1803), Shelter Island
Havens actively engaged in both carpentry and furniture-making. Among the records relating to the probate of his estate (SCSC) is a note, dated 1799, which describes two of Havens' debts, one to Ben Nicoll for 1,065 feet of timber and the other to William Albertson for 6,000 bricks. Havens was probably building a house at the time. The inventory of his estate, which provides some evidence of cabinet work, lists the following items: a tool chest, five saws, five bench planes, a broad axe, a square, a hammer, a drawknife, two chisels, four augers, sixteen "Joiners planes," a box of small tools, "1 Beaurow unfinished," a chest of drawers, "1 new pine chest," a grindstone, and a workbench.

Havens, R. E. (active ca. 1831), Sag Harbor
The cabinetmaker Nathan Tinker announced his intended "leave" from Sag Harbor "for some weeks," in the August 13, 1831 issue of *The Corrector* and he instructed customers to apply to Havens or Nathan T. Maxon, "persons in my employ."

Hedges, Ruben (active ca. 1773), East Hampton
According to an entry in David Gardiner's account book (EHFL), Hedges made a "table chare wheal and real" for Gardiner in January, 1773.

Hegeman, Elbert (– 1821), Queens County
As noted in the inventory of his estate (QCSC), Hegeman owned at

the time of his death a "lot of lumber in the work shop," carpenter's tools, a work bench, and a turning lathe.

Hess, John H. (active ca. 1826–1830), Brooklyn
On April 5, 1827, Hess announced in the *Long Island Star* that he had established a "manufactory of the various kinds of Cabinet Furniture" at the corner of Fulton and Concord Streets in Brooklyn. The previous year, according to a listing in Spooner's *Brooklyn Directory,* he occupied a residence/shop at 179 Fulton Street. He apparently moved regularly during this period for the *Directory* for 1829 gives his address as 358 Pearl Street. His name also appears in Nichols' *Brooklyn Directory* for 1830.

Hildreth, John T. (active ca. 1832), Brooklyn
Hildreth placed an advertisement in Bigelow's *Brooklyn Directory* for 1832 stating that he would continue to operate his cabinet warehouse and manufactory at 18 Hicks Street, where furniture was available at short notice and pianos were "tuned and put in order."

Homan, Mordecai (active ca. 1729–1755), East Hampton/ Southold
A 1729 East Hampton town account (EH *Trustees Records*) documents a payment to Homan for making a coffin and a "mahgeny table" for the schoolhouse.

Hooper, Bartholomew (– 1684), Southold
Recorded in one of the documents relating to the probate of Hooper's estate (QCHDC) is the statement that Hooper, a carpenter, "was drownd in the Sound out of his sloop Nightingale." A number of woodworking tools, notably four mattocks, four saws, augers, drawknives, chisels, planes, and iron and brass compasses, were a part of his estate.

In 1686, Hooper's father, a shipwright of Plymouth, England, granted his son, Thomas Hooper, also a shipwright of Plymouth, the power of attorney to collect Bartholomew's estate (ShdTR).

Hooper, George H. (active ca. 1823–24), Brooklyn
Hooper advertised his "Carving and Gilding" business in the *Long Island Star* on July 3, 1823. He advised the public that he practiced his craft "in its various branches," such as "framing glazing and varnishing looking glasses and pictures of every description." The address of his shop was 24 Fulton Street although the following year his address, as noted in Spooner's *Brooklyn Directory,* was 47 Fulton Street.

Howell, Arthur (– 1683), Southampton
The inventory of Howell's estate (*Court of Sessions,* SCCO) lists the following woodworking tools: two augers, a handsaw, ten axes, a chest with carpenter's tools, cooper's jointers, a crosscut saw, and a whip saw.

Howell, James (active ca. 1791–1809), Sag Harbor
There is no question that Howell made furniture. John Lyon Gardiner, the wealthiest individual on eastern Long Island and a regular patron of the Dominys of East Hampton, noted in his account book (EHFL) that he purchased from Howell "1 Dozen common chairs at 5/," a stand, a bedstead, and six chairs in 1791.

The inventory of Howell's estate (SCSC) itemizes numerous "Carpenters and Joiners tools," including turning chisels and "instruments." The total value of his woodworking tools was $53.96. In addition to these tools, he also had on hand "Chair backs in the Frame, Sundry articles of wheel and chair stuff, 11 small pieces

Lignum Vita, Sundry pieces of lumbar overhead in the shop and ½lb. Glue." The inventory also provides evidence of the range of woodworking activities he performed from carpentry ("426 lights of 6 by 8 and 7 by 9 of sashes") to tool-making ("6 Rake heads, unfinished").

Considering the widespread local use of cherry, it is interesting to note that all of Howell's furniture described in the inventory, with the exception of a white oak table, was made of black walnut. Two unfinished pieces of furniture in the shop, a table and a desk, were also of black walnut.

Howell left his tools to his grandson, Charles James Howell.

Howell, Jesse (active ca. 1742), Southampton
According to an entry in a Southampton town account for 1742 (Sh *Trustees Records*), Howell made a coffin that year for a Daniel Gard.

Howell, Jonathan (– ca. 1807), Southampton
In the Chauncey Perkins Howell Collection (SCHS) is a document which records the vendue or sale in 1807 of woodworking tools belonging to Jonathan Howell. Among the tools sold were a turning lathe, several chisels and planes, a jointer, a square, an auger, and a drawknife.

Howell, Walter (– 1830), Southampton
Although the estate information sheet (SCSC) identifies Howell as a farmer, the inventory specifies a work shop, two work benches, "one lot of lumbar in the shop," a set of carpenter's tools, a turning lathe, and eleven new chairs.

Iveson, John (active ca. 1822), Hempstead Harbor
On March 28, 1822, a notice of the dissolution of the cabinetmaking partnership of John Iveson and James Chamberlain appeared in *The Long Island Farmer and Queens County Advertiser.* A subsequent advertisement announced that Iveson had "removed from the dwelling house and workshop lately occupied by him near the end of the grist mill dam, to the upperpart of the village a few rods east of Joseph Starkon's Blacksmith Shop. . . ." According to this notice, Iveson had in his shop "a good stock of well-seasoned mahogany etc. suitable for his business" and he was ready to accept orders.

Jagger, Samuel (active ca. 1789–1845), Southampton
A miscellaneous paper in the library of the Southampton Colonial Society refers to Samuel Jagger's "Account Book B, 1789–1823." It is the only record of the missing book. Fortunately, it includes transcriptions of some of the accounts and provides documentation of Jagger's work as a carpenter and furniture maker.

In addition to building houses and barns, hewing timber for house frames, painting houses, making window sashes, and building wagons, Jagger made chairs, cradles, coffins, a chest with drawers, and a birch bedstead. He also sold produce, wrote deeds, and surveyed property. An entry in the account book of Elias Pelletreau, Jr. (ShCS) notes that Jagger received nails, a handsaw, handsaw files, and several augers in 1798 in exchange for "fixing [the] shingle roof" and doing "joinering work," with the help of "Oliver," probably Jagger's apprentice.

The inventory of Jagger's estate (SCSC) lists among his personal effects eighteen carpenter's planes, ten augers, a turning lathe, an adze, five saws, a crosscut saw, one "lot" of carpenter's tools, and one "old chest containing tools."

Jennings, Elias (active ca. 1789–1823), Southampton
A modern handwritten record summarizing the contents of Samuel

Jagger's "Account Book B, 1789–1823" (ShCS) includes the notation that Jennings made a coffin for Jagger's mother. No specific date is given for Jennings' work.

Jervis [Jarvis], Nicholas (active ca. 1808–1828), Smithtown
References to Jervis appear from 1808 through 1828 in several of Elias Smith's account books (Lawrence Collection, SmPL). In 1809, Jervis made a bedstead for Smith. He also repaired wagons, worked on the cider mill, and assisted Smith with the building of a new house in 1822. Since he performed almost every type of woodworking task, it is not surprising to find Jervis making a coffin for the wife of one of Smith's employees in 1825.

Johnson, William Martin (active ca. 1790–1795), East Hampton
Johnson is an enigmatic figure, known only from a secondary account. In an article entitled "Our Neglected Poets" (*United States Magazine and Democratic Review,* 1838), John Howard Payne discusses Johnson who was a poet as well as a woodworker. Payne states that Johnson came from Massachusetts to Bridgehampton in 1790 to become headmaster of a Bridgehampton school. The following year, according to Payne, Johnson was studying with a Dr. Sage of East Hampton, and "contracted to pay his board . . . with a cabinet maker, by working for him two days in the week." Payne adds that Johnson "could turn out chairs and tables and all sorts of furniture" with "readiness and finish."

Jones, John Thomas (–1828), Jamaica
The inventory of Jones' estate (QCSC) documents his ownership of a turning lathe and tools, carpenter's tools, a carpenter's chest, and a work bench.

Jones, Obadiah (active ca. 1774), East Hampton
On November 1, 1774, David Gardiner recorded in his account book (EHFL) payments to Jones for a looking glass (£6 6s.) and for "Cabnet work" (£22 18s.). Gardiner also noted that Jones bottomed six chairs.

Ketcham, Israel (active ca. 1755–1795), Huntington
A fragment of Ketcham's account book is in the Ketcham Papers (NCHM). The earliest date recorded is 1755 while the last is 1771. Pertinent entries document Ketcham's charges for making ropes and bedcords, for "puting on a pair of cradle rockers," and for making a wagon tongue. Also in the Ketcham Papers is a deed, dated 1767, identifying him as a carpenter, and a copy of his will written in 1795.

Ketcham, Nathaniel (–1810), Islip
Even in 1810, the terms carpenter and joiner were interchangeable. The estate information sheet for Ketcham's estate (SCSC) gives his occupation as carpenter, yet the inventory itemizes the tools and supplies found in his "Joiners Shop." These included five saws, one brace and bits, eight paring gouges, four sliding gouges, fourteen mortising files, eight drawer locks, five trunk locks, brass hinges and handles, a paint sieve and nine brushes, sandpaper, screws, two screw planing benches, a keg of paint, a keg of varnish, a glue kettle, maple bedstead timber, and poplar bedstead timber.

King, Joseph (–ca. 1733), Southold
In his will proved in 1733 (NYHS *Abstracts,* III), Joseph King left his joiner's tools and ship timber to his brother, Elisha.

King, Peleg C. (active ca. 1804), Southold
On July 9, 1804, King advertised his chair-making business in the

Suffolk Gazette. He stated that he made Windsor chairs and "slatbacks of all kinds" in his establishment located "at the landing of Oyster Pond Harbor."

Lamberson, John (–1826), Jamaica
The inventory of Lamberson's estate (QCSC) suggests that he was a substantial and active craftsman when he died. He had in stock the locally popular woods, cherry and bilsted, as well as mahogany. The inventory also lists a substantial number of tools and supplies as follows:

1 small Box paint	1 hand vice
2 Barrell with Sundries	1 Glue pot
1 Turning Laythe	1 Lot Squares and Compass
Tools for d⁰	1 Lott Scribes and awls
2 Nail Boxes	1 Lot gauges
Contents of three Shelves	1 Adds
1 Grind Stone	Hammer and Malletts etc.
8 saws Assorted	3 drawing knives
8 plaines Assorted	1 Led Glue pot
2 Setts Screw Cutters	1 tub and Contents
1 Oil Stone	5 Augers
7 Gouges	1 Tool Chest
1 Saw Grips	1 Cramp
1 hand vice	1 Shop Stove
1 Box Sundries	1 Lot Bottles and paint bowls
1 Sett Castors	5 axes
30 grooving and Molding plains	Nail Box and Contents
15 chisels	Box and Contents
7 plain Irons	2 Saw Benches
1 Sett Brass and Bits	2 Work benches

Lefford, William (–1808), Huntington
As noted in the inventory (SCSC), Lefford's estate included a considerable number of planes, chisels, gouges, and other tools used by a carpenter or joiner. Lefford also had window panes, plank, and timber on hand.

Long, Richard F. (active ca. 1807–1819), Huntington
A detailed inventory of Long's estate (SCSC) indicates that he was an active and skilled furniture maker. In addition to planes, chisels, saws, and other small hand tools, Long owned a turning lathe, "1 Screw Machine and Screw," one keg and glue kettle, a grindstone, and a "Screw Bench." Also in his possession were furniture brasses, cherry and mahogany boards, "1 lot veneer," "1 crest pattern and Slats," an unfinished "Bureau frame," and an unfinished candlestand frame. Eight wooden clocks in Long's shop may have been for resale.

One can find further evidence of Long's craft practice in Nathaniel Potter's day book (HHS) which documents Long's purchase of "Spanish brown" paint pigment, "whiting," and fifty brass nails in 1807.

Lowerre, John H. (–1831), Flushing
The tools and materials itemized in the inventory of Lowerre's estate (QCSC) were those of an active carpenter and furniture maker. The portion of the inventory pertinent to his craft activity is given in full below:

1 pannel gage and floor gage	[$] —.25
5 Beades planes	2.50
1 plough & Irons	6. "
Ovlo Square & Beed	1.25
1 Fancy plane & gothic plane	1.50

Item	Price
1 pr. Snipe Bills shouldering	".15
3 Rabett planes	1.25
1 philister	2. "
9 guages	".75
33 hollows & Rounds	6. "
1 pr. ¾ Match planes	1. "
1 pr. Side Rabetts	".50
2 Old fancy planes	".25
1 Adadio plane	".75
1 pr. floor planes	1. "
1 pr. d⁰ d⁰	2. "
1 Sash plane	2. "
3 Jack planes	1.50
2 fore planes & Jointer	4. "
12 Augers	2.50
1 Turning Saw and frame	".50
2 Saws	1.12
2 trying Squares 1 Bevel	1.50
1 Saw handle 2 files	.18
2 panell Saws	1.25
9 Framing Chisells	2.50
6 Furmer Chisels	1. "
3 Screw Drivers	.75
2 Spoke Shaves 2 drawing knifes	".87
9 gouges	".50
2 Smoothing planes	".25
Pinchers Vice & Wetstone	".50
2 hammers	".67
2 Adds	1.50
2 Broad axes 1 hatchett	3. "
2 Oil Stones	2.50
1 Ladder	".25
1 Lot of plane Irons	".25
2 Chalk Lines	.37
1 Brace & Bitt	3. "
1 Lot gimblets & Cork Screw	".25
1 Lot of Hinges	".12
1 Compass Saw punch Saw set	".50
2 Mallets	".19
1 Tool Chest	6. "
1 Cart Body	8. "
1 Glue Kettle	".12
1 Lot Spokes	2. "
1 Washing Machine	1. "
1 Large Chest	1.50
2 Nail Boxes	".25
14 Whitewood Boards	4. "
1 plank	".50
1 Sign	1. "
2 Work Benches	2. "
1 Wheelbarrow	1. "
1 Grind Stone & frame	1.50
5 Window Frames	1.25
1 Lot of pickett pales	6. "
3 Bows for gig tops	".50
1 Lot of Sashes	".25
1 Lot of Sash Stuff	".25
3 peices of Quilting frames	".50
2 hub Benches	1. "
2 Bench Screws	".75
2 Boxes of Glass	3. "
1 Lot of paint-Kegs	".50
1 Lot of Nails	".25
1 Lot of fire Wood	".50
1 Lot of old Stuff	1. "
1 Work Bench, 2 Saw Benches	1.12
2 Cramping Screws	".50
1 plank, ½ of it Board	".50
2 300 feet of Timber @ 2 ½ cts	57.50
Ovlo & Square Chisel Gouge	1.

McCoun, Walter (– 1822), Brooklyn

Most of McCoun's tools were those of a blacksmith or metalworker, but the inventory of his estate (KCSC) suggests that he was a woodworking craftsman as well. Among his possessions were two anvils, two bellows, "heading tools," swages, chisels, punches, a turning lathe and wheel, "lots of small tools," and a stock of iron and wood.

Mapes, Timothy (active ca. 1824–1825), Sag Harbor/ Riverhead/[Southold?]

On June 26, 1824, an announcement of an auction of "All kinds of chairs, fancy, rocking, etc.," scheduled for July 6 in Sag Harbor, appeared in *The Corrector.* The notice was signed by Timothy Mapes, "Chairmaker." On May 21, 1825, however, Mapes stated in the same paper that he was "quitting business" and therefore arranging another auction to be held near "Wm. Griffings, River-head," where chairs and "Household furniture of various kinds" would be sold.

Marshall, Joseph (– 1685), Southampton

It is clear from the inventory of Marshall's estate (*Court of Sessions,* SCCO) that he was a cooper. Barrels were much in demand in Southampton during the seventeenth and early eighteenth centuries for packing whale oil and Marshall probably serviced this market. He possessed a sufficient number of tools and materials to suggest a broad range of woodworking skills. The inventory lists a "dwelling House and Shop/ a thousand halfe of staves with som heading/ a percell of hoops with some new cask and some stuff that is wrough," a grindstone, six drawknives, two heading knives, two handsaws, three broadaxes, twelve jointer irons, "Joynters stocks and trus-hoops," and a stock of lumber in the house "with ye chayres." Also of interest is the mention of a "chest of drawers" worth 30s. Other chests in the inventory were valued at only 3s., 4s., and 5s.

Maxon, Nathan T. (active ca. 1831), Sag Harbor

A brief advertisement in the August 13, 1831 issue of *The Corrector,* placed by the local cabinetmaker Nathan Tinker, identified Maxon as an employee in his shop.

Meeker, Benjamin (active ca. 1809–1820), Brooklyn

Beginning with the July 6, 1809 issue of the *Long Island Star,* Meeker and his partner, Barry Colles, advertised their "House Carpenters and Cabinet Making Business" for twelve suceeding weeks. The short-lived partnership ended the same year. Meeker's continuing craft activity is documented in a ca. 1820 painting by Francis Guy (1760–1820), now in the Long Island Historical Society, entitled "Summer Scene, Brooklyn." This painting shows Meeker's shop with the sign, "B. Meeker/House Carpenter/Joiner." Meeker was active in Brooklyn at least through 1830, for his name appears in the Spooner *Directory* for 1822, 1824, 1825, 1826, and 1829 and the Nichols *Directory* for 1830.

Messenger, Samuel (–1816), Queens County
The inventory of Messenger's estate (QCSC) documents his owner-ship of the tools and supplies of a possible furniture maker, including paint cups and jugs, two paint stones, six workbenches, and a number of chisels, planes, handsaws, and other woodworking tools.

Miller, Josiah (–1728), Brookhaven
The inventory of Miller's estate (QCHDC) lists, in addition to "carpenter and Joyners tools," a barrel of nails, "some glasers tools," lead, and glass. He was apparently skilled at making leaded casement windows.

Moore, Samuel (active ca. 1810), Brooklyn
On March 29, 1810, Moore announced in the *Long Island Star* that he had "commenced all kinds of TURNING connected with the Carpenters business at his shop in Pearl Street."

Moore, Simon (active ca. 1740–1802), Southold
Evidence that Moore was a carpenter and possibly a joiner comes from a variety of account book sources. A Southold account book, possibly a Salmon family book (Southold Free Library), contains an entry crediting Moore for "work on the house" in 1766. Another entry in a 1740 Salmon family account book (Southold Free Library) documents Moore's purchase of lampblack, lime, and sheepskins. Moore supplied the Salmon family with a door latch, a bolt, and sixty-two feet of boards as partial payment for those purchases. Finally, Ezra L'Hommedieu noted in his account book (SCHS) in September, 1765, that Moore repaired a desk for him.

Mott, John (active ca. 1799), Brookhaven
Mott made a coffin for Thomas Avery of Brookhaven in 1799, as noted in the inventory of Avery's estate (SCSC).

Mulford, Timothy (active ca. 1754–1760), East Hampton
In a land indenture of 1754 (Deed Liber B, SCCO) Mulford identi-fied himself as a joiner. This documentation substantiates the tradi-tion that he made a slant-front desk with bracket feet owned by the East Hampton Historical Society and located in the Mulford House in East Hampton. Mulford signed the desk and it bears the date 1760.

Newman, John (–1697), Oyster Bay
In 1681, the town of Oyster Bay granted Newman a home lot and land for a yard for the "Building of vesells and [for] Layeing his timber in" (OBTR). The inventory of his estate (QCHDC) itemizes a variety of tools including turning chisels and "2 parsell of Augors and turners tools."

Oriel, James (–1815), Hempstead
The inventory of Oriel's estate (QCSC) includes a long and fascinat-ing list of tools and materials pertinent to his craft practice. He owned several "lots" of carpenter's, joiner's, and blacksmith's tools. He also had on hand at the time of his death a large supply of lumber, including eighty-seven Albany boards, "a lot of bilstill for bed-steads," and twenty-seven planks, "plained and grooved." Perhaps he operated a saw mill at one time for the inventory notes specifically "Birch pine and maple plank in old mill chamber." There is also evidence in the inventory that he made machines but the precise nature of these devices has not been determined. It is possible that the metal and woodworking items described in the inventory all relate to the manufacture of these machines.

Osborn, Septimus (–1852), East Hampton
A loose sheet of paper in the Jonathan Mulford account book (EHFL) records at least some of Osborn's woodworking activities from 1811 to 1840. These included general carpentry and house repairs, mending furniture, and making a "lined Coffin" in 1840. According to an entry in the Gardiner and Parsons account book (EHFL), Osborn made a cradle and a "great" chair in 1815.

Owen, George (–1684), Brookhaven
The inventory of Owen's estate (*Court of Sessions*, SCCO) provides evidence of some woodworking activity. Owens owned at the time of his death an adze, an ax, a handsaw, four chisels, three augers, a jointer, "2 fore plaines," "a hand plaine," "a creas plaine," "a rabiting plaine," a gouge, and a hammer.

Paine, Ezra (1767–active ca. 1788), Southold/Oneida County, New York
Ezra Paine was the son of John Paine, mentioned below. Entries in John Paine's account book (Colonial Institute Records, SUSB) doc-ument Ezra's participation on several occasions in agricultural and general carpentry work. A notation dated April 17, 1788, reads: "Joshua and Ezra went over to Sagg Harber to goo to New York . . . in order to goo up to the new contres to work." The *Paine Family Register* confirms that the two sons moved to Whitestown in Oneida County, New York.

Paine, John (1739–1815), Southold
The discovery of Paine's account book (Colonial Institute Records, SUSB), which records his craft activities from 1761 until his death in 1815, has saved this craftsman from complete obscurity. Paine's accounts testify to his skill and versatility. He made "fiddleback," slatback, and windsor chairs, bedsteads, stands, tables, cupboards, and other furniture forms. He supplied the town hat-maker with hatblocks, the brick-maker with brick moulds, the weaver with spools and wheels, and Benjamin Prince, a silversmith, with button moulds. Among the more than sixty-five coffins he made were those for Prince, the silversmith, and Ezra L'Hommedieu. Paine's carpentry projects included building a shop for John Prince and the renovation or enlargement of L'Hommedieu's house. Paine also worked on L'Hommedieu's mill and several other mills as well. He made his own bed cord for rope beds and turned this skill to even greater advantage by producing and selling rope and rigging for ships.

Paine made furniture from a variety of woods, including poplar, cherry, pine, walnut, maple (used particularly for chairs), and mahogany, which he obtained from Ezra L'Hommedieu. Several account book entries document Paine's purchase of boards in New London, Connecticut.

Paine, of course, did not record all of the items he made in his account book. David Conkling of Southold noted in his accounts (Landon Papers, LIHS) a purchase of tables from Paine in 1779, but there is no mention of this transaction in Paine's account book.

Of Paine's six sons, at least four, John, Jr., Ezra, Phineas, and Joshua became woodworkers. They assisted with other activities as well, including agricultural labor for Ezra L'Hommedieu and the operation of their father's cider mill, from which Paine produced and sold thousands of gallons of cider.

The inventory of Paine's estate (SCSC) does not suggest the active craft practice documented in the account book. However, it does record Paine's ownership of a turning lathe, turning tools, two work benches, and shop joiner's tools valued at $20.00. The com-plete inventory follows:

Item	$	¢
1 Mare 10 years old	50	—
2 Cows	35	—
2 Yearlings	20	—
7 Sheep	14	—
1 Hog $10—one shoat 20/	12	50
1 Desk and draws	5	00
5 Flag bottomed chairs	2	00
1 Bedstead Cord & Underbed	1	00
1 Chest		75
1 Cherry Table	1	50
1 Old Cupboard	1	50
1 Small Candle Table		50
1 Watch	2	—
1 Decanter & 2 Tumblers		75
6 Silver teaspoons	1	50
1 Jug an pot		10
2 blue saucers & 3 cups		25
1 Vinegar Cruet		12½
1 Bowl /6 4 white cup		12½
1 Milkpot 2 soup plates		15
1 teapot—1/ 1 white pitcher		25
1 Sugar Dish /3 1 Bowl /3		06
1 Iron Candle Stick		25
1 set china tea dishes		50
3 cups 2 vials 2 small bottles		25
2 smoothing irons		50
7 old tumblers & wine glasses		25
1 white mug & broken pitcher		06
2 Vials & milk pot		10
1 looking glass	1	50
Turning laythe and tools	2	00
2 Work benches	2	50
3 Eells spears		25
1 Musket	1	50
1 pr steel yards	2	00
2 axes 12/ beetle & 4 wedges	3	00
4 pails	1	—
1 Bellows 2/ 1 Scythe & well drags		50
1 Pr tongs / 2 shovels 3 pr handirons	2	—
1 large pot 4/ 1 kettle 4/	1	—
1 tea kettle 4/ 1 spider 4	1	—
2 trammels 12/ Great kettle 2/	4	—
1 Brass kettle 2/ 1 Brass ladle		50
burning & soldering Irons		12½
Shop Joiners tools	20	—
bushel & peck measures		50
1 pr small steelyards 1/ 1 small chest 2/		37½
1 Corn basket 1 Peck Dº		12½
1 Case of bottles 12/ looking glass 4/	2	—
½ doz oil bottles		50
Books of all Kinds	1	—
1 Slate 1/ 1 warming pan 4/		62½
1 Beadstead cord bed Pillows & bolster	10	—
1 table 2/ tunnel [?] 1/		37½
5 Pewter platters 16/ 8 tin pans	3	—
2 tin pails 2/ Sausage filler		50
1 small pot 4/ 1 old round table		75
seals & weights		25
1 small pine table 2/ 1 cherry Dº 4/		75
1 Candle sticks 2/ one lanthurn		37½
Salt Mortar & sundries		25
2 Sives 3/ 1 fat tub		50
1 Cullander & brass ladle		25
1 Jug & stonepot		50
1 silver spoon 6/ 1 pewter bason	1	25
1 pepper box, spoons & porringer		50
3 pewter basons 4/ 7 pewter plates	1	50
2 Dº mugs 3 Dº Basons	1	—
1 Chopping knife 2/ 1 old Bbl		37½
1 pr cards 1/ 1 chamber pot		37½
2 junk bottles 1/ 2 baskets		32½
1 Bedstead Cord & beds	8	—
1 Dº Dº Dº	10	—
2 coverlid 24/ 6 Blanket 20/	5	50
woolen yarn 10/ Chest and drawers	5	50
1 Wollen wheel 4/ 1 Needle	1	25
1 Chest & Bedlinnen	3	—
1 Chest & draws 2/ 1 HK & oats		75
1 Bbl & churn		62½
Box garden seeds 1/ Flax 3/		50
1 old Cask 2/ 1 bag tow		37½
Cask & 6 bus wheat	10	—
2 Casks soap 10/ 4 old cask	2	50
1 Iron Pot 16/ 1 cask corn	3	50
1 old tea kettle 2 cask with salt	1	50
1 Dutch fan 4/ blocks & fulls	1	50
250 ft boards	2	50
1 quill wheel 2/ 1 Flail		37½
Leather 6/ box of toro 6/ basket of Dº		87½
12 empty casks	2	50
3 old churns 3/ 1 Hatchet 8/	1	37½
1 cradle & Scythe	1	—
box of old iron 2 ox yokes	1	50
1 crowbar 6/ 3 hoes 4/	1	25
1 spade 4/ 1 shovel 3/		87½
1 stubbing hoe		37½
2 oars 2/ 1 Rat trap		37½
1 Water cask 4/ 1 tub & hydes therein	4	50
1 Wash barrel		25
1 grind stone	1	50
1 Riving horse		12½
1 Horse wagon & harness	35	—
1 Saddle	2	—
1 tarbbc & tub		75
Cider mill & press	15	—
1 corn basket		12½
1 hen coop 2/ 1 shaving horse		50
8 old casks in barn	3	—
1 Sled 4/ Rope works	1	50
1 brake 4/ 1 double swivel tree		75
1 Ladder		12½
2 pails		25
horse cart & harness	6	—
3 forks 6/ 3 rakes	1	—
hay in the barn	25	—
wheat in the barn	17	50
Oats in the barn	8	—
flax Dº	4	—
1 Plough		50
horse harrow clevis & chain	1	25
1 ox chain	1	—
Meadows hay	3	—
Corn growing on ground	12	50
Salt pork in casks	18	—

3 Cags of vinegar	2	—
Cask of Salted beef	1	75
1 quart measure Pewter		25
1 Stone pot & butter	1	—
1 Pot of D⁰	1	25
3 tubs 3/ 1 Meat cask 4/		87½
Wearing apparel	10	—
William Eldridge & Moses Clark note [pruufed?]	100	—
Daniel Goldsmith Note D⁰	100	—
Jonathan Conkling Note D⁰	11	86
Peter Vail & Russel Vail Note D⁰	50	—
Cash in [Specie?]	200	—
	933	36

Paine, John, Jr. (1763–1821), Southold
According to entries in John Paine's account book (Colonial Institute Records, SUSB), John, Jr., assisted his father with carpentry and farm work for other Southold residents. One such entry notes "to myselfe and John 5 days an halfe worke on the mill." John, Jr., probably trained with his father but there is no evidence of the period of apprenticeship or of the kinds of tasks he performed.

John, Sr., did not maintain a separate account with his son until 1790 when he recorded the loan to him of five pounds of nails. In 1791, John, Jr., made well cord and worked three days in the shop making "chairs." Again in 1802 and 1803, he worked in the shop, shingled a house, and mended "scru in shop." Three years later he assisted with the making of several coffins. John, Jr., probably wrote several of the entries in his father's account book, including the notation that "John Paine, Sr. died in the 76 year of his age."

Paine, Joshua (1765–active ca. 1788), Southold/Oneida County, New York
Joshua was the son of John Paine, Sr., mentioned above, and he probably learned his woodworking skills from his father. John Paine mentioned in his account book (Colonial Institute Records, SUSB) that Joshua helped make a settle for Sylvester Lester in 1786. Two years later Joshua moved with his brother, Ezra, to Oneida County to pursue his career as a carpenter/joiner.

Paine, Phineas (1769–), Southold
Phineas, also the son of the aforementioned John Paine, assisted his father with carpentry work, as described in several entries in John Paine's account book (Colonial Institute Records, SUSB). Since he was the fourth son and since his older brother, John, took over their father's woodworking shop, Phineas probably devoted his attention to farming when he reached his majority.

Parish, Ambrose (1764–1847), Oyster Bay
As noted in Ludlam's *Parish Genealogy*, Ambrose was the son of Townsend Parish and the brother of Isaac Parish, both mentioned below. Extant spinning wheels marked "A. PARISH" (No. 236) were undoubtedly made by Ambrose Parish who may have worked in partnership with his brother.

Parish [Parrish], Daniel (active ca. 1750–1754), Oyster Bay
Several members of the Parrish family of Oyster Bay were woodworking craftsmen. An entry in an Oyster Bay merchant's account book (NYHS), probably that of Samuel Townsend, records Parrish's purchase of a dozen brass handles and a half-dozen escutcheons in 1750. In a 1754 indenture (OBTR) Parrish called himself a joiner.

Parish, Isaac (1766–1836), Oyster Bay
Isaac Parish was the brother of Ambrose and the son of Townsend Parish (Ludlam, *Parish Genealogy*). He was no doubt the maker of the many spinning wheels marked "I. PARISH" found in central Long Island (No. 235). An entry in Henry Hagner's day book (QbPL) provides documentation for this assumption. Hagner noted on January 19, 1807, that Isaac Parish had supplied him with six spinning wheels.

Parish, Townsend (1732–1828), Oyster Bay
An entry in Samuel Townsend's account book (EHFL) records the sale to Parish of a number of "Duftail" hinges and nails in 1759 and 1760 and this suggests that Parish was a woodworking craftsman. Townsend was the father of Ambrose and Isaac Parish, both turners, and it seems likely that he trained his sons. However, the Parish family genealogy states that Townsend was a Quaker preacher and a farmer and gives no information about his craft activities (Ludlam, *Parish Genealogy*).

Parsons, John (active ca. 1674–1693), East Hampton/Cape May, New Jersey
In 1942, John Parsons' account book was in the library of the Cape May (New Jersey) County Historical and Genealogical Society. A photocopy of that account book is extant locally (NYHS). Unfortunately, it is only partially legible and it is not a very detailed document. Nevertheless, it is one of the few surviving records of the craft practice of a seventeenth century woodworking craftsman and it tells something about the activities of this previously unknown East Hampton furniture maker and carpenter.

Although Parsons was a skilled woodworker, he apparently considered himself a weaver as indicated by the inscription in his account book: "John persons weaver his booke/may: the: 21: 1679." While many of the entries document weaving work, almost an equal number record woodworking activities. From at least 1674 to 1685, Parsons was occupied with carpentry, coopering, and joinery. His customers included Richard Shared, John Carle, Richard Stratton, Joseph and Thomas Osborne, and John Edwards, all apparently residents of East Hampton.

Parsons made "oyl bariles," "woling" wheels and at least one coffin and he also repaired tools. In 1674, he made a bedstead for John Carl. He charged John Edwards for a table and a shelf in 1676 and Obediah Abbey for "2 chares," apparently in the same year.

The notation, "by house 20 ˢ13 ᵈ6," debited against Joseph Osborne's account, indicates that Parsons built a house for Osborne. He also built a shop for Thomas Osborne and at least part of a house for John Edwards. Parsons charged Edwards for two windows, for a door, for "siding hous so far," and for "making a piare stares." In 1676, Parsons supplied a house frame for Benjamin Franklin and for the "Elder" Baker, Parsons worked for three and a half days laying a barn floor.

In 1690, Parsons took on a six year-old apprentice, Thomas Evans of "harford [Hartford] in Neuw ingland." The following year Parsons moved to Cape May, New Jersey.

Peck, Curtis (active ca. 1806), Flushing
Edward Lawrence noted in his receipt book (NYHS) that Peck charged him $6 for making bilsted coffin in 1806.

Petty, Jeremiah (–1795), Riverhead
Many craftsmen were adept at several trades. Judging from the assortment of tools itemized in the inventory of his estate (SCSC), Petty was an active carpenter and blacksmith. The milling of lumber was an important industry in Riverhead about 1800, and Petty may

also have worked at this trade. Among his assets when he died were 100 feet of pine boards, fourteen "saw logs," and the twenty-ton sloop, *Unity of Riverhead.*

Plumbe, Samuel (active ca. 1727–1752), Huntington
Henry Lloyd's account and waste books (LIHS) provide evidence of Plumbe's craft activities. In 1727, Lloyd noted a purchase of two bedsteads from Plumbe. Two years later Plumbe charged Lloyd 25s. for a tea table and 16s. for another bedstead. Nine entries, all dated 1732, record Plumbe's purchase of hinges, "3 gross keyed locks," brads, and "½ gross scutcheons" from Lloyd. Plumbe was a carpenter as well as a furniture maker. A Huntington town account for 1728 (HTR) credits Plumbe for repairs to the schoolhouse and the meeting house. In his will proved in 1752 (NYHS *Abstracts,* IV), Plumbe identified himself as a joiner and left his "carpenter and joiner tools" to his son, Samuel.

Pontine, Thadies (–1814), Jamaica
The inventory of Pontine's estate (QCSC) lists only a few possessions, mostly simple woodworking tools such as saws, chisels, augers, gimlets, planes, and axes.

Poole, Dears (–1808), Hempstead
The inventory of Poole's estate (QCSC) documents his ownership of a considerable number of tools, but he seems to have engaged chiefly in making wagons and sleighs.

Poppen [Poppe], Jan (active ca. 1675–1689), Flatlands/Flatbush
An apprenticeship indenture of 1684 (FbTR) states that Poppen was a chair and wheel turner. In that year he accepted Albert Van Ekelen as an apprentice. According to Bergen, *Kings County,* Poppen moved from Flatlands to Flatbush sometime after 1677 and he was a farmer as well as a craftsman.

Remsen, Jeremiah (active ca. 1813–1832), North Hempstead
Remsen's account book in the Bryant Memorial Library in Roslyn is the only source of information concerning his craft activities. The entries date from 1813 to 1832 and indicate that Remsen was typical in the variety of tasks he performed. In addition to repairing furniture and making coffins, he made beds, chests, desks, "closets," "close" [clothes] chests, and a paper press. He also supplied his customers with sleds, sleighs, and wagons, but there is no evidence to suggest he was a wheelwright. In 1817 and 1820, he made dozens of "fork handles" for David and Elias Jarvis. The account book also contains a few references to carpenter's work but the majority of the entries simply note "work" or a "day's labor."

Renne, Samuel (–1801), Queens County
Renne was probably a very active craftsman since the inventory of his estate (QCSC) lists six work benches and a variety of metalworking and woodworking tools. Renee may have limited his blacksmith's work primarily to nail-making since he owned thirteen heading irons. Among his other tools were a frame saw, a turning "lay" and wheel, eight saw benches, six handsaws, "a lot of augers," a paint stone, a pair of strainers, a chest and turner's tools, and "one lot of small tools."

Roe, Austin (1749–1830), Setauket
One can find evidence of Roe's craft practice in Abraham Woodhull's account book (EHFL). Between 1781 and 1792, Roe made a stand, a bread tray, a cradle, a coffin, six chairs, and a desk for Woodhull. Roe also assisted with the construction of Woodhull's new house after 1789, supplying at least fifteen window frames,

sashes, and lights for the new structure. Roe identified himself as a cabinetmaker in a land indenture of 1797 (Deed Liber C, SCCO). During the Revolutionary War, Roe operated a tavern in Setauket. He participated in a local spy ring in support of the Patriot cause and worked closely in that effort with Abraham Woodhull, who was a key member of the Setauket spy group. After the war, in 1790, President George Washington visited his spies on Long Island and spent an evening at Roe's home, which Washington described in his diary as "tolerably decent with obliging people in it" (Edwin P. Adkins, *Setauket*).

Roe, Phillips (active ca. 1762–1815), Brookhaven
Roe's possessions, as described in the inventory of his estate (SCSC), were not extensive but did include a "turning lathe" and "a lot of timber." Interestingly, Roe acted as an agent for Elias Pelletreau, the Southampton silversmith, selling Pelletreau's jewelry and small silver work. Pelletreau noted in his accounts (EHFL) that Roe received goods for sale from 1762 through 1765.

Rose, Major (active ca. 1814), Brookhaven
According to a notation in the inventory of William Rose's estate (SCSC), Major Rose made a coffin for the deceased.

Rose, Timothy (active ca. 1733), Brookhaven
Possibly a woodworking craftsman, Rose's name appears in the account book of the Brookhaven blacksmith, Joseph Jayne (NYHS). Rose purchased "a peare of sm. bits," a hammer spring, and a hinge from Jayne and he also asked the blacksmith to supply "work for a chest."

Ross, Robert (active ca. 1811), Brooklyn
Ross placed the following advertisement in the *Long Island Star* for June 12, 1811: "Cabinet Maker / The subscriber respectfully informs the public that he carries on the above business in Old Ferry Street . . . An assortment of furniture is kept on hand for sale or made at the shortest notice." Ross' establishment in Brooklyn is also listed in Longworth's *Directory* for 1811.

Ruland, John (–1768), Hempstead
The inventory of Ruland's estate (Deed Liber C, CROJ) lists the tools of an active craftsman. He owned thirty-eight plane stocks and irons, twenty chisels and gouges, three handsaws, a workbench, vices, a grindstone, and two "turners" lathes. As with most rural craftsmen, the total value of his estate was small, only £37.

Rusco, David J. (–1806), Huntington
The assortment of tools listed in the inventory of Rusco's estate (SCSC) suggests that Rusco possessed a range of woodworking skills. He owned two handsaws, a crosscut saw, bolts and clevises, two riddles, a hand vice, a beetle and wedges, a cooper's adze, four gimlets, a box of nails, a turning lathe and tools, several jointers, a cutting box, and "16½ Albany boards."

Russel, Bazillai (active ca. 1832), Brooklyn
Russel and his partner, Joseph Weeks, placed an advertisement in Bigelow's *Brooklyn Directory* for 1832, thanking "their friends and the public in general for their liberal share of patronage," listing a wide variety of furniture forms "on hand," and noting that they also "matted" chairs at their "Cabinet Warehouse," located at 11 Hicks Street.

Sammis, Daniel (active ca. 1817–1834), Huntington
Sammis' account books (HHS) provide a detailed record of his craft

activities from 1817 through 1830. He was a carpenter and a joiner, but after 1825 he was involved primarily with the operation of a sawmill which he had built that year. Prior to that date, his activities included house carpentry, furniture repair, and coffin-making. Sammis also made and repaired farming implements and he supplied various customers with small household items—specifically, "rockers for a cradle," a bread tray, a "washing bord," a washing machine, and broom handles. In 1820, he turned a bedstead post for Silas Ketcham and the following year he mended and painted six chairs for Ebenezer Gould. In 1826 and 1827, Sammis supplied Jeremiah Ketcham with two desks and a chest. Other entries in Sammis' accounts show that he "cut" a bedstead and a table in 1819, made a second table in 1823, and made a "Large" and a "Small" chair in 1834.

Sandford [Sanford], Daniel (1734–1811), Southampton

Grover Merle Sanford states in *Sandford Families* that Daniel was the son of Zachariah and the grandson of Ezekiel Sandford, a wheelwright of Bridgehampton. Ezekiel, according to this source, came to Long Island from Milford, Connecticut, about 1670. In 1678, the town of Southampton granted Ezekiel fifteen acres of land on the condition that he would remain in the town and work as a wheelwright for seven more years (ShTR). Ezekiel was probably related to the Sanford brothers of Milford, Ezekiel and Andrew, recently identified as seventeenth century furniture makers in Patricia Kane's *Furniture of the New Haven Colony*.

Fortunately, Daniel Sandford's account book survives (QbPL) and it is the only known record of his extensive woodworking activities from 1754 through 1803. Following the pattern of even the most successful of his contemporaries, Sandford farmed his own land and served as a town handyman, mending a variety of objects from warming pans and teapot handles to tables and "cartain rods." He also built houses and made doors and window sashes. His versatility extended to the construction of three boats and to the building or maintenance of at least four mills, including one owned by Deacon David Hedges. Sandford also assisted with the maintenance of the schoolhouse and the meeting house.

The range and proportional number of furniture forms produced by Sandford correspond roughly to inventory evidence of the contents of an eighteenth century Long Island house. Over a forty-nine year period, he made at least 240 chairs, sixty-four bedsteads, sixty chests, forty-six tables, fourteen stands, nine cupboards, eight cases or chests of drawers, five desks, and a bookcase. As one might expect, he also made more than fifty coffins and many smaller objects, such as wig boxes, bread trays, sinks, ink stands, and a cartridge box. Sandford mentioned making a number of cradles and these may have been the traditional infants' beds or perhaps farm tools. It is interesting to note that despite his activity as a furniture maker, Sandford still called himself a carpenter when he witnessed the will of Thomas Sandford in 1785 (Van Buren, *S.C. Wills*, EHFL).

Considering the extent of his craft practice, the inventory of Sandford's estate (SCSC) lists relatively few woodworking tools and suggests, rather, the household of a farmer. By the time of his death Sandford may have passed on his business and some of his tools to a younger craftsman. The inventory is given in full below.

	£	s	d
16 Bushels of wheat 1 Bushel of Beans, 1 Cart	8		0
1 Plow 2 Harroughs 2 ox chains, 1 riding chair 2 pick forks	14	8	0
3 ox yokes 1 pair of geers Iron shovel spade 3 hoes	2	16	0
6 silver teaspoons 8 table spoons 5 towells, 3 tablecloths	3	8	0
3 Jugs 1 warming pan 10 Bushels potatoes 6 Barrels	2	11	0
2 Barrels pork, 1 laddle wedges beetle	15	4	0
2 Sythes 2 sicles hoes 5 saws 2 augers, pair oyster tongs	4		0
18 chisels, 1 saw 4 hammers 1 Bucket 1 Bridle	1	18	0
30 planes, 1 log 12 loads manure 5 loads wood	12		0
50 Bushels corn 12 bushels rye 30 bushels oats	20		0
1 yoke of oxen, 1 cow 1 calf, 1 horse 10 [?] Hay, 8 sheep	42		0
2 Barrels, 4 rakes 2 flails & cradle	1		0
1 grindstone, 112 pounds pork	3	12	0
1 pair stears	12		0
150 shaves of flax	4		
2 chests 2 dollars each	1	12	0
1 chest with six pare of sheets	3		0
2 feather beds	8		0
3 Bedstids, 2 pillow cases 4 table chairs	5	12	0
1 looking glass, 8 plates 1 great Cettle 1 pot, 1 cettle	4	8	0
4 Basens, 1 low chest 1 stand, 2 pr. handirons	3	4	0
12 books, 1 chest of drawers 1 silk gown, 1 long cloak	11	4	0
1 Necklace of gold beeds, 1 pair of tongs 2 shovels	4	8	0
2 smoothing irons, 3 gowns 2 petticoats, 2 candlesticks	3	8	0
1 case of bottles, one carpet 1 piece of drugget	2	8	0
1 hat case, basket earthen ware	4		0
Wearing apparell, 1 gun, carting box, bayonet	18	8	0
1 pan stilyards & bellows, trammel, crane	1	16	0
1 pot, 1 cettle, 3 skillets 3 pails 3 tubs 3 chairs	2	16	0
1 Oven lid, 1 beer treve and piggen	1		0
1 desk, 7 cheeses 5 tea pots	4	16	0
5 basons 7 puter plates 2 puter plates	12	2	0
1 Barrel flour, 5 tubs 3 stone pots 5 jugs	1	7	0
20 weight of butter 100 of hogs lard	2	4	0
1 churn 3 pots 8 barrels	1	11	0
1 Cupboard, 1 bedquilt 2 coverlids 1 bed tick	3	12	0
3 spinning wheels, 1 reel 1 great chair 1 under bed	1	16	0
1 sheet, 1 bed spread 2 barrels, Sundrys	1	4	0
1 meal chest & flour 7 meal bags 3 soils, 1 shoe bench	2	2	0
4 Hogs heads 2½ Bushels 2 Barrels & Sundrys	3	5	0

Satterly, Samuel (1777–), Setauket

Family tradition has always identified Samuel Satterly, son of Elnathan Satterly (1734–1797), as a cabinetmaker. In an article entitled "The Satterlys of Setauket," published in the *Long Island Forum* in April, 1943, Emily Steffens, a descendant, mentioned that Samuel built a house in East Setauket for his daughter, Anne. Steffens also noted that Samuel made a desk, a bureau, a drop-leaf table, chairs, "and many other pieces." In an April, 1947, article, Steffens described a slant-front cherry desk which she owned and which family tradition attributed to Satterly.

Samuel probably apprenticed with William Satterly, mentioned below. Abraham Woodhull of Setauket noted in his account book (EHFL) that Samuel and William worked together on the construction of his house in 1792.

Satterly, William (active ca. 1792–1797), Setauket

Satterly family tradition tells nothing of William Satterly's craft practice although Samuel Satterly's woodworking activities, described above, have received some attention in recent years. The inventory of William Satterly's estate (SCSC), however, indicates that Satterly was an important woodworking craftsman and a furniture maker. All of the wood he owned at the time of his death—notably, cherry, apple, and maple—could be obtained locally. He certainly engaged in making furniture, wagons, and sleds as well as general carpentry at the time of his death. One can find evidence of his skills as a carpenter in Abraham Woodhull's account book (EHFL) which contains references to Satterly's work on Woodhull's new house in 1792. Since there are few detailed inventories of the estates of Long Island craftsmen, the inventory of Satterly's estate is particularly interesting and is reproduced here in full.

523 feet Cherry Boards	6-10-9
100 d⁰ Maple & Apple Tree d⁰	1-0-0
Pine Boards	1-3-0
12 Stand Posts	0-6-0
4 Crown pieces for Slays	0-16-0
1 Scythe & Cradle	0-16-0
1 Set Waggon Hubbs	2-0-0
26 Chairs and Bottoms	7-16-0
7 d⁰ without d⁰	1-15-0
7 d⁰ Small	1-0-0
9 Window Frames	3-3-0
108 Lights of Sash	3-3-0
2 Bureaus	7-0-0
1 Bench Plank	0-16-0
1 Frame of a Dutch Fan	1-10-0
1 Sickle	0-2-6
Tool Chest & Contents	0-16-0
2 Setting Poles	0-12-0
1 Cloaths Press	16-0-0
2 Dining Tables	7-0-0
1 Breakfast d⁰	2-4-0
2 d⁰ unfinished	3-0-0
1 Candle Stand	0-12-0
2 Desks	20-0-0
1 Dutch Fan unfinished	6-0-0
1 Riddle	0-12-0
2 Slays	22-0-0
2 Wood Sleds	3-5-0
1 Cherry Log	0-4-0
White Oak Timber	0-6-0
1 Sled Runner	0-4-0
Grind Stone & frame	0-16-0
1 Fire Stove	3-0-0
1 Kings Arm Musket	1-12-0
1 Gun & Accoutrement	2-8-0
Lumber	1-12-0
Broad Ax	1-2-0
Narrow d⁰	0-4-0
3 Adzes	1-5-0
1 Fro	0-4-0
1 Block Knife	0-4-0
9 Augurs	1-4-0
9 Turning Tools	0-12-0
1 Cross cut Saw	1-12-0
6 Saws	1-16-0
2 [Iren?] Squares	0-4-0
6 Carpenter Chissels	0-6-0
19 Firmers d⁰ & Gouges	0-16-0
9 files	0-4-0
3 Hammers	0-12-0
5 Mallets	0-2-0
4 Bevels	0-1-0
3 Rules & ½ d⁰	0-6-6
1 Oil Stone	0-4-0
2 Screw Drivers	0-1-0
3 Trying Squares	0-6-0
3 Gages	0-1-0
5 Gimblets	0-1-6
Chalk line, Scraping Iron & Compasses	0-2-0
Sundry small Irons	0-1-0
Iren & Press Wire	0-8-0
part of a Bar of Iren	0-4-0
1 Drawing Knife	0-5-0
½ Set of Grooving plains	0-10-0
1 Raising plain	0-12-0
Small pair Grooving plains	0-8-0
2 Rabbitt d⁰, 4 Halving d⁰	1-0-0
1 Sash plane & Guage	0-5-0
Set of Table Joints	0-8-0
13 Moulding Tools	2-6-0
1 Bed Mould	0-10-0
28 Hollows & Rounds	2-18-0
Joiners Plough with irens	1-8-0
1 Brace & 18 Bitts	2-0-0
part of Desk furniture	0-18-0
6 Till locks	0-8-0
2 plaine irens, 3 Chest Hinges	0-4-0
1 Stand latch	0-1-3
9 Table Butts	0-4-6
1 Pad Lock	0-4-0
Drawer with Sundries	0-12-0
1 Sett Cupboard Butts	0-3-0
3 Jugs, 2 Bottles, paint cups, etc.	1-0-0
5 jointers	1-8-0
5 Jack plains	0-12-0
8 Smoothing d⁰	1-6-0
Chair Stuff	2-8-0
Shop & Benches	67-0-0
Glue pot	0-8-0
Leather	1-0-0
Shovel & Hoe	0-8-0
1 Set of Breech Collars	2-0-0
1 Saddle & Bridle	3-0-0
Iren Traces & Curry Comb	0-14-0
Wheat Riddle	0-2-0
1 hatter	0-1-6
Bee House & ½ the Bees	4-10-0
1 Mare	30-0-0
1 Cow	7-0-0
1 Yearling Heifer	2-12-0
English Hay	6-0-0
3 Cartes	0-18-0
1 Sled	0-2-0
½ of a plough	11-0-0
1 Breakfast Table	1-8-0
1 Dining d⁰	2-10-0
1 Dutch Wheel	0-16-0
1 Chest	0-8-0
Square Table	0-10-0
Tin Ware	1-8-0

Iren Kettle & Griddle	0-16-0
pair of Bellows	0-4-0
Earthen pitcher & Jug	0-1-6
Coffee Mill	0-8-0
7 Silver Tea Spoons	1-10-0
parcel of Books	1-4-0
Set of Knives & forks	0-6-0
1 Slate	0-1-6
China, Glass, & Earthen Ware	2-0-0
7 Chairs	1-8-0
Candle Stand	0-8-0
1 Desk	2-0-0
Mohogany Tea Chest	0-6-0
Gin Case & Bottles	0-6-0
9 Bottles & 1 Jug	0-4-6
2 Cotts	0-16-0
Bedstead, Bed & Bedding	6-0-0
7 pr sheets & pillow Cases	4-0-0
5 Table Cloths	1-10-0
10 Towels	1-0-0
20 yds new linnen	2-10-0
Suit of Curtains	3-0-0
Wearing Apparrel	10-0-0
3 Trunks	1-10-0
1 Small Chest	0-4-0
1 Meal Chest	0-8-0
1 Band Box	0-3-0
pair of Snuffers	0-1-0
Notes to the value of	152-0-0
Cash	26-0-1
Book Accompts	95-12-10

Sayre, Capt. David (active ca. 1773–1819), Bridgehampton
David Sayre identified himself as a joiner when he witnessed the will of William Mulford in 1773 and the will of the Rev. Silvanius White in 1782 (*N.Y. Wills,* SCSC). One can find more specific evidence of his craft activity in *The American Eagle,* for March 27, 1819, which carried the following announcement: "Dutch Wheels/ Just received from the manufactory of Capt. D. Sayre, in Bridgehampton, a number of Dutch or small spinning wheels, which will be sold cheap for cash at the office of *The American Eagle.*"

Schellinx [Shellinx, Schellinger], William (active ca. 1697–1725), East Hampton
Mary Hunting's account book (EHFL) includes a reference to "Wm. Shellinxe" who made "one round" for a chair in 1725. It seems likely that this craftsman is the same William Schellinx who is identified as a cooper in land indentures of 1697, 1702, and 1723 (EHTR). An East Hampton town account for 1698 (EHTR) records a payment, also to a William Schellinx, for building and furnishing the prison. It is entirely possible that the same craftsman who engaged in carpentry and coopering about 1700 also turned a chair round in 1725.

Sealy, William (active ca. 1806), Hempstead
An entry in the Henry Hagner Account Book (QbPL) records that Sealey made a coffin in 1806.

Seaman, Stephen (active ca. 1818–1848), Oyster Bay
Various receipts in the Woodnutt papers (NCHM) show that Seaman made a pine coffin for Mary Cock in 1818, made a second coffin for George Allen in 1848, and also mended a table.

Sherrill, Jeremiah (active ca. 1769–1778), East Hampton
Jeannette Rattray in her *East Hampton History* mentions two Jeremiah Sherrills. They were contemporaries. One, the son of Jacob, was born in 1755, while the other, the son of Jeremiah, was born in 1750. Either could be the "Jereme," later identified as Jeremiah Sherrill, who is mentioned in 1769 and 1770 in an account book kept by Nathaniel Dominy IV (Winterthur). Several entries document Jereme's work which included sawing lath, hewing timber, and "laying Stable floor." Possibly he was an apprentice during this period since Dominy charged for his services in various accounts but recorded no payments to him.
 If he was an apprentice, he had apparently completed his term of indenture by 1772 when Dominy credited him for "2 Days work (@) 3/6." Several entries, dated 1773–1775, indicate he was a skilled joiner. He worked ten days in the Dominys' shop, made a table for John Gardiner, and worked in his own shop one-half day "on Sundries." Sherrill's last transaction with the Dominys occurred in 1778, when he supplied Nathaniel Dominy with "flyars and 2 spoles." Since there is no further mention of him in the Dominy accounts, this craftsman may have been the Jeremiah Sherrill born in 1750, who, according to Rattray, left East Hampton in 1782 and settled in Stanford, New York.

Skillman, Thomas (–1814), Riverhead
Among the probate records for Skillman's estate (SCSC) is a note describing a debt due the estate for fifty white oak posts, twenty-five oak boards, a "chest of drawers," and a desk. The inventory of the estate lists a crosscut saw, augers, chisels, a gauge, a drawknife, and "carpenters & joiners tools." Clearly, Skillman was active as a carpenter and a joiner.

Smith, Carman (active ca. 1826), Huntington
Smith placed a notice of the establishment of his "Fancy & Windsor Chair Manufactory" in Huntington in *The Portico* for July 20, 1826. He stated that a "great variety of Fancy, Windsor and Common CHAIRS, Settees, etc." were available and he added that old chairs were "Matted, Mended, Painted, and re-gilt or Bronzed, in the neatest manner, and at the shortest notice."

Smith, Daniel (active ca. 1769–1814), Setauket
In 1789, Abraham Woodhull of Setauket entered into an agreement with Daniel Smith, a carpenter, to have Smith build a new house. Entries for work on the house appear in Woodhull's account book (EHFL). Daniel Smith's account book is also extant (Lawrence Collection, SmPL) and it documents his woodworking activities from 1792 through 1814. For the most part, Smith made and repaired wagons and carts and worked as a house carpenter. He did, however, make a bedstead and a trunk for Ruth Tucker in 1799. Two workmen, possibly apprentices, frequently assisted Smith. One was Benjamin Phillips and the other Smith identified simply as "Henry."
 When Smith witnessed the will of Charles J. Smith in 1769 (*N.Y. Wills,* SCSC), he called himself a carpenter. He is also identified as a carpenter on the Brookhaven tax list for 1775 (EHFL) and in a land indenture of 1795 (Deed Liber C, SCCO).

Smith, Thomas (active ca. 1711–1730), Huntington
The Henry Lloyd account book (LIHS) provides information about Smith. In the accounts relating to the building of Lloyd's house in 1711, Lloyd noted that Smith was responsible for the "finishing" work—the panelling, moldings, and other fine interior details which require special skill. It is not surprising, then, to find in the account book an entry dated 1729 crediting Smith for "tables." Lloyd's

accounts also show that Smith was largely, if not entirely, responsible for the masonry work on the house. The following year, Smith made the stocks for the town of Huntington, as noted in a 1730 town account (HTR).

Smith, William V. (active ca. 1826), Brooklyn
Smith advertised his "Fancy & Windsor Chair Manufactory" in the *Long Island Star* on August 10, 1826. He stated that he had ended his partnership with Joseph Van Nostrand and he planned to carry on his "Carpentry Business . . . as before." In addition, he promised to perform "all kinds of wood turning at the shortest notice and in the best manner." Spooner's *Brooklyn Directory* for 1826 lists Smith, a "Fancy chair maker," at 70 Fulton Street. Smith does not appear, however, in the 1829 *Directory*.

Sniffen, Peter (– 1785), Oyster Bay
Since the inventory of Sniffen's estate (QCSC) was taken in no particular order, it is difficult to determine if Sniffen made any of the furniture listed with the tools and supplies. Among his possessions were a number of basic woodworking tools, 1,350 shingles, 100 white pine boards, a bench, a "sett of slay making tools," a tea table, and a high chest.

Squam, Jonas (active ca. 1773), Sag Harbor
An eighteenth century desk now owned by the Wading River Historical Society was apparently made by Squam.
A previous owner discovered in the desk an old pocket book, belonging to her antecedent, Nathan Benjamin, which contained a memorandum relating to the history of the piece (see SPLIA Newsletter, June, 1959). According to this document, the desk was purchased from Squam, a Sag Harbor cabinetmaker, in 1773. Its value was £5 9s., and Squam was to receive winter butter and linen yarn as part payment.

Stansbury, Isaac (active ca. 1823), Flushing
Perhaps Isaac was John Stansbury's son. He may have worked with John, mentioned below, since he is credited in John's account book (LIHS) with making "two Chimeny pieces for Van" for which he charged £10.

Stansbury, John (active ca. 1809–1823), Flushing
Part of Stansbury's account book survives (LIHS) and shows that John, like most rural craftsmen, performed a variety of woodworking tasks. Several entries record the repairing of furniture and the making of coffins. He also made a "wrighting table" and a bottle rack. In August, 1809, he made a knife box for Joseph Lawrence of Flushing, a service that was recorded only in Lawrence's "Farming and Household Account Book" (LIHS).

Stoddard, William (active ca. 1752–1758), Oyster Bay
Two separate documents, a land indenture of 1752 (OBTR) and Stoddard's will (NYHS *Abstracts,* V), identify him as a joiner. In 1752, Stoddard sold his house and shop to James Whippo, mentioned below. Stoddard had some connections with Rhode Island. According to Margaret Townsend's Townsend family genealogy, Stoddard, who married a Townsend, once lived in Rhode Island. Stoddard stated in his will that his son, Robert, was then living in Rhode Island.

Sweezey, John (– 1814), Brookhaven
The inventory of Sweezey's estate (SCSC) records his ownership of "1 Lathe and turning tools" valued at $4.00 and "Carpenters tools" valued at $3.00.

Swezey, Christopher (– 1798), Brookhaven
According to the estate information sheet (SCSC), Swezey was a miller but the inventory lists a "turning lathe, chisels and gouges," "plank" for waggon fellows, and timber for sleds and bedsteads. He may have done some woodworking as well.

Tabor [Taber], Amon (1706–1786), Southold
Augustus Griffin states in his *Journal* that Tabor came to Southold from New London, Connecticut, about 1730. According to Griffin, Tabor gained recognition as a skilled carpenter and joiner and the town hired him to finish the inside of the meeting house in 1732. The documentation of this employment, Griffin writes, is in the unpublished Southold town records which have not been consulted for this study. A land indenture in the published records, however, offers contradictory evidence as to the date of Tabor's arrival in Southold, and documents that Tabor "of New London" purchased Southold land in 1752. Perhaps he returned to New London after coming to Southold in the 1730's. He was certainly living in Southold when he witnessed the will of Benjamin Brown in 1744 (*N.Y. Wills,* SCSC). At that time Tabor stated that his occupation was carpentry. Interestingly, his brother, John Tabor (1690–1756), was a carpenter and joiner of Newport, Rhode Island (Wright, *Taber Genealogy*).

Tabor [Taber], Pardon (1789–1842), Sag Harbor
Tabor probably learned his woodworking skills from his father, Amon Tabor, Jr. Pardon Tabor's account book (QbPL) documents his craft practice from 1817 through 1841. In addition to making coffins and repairing furniture, he made cradles, bedsteads, chests, a toilet table and a clock case. He repaired the shop of Elijah Simons, a local clock-and-watchmaker in 1812 and in 1817 he worked seventeen weeks on the construction of the meeting house in Sag Harbor. In this busy port town, many carpenters probably helped fit out the ships built there. Tabor's accounts note his work on the "Ship American" and the "Ship Hanable" in 1828. By 1829, Cornelius Tabor, Pardon's son, had begun to assist his father with house carpentry.

Talmage, Simus (– 1723), East Hampton
The inventory of Talmage's estate (QCHDC) specifies as part of his personal property 8,000 cedar shingles, 900 clapboards, and "3½ thousand of nails." Either Talmage was preparing to construct a house or barn or he kept a stock of carpentry materials on hand. The inventory lists no woodworking tools.

Teebone, Gabriel (active ca. 1702–1703), Jamaica
Teebone is identified as a "Joyner" in the Woolsey family account book (Hillhouse Collection, Yale). Entries dated 1702 and 1703 in this book record Teebone's purchase of three pounds of glue, ten "drops" or furniture brasses, five "scutching," and fifty-five gallons of rum.

Thorn, Stephen (– 1750), Flushing
The number and variety of woodworking tools listed in the inventory of Thorn's estate (QCHDC) suggest that he was an active and skilled craftsman. Curiously, there is no mention in the inventory of livestock, farming tools, or produce. Perhaps woodworking was a full-time occupation for Thorn—an unusual situation for a Long Island craftsman. At the time of his death, Thorn owned a variety of augers, gimlets, chisels, squares, files, saws, bead planes, quarter-round planes, jack planes, grooving planes, smoothing planes, and plane irons.

Thurston, Joseph (– 1688), Jamaica
The inventory of Thurston's estate (Deed Liber A, CROJ) records his possession of one hundred acres of land, livestock, and a number of woodworking tools at the time of his death. Among his tools were three augers, seven axes of various size, a handsaw, two broad chisels, a narrow chisel, a gouge, a drawknife, a crosscut saw, beetles, wedges, pincers, two "great" gimlets, and a branding iron. Significantly, a lock and "two pieces of chair" were also among his effects. The total assessed value of his estate was £220.

Tilley, David (active ca. 1747–1755), Jamaica
In a Woolsey family account book (Hillhouse Collection, Yale), Tilley's name appears in a series of entries dated 1747 through 1755. During this eight-year period Tilley made several plows, an ox cart, an oak pail, a molasses cask, a beer keg, and a "fat Tubb" for Melancton Taylor Woolsey.

Tinker, Nathan (active ca. 1819–1849), Sag Harbor
Tinker is one of the most interesting Long Island craftsmen of the early nineteenth century. He placed dozens of advertisements in the Sag Harbor newspapers throughout his career and these provide extensive information about his activities. He was an extraordinary entrepreneur who, unlike his eighteenth century predecessors on Long Island, conducted an aggressive campaign to sell his wares.

Tinker began his career in Sag Harbor in partnership with another cabinetmaker by the name of Woodward. They advertised together only in 1819. Tinker advertised again in 1822, noting in the August 3 issue of The Corrector that he continued "the CABINET FURNITURE Business in all its branches, at his old stand opposite the Engine House." He added that he kept "a constant supply of furniture at Mr. Wm. Griffing's & Israel Fannings Riverhead." The following year he also supplied agents in Bridgehampton, East Hampton, and Southold.

In 1822, Tinker announced in The Corrector the first of his many supplementary businesses, a lumber yard. Between 1823 and 1826, he advertised for sale a variety of miscellaneous items, such as anti-dysenteric pills, a "labor saving" washing machine, and a corn-husking machine. In 1827, he advertised a milk delivery service, and that same year and again in 1830 Tinker entered into brief and apparently unsuccessful partnerships in the blacksmithing business.

Tinker's primary business, however, was cabinetmaking, and he maintained an active shop. He suffered a loss from fire on December 31, 1822, but, typically, turned the situation to his own advantage by announcing sale prices on merchandise in The Corrector for January 18, 1823. Tinker always advertised an impressive variety of furniture forms and usually described them as less expensive and better made than New York City furniture. He also offered free delivery of furniture "to any part of the United States" and he accepted "country produce" as payment. One can measure the success of his business not only by his advertising campaign and his long period of activity but also by the frequent notices he placed in the local papers requesting apprentices to work in his shop. Such requests appeared in The Corrector in 1824 and from 1826 through 1831, Tinker usually stated that two or three positions were available for "lads . . . from good family." In addition, when Tinker announced one of his several trips "southward," he identified the employees in his shop who carried on his business. In December, 1826, Tinker mentioned Augustus Bulkeley, and in August, 1831, Nathan T. Maxon and R. E. Havens, "persons in my employ."

Although other furniture makers were active during this period in Sag Harbor and nearby towns, Tinker seems to have regarded only Henry P. Byram as a major competitor. Tinker ran a series of advertisements in The Corrector in 1830 in order to counter

Byram's own advertising campaign. In the February 27 issue, Tinker stated that he would "sell all kinds of Cabinet Furniture cheaper than his friend in this port, who has undertaken to undersell him, and who has pompously advertised that a 'penny saved is two pence clear.'" Tinker was determined to sell "cheaper than the other shop," and he declared: "if I don't get enough for the stuff and trimmings, . . . for pay I will take anything that is offered, at the market price." Tinker and Byram continued to battle verbally during the next several years and then, surprisingly, both announced in May, 1834, that they were closing their shops. However, Tinker apparently continued his business for a notice in the July 1, 1837 issue of The Corrector, announced that Joseph G. Lamb had purchased Tinker's "Cabinet Making Establishment." Another announcement in the September 30, 1837 issue of The Corrector stated that Lamb was selling his remaining stock at "Nathan Tinkers Wareroom," thus indicating that Tinker was still in business at another location.

Tinker did not advertise again until August 3, 1839, when he placed the following notice in The Corrector:
> The subscriber has again commenced the Cabinet Making Business, at his old stand where he will be pleased to see his old customers as well as new ones.

Tinker soon made his son, Samuel, his partner, and in June, 1846, they announced the completion of their new shop. Tinker advertised in The Corrector for May 10, 1848, that he had in stock "the greatest assortment of Cabinet Furniture ever offered for sale in this place." He called attention to his well-established reputation, "having carried on the business for 29 years." The following March, however, he died, at the age of fifty-five, and his son, Samuel, continued his business.

Townsend, Henry (active ca. 1729–1771), Oyster Bay
A notation dated 1758 in a document entitled "Record of Mortgage 1754–60" (QbPL), identifies Townsend as a "joyner." According to an entry in Samuel Townsend's account book (EHFL), Henry Townsend made "a pair of chair wheels" in 1760 and purchased several "Cubbord" locks in 1758 and 1759. Land indentures dated 1729, 1730, 1731, 1734, 1746, and 1763 (OBTR) also document Townsend's craft as joinery. Townsend was still active in 1771. In a letter dated February 1, 1771, and addressed to "Brother Larance" (Lawrence Scrapbook, EHFL), Townsend wrote that he was planning to send "Larance" some wheels and "for or five cord of warnot wood".

Townsend, Nicholas (active ca. 1769–1776), Jamaica
Several papers in a "Miscellaneous Documents File" (QbPL) provide information about Nicholas Townsend. One document is apparently a listing of Townsend's estate which was sold at vendue in 1776. Among his effects were numerous axes, jointers, saws, several lots of "tools," four workbenches, planes, chisels, files, and turning tools. Other documents record charges for Townsend's work, notably £3 12s. for "Sunderes Done on a chair" and for "lether for wings and cheek peses." In 1769, Joseph Lawrence, a merchant, recorded in his account book (LIHS) two separate purchases of twenty-eight "weels" and twelve "spinning wheels" from Townsend, thus specifically documenting Townsend's activity as a joiner and a turner.

Travally [Trevally], Thomas (– 1687), Southampton
The inventory of Travally's estate (Court of Sessions, SCCO), itemizes many woodworking tools, particularly cooper's tools. Off-shore whaling was an important industry in seventeenth century Southampton, and it is not surprising to find several craftsmen there who

practiced coopering to supply the barrels necessary for the whale oil trade. In all probability, these craftsmen could build houses and make furniture as well.

Travally's estate included the following items: "one thousand and of staves at ye end of the shop/ 500½ & 20 pieces of hewed heading & 100¼ of unhewed/ 1100 of staves by the gate/ a chest with lock & key/ 2 Joynters, one 6s, ye other 4s/ 2 croase stacks & Irons 4s/ 2 howells 8s to 1 ax 12s/ Compasses & Crusset 18s/ . . . 2 spoke shave 3s/ . . . a round shave 18s/ another ditto 2s/ the best heading knife 4s/ 2 old ditto 4s/ a drawing knife 4s 6d/ 2 old drawing knives 4s/ another ditto 3s 2 Adses 10s/ a plaine Iron 18d/ . . . a spike 6d/ a jak plaine stock 2s/ truss hoops 10s/ a hand saw 8s/ a brest wimblestock 18d/ a long boarer 5s/ . . . to ½ a Cross cut saw 5s/ to the shop 40s/ . . . a grind stone 5s."

Trim, Christopher (–1797), Huntington
Among the items listed in the inventory of Trim's estate (SCSC) were carpenter's tools including a vise, axes, a grindstone, two handsaws, a fine saw, a compass saw, a jointer, a fore plane, a jack plane, a smoothing plane, an adze, augers, gouges, and gimlets.

Tymmer, Klas (active ca. 1663), Flatbush
A Flatbush town account for 1663 (FbTR) notes a payment of 112 guilders to Tymmer for "laying the ceiling and hanging the bell and making the reader's seat" for the church.

Underhill, Samuel (active ca. 1810), Brooklyn
On April 5, 1810, a notice of the dissolution of the firm of Samuel Underhill & Co. appeared in the *Long Island Star.* Underhill and his associates offered for sale "their valuable stock in trade, consisting of a quantity of elegant furniture, manufactured of the best mahogany" as well as "a quantity of manufactured mahogany, together with a variety of materials useful to Cabinet Makers."

Vail, Thomas (1734–1801), Southold
Henry Vail writes in the family genealogy, entitled *Vail Family,* that Thomas Vail learned carpentry and joinery when he was fifteen years old, just after his parents died. The inventory of his estate (SCSC) documents his ownership of planes, chisels, squares, gouges, a drawknife, a hammer, and "old iron & Sundries in a chest," and thus confirms that he was a carpenter. A notice in the *Suffolk County Herald* for September 4, 1802, announced the sale of several saws from the estate of Thomas Vail, "late of Southold, carpenter, deceased."

Van Dwyn, Gerret (–1706), New Utrecht
The inventory of Van Dwyn's estate (NYHS) reveals that he was a carpenter and wheelwright. He owned at the time of his death "carpenters & wheel wright Tooles" and twelve wheels "not yet made up."

Van Ekelen, Albert (active ca. 1684), Flatbush
As recorded in an apprenticeship indenture of 1684 (FbTR), Albert Van Ekelen apprenticed himself to Jan Poppen, mentioned above, to learn the trade of chair and wheel turner.

Van Nostrand, Aaron, Sr. (–ca. 1751), Hempstead
The source of information about Aaron Van Nostrand and his sons, Aaron and John, mentioned below, is Stoutenburgh, *Dutch Reformed Church.* Aaron, Sr., was born in Albany but was apparently living in Flatbush by 1693. He and his family had moved to Hempstead by 1715 and he was living there at the time of his death. In his will proved in 1751 he called himself a turner.

Van Nostrand, Aaron, Jr. (–ca. 1764), Jamaica
According to Stoutenburgh, *Dutch Reformed Church,* Aaron Van Nostrand, Jr., of Jamaica, the son of Aaron, Sr., of Hempstead, called himself a turner in his will proved in 1764. He left each of his daughters a linen wheel, probably of his own manufacture.

Van Nostrand, Anthony (–1802), Oyster Bay
The inventory of Van Nostrand's estate (QCSC) indicates that he was a capable craftsman engaged in a variety of woodworking activities. The inventory mentions a wagon house, an old shop, and a "new shop chamber." These shops contained quantities of unspecified types of wood. He also owned a turning lathe, a workbench, and an assortment of saws, files, chisels, gouges, hammers, planes, jointers, augers, and drawknives.

Van Nostrand, Isaac (–1829), Flushing
Judging from the inventory of his estate (QCSC), Van Nostrand was a wheelwright, a carpenter, and possibly, a joiner. In addition to tools, he owned a number of wagon parts. The total value of his estate was $288.25.

Van Nostrand, Joseph H. (1806–1851), Brooklyn
According to Stoutenburgh's *Dutch Reformed Church,* Joseph was the son of John and Sarah (Hewlett) Van Nostrand. On August 10, 1826, Joseph announced the termination of his partnership in a chair manufactory with William V. Smith in the *Long Island Star.* Calling himself a "Carpenter and Joiner," he advertised in the *Star* for October 19, 1826, the opening of his shop "in the rear of 74 Fulton Street." He stated that he would make "furniture of all descriptions, Book Binders, presses, Printing Presses, stands, sewing benches, Jullers presses, copperplate presses," and coffins. By June 21, 1827, when he advertised again in the *Star,* he had entered into another partnership, Van Nostrand, Rogers and Co., which operated a chair store at 14 Hicks Street.

Van Nuyse, Jan Auckes (active ca. 1678–1710), Flatbush/Jamaica
In 1678, Van Nuyse and Rut Albertse, mentioned above, entered into an agreement (FbTR) to build a parsonage house in Flatbush. According to the terms of the agreement, they were to finish part of the interior and also make "a bedstead and a four poster." Bergen states in *Kings County* that Van Nuyse later moved to Jamaica and was living there in 1710.

Van Sindern, Ulfranus (–1804), Flatlands
Among Van Sindern's personal effects, as itemized in the inventory of his estate (KCSC), were a chest of joiner's tools, a chest of drawers, "1 lot of boards and timber," and a hundred cedar rails.

Van Wyck, Samuel (–1831), North Hempstead
The inventory of Van Wyck's estate (QCSC) suggests that he was a carpenter and a joiner. Among his possessions were a turning lathe, planes, augers, gimlets, chisels, saws, squares, a "cooper scrape," mallets, a drawknife, a paint stone, bedstead timber, a window frame, and window sash.

Waldron, I. [Johanes?] (active ca. 1759), Queens County/ [Flushing?]
Probate records for the estate of Jacobus Lott (LIHS) include a document describing a payment to Waldron "for work to a spinning wheele." This craftsman was probably Johanes Waldron who identified himself as a turner when he witnessed the will of Peter Leffertse in 1774 (NYHS *Abstracts,* XI).

Ward, John (active ca. 1682), Brookhaven
Ward entered into an agreement with the town of Brookhaven (BhTR) to build a "good sufissiant substantiall pulpett handsom panell fashon sett . . ." with "a handsom canape above hed." This important commission suggests that Ward was one of the more skilled craftsmen in the town and that he was capable of making furniture.

Wareing, Michael (active ca. 1711–1712), Huntington
One can find evidence of Wareing's craft activities in the account book of Henry Lloyd I (LIHS). Wareing helped make the frame for Lloyd's house, still standing on Lloyd's Neck, in 1711. The following year he made a "bedsted" for one of Lloyd's slaves, Oboum.

Warner, Everadus (active ca. 1801), Brooklyn
On November 18, 1801, an advertisement appeared in the *Long Island Courier* illustrating a windsor chair and informing the public that Warner, the subscriber, conducted his chair-making business "in its various branches, at his manufactory, opposite the Brooklyn Printing-Office."

Weaber, William (–1806), Flushing
Weaber seems to have worked as a nurseryman and a joiner. The inventory of his estate (QCSC) documents his ownership of "2 thirds of a nursary on the property of David Gardiner" and "1 Nursery on property of Samuel Van Wycks." At the time of his death he also owned a turning lathe, turner's tools, a workbench, four drawknives, a paint stone, an oil stone, a glue pot, eight gimlets, "files and sundries," two squares, two braces with bits, three guages, eleven augers, two handsaws, two broadaxes, a frame saw, and more than fifty planes. Listed with the woodworking tools were "2 sets of bedsted stuff," a "Box of draws," a cupboard, and "1 Box with Gold leaf."

Weekes [Weeks], Henry (active ca. 1700–1744), Oyster Bay
The inventory of Weekes' estate (Deed Liber C, CROJ) shows clearly that he was a farmer but he also owned a lathe, turning "utensils," several gouges, four gimlets, three augers, wimble bits, a square, and a hammer. In land indentures of 1700, 1713, and 1718 (OBTR) Weekes called himself a carpenter.

Weeks, Daniel (active ca. 1697), Oyster Bay
The inventory of the estate of John Newman (QCHDC) records a debt to Weeks for making Newman's coffin.

Weeks, Joseph S. (active ca. 1829–1832), Brooklyn
A notice in the *Long Island Star* for June 4, 1829, announced the establishment of Weeks' shop at 11 Hicks Street. Weeks planned to have on hand or make to order "sideboards, secretaries, bureaus, tables, washstands, bedsteads, etc." He stated that he would handle "all orders from the country" and pack items for shipping. Spooner's *Brooklyn Directory* for 1829 verifies the address given in the newspaper. An advertisement in Bigelow's *Directory* for 1832, however, documents Weeks' new partnership with Bazillai Russel, mentioned above.

Weeks [Weekes], Samuel (active ca. 1789–1827), Oyster Bay
In January, 1793, Robert Townsend of Oyster Bay credited Weeks for a spinning wheel, as recorded in an entry in Townsend's day book (EHFL). Again, in March 1794, Townsend paid Weeks for mending a chair. Another Oyster Bay account book (SPLIA), apparently kept by Robert F. Underhill, contains an entry crediting Weeks for the repair of seven chairs in 1827. Weeks is identified as a "C.

Maker," probably a chair maker or cabinetmaker, on an Oyster Bay assessment list for 1789 (EHFL).

Wells, Daniel, Jr. (active ca. 1810), Riverhead
A Riverhead town account (RTR) for 1810 records a payment to Wells for making a coffin.

Wells, Elisha (1766–1849), Aquebogue
A copy of Wells' account book (SCHS), dated 1788–1848, offers some evidence that he was a woodworking craftsman. He repaired parts for a wagon and fashioned turned knife handles. He was probably trained by his father, Micah Wells, mentioned below.

Wells, Jonathan (active ca. 1814–1827), Southold
Entries documenting Wells' purchase of nails, plane irons, hinges, and "butts & screws" between 1814 and 1827 appear in the store account book kept by Samuel S. Vail of Southold (NYHS). These purchases suggest that Wells was a woodworking craftsman.

Wells, Micah (1733–1790), Aquebogue
A transcription of Micah Wells' account book (SCHS) documents his woodworking activities from 1754 to 1787. It is clear from this record that Wells made furniture, specifically chairs, "grate" chairs, tables, chests, cases of drawers, bedsteads, cradles, a bookcase, and a desk. Although there is no evidence in the account book that he built houses, he did make doors and window sash. In addition there are numerous references to "turning" and "cooper stuf" in his accounts.

Much Long Island furniture was painted and Wells frequently mentioned the "cullering" of tables and "blacking" of chairs. Chairs were among the least expensive pieces of furniture Wells made. He generally charged about 2s. 6d. for a chair. Chests ranged in price from 1s. to 10s. and a chest of drawers from 19s. to £4 5s. The single most expensive item noted in the accounts was a case of drawers made in 1756 for the "widow" Mary Youngs of Southold. Wells charged £4 10s. for this piece.

Wells later married a Mary Youngs, probably of Southold, and thus established a connection with the Youngs family. Wells' account book contains a number of references to "work for rufus" between 1764 and 1768, and it is possible, given family ties, that Rufus Youngs, mentioned below, apprenticed with him. Wells and Youngs were certainly acquainted, for they both witnessed the will of Rufus Downs in 1769 (*N.Y. Wills*, SCSC).

Weston, Valentine W. (active ca. 1816), Brooklyn
Weston placed an advertisement in the June 12, 1816 issue of the *Long Island Star* announcing his business in "Chairs and Cabinet Work." Weston stated his intention to keep in stock "fancy and every other description of chairs of the first quality." He noted that he repaired and painted "old work" and performed such related services as "ornamental painting, lettering and gilding."

Whaley, Thomas (–1821), Queens County
The personal property itemized in the inventory of Whaley's estate (QCSC) included woodworking tools, a screw bench, a workbench, wagon and boat timber, and cedar boards.

Wheeler, Ebenezer (active ca. 1810–1819), Smithtown
Entries describing Wheeler's woodworking activities appear in the account book of Caleb Smith (SmHS). In 1810, Wheeler laid a floor for Smith and several years later, in 1815, he worked "on the house," made a sled and sides for a wagon, repaired a "garden fence," and made a desk for the schoolhouse.

Whippo, James (active ca. 1752–1753), Oyster Bay
An Oyster Bay land indenture of 1752 (OBTR) documents Whippo's purchase of a dwelling house and adjacent craft shop from William Stoddard, a joiner of Oyster Bay. Whippo is identified as a joiner in this indenture and in a second land indenture dated 1753 (OBTR).

White, John (–1662), Southampton
In his will (ShTR) White left each of his daughters a chest that he had made for them. The inventory of his estate lists "Carpenters tools" and "turning tools," thus providing additional evidence of his wood-working capabilities. The total assessed value of his estate was £885 8s., a very substantial sum, and most of his wealth was in land and livestock.

Wickham, Isaac (active ca. 1791–1825), East Hampton
There is substantial evidence that Wickham made furniture and coffins. According to an entry in Jonathan Mulford's account book (EHFL), Wickham made a "seat" and a chest in 1791. John Lyon Gardiner recorded in his account book (EHFL) separate payments to Wickham for a knife box and a table in 1792 and 1793. Wickham also supplied Gardiner with a coffin for a "servant woman" in 1802, as noted in Gardiner's day book (EHFL). An entry in David Hedges' account book (EHFL) documents Hedges' payment to Wickham for a coffin in 1799.

The inventory of Wickham's estate (SCSC) lists "Sundry joiners planes, . . . Sundry carpenters tools—gimblets—chisels—files etc.," and a joiner's bench along with a number of locks, latches, hinges, window lights, and other woodworking supplies. It seems likely, however, given the length of this inventory—ten pages—and the variety of goods listed in quantity, that Wickham was operating a store at the time of his death.

Williamson, David (active ca. 1789–1814), Southold
The inventory of Williamson's estate (SCSC) describes the contents of his shop as follows: "1 grindstone/ 1 Tenon saw / 12 Moulding planes/ 10 chissels, 1 Rasp, 2 Gimblets, 1 Pencers/ 1 Breast whimble & 2 Bits/ 4 Handsaws, much worn some of them/ 3 Jointers & 4 Playnes/ 2 Old squares & 1 crooked knife/ 2 Baskets, 1 Frow, 1 Beetle, 4 wedges/ 2 Carpenter's Addz./ 8 Augers/ 1 broad Ax, 3 narrow D⁰ & 1 holing D⁰/ sundries of Timber in the shop/ Sundries of Old paint cups & oil Bottles/ 3 Chissels, 2 Gouges & 1 Carpenters plow / 8 Moulding planes/ 1 Shaving Horse for shingles." According to entries in a Franklinville store ledger (SCHS), Williamson purchased a number of tools, including files, a saw, gimlets, and several augers, between 1789 and 1798. He apparently paid for his purchases with "work on mill and cheese press," and with "work by his prentice."

Williamson, Jedediah (active ca. 1788–1837), Stony Brook
Williamson's account book (Museums at Stony Brook) documents his work as a carpenter, joiner, and wheelwright from 1788 through 1833. In addition to making numerous coffins, he undertook the repair and construction of furniture, plows, wheelbarrows, "woling" wheels, and other tools. Over a three year period, beginning in 1799, he made a pine table, a cherry stand, two bedsteads, and two chests for Tabitha Davis.

Several entries, such as those debited against the account of George Hallock in 1804, indicate that Williamson was also a house carpenter. For Jonas Hawkins, whose house and barn (the Hawkins-Mount house) still stand, Williamson built a wash-house, repaired the barn, and removed a sawmill. Other entries refer to wagon-making, sled-making, and wheel-making. Williamson mentions two appren-

tices, Samuel and Timothy, in the account book, but gives no other evidence of their identity. Williamson died in 1837.

Willmott, Alexander (active ca. 1697–1721), Southampton
According to a land indenture of 1697 (ShTR), Willmott, then of New Haven, Connecticut, purchased a house in Southampton and, presumably, moved there in that year. An East Hampton town account for 1698 (EHTR) places Willmott in the area the following year and identifies him as "ye Joyner." In his will proved in 1721 (NYHS *Abstracts,* II) Willmott called himself a joiner and left "his part of the Water Mill" to his son, Walter. At the time of his death he also owned land in New Haven.

Wind, Samuel (active ca. 1675), Southold
The inventory of the estate of Joseph Youngs (*Court of Sessions,* SCCO) lists a debt to Wind for making a coffin for the deceased.

Woodhull, James (active ca. 1809), Setauket
See Lewis F. Greene, mentioned above.

Woodward, _____ (active ca. 1819), Sag Harbor
Woodward is known only from his advertisements in the *American Eagle and Suffolk County General Advertiser* during 1819. He was in partnership with Nathan Tinker, and on February 6, 1819, they informed the public "that they continued the Cabinet Making business." Among the types of furniture advertised were sideboards, bureaus, desk and bookcases, sofas, clock cases, lolling chairs, and "Dining, end, card, pembrook, Toilet, breakfast and dressing tables." The final advertisement placed jointly by Woodward and Tinker on August 7, 1819, suggests the problems encountered by nineteenth century Long Island craftsmen:

It is a ridiculous idea of the people in this vicinity that they can purchase handsomer and cheaper furniture in New York than they can in Sag Harbors. It is a fact that most of the furniture sold in New York is made in the country indeed the most of our work is sent to New York and people from this vicinity will go to New York and there give thirty five dollars for the same bureau that was offered them here for thirty dollars and other furniture in the same proportion.

Woolley, Henry (active ca. 1770), Oyster Bay
A receipt dating from the 1770's in the Mott-Appleby collection of receipts (NCHM) documents a payment to Woolley for a coffin.

Worth, Laban (active ca. 1792–1814), Brookhaven
Worth was a carpenter and possibly a furniture maker. One can find documentation of his skill as a carpenter in Abraham Woodhull's account book (EHFL) which demonstrates that Worth worked more than seventy days on Woodhull's new house in 1792. Among the items listed in the inventory of Worth's estate were a "turning lathe and tools" valued at $35.00, carpenter's tools worth $30.00, two workbenches, and "jugs and painting cups." The number of tools he owned was probably extensive since his contemporary, John Sweezey, owned a lathe and carpenter's tools appraised at only $4.00 and $3.00, respectively. Worth apparently died intestate and Austin Roe, the Setauket cabinetmaker, served as the administrator of his estate. In 1816, Roe arranged an auction to sell Worth's farm, house, and carpenter's shop, as noted in an undentified newspaper clipping of that date (Roe Family Papers, EHFL).

Wright, Jesse (–1816), Oyster Bay
The inventory of Wright's estate (QCSC) lists wagon spokes, sleigh runners, and wagon sides, thus documenting some of the products

of Wright's shop. Yet, the number and variety of tools he owned suggests a broad range of woodworking skills. Wright called himself a carpenter in his will proved in 1816 (QCSC), however, as the following excerpts from his inventory suggest, he was probably active as a joiner as well. Among his tools and supplies were:

3 Broad axes	$—4.50
1 Adze	0.07
6 [?] Augurs	1.25
2 Screw Augurs	1.00
3 fine Saws	3.00
1 hand Saw	1.00
1 bow Saw	1.25
3 new planes	4.00
1 Jointer & 3 fore planes	4.50
2 Jack planes & 3 smoothing planes	2.50
1 rounding Adze and plane	1.25
1 plow plane and 8 Irons	5.00
1 Philaster D⁰	2.50
1 pair plank groves	2.50
1 pair hallows and rounds	0.75
1 Philaster	0.50
1 Pair hallows & rounds	0.25
1 Sash plane	1.50
1 pair Groving Planes	1.00
1 Ogee Ditto	0.75
1 Ogee & Beed	1.00
2 pair small hallows and rounds	1.75
1 Cove and Beed	1.00
1 Croko and Beed	1.25
1 half round	0.75
1 old Ogee	0.25
4 Beed planes	3.00
1 Rabit plane	0.37
1 small hallow & round	0.25
12 pine plank @ 3/ each	4.50
2 Setts waggon Spokes	6.00
Plow Timber	3.25
10 Block tongues 1 axletree 4 Bolsters	5.37
1 pair Sleigh Runners, Slats, beams etc.	3.00
2 pair waggon sides	10.00
1 Lott of cut boards	0.75
1 Screw for work bench	1.00
1 work bench for carpenter	1.25
2 saw benches and 1 spoke bench	0.75
1 two inch pine plank	0.75
2 Oak plank for fellow stuff	1.25
1 turning Lathe & wheel bench	2.50
14 Plow mold boards	3.50
1 Small Croks and Beed	0.75
1 Reeding plane	1.50
1 pair old hallows & rounds	0.25
2 old mouldings	0.25
1 Brace and Bit	8.00
7 ——hand saw files & one half round	0.28
4 pair butt hinges, & screws and brads	1.12
2 Oil Stones	1. 0
3 Chalk lines and spools	0.50
1 Lott old Gimblets, punches, saw setts etc.	0.75
1 Glue Pot & Glue	0.75
2 Iron Squares	0.62
3 Steel blades Ditto	2.25
3 pair Chissels	1.25

1 new Ditto	0.31
4 Ducks bill Ditto	1. 0
14 paring chisils	1.75
17 Gouges, 1 Raspe & rat tail file	2.00
3 Squares and 1 Bevel	0.25
7 Gages	0.75
1 Dowel Iron	0.25
2 Screw drivers	0.37
1 Drawing knife, lathing hammer & spoke shaver	0.62
1 Scraper, Dog & Mallet, & small Oil jug	0.25
1 Box of old Gimblets, Gages etc.	0.25
1 hammer and brush	0.50
1 narrow ax	0.50
1 Cross Cut Saw	2.00
1 Large tool Chest	4.00

Wright, Stephen (active ca. 1792), Oyster Bay
Robert Townsend, the son of Samuel Townsend of Oyster Bay, noted in his day book (EHFL) in an entry dated March, 1792, that Sarah Townsend and her family owed Stephen Wright for "mending chairs."

Wright, William (active ca. 1796), Oyster Bay
Among the probate records for the estate of Samuel Townsend of Oyster Bay (EHFL) is a loose sheet, dated May 12, 1796, which records Townsend's debt of £ 7 4s. to Wright "for his accot. of making two Bureaus."

Wyckoff, Folkert (–1814), Bushwick
The inventory of Wyckoff's estate (KCSC) suggests that he ran a small farm, probably with the help of the three slaves in his service. However, he also owned "carpenters tools" valued at $100.

Youngs, Henry (–1830), Brooklyn
The inventory of Youngs' estate (KCSC) includes an extensive listing of woodworking tools suggesting that Youngs was an active carpenter and joiner. Selections from the inventory follow.

one lot of carpenters tools sold previous to the above date appraised at	[$] 12	22
1 broad ax	2	25
1 sash saw and whet stone		68
1 wooden square		50
1 pannel gouge		25
2 pair of hollows & rounds	7	
1 gutter plane		10
1 ⅜ astringe plane		37
1 goltick [gothick]		50
1 rabit plane		50
1 ¾ match plane		37
1 sash plane	1	25
1 ⅞ fancy moulding plane		75
1 ½ inch ovoll plane		37
1 hollow smothing plane		62
1 fore plane		62
1 bevel		18
1 Jack pillister		50
1 Jointer plane		50
1 smothing plane	1	50
1 mallet		50
1 [?] or key hole saw	1	50
2 gauges		25

		
1 gauge		25
1 1 inch framing chisel		25
4 small frame chisels		37
1 reviting hammer		44
3 mortising chissels		25
1 2 foot rule		75
1 twelve inch still blade square		62
5 parr compasses		25
1 lot of nail punches		12
1 small paint brush		12
2 scrapers		12
1 lot small files		12
1 screwdriver		12
1 saw set		6
1 plum line		6
1 bulett mould		6
1 turning saw		12
1 fore plane		75
1 malit		25
1 one inch auger		25
1 ½ inch auger		37
1 ⅜ inch auger		37
1 ¼ inch patent auger		50
1 drawing knife		25
½ inch framing knife		50
½ inch framing chisel	1	25
adds		31
1 screwdriver		25
1 two inch framing chisel		2
1 spike gimblet		25
½ inch framing chisel		68
1 lot of large flat files		25
1 lot of cold chissels		12
1 gauge		6
1 brad awl 2 gimblets		25
2 small turkey oil stones		62
1 lot old iron		50
1 1¼ patent auger		50
1 1½ patent auger		50
2 tool boxes		12
1 tool box		18
1 2 foot square	2	25
1 " " "	2	25
1 tool chest	2	50
1 tool chest	2	25
1 tool chest	1	50
1 bench saw		75

Youngs, Joseph (1756–1837), Franklinville/Eatonville, New York
Selah Youngs in *Youngs Family* identifies Joseph as a "carpenter by trade." Born in Franklinville, Joseph left Long Island during the Revolution and married Chloe Griswold of Killingworth, Connecticut, in 1781. By 1796, he had moved to Eatonville, in Fairfield Township, New York, where he operated a cabinetmaking shop and a grist mill. He may have learned his trade on Long Island from Rufus Youngs or other Youngs family woodworkers.

Youngs, Rufus (active ca. 1769–1828), Riverhead
Selah Youngs in his genealogy entitled *Youngs Family* mentions a Rufus Youngs, son of Daniel Youngs, born in 1748 and a second Rufus Youngs born in 1760. There is apparently a mistake in the recording of birthdates in this source. The primary sources strongly suggest the existence of only one Rufus Youngs, a carpenter and

joiner, who was active in the Riverhead area as early as 1769 and who died in 1828. This craftsman was no doubt the Rufus Youngs whom Selah Youngs describes as a "carpenter and cabinet maker" residing "on the North Road" in Riverhead.

When Youngs witnessed the will of Rufus Downs in 1769 and the will of Ezekiel Petty in 1786 (*N.Y. Wills,* SCSC), he called himself a carpenter. He witnessed Downs' will with Micah Wells, mentioned above, and this evidence strengthens the assumption suggested by the entries referring to "rufus" in Wells' account book, that Rufus Youngs apprenticed with Micah Wells.

Between 1788 and 1798, Youngs was a frequent customer at a store near Riverhead and the store ledger (SCHS) documents his repeated purchases of table hinges, "brasses," and locks. Youngs also bought nails, screws, "2 lites of window glass," and, on one occasion, a bottle of varnish. It seems clear from this evidence that he was making furniture. The inventory of his estate (SCSC), which lists only small amounts of livestock and produce and joiner's tools worth just $4.00, is given below.

	
grane growing	$12.00
hay	42.00
stalks & straw	4.00
wheat & rye	26.00
Corn	22.00
flax	6.00
2 cows	36.00
3 young cattle	18.00
sheep	11.25
hogs & shoats	27.00
swine	30.00
Joiners tools	4.00
Chains Clevis Shovel Spade/ forks & hoe Bettle rings/ old [?]	3.25
	$241.50

Youngs, Thomas, Sr. (ca. 1645–1720), Oyster Bay
In his Youngs family genealogy, Selah Youngs mentions that Thomas Youngs, Sr., of Oyster Bay, leased to his sons, Thomas and Richard, his house and farm in 1670. According to the genealogy, Youngs also allowed his sons the use of the following tools:
 . . . two broad chisels, two narrow chisels, one saw, two adze, compasses, one inch and a half auger, three lesser augers, one bung borer, one presser bit, one mattock, one crosscut saw, one new file, a beetle, three wedges, one saw set, two great clevices with the bolts, two lesser clevices with the bolts.
Several years later, in 1687, Youngs was granted permission to spin rope yarn and make rope "up the Hollow by his shop on ye Commons."

Youngs, Thomas (1763–1838), Franklinville
In the same Franklinville store ledger (SCHS) which provides information about Rufus Youngs, there is also evidence of Thomas Youngs' craft activities. Between 1794 and 1799, he purchased a hand saw, "brass handels," chest locks, "Scutchins and locks," glue, hinges, screws, and sets of table hinges, thus indicating that he made furniture. Selah Youngs in *Youngs Family* states that Thomas was a "cabinet maker and farmer" who inherited his father's farm in Franklinville and "lived and died there."

Youngs, Waite (ca. 1712–1736), Southold
As noted in the inventory of his estate (QCHDC), Youngs owned only "Joyners tools" and clothing. Selah Youngs in *Youngs Family* notes that he was the son of John Youngs of Southold.

APPENDIX II
LONG ISLAND SILVERSMITHS, CLOCKMAKERS, WATCHMAKERS, AND PEWTERERS, 1640–1830

A. LIST OF CRAFTSMEN

Name	Occupation	Date	Location	Birthplace	Age	Document	Source
*Adams, Nathan	Watchmaker/ Engraver	1808	Sag Harbor	—	—	Advertisement, *Suffolk Gazette,* Nov. 26, 1808	EHFL
Allen, Isaac B.	Jeweler	1826	Brooklyn	—	—	Spooner, *BD*	—
Barker, Brian B.	Watchmaker	1787–1802	New York City/ Brooklyn	—	—	Longworth, *NYCD,* 1802 —	— Darling Foundation, *Silversmiths*
Barnes and Olmstead	Watchmakers	1829	Brooklyn	—	—	Spooner, *BD*	—
Bliss, Jonathan	Pewterer	1822–1823	Brooklyn	—	—	Spooner, *BD*	—
*Byram, Ephraim N.	Clockmaker/ Joiner	b. 1809– d. 1881	Sag Harbor	—	—	—	Thompson, *History of Long Island*
						Advertisement, *The Corrector,* Jan. 18, 1834	EHFL
						—	Holsten, "Byram Account Book"
*Carman, Samuel	Clockmaker/ Watchmaker/ Goldsmith	1818–1826	Brooklyn	—	—	Advertisements *Long Island Star,* June 10, 1818, June 21, 1821, July 3, 1823	LIHS
						Spooner, *BD,* 1824–1826	—
*Coleman, Benjamin	Silversmith/ Blacksmith	1802– d. 1820	Sag Harbor	—	—	Advertisements, *Suffolk County Herald,* Oct. 18, 1802	EHFL
						Suffolk Gazette, Dec. 21, 1807	EHFL
						John Lyon Gardiner AB	EHFL
						John Lyon Gardiner DB	EHFL
						Samuel S. Vail AB	NYHS
						Inventory	SCSC
Coles and Hart	Watchmakers/ Gunsmiths	1830	Hempstead	—	—	Advertisement, *Long Island Telegraph and General Advertiser,* May 6, 1830	LIHS
Coles, Jacob	Watchmaker/ Gunsmith	1830	Hempstead	—	—	Advertisement, *Long Island Telegraph and General Advertiser,* May 6, 1830	LIHS
*Conklin, Charles J.	Silversmith/ Gunsmith/ Watchmaker/ Jeweler	1832–1837	Sag Harbor	—	—	Advertisements, *The Corrector,* July 14, 1832, Sept. 30, 1837	EHFL
*Conkling, William Sherrill	Silversmith	bpt. 1779– d. 1832	Southampton	—	—	Elias Pelletreau AB	EHFL
						—	Rattray, *East Hampton History*
						—	Failey, "Elias Pelletreau"
*Davison, Clement	Watchmaker/ Silversmith/ Jeweler	1822–1829	New York City/ Brooklyn	—	—	Advertisements, *Long Island Star,* Sept. 25, 1822, March 27, 1828	LIHS
						Spooner, *BD,* 1822–1826, 1829	—
Deane, James	Silversmith	1759	Queens County	Ipswich, Massachusetts	23	Muster roll, 1759	NYHS *Collections,* 1891
*Dominy, Felix	Clockmaker/ Carpenter/ Joiner	b. 1800– d. 1868	East Hampton	East Hampton	—	—	Hummel, *With Hammer in Hand*

Name	Occupation	Date	Location	Birthplace	Age	Document	Source
* Dominy, Nathaniel IV	Clockmaker/ Joiner	b. 1737 – d. 1812	East Hampton	East Hampton	—	—	Hummel, *With Hammer in Hand*
* Dominy, Nathaniel V	Clockmaker/ Joiner	b. 1770 – d. 1852	East Hampton	East Hampton	—	—	Hummel, *With Hammer in Hand*
* Elliot, Zebulon	Clockmaker/ Watchmaker/ Silversmith	1822 – 1846	Sag Harbor	—	—	Advertisements, *The Corrector,* Aug. 3, 1822, Nov. 20, 1824, May 2, 1825, Nov. 19, 1825, Aug. 19, 1826, May 16, 1829, June 6, 1846	EHFL
Fordham, Merrit	Silversmith	1827 – 1833	Brooklyn/ New York City	—	—	Nichols, *BD* —	— Darling Foundation, *Silversmith*
* Gray, James	Clockmaker/ Watchmaker/ Machinist	1821	Brooklyn	—	—	Advertisement, *Long Island Star,* June 14, 1821	LIHS
* Griffen, Peter	Silversmith	1810	Queens County	—	—	Henry Demitt AB —	NCHM Darling Foundation, *Silversmiths*
Hart, Benjamin	Watchmaker/ Gunsmith	1830	Hempstead	—	—	Advertisement, *Lond Island Telegraph and General Advertiser,* May 6, 1830	LIHS
* Hedges, David	Silversmith	b. 1779 – d. 1857	East Hampton	—	—	John Lyon Gardiner AB John Lyon Gardiner DB —	EHFL EHFL Rattray, *East Hampton History*
* Hedges, John Chatfield	Silversmith	b. 1770 – d. 1798	East Hampton	—	—	John Lyon Gardiner DB —	EHFL Rattray, *East Hampton History*
Howell, David	Goldsmith	1775	Southampton	—	—	Will of William Smith, 1775	NYHS *Abstracts,* VIII
* Howell, Silas	Silversmith	1761	Southampton	—	—	Elias Pelletreau AB	EHFL
Hutchinson, Thomas	Silversmith	1778	Southold	—	—	Suffolk County inhabitants, 1778	*NYGBR,* 1973
* Hutton, John	Silversmith	[b. 1684?] – 1735	[New York City?]/Oyster Bay [Philadelphia?]	—	—	Land indenture, 1735 —	OBTR Darling Foundation, *Silversmiths*
Iagoe, Henry	Silversmith	b. 1716 – d. 1761	Kings County	Dublin, Ireland	44 (in 1760)	Muster roll, 1760 —	NYHS *Collections,* 1891 Darling Foundation, *Silversmiths*
Jennings, William	Silversmith	1826	Brooklyn	—	—	Spooner, *BD*	—
* Jular, George	Silversmith/ Clockmaker/ Watchmaker	1811	Sag Harbor	—	—	Advertisement, *Long Island Star,* Dec. 25, 1811	LIHS
* King, Henry N.	Clockmaker/ Watchmaker	1807 – 1811	Sag Harbor/ Brooklyn	—	—	Advertisement, *Suffolk Gazette,* Dec. 21, 1807 Advertisement, *Long Island Star,* Sept. 20, 1810 Longworth, *BD,* 1811	EHFL LIHS —

Name	Occupation	Date	Location	Birthplace	Age	Document	Source
Lightfoot, James	Silversmith	b. 1726–1758	New York City/Queens County	England	32 (in 1758)	Muster roll, 1758 —	NYHS *Collections*, 1891 Darling Foundation, *Silversmiths*
*Lowe, John	Silversmith/Watchmaker/Jeweler	1826–1830	Brooklyn	—	—	Advertisement, *Long Island Star*, Nov. 23, 1826 Spooner, *BD*, 1829 Nichols, *BD*, 1830	LIHS — —
McDaniel, Peter	Silversmith	b. 1722–1760	New York City/Suffolk County	England	38 (in 1760)	Muster roll, 1760 —	NYHS *Collections*, 1891 Darling Foundation, *Silversmiths*
McKinney, John	Watchmaker	1811	Brooklyn	—	—	Longworth, *NYCD*	—
*Malcom, Hugh	Silversmith	1791	Southold	—	—	Advertisement, *Frothingham's Long Island Herald*, Dec. 17, 1791	EHFL
Olmstead and Barnes	Clockmakers	1829	Brooklyn	—	—	Spooner, *BD*	—
Peale, Henry	Pewterer	1823	Brooklyn	—	—	Spooner, *BD*	—
*Pelletreau, Elias	Silversmith	b. 1726–d. 1810	Southampton	—	—	Pelletreau papers Elias Pelletreau AB Elias Pelletreau ABs —	LIHS LIHS EHFL Failey, "Elias Pelletreau"
*Pelletreau, Elias, Jr.	Silversmith	b. 1757	Southampton/New York City	—	—	—	Failey, "Elias Pelletreau"
*Pelletreau, John	Silversmith	b. 1755–d. 1822	Southampton	—	—	Elias Pelletreau ABs Elias Pelletreau AB Inventory —	EHFL LIHS SCSC Failey, "Elias Pelletreau"
Pelletreau, William Smith	Silversmith	b. 1786–d. 1842	Southampton/New York City	—	—	—	Darling Foundation, *Silversmiths*
*Pierson, Daniel	Goldsmith	1791	Sag Harbor	—	—	Advertisement, *Frothingham's Long Island Herald*, Aug. 30, 1791	LIHS
*Potter, Nathaniel	Silversmith	b. 1761–d. 1841	Huntington	—	—	Nathaniel Potter DB Letters of administration, unidentified estate, 1790 Potter genealogy	HHS SCSC HHS
Pressag, John	Watchmaker	1830	Brooklyn	—	—	Nichols, *BD*	—
*Prince, Benjamin	Silversmith	1770–1789	Southold	—	—	John Paine AB Suffolk County inhabitants, 1778 Advertisement, *Frothingham's Long Island Herald*, Dec. 13, 1791	Colonial Institute Records, SUSB *NYGBR*, 1973 LIHS
Prince, Joseph	Silversmith	1774	Southold	—	—	Will of Robert Hempstead, 1774	*N.Y. Wills*, SCSC
*Roe, Walter	Silversmith	b. 1770–d. 1827	Flushing	—	—	Inventory —	QCSC Torrey, *David Roe of Flushing*

Name	Occupation	Date	Location	Birthplace	Age	Document	Source
*Sayre, Caleb	Goldsmith/ Jeweler	b. 1764– d. 1847	Southampton/ Seneca County, New York	—	—	—	Banta, *Sayre Family*
*Sayre, Joel	Silversmith	b. 1778– d. 1818	Southampton/ New York City	—	—	—	Banta, *Sayre Family*
*Sayre, John	Silversmith	b. 1771– d. 1852	Southampton/ New York City/Cohoes, New York/ Plainfield, New Jersey	—	—	—	Banta, *Sayre Family*
*Sayre, Paul	Silversmith	b. 1760– 1800	Southampton	—	—	—	Banta, *Sayre Family*
*Simons, Elijah	Silversmith/ Clockmaker/ Watchmaker/ Jeweler/ Blacksmith	1804–1831	Sag Harbor	—	—	Advertisements, *Suffolk Gazette,* Aug. 27, 1804– July 21, 1810; *Suffolk County Recorder,* Aug. 2, 1817; *The Corrector,* May 26, 1827, June 4, 1831	EHFL
Smith and Lowe	Watchmakers	1829	Brooklyn	—	—	Spooner, *BD*	—
Smith, John G.	Watchmaker/ Jeweler	1832	Brooklyn	—	—	Advertisement, Bigelow, *BD,* 1842	—
*Smith, Samuel	Silversmith/ Clockmaker/ Watchmaker/ Jeweler	1818–1837	London, England/ Huntington/ Brooklyn/ [Sag Harbor?]	—	—	Advertisements, *Long Island Star,* July 22, 1818–Nov. 23, 1826 Advertisement, *The Corrector,* Sept. 30, 1837 Spooner, *BD,* 1822–1826	LIHS EHFL —
*Smith, Thomas	Watchmaker	1782	New York City/ Brooklyn	—	—	Advertisement, *Brooklyne Hall Super-Extra Gazette,* June 8, 1782	Stiles, *History of Brooklyn*
Stanbrough, Lewis	Silversmith	1783–1792	Southampton	—	—	Land indentures, 1783, 1792	Howell Collection, LIHS
Taylor, John	Silversmith	1802	Hempstead	—	—	—	Darling Foundation, *Silversmiths*
*Tiley, James	Silversmith	1740–1792	Hartford, Connecticut/ Southampton/ Norfolk, Virginia	—	—	Pelletreau papers Elias Pelletreau AB Elias Pelletreau ABs —	LIHS LIHS EHFL Failey, "Elias Pelletreau"
Underhill, Andrew	Silversmith	b. 1749– d. 1800	Westbury/ Islip/New York City	—	—	Will of William Nicoll, 1778 —	NYHS *Abstracts,* IX Darling Foundation, *Silversmiths*
Van Voorhis, Daniel	Goldsmith/ Dentist	b. 1751– d. 1824	New York City/ Philadelphia/ Princeton, New Jersey/ Vermont/ Brooklyn	—	—	Spooner, *BD,* 1823 —	— Darling Foundation, *Silversmiths*
Waters, John J.	Watchmaker	1778	Newtown	—	—	Will of Alexander Meharg, 1778	NYHS *Abstracts,* IX

Name	Occupation	Date	Location	Birthplace	Age	Document	Source
*White, Edward	Silversmith	b. 1732– d. 1767	Southampton/ Hartford, Connecticut/ Orange County, New York	—	—	Pelletreau papers — —	LIHS Failey, "Elias Pelletreau" Howell, *History of Southampton*
*White, Frederick	Watchmaker	1825–1829	Brooklyn	—	—	Advertisement, *Long Island Star,* Oct. 19, 1826 Spooner, *BD,* 1825–1826, 1829	LIHS —
*White, Silas	Silversmith	b. 1742– d. 1798	Southampton/ Orange County, New York	—	—	Letter, Lydia King to the author, Sept. 9, 1973 —	— Howell, *History of Southampton*
Whiteman, Ira	Goldsmith	1759	Suffolk County	Durham, Connecticut	19	Muster roll, 1759	NYHS *Collections,* 1891
Wright, John	Watchmaker	d. ca. 1768	Flushing	—	—	Will	NYHS *Abstracts,* VII

Henry N. King,

BEGS leave to inform his friends and the public in general, that he has commenced the

Clock and Watch-making Business,

at Sag-Harbor. He flatters himself he shall be able to make the dumb to speak, and bring the dead to become a living and useful piece of machinery. Those who think proper to favor him with their custom, and direct their Watches or Clocks to be left at the shop formerly occupied by Mr. Benjamin Coleman they will be carefully repaired and forwarded to the owner.

December 19 1807.

APPENDIX II
LONG ISLAND SILVERSMITHS, CLOCKMAKERS, WATCHMAKERS, AND PEWTERERS, 1640–1830

B. SKETCHES OF CRAFTSMEN

Adams, Nathan (active ca. 1808), Sag Harbor
Despite his appeal to Sag Harbor citizens in the November 26, 1808 issue of the *Suffolk Gazette* to "COME AND SEE," Adams' business was apparently short-lived. He advertised only once in the *Gazette,* stating that he would repair watches and clocks and execute ornamental engraving.

Carman, Samuel (active ca. 1818–1826), Brooklyn
Carman's advertisement in the June 10, 1818 issue of the *Long Island Star* began with his expression of gratitude "to his customers of the counties of Kings, Queens and Suffolk for their former patronage." He stated that he offered a seven-year guarantee on the "Time Pieces Clocks and movements" that he manufactured, and he promised that "every kind of gold work" would be "neatly made and repaired." Other notices which appeared in the *Star* in 1821 and 1823 document his move from a previous location on Fulton Street to 59 Fulton Street. In both 1824 and 1825, Spooner's *Brooklyn Directory* lists Carman's address as 57 Fulton Street, but the 1826 *Directory* places him at 68 Fulton Street.

Coleman, Benjamin (active ca. 1802–1820), Sag Harbor/Southold
In 1802, Benjamin Coleman of Sag Harbor placed the following advertisement in the *Suffolk County Herald:* "WANTED IMMEDIATELY/ A smart lad, 14 or 15 years of age, as an apprentice to the Gold & Silver-Smiths Business." The John Lyon Gardiner account and day books (EHFL) also contain references to Coleman. In 1802, he supplied Gardiner with "one mourning ring for D. Buell," mended a tea kettle, and repaired a gold watch key. The following year Coleman fashioned for Gardiner "two silver hoops for M. Curdy" and "two Rings," apparently intended for "Mrs. G. and Mrs. Dayton." According to an advertisement in the *Suffolk Gazette* for December 21, 1807, Henry N. King had established his "Clock and Watch Making Business at Sag Harbor" in Coleman's former shop. This notice supports the local tradition that Coleman at one time operated a shop near Sag Harbor on Poxabogue Road.

Perhaps Coleman made only jewelry and flatware. The only known products of his shop to survive are spoons. He was probably not a very successful silversmith since he was doing "Blacksmith work" in 1819, as noted in an account book kept by the Southold merchant, Samuel S. Vail (NYHS). Nor does the inventory of Coleman's estate (SCSC) suggest an active or successful craftsman. At the time of his death, he owned the following tools and supplies: "Coopers edge/ 2 plain/ 4 chissels/ 6 gimbels/ 1 pr bellows/ anvil/ vice/ set of blacksmith hammers/ set of tongs, nail tools/ set punches/ 12 cole chissels/ lot old iron/ 1 brace & bits/ 3 hand [?]/ 1 [?] mould/ 1 pr. steelyards/ lot wire/ wood in shop chamber/ 1 lot old silver & gold in the last shop."

Conklin, Charles J. (active ca. 1832–1837), Sag Harbor
Conklin advertised his silversmith's and gunsmith's skills in the July 14, 1832 issue of *The Corrector.* His shop was located "one door below N. Tinker's," the Sag Harbor cabinetmaker's shop. Conklin apparently discontinued this advertisement after twelve weeks and did not place another notice in *The Corrector* until September 30, 1837. He then stated that he had "taken the shop formerly occupied by S. Smith, Watch Maker" and would continue "the Watch and Jewelry Business."

Conkling, William Sherrill (bpt. 1779–1832), Southampton
Although business was never quite as good for Elias Pelletreau after the Revolution as it had been before, there was enough activity in the shop for him to take on Conkling as an apprentice. Family relations may also have influenced Pelletreau's decision since "Sherry," as Pelletreau called him, was a nephew of Pelletreau's second wife. Pelletreau first referred to his "apprintice Sherry Conkling" in his fourth account book (EHFL) in an entry dated December 3, 1793. Again, in 1795, Pelletreau credited Conkling for making a "steal top thimble." Pelletreau did not mention Conkling again and no further evidence of Conkling's career as a silversmith has been located.

Davison, Clement (active ca. 1822–1829), New York City/Brooklyn
Davison's shop was located on Fulton Street, near the corner of Pearl Street, in New York City, as listed in the Brooklyn directories for 1822 through 1826 and 1829. An advertisement in the *Long Island Star* for September 25, 1822, provides an explanation for Davison's listing in the directories. In this advertisement Davison stated that he had moved his shop "for the present from . . . New York to the office of the *Long Island Star* No. 60 Fulton Street, Brooklyn," where he kept "a general assortment of watches . . . seals and keys, silver and plated Table and Tea spoons . . . etc." He may have used this location only as a sales shop.

Elliot, Zebulon (active ca. 1822–1846), Sag Harbor
On August 3, 1822, Elliot announced in *The Corrector* that he had established a "Clock and Watch Making" business in Sag Harbor. He also stated that he made and repaired silver and jewelry. Two years later, when he advertised in *The Corrector* for November 20, 1824, he mentioned only his silver work and jewelry, noting that "silver spoons and thimbles, Finger Rings, Ear Rings, Breast Pins, Watch Chains, Seals, Keys, etc." were available at his house. The following year he offered his customers "silver spectacles" of his own manufacture. On May 16, 1829, in *The Corrector,* Elliot listed "a new and fashionable assortment of Jewelry Watches and fancy articles" he was offering for sale. These included "English French and Swiss watches," gold earrings, gold and pearl finger rings, and flatware, thimbles, pens, and toothpicks, all made of silver. The advertisement does not indicate which of these items he made. The last notice of Elliot's business appeared in *The Corrector* on June 6, 1846, when he announced that he had recently returned from New York City with "watches, clocks, jewelry, fancy goods, cutlery, etc." which he planned to sell "at very low prices."

Gray, James (active ca. 1821), Brooklyn
In the June 14, 1821 issue of the *Long Island Star,* Gray informed "the inhabitants of Brooklyn and its vicinity" that he pursued the trade of "Clock Making, Watch Repairing & Machinist . . . in its various branches," at his shop on Front Street.

Griffen, Peter (active ca. 1810), Hempstead
Griffen has not been positively identified as a silversmith, however, he did purchase button molds of varying size from Henry Demitt of Hempstead in 1810, as noted in Demitt's account book (NCHM). Silversmiths, of course, used these molds to make buttons.

The Darling Foundation's *New York State Silversmiths* lists a Peter Griffen working in Albany, New York, about 1815, who later went into partnership with his son and moved to New York City in 1832. Perhaps this Peter Griffen began his career on Long Island and was the craftsman mentioned in the Demitt account book.

Hedges, David (1779–1857), East Hampton
Unlike several of his competitors, Hedges did not advertise in the nearby Sag Harbor newspapers. Perhaps his reputation was suffi-

ciently well established in the vicinity, or perhaps his duties as town supervisor and representative in the State Assembly diverted his attention from silversmithing. His activity as a craftsman has been the subject of considerable local attention, however, and requires examination.

The discovery that David's older brother, John Chatfield Hedges, mentioned below, was a silversmith necessitates a reevaluation of the traditional assumption that David apprenticed with Elias Pelletreau in Southampton. Pelletreau's account books, in fact, provide no evidence of David Hedges' apprenticeship. It is more likely that Hedges trained with his own brother. When John Chatfield died in 1798, David was just old enough to take over his brother's trade.

In addition to many marked spoons, two porringers by David Hedges are also extant. One can find additional information about the range of forms he produced in John Lyon Gardiner's account and day books (EHFL). An entry dated 1801 is the first documented reference to Hedges' silversmithing activities, and at that time he made a pair of knee buckles and salt spoons, hardly an ambitious order. In 1803, Gardiner commissioned several spoons and rings from Hedges. It is interesting to note, however, that in 1802 Gardiner ordered hollow ware from John Pelletreau (No. 192). Gardiner was apparently satisfied with Hedges' work on small items for he continued to place orders with him as follows: fifty gold beads "for D. J. Gardiner" and "one coco [coconut] dipper" in 1804, "One silver cup for D. J. G." in 1805, a "handle to punch spoon" in 1806, and in 1809, salt spoons and "2 spoons silver."

It is difficult to determine Hedges' period of activity as a silversmith, especially since he began his State Assembly terms in 1825. His shop, which may also have been his brother's, once stood between Clinton Academy and the Hedges house in East Hampton. In 1901, the shop was moved and joined to the house. For a mid-nineteenth century description of the shop and character sketch of Hedges, see Chapter IV.

Hedges, John Chatfield (1770–1798), East Hampton

John Chatfield Hedges was the son of William and the brother of David Hedges. His early death and the extent of his brother's reputation as a silversmith may account for his current anonymity. It is reasonable to assume that John Hedges trained his brother, David, but there is no evidence of John's own apprenticeship.

Pelletreau's surviving account books contain no references to a period of training for Hedges, but Pelletreau did credit Hedges for "workmanship" in 1791 and for "10 weeks Jorney work" in 1792, for which Hedges received £12. Entries in John Lyon Gardiner's day book (EHFL) document Hedges' craft activity in the late 1790's. In 1797, Gardiner paid Hedges for the mending of a key and in 1798 credited Hedges for mending a key and seal and for making "one pair buckle" and spoons. Again, in 1798, Gardiner noted that he had written "J. C. Heges" to inquire if he could "make or get made 2 porringers."

It is only conjecture at this point, but John Chatfield may well have fashioned some of the silver marked simply "HEDGES" and usually attributed to David.

Howell, Silas (active ca. 1761), Southampton

In August, 1761, Elias Pelletreau credited Stephen Rogers for writing an apprenticeship indenture for Silas Howell, as documented in Pelletreau's second account book (EHFL). Pelletreau, however, did not mention Howell again in his accounts, and it is possible that the indenture was nullified.

Hutton, John (active ca. 1735), Oyster Bay

Hutton is identified as a silversmith in a land indenture of 1735 (OBTR). The Darling Foundation's *New York State Silversmiths* includes a listing for a John Strangeways Hutton, born in 1684 and active in New York City about 1720. This Hutton later moved to Philadelphia. He was, perhaps, the Hutton mentioned in the Oyster Bay land indenture.

Jular, George (active ca. 1811), Sag Harbor

Jular advertised in the *Long Island Star* on December 25, 1811, calling himself a "Clock and Watch Maker, Silversmith, etc." He informed Sag Harbor residents that he had opened a shop "next door to Dr. Prentices" and added that because of "his unremitted attention and experience in business (as being from the first manufactories in England)," he hoped he might gain public support.

King, Henry N. (active ca. 1807–1811), Sag Harbor/Brooklyn

On December 21, 1807, the *Suffolk Gazette* carried an advertisement stating that Henry N. King had "commenced the Clock and Watch Making Business at Sag Harbor." Three years later, however, King advertised in the *Long Island Star* that he had established his "Clock and Watch Making Business in Brooklyn . . . in Old Ferry Street." His presence there is confirmed by a listing for his shop in Longworth's *Directory* for 1811.

Lowe, John (active ca. 1826–1830), Brooklyn

On November 23, 1826, Lowe announced in the *Long Island Star* that he had formed a partnership with Samuel Smith to conduct the watchmaker's, jeweler's, and silversmith's business at their shop on Fulton Street. A listing for this firm in Spooner's *Brooklyn Directory* for 1829 documents their continued activity through 1829. However, only Lowe's name appears in Nichols' *Brooklyn Directory* for 1830.

Malcom, Hugh (active ca. 1791), Southold

The only reference to Malcom is the following advertisement which he placed in David Frothingham's *Long Island Herald,* published in Sag Harbor, on December 17, 1791:

> Gold and Silversmith begs leave to inform the inhabitants of Southold and its vicinity, that he carries on the Silver Smiths business in all its various branches, at the shop formerly occupied by Mr. Benjamin Prince, in Southold, where every command in his way will be speedily complied with and faithfully executed on the most reasonable terms: He begs the continuance of Mr. Princes old customers. N.B. Cash will be given for old brass and copper.

Perhaps Malcom apprenticed with Prince, mentioned below.

Pelletreau, Elias, Sr. (1726–1810), Southampton

Unquestionably, Pelletreau was Long Island's most noted and successful eighteenth century silversmith. Of French Huguenot descent, Pelletreau apprenticed in 1741 with another Huguenot craftsman, Simeon Soumaine. After serving his seven year indenture, he remained for a time in New York and was named a Freeman of that city. By the early 1750's he had returned to Southampton, where he practiced silversmithing until the Revolution. Fearing reprisals because of his sympathy for the Patriot cause, Pelletreau fled to Connecticut after the British occupation in 1776. He returned to Southampton in 1782 and remained there until his death in November, 1810.

Pelletreau's four account books (EHFL, LIHS) and a number of miscellaneous Pelletreau papers (LIHS) have provided the basic

primary evidence for a detailed study of his craft practice by Dean F. Failey, entitled "Elias Pelletreau: Long Island Silversmith." As noted in this study, Pelletreau fashioned a variety of silver forms, including tankards, canns, cups, mugs, porringers, milkpots, sugar cups, teapots, coffee pots, pepper boxes, spoons, and jewelry. Representative Pelletreau hollow ware appears in this catalogue.

Pelletreau attracted customers from all over Long Island, including some of the most prominent families—the Townsends, Woodhulls, Floyds, L'Hommedieus and Gardiners. A unique aspect of Pelletreau's business was his use of more than twenty salesmen, or agents, who from their shops in Southold, Brookhaven, Huntington, and elsewhere, sold spoons, buckles, beads, and other pieces of jewelry on a commission basis.

Because of Pelletreau's fame, tradition often identifies other local silversmiths, such as David Hedges and the Sayre brothers, as his apprentices. While there is no evidence to substantiate some of these claims, Pelletreau's accounts indicate that he trained Silas Howell, "Sherry" Conkling, James Tiley, his son, John, and, possibly, his brother-in-law, Edward White.

The inventory of Pelletreau's estate (SCSC) lists silversmith's tools valued at $100. The complete inventory follows:

Six pr Cent Stock	[$]	452	24
Three pr Cent D⁰		660	24
Apparel		10	00
5 Beds & beding			
3 bed steads		50	00
1 bureau		5	00
1 large looking glass		6	00
1 Small D⁰		2	50
1 Square table		1	00
1 Small D⁰			75
8 Chairs		3	75
1 Old Desk and bookcase & books		13	00
1 House Clock		35	00
1 Old chest			50
2 Silver porrenger		14	00
1 Silver tankord		25	00
1 pepper box		1	50
4 table Spoons		6	00
1 pair of Sugar tongs		1	00
1 case of bottles		3	00
crockery			75
1 pair of bellows			25
Hollow ware		1	00
Andiron Shovel & tongs		2	50
Puter [Pewter]		1	75
Kitchen Furniture & [?]			
1 [?] table			75
1 Meal chest			50
1 Cupbord			37
2 Skimmers & 2 tea kettles			25
Old chair		1	50
2 chests			25
2 wheels & clock reel			75
2 Stands		1	25
6 Windsor Chairs		2	50
2 tables		4	00
1 trunk			75
pickters [pictures?]			50
Old chest			25
3 Hogsheads			75
1 buchel [bushel] of 1 D⁰ barn 4/		1	50

2 Old chests		25
Silversmiths tools	100	00
14 Silver Stock buckels	7	00
6 pair plated buckels	3	00
1 pair Silver D⁰	2	00
Old Silver & Gold etc.	30	00
1 Silver Watch	10	00
Slive buckels Stock etc.	3	50
1 glass Case	1	00
1 pair Gold sleave buttons	2	00
Total	$ 1,473	65

Pelletreau, Elias, Jr. (1757–), Southampton

Elias Pelletreau's oldest son, John, apprenticed with him and succeeded him in his Southampton shop. It is possible, then, that Elias Pelletreau, Jr., never learned silversmithing. There is no evidence to suggest that he actively practiced this craft. In 1773, he advertised in the New York Mercury that he had set up a shop in the city for the "cutting of whalebone." He also announced that he had for sale a "parcel of Silver Smith's Tools." Following the Revolution, Elias, Jr., may have briefly helped his father and brother re-establish their Southampton shop. He soon opened a general store in Southampton, however, and pursued his mercantile interests. The Darling Foundation's New York State Silversmiths confuses Elias, Jr., with his well-known father.

Pelletreau, John (1755–1822), Southampton

As the oldest son of the Southampton silversmith, Elias Pelletreau, John was the natural successor to his father's business. Entries in Elias Pelletreau's account books (EHFL, LIHS) indicate that John was active in the shop by 1774. The outbreak of the Revolution forced John to move to Connecticut with his father in September, 1776. Upon their return to Southampton in 1782, John generally shared the work equally with his father and by 1800, he was the dominant figure. Like Elias, John also ran a substantial farm.

Although a porringer bearing an "IP" mark, and said to be the work of John Pelletreau, was exhibited at the Brooklyn Museum in 1957, it is likely that John continued to use his father's "EP" touchmark (No. 192 in this catalogue). John sought and obtained an appointment as County Coroner in 1798, indicating that his business was on the decline. John continued his father's last account book and after 1810 he recorded only six orders for hollow ware. It is, therefore, not surprising to find that John's son, William, also a silversmith, left Southampton to work in New York City.

When Elias died, John inherited most of the estate. The inventory of John's estate, dated 1822, lists silversmith's tools with an appraised value of $100. The total value of his estate was $770.

Pierson, Daniel (active ca. 1791), Sag Harbor

The following advertisement appeared in Frothingham's Long Island Herald several times during 1791: "A generous price will be given for old brass and copper by Daniel Pierson, Goldsmith, Sagg Harbour."

Potter, Nathaniel (1761–1841), Huntington

Potter was the son of Dr. Gilbert and Elizabeth Potter of Huntington. He is identified as a silversmith in the letters of administration, dated 1790, of an unidentified estate (SCSC). Potter's day book (HHS), which deals with his activities from 1807 through 1829, shows that he later combined silversmithing and jewelry work with general merchandising. Since so few references to silver and gold work

appear in this book, he may have kept a record of his craft practice in a separate account book. Several day book entries, however, document his fashioning of spoons, sugar tongs, and jewelry. He also engraved some items and repaired watches. Genealogical notes on the Potter family (HHS) include a reference to his silversmith's shop on Shoemaker Lane and suggest that some of his table silver is extant. No examples of his work, however, have been located.

Potter, like his contemporary, David Hedges of East Hampton, served several terms as a representative in the State Assembly. When he died, he bequeathed $10,000 to the Huntington Union School for the education of the poor.

Prince, Benjamin (active ca. 1770–1789), Southold
Prince is identified as a silversmith in a list of the inhabitants of Suffolk County compiled in 1778 for the British governor in New York City (*NYGBR,* 1973). One can find earlier references to Prince in the account book of the Southold joiner John Paine (Colonial Institute Records, SUSB). In 1770, Paine made three dozen button molds and a shovel for Prince and several years later, in 1789, Paine made his coffin. In the December 13, 1791 issue of Frothingham's *Long Island Herald,* Hugh Malcom announced that he conducted "the Silver Smiths business . . . , at the shop formerly occupied by Benjamin Prince. . . ." Malcolm requested "the continuance of Mr. Princes old customers."

Roe, Walter (1770–1827), Flushing
The inventory of Roe's estate (QCSC) refers to the "Shop Chamber" and lists "1 Lott Silver Smith Tools" with an appraised value of $50.

Sayre, Caleb (1764–1847), Southampton/Seneca County, New York
Thomas Banta's *Sayre Family* provides basic information about the Sayre family silversmiths. The Darling Foundation's *New York State Silversmiths,* does not list Caleb, whom Banta identifies as a jeweller and a goldsmith. Caleb was the brother of Paul, also a silversmith, mentioned below, and the son of Joshua Sayre, a Southampton farmer. The master craftsmen with whom the Sayres apprenticed remains unidentified. Presumably, Caleb was active in Southampton before moving to Seneca County in 1816.

Sayre, Joel (1778–1818), Southampton/New York City
Joel Sayre, according to Thomas Banta's *Sayre Family,* was the son of Matthew Sayre of Southampton and the brother of the silversmith, John Sayre, mentioned below, also of Southampton. By 1802, Joel, a silversmith, resided in New York City on William Street and occupied a shop on Maiden Lane. In order to practice his craft full-time, he probably found it necessary to leave rural Southampton.

Sayre, John (1771–1852), Southampton
There is a persistent tradition that the Sayre family silversmiths apprenticed with Elias Pelletreau. This contention seems logical, but, unfortunately, lacks documentation. According to Banta's *Sayre Family,* John, the brother of Joel Sayre, mentioned above, was active as a silversmith in Southampton for a time, but then moved to New York City and became a book publisher. John's name appears in the New York directories between 1796 and 1814. John later moved to Cohoes, New York, where he managed a cotton factory in 1824. He died in Plainfield, New Jersey, in 1852.

Sayre, Paul (1760–active ca. 1800), Southampton
Paul was the brother of Caleb, mentioned above, and the son of

Joshua Sayre, a farmer. In the family genealogy, *Sayre Family,* Thomas Banta writes that Paul, also a silversmith, was a member of the church in Southampton in 1800 and thus, apparently, still a resident there.

Simons, Elijah (active ca. 1804–1827), Sag Harbor
The first evidence of Simons' craft practice is an advertisement he placed in the *Suffolk Gazette* for August 27, 1804. Under the heading of "GOLD AND SILVER SMITH," he announced the opening of his shop "a few rods north of the Market." He called attention to his clock- and watch-repairing skills and noted that he would pay cash for old gold and silver. His advertisements over the next thirteen years described the watches and clocks he had for sale. These were not always of his own manufacture, and frequently his notices began with the statement, " . . . just received from New York. . . ." Occasionally, he mentioned jewelry items which he had for sale, such as "a handsome assortment of Ear hoops and Knobs, gold Breast pins, and finger rings." Each of Simons' advertisements usually ran for several months, including the notice which first appeared on June 1, 1807, reporting that Simons had "lately removed to the lower story of the new Printing Office."

On March 17, 1810, Simons dropped his "GOLD AND SILVER SMITH" heading in the *Suffolk Gazette* and replaced it with "CLOCKS & WATCHES." He proceeded to state that he still continued his "business of Clock Making and Watch Repairing." His business took a strange turn when, on July 7, 1810, he offered groceries for sale, in addition to jewelry and watches. An advertisement which appeared on August 2, 1817, again announced clocks "just received," and clock cases for sale.

Although he stopped advertising in the local papers for several years after 1817, the continuation of his clock and watch business is verified by correspondence between Simons and Felix Dominy of East Hampton (Hummel, *With Hammer in Hand*). Dominy, whose own business was declining, made clock gears for Simons from at least 1820 to 1822. There is evidence, however, that Simons had diversified his activities by 1827 when a notice appeared in the May 26 issue of *The Corrector* announcing Simons' new partnership in the blacksmith's business. He apparently remained active as a blacksmith, for the June 4, 1831 issue of *The Corrector* carried his request for the return of a runaway apprentice to the blacksmith's trade.

Smith, Samuel (active ca. 1818–1837), Huntington/ Brooklyn/[Sag Harbor?]
Smith first advertised on July 22, 1818, in the *Long Island Star* as a clock- and watchmaker and silversmith "From London." In addition to describing the articles he had for sale, he noted that his shop was in Huntington and stated that he would accept "wool and grain . . . in payment." An advertisement in the *Long Island Star* for June 2, 1819, documents his move to Brooklyn, where he "commenced business at the house lately occupied by Judge Sharp in Fulton Street." During the next few years he expanded his business and sold a wide variety of goods including jewelry, lamps, and imported watches. Listings for Smith appear in Spooner's *Brooklyn Directory* for the years 1822 through 1826 and 1829.

In the November 23, 1826 issue of the *Long Island Star,* Smith announced his new partnership with John Lowe. The partnership lasted until 1829, as the firm was listed in Spooner's *Brooklyn Directory* for that year.

Evidence that Smith may have moved to Sag Harbor sometime thereafter can be found in an advertisement in the Sag Harbor paper, *The Corrector,* for September 30, 1837. Charles Conklin

stated in this notice that he had moved into the shop "formerly occupied by S. Smith, Watchmaker."

Smith, Thomas (active ca. 1782), Brooklyn
Smith advertised in the *Brooklyne Hall Super-EXTRA Gazette* for June 8, 1782, as follows: "Watch Maker, from New York acquaints the public he has moved into the house formerly occupied by Mr. Ross, at Brooklyn Ferry, where he carries on the business in its different branches."

Tiley [Tilley], James (1740–1792), Hartford, Connecticut/
 Southampton
In *The Heritage Foundation Collection of Silver,* Martha Gandy Fales describes Tiley's silversmithing activities in Hartford. He is included here because of new information which indicates that he worked on Long Island as a journeyman in the shop of Elias Pelletreau. Tiley's introduction to Pelletreau came through Pelletreau's brother-in-law, Edward White, mentioned below, a previously unrecorded Hartford silversmith with whom Tiley apparently apprenticed. In a 1761 letter in the Pelletreau papers (LIHS) White wrote Pelletreau as follows: "James Tiley's time is out with me, [and] he hath a mind to travel about to perfect himself in the Goldsmiths trade more especially in the larger branch of the same viz such as making of tankards canns porringers. . . ." White spoke well of Tiley's background and asked Pelletreau to take him on in his shop.

 Tiley arrived on Long Island in July, 1761, but the specific date of his training with Pelletreau is not known. Pelletreau's surviving account books (EHFL, LIHS) contain references to Tiley from 1761 through 1769, several years after his return to Hartford. It is possible he stayed in Southampton, at least part of the time, until 1765. During this time, Pelletreau credited Tiley only for the fashioning of flatware and for "stone" and jewelry work. Since Tiley apparently did not make hollow ware for Pelletreau, he may not have perfected his skills as he had wished. However, he did find a bride in Southampton. He married Edward White's sister, Phebe, a resident of that town.

White, Edward (1732–1767), Southampton/Hartford,
 Connecticut/Orange County, New York
White was the second son of Southampton's well-known pastor, the Rev. Sylvanus White (1704–1782). Both Edward and his brother, Silas, became silversmiths, although little is known about their careers. Edward married Hannah Pelletreau, sister of Elias Pelletreau, mentioned above. Although White may have apprenticed with Pelletreau, it is more likely, given White's age, that he completed his training shortly after Pelletreau finished his apprenticeship in 1747–48. Furthermore, the style of White's touchmark suggests New England training, possibly Boston.

 White was, however, familiar with the activities of Pelletreau's shop and corresponded with Pelletreau after establishing himself in Hartford. White wrote a revealing letter in 1761 (LIHS), requesting the Southampton silversmith to take on his (White's) former apprentice, James Tiley, for further training. White believed that Tiley "would have a chance to see more large work made in your [Pelletreau's] shop in one winter than he will in mine in 3 years." White was in Hartford at least until 1763. Sometime thereafter he moved to Orange County, New York, possibly settling near his brother who had also moved there. He died in Orange County in 1767.

White, Frederick (active ca. 1826–1829), Brooklyn
The watchmaker, "F. White," who advertised in the October 19, 1826 issue of the *Long Island Star* that he had "recommenced business at his former stand, No. 4 Sands Street," is the same Frederick White, watchmaker, listed in Spooner's *Brooklyn Directory* for 1825, 1826, and 1829.

White, Silas (1742–1798), Southampton/Orange County,
 New York
An extraordinary number of silversmiths can claim Southampton as their birthplace, including Silas White, his brother Edward, the Sayres, and the Pelletreaus. Silas, the fifth son of the Rev. Sylvanus White, may have trained with his brother, Edward, who was active in Hartford, Connecticut, or elsewhere in New England. There is no evidence to suggest that he apprenticed in Southampton with Elias Pelletreau. Several spoons owned by a descendant bear his touchmark.

Production Credits

Project photography by Joseph Adams
Catalogue designed by Joseph del Gaudio Design Group Inc.

Production Credits for Second Edition

Pages 9-1 to 9-49 designed by The Market Street Group
Printed by Thomson-Shore, Inc.